HARMONY+DISSENT

Film and Avant-garde Art Movements in the Early Twentieth Century

R. BRUCE ELDER

Wilfrid Laurier University Press

WLU

This book has been published with the help of a grant from the Canadian Federation for the Humanities and Social Sciences, through the Aid to Scholarly Publications Programme, using funds provided by the Social Sciences and Humanities Research Council of Canada. We acknowledge the financial support of the Government of Canada through its Book Publishing Industry Development Program for its publishing activities.

Canada Council for the Arts Conseil des Arts du Canada ONTARIO ARTS COUNCIL / CONSEIL DES ARTS DE L'ONTARIO

Library and Archives Canada Cataloguing in Publication

Elder, Bruce (R. Bruce)
Harmony and dissent : film and avant-garde art movements in the early twentieth century / R. Bruce Elder.

(Film and media studies series)
Includes bibliographical references and index.
ISBN 978-1-55458-028-6

 1. Art and motion pictures. 2. Avant-garde (Aesthetics). 3. Modernism (Art). I. Title. II. Series.

NX175.E43 2008 791.4309'041 C2008-901637-8

© 2008 Wilfrid Laurier University Press

Cover design by Blakeley. Front-cover image from Eisenstein's film *Strike* (1924). Author photo on back cover by Martin Lipman. Text design by Pam Woodland.

Every reasonable effort has been made to acquire permission for copyright material used in this text, and to acknowledge all such indebtedness accurately. Any errors and omissions called to the publisher's attention will be corrected in future printings.

This book is printed on Ancient Forest Friendly paper (100% post-consumer recycled).

Printed in Canada

CONTENTS

v

L et us begin with a potted taxonomy of vanguard movements in early twentieth-century art so extreme that it amounts to a parody. Some avant-garde movements seem coolly rational, committed to principles of harmony and to means of social reform that arise from those principles; others seem to proffer riotous dissent whose proposed manner of social reform would be far less integrative. Some avant-garde movements (De Stijl, European Constructivism, Minimalism, Orphism, and even, in some measure, Cubism) seem committed to rigorous Pythagorean principles of order, and other avant-garde movements (Futurist, Dada, and Surrealist) to attacking the received principles of good form (of form as order, coherence, and harmony). Thus, we commonly think of an Apollonian avant-garde and a Dionysian avant-garde.

Few would doubt that this taxonomy is all too simple. It is already well established that Neo-Plasticism and Dada, for example—on this too simple schema, movements that seem radically opposed—were in fact closely related (and certain individuals, including Piet Mondrian and Theo van Doesburg, participated in both simultaneously). And more generally, affinities among the various avant-garde movements of the early modernist era have been demonstrated. Moreover, that the avant-garde movements of the twentieth century were varying responses to common (and evolving) social factors is commonly understood. In this book I want to lay the groundwork for

proposing an additional reason for rejecting this too simple dichotomy—I want to open up an additional way of understanding ties that link various avant-garde movements together. I argue that the ideals of many of these vanguard movements, including seemingly opposed movements, were influenced by beliefs then current regarding the character of the cinema: the authors of the manifestos that announced in such lively ways the appearance of yet another artistic movement often proposed to reformulate the visual, literary, and performing arts so that they might take on attributes of the cinema. Indeed, I argue, the role of the cinema in helping shape the new artistic forms that emerged in the first decades of the twentieth century was more than that of one among many influences that cooperated to produce that remarkable flowering of the arts. The cinema, I argue, became, in the early decades of the twentieth century, a pivotal artistic force around which took shape a remarkable variety and number of aesthetic forms.

To get a sense of this claim, let us take a ready-to-hand way of thinking about how the cinema helped shape Constructivism's ideals. Like many of the vanguard movements of the twentieth century, European and Soviet Constructivists proposed to integrate art and life. They argued that to effect this integration, a new art would have to come forth—an art appropriate to the modern age, one that would make use of contemporary (i.e., industrial) materials and adopt contemporary methods of production. Thus, this new (visual, literary, and performing) art would possess some key features of film, for films are made using machines, and often in teams that reflect the industrial manner of organizing production. Moreover, Constructivists contended, to reflect reality, art would have to draw on the actual world; and in keeping with modern scientific principles (as they conceived them), the forms into which this real-world material would be wrought would have to be dialectical in character (for forms arising from dialectical principles reflect the basic underlying dynamic that gives reality its shape). But the cinema was understood as an art form that by its very nature draws on the actual world (its basic material, the filmmaker Sergei Eisenstein contended, are photo-fragments of reality), and these raw materials are organized into dialectical patterns (patterns of conflict). Thus, in these respects, too, the new art the Soviet and European Constructivists hoped to create would be an art that possessed key attributes of the cinema.

These are among the more ready-to-hand ways of thinking about the assertion that the cinema helped shaped the ideals of the Constructivist movement (and more generally, of vanguard movements in early twentieth-century art). The more interesting part of that story lies buried in my comment that the ideals of various avant-garde movements were shaped by then current understandings of the nature of cinema. For the cinema—partly owing to the enthusiasm its novelty engendered and partly owing to the lingering hold of

certain *fin de siècle* notions—was understood in the first decades of the twentieth century far, far differently than we, who live after the end of the machine age, understand it. (Establishing that there were such differences is a principal objective of this book.) To demonstrate this, I have had to begin with a wide-ranging discussion—I have begun by exploring some topics relating to the very broad topic of modernity's cognitive (and perceptual) regime, with a view to establishing that a crisis within that regime engendered some peculiar (and highly questionable) epistemological beliefs and enthusiasms. The relations among the various topics I explore in this opening section of the book are joined by the claim that a crisis of cognition precipitated by modernity engendered, by way of reaction, a peculiar sort of "pneumatic epistemology." Though I fear the meaning of that term may be too antique to be widely understood, that antique linguistic trope has its uses: modernity repudiated pneumatic concerns—and the void created by that repudiation led many early twentieth-century thinkers to conjecture that, if modernity had encountered a crisis, then considering what had been lost in modernity's relentlessly progressive thrust might perhaps help produce a solution to the crisis.

There are many reasons why one might want to explore this pneumatic epistemology—and I wish I had space and time enough to consider more of its aspects than I have. Nonetheless, my reasons for examining the pneumatic epistemology justify limiting the scope of this exploration rather drastically, in that my goal is to explain how the media of film and photography—media that the crisis of cognition called into being (if only to answer to the central spiritual absence that haunts the modern paradigm)—came to be understood as pneumatic devices. These spiritual interests were largely of a peculiar, woolly character; despite that oddity, a belief that the cinema had pneumatic effects accounts in part for the appeal that film exerted in this era—that is, the cinema seemed to give technological (and so scientific) validity to the occult conceptions that formed the core of this pneumatic epistemology. And this phenomenon is even more remarkable: the pneumatic conception of the cinema accounts largely for the extraordinarily important role the cinema played when it came to establishing the ideals formulated by the participants in the various avant-garde movements in the first decades of the twentieth century.

To show how deeply this pneumatic epistemology affected the way art was understood in the first decades of the twentieth century, in the opening sections of this book I explore some broad notions about the nature of art that arose in those years and consider their association with ideas of harmony and purity that many other commentators have also treated. Unlike those art theorists/historians, however, I take up these notions and examine them closely in order to expose the stain that marks them. I try to track these ideas to their lair—for only after doing so can I pursue the more interesting parts of the story of cinema's role in establishing the aesthetic ideals of movements

in visual, literary, and performing arts that arose in the first decades of the twentieth century. Having outlined this more common understanding regarding the nature and role of art, I will be well placed to demonstrate that these ideas were associated with then current beliefs about the nature of cinema. Many historians of art and film have pointed out that in the first decades of the century, visual artists often envied cinema's modern dynamism, and that some turned to film to convey their enthusiasm for modern life. Many scholars, too, have analyzed a particular film's relation to one or another modern art movement: certain films are said to be examples of Dada or of Surrealism, others to be examples of Impressionism, Cubism, Constructivism, or Expressionism. My ambition is grander: to show that the enthusiasm that thinkers of the first decades of the twentieth century felt for cinema led vanguard artists to take cinema as a model for the new art—to take it, then, as a model for recasting the other arts. The fact that cinema appeared (to some) to be a pneumatic influencing machine that answered to the crisis in cognition that modernity had brought on itself was a key part of cinema's appeal. And that appeal—which seems so strange to many of us today—is part of what makes the story so fascinating. This understanding of cinema played a central role in the efforts artists made to recast the arts they practised, as they strived to reformulate them on the model of the cinema (as they understood it).

Thus, I take two approaches to considering the relations between film and the other arts. First, I explore cinema's role as a model for several major twentieth-century art movements. This approach involves demonstrating that the film medium had a privileged status for most of the twentieth century's art movements, and that the participants in these art movements wanted to reformulate poetry, literature, and painting so that those forms might take on some of the virtues of the cinema. Second, I study how the advanced ideas about art and art making proposed by the actual participants in modern art movements, and the advanced artistic practices they developed, reciprocally influenced the cinema.

I focus on the effort to develop an abstract art rooted in a conception of pure visuality and on Constructivism partly because the histories of the two movements are so intertwined—indeed, as I point out, central figures in the movement for *gegenstandlose Kunst* in Germany, including some key figures in the Absolute Film, had close contact with Soviet Constructivists and even viewed themselves as European Constructivists. I focus on the efforts to develop an abstract art based on a conception of pure visuality and on the Constructivist movement for another reason as well: these movements are sites well suited for exposing the extraordinary influence that the pneumatic philosophy had on the arts in the first decades of the twentieth century. Discussions of the development of abstract art, and of Constructivism generally, have long asserted that materialist principles were at their core. This assertion

is not untrue—but its truth depends on how one understands the nature and aesthetic potential of material, and I believe that the notion of materiality that is usually said to be at the heart of this enterprise is woefully truncated. Approaching the concept of material as the pneumatic philosophy construed it results in a radically new understanding of the nature of the artistic movements I deal with in this book and in a new appreciation for the important association that the notion of materiality had with an idea of pneumatic influence (and with cinema as a pneumatic influencing machine). For example, it makes the Constructivists' formulation of their movement's ideals far less Apollonian that it is usually presented as being. In this way, I hope to demonstrate the need for a new history of early avant-garde art, one that acknowledges the role that cinema (understood as those who lived in the first rush of excitement about it might have understood it) played in establishing the aesthetic ideals of those movements.

These topics of pure vision and the relationship between spirit and matter, concept and medium, bring us inevitably to a theme that runs throughout this book—that of the Inter-Arts Comparison. The history of the debates around that topic is probably familiar to many readers. The prehistory of the notion of the Sister Arts is rich and enormously interesting (and, for many of us, its implications have helped us challenge the epistemological basis of modernity). Yet we also know that the eighteenth century saw key developments in the history of aesthetics: thinkers of that period fundamentally transformed the discussion of the arts—indeed, it is unlikely that the "fine arts" as an idea even existed before the eighteenth century. It is Paul Oskar Kristeller whom one cites on this matter, and his renowned two-part essay, "The Modern System of the Arts: A Study in the History of Aesthetics," which begins with a summary of common claims about eighteenth-century aesthetic theory. In that summary he points out that the very term "aesthetics" was coined during the eighteenth century and that the "philosophy of art" was invented at that time. Only with reservations can we apply the term "philosophy of the arts" to discussions of earlier times. It was only in the eighteenth century, Kristeller points out, that the dominating concepts of modern aesthetics—concepts such as sentiment, genius, originality, creative imagination, and so on—assumed their modern meaning.

Especially germane to our study of the interactions among the arts is the following point, which Kristeller makes in his summary of received ideas: it was only in the eighteenth century that the various arts were compared and that common principles were discussed: "Up to that period treatises on poetics and rhetoric, on painting and architecture, and on music had represented quite distinct branches of writing and were primarily concerned with technical precepts rather than with general ideas."[1]

Kristeller's distinctive contribution to this discussion is to point out that the system of the five major arts—painting, sculpture, architecture, music, and

poetry (these are commonly thought to form the irreducible nucleus of the fine arts, though to them are sometimes added gardening, engraving, decorative arts, dance, theatre, opera, and prose literature)—is of comparatively recent origin. He explores the notion of a system of the arts and points out that an idea generally taken for granted—that these five arts are clearly separated from craft, science, religion, and practical activity—emerged only in the eighteenth century. The Greek term for art, τέχνη (techne), and the Latin ars were applied to other activities, including crafts and sciences: included under the term τέχνη were all activities that required skill and so could be taught. Even the Greek term for beauty, καλόν (kalon), and the Latin term, pulchrum, did not have the same meaning as our modern term beauty. The Greek καλόν and the Latin pulchrum included the moral good. καλόν can be translated as beautiful, honourable, noble, fine. Thus, in the Symposium, Plato argued that the beautiful is the good and that the good is the beautiful. For thinkers of the Classic era, the term "beautiful" referred above all to spiritual beauty, and by "spiritual beauty" they understood moral beauty. Cicero accordingly translated καλόν not as pulchrum but as honestum. St. Augustine took over Cicero's understanding of καλόν, and so that view of beauty came to persist throughout the Middle Ages. In the Middle Ages too, the beautiful was understood also to refer paradigmatically to transcendental beauty as opposed to sensuous beauty.

In the Phaedrus 246d-e, Socrates offers a passing remark, τὸ δε θεῖον καλόν, σοφόν, ἀγαθόν, καὶ πᾶν ὅτι τοιτοῦτον (to de theion kalon, sophon, agathon, kai pan hoti toiuton; "the divine is beauty, wisdom, goodness, and all such things"). As Kristeller correctly points out, that comment was not meant to express the Medieval idea of the identity of the transcendentals, Beauty, Truth, and Goodness. However, the Stoics and Neoplatonists offered precisely that interpretation of the comment.[2] Augustine was influenced by his Neoplatonist masters to accept that interpretation, and to the Middle Ages he passed down Plato and the Neoplatonists' belief in the identity of the Beautiful and the Good, with the Good being the ultimate transcendental being. Our discussion of the relations among the arts will show that modern artists reaffirmed this belief.

Kristeller identified ideas of the Classical, Medieval, and Renaissance eras that anticipated the eighteenth-century idea of the system of fine arts. Plato and Aristotle linked poetry, music, and the fine arts through the concept of mimesis: they considered poetry, music, dance, painting, and sculpture all to be imitation. (Note, though, that what the Greeks understood by fine arts comprised much more than we understand by that term.) Among the fine arts was μουσική [mousikê; "music"]. However, the term μουσική concerned all that had to do with the Muses and so included much more than what we refer to as music: it actually referred to the union of song, dance, and the word, a complex of instrumental music, poetry, and coordinated movement. As the

Greeks understood it, μουσική played a vital role in shaping communities, for it was central to shaping the ideals of behaviour that guide humans in their lives; the moral principles regulating communities; the practices of the polis; and even ideas about proper and desirable body types. Up to the age of thirty, males belonging to certain classes were provided with instruction in μουσική that required them to demonstrate proficiency in instrumental performance and dance as well as expertise in managing the voice. Later Classical thinkers in the ancient world developed the system of the liberal arts. Marianus Capella (flourished fifth century, after 410 CE) enumerated the seven liberal arts as follows: grammar, rhetoric, dialectic, arithmetic, geometry, astronomy, music. Ancient writers did not separate aesthetic quality from intellectual, moral, religious, and practical functions, and that same catholic understanding of the arts persisted into the Middle Ages.

Insofar as Classical and Medieval writers on rhetoric did consider the relations among the arts, they generally concerned themselves more with identifying which of the arts was superior to the others. Often, the relations among the arts arose in connection with ekphrastic art. The term ekphrastic is from the Greek words *ek* ("out") and *phrazein* ("to tell, declare, pronounce"); originally, ekphrasis meant "telling in full." It was first employed as a rhetorical term in the second century CE to denote simply a vivid description; by the third century the term designated a graphic (and often dramatic) verbal representation of a work of art. The term first appeared in English around 1715, when, according to the *OED*, it was used to signify "a plain declaration or interpretation of a thing"; more often it was used to refer to "the rhetorical description of a work of art" (*Oxford Classical Dictionary*). Often cited examples include the description, beginning at line 450 of Book 1 of Vergil's *Aeneid*, of what Aeneas saw engraved on the doors of Carthage's temple to Juno, and Homer's lengthy description, in Book 18 of the *Iliad*, of how Hephaestus made the Shield of Achilles and of its completed shape. Another oft-cited example is in Book III of Spenser's *The Faerie Queene*, where the poet treats the virtue of chastity. Britomart arrives at the house of the sorcerer Busyrane, where she sees tapestries depicting Jove's amorous exploits; the tapestry provides a counter-example of the virtue being dealt with, so Spenser describes the tapestry at some length. Other, more recent examples of ekphrasis include Marvell's "The Picture of Little T.C. in a Prospect of Flowers"; Keats's "Ode on a Grecian Urn," "On Seeing the Elgin Marbles," and "To Haydon with a Sonnet Written on Seeing the Elgin Marbles"; Shelley's "On the Medusa of Leonardo Da Vinci in the Florentine Gallery"; and Browning's "My Last Duchess."[3] The practice of *ekphrasis* led many writers to consider which of the arts was superior, the visual art being described or the verbal art describing it.

The formula that is often used to start discussions of this topic hails from as far back as Horace (65–8 BCE), in his *Epistle to the Pisos* (commonly known

as *Ars poetica*). Horace wrote, "ut pictura poesis" ("as is painting so is poetry"). This remark has become one of the commonplaces of the history of aesthetics and a common launching point for what turned out to be the most divergent discussions of the character of poetry (and of even literature in general) and of poetry's relationship to painting and the other arts. Horace did not intend the remark to make a sweeping theoretical point.[4] In fact, his *Ars poetica* is anything but a systematic treatise: it is impressionistic, deliberately opinionated, seemingly casual, epistolary in form, often personal in content, and somewhat cryptic. But many who have adopted the term have used it to make a theoretical point, and some have even modified the phrase, to the prescriptive: "ut pictura poesis erit" ("let poetry be like a picture"). An early Medieval text offered a similar principle: "non erit dissimilis poetica ars picturae" ("a poem should not be dissimilar from the art of a picture").

An opposing tradition declared that poetry's scope and depth was greater than that of the visual arts. Dion of Prusa (Chrysostom), in his xiith Olympic Speech, written in 105 CE, extolled the superiority of poetry over painting: a poem can conjure up images of any thing that might come to mind, and can depict that which, like thought, cannot be represented visually (painting can represent thoughts only symbolically). Furthermore, the poetic medium offers the poem's maker less resistance than does the medium of painting and so affords the creator more freedom. Poetry is also more successful in stimulating the imagination (which sometimes allows the poet to deceive the reader). Finally, a poem can produce effects through sound whereas a painting relies on sight alone.

The contest between poetry and painting lasted for centuries, and far more Classical and Medieval thinkers sided with Dion of Prusa than with Horace. Indeed, for centuries, most authors who described the superior powers of poetry did so in precisely the terms Dion had employed. In *Ioannis Evangelium*, Augustine offers as evidence of the greater value of text that it suffices merely to view a painting, but it is not enough simply to enjoy the ornamental aspect of letters—one must as well understand what they mean. Other Medieval writers stressed that writing is capable of encompassing spiritual matters (as Dion had proclaimed that poetry is capable of representing thought), and that it can deal with matters about which hearing, taste, smell, or touch report nothing.

As to the question of which art is superior, visual art or poetry, authors of the Classical and Medieval rhetorical traditions always resolved this question in favour of poetry: *verbum* held sway over *visio* for thousands of years. In the Italian Renaissance, this changed. Against the tradition that privileged *verbum* over *visio*, the first part of Leonardo's *Trattato della pintura* (1651), his famous comparison between painting and poetry, or so-called Paragone, argued for the superiority of painting. The concept of imitation remained central to discus-

sions of art during the Renaissance, and Leonardo contended that poetry cannot imitate certain visible objects because it possesses no words for them. Furthermore, it is concerned not with nature (God's creation), but rather with the lowlier realm of human creation. Moreover, poetry relies on the ear, and the ear is much less perfect than the eye. Poetry uses letters, arbitrary forms that do not resemble the objects they represent. What is more, because we respond to the signs it offers sequentially, through time, any efforts on the poet's part to reproduce simultaneous events are bound to result in tedium. The concept of harmony, too, was central to Renaissance discussions of the arts (a feature attributable to the Pythagorean and Neoplatonic strains in Renaissance thought), and here, Leonardo argued that poetry cannot present harmonious beauty because "the parts of beauty, are divided by time, one from another. Forgetfulness intervenes and divides the proportion into its elements, but since the poet is unable to name it he cannot compose its harmonious proportion, which is derived from divine proportion. The poet cannot describe a beauty in words in the short time required to reflect on the beauty of painting." The poet, Leonardo concluded, can only present the discourse of people exchanging conversation (a statement that provides further evidence of the mimetic assumptions that were at the core of Renaissance art). But for that single virtue, in all matters the poet was surpassed by the painter.

But the visual arts' rivalry was not with poetry alone. A contrarian strain within this tradition dismissed poetry's claim to superiority; moreover, it began to stress the supremacy of one of the visual arts over all the others and to stress the supremacy of that *ottima arte* ("top art") over the arts of language. Intense artistic rivalry broke out within the camp ruled over by Muses; the idea that sibling bonds held in harmony the "Sister Arts" (so they were represented in the minds of poets and orators) was displaced, and the idea of an intense artistic rivalry between the culture of the Image and the culture of the Book took its place. In this attack on the Sister Arts tradition, painting and sculpture contended for the role of the *ottima arte*.

Leonardo's *Trattato della pintura* staked painting's claim. Benedetto Varchi's *Due lezzioni* presented the case for sculpture being the *ottima arte*. Varchi's two lectures *Sopra la pittura e scultura* have an undeserved reputation for being dry, tedious, inflated, and overintellectual. In fact, Varchi's application of literary theory to the visual arts marked a real step forward in the development of art theory, and the work's arguments are presented compellingly. *Due lezzioni*'s rhetoric form, an outgrowth of the tradition of the *disputatio* (which had been revived in the Cinquecento universities), typifies much that is strongest and most vital in Cinquecento's art theory, for it made possible a truly philosophical elaboration of issues of art theory as well as a demonstration of art's intellectual virtues. The case Varchi made was that art is a productive activity governed by the free will of the artist. He presented

his case by developing a theory of beauty that drew from treatises on the Art of Love.

The first lecture in *Due lezioni* concerns a sonnet by Michelangelo. Benedetto Varchi's analysis conforms to already established patterns in humanist poetic exegesis, though his emphasis on understanding the poetic process through the art of love is original and insightful. But it is the second lecture that is important for our purposes. In it, Varchi attempts to describe the character of the arts, to identify their different nobilities and then bring them together through their common principle of design. (We shall see that this anticipated Giorgio Vasari's identification of the *Arti del Disegno*.) The third dispute presented in this second lecture, *In che siano simili, ed in che differenti i Poeti ed i Pittori* ("In what are poetry and painting similar and in what are they different"), seems almost to conform to the convention of measuring painting and sculpture against poetry. That really is not Varchi's purpose. What he does is compare painting to sculpture for the purpose of establishing sculpture as the *ottima arte*. He notes that the arguments for painting—that it requires more artifice, is more difficult, and requires greater wit—can be turned *against* painting: he argues that painting requires the degree of artifice that it does because (and here Varchi takes a cue from Plato) a painting embodies an intentional deceit. Sculpture, by contrast, embodies truth.

Renaissance Florence also saw a revival of Neoplatonism, which had the effect of spreading further the conception of the identity of the "Transcendentals": Goodness, Beauty, and Truth. The Renaissance saw painting gaining in status until it approached the esteem that poetry had traditionally enjoyed. The sixteenth century saw the separation of poetry from the crafts reflected in Vasari's "Arti del disegno" (a preface to the much enlarged second [1568] edition of Varsari's *Le Vite delle più eccellenti pittori, scultori, ed architettori*). This was a seismic shift, as craftmanship had been at the very core of Classical conceptions of τέχνη (*techne*) and *ars*. Moreover, Varsari declared that design is the father of three arts—architecture, painting, and sculpture; design is what these arts have in common and what they do not share with non-visual arts such as poetry and music. (In 1563, on Vasari's initiative, the Accademia del disegno was established in Florence with the aim of educating architects, painters, and sculptors; its founding reinforced the emerging belief in the kinship of these visual arts, but also their separateness from the sister arts of poetry and music.) We glimpse, then, an evolving tension between, on the one hand, the transcendental enthusiasms of Florentine Neoplatonism, which saw the arts as alike insofar as all lead the mind to an apprehension of the transcendental Form of the Good (identical with Beauty and Truth); and, on the other, a growing separation of the character of the different arts and notions about their differing competences.

In 1746, Abbé Charles Batteux published the first system of the fine arts, *Les beaux arts réduit à un même principe* (The Fine Arts Reduced to a Single Principle). That work was an important step toward a general theory of aesthetics, for in it Batteux sought a principle common to all the fine arts. He did so by extending ideas that Horace and Aristotle had advanced regarding the relationship of poetry to painting and other arts. He proposed that the single principle that is common to all the arts is the imitation of beautiful nature. Batteux also distinguished the fine arts from the mechanical arts (another example of the repudiation of the Classical understanding of art as τέχνη). Among the fine arts, according to Batteux, are music, poetry, painting, sculpture, and dance. In addition, he believed that certain arts combine pleasure and usefulness: these include eloquence and architecture. Batteux saw theatre as a combination of the other arts.

Kristeller showed that this sort of system of the arts had considerable influence in Germany and became typical of pre-Enlightenment thinking about the arts. The Enlightenment challenged its hegemony. Jean Baptiste Dubos, James Harris, Moses Mendelsohn, and Gotthold Ephraim Lessing brought to bear on the arts Cartesian reason, which thrives on making distinctions necessary to clarify the topic on which one works. As a result, the various arts were distinguished from one another in terms of their characters and abilities. Lessing, for example, proposed that the proper subject matter of each medium was determined by the physical properties of its constituent signs. Since in poetry, words are encountered sequentially, poetry is a temporal art; thus, it specializes in representations of events and processes. The signs in a painting, on the other hand, are encountered simply as spatially contiguous, so its subjects are what appears in a single moment.

One strain of Romantic art theory had the effect of further separating the arts. For Romantics, the difference between word and image was paramount. The advice "ut pictura poesis erit" once again seemed cogent. By the nineteenth century the aesthetic claim that the visual arts were superior to their verbal rivals came to be known in Italian aesthetic debates simply as the *Paragone* (Comparison). In some measure, this work is an effort to incite again this old dialectical rivalry, with cinema replacing painting and sculpture as the top visual art and with all the literary arts recast as mere images of cinema's paradigmatic modernity.

The Romantic era saw a shift in the conception of the fundamental nature and purpose of art, away from the mimetic and toward the expressive. Poetry came to be thought of less as resembling painting and more as resembling music. Yet insofar as poetry was also treated as capable of disclosing transcendental truths (or even of bringing transcendental truths into being), the issue of poetry's resemblance to image making continued to compel interest. Accordingly, an important strain in the Romantic era is represented by

poetic theorists who extolled the revelatory power of images and who dispar-
aged the capacities of the word. The poet was celebrated as the person who
thought in images. We see this in John Livingston Lowes's renowned *The Road
to Xanadu* (1927), which argues that Coleridge had a heightened sensitivity to
visual imagery and that he often was capable of actually seeing what his imag-
ination produced, as clearly as if he were actually in the scene. The poet's task
was to find language capable of conveying, in its visual form, the revelation that
had excited the poet to the act of making.

Thus, it is clear how Romanticism—or one strain in Romanticism—re-
solved the contest of the arts: language was disparaged in favour of image. In
this respect, the Romantics resolved the question of which was the *ottima arte*
in favour of *visio*, not *verbum*. But this is only one side of the story. The other
side, though much less known, is perhaps more interesting.

As I have noted, the Romantics believed that the poet's task was to find a
way to find language that would convey, in its visual form, the revelation that
had excited the poet to the act of making. The emphasis on metaphor in Ro-
mantic poetics is evidence of that. The Romantics believed that metaphorical
identities embody real correspondences that exist in the order of reality (or Re-
ality) itself. This conviction was a metaphysics that saw all parts of creation as
related by analogy and every material form as a signature corresponding to a
similar form in a higher order of reality. Thus, in Romantic poetics, *figura*
("similitude" or "metaphor") was thought to unite the visible with the invis-
ible; poetic symbolism became, according to this view, a means of revealing the
correspondences that belong to the higher order. Metaphor was not thought
of as just an ornamental device: the Romantics believed that it activated a
form of thinking that disclosed the reality of a unitary world. Metaphor, they
believed, overcame the pernicious effects of language (which they believed de-
rived from the following: its conventional nature; its use of general terms to
refer to specific things; the consequent reduction in the vivacity and speci-
ficity of vision; and its tendency to convert thinking into chains of logical rea-
soning and, consequently, to reinforce a divorce of the experiencing subject
from the object of experience that only a re-empowering of the imagination
could heal). Metaphor, they contended, used sensible correspondences as
analogies of the integral form of a higher-level reality. Furthermore, the Ro-
mantics believed that metaphor made language possible in the first place: even
to describe different objects by the same name, one had to detect the similar-
ities between them. Language might still be redeemed if one could release the
power of metaphor that lay at its core.

According to this transcendental theory of poetry, one releases that power
by creating a form that makes evident the relatedness of every element it
contains to every other and to the whole, which exemplifies the unique or-
dering principle that belongs to that form and to no other. The form of a

poem, according to this view, draws all the form's elements into relation. A poem possesses an integrated structure of rhymes and repetition whose formal correspondences reflect the correspondences that obtain in the higher order of reality.

If a poem's essence lies in the fact that it exemplifies organic unity (analogous to the organic unity that binds every thing together in a higher unity), then, for one thing, the unity need not be simple, precise, measurable; nor is it necessary that the unity simply be a concord. Indeed—to explain one of the significances of the title of this book—it can incorporate discordant elements into its harmony. It can even incorporate elements that seem to protest against—and, in some measure, successfully resist—the poem's effort to integrate these dissenting elements into any resolved form. (Many of those who participated in twentieth-century vanguard art movements celebrated this strife that ends in concord. This dissent that ends in dynamic harmony mirrors the necessity for social dynamics to engender and resolve protest, opposition, and dissent. Many extended this conviction as well to the realm of metaphysics. It is to indicate that aesthetic, social, and metaphysical conviction that I have chosen to refer to this seemingly contrarian dynamic as "dissent" rather than "discord.") Dante recognized the mighty power of love in its capacity to bind together pages that had become separated and scattered; the reader, similarly, recognizes the power of the artwork's principle of unity in the capacity of the work to incorporate elements that seem discordant with the work's primary tenor—elements that dissent from its organizing principle. This explains the interest that developed during the Romantic era (and that has become so prevalent in recent years) in forms that appropriate materials that seem almost impossible to reconcile with the artwork's overriding principle.

Thus, in increasing degrees, first Romantic art, then Symbolist art, later modernist art, and finally postmodernist art have all affirmed the importance of what I call the principle of "dissent": the necessity that elements break with the Whole (which term the reader should understand as being polyvalent, intending alike the aesthetic unity, the social order, and the metaphysical One) to contend against it—that is, engage in strife against the Whole—so that when the Whole once again takes those elements into itself, they transform the Whole. This principle certainly preceded the birth of cinema, but it is important to acknowledge that the advent of cinema reinforced that principle and was viewed by many as providing a scientific (technological) endorsement of that principle. Cinema is an art whose very character is to assemble the scattered parts of a broken reality, all of which resist being unified: as when Osiris's scattered limbs are gathered together and reunited, a different whole emerges through that unification. Cinema's delicate empiricism might seem to trade in quotidian and material forms that would be unavailable to the higher spiritual unities (manifest in the condition of harmony) that concerned so much of

twentieth-century art. What I hope to show is that, in fact, the dissent of cinema's elements from an easily achieved whole was precisely what made it seem an exemplary art form for so many early twentieth-century artists. (That is the dialectical truth I hope to establish in this book.)

Another implication of the view that a poem's essence lies in the fact that it exemplifies organic unity is that there is no contest among the arts—indeed, it is the web of interrelations, not the actual material itself, that allows a work of art to fulfill its transcendental mission. Sounds, daubs of paint, words, and bodily gestures can all be formed into wholes in which each individual element resonates with every other—and all are capable of elevating the mind to contemplate higher things.

But perhaps not equally capable. In this book I argue that many artists and thinkers active at the beginning of the twentieth century began to think that film possessed special powers to elevate the mind and to disclose something of the nature of the higher reality. Cinema had a status analogous to that of "Transcendental Poetry" in the work of Friedrich von Schlegel (who thought of himself as an artist with classicizing tendencies, and who, like the Classical artists, extolled poetry over the other arts):

> Even poetry is no fourth art alongside of the other three [music, painting, architecture]. It does not stand on the same line with and form as it were the complement of their number. It is rather the universal symbolical art which comprises and combines in different mediums all those other exhibitive arts of the beautiful. In its rhythm and other metrical aids it possesses all the charms of a music in words; in its figurative diction it maintains an endless succession of shifting pictures in the vivid colouring of diversified illustration; while in its entire structure (which must be neither purely historical, nor logical, or even rhetorical) it strives to attain, by a beautiful organic development and disposition of its parts, to an arrangement of the whole both architecturally great and correct.[5]

Yet at the same time, Schlegel's "Transcendental Poetry" proffers a ringing declaration of the unifying powers of Universal poetry, and poetry that can reconcile discord into harmony. So central is Schlegel's declaration to the project of this text that I shall quote it at length:

> Die romantische Poesie ist eine progressive Universalpoesie. Ihre Bestimmung ist nicht bloß, alle getrennte Gattungen der Poesie wieder zu vereinigen, und die Poesie mit der Philosophie und Rhetorik in Berührung zu setzen. Sie will, und soll auch Poesie und Prosa, Genialität und Kritik, Kunstpoesie und Naturpoesie bald mischen, bald verschmelzen, die Poesie lebendig und gesellig, und das Leben und die Gesellschaft poetisch machen, den Witz poetisieren, und die Formen der Kunst mit gediegnem Bildungsstoff jeder Art anfüllen und sättigen, und durch die Schwingungen des Humors beseelen. Sie umfaßt alles, was nur

poetisch ist, vom größten wieder mehrere Systeme in sich enthaltenden Systeme der Kunst, bis zu dem Seufzer, dem Kuß, den die dichtende Kind aushaucht in kunstlosen Gesang.

Schlegel declares that life will be made poetic—that life and art will be integrated. Neither Schlegel nor the avant-garde art movements of the early twentieth century understood the integration of art and life in the way that many commentators on the avant-garde (e.g., Peter Bürger) understood it.[6] For Schlegel, and later for avant-garde artists, art and life would be integrated when life is lived with intensity, when the imagination is liberated, when ordinary objects are experienced imaginatively, as hieroglyphs of unknown forms, when the everyday is experienced as belonging to a greater mystery and natural forms as being the product, and in the embrace of, an immanent divine, when all we know evokes in us a feeling for the infinite.[7]

The text continues:

Sie kann sich so in das Dargestellte verlieren, daß man glauben möchte, poetische Individuen jeder Art zu charakterisieren, sei ihr Eins und Alles; und doch gibt es noch keine Form, die so dazu gemacht wäre, den Geist des Autors vollständig auszudrücken: so daß manche Künstler, die nur auch einen Roman schreiben wollten, von ungefähr sich selbst dargestellt haben. Nur sie kann gleich dem Epos ein Spiegel der ganzen umgebenden Welt, ein Bild des Zeitalters werden. Und doch kann auch sie am meisten zwischen dem Dargestellten und dem Darstellenden, frei von allem realen und idealen Interesse auf den Flügeln der poetischen Reflexion in der Mitte schweben, diese Reflexion immer wieder potenzieren und wie in einer endlose Reihe von Spiegeln vervielfachen. Sie ist der höchsten und der allseitigsten Bildung fähig; nicht bloß von innen heraus, sondern auch von außen hinein; indem sie jedem, was ein Ganzes in ihren Produkten sein soll, alle Teile ähnlich organisiert, wodurch ihr die Aussicht auf eine grenzenlos wachsende Klassizität eröffnet wird. Die romantische Poesie ist unter den Künsten was der Witz der Philosophie, und die Gesellschaft, Umgang, Freundschaft und Liebe im Leben ist. Andre Dichtarten sind fertig, und können nun vollständig zergliedert werden. Die romantische Dichtart ist noch im Werden; ja das ist ihr eigentliches Wesen, daß sie ewig nur werden, nie vollendet sein kann. Sie kann durch keine Theorie erschöpft werden, und nur eine divinatorische Kritik dürfte es wagen, ihr Ideal charakterisieren zu wollen. Sie allein ist unendlich, wie sie allein frei ist, und das als ihr erstes Gesetz anerkennt, daß die Willkür des Dichters kein Gesetz über sich leide. Die romantische Dichtart ist die einzige, die mehr als Art, und gleichsam die Dichtkunst selbst ist: denn in einem gewissen Sinn ist oder soll alle Poesie romantisch sein. (from "Athenäum-Fragment" 116, 1798)[8]

According to Schlegel's idea of a "progressive Universalpoesie," a poem would be a whole entity "organized uniformly in all its parts" (in "alle Teile ähnlich organisiert")—that is, it would be a form that makes evident the

relatedness of every element it contains to every other and to the whole (*das Ganzes*), and thus would exemplify the unique ordering principle that belongs to that form and to no other. Moreover, according to Schlegel's idea of universal, transcendental poetry, a poem would be an integral configuration that can incorporate diverse materials, mingle and fuse them, and yet it would not elide the difference of opposites—an integral configuration that, like the Hegelian principle of the dialectic, embeds dissent in the very heart of harmony. It would, in a sense, encourage dissent among its parts, to mark the freedom of the artist; but it would also reconcile them in a harmonious unity that is essentially Classical. Thus, Schlegel undertook (but did not complete) the novel *Lucinde* (published in unfinished form in 1799, while Schlegel was still alive); it was, according to Schlegel, an attempt at a "shaped, artistic chaos." It was meant to be "chaotic and yet systematic," for Schlegel declared for himself the "incontestable right to a confused style." Schlegel managed chaos very successfully, and an aspect of its success is that his novel presents a romantic "contest" of competing novelistic possibilities.

Vanguard artists in the early twentieth century likewise proposed that a universal, transcendental art might yet come forth, might yet reunite the arts, might yet re-enchant the world of nature and even of ordinary objects by treating them as hieroglyphs of an invisible reality, and so sway the mind toward a creator-unity immanent in nature—that a new art might yet come forth that could fully express the artist's mind. At the beginning of the twentieth century, cinema seemed to many the art that most closely approximated this ideal. Furthermore, like Schlegel, they believed that since it was a synthetic art that exemplified the best attributes of each of the other arts, it was the *ottima arte*.

So it was that artists came to understand cinema as proposing artistic ideas that should guide them in reconstructing their respective disciplines. In this book I trace the influence on early twentieth-century art of the idea that film might unite the arts, re-enchant ordinary objects by treating them as hieroglyphs of an invisible reality, sway the mind toward a creator-unity immanent in nature, and fully express the artist's mind. To do so I have had to practise what Schlegel has called "eine divinatorische Kritik," a divinatory criticism. So rich and prophetic is Atheneum-Fragment 116 that one could rewrite the history I have told, showing how vanguard art movements of the early twentieth century attempted to bring forth Schlegel's *Universalpoesie*, and showing as well that many artists and thinkers of the early twentieth century believed that cinema was its closest approximation. (This approach would be especially interesting because it would allow one to show the influence of Jackob Böhme's theosophy on Schlegel and other German Romantics; this in turn would permit one to reveal the occult concepts that permeated the early twentieth-century avant-garde. This approach would also have the benefit of drawing on the

early literary criticism of Walter Benjamin, which, despite the occasional allegations he made against the author, is essentially a form of Schlegelism.)

■

Schlegel's text was massively influenced by the pneumatic tradition. The pneumatic philosophy perhaps expounded ideas about consciousness, reality, and the fate of the self that seem odd to us; yet it also (as Schlegel recognized more than two hundred years ago) responded to deep-seated needs—needs that modernity has shortchanged. In the seventeenth century, a new image of the reality—of the world of matter and of consciousness/the spirit's relation to it— began to consolidate itself, becoming at once ever more restrictive and more normative. No longer was matter viewed as a realm whose origin was divine and whose order was providential and purposive. Rather, according to this new image nature was a realm whose constitution could not be accounted for on any grounds outside itself—certainly not through the purposes its entities and their activities served. The task of understanding nature, on this view, became that of understanding the regularities in occurrences, of identifying laws that describe patterns in the succession of events. The belief that all that cognition can afford is knowledge of the regularities that characterize the succession of events is a principal factor limiting moderns' conception of time to nothing other than a linear process. The function of consciousness is understood to be solely cognition, and cognition is understood as nothing other than the organization and classification of the world according to its laws governing the succession of appearance. In this way, knowledge is reduced to the products of calculative reason. In the seventeenth century some of the most profound realms of human consciousness were reconceived as lying beyond the bounds of the legitimate activities of the cognitive enterprise. The predicament of consciousness has come to be understood as arising from the fact that consciousness confronts a world the reasons for whose order we cannot know—a world indifferent to individual lives, a world that came into being by accident and that will disappear at a time mandated by the initial accidental conditions that gave rise to it. All we can hope to experience are the consequences of consciousness encountering an indifferent accidental world of matter.

For many later moderns, this image of consciousness and reality seemed frightfully inadequate. They felt the noetic strength of forms of experience that modernity had disenfranchised. Like Walter Benjamin in "The Project for a Coming Philosophy," they claimed that cognition encompasses a broader, richer, and more rewarding realm of experience. Prayer, meditation, trance, dream, and contemplation all provide genuine understanding of reality (including the reality of the divine)—and these are the domains of experience

mined by the religious seeker, the mystic, and the artist, but not by the typical modern. Intuitive, bodily knowledge, which remains largely preconscious and unconceptualized, informs us of the continuity of our be-ing with that of other beings. Only a mode of experience that appreciates the performative dimension of awareness, a mode of experience that does not reduce experience to the activities of instrumental reason, can undo the reductive effects of modernity's advent—and the performative is the domain of religion and of art. The artists associated with a number of the avant-garde movements of the twentieth century felt the importance of these modes of experience, and they attempted to develop artistic forms that might revitalize those experiences so that they might assume an expanded role once a new paradigm of knowledge and a new understanding of reality had emerged. Indeed, the role of avant-garde movements was also understood as hastening this emergence.

The experiences of prayer, meditation, contemplation, trance, dream, and contemplation are not incorporated into modernity's model of normative cognition. The Enlightenment drove them out of the public realm; thus they have become organs, like the human appendix, that in losing their purpose have been reduced to an underdeveloped, vestigial form. That atrophy accounts for the peculiar, unhealthy, "new-agey" vulgarity that characterizes the way these experiences have been so often been discussed over the past 150 years—including among the often breathtakingly brilliant participants in the vanguard art movements that developed during the twentieth century. That it gives these experiences pride of place provides the avant-garde with its importance.

The demands entailed in efforts to reach the source of the ungainly notions that had so important an influence in shaping twentieth-century art have made it impossible to demonstrate their influence on more than two key moments in early twentieth-century art: the project to develop an abstract art based on a conception or pure visuality, and Constructivism. In later ventures, I hope to explore in greater depth some of the themes I open up here, and show that the same themes I open up in this book influenced many other artistic movements of the early part of the twentieth century. I hope, that is, to do much more to demonstrate that ungainly ideas about the character of cinema played a role in shaping the ideals of some of the more prominent artistic movements of the twentieth century.

NOTES

A note to readers: In the notes, the spellings of Russian names reflect the source materials. In the text, those names have been regularized.

1 Paul Oskar Kristeller, "The Modern System of the Arts: A Study in History of Aesthetics, Part 1," *Journal of the History of Ideas* 12, no. 4 (October 1951): 497.
2 A Stoic text ονον τό καλόν'αγαθόν (*monon to kalon agathon*) that suggests that interpretation. V.H. Von Armin, ed., *Stoicorum Veterum Fragmenta*, III:9).

3 Ekphrasis became rather prominent in twentieth-century poetry (a fact we might take as evidence of the Inter-Arts Comparison in recent times). Well-known examples include these: Rilke's "Archaic Torso of Apollo"; Marianne Moore's "No Swan So Fine," on a china swan, and "Nine Peaches," on a representation on a piece of porcelain *chinoiserie*; Wallace Stevens' "Angel Surrounded Paysans," on Pierre Tal Coat's *Still Life* (ca. 1945–46;) and "Man with Blue Guitar," on Pablo Picasso's *Old Guitarist*; most of the poems in William Carlos Williams's great poem sequence *Pictures from Breughel*, as well as his "Classic Scene," on Charles Sheeler's *Classic Landscape*; John Berryman's "Hunters in the Snow," on Pieter Brueghel's *Hunters in the Snow* (Walter de la Mare's "Breugel's Winter," Joseph Langland's "Hunters in the Snow: Breugel," and William Carlos Williams's "Hunters in the Snow" are other ekphrastic poems on this familiar painting); Paul Engle's "Venus and the Lute Player," on Titian's *Venus and the Lute-Player*; Randall Jarrell's "The Bronze of Donatello," on Donatello's *David*, "Knight, Death and the Devil," on Albrecht Dürer's eponymous Meisterstiche; W.H. Auden's "Musée des Beaux Arts," on Pieter Brueghel, *The Fall of Icarus*, and his allusive "The Shield of Achilles," a retelling of the passage in Book 18 of Homer's *Iliad*; Elizabeth Bishop's "Large Bad Picture," on a fictional painting, inspired by a pair of lines in "Rime of the Ancient Mariner," and her "Poem," on a tiny, unsigned painting the poet believed to be painted by her great-uncle ("Uncle George"); Edith Wharton's "Mona Lisa," on Leonardo's *Mona Lisa*; May Swenson's "The Tall Figures of Giacometti," on Alberto Giacometti's *City Square*; John Stone's "American Gothic—after the painting by Grant Wood, 1930," on Grant Wood's *American Gothic*, his "Three for the Mona Lisa," on Leonardo's *Mona Lisa*, and his "Early Sunday Morning," on Edward Hopper's *Early Sunday Morning*; Robert Foerster's "Brueghel's Harvesters," on Pieter Brueghel's *The Harvesters*; Derek Mahon's "St. Eustace," on Antonio Pisanello's *Saint Eustace*, and his "The Hunt by Night—Uccello, 1465," on Paolo Ucello's *A Hunt in the Forest*; Anne Sexton's "The Starry Night," on Vincent Van Gogh's *Starry Night*; Derek Mahon's "Courtyards in Delft—Pieter de Hooch, 1659," on Pieter de Hooch's *Courtyards in Delft*; John Stone's "The Forest Fire—Piero Di Cosimo, ca. 1505 Ashmolean Museum, Oxford," on Piero Di Cosimo, *The Forest Fire*; Edward Hirsch's "Edward Hopper and the House by the Railroad (1925)," on Edward Hopper's *House by the Railroad*; Lawrence Ferlinghetti's "Monet's Lilies Shuddering," on Claude Monet's *Nymphéas*, and his "The Wounded Wilderness of Morris Graves," on Morris Graves's *Bird in the Spirit*; Wislawa Szymborska's "Two Monkey's by Brueghel," on Pieter Brueghel's *Two Monkeys*; Cathy Song's "Girl Powdering Her Neck—from a ukiyo-e print by Utamaro," on Kitagawa Utamaro, *Girl Powdering Her Neck*; Stephen Dobyns's "The Street," on Balthus' *The Street*; Greg Delanty's "After Viewing *The Bowling Match at Castlemary, Cloyne* (1847)," on Daniel MacDonald's *The Bowling Match at Castlemary, Cloyne*; W.D. Snodgrass's "The Red Studio," on Henri Matisse's *The Red Studio*; Lisel Mueller's "Paul Delvaux: The Village of the Mermaids—Oil on canvas, 1942," on Paul Delvaux's *The Village of the Mermaids*; Mary Leader's "Girl at Sewing Machine (after a painting by Edward Hopper)," on Edward Hopper's *Girl at Sewing Machine*; Allen Ginsberg's "Cézanne's Ports," on Paul Cézanne's *L'Estaque* (1883–85); X.J. Kennedy's "Nude Descending a Staircase," on Marcel Duchamp's *Nude Descending a Staircase No. 2*; and (turning to examples that describe a photograph) Adrienne Rich's "Snapshots of a Daughter-in-Law" and Greg Williamson's "Double Exposures."

4 The context for the quotation is:

> Ut pictura, poesis: erit quae, si propius stes,
> Te capiat magis; et quaedam, si longius abstes:
> Haec amat obscurum; volet haec sub luce videri,
> Judicis argutum quae non formidat acumen:
> Haec placuit semel; haec decies repetita placebit.

—Q. Horatii Flacci, "Epistola Ad Pisones, De Arte Poetica," lines 361–65.

A very rough translation: "A poem is like a painting: the closer you stand to this one the more it will impress you, whereas you have to stand a good distance from that one; this one loves a rather dark corner, but that one wants to be seen in a full light and will stand up to the keen judgment of the critic; this one pleased you only when you saw it for the first time, but that one goes on pleasing you as many times as you see it." Which seems to me to state that a poem is like a painting in that how it is seen affects the pleasure we have from it.

5 Friedrich von Schlegel, "Philosophy of Life," in *Philosophy of Life, and Philosophy of Language: In a Course of Lectures*, trans. A.J.W. Morrison (London: Bohn, 1847), pp. 265–66.

6 Here is another German Romantic poet's proposal to integrate art and life: "Der Welt muss romantisiert werden. So findet man der ursprünglichen Sinn wieder. Romantisieren ist nichts als eine qualitative Potenzierung. Das niedre Selbst wird mit einem bessern Selbst in dieser Operation identifiziert. So wie wir selbst eine solche qualitative Potenzreihe sind. Diese Operation ist noch ganz unbekannt. Indem ich dem Gemeinen einen hohen Sinn, dem Gewöhnlichen eine geheimnisvolles Ansehn, dem Bekannten die Würde des Unbekannten, dem Endlichen einem unendliche Schein gebe, so romantisiere ich es." (The world must be romanticized. So its original meaning will again be found. To romanticize is nothing other than an exponential heightening. In this process, the lower self becomes identified with a better self. Just as we ourselves are part of an exponential sequence. This process is still wholly unknown. By investing the commonplace with a lofty significance, the ordinary with a mysterious aspect, the familiar with the prestige of the unfamiliar, the finite with the semblance of infinity, thereby I romanticize it.) Novalis, *Fragmente des Jahres 1798, Gesammelte Werke*, Vol. III, p. 38. The German and English texts appear in Lilian R. Furst, ed., *European Romanticism: Self-Definition: An Anthology* (London: Methuen, 1980), p. 3.

7 Some of Schlegel's remarks on the immanent divine were extraordinary. Example: "The phenomenon of magnetism presents a remarkable manifestation of the universal life of the world, which eludes all mathematical calculations of magnitude, while the little piece of this wonderful iron balances by its living agency the whole globe itself' (Friedrich von Schlegel, *Philosophy of Life*, in *Philosophy of Life and Philosophy of Language: A Course of Lectures*, p. 80.

8 "Romantic poetry is a progressive universal poetry. It is destined not merely to reunite the separate genres of poetry and to link poetry to philosophy and rhetoric. It would and should also mingle and fuse poetry and prose, genius and criticism, artistic poetry and natural poetry, make poetry lively and sociable, and life and society poetic, poetise wit, fill and saturate forms of art with worthy cultural matter of every kind, and animate them with a flow of humour. It embraces all that is poetic, from the greatest art system that enfolds further systems, down to the sigh, the kiss uttered in artless song by the child. It can so identify with what is being represented that one might well think its sole aim was to characterize poetic individuals of every sort; but there is as yet no form designed fully to express the author's mind: so that some artists, who want only to write a novel, have come to portray themselves. Romantic poetry alone can, like the epic, become a mirror to the whole surrounding world, an image of its age. At the same time, free of all real and ideal interests, it can float on the wings of poetic reflection midway between the work and the artist, constantly reinforcing this reflection and multiplying it as in an unending series of mirrors. It has the potential for the highest, most manifold evolution by expanding not only the outward but also the inward, for each thing destined to be a whole entity is organized uniformly in all its parts, so that the prospect is opened up of a boundlessly developing classicism. Among the arts, Romantic poetry is what wit is to philosophy, and what sociability, friendship and love are to life. Other types of poetry are complete and can now be wholly analysed. Romantic poetry is still in a process of becoming; this indeed is its very essence, that it is eternally evolving, never completed. It can-

not be exhausted by any theory, and only a divinatory criticism could dare try to characterize its ideal. It is alone infinite, just as it is alone to be free, recognizing as its prime law that the poet's caprice brooks no law. Romantic poetry is the only type of poetry that is more than merely a type of poetry; it is in fact the very art of poetry itself: for in a certain sense all poetry is or should be Romantic." The German and English texts appear in Furst, *European Romanticism*, pp. 4–6.

ACKNOWLEDGEMENTS

To say that the arts no longer occupy a central place in the North American mind is to state the obvious. Dreams fostered by commerce's romance with technology have long since supplanted the arts in North Americans' imaginations. Historical forces that arose in the Renaissance and acquired additional strength in the Enlightenment now have entered into an astonishingly unlikely association with novel authoritarian currents of our time, unleashed by another "awakening." Universities, by and large, have proven impotent in resisting these dire trends, and many of those who are charged with the responsibility of defending the life of the mind have shown themselves to be quislings. The limits of the social have been allowed to circumscribe understanding's reach. This is an age when academics for the most part don't read Plato, Virgil, Aquinas, Milton, or Spinoza (nor listen to J.S. Bach or Thomas Tallis)—and, what is worse, when academics condemn those among their colleagues who do, for being irrelevant.

The ironies of history are legion. I remind myself of the fact when melancholy brings me to ponder the appalling conditions under which I began work on this volume—conditions that persisted nearly until I had completed it. The less said about those conditions, the better. However, a heart full of gratitude compels me to acknowledge the solace many afforded. Michael Snow, Jonas Mekas, and Stan Brakhage have all taken an interest in my writing and in my filmmaking. I wish that Stan Brakhage were here to read

this work, which he so often inquired after and for which he ventured so many suggestions.

Jo Ann Mackie's, Prof. Don Snyder's, and Dr. Maurice Yeates's many kindnesses helped sustain me. Dr. Susan Cody stepped in several times to prevent a bad situation from becoming unbearable. I have been very fortunate that a remarkable group of young artist/filmmakers have been drawn to my classes and to working on my projects. Those who assisted in this project (in the order in which they joined) are: Jowita Kepa, Annie MacDonell, Samantha Rajasingham, and Luba Galvanek. All showed unflagging persistence in tracking down nigh impossible-to-find sources. I enjoyed discussions with them and, with them, poring over selections from my collection of art books.

As great a source of delight has been to find oneself joined in the belief in the human value of artmaking by a number of talented artist/scholars who are utterly committed to avant-garde cinema. Over the past few years, such a group have come to occupy an ever larger place in my thoughts, so that now I don't know how I could have survived a dreadful period without them. It has been such a great pleasure to see them at nearly all my screenings and public lectures and seminars. Their insistence on attending my classes (whether they were officially enrolled or not) gave me faith that, however harrowing my circumstances, I was reaching some with ears to hear. Alla Gadassik, Angela Joosse, Erika Loic, and Izabella Pruska-Oldenhof have enriched my life enormously, by making me believe that, somehow, the art of film will survive, just because it can attract the likes of them. Working with them has enlarged my heart.

It is routine for academics' acknowledgement pages to discharge the obligation of recognizing any funding that supported their work. In mentioning that I received support for my work on this volume from the Social Sciences and Humanities Research Council of Canada, I do not want to be mistaken for doing just that. For I want to express my deepest thanks for the opportunities that SSHRC made possible. SSHRC's support (and the high ranking their assessment panel gave this project) did much to rally my faith that I would be able to endure the onslaught I faced when I embarked on this project. In addition, support that that agency, and the Canada Council for the Arts, provided for my filmmaking and my work in software engineering has meant more to me than I can ever say. Ryerson University, through the Office of Research Services and the Office of the Dean of the Faculty of Communication and Design, also provided generous financial assistance, in the form of project grants, stipends for student assistants, a publication grant, and a research chair that helped shelter me. The Canadian Federation for the Humanities and Social Sciences, through the Aid to Scholarly Publications Programme, using funds provided by SSHRC, provided a subvention for this publishing project. The ASPP plays a key role in fostering scholarship in Canada; I am delighted they have continued to support the dissemination of my writings.

The people at WLU Press have been remarkably steadfast in dealing with many issues in the course of producing this volume. Brian Henderson, Lisa Quinn, and Rob Kohlmeier have all been unfailingly encouraging and understanding. A problem that arose toward the end of the production of this volume (one that falls in the category of "dumb things that computers do") meant that the process of proof checking was unusually fraught. Cheryl Lemmens went far, far beyond what one should expect of an indexer in the way of fact checking and prepared a detailed list of errata, for which I am extremely grateful.

Two readers whom the Press engaged did far more than offer endorsements of the manuscript. Both warmed my heart greatly with the enthusiastic tone of their (excessively generous) assessments. More than that, both offered constructive suggestions, which I incorporated—I hope to their satisfaction. Still, the usual statement that any remaining inadequacies are the fault of the author is more than usually true in my case: it is unlikely that even the most insightful reader and forceful commentator could prevent me from lapsing into the sort of folly that results from an excess of enthusiasm for vanguard art. I am far too stubborn.

None but a spouse could ever understand the financial and, more, the emotional costs involved in avant-garde filmmaking—especially when one tries to make a go of paying Caesar by working in an academic environment. My wife, Kathryn Elder, has stood by me though an appalling series of events, even while my health made doing so an absolute ordeal. What can I possibly say?

> Oh quanto è corto il dire e come fioco
> al mio concetto! e questo, a quel ch'i' vidi,
> è tanto, che non basta a dicer 'poco'.

PART ONE

MODERNISM AND THE ABSOLUTE FILM

THE OVERCOMING OF REPRESENTATION

THE PHILOSOPHICAL AND OCCULT
BACKGROUND TO THE ABSOLUTE FILM

PHOTOGRAPHY, MODERNITY, AND THE CRISIS OF VISION

The development of photography and film was a response to the crisis of vision that by the early nineteenth century had reached alarming intensity. The camera served as a prosthetic for vision: it allowed us to see, and therefore to understand, what the human eye cannot see unaided. It contributed to the effort of giving the real a rightful place in works of art. Henri Cartier-Bresson's "decisive moment" refers to the discovery of the eternal, perfect form in the contingencies of the flux of mundane, everyday life. "The decisive moment" captures precisely what Charles Baudelaire claimed would interest the painter of modern life: "By 'modernity' I mean the ephemeral, the fugitive, the contingent, the half of art whose other half is the eternal and the immutable … This transitory, fugitive element, whose metamorphoses are so rapid, must on no account be despised or dispensed with."[1] Likewise, the cinematic apparatus answered to the desire to reproduce movement so that the fugitive might be subjected to inquiry (modernity's model of knowledge). Edgar Allan Poe came close to describing the condition of the later modern spectator when he described passersby casting aimless glances off in all directions; but as Walter Benjamin points out, Poe's spectator is not the later modern spectator-cum-pedestrian who typifies the condition of modern existence: the modern pedestrian is overwhelmed with a barrage of sensory information that he or she has to keep up with, just to preserve

life and limb, to say nothing of perceptual integrity. Technology has retrained the human sensory apparatus so that it can process multiple inputs.

The new perceptual regime is intimately related to the cinema, for in the perceptual world of modernity as in the cinema, perception is conditioned by a series of engendering shocks, a relentless rhythmical pulse.

> Moving through [the traffic of a big, modern city] involves the individual in a series of shocks and collisions. At dangerous intersections, nervous impulses flow through him in rapid succession, like the energy from a battery. Baudelaire speaks of a man who plunges into the crowd as into a reservoir of electric energy. Circumscribing the experience of the shock, he calls this man "a kaleidoscope equipped with consciousness." Whereas Poe's passers-by cast glances in all directions which still appeared to be aimless, today's pedestrians are obliged to do so in order to keep abreast of traffic signals. Thus technology has subjected the human sensorium to a complex kind of training. There came a day when a new and urgent need for stimuli was met by the film. In a film, perception in the form of shocks was established as a formal principle. That which determines the rhythm of production on a conveyor belt is the basis of the rhythm of reception in the film ...
>
> Poe's text makes us understand the true connection between wildness and discipline. His pedestrians act as if they had adapted themselves to the machines and could express themselves only automatically. Their behavior is a reaction to shocks. "If jostled, they bowed profusely to the jostlers." [2]

These shocks destroyed the aura surrounding precious objects/creations, and that changed forever humans' understanding of space and distance. Even Benjamin deemed the effect a mixed blessing.

The camera developed in response to a crisis of sensation, as a cognitive tool that served as a prosthetic for vision. Yet the modernists recognized that the camera's eye—including that of the movie camera—posed significant aesthetic difficulties. [3] For if the camera was invented as a cognitive tool for revealing reality rather than for transforming it into an autonomous form, then it is difficult to see how the photographic (or cinematographic) image can be of much use in carrying out the artist's task—that is (according to the time's reigning aesthetic principle), in constructing artistic forms. Indeed, it is even difficult to see how a camera image could possibly provoke an aesthetically valuable experience.

The Absolute Cinema answered these objections about the character of a camera image. The makers of Absolute Film proposed to avoid using the camera to reproduce the appearance of reality, and even to avoid reproducing movement. Instead they would create films from concrete forms, forms they would create by hand (using cut paper or cardboard, paints, and dyes)—forms that would lack any representational import; they would use the camera not to reproduce movement but to create a pure, artificial dynamic. Their films,

then, would consist of abstract forms whose movements would describe satisfying shapes that have intriguing relations one to another.

The Absolute Film movement was centred in Germany (and primarily in Berlin, which then rivalled Paris as capital of the art world). The principal figures associated with the Absolute Film were Viking Eggeling, Hans Richter, Walther Ruttmann (probably the movement's pioneering figure), and, somewhat later, Oskar Fischinger; other figures who had a briefer involvement with this type of filmmaking were Werner Graeff and László Moholy-Nagy.[4]

THE ANALOGY TO MUSIC

At the beginning of the twentieth century, many artists sought some means to escape "the tyranny of the object" and to create an art free from the constraints of the visible and tangible realm. Music provided a model for how a work constituted of pure, non-representational elements could be formed without falling into ornamentation, arbitrariness, or disorder. Contrapuntal music, in particular, showed artists how to resolve abstract elements. Thus, in 1922, Richter, with Werner Graeff's assistance, embarked on a project titled *Fuge in Rot und Grün* (Fugue in Red and Green). To be sure, this was not the first visual fugue to be predicated in the assumption that film and music were analogous. Around 1910, the Czech artist František Kupka, a Symbolist painter who was deeply involved with Theosophical ideas generally (he claimed to be a medium)—and in particular with their ideas on synaesthesia and on colour—became the first painter to arrive at the principle of sequential composition based on chromatic progressions. He described his goal thus: "By using a form in various dimensions and arranging it according to rhythmical considerations, I will achieve a 'symphony' which develops in space as a symphony does in time." These ideas led to *Amorpha—Fugue in Two Colours* (1912).

That music is an art of time helps explain why visual artists regarded it as an ideal to which they might aspire. Music could achieve a constantly changing quality of tone space, and painters longed to find a means to achieve analogous effects in their medium. Karin von Maur explains:

> The disintegration of the unified pictorial space, the fragmentation of the object, the autocratic employment of liberated motif elements, the autonomy of color, form, and line, and the increasing dynamism of all three—these developments, which took place between 1908 and 1914 in the guise of Cubism, Futurism, Orphism, Vorticism, or Synchronism—were basically directed towards opening visual art to the dimension of time. Never before in the numerous programs and manifestos of the avant-garde did there appear so many temporal concepts, such as rhythm, dynamics, speed, and simultaneity, or musical terms such as cadence, dissonance, polyphony, etc., proving the existence of a close link between the temporalization tendencies in art and the reception of musical phenomena.[5]

In his paintings from his Bauhaus years (1921–31), Paul Klee embarked on a program of discovering the dynamic properties of colour and form. He formalized his thoughts while teaching at the Bauhaus in the 1920s, where he wrote his *Pädagogisches Skizzenbuch* (Pedagogical Sketchbook), which presented a complete course on the dynamics of static form (see, for example, Pedagogical Sketchbook, Figure 2). Klee's paintings represent a movement toward dynamic form in abstract painting, and he connected this dynamism to music. Klee took up the problems of painting music in the monochrome *Fuge in Rot* (Fugue in Red, 1921). This work unfolds its visual themes in fugal form, as different shapes moving from right to left over a dark ground, leaving trails of afterimages behind, to produce effects similar to those produced by the repetitions of musical themes in a fugue. Like Kandinsky, Klee used the analogy with music when describing his work; indeed, some of Klee's later works developed directly out of musical structures. Thus, fugal form was the subject of *Ad Parnassum* (1932), which used a dappled grid of shifting colour within an architectonic framework to produce in a visual medium effects similar to those produced by the patterns of the repeated elements of a musical fugue.

The American Synchromists Morgan Russell and Stanton Macdonald-Wright also pursued the analogy between sound and colour. Writing at the time of their first solo exhibition, at Munich's Neuer Kunstsalon, they proposed that until then, music alone had been able to communicate the highest spiritual sensations. Now, they proclaimed, abstract painting's time had come: having overcome the obstacles that the effort to render material reality had placed in their path, painters could now direct their interests to the higher reality. Painting had developed to the point where it could now convey the mysterious reality hidden in ordinary reality. Several artists and theorists went so far as to argue that painting was closer to this supreme reality than music, because visual perception is more intimately linked than aural perception to the inner reality of nature.

Robert Delaunay, too, argued that painting is superior to music, though his reasoning was different. For him, painting's superiority turned on its capacity to apprehend several objects and events simultaneously. He unpacked the significance of this principle of simultaneity in Bergsonian terms: "The idea of the vital movement of the *world* and *its movement is simultaneity*...The auditory perception is not sufficient for our knowledge of the world ... Its movement is *successive*, it is a sort of mechanism; its law is the *time* of *mechanical* clocks which, like them, has no relation with our perception of *visual movement in the Universe*" (italics in original).[6] Delaunay used interacting complementary colours to generate a sense of optical motion. His interest in the interactions of colour led him to consider the importance of light: he wrote about light as an ordering force, a force whose nature is harmony and rhythm. Different

proportions in the mixture of colours led to different harmonies and different rhythms (different rates of vibration).

The dynamics of the modern world had raised the phenomenon of change to a new level of importance. Morgan Russell, Stanton Macdonald-Wright, Robert Delaunay, and their ilk were all seeking ways to invest a dynamic medium—a medium that could convey the flux of energy—with the privileges of sight. This is especially clear with Delaunay: though he advocated simultaneity, he used sequential development in such works as *Les Fenêtres sur la ville* (Windows on the Town, 1912), a work that uses a scroll form to unfold colour contrasts through time. In a diary entry from July 1917, Klee noted that "Delaunay has attempted to shift the accent in art to the temporal, based on the example of the fugue, by choosing a format so long it cannot be taken in at a glance."[7] Another medium had led the way—cinema. Like many artists, Delaunay, Russell, and Macdonald-Wright proposed to reformulate their medium to endow it with attributes of cinema. The similarities among Delaunay's scroll painting *Les Fenêtres* (The Windows, 1912), Viking Eggeling's scroll painting *Horizontal-Vertikal Orchester* (Horizontal-Vertical Orchestra, 1919–21), and Hans Richter's scrolls, *Präludium* (Prelude, 1919), a series of drawings presenting a declension of forms on the theme of contrast, especially contrast between planes, and *Fuge* (Fugue, 1920)—and their similarity to cinema—suggest the influential role cinema played in twentieth-century visual arts history. The theoretical writing of Eggeling and Richter testifies to their interest in creating visual works whose elements could be experienced both as developing through time and as existing simultaneously.

The makers of Absolute Film proposed to reconfigure film so as to highlight its innermost dynamics, its essential animation. In doing so they would release cinematic form from representation. Light and time, they insisted, were cinema's true materials—the artists engaged in the creation of the Absolute Film shared an interest in light and time with makers of light sculptures and *Lichtspielen*. These works were as immaterial as music—indeed, that something as immaterial as coloured light came to represent an ideal medium for artists in the nineteenth and twentieth centuries must be taken as evidence of the important role that music (and cinema) had assumed in thinking about the arts.[8]

Photography, perhaps more than film, seemed well suited to make a valuable contribution toward a non-objective art. In *Iz knigi o bespredmetmosti* (From the Book on Non-Objectivity), Kazimir Malevich outlined how photography could contribute to *bespredmetnosti* art: as a form of post-abstract art (art lacking a subject), *bespredmetnosti* art (art lacking a tangible medium) could use the techniques of the photogram and superimposition to highlight the photographic image's immateriality.

The Absolute Film proposed to emphasize film's immateriality, its gaseousness, and in doing so release cinematic form from representation. Light and time,

the makers of Absolute Film insisted, were cinema's true sources. Clearly, the artists engaged in the creation of the Absolute Film shared an interest in light and time with makers of light sculptures and *Lichtspielen*.

ABSOLUTE FILM AND VISIBILITY
THE THEORIES OF CONRAD FIEDLER

The conception of light embodied in the film forms offered by the makers of Absolute Film hark back to premodern ideas. To understand the appeal of those ideas, recall the crisis of perception that haunted the nineteenth century, the very crisis that had given birth to photography and film. The crisis arose from the recognition that perception does not provide us with an image of external reality—that a percept is only a sign of the external factor that causes it, and not an accurate image of it (to use Helmholtz's formulation). Johannes Müller proposed the doctrine of "specific nerve energies"; his research provided the basis of Helmholtz's famous *Optics*, a book that dominated the theory of vision in the second half of the nineteenth century and that almost certainly influenced Fiedler. Jonathan Crary outlines the theory.

> The theory was based on the discovery that the nerves of the different senses were physiologically distinct. It asserted quite simply—and this is what marks its epistemological scandal—that a uniform cause (e.g., electricity) would generate utterly different sensations from one kind of nerve to another. Electricity applied to the optic nerve produces the experience of light, applied to the skin the sensation of touch. Conversely, Müller shows that a variety of different causes will produce the same sensation in a given sensory nerve; in other words, he describes a fundamentally arbitrary relation between the stimulus and the sensation. It is a description of a body with an innate capacity, one might even say a transcendental faculty, to misperceive, of an eye that renders differences equivalent.
>
> His most exhaustive demonstration concerns the sense of sight, and he concludes that the observer's experience of light has no necessary connection with any actual light. Müller enumerates the agencies capable of producing the sensation of light. "The sensations of light and colour are produced wherever parts of the retina are excited 1) by mechanical influences, such as pressure, a blow or concussion 2) by electricity 3) by chemical agents, such as narcotics, digitalis 4) by the stimulus of the blood in a state of congestion." Then last on his list, almost begrudgingly, he adds that luminous images can also be produced by "the undulations and emanation which by their action on the eye are called light."[9]

Hermann von Helmholtz, one of the nineteenth century's most eminent scientists, made the same point in his famous (and still much read) treatise on psychoacoustics:

Nerves have been often and not unsuitably compared to telegraph wires. Such a wire conducts one kind of electric current and no other; it may be stronger, it may be weaker, it may move in either direction; it has no other qualitative differences. Nevertheless, according to the different kinds of apparatus with which we provide its terminations, we can send telegraphic despatches, ring bells, explode mines, decompose nerves. The condition of excitement which can be produced in them, and is conducted by them, is ... everywhere the same.[10]

To suggest the prevalence of these ideas in the early part of the twentieth century, I point out that the early French filmmaker, Jean Epstein, adopted Müller's ideas.

The senses, of course, present us only with symbols of reality: uniform, proportionate, elective metaphors. And symbols not of matter, which therefore does not exist, but of energy: that is, of something which in itself seems not to be, except in its effects as they affect us. We say "red," "soprano," "sweet," "cypress" when there are only velocities, movements, vibrations. But we also say "nothing" when the tuning-fork, diaphragm and reagent all record evidence of existence.

Epstein goes on to argue that the cinematic apparatus embodies, and so serves as confirmation of, Müller's ideas.

Here the machine aesthetic—which modified music by introducing freedom of modulation, painting by introducing descriptive geometry, and all the art forms, as well as all of life, by introducing velocity, another light, other intellects, has created its masterpiece. The click of a shutter produces a photogénie which was previously unknown ...

This is why the cinema is psychic. It offers a quintessence, a product twice distilled. My eye presents me with an idea of a form; the film stock also contains an idea of a form, an idea established independently of my awareness, an idea without awareness, a latent, secret but marvellous idea; and from the screen I get an idea of an idea, my eye's idea extracted from the camera's; in other words, so flexible is this algebra, an idea that is the square root of an idea.

The Bell and Howell [then far and way the most popular film camera] is a metal brain, standardised, manufactured, marketed in thousands of copies which transforms the world outside it into art. The Bell and Howell is an artist, and only behind it are there other artists: director and cameraman. A sensibility can at last be bought, available commercially and subject to import duties like coffee or Oriental carpets.[11]

Wilhelm Wundt's (1832–1920) response to Helmholtz's psychological/epistemological propositions foreshadow the enormous impact that Helmholtz's philosophy would have on the world view of denizens of the late nineteenth and early twentieth centuries.[12] Wundt was one of the founders of experimental psychology; in 1875 he founded the Institut für Experimentelle Psychologie (Institute for Experimental Psychology) in Leipzig, the world's first

experimental laboratory in psychology. His earliest studies, from 1858 to 1862, were of sensory perception, and an interest in perception animated most of his later research.[13] Wundt's research methods combined experiment with introspection (for he believed that experimentation established the ideal conditions for introspection); however, introspection played the larger role. The important role that Wundt accorded introspection gave his psychology a phenomenological cast. Wundt claimed to be investigating experience as it is actually given to the subject; to this end, he strived to capture the content of experience in its immediate nature, unmodified by abstraction or reflection.

It is Wundt's early studies of perception that concern us here. Wundt claimed that the process of forming a perception has several stages. The first stage, or "the first psychic act," he called "sensation" to distinguish it from "perception." Sensation, the way he used the term, precedes perception proper; it is an elemental stage that cannot be broken down into component parts. At this elemental stage, the self and the world meet, for the physical material from the outside world is transformed into psychic material.[14]

Many nineteenth-century thinkers suggested that there exists an elemental stratum that precedes conscious, formulated experience. Indeed, the commonplace claim that art strips away the spiritual dust and grime that sully the perceptual faculties, in this way restoring experience to us, has its roots in a related (if less radical) notion of sensation. In a purer form, and closer to Wundt's original formulation, this idea provides the basis for Dennis Lee's poetics and for Stan Brakhage's filmmaking—one would not be far off the mark to assert that Brakhage's filmmaking, at least from the mid-1960s, is a quest for a means to convey his ever deepening experience of the precursors of conscious perception—to uncover the phenomenon that Wundt called "sensation." We must consider the appeal of the claim that there is a primal stage of experience that precedes consciousness, that does not know the distinction between the self and the world, for that claim is what carries us to the very core of one of the drives that led to the Absolute Film.

Notions about elemental perception contributed to the development of the theories of "pure visuality" that played such an important part in late nineteenth-century art theory.[15] Among the most important of late nineteenth-century theorists whose names we associate with an interest in pure visuality are Conrad Fiedler (1841–1895) and Aloïs Riegl (1858–1905). Here, we focus on Fiedler.

Fiedler's interest in the topic grew out of his thinking about the role that language plays in perception. The commonsense conception of language holds that nouns are the key terms of language and that nouns name pre-existing objects. Fiedler rejected the idea that language is a notational system that denotes objects that lie outside language. He rejected that conception of language on the grounds that language played an evolutionary role. He maintained

that language evolved out of an *Ausdrucksbewegung*, a straining toward expression that developed at a certain stage in psycho-physical development, and not as a means for naming extramental, extralinguistic objects.

If we look into ourselves and consider experience, we discover that the contents of consciousness are not fixed forms with unchanging properties. Rather, what we experience is in perpetual flux. All that is fixed is that which linguistic energies themselves create. It is *words* that create fixity: we hang on to the word because of its stabilizing effects. However, words belong to the mind itself, and they are incommensurate with anything outside language. Certainly, we can summons words back into consciousness, and when they return to consciousness they can reanimate the experience with which they were previously associated. But a word does not represent an extramental reality or denote the experience with which it is associated—it is associated with it, and that is all. Language is completely autonomous of any possible extramental world.

Fiedler and his many followers argued that a host of mistakes follow from the erroneous belief that language is denotation, and that paramount among these errors were faulty ideas about the relation between the contents of consciousness and the world. The belief that language is denotation encourages us to conclude, incorrectly, that visual representations denote extramental realities and that their accuracy can be assessed by comparing visual sensations with reports from other senses—that is, by verifying that what we are seeing is really there (and is as our visual mechanism presents it) by reaching out and touching the object. But the reports of the different senses are strictly incommensurate, Fiedler noted: there is no ground for comparing a tactile experience with a visual experience. Only the proposition that the tactile experience and the visual experience derive from the same object leads us toward the conclusion that there is some homology between the different experiences. Thus, our inference is based on a *petitio principii*. The different senses corroborate one another's reports about the nature of an external object, and we conclude that the existence of the object is independent of the mind. Our conclusion, however, rests on the assumption that different sensations stem from the same object makes them commensurate. But there is no reason to believe that we know anything of these extramental existents.

Fiedler also critiqued the belief that the object represented in a visual perception has an independent, extramental existence—a belief that has long influenced artistic theory and practice. Since Classical Greece (consider the famous story of Zeuxis and Parhassios), an ideal of the artistic tradition has been that of "the correct" (i.e., correct representation). Even so, the belief that we can appraise the accuracy of a visual representation by comparing it with its model has no foundation: we have no access to extramental reality. We are forever locked into the circuit of experience.

MODERNISM AND THE ABSOLUTE FILM

What happens when we accept the notion that the visual forms we experience are not representational at all, and have a strictly autonomous existence? And what happens when we isolate visibility from other sorts of sensuous experience, and take it as mental experience, without assuming anything about any extramental referent? Fiedler's radical program was to propose that we unpack the consequences of the beliefs these questions implied. His program was so groundbreaking that it anticipated features of Edmund Husserl's project for a scientific phenomenology. Just as Husserl proposed that we "bracket" the existence of the external world, so Fiedler suggested that considerations about "outside reality" should be irrelevant to the scrutiny of the actual contents of visual experience. And just as Husserl's new science devoted itself to providing precise descriptions of what appears in consciousness, so Fiedler's method dedicated itself to scrutinizing the details of visual experience itself. Both Husserl's methods and Fiedler's focused attention on phenomena that happen inside the mind.

But unlike Husserl, Fiedler was concerned primarily with the visual modality. Visual experience has qualities that all other sensory modalities lack. Fiedler identified these qualities as colour, tonality (lighter and darker areas), and *Glanz* ("lustre," or "shine"). These qualities are present only in visual experiences and cannot be reduced to any feature not present in visual experience. It follows that we cannot measure non-visual experience against visual experience; nor can we compare visual experiences with experiences of any other sort. All we can possibly do is compare visual experiences with one another. These propositions provided a compelling basis for arguments about the uniqueness of visual experience that would become common in artistic circles in the first decades of the twentieth century.

Philosophers and art theorists who expounded a theory of pure visuality had a yet more fundamental influence on the development of modernist theory. Philosophers, like common people, took it for granted that the purpose of the visual faculty was to provide us with information about the world. Fiedler, and others concerned with pure visuality, argued that visual experience does not tell us anything about a possible world of objects that exists independent of the mind. Visual experiences tell us about themselves, and only about themselves. What, then, is their purpose? Fiedler was insistent: seeing is for its own sake.

By the opening years of the nineteenth century it was becoming evident that vision could no longer assert radical claims for its value as a source of information about the world. The Western philosophical tradition had often disparaged the senses—nonetheless, whatever value philosophers attributed to the senses, they generally had maintained that, among the senses, vision is supreme. But if vision had once enjoyed that status, it was rapidly losing it. In the theories of Fiedler and of other exponents of the notion of pure visuality, this crisis of visual perception—indeed, perception in general—has become ex-

plicit. In response to this epistemological crisis, Fiedler propounded the extreme thesis that vision is altogether wanting when it comes to informing us about the condition of the world beyond our minds, that vision is not so much a cognitive instrument as an aesthetic agent. Vision is utterly autotelic: it represents nothing. This conception of vision played an important role in the modernists' conception of aesthetic experience. The etiology of that conception of vision is instructive: it developed out of the crisis of vision, that same crisis to answer which photography and film came into existence. This connection alerts us to the tight links that photography and film have to modernism (even though, as media with an affinity for representation, they might seem, *prima facie*, to be the antithesis of modernism).

Fiedler's ideas on sheer visibility (*Sichtbarkeit*), his concern with "seeing for its own sake," his belief that we achieve full seeing only when the ligatures between the images in our mind and objective reality have been severed, were the basis of his aesthetic theory. Fiedler's purpose was to write a defence of the visual arts; he pursued his questions about visual art to the core of the concept of representation, the relationship between the model and image (or, as Fiedler called them, between the *Vorbild* and the *Nachbild*). Linguistic theories are founded on a conception of the relationship between the signifier and the signified. Fiedler accused thinkers of extending this conception of the sign to apply across all significatory modalities, assuming that signifiers represent (directly or indirectly) an extramental reality. However, Fiedler insisted, the painter or sculptor does not juxtapose model and image. The external object belongs to nature, a domain that lies beyond our reach. The external object is not the model; rather, the model is the artist's visual perception.

The activities involved in making art continue the processes involved in perception. The artist's hand does not reproduce what the artist's mind has just perceived—the hand actually plays a role in shaping the perception. The artist's activities in making an object are part of the artist's process of experiencing.[16] The bodily gesture is part of the process of articulating a percept, so in artistic perception body and spirit are one. Art making is forming visibility (*Sichtbarkeitgestaltung*). Visible nature is a welter of intuitions and perceptions; but art gives visibility a splendid order. Art is therefore nature transformed. Nature has a form, for if it did not, it would not be visible; yet its form is rudimentary. Art takes this rudimentary form, which nature offers as a gift in such abundance, and refines and elaborates it. Thus, art making is a process that carries perception from confusion to clarity, from indefiniteness to exactitude. Thus, as in Collingwood's aesthetics, natural form and artistic form are not related to each other as *Vorbild* to *Nachbild*, as model to image, but rather as a less definite image to a more definite image. Art making brings that which is incipient in nature to a distinct and well-patterned form in which human consciousness can more adequately grasp it.

BERGSON AND INTUITION

Fiedler argued that we apprehend an object through a sort of intuition. The topic of intuition was central to the philosophy of another important thinker, an intellectual giant of the last decade of the nineteenth and first decades of the twentieth century, Henri Bergson. Bergson contrasted the activities of the intelligence with those of instinct—and instinct, he contended, leads us to the vital core of reality:

> Instinct is sympathy. If this sympathy could extend its object and also reflect upon itself, it would give us the key to vital operations—just as the intelligence, developed and disciplined, guides us into matter. For—we cannot too often repeat it—intelligence and instinct are turned in opposite directions, the former towards inert matter, the latter towards life. Intelligence, by means of science, which is its work, will deliver up to us more and more completely the secret of physical operations; of life it brings us, and moreover only claims to bring us, a translation in terms of inertia. It goes all round life, taking from outside the greatest possible number of views of it, drawing it into itself instead of entering into it. But it is to the very inwardness of life that *intuition* leads us—by intuition I mean instinct that has become disinterested, self-conscious, capable of reflecting upon its object and of enlarging it indefinitely.[17]

Bergson recognized that such assertions must appear to many to be ethereal and ungrounded. To counter these accusations, he pointed out that intuition is possible—and as an example of intuition, he pointed to the aesthetic experience and its ability to reveal the inner principles that organize shapes and lines in a comprehending form:

> That an effort of this kind is not impossible, is proved by the existence in man of an aesthetic faculty along with normal perception. Our eye perceives the features of the living being, merely as assembled, not as mutually organized. The intention of life, the simple movement that runs through the lines, that binds them together and gives them significance, escapes it. This intention is just what the artist tries to regain, in placing himself back within the object by a kind of sympathy, in breaking down, by an effort of intuition, the barrier that space puts up between him and his model. It is true that this aesthetic intuition, like external perception, only attains the individual. But we can conceive an inquiry turned in the same direction as art, which would take life *in general* for its object, just as physical science, in following to the end the direction pointed out by external perception, prolongs the individual facts into general laws. No doubt this philosophy will never obtain a knowledge of its object comparable to that which science has of its own. Intelligence remains the luminous nucleus around which instinct, even enlarged and purified into intuition, forms only a vague nebulosity. But, in default of knowledge properly so called, reserved to pure intelligence, intuition may enable us to grasp what it is that intelligence fails to give

us, and indicate the means of supplementing it. On the one hand, it will utilize the mechanism of intelligence itself to show how intellectual molds cease to be strictly applicable; and on the other hand, by its own work, it will suggest to us the vague feeling, if nothing more, of what must take the place of intellectual molds. Thus, intuition may bring the intellect to recognize that life does not quite go into the category of the many nor yet into that of the one; that neither mechanical causality nor finality can give a sufficient interpretation of the vital process. Then, by the sympathetic communication which it establishes between us and the rest of the living, by the expansion of our consciousness which it brings about, it introduces us into life's own domain, which is reciprocal inter-penetration, endlessly continued creation.[18]

ABSTRACTION AND THE OCCULT

To this point, my comments on the origins of abstract art have presented ideas that have widespread acceptance. Yet there is another view of the origins of abstract art, one far different from the account commonly offered, though the ideas on which this view is founded were pervasive in artistic circles in the early decades of the twentieth century. This view links the commitment to abstraction with the quest for transcendence. Any historical examination of the beliefs and engagements of the key figures involved in developing abstract art will find that a significant number of them belonged to groups that promoted esoteric beliefs of various sorts, and that they engaged in spiritualist practices or participated in various heterodox activities. This account explains the turn toward abstraction by the fact that these artists' religious or metaphysical interests could not be presented in traditional pictorial terms, as concrete images.

Even during the years when the Alfred Barr/Clement Greenberg etiology of modernist art held sway, scholars were producing an extensive body of writing that alluded to the interest many of the pioneering abstractionists took in non-aesthetic (non-materialist, non-formal) matters and that highlighted how that interest shaped their art. Robert Rosenblum's impressively researched *Modern Painting and the Northern Romantic Tradition: Friedrich to Rothko* traced the lineage of modernist art to figures outside the School of Paris, outside the circle of European painters to whom Greenberg regularly returned when he wished to discuss the relationships between American and European painters. Meyer Shapiro's writings during the 1940s, 1950s, and 1960s challenged the dominant formalism, accusing it of being unhistorical. Sixten Ringbom's writings on Wassily Kandinsky and "the epoch of the spiritual," and Robert P. Welsh's writings on Mondrian and Theosophy, challenged those views which limited the significance of modernist art to purely formal issues.

Acknowledging the role that hermetic ideas played in early modernism raises a challenge to Greenbergian theories about the role of abstraction.

Associated with the idea that art is a spiritual practice is the concept of "non-objective art" (*gegenstandlose Kunst*), a term that enjoyed great prominence in the early decades of the twentieth century. Kandinsky (1866–1944) asserted that by his time painting had reached a dividing point, with its two major types separated according to their objects. There was that art which depicts a "natural object" or "nature," a traditional art that does what art had aspired to do for centuries: to represent the material reality around us. Up until Kandinsky's time, almost all art had strived to do exactly that, and even in Kandinsky's day that aspiration persisted: "Painting today is still almost entirely dependent upon natural forms, upon forms borrowed from nature," Kandinsky wrote.[19] Non-objective art, that art which today we call "abstract," arose from the effort to dispense with subjects borrowed from nature; the creators of non-objective art strived to free their art from its bonds to material objects. Yet that does not mean that they sought to dispense with "subject matter" altogether, or to convert the work into, simply, a self-reflexive object that reflected on its own material conditions or the process through which it came into being. Non-objective art, Kandinsky stated, deals with a hidden reality, a reality that lies "veiled in darkness," with an "inner nature" of beings that can only be apprehended by a developed spirit.[20] However, this experience, though non-rational (or suprarational), is not entirely subject to the vagaries of transient emotional states, for we apprehend the inner nature of beings not through the soul, but rather through the spirit (to use that distinction of which Mme Blavatsky and Steiner made so much).

In the early years of the modernist period, occult, hermetic, and mystical systems attracted artists of many different stripes and dispositions. The names of the exponents of several of these systems will be familiar to most readers: Eliphas Lévi, Stanislas de Guaita, "Papus," Sar Péladan, Mme Blavatsky, A.P. Sinnett, MacGregor Mathers, Wynn Westcott, Annie Besant, and "Archbishop" Leadbeater. These people founded groups that differed in significant ways, but all of them held certain ideas in common: that the universe is a single, living being with attributes we understand as pairs of opposites (male–female, positive–negative, light–dark, active–passive, yin–yang, vertical–horizontal); that this single being undergoes evolution; that this evolution reconciles the differences between what we understand as the opposing features of this single being; that a principle of analogy (signatures) interrelates all entities, and relates those on a lower plane with those on a higher plane—matters are above as they are below, and objects with similar appearances have similar spiritual powers (thus the great interest in diagrams, charts, and symbols among members of these groups); that epiphanies reveal beings which our senses are unable to present; that the imagination makes reality, hence mind and world are one; and that spiritual beings undergo an evolutionary process through which they come into possession of ever higher states of consciousness. Further-

more, most of these groups concerned themselves with the cultivation of the inner life, and their members sought a mental state characterized by feelings of being at peace, and at one, with the universe and by the sense of having become privy to the secret that unlocks the mystery of being.

At the core of all occult teaching is the belief that hidden behind (or within) the material world around us is a spiritual reality. Occultism purports to coach seekers on the ways to study those hidden forces, those hidden realities, that reason or science cannot uncover. The "dissolution of the atom" that so troubled (and excited) Kandinsky seemed to many artists to confirm what occultists had been asserting for centuries: that reality is not something solid and inert, but something spiritual.[21] Matter is only congealed, condensed spirit. At a certain stage in their spiritual development, seekers discern that the material world, apparently so solid, is really only the outward appearance of an inner spiritual reality—it is how true spiritual reality shows itself to the base senses.

Other beliefs, while not as widely held as those just set out, were nonetheless common among these occult groups. Many occultists were convinced that the underlying substance that makes up the universe is more like energy than like matter or mind (or at least, what matter and mind are ordinarily thought to be), but more like mind than like matter; many believed that since all sensation is a response to the vibratory actions of this energy, all of the sensory modalities are essentially alike, and that synaesthesia (seeing sound, hearing light, tasting fragrance, etc.) is therefore a real possibility; many believed, too, that our sensory faculties are restricted to three-dimensional presentations of the world, though actually the cosmos has four (perhaps even more) dimensions; some also believed that humans could train their imagination to picture objects in four dimensions.[22]

Among those who embraced such beliefs was the pioneering abstractionist Kandinsky, who made it clear that making people aware of this spiritual dimension was the goal of his art and, especially, of his writing:

> I believe the philosophy of the future, apart from the existence of phenomena, will also study their spirit with particular attention. Then the atmosphere will be created that will enable mankind in general to feel the spirit of things, to experience this spirit, even if wholly unconsciously, just as people in general today still experience the external aspect of phenomena unconsciously, which explains the public's delight in representational art. Then, however, it will be necessary for man initially to experience the spiritual in material phenomena, in order subsequently to be able to experience the spiritual in abstract phenomena. And through this new capacity, conceived under the sign of the "spirit," an enjoyment of abstract (= absolute) art will come about.
>
> My book *On the Spiritual in Art* and the *Blaue Reiter* [*Almanac*], too, had as their principal aim to awaken this capacity for experiencing the spiritual in

material and in abstract phenomena, which will be indispensable in the future, making unlimited kinds of experiences possible. My desire to conjure up in people who still did not possess it this rewarding talent was the main purpose of both publications.[23]

Kandinsky's beliefs were an idiosyncratic mixture of idealist philosophy (such as that of Hegel), Mme Blavatsky's Theosophy, Russian Orthodoxy, and Christian Gnosticism. The Orthodox elements of Kandinsky's thought were especially pronounced. He adopted Russian Orthodoxy's idea that there had been three historical epochs: during the first, Imperial Rome had been the world capital; during the second, the capital had been Byzantium (Constantinople), the "Second Rome"; and during the third and present epoch, the capital was Moscow.[24] He also accepted the Orthodox view that these phases correlated with the three persons of the Godhead; thus Imperial Rome represented the Father, and Byzantium the Logos, while Moscow, by embodying the collective life of the entire nation, would be inspired by the Holy Spirit. He also accepted the Orthodox prediction that three historical epochs would be needed to bring about the *eschaton* (the end of everything) and that at the end of the third era the Divine Kingdom would be fully realized on earth.

From Russian Orthodoxy, too, Kandinsky adopted the belief that with the fall of Byzantium to the Muslim Turks in 1453, the torch of Christianity had been passed to Moscow. Since then, Moscow's spirit had been evolving toward that of the Holy Spirit so that it might fulfill its historico-spiritual mission. In the last years of the nineteenth century and the early years of the twentieth, a millenarian enthusiasm persuaded many adherents to Russian Orthodoxy that the end of the twentieth century would see the kingdom's perfection. Kandinsky shared in this enthusiasm. In their preface to *Der Blaue Reiter* (The Blue Rider), Kandinsky and Franz Marc opined that "a great era has begun: the spiritual 'awakening,' the increasing tendency to regain 'lost balance,' the inevitable necessity of spiritual plantings, the unfolding of the first blossom. We are standing at the threshold of one of the greatest epochs that mankind has ever experienced, the epoch of great spirituality."[25] Or again, in *Über das Geistige in der Kunst* (Concerning the Spiritual in Art), Kandinsky quoted Mme Blavatsky's statement that "in the twenty-first century this earth will be a paradise by comparison with what it is now."[26]

Kandinsky's prewar paintings make evident his belief that Moscow would become the New Jerusalem and that on His return the Kremlin would be Jesus' abode and the centre from which He would exert his dominion over all the earth. Kandinsky believed that aesthetic education would play a vital role in the arrival of the *eschaton*, for it would cultivate the spirit, leading it away from materialism toward pure spirituality:

The more freely abstract the form becomes, the purer, and also the more primitive it sounds. Therefore, in a composition in which corporeal elements are more or less superfluous, they can be more or less omitted and replaced by purely abstract forms, or by corporeal forms that have been completely abstracted. In every instance of this kind of transposition, or composition using purely abstract forms, the only judge, guide and arbitrator should be one's feelings. Moreover, the more the artist utilizes these abstracted or abstract forms, the more at home he becomes in this sphere, and the deeper he is able to penetrate it. The spectator too, guided by the artist, likewise increases his knowledge of this abstract language and finally masters it.[27]

Sometimes occultists understood the unifying reality as being not energy but form: everything that exists is subsumed in one great, overarching, all-embracing form, the constructive patterns of which repeat throughout the cosmos.[28] This tells us why many occult practitioners turned to geometry for principles to explain those patterns which hold reality together in a primal unity. Out of this emerged a discipline called "sacred geometry." That discipline elevated pattern almost to the status of *nous*—to being an "ideal being" akin to the fundamental reality. And the informing principles of that reality could be grasped by an intellectual act higher than the idolous (in the sense that derives from *eidolon*) distortions of sense perception (thus higher than the cognitive acts that Plato refers to as *eikasia*); higher than knowing through practical principles whose underlying justifications we do not understand (and thus higher than the cognitive acts that Plato referred to as *pistis*); higher even than knowing through reasoning from first principles (and thus higher even than the cognitive acts that Plato referred to as *dianoia*). Higher than all of these is intuition (akin to Plato's *noesis* or *episteme*), through which we grasp the ideal order of reality.[29] A popular account of the idea of sacred geometry by a committed practitioner opens with this statement:

> Both our organs of perception and the phenomenal world we perceive seem to be best understood as systems of pure pattern, or as geometric structures of form and proportion. Therefore, when many ancient cultures chose to examine reality through the metaphors of geometry and music (music being the study of the proportional laws of sound frequency), they were already very close to the position of our most contemporary science.
>
> Professor Amstutz of the Mineralogical Institute of the University of Heidelberg recently said:
>
> > Matter's latticed waves are spaced at intervals corresponding to the frets on a harp or guitar with analogous sequences of overtones arising from each fundamental. The science of musical harmony is in these terms practically identical with the science of symmetry in crystals.
>
> The point of view of modern force-field theory and wave mechanics corresponds to the ancient geometric-harmonic vision of universal order as being an

interwoven configuration of wave patterns. Bertrand Russell, who began to see the profound value of the musical and geometric base to what we now call Pythagorean mathematics and number theory, also supported this view in *The Analysis of Matter*: "What we perceive as various qualities of matter," he said, "are actually differences in periodicity."[30]

Another book on sacred geometry, André Vandenbroeck's *Philosophical Geometry*, describes the purposes of the discipline in even more starkly Platonic terms. Plato distinguished *dianoia* (deductive reasoning) from *noesis* by noting that *dianoia* depends on assumptions we call axioms, of which it does not give an account, whereas *noesis* grasps the internal necessity that determines that the propositions the axioms state must be true. Socrates expounds the difference, describing first *dianoia*.

> You know, of course, how students of subjects like geometry and arithmetic begin by postulating odd and even numbers, or the various figures and the three kinds of angle, and other such data in each subject. These data they take as known; and, having adopted them as assumptions, they do not feel called upon to give any account of them to themselves or anyone else, but to treat them as self-evident. Then, starting from these assumptions, they go on until they arrive, by a series of consistent steps, at all the conclusions they set out to investigate ... You also know how they make use of visible figures and discourse about them, though what they really have in mind is the originals of which these figures are images. [At this level of understanding] the mind, in studying [intelligible things,] is compelled to employ assumptions, and, because it cannot rise above these, does not travel upwards to a first principle; and second, that it uses as images those actual things which have images of their own in the section below them.[31]

Vandenbroeck writes analogously:

> In the gravitational universe ... experience again and again conforms to the mathematical language expressing the laws of falling bodies, but in no way do bodies dictate a set of signs expressive of their fall. By induction, and in a language expressing concepts of time, space, mass, and motion (which a falling body might well imply, although never solicited for its experience), laws are worded to which any falling body must comply. These laws in turn convert into a syntax of signs chosen from a specialized language, or better, an existing language is syntactically fitted to the experience in order to spell out its law. At the root of this language but beyond our present concern, there festers a mere hypothesis as to the nature of the universe in which bodies fall ...
>
> Not so in Philosophical Geometry, where experience of fact and theory of language are carefully sundered from the start. Language here evolves from a set of signs dictated by an experience of absolute necessity, so that the order of signs can never be elsewhere applied. Necessity qualifies geometric facts, ex-

cluding all variants of experience, and no laws can be induced save a sole-singular law governing a unique experience, a law at best identical with the experience itself ... Where a falling body can never find independence from the total mass of the universe within which it is observed, Philosophical Geometry maintains the possibility of independent inception and necessary order: If there exists a syntax of signs that is expressive of a sequence of facts, and if it exists without former referents and without presuppositions, such a structural version of facts can be evolved by Philosophical Geometry.[32]

So Vandenbroeck attempts to justify his extraordinary claims.

It will be immediately apparent that geometric facts present themselves ready-named, and if their name is called, will respond with proof of their identity, so that a set of signs can be evolved which accurately denotes a universe of facts. Such a set of signs would constitute perfect language, as signs conforming to a universe of facts offer the basis for a linguistic structure identical to a structure of experience.[33]

The idea of a perfect language, one in which nouns actually present that to which they refer and whose syntax reflects the order of things, is a venerable one in the occult and hermetic traditions. The seventeenth-century Jesuit scholar Athanasius Kircher (sometimes Kirchner, 1602–1680) proposed similar views about Chinese, which he thought might have been the language of Adam. The occultist John Dee described a perfect language, the nature of which the angel Gabriel revealed to him, and in which "every word signifieth the quiddity of the substance." Dee believed as well that this perfect language was the primal language, the language of our origin and the language to which humankind will eventually return. The twentieth-century philosopher Walter Benjamin alluded to such ideas in "Über die Sprache überhaupt und über die Sprache des Menschen" (On Language as Such and the Language of Man, 1916) and "Die Aufgabe des Übersetzers" (The Task of the Translator, 1923).

Practitioners of sacred geometry, too, described an ascent to the higher forms of knowledge. Robert Lawlor's *Sacred Geometry: Philosophy and Practice*, discusses the curriculum of the Medieval era as a ladder of knowledge, of the sort that any reader of Mme Blavatsky would find familiar:

Geometry is the study of *spatial order* through the measure and relationships of forms. Geometry and arithmetic, together with astronomy, the science of *temporal order* through the observation of cyclic movement, constituted the major intellectual disciplines of classical education. The fourth element of this great fourfold syllabus, the Quadrivium, was the study of harmony and music. The laws of simple harmonics were considered to be universals which defined the relationship and interchange between the temporal movements and events of the heavens and the spatial order and development on earth.[34]

The goal of learning, according to this statement, is to inculcate the hermetic principle of the "analogy of the two orders"—the principle that patterns here on earth reflect the patterns that obtain in the higher orders of existence. Lawlor continues his commentary on Medieval education, identifying the spiritual values of the study of geometry:

> The implicit goal of this education was to enable the mind to become a channel through which the "earth" (the level of manifested form) could receive the abstract, cosmic life of the heavens. The practice of geometry was an approach to the way in which the universe is ordered and sustained. Geometric diagrams can be contemplated as still moments revealing a continuous, timeless, universal action generally hidden from our sensory perception. Thus a seemingly common mathematical activity can become a discipline for intellectual and spiritual insight.[35]

Lawlor expounds on the Platonic metaphysics that underlies these beliefs:

> Plato considered geometry and number as the most reduced and essential, and therefore the ideal, philosophical language. But it is only by virtue of functioning at a certain "level" of reality that geometry and number can become a vehicle for philosophical contemplation. Greek philosophy defined this notion of "levels," so useful in our thinking, distinguishing the "typal" and the "archetypal." Following the indication given by the Egyptian wall reliefs, which are laid out in three registers, an upper, a middle and a lower, we can define a third level, the ectypal, situated between the archetypal and typal.
>
> To see how these operate, let us take an example of a tangible thing, such as the bridle of a horse. This bridle can have a number of forms, materials, sizes, colours, uses, all of which are bridles. The bridle considered in this way, is typal; it is existing, diverse and variable. But on another level there is the idea or form of the bridle, the guiding model of all bridles. This is an unmanifest, pure, formal idea and its level is ectypal. But yet above this there is the archetypal level which is that of the *principle* or *power-activity*, that is a *process* which the ectypal form and typal example of the bridle only represent. The archetypal is concerned with universal processes or dynamic patterns which can be considered independently of any structure or material form. Modern thought has difficult access to the concept of the archetypal because European languages require that verbs or action words be associated with nouns. We therefore have no linguistic forms with which to image a process or activity that has no material carrier. Ancient cultures symbolized these pure, eternal processes as gods, that is, powers or lines of action through which Spirit is concretized into energy and matter.[36]

Here Lawlor adopts the stance of Ernest Fenollosa's "The Chinese Written Character": other cultures describe reality more accurately because, by making the verb rather than the noun the primary lexical type, they can understand reality as made of processes and not of static objects.

Lawlor ends his survey of the site where a metaphysic of energy meets with sacred geometry with a most astonishing statement: "The bridle, then, relates to archetypal activity through the function of *leverage*; the principle that *energies are controlled, specified and modified through the effects of angulation.*"[37]

These ideas may seem odd, but in the first decades of the twentieth century they attracted even so hard-headed a thinker as Sergei Eisenstein. Eisenstein expended much effort on explicating the notion of the Golden Section (which he took as a perfect expression of the harmony between part and whole) and on expounding on the aesthetic potential of other mathematical functions (such as the logarithmic spiral). His book *Neravnodushnaia priroda* (Nonindifferent Nature) is presided over by a Neoplatonic belief in the sensuous truth of mathematical harmonies, exemplified in musical intervals: it was this that led him to conduct his analysis of *Pyramids*, a visual sonata by the renowned musical painter M.K. Čurlionis (through which he claimed to have discerned the musical principles that inform traditional Chinese landscape painting). More important yet, *Neravnodushnaia priroda* is dominated by a pantheism (or, perhaps, pseudo-pantheism) that has close affinities with Neoplatonism.

THE EXTRAORDINARY INFLUENCE OF ANNIE BESANT AND CHARLES LEADBEATER'S *THOUGHT FORMS*

The Theosophical Society was founded in New York City on November 17, 1875, by Helena Petrovna Blavatsky (1831–1891), Henry Steel Olcott, and William Quan Judge. Mme Blavatsky became interested in occultism and spiritualism shortly after the breakup of her marriage (in 1848). For many years after that, she travelled extensively in Asia, Europe, the United States, and Canada; later she would claim to have spent several years in India and Tibet studying under Hindu gurus. In 1873 she went to New York City, where she met and became a close companion of Henry Olcott; in 1875 they and several other prominent people founded the Theosophical Society. In 1877 she published her first major work, *Isis Unveiled*, which criticized the science and religion of her day and asserted that mystical experience was the means to attain true spiritual insight and authority. Though *Isis Unveiled* attracted much attention, membership in the Society collapsed in the late 1870s. In 1879 Blavatsky and Olcott went to India; three years later they moved the Theosophical Society headquarters to Adyar, near Madras, where they began publishing a journal, *The Theosophist* (which Mme Blavatsky edited from 1879 to 1888). The Theosophical Society soon developed a strong following in India.

This popularity brought attacks down on Mme Blavatsky. On trips to Paris and London she claimed that she possessed extraordinary psychic powers. Late in 1884, the same claims prompted criticisms in the Indian press, which

accused her of concocting fictitious spiritualist phenomena. That same year she travelled to Germany, where her protestations of innocence garnered an enthusiastic reception. The following year, the Hodgson Report—the findings of an investigation by the London Society for Psychical Research—declared her a fraud. Soon after, she left India in failing health. She lived quietly in Germany, Belgium, and finally in London, working on *The Voice of Silence* (1889) and on her *magnum opus*, *The Secret Doctrine* (1888), which was an overview of theosophical teachings. That book was followed in 1889 by her *Key to Theosophy*. Her *Collected Writings* have been published in sixteen volumes (1950–91).

In 1889, Annie Besant (née Wood, 1847–1933), a former Fabian, union leader, strike organizer, and promoter of secularist causes (she was vice-president of the National Secularist League and a passionate atheistic materialist who in 1877 had published *The Gospel of Atheism*) was converted to Theosophy by reading Mme Blavatsky's *Secret Doctrine*. Besant followed in Mme Blavatsky's path by travelling to India. There, in 1893, she met Charles Leadbeater (1847–1934), an Anglican cleric who claimed to have clairvoyant powers. He became her spiritual companion.

In the first decades of the twentieth century, Theosophy extended its teachings into new areas. This occurred largely while the Theosophical Movement was under the direction of Besant, Mme Blavatsky's successor (Besant had been elected president of the Theosophical Society in 1895). Mme Blavatsky had claimed a spiritual provenance for Theosophy in several esoteric traditions and had combined ideas drawn from those traditions with others taken from Judaism, Christianity, Buddhism, and Hinduism. Besant focused on Theosophy's connection with Hinduism. Besant and Leadbeater were also interested in ideas that had only secondary importance under Mme Blavatsky, ideas that included the following: the energetic constitution of reality, the geometry of forms, a more thoroughgoing monism than ever its founder had propounded, a more schematized (and rigid) conception of the cosmic evolutionary schema, the astral plane (through which the soul ascends after death), and, finally, thought forms.[38] The last idea, which points to Leadbeater's lingering interest in Spiritualism, was propounded in a book that Leadbeater and Besant wrote together: *Thought Forms* (1909), which was to have enormous influence on twentieth-century art.

The basic notion underlying *Thought Forms* is that the entire cosmos is made up of a single, subtle substance that vibrates. This notion informed Besant and Leadbeater's version of Theosophy, which proposed that everything is made up of a single reality, the Logos, which assumes more or less subtle forms. The Logos is active: it vibrates, and the speed and amplitude of this vibration determine how subtle are the local forms this reality assumes. The human body is a tripartite entity: the physical body; the mental body, which is responsible for cognition; and the astral body, which is the locus of emotion, of desire and pas-

sion. The mental body and the astral body interpenetrate to form a "cloud-like substance" or "aura" around the physical body. In the present day, most humans cannot see this "aura"—only spiritually developed individuals who have clairvoyant powers can do so. Evolution, however, will enable increasing numbers to see this phenomenon.

The aura is an amalgam of the mental body and the astral body; every thought and every emotion has its own, peculiar rate of vibration, and that particular rate of vibration correlates with a particular colour and a particular form of the aura. The activities of the mental and astral bodies (which are responsible for cognitive and emotional functions respectively) are also associated with specific vibrations, each of which is in turn associated with a specific colour, form, and outline (with the quality of the thought the activity produces determining the colour of the thought-form/aura, the nature of the thought determining its form, and the definiteness of the thought determining the clarity of its outline).

Besant and Leadbeater were precise about how colours correspond to the particular spiritual/emotional qualities of thoughts. Thus, shades of deep red, dark brown, and muted grey correspond to anger, sensuality and avarice, and depression, respectively. Also, the various shades of blue all correspond to religious feelings: dark-brownish blue correlates with selfish devotion; pallid grey-blue with fearful fetish worship; deep, rich, clear blue with heartfelt adoration; pale azure with the highest form of feeling, implying self-renunciation and union with the Divine; and the deep blue of the summer with the devotional thought of an unselfish heart. Green represents sympathy, crimson represents affection, pink represents unselfish love, and yellow represents intellectual effort. Combinations of colours, when harmonious, represent the harmonious sounding of the cosmos.

It was characteristic of modern art movements that they strived to bypass meaning in communicating and to deliver effects immediately, directly, and without semantic reference. Besant and Leadbeater held similar ideals. Communication, they stated, is the effect of vibrations of the Logos, that all-pervasive substance; under the influence of these Theosophic ideas, Kandinsky concluded that to hear the sound of the cosmos was to receive communication from the Logos. The all-pervading Logos creates harmonious vibrations as all things sound together (Kandinsky referred to this sounding together as *Zusammenklingen*).

Several artists founded their theories of art on the proposition that reality is made up of vibrations. Kandinsky, for example, believed that the finer emotions are vibrations. He believed, too, that vibrations affect all the stages the artwork goes through in reaching the viewer: vibrations of the maker's soul shape the work of art; then the work itself communicates through vibration; and as these vibrations impact on the beholder, his or her soul is set into

MODERNISM AND THE ABSOLUTE FILM

motion.[39] In this way he was using Theosophical principles to explain how works of art could affect the recipient directly and non-verbally.

If reality is fundamentally energy in vibration, then sensation is humans' response to reality's vibratory dynamism. Reality induces sympathetic vibrations in the human soul, and those vibrations are the basis of our sensations. This common belief was the grounds for a perlocutionary conception of a work of art, according to which a work of art's meaning lies in its direct, immediate effects. Thus Kandinsky maintained that the purpose of art is to make the spectator's soul vibrate and that the internal necessity that constrains the artist's work results from the requirement to create a harmony among those vibrations. Some "highly sensitive people are like good, much played violins," he added, "which vibrate in all their parts and fibres at every touch of the bow."[40]

If all sensation is merely vibration, then all sensory modalities are essentially the same—all are stimulated by the events of a common type: "If one accepts this explanation [that sensation is vibration], then admittedly, sight must be related not only to taste, but also to all the other senses. Which is indeed the case. Many colors have an uneven, prickly appearance, while others feel smooth, like velvet, so that one wants to stroke them … Even the distinction between cold and warm tones depends on this sensation. There are also colors that appear soft … others that always strike one as hard."[41]

The idea that reality is energy grounds another idea that the occult left to modern art. John Cage often recounted an anecdote, and the persistence with which he restated it has made it well known: Cage was a young man living in Los Angeles when he met the great avant-garde filmmaker Oskar Fischinger. He suggested that he create a soundtrack of percussion music for one of Fischinger's films. Fischinger was interested but wanted to be sure that Cage adequately understood the film medium. He suggested that he learn how to animate a film, to better understand the medium's potential, especially how it can arrest time and set it back in motion. Fischinger was working on *An Optical Poem* (1937), which he was making by suspending dozens of paper objects, mostly circles, on strings so that they formed elaborate three-dimensional compositions within the space of a traditional proscenium theatre. Fischinger encouraged Cage to participate and assigned him the task of taking a long pole topped by a chicken feather and moving each of the dozens of circles a small, unvarying increment, then steadying each in preparation for the next exposure, then going through the same process for the next frame. Fischinger waited by the camera, supervising Cage as he engaged in the painstaking chore. All the while, Fischinger puffed on a cigar. It took Cage a long time to move each of the circles with every new frame, and Fischinger dozed off as Cage prepared the set for an exposure. Fischinger's cigar fell to the floor, igniting some rags and papers lying nearby. Cage took hold of a nearby bucket of water and threw the contents over the fire, soaking the camera.

That was the end of Cage's film apprenticeship. His brief involvement with the medium was not entirely a misadventure, though. Fischinger had told Cage of work he had done a few years earlier: he had done simple, ornamental sketches (arabesques, etc.) and photographed them onto the soundtrack area of film; in doing so, he believed, he had released the shapes' inherent spirit, which gave them their visual form, so that they were able produce their equivalent auditory values. This notion that each object contains its intrinsic sound spirit and that one releases this spirit by striking the object intrigued Cage enormously and reinforced his interest in percussion. Cage insisted repeatedly that Fischinger's teaching him that every object has a sound within it was crucial in the formation of his aesthetic ideals.

Fischinger was not the original source of that idea, however. The Vedas stated as much, and so the idea influenced Mme Blavatsky. Kandinsky, too, proposed it: our sense of limitless freedom, he wrote, "arises from the fact we have begun to sense the spirit, the inner sound within every object."[42] This inner sound, of course, correlates with the rates at which the object tends to vibrate. The core idea, that sound is a primordial form of energy that gives rise to elementary forms, became widespread.

Besant and Leadbeater believed that they had found scientific justification for the cosmological doctrine that vibration is an all-pervading force that produces the forms of all perceptible objects. In the eighteenth century, Ernst Florens Friedrich Chladni had studied the form-making potential of vibrations. In 1787 he began a series of experiments to study vibration. Using a violin bow, he induced vibrations in a glass plate on which he had spread fine sand (a flat plate of the type he used is now called a "Chladni plate"). The vibrations of the glass moved the particles so that they formed shapes: sand collected at the nodes but was shaken off the moving regions. Chladni called these geometric patterns "tone figures"; later they became known as "Chladni shapes."[43] Chladni greatly inspired Goethe and the German Romantics. The latter interpreted his sound figures as evidence that nature was musical to the core— as tangible confirmation that God's creation was made up of meaningful signs (for they resembled the meaningful symbols that humans produce). Indeed, some aesthetic theorists contended that sound figures were evidence of a fundamental kinship between nature's signs and those that humans produced. Sound figures seemed to make the auditory visual: acoustic beauty seemed to be reflected in the elegance of the sound figures, and they became a symbol of the pleasurable sounds to which the ear was attuned.

Another German Romantic, the poet and philosopher Novalis (Friedrich Freiherr von Hardenberg, 1772–1801), took an interest in sound figures because they united aural properties with geometrical shapes; thus they were evidence of correspondence between mathematical forms and the senses. Novalis was fascinated by the structural similarities among musical, mathematical,

and linguistic forms. (He often described language, philosophy, and mathematics as having rhythm, tone, beat, etc.) Johann Wolfgang von Goethe (1749–1832), the painter, novelist, dramatist, poet, humanist, scientist, politician, and philosopher, was interested in the forms, for one of the same reasons they interested Novalis: for him, they brought together science, art, and symbolism.

Chladni's illustrations of these elementary forms resemble the forms in Fischinger's *Wachs Experimente* (Wax Experiments), which he produced by slicing wax that had been melted and left to harden.[44] Indeed, these Chladni forms probably influenced the core concept of Fischinger's notion of visual music—the idea that every object has its unique spirit, which is revealed through vibration. But it is not surprising that someone should have noted the correspondence between film and Chladni forms: beginning with eighteenth-century art theory, one can see a change in the conception of visual forms—visual form was likened more and more to music, less and less often to verbal representations (hence the idea of ekphrasis became increasingly suspect). When connected to music, painting takes on a temporal form; it becomes dynamic instead of static. The accentuation of the musicality of thinking, of visual form, and of language we can observe in this period indicates a new understanding of the nature of truth. Truth itself is dynamized.

Chladni was drawing on a venerable tradition. Leonardo da Vinci (1452–1519) had pointed out that when a table is struck with a hammer, small heaps of dust appear in mounds on its surface. He then generalized from this observation: vibrations of the earth give rise to hills as particles of earth mound up, just as dust mounds up on the table surface and waves of sand carried by the wind create mountains in Libya. The dance of vibrations creates natural forms, he contended.[45] Even before Leonardo, the Neoplatonist Plotinus had used the image of one string vibrating sympathetically with another, of one lyre trembling as though it had been touched by the motion of the first (the phenomenon of sympathetic vibration also fascinated Leonardo), as the basis for his view that the elements of the universe were beating together in a mutually felt desire to offer mutual assistance—a desire that arose from the interaction of opposites. Marsilio Ficino (1433–1499), having translated Plotinus (1492), thought of body and soul as joined together in harmony and believed that harmony might be the basis of therapeutic practice. The physicist, astronomer, and microscopist Robert Hooke (1635–1703) spoke of the universe being made up of so many invisible particles, vibrating in harmony like so many equal musical strings, filaments wiggling in a cosmic dance. Isaac Newton (1642–1727) thought that the furniture of the universe might simply be different constituents of an eternal harmony and that the laws of gravity might be the laws that govern the movement of musical strings.

In fact, we find much the same ideas in all the world's philosophical traditions. For example, Taoism teaches that before the things of the world were

created, there was a formless, changeless, eternal, and undifferentiated whole. Though hidden by the ten thousand things it has brought forth, that originary primal source, that divine ground of being, is still around us, engaged in an endless dance of yin and yang, male and female, darkness and light, earth and heaven, fullness and emptiness. This ground of being seeks to effect a harmony of opposites, to create at every moment a fleeting balance. Humans find their place in the fleeting order by discovering a resonance in the vital force behind the dance. This occurs in just the same way as a lute begins to vibrate when the note *kung* is struck on another lute some distance away. What is more, there is another sort of music, a mysterious and subtle music, a sound that can set not just one of the lute's strings vibrating, but all twenty of the (Chinese) lute's strings. This is the supreme harmony: the man who drifts into the midst of this sweet contentment experiences the Great Merging—becomes as one who has not emerged from his or her origin. This soul enters into sympathetic vibration with everything.[46]

Chladni published the results of his experiments in *Entdeckungen über die Theorie des Klangesor* (Discoveries Concerning the Theory of Music), which was widely read and helped found the science of acoustics. Chladni shapes became influential in the early part of the twentieth century and are still much studied by musical instrument makers, for many percussion and string instruments rely on sound produced from vibrating plates. (Chladni himself was an amateur musician whose avocation impelled him into his studies of acoustics.) Chladni shapes also influenced those who maintained that reality is fundamentally vibratory. For this reason they are illustrated in Besant and Leadbeater's *Thought Forms*. The well-known Dutch painter Georges Vantongerloo painted them, as did the less well-known French occultist and painter Albert de Rochas d'Aiglun.

For Besant and Leadbeater, Chladni's experiments showed that mental activities are vibrations that produce thought forms in etheric matter and that vibrations that take place in humans' bodies produce higher matter (thought) in just the same way that vibrations that take place elsewhere produce physical matter.

Both Goethe and Kandinsky followed an intuitive feeling that there is a basic similarity among the kinds of information we can receive from the various senses. Empirical researchers took an interest in the subject as well. Lawrence E. Marks's *The Unity of the Senses—Interrelations Among the Modalities* reported experimental evidence supporting that intuition; for example, he reported on experiments in which people tried to identify the direction of a light source with and without the presence of sounds. Marks showed that sound influences a person's perception of direction. This sort of evidence was taken as proving that light and sound impulses meet each other and interact within the brain. In fact, many writers and artists, including Goethe and Kandinsky, have described a

correspondence between music and light (though Goethe, having first accepted the correspondence, later rejected it). Colour and sound are simply different vibrations of the same all-pervading reality; it follows that colours are just a different form of sound and sounds just a different form of colour. This constitutes the basis of synaesthetic experience. [47] Kandinsky proposed correlations between colours and tones:

Yellow This color, "which is strongly inclined to lighter tones can be given a power and intensity that is intolerable to the eye and feelings. Intensified in this way, it sounds like an ever louder trumpet blast or a fanfare elevated to a high pitch."

Orange "This color sounds like a church bell of medium pitch ringing the angelus, or like a rich contralto voice, or a viola playing largo."

Red "Musically it recalls the sonority of fanfares with contributions from the tuba—a persistent, intrusive, powerful tone ..."

Vermilion "Sounds like the tuba and parallels can be drawn with powerful drumbeats."

Purple "Cold red, if it is light ... sounds like youthful, unalloyed joy, like a fresh, young figure of a girl, pure and unsullied. This image can be easily given musical expression by the high, clear, singing tones of the violin. Pure, joyous often successive tones of little bells (including horse bells) are called 'raspberry-colored sounds' in Russian."

Violet "It resembles in sound the cor anglais or shawm, and in its depths the deep tones of the woodwind instruments (for example, bassoon)."

Blue "In musical terms light blue is like a flute, dark blue the cello, and going deeper, the wonderful sonority of the contrabass; in its deep solemn form, the sound of blue is comparable to the bass organ."

Green "I would characterize green best by comparing it to the quiet, drawn-out, meditative tones of the violin." [48]

Leadbeater and Besant maintained that thoughts and emotions could be transmitted between people through the appropriate colours and forms—indeed, that communication through colour is the ideal form of communication. Their claim would exert considerable influence on the Absolute Film. They also found an immediate application for their ideas: they developed a form of spiritual therapy that involved sending helpful thoughts and noble emotions to those in need of them by embodying those thoughts and emotions in abstract drawings. These convictions led them to produce some remarkable abstract drawings.

VIBRATORY MODERNISM
RUDOLF STEINER, ANTHROPOSOPHY, AND SYNAESTHESIA

The occultists' belief that reality is essentially a single, all-pervading spiritual substance was the foundation for teachings about synaesthesia. Besant and Leadbeater offered ideas on this topic, but the ideas of a third member of Mme Blavatsky's inner circle were especially influential. That person was Rudolf Steiner (1861–1925). Steiner's relations with Theosophy's inner circle were conflicted. "Archbishop" Leadbeater had convinced Besant of the holy provenance of a fourteen-year-old boy, Jiddu Krishnamurti. Krishnamurti, he insisted, was the reincarnation of the Lord Maitreya, the same World Teacher who in earlier eras had appeared on earth as Krishna and Jesus. Krishnamurti remained associated with the Theosophical Movement for three-quarters of a century, and on Besant's death in 1933 he became its leader. From that time until his death in 1986, he continued to teach a version of Theosophy, altered somewhat to accord with his individual convictions.

Steiner could not abide Besant and Leadbeater's belief that Krishnamurti was Jesus reincarnate or their unchecked proclivity for according him privileges and honours to conform with that belief—there was a deeply Christian streak in Steiner's thinking (he was born in what is now Croatia) that could not tolerate such blasphemy. Besant and Leadbeater's support for Krishnamurti led Steiner to defect from the Theosophical Movement and establish his own organization, the Anthroposophical Society. Anthroposophy has something of the character of a Christianized Theosophy, for it depicts the Incarnation as a central event in the evolution of the cosmos.

Steiner's writings exhibit that amalgam of science and religion that was typical of many great thinkers of his era. Recognizing his intellectual talents, his father had enrolled him in the *Realschule* in Wiener Neustadt and later in the Technical University in Vienna, hoping he would pursue his mathematical gifts. At the Technical University, Steiner studied biology, chemistry, optics, and mathematics, but he also attended classes on literature and philosophy. Steiner claimed that from a young age, he was aware of the problem of knowledge, and that his thinking and studying returned always to that subject: he was aware that in experiencing oneself as an ego, one is in the world of the spirit. He needed "to find an answer to the question: How far is it possible to prove that, in human thinking, real spirit is the agent?" Steiner studied the works of Kant, but even there did not find a system that took its start from a direct experience of the spiritual nature of thinking.

The closest he found were the writings of Goethe, which he studied with Julius Schröer, a great Goethe scholar. As a result of reading Goethe, Steiner's principal goal became the Goethean one of reconciling science and religion with philosophy. His relationship with his great German predecessor was

profound—and as an eventual result of Goethe's impact on Steiner, the former would inspire many efforts by late nineteenth- and early twentieth-century thinkers to develop a philosophy of integration, one that sees all reality as part of a single organic process.

Steiner, who was recognized as a prodigy by the time he was twenty-two, had worked on a project editing Goethe's scientific writings, and that involved editing and composing the introductions to several volumes of Goethe's scientific writings (1883–97). Steiner carried out this work in Weimar, which at various times had been the home of J.S. Bach, Schiller, Herder, Wieland, Richard Strauss, Franz Liszt, Henrik Ibsen, and Gustav Mahler and was at the time one of the world's great intellectual and artistic capitals.[49] In 1886, he published an introduction to Goethe's science titled *The Theory of Knowledge Tacit in Goethe's World-Conception*. A close study of his writings had led him to recognize in Goethe someone who had been able to perceive the spiritual in nature. Goethe's writings on optics and colour strengthened his conviction that the materialist concepts of the natural sciences of his time could explain only dead matter, not life. Goethe, he believed, had been unable to push his spiritual insights far enough to achieve a direct perception of the spirit. Steiner set himself the task of completing (as he saw it) Goethe's thinking by providing a statement of its spiritual/epistemological foundations.

While editing Goethe's scientific writings, Steiner wrestled with the problem of how to present his ideas about knowledge to the world. The problem, as he understood it, was this: How can one reconcile scientific and mystical insights with reality? For both the scientist and the mystic have important truths to tell. Steiner believed that he had worked out a method for applying scientific strategies to induce spiritual visions, which would allow people to validate empirically the contents of spiritual experience. He claimed to have developed exact, scientific methods for studying—for *observing*—the spiritual side of existence. He understood, however, that his experience of the reality of ideas was akin to the mystic's experience: he appreciated that mysticism presents the intensity of immediate knowledge with conviction. The shortcoming of mysticism is that it deals only with subjective impressions and fails to deal with the reality that lies outside human subjectivity. Science, by contrast, proposes ideas about the world beyond the subject, but the ideas it proposes are, for the most part, materialistic.

Steiner proposed to reconcile science and mysticism by taking the spiritual nature of thinking as his starting point. This would allow him to work out ideas that apply to the spiritual realm in the same manner that the ideas of natural science bear on the physical realm. That is, he proposed to conduct introspective observations following the methods of natural science. He presented an outline of this method in his doctoral dissertation, *Wahrheit und Wissenschaft*. His first major work appeared in 1892: *Vorspiel einer "Philosophie der Freiheit"* (Pre-

lude to a "Philosophy of Freedom.") *Die Philosophie der Freiheit* (The Philosophy of Freedom) itself appeared in 1894. Both works attempt to apply the method of exact observation that is characteristic of the natural sciences to the study of external nature *and* the inner world. *Wie erlangt man Erkenntnisse der höheren Welten?* (How Does One Acquire the Knowledge of Higher Worlds? 1905) shows the practical leaning of Steiner's Theosophical studies. Books he published after he broke with the Theosophical Movement in 1907 include *Luzifer-Gnosis: Grundlegende Aufsatze* (Lucifer-Gnosis: Basic Studies; 1908), a book that Kandinsky mentions in a note in *Über das Geistige in der Kunst* (On the Spiritual in Art); and, from the same year, *Theosophie: Eiführung in die übersinnlich Welterkenntniss un Menschenbestimmung* (Theosophy: An Introduction to the Supersensual Knowledge of the World and the Destination of Man).

Anthroposophy proposes that there is a spiritual world, which is structured in complex forms at various levels. According to Anthroposophy, physical substance is a condensation of the spiritual, non-physical substance, one of the states of spiritual being. In that sense, Anthroposophy offers a monistic view of reality's constitution. What distinguishes physical matter is its greater degree of concentration. Human beings have a higher level of spiritual, non-physical "substance" than plants and animals do. Besides plants, animals, and humans, there also exist purely spiritual beings, who do not have physical expression. Even so, we can observe them with as much clarity as we view the physical world with our eyes. To do this, an individual must develop organs of perception, which exist in a latent state in every human being—that is, we must develop what we commonly call "intuition." Steiner and his Anthroposophist followers considered intuition a form of spiritual perception—and Steiner developed meditation exercises to stimulate those organs.

Steiner's anthropology proposed that humans are tripartite (composed of body, soul, and spirit) and that they live in three worlds (the physical, the psychical, and the spiritual). Humans know the physical world through their bodies, that is, through their senses, which they share with other beings. The soul of each person, on the other hand, is unique; and through his or her soul, each person creates a unique world, an individuated world set alongside human reality. The opposition between the body and the soul is the opposition between the objective and the subjective. The spirit has features of the body as well as features of the soul: it is like the soul in being immaterial, but unlike the soul it is not "subjective" (i.e., it does not create its own individuated world). What the spirit knows is "objective" (i.e., independent of the self), just as the objects the senses acquaint us with are, though unlike the objects with which the senses acquaint us, they are suprasensible and non-material. Unlike the realities with which the soul is familiar, the realities the spirit knows are not changed by being apprehended by the spirit. The world of the spirit, though suprasensible, possesses a firm structure.

NOTES

1 Charles Baudelaire, "The Painter of Modern Life." Originally published in *Figaro* (November 26 and 28 and December 3, 1863); an English version, translated by J. Mayne, appears in Francis Frascina and Charles Harrison, eds., *Modern Art and Modernism: A Critical Anthology* (London: Open University, 1982), p. 23.

2 Walter Benjamin, "On Some Motifs in Baudelaire," *Illuminations*, ed. and intro. H. Arendt (New York: Schocken, 1969), pp. 175–76.

3 Many classical film theorists argued that the primary value of cinema arose from the contribution it could make to overcoming skepticism (and in this it was allied to photography)—the cinema could eliminate the subjective element and allow the world to make a mechanical image of itself that would dispel the bias of the subject and overcome some of the limitations of the senses. The film theories of Dziga Vertov, László Moholy-Nagy, Béla Balázs (especially in the *Der sichtbare Mensch* (The Visible Man, 1924), Jean Epstein, and Siegfried Kracauer all testify to the cinema's capacity to reveal a reality that the unaided human eye cannot perceive. Epstein even relates cinema's contribution to overcoming skepticism to the philosophical notion of secondary qualities and to (the nineteenth century's particular version of that idea) the doctrine of specific nerve energy. That doctrine had been proposed by Johannes Müller, the most important researcher in the science of vision in the first half of the nineteenth century; Müller's research provided the basis of Helmholtz's famous *Optics*, a book that dominated the theory of vision in the second half of the nineteenth century. Epstein wrote in 1921: "The senses, of course, present us only with symbols of reality: uniform, proportionate, elective metaphors. And symbols not of matter, which therefore does not exist, but of energy; that is, of something which in itself seems not to be, except in its effects as they affect us. We say 'red,' 'soprano,' 'sweet,' 'cypress,' when there are only velocities, movements, vibrations." Jean Epstein, "The Senses I (b)" (1921), in *French Film Theory and Criticism: A History/Anthology*, vol. 1, 1907–1929, ed. Richard Abel (Princeton: Princeton University Press, 1988), p. 244. I comment further on Müller's extraordinary influence on early twentieth-century art theory below, when I discuss the idea of pure visuality.

4 The claim for Ruttmann's priority is contested: most scholars attribute priority to Hans Richter. Richter himself claimed to have been the first to make an Absolute Film and to be the movement's principal theoretician. The forcefulness of Richter's writings, along with Richter's presence on the New York art scene after the war (by which time Ruttmann was dead) resulted in his claim's gaining widespread acceptance. As important, perhaps, in derogating Ruttmann's achievement is the fact that Richter had gone into exile when the National Socialists took power in Germany, while Walther Ruttmann stayed behind and assumed a cozy place in the Nazi film industry; his unfortunate decision did not sit well with expatriate film scholars such as Siegfried Kracauer and Lotte Eisner when they reckoned the relative importance of the various artists. Their influence, and their distaste for Ruttmann's decisions about the course he would pursue when confronted with the reality of the Nazi takeover, diminished his reputation considerably.

However, an unpublished manuscript in the German Film Museum, dating from 1913—in which Ruttmann described a cinema that did not yet exist and that would have to come forth, a cinema that a few years later would be the Absolute Film—casts considerable doubt on Richter's story. (For arguments in favour of Ruttmann's priority, against the views of most commentaries on the history of avant-garde film, see the introductory essay in Walter Schobert, *The German Avant-Garde Film of the 1920s/Der deutsche Avant-Garde Film der 20er Jahre*, an exhibition catalogue published by the Goethe-Institut München to accompany a travelling exhibition.)

5 Karin von Maur, *The Sound of Painting: Music in Modern Art*, trans. John W. Gabriel (New York: Prestel, 1999), p. 44.

6 Robert Delaunay, "Light, 1912," in H.B. Chipp, ed., *Theories Of Modern Art*, p. 319. Emphases in original.

7 "Diary entry, July 1917," *Tagebücher von Paul Klee 1898–1918*, ed. F. Klee, p. 380; cited in Maur, *The Sound of Painting*, pp. 54–56.

8 This is so despite early film stocks being black and white. Even in Méliès's time, films were often tinted or coloured by hand (as *Ballet Mécanique* was). Early artists who gravitated toward film first conceived of colour projects and only later, and by dint of necessity, realized them in black and white. As the title suggests, Richter's *Fuge in Rot und Grün* was to be a colour film; since no colour stocks existed at the time, Richter was prepared to colour each frame red or green by hand. He hoped that the unevenness of hand colouring would not be noticeable against the black ground. Graeff convinced Richter that the project was not feasible, that every coloured stroke would be visible; so the film remained in black and white. Even so, colour was among Richter's central concerns at this time; the importance he accorded colour is evident in the fact that the same year he made the film, Richter produced *Orchestration der Farbe* (Orchestration of Colour), an "orchestration of color in complementary, contrasting, and analogue colors, as a Magna Carta for colors," and another work, *Farbenordnung* (Colour Order), a work that was included in the notorious *Entartete Kunst* exhibition and probably destroyed thereafter. (See Hans Richter, *Hans Richter, Monographie*, p. 37, quoted in Justin Hoffmann, "Hans Richter: Constructivist Filmmaker," in Stephen C. Foster, ed., *Hans Richter: Activism, Modernism, and the Avant-garde*, p. 83.) Moreover, as Oskar Fischinger's involvement with Gasparcolor makes clear, the makers of Absolute films used colour as soon and as much as they could.

9 Jonathan Crary, "Modernizing Vision" in Hal Foster, ed., *Vision and Visuality* (Seattle: Bay, 1988), p. 39. Crary's quotation from Müller is from Johannes Müller, *Elements of Physiologie*, trans. W. Baly (London: Taylor and Walton, 1848), p. 1064.

10 Hermann von Helmholtz, *On the Sensations of Tone as a Physiological Basis for the Theory of Music*, 2nd English ed., trans. A.J. Ellis (New York: Dover, 1954), p. 149.

11 Epstein, "Les Sens I bis." What Epstein says reminds one of the sections in Brakhage's *Metaphors on Vision* titled "The Camera Eye" and "My Eye." Their similarity lies in a shared acceptance of Müller's ideas. The difference lies in the value each attached to the impersonality of the camera vision: Epstein celebrates it, Brakhage does not.

12 Wundt served as a *Privatdozent* at Helmholtz's Psychological Institute in Heidelberg from 1858 to 1862. But it is doubtful that Wundt formulated his ideas as a response to Helmholtz. In fact, the genesis of his ideas involved more dramatic events: in 1856 he fell so ill that his doctors gave up on him. In the several weeks while he lay near death, he struck upon the ideas about the mental phenomena that he was to elaborate and expound over the remainder of his life.

13 For Wundt, as for most thinkers of his time (consider William James), psychology and philosophy were not distinct subjects—in fact, Wundt considered psychology to be the science directly preparatory to philosophy. Wundt wrote extensively on philosophy—on logic, ethics, and social thought. However, his philosophical work is eclectic and unoriginal; his contributions to psychology, on the other hand, are original.

14 Wundt's junior contemporary, Sigmund Freud, also asserted that this is an early stage of experience in which the self has not yet separated out from the world.

15 Though, it is important to stress, the important place of issues associated with the idea of pure visuality reflects how pressing concerns arising from the crisis in vision had become.

16 One of the greatest aestheticians of the twentieth century, R.G. Collingwood, proposed similar ideas in his seminal book *The Principles of Art* (Oxford: Oxford University Press, 1958).

17 Ibid., p. 194.

18 Ibid., pp. 194–95.

19 Wassily Kandinsky, *Kandinsky: Complete Writings on Art*, ed. K.C. Lindsay and P. Vergo (New York: Da Capo, 1994), p. 155.

20 Ibid., pp. 153, 131.

21 The issue here was stated most clearly in the debate between Sir Arthur Eddington and Professor Susan Stebbing in the 1930s (though it was much discussed earlier among physicists, philosophers, and artists). Eddington argued that atomic theory had disproved the "solidity" of ordinary objects (such as the table on which I type this), and that it showed that ordinary objects are full of holes—indeed, that they are mostly just empty space. Stebbing responded by asking, "If this table is not solid, where can I find an object that can serve as a paradigm example for what 'solid' means?" For Eddington, the fact that at the atomic level an object is mostly empty space means that it is not solid. For Stebbing, the fact that we can pound our fist on the table means it is. Stebbing's position was formulated as an attempt to put to rest the extravagant metaphysical conjectures (such as those of Kandinsky) that followed on the revelation that atoms are mostly empty space.

22 A film artist with an especially strong interest in four-dimensional geometry is the Canadian animator Norman McLaren. As Don McWilliams shows in his fine documentary *Norman McLaren: Creative Process*, McLaren expended considerable energy on attempts to visualize the hypercube. McLaren's interest in four-dimensional geometry becomes more interesting when we consider it together with the synaesthetic forms of his films and with Duchamp's *Nue descendant l'escalier* (a work known to have been influenced by Duchamp's interest in conceptions of four-dimensional space-time): the images in McLaren's *Pas de Deux* of 1967 resemble *Nue descendant l'escalier*, and one is justified in wondering whether that work, too, is inspired by the idea of the fourth dimension.

23 *Reminiscences* first appeared as part of the album *Kandinsky, 1901–1913* (Berlin, 1913). It appears in Kandinsky, *Complete Writings on Art*. The passage cited appears on pp. 380–81.

24 On the idea that the twentieth century was the threshold of the third revelation, see ibid., p. 378. On this matter, his beliefs paralleled those of Andrei Bely, who between 1916 and 1918 published Athroposophically tinged essays that extolled the coming apocalypse and that depicted Russia as the "God-carrier," the Messiah of the nations, the "woman clothed in sun."

25 Kandinsky and Franz Marc, "Almanac: Der Blaue Reiter," in *The Blaue Reiter Almanac*, ed. and intro. Klaus Lankheit (New York: Viking, 1974), p. 50.

26 Kandinsky, "Concerning the Spiritual in Art," in *Complete Writings on Art*, p. 145.

27 Ibid., p. 169.

28 So in recent years Mandelbrot's geometry of self-similar structures has had to take on some of the burden of the practice of "sacred geometry" (discussed below).

29 The Platonic terms derive from Plato's famous allegory of the divided line (the *Republic*, book 24, 509d–511e). Enthusiasts of "sacred geometry" would not have missed the fact that in the allegory of the divided line, Plato describes the line as being divided according to a principle of the golden mean, for the line is divided first into two unequal parts, and then each of the parts is divided again into parts whose ratio is the same as that into which the whole line is divided.

30 Robert Lawlor, *Sacred Geometry: Philosophy and Practice* (London: Thames and Hudson, 1982), p. 4. The point should be made: Bertrand Russell would certainly not have en-

dorsed sacred geometry. The misappropriation of Russell's view here exemplifies a fairly common ruse among those who harbour an enthusiasm for sacred geometry (and indeed among those who harbour an enthusiasm for the occult in general).

31 The *Republic,* book 6, 510c. As translated by Francis MacDonald Cornford, in an edition with an introduction and notes by the same (London: Oxford University Press, 1941).

32 André Vandenbroeck, *Philosophical Geometry* (Rochester: Inner Traditions, 1987), p. 2.

33 Ibid., p. 1.

34 Lawlor, *Sacred Geometry,* p. 6.

35 Ibid.

36 Ibid., pp. 6, 8. Along with the peculiarity of the manner with which Lawlor makes the transition from two levels of being (the typal and the archetypal) to three (the typal, the ectypal, and the archetypal), note the oddity of leaping from the assertion of the archetypal's being a principle to the assertion of the archetypal's being a "power-activity." Plato does present his conception of the forms (or archetypes) in at least two ways (though this is considerably different from maintaining different conceptions of the forms). He sometimes presents them more or less as Lawlor presents the ectypal, as exemplifying the common features which make any object the sort of thing that it is (the features that make a horse a horse and not a cow); while at other times he presents them as the principle that makes something able to serve the ends that things of its type serve—for example, a doctor is different from a lawyer because the doctor has attributes that suit him or her to creating and maintaining health while the lawyer has attributes that fit him or her to presenting arguments in a certain fashion.

Converting the different ways of describing the Forms into a difference between two types of entities (which Lawlor labels "ectypal" and "archetypal") is a precarious move. Many commentators have pointed out that the crucial feature distinguishing the Greek world view from that of moderns is that the Greeks considered being and purposes as mutually implicated: any object is what it is because it suited to fulfill the purposes which objects of that type serve. Many (myself among them) believe that the separation of ends from essences is the single most deleterious feature of the modern world view.

37 Lawlor, *Sacred Geometry,* p. 8.

38 Besant and Leadbeater referred to their new version of Theosophy as Adyar-Theosophy. Many of its distinctive features have just been mentioned, but perhaps the most important distinguishing feature of Adyar-Theosophical cosmology was the result of Leadbeater's interest in Spiritualism—that is, in the existence and experiences of the consciousness after physical death. (Gregory Tillet, in *The Elder Brother* [London: Routledge and Kegan Paul, 1982], has shown that prior to his entry into the Theosophical Society, Leadbeater was much involved in Spiritualism.) Blavatsky generally downplayed the notion of after-death experience, but Leadbeater placed considerable emphasis on it (shifting the emphasis of Theosophy from cosmology to the afterlife). Blavatsky held a skeptical view regarding the survival of the personality (as opposed to the higher or spiritual self) after death, and was a bitter opponent of Spiritualism, accusing it of limiting its interest to the lower psychic levels. Leadbeater and Besant were much less skeptical about the survival of personality after death, and they assimilated certain spiritualist ideas into the Theosophical Movement.

39 This is exactly the same chain of transmission that Charles Olson describes in "Projective Verse," an essay that exerted considerable influence on Stan Brakhage.

40 Kandinsky, *Complete Writings on Art,* p. 158.

41 Ibid., pp. 158–59.

42 Ibid., p. 240.

43 One might wish that Chladni's term had become the more generally accepted, for it suggests the connection between tone (sound) and figure (the visual); that they visualize sound is one reason people took an interest in them.

44 The irregularity of the shapes of the melted wax offered an unprecedented style of organic abstraction.

45 What is more, as *La Gioconda* shows, the earth and its forms interweave the forms of human beings; Leonardo believed in fact that the earth has an organic form: the rocks are its skeleton, the soil its flesh, the ebb and flow of the oceans its respiration, and fiery volcanoes a manifestation of its spirit.

46 Thus we see that ideas about sympathetic vibration were applied to the tuning of the soul. The interest that proponents of the heterodox took in Chladni forms in particular—and more generally in vibration, resonance, and waveform cancellation and reinforcement—also was associated with their belief that these ideas had application in spiritual therapy.

47 This doctrine (variously of Theosophic, Spiritualist, or other cultic and non-cultic provenance) had widespread influence on the inventors of the telegraph, the radio, and the television as well as on Russian artists of the early twentieth century.

48 As a Theosophist, Kandinsky believed that certain combinations of colour and light could induce spiritual experiences. Theosophical books are filled with coloured forms that, Theosophists claim, can prompt such experiences. Many artists and people in the art world shared Kandinsky's Theosophical beliefs concerning colour. Among the most prominent was an early patron of abstraction, Hilla Rebay, curator of the Guggenheim Foundation from the 1920s to the 1950s.

49 Writings that have since been collected and issued by Steiner's followers under the title *Goethe the Scientist.*

MODERNISM AND THE ABSOLUTE FILM

THE ABSOLUTE FILM PRECURSORS AND PARALLELS

There is a long prehistory to the Absolute Film. We might note the following influences on it: light sculpture; scroll painting; various devices for producing colours to accompany musical pieces ("coloured-light organs" being the best known); various forms for fixing movement on a static surface; and kinetic devices for incorporating dynamic, non-objective forms into stage presentations.[1]

PRECURSORS OF THE ABSOLUTE CINEMA
LIGHT SCULPTURE

Composers and filmmakers of the early part of the twentieth century invented the elements of, and experimented with, an art that fused sound, colour, and dynamism. Several of these developments took place at the Bauhaus, where Wassily Kandinsky and Paul Klee speculated on similarities between music and painting and László Moholy-Nagy built kinetic sculptures to explore light in motion. Moholy-Nagy believed it was possible to handle light constructively, with the same sort of definiteness of means as colour in painting. Earlier, he had explored the "photogram": his aim for the photogram, as for photomontage (which he called Fotoplastik or photo-sculpture), was to create a

constructive representation in two dimensions of objects that occupy three-dimensional space.[2] The desire to build forms in light led him to extend the chiaroscuro effects of the photogram into real space by inventing the *Lichtrequisit einer elektrischen Bühne* (commonly referred to as the Light-Space Modulator, though the literal translation would be Requisite Light for an Electric Stage) of 1922–30. *Lichtrequist* is a kinetic sculpture comprising perforated, rotating metal parts whose multiple light effects and shadows rearticulate the actual object. Such "light machine" sculptures incorporate the transmitted and the reflected—the sculpture is a fusion of metal, light, and shadows, all of which move. The interplay of pierced metal and other areas, which are visible through opaque areas in the work, create a paradoxical intermingling of depth and surface. Moholy-Nagy's efforts to build light-forms led him to make a film based on *Lichtrequisit*. This film, *Lichtspiel: schwarz-weiss-grau* (Light-play: Black–White–Grey) is a quasi-abstract work from 1930 that concerns itself with the parallels between film and light-sculptures. The way that Moholy-Nagy filmed the machine brought its abstract implications to the fore—nonetheless, we can at times make out what is being photographed, thus the film serves both as documentation and as an abstract *Lichtspiel*.

The drive to vivify colour surfaces and to incorporate actual change into works in heretofore static media focused especially on sculpture. Sometimes the resulting works involved projecting light onto a screen, with the light reflected from a mobile and often modulated by a filter.[3] Other works used means for enhancing the reflective effects of surfaces. Such effects had long been an attribute of sculpture, but hitherto they had been underplayed, with the reflections left to chance. An early example (probably the first) to purposely bring reflections into a work is Naum Gabo's *The Rotating Rod*. A striking feature of sculptures that animate light is the capacity of light and movement to "dematerialize" the sculpture. That feature, too, has parallels in film, for similarly, the material of film—choreographed light—is seemingly insubstantial, gaseous, and indefinite.

PRECURSORS OF THE ABSOLUTE FILM
THE SCROLL

Another artistic practice whose concerns parallel those of the Absolute Film is the scroll (not as the starting point for an abstract film, but as an art form in itself). Hans Richter, Viking Eggeling, Werner Graeff, Robert Delaunay, Sonia Delaunay, and Duncan Grant all made scrolls. Similarly, there were the abstract series paintings as made by Duncan Grant (in 1914) and Josef Albers (from 1922 to the 1960s). For Richter, the scroll represented a fundamental change in the arts: the human capacity for optical conception had long rested on static spatial forms; the time had now come to develop the ability to think

in optical series. The scroll required a new way of composing, for it imposed the problem of arranging individual forms in such a manner that the scroll unwound in a well-ordered progression. Problems of continuity and rhythm presented themselves in a new way. Thus, the scroll represented a further means of creating dynamic form. Herzegenrath points out another attribute of scroll and series paintings that made them attractive to artists committed to modernist ideals: they were non-hierarchical. They could and often did display a series of variant solutions to a single pictorial problem, without according some solutions greater value than others.[4]

It was Robert Delaunay who wrote the most lucid and cogent *défense et illustration* of the scroll and its aesthetic implications. In his argument, he evoked the traditional theme of the Inter-Arts Comparison by arguing that painting is the "ottima arte" (or, at least, is greater than music). Painting is the superior art to music, Delaunay argued, because our perception of all the elements in a painting is potentially simultaneous—we can take in a painting "all at once":

> Simultaneity in light is *harmony, the rhythm of colors* which creates the *Vision of Man*. Human vision is endowed with the greatest Reality, since it comes to us directly from the contemplation of the Universe. The *eye* is the most refined of our senses, the one which communicates most directly with our mind, our consciousness ...
>
> The auditory perception is not sufficient for our knowledge of the world; it does not have vastness.
>
> Its movement is *successive*, it is a sort of mechanism; its law is the time of *mechanical* clocks which, like them, has no relation with our perception of *visual movement in the Universe.*"[5]

Robert Delaunay's theory of simultaneous contrast (which was later expanded by his wife, Sonia) was based on Michel-Eugène Chevreul's ideas about colour perception: Chevreul had asserted that colour values are determined by contrasts of juxtaposed tones. The Delaunays transformed Chevreul's theory into a technique of "simultanéité"—that is, the technique (as Blaise Cendrars explained) of assigning one entity its identity through its contrast with another. A radical aspect of Delaunay's theory of *simultanéité* was that it reinterpreted pictorial depth ("profondeur") as an illusion produced by surface planes of colour rather than by vanishing-point perspective. The art historian John Golding explains:

> Delaunay conceived of a type of painting in which the colours used to produce a sensation of light would not blend but would retain their separate identities; by their interaction these colours could furthermore be made to produce a sensation of depth and movement. Since movement implies duration, time was also an element of this new art. Using the terminology of Chevreul, Delaunay called these colour contrasts "simultaneous" to distinguish them from the colour

contrasts used by the Impressionists and their successors, which were "binary" and tended to fuse together when seen at a distance.[6]

In this interest in light and time we glimpse how the cinema influenced the artistic theory of Simultaneism.

As did Fernand Léger, Delaunay based his theory on the idea of contrasts: he proposed that an artist strives for a proportionality in colour contrasts. He believed that the importance of colour contrasts in art testified to the centrality of light in human life. Light, he posited, is an ordering force in life as well as a basis for harmony and rhythm. "Simultaneity in light is *harmony, the rhythm of colors* which creates the *Vision of Man*," he declared. In stressing light's importance, Delaunay was restaking claims that had been asserted by another major artist of the first years of the twentieth century, Kazimir Severinovich Malevich, who argued that, for Suprematists, a painting consists of light, form, and colour. Thus, works of art are distillations of form organized according to hidden (occult) laws, which are accessible only to artists (and even then only through the unconscious). The idea of a form whose material is light and that develops over time was conceived under the impact of the advent of cinema—indeed, Malevich hoped to pursue his artistic goals in cinema.[7] The cinema, we shall see, did much to shape the artistic ideals of those painters, sculptors, writers, and choreographers who were active in the first decades of the twentieth century.

Delaunay's theory of contrasts, and of the simultaneous presentation of several contrasts, reverberated through the artistic communities of the early twentieth century. His ideas on simultaneity would influence the German artists associated with the Blaue Reiter as well as the American artists associated with the Synchromism of Morgan Russell and Stanton Macdonald-Wright. They would also influence Blaise Cendrars, who would interpret them in a Bergsonian fashion—for Cendrars, contrast became a principle of vitality: "The movement is in depth [le mouvement est dans la profondeur]. Life is the most immediate expression of this movement and this depth. Life is the form of this depth (sensuality), the formula of this movement (abstraction). Animism. Nothing is stable. Everything is movement in depth. Passion."[8]

The decorative objects that Sonia Delaunay created while her husband was expounding his principle of simultaneous contrast were an equally important influence on the development of Cendrars's literary practice. During the First World War, driven by financial exigencies, Sonia Delaunay began to transfer Robert's modernist iconography onto decorative objects: curtains, upholstery, lampshades, book bindings, scarves, and dresses. In doing so, she expanded the theory of *simultanéité* until it became a basis for cultural production. For example, her *robe simultanée* (simultaneous dress, first created in 1913) both drew from and extended Robert's theories of simultaneous contrast, but it was also applying the theory to a utilitarian production. Her purpose was not

to discover how one tone affected the perception of another. Hers was, rather, a mimetic aspiration: she wanted to transform every available surface by applying an eminently reproducible *Simultanéiste* iconography to it. In doing so, she erased the cultural distinctions between elements drawn from different institutional frameworks.

Sonia Delaunay's experiments with the techniques of *assemblage*, applied in the realm of the decorative arts, compelled Cendrars to revise his approach to verbal construction. Impressed by her approach to everyday objects, Cendrars began to apply the *assemblage* or "patchwork" technique to poems, novels, screenplays, and radio plays, integrating elements drawn, even, from paraliterary and commercial sources. For example, Sonia Delaunay's *assemblages* led to the pastiche techniques that Cendrars developed in *Dix-neuf poèmes élastiques* (Nineteen Elastic Poems), which were a poetic response to Delaunay's "objets simultanés." Delaunay's new understanding of depth—that it is a function of surface contrasts between colours rather than an effect of the vanishing point—stimulated Cendrars's interest in pastiches of citations. He understood that, like Sonia Delaunay's "robe simultanée," a poem could be conceived as a play of surfaces, a texture patchwork of citations, brought together by the ingenious *assembleur*.

The scroll, too, offered a complex unity uncharacteristic of traditional visual art. Indeed, the scroll was understood as evoking a more complex temporality than one in which all elements (and all constrasts) are apprehended simultaneously. This was a reason why the scroll was admired: a scroll, or a series of abstract images, could be considered either as a form that unfolds through time or as a complete, integrated entity the whole of which we apprehend all at once. Georg Schmidt, at one time a director of the Basel Museum, and a contemporary of Eggeling, Graeff, and Grant, remarked on this feature of the scroll:

> The scroll painting principle they developed in 1918 is by no means yet exhausted but, in contrast to the merely static image, is still full of marvellous possibilities ... While film and its tempo compel us irresistibly forward and allow no time to pause or look back, the scroll painting gives us the freedom to control the tempo; we can stop at any time and consider smaller or larger sections simultaneously, we can even change the direction. And while the still image spills out all its trump cards over us in spatial simultaneity, the scroll painting unfolds before us step by step, at the same time both a temporal sequence and a spatial unity ... Since that time, I have dreamed of scroll paintings as one of the most beautiful potentialities in creative art.[9]

Schmidt's remarks on film notwithstanding, the film medium actually shares this paradoxical temporal constitution; as filmmakers have realized, the series of visual forms a film offers sometimes can be considered both sequentially and (usually in memory) simultaneously. The similarities between

scroll painting and film drew painters who had been producing scrolls into cinema.[10] Richter, for example, deliberating on a film based on his *Präludium* (Prelude) scroll, remarked on its relation to his methods in the visual arts: in film, too, he could apply his principles of contrast and analogy:

> The simple square of the movie screen could easily be divided and orchestrated by using the rectangle of the cinema-canvas as my field of pictorial vision. Parts of the screen could then be moved against each other. Thus it became possible on this cinema-canvas to relate (by both contrast and analogy) the various movements to each other. So I made my paper rectangles and squares grow and disappear, jump and slide in well-articulated time-spaces and planned rhythms.[11]

As he worked with film more, Richter became even more impressed with film's time aspect:

> After our, as it appeared to me, unsuccessful attempts to set scrolls into motion, I recognized that the problem of film lies essentially in the articulation of time and only very secondarily in the articulation of form. The more I delved into the phenomenon of film, the more convinced I was that articulated time, namely rhythm, is to be regarded both as the elementary dimension of film and its inner structure.[12]

PRECURSORS OF THE ABSOLUTE CINEMA
THE COLOUR ORGAN AND THE *LICHTSPIEL*

Some early twentieth-century artists and thinkers used the idea that reality is fundamentally vibratory to resolve the contest of the arts. The arts would be brought together in a new form of *Universalpoesie*. The vibratory nature of reality would permit a synthesis of the arts, these thinkers declared. New forms of *Gesamtkunstwerk* could then come forth, including the Absolute Film. Among occult groups of the first half of the twentieth century, the Theosophists were not alone in hypothesizing that ultimate reality has the character of vibration, and for whom that hypothesis motivated efforts to produce synthaesthetic art. The *Rosicrucian Digest* of February 1933 contains a fascinating piece by the Grand Secretary of AMORC (Ancient Mystical Order Rosae Crucis). It concerns the first private performance, on Wednesday, January 4, 1933, on a Colour Organ. The event took place at San José's Francis Bacon Auditorium, before "a very select and important group of musicians, artists, scientists, instructors, and patrons of art and music who were present by special invitation to witness the performance of the largest and most perfected form of color organ ever built" and a public performance on the organ four days later.[13] The Grand Secretary went on to explain the purpose of the massive investment in time and effort creating the Colour Organ. It was, he said,

solely to demonstrate the psychological facts pertaining to the relationship of color and music as taught by the Rosicrucians in the middle ages, and at the present in connection with their doctrines of transmutation in which they have always claimed that the rates of vibration of all *atomically* constructed matter are related by harmonic cycles and periods, and that by changing the rates of vibration of one element or one manifestation, the element or manifestation may be changed in nature. The recent demonstrations on the part of science in the field of metallurgy have proved that gross elements can be transmuted into gold in accordance with the theory taught by the Rosicrucians. But this process is of no commercial value because of the extreme cost involved in producing even a small grain of gold. The *Luxatone* is now the most recent and elaborate device for the demonstration of the transmutation of sound into color. It is said by those who have witnessed the preliminary demonstrations of the color organ that those who are deaf easily recognize the theme of musical composition by the pictures produced on the screen. Many eminent psychologists insist that the sound waves do create in a subjective form of our consciousness invisible pictures which we sense through a little-known faculty that may be brought into development, or awakened in some way, by a proper adaptation of sound pictures produced through color.[14]

A press release concerning the Colour Organ, issued by the Rosicrucian Order for North America, made the relations among colour, sound, and harmony even more definite:

> One point of extreme importance realized by Aristotle but never evolved by technicians, who attempted to carry out the idea, is that each musical note has a definite relationship to one color or shade of color in the solar spectrum, and unless the proper shade of color is attained by each note the interpretation of the theme of the music into color pictures is erratic, unscientific and inharmonious. With the definite relationship of color to sound determined and fixed, a harmonious chord of music will produce a harmonious combination of colors, producing a pleasing picture, whereas a dischord will produce the very opposite effect and give one the sight sensation of inharmony and unpleasant relations of sound and color.[15]

Another report on the event, also published in the *Rosicrucian Digest*, made it clear that the notion that reality is fundamentally vibratory is what had motivated Rosicrucians' efforts to build a Colour Organ:

> Dr. Lewis [Imperator of the Rosicrucian Order for North America] in his brief lecture preceding the demonstration of the organ pointed out that all of the human sense impressions are the results of vibratory effects, and that our lives are greatly influenced by the subtle impressions made upon the consciousness by the vibrations which appear to be classified as distinctively associated with the five physical senses in all of their outer forms, but not properly related and unified into one form of consciousness within the brain or mind of the human

body. As the audience sitting in the darkened auditorium was bathed in the illumination of the constantly-changing lights and pictoral [sic] effects of the screen many and various emotions were produced in the sympathetic reactions of the human consciousness, setting up what may eventually be found to be a third or psychic form of receptivity to the vibrations of the Cosmic keyboard. At least this is the contention of the Rosicrucians, and one which they seek to demonstrate through the association of scientific and fine art principles.[16]

This occult idea that colour and sound are simply different forms of vibration had a stunningly pervasive influence on late nineteenth- and early twentieth-century art. The idea can be traced back to Aristotle, who had proposed that colours may mutually relate to one another rather as the tones in musical concords do, inasmuch as for their most pleasant arrangements the different vibratory frequencies represented in those concords must be mutually proportionate. The music theorist Gioseffe Zarline drew parallels between the Pythagorean system underlying Renaissance harmonics and the visual beauty of colours. In *Le Institutioni harmoniche* of 1558 he proposed that the reaction of the ear to the combination of sounds is analogous to the reaction of the eye to the combination of colours. The task of accounting for such parallels by developing a more precise colour theory was carried out by the extraordinary Milanese painter Giuseppe Arcimboldo (1527–1593). During his years as court artist and general maestro of visual effects for the Habsburg emperors in Prague (1562–87), Arcimboldo discovered that all musical tones are consonant with colours and that the ratios involved in their mutual harmony are precisely equivalent to the harmonic proportions discovered by Pythagoras. A table of precise equivalences for notes and colours was constructed by Athanasius Kircher in 1650:

octave	green
seventh	blue-violet
major sixth	fire red
minor sixth	red-violet
augmented fifth	dark brown
fifth	gold
diminished fifth	blue
fourth	brown-yellow
major third	bright red
minor third	gold
major wholetone	black
major wholetone	black
minor second	white
minor wholetone	grey

By the end of the sixteenth century, speculations about the possibility of constructing a table of correspondences between tones and colours were rampant, and they continued to flourish unabated throughout the seventeenth and eighteenth centuries. These speculations were fuelled in part by the publication, in 1690, of John Locke's *An Essay Concerning Human Understanding*. Locke's text contained the incidental statement that a blind man had claimed that the sound of the trumpet was like the colour scarlet. The remark prompted much discussion during the eighteenth century regarding the analogies between sound and colour. In England it was a topic of discussion among Anthony Cooper (the third Earl of Shaftesbury and an important founder of aesthetics), Henry Fielding, Adam Smith, and Erasmus Darwin. On the continent, the topic was taken up by Louis-Bertrand Castel and Mme de Staël. In all of these discussions, the nature of light was as central an issue as the character of the different art media. (Both sides of the debate were later taken up by Goethe, who embraced the analogy between sound and colour before later rejecting it.)[17]

An even earlier figure, however, is the principal source for the analogy between colour and sound.[18] Isaac Newton divided the visual spectrum into seven colours and posited that these divisions corresponded to the diatonic scale:

red	tonic
orange	minor third
yellow	fourth
green	fifth
blue	major sixth
indigo	seventh
violet	eighth (octave)

Newton also conjectured that colour is a vibratory effect, that the most refrangible rays excite the shortest vibrations and the least refrangible the longest, and that the harmony and discord of colours arise from the proportions of the vibrations propagated through the fibres of the optic nerve into the brain, just as the harmony and discord of sounds arise from the proportions of the vibrations of the air.[19]

The Newtonian analysis of the colours that constitute the rainbow is so familiar that its artificiality commonly escapes notice. Anyone who looks at a rainbow will see that only six colours predominate: indigo is not a perceptually distinct colour, but a theoretical construct, fabricated to create symmetry between the seven tones of the octave and the colours of the rainbow. Its inadequacies notwithstanding, several people elaborated on the Newtonian analogy between colour and sound. Julian Leonard Hoffmann (1740–1814) developed it in a Goethean direction. Hoffmann, a painter as well as a writer, produced an

essay in 1786 in which he sought to establish relationships between "painterly harmony" and "colour harmony" and tried to relate colour to sound. Hoffman's system, though highly theoretical (it was based on the concept of polarities or opposites), was quite subjective and based on arbitrary personal choices. The Scottish painter David Ramsay Hay in *A nomenclature of colours applicable to the arts and natural sciences* developed the Newtonian analogy and proposed a numerical system of colour relationships.[20] Hay's early collection of colour samples is said to have been influenced by Field's treatise on colour and pigment as well as by Buffon's analysis of colour as being parallel to music scales.[21] Hay and Field both based their science on that conducted by Brewster and Newton as well as on Buffon's analysis of colour. He directed his efforts at demonstrating that colours can be arranged into a scale, just as musical sounds can.[22] Thomas Young (1773–1829) also made contributions: he was the first to describe and measure astigmatism (1801); while still in medical school, he made original studies of the eye; later he developed what is now known as the three-colour theory of vision (his three primaries were red, green, and violet). Young also showed that many of Newton's experiments with light could be explained in terms of a simple wave theory of light. This conclusion was sharply attacked by some scientists in England, who defended Newton. But his most famous work was his now famous double-slit experiment (1801), which demonstrated the interference of light waves, thus leading him to support Huygens's wave theory of light.

In fact, Young had been drawn to optics by his interest in acoustics. His recognition that light rays bore some resemblances to sound waves led him to elaborate on Newton's analogy between the two senses. He used the phenomenon of wave interference (which his background in acoustics had prepared him to understand) to calculate the wavelengths of various colours of light. Between 1797 and 1799 he carried out experiments at Cambridge that involved placing a screen with two pinholes in it in front of a point source of light. His published findings, which he presented in 1801, described the pattern of dark and light bands seen on the screen behind the holes. He also used two slits to produce interference patterns. He argued persuasively that these observations could be explained using a wave theory; he even related the index of refraction of a light ray to its wavelength. Using Newton's own experimental data, he then calculated the wavelengths of different colours.

Young's understanding of light's undulatory character led him further, to grasp the continuity of visible and ultraviolet radiation—to understand that heat is simply a vibration that lies above the visible spectrum. His work on light was used extensively by Sir John Herschel (1792–1871); indeed, Herschel would surmise that, if our eyes could see them, the colours of the visible spectrum would probably repeat themselves in the ultraviolet spectrum in successive octaves.

The broad influence of these ideas about colour's correspondences to sound can be seen in the widely read work of the popular aesthetician and architectural theorist Edward Lacy Garbett. His design textbook, aimed at architecture students, *Rudimentary Treatise on the Principles of Design in Architecture, as Deducible from Nature and Exemplified in the Works of the Greek and Gothic Architects*, appeared in no fewer than nine editions between 1850 and 1906. Its teachings drew largely from Herschel. Garbett asserted that as both light and sound affect the sensory organs by rapid vibrations (or repeated pulsations), the pleasurableness of the sensation, whether of sound or colour, increases just in proportion as these pulsations (vibrations) are more regular and isochronous (i.e., spaced in equal intervals of time). Thus regular vibrations are soothing, irregular ones irritating. This is so with colour as much as with sound; hence Garbett contended, the more isochronous the vibrations of any given colour, the more pleasing it will be in itself, apart from fitness and association. This principle, which was certainly not original to Garbett—indeed, it was widespread—was sometimes referred to as that of "harmony in succession." Antonio Rosmini (1797–1855), a Catholic priest and philosopher who attempted to uproot the seedlings of skepticism that had taken root during the Enlightenment (and who like Garbett attempted to reunite faith with reason, belief with science), offered exactly the same proposition in Chapter 35 of *Psychology: Development of the Human Soul, Volume IV*.

Garbett attempted to refute views on the relation of colour to sound that had grown out of Herschel's work (and Hay's use of that work). Hay had attempted to superimpose musical proportions onto Herschel's measurements, and this had led to the bald assertion by Frank Howard, in *Colour as a Means of Art for Amateurs* (1838), that isochronous colours are pleasing to the mind. Howard believed that physical science would in time reveal that the duller tones of each colour are isochronous and that the gaudy and harsh tones are non-isochronous. In Howard's system of colours, the duller ones corresponded to musical notes, the harsher ones to mere noise. Garbett, to the contrary, argued that harmony of colour is identical to harmony of sounds only because of the eye's limited sensitivity to vibration (i.e., relative to the ear's).[23]

The great nineteenth-century scientist Hermann von Helmholtz contributed to this discussion of parallels between sound and colour. Extending earlier research by Thomas Young, James Clerk Maxwell, and others, he encapsulated the view of the new science on the relation in *Handbuch der Physiologischen Optik* (Handbook of Physiological Optics, 1856–67). In Maxwell's book, a set of additive primaries (red, green, blue-violet), known as the Young–Helmholtz primaries, supplemented the traditional set of painters' primaries (red, yellow, blue); later in his work, Maxwell defined the tonal range more clearly, from darkest to lightest. Maxwell identified pairs of complementary colours (such as red and blue-green) and showed that any pair, combined,

produced white light when a disc painted with a segment of each colour was set spinning.

Helmholtz was very taken by the colour/music analogy: he was interested in both sound (he was a pianist) and colour (his father was a painter); and his book, *Von den Tonempfindungen als physiologische Grundlage fuer die Theorie der Musik* (On the Sensation of Tone as a Physiological Basis for the Theory of Music, 1863), was one product of those interests. In book 2, chapter 19, of that work, titled "Simple Colours," he set up a colour/music scale. He aligned the note G to the Fraunhofer line A—that is, the dark line in the optical spectrum of the sun that appears in the far reaches of the deep-red region of the spectrum (caused by the absorption, by oxygen, of wavelengths of 759.370 nanometres). Working on the principle that each octave doubles the frequency, and following the colours of the spectrum, a scale of colours would be roughly as follows: very deep red, deep red, red, orange, yellow, greenish-blue, indigo-blue, violet, ultraviolet (spanning the A, B, C, D, E, G, H, K Fraunhofer lines); these colours would correspond to the notes of the white piano keys. (Helmoltz personally preferred the A scale, so that his additive primaries of red, green, and blue-violet would most closely match the major chord A–C#–E.) For Helmholtz, spacing was another consideration—indeed, an all-important one: closer colours were not so harmonious, nor in his view did they give as pure an impression. The complementaries, such as red and blue-green, satisfied him more; he likened them to the satisfying musical intervals of the fourth and the major third.

In his studies on the relation between optics and acoustics, Helmholtz had described the stimulating effects of colour and music in similar terms. Yet he remained cautious, even doubtful, when it came to close analogies: he recognized that his table of correspondences did not yield the preferred colours for the chord at A major (in reality, E aligned with indigo-blue rather than the ideal blue-violet). About others' colour/music codes he harboured even greater doubts: the span of the spectrum, from red to violet, was not large enough to be compared to a complete musical octave, so he believed. He concluded that colour harmony lacks the absolute, definite relations characteristic of musical intervals.

Nonetheless, the notion of an analogy between colour and sound had wide influence in the arts in the early twentieth century. The University of Hamburg hosted an international Colour-Music Congress in 1927, 1930, 1933, and 1936, which brought together artists in music, dance, film, and painting, as well as perceptual psychologists and critics, to explore topics such as synaesthesia and multidisciplinary art forms. Colour Organ performances included those by the Austrian Count Vietinghoff-Scheel on his Chromatophon, as well as the elaborate *Reflektorische Lichtspiel* (Reflectorial Colour Play) by the Bauhaus artists Kurt Schwerdtfeger and Ludwig Hirschfeld-Mack. The Swiss artist

Charles Blanc-Gatti also attended the Colour-Music Congress: Blanc-Gatti was one of a number of "Musicalist" artists who created paintings inspired by specific pieces of music. Blanc-Gatti, too, took an interest in the Colour Organ: he referred to his version as the "Chromophonic Orchestra." His device displayed colours based on a system that equated the frequencies of sound with colour vibrations: low tones were red (red has a low rate of vibration); medium tones were yellow and green; and high pitches were violet. In 1938 he founded an animation studio in Lausanne to make *Chromophonie*, an animated film whose colours are correlated to the pitches in Fucik's *Entrance of the Comedians*—thus the piece gives us, essentially, what *Entrance of the Comedians* would have looked like if it had been played on Blanc-Gatti's Chromophonic Orchestra.[24]

The phenomenon of synaesthesia has long fascinated artists—and never more so than in the late nineteenth and early twentieth centuries. Many composers and performers from those decades claimed to have experienced synaesthetically, including Richard Wagner, Hector Berlioz, Nikolai Rimsky-Korsakov, Arthur Bliss, Carl Maria von Weber, Claude Debussy, Dane Rudhyar, Kay Gardner, Edgar Varèse, André-Ernest-Modeste Grétry, Ivan Wyschnegradsky, Arnold Schoenberg, Charles Ives, Franz Liszt, Aleksandr Scriabin, Gustav Mahler, Olivier Messiaen, Michael Torke, and Iannis Xenakis. Note in that list the preponderance of late Romantic composers and of composers inspired by Romanticism. This is hardly surprising: Romantic thought had Idealist proclivities that became ever more pronounced as the movement developed; the phenomenon of synaesthesia can in fact be seen to lend weight to the Idealist hypothesis, for an implication of the fact that the synaesthete experiences reality differently from the rest of humanity is that experience is phenomenal, subjective, and not entirely determined by the conditions of external reality. So the subjectivism that is such a predominant feature of late modernity has brought this phenomenon into sharper focus.

Another important reason for the widespread interest in the Colour Organ and in *Lichtspielen* (light-plays) was the immateriality of coloured light. Painters had long been intrigued by music's immateriality and by its independence from the visible, tangible world. The immateriality of light and its mutability suggested a connection both with music and with an ultimate reality. The *Lichtspiel*—and cinema, as a form of light-play—seemed to promise a visual form as immaterial, as regally independent of the visible and the tangible, as music is. A familiar quotation from Wassily Kandinsky highlights the importance of the ideal of immateriality to some of the pioneers of abstract art: "[a] scientific event removed one of the most important obstacles from my path [towards abstraction]. This was the further division of the atom. The collapse of the atom was equated, in my soul, with the collapse of the whole world. Suddenly the stoutest walls crumbled. Everything became uncertain,

MODERNISM AND THE ABSOLUTE FILM

precarious and insubstantial. I would not have been surprised had a stone dissolved into thin air before my eyes and become invisible."[25]

Many late nineteenth- and early twentieth-century intellectuals acknowledged their astonishment at "the further division of the atom." The discovery of subatomic particles made it seem to many people that matter could no longer be considered solid. After that discovery, matter presented itself more as void than as substance. When the world seems insubstantial, the *Lichtspiel* seems singularly appropriate (as does the Absolute Film): like music, the *Lichtspiel* and cinema are free of physical fetters—and cinema in particular seems an almost gaseous, immaterial shadow-form.

Since it developed out of a confluence of traditional notions about harmony and temperament with ideas of synaesthesia, the idea of a coloured-light organ was allied with that of an octave of semitones, with twelve colours corresponding to the traditional twelve pitches of the scale. The notion of building an instrument to play graphics the way musicians play sound has always had its appeal. As already noted, Arcimboldo was committed to that project: he must have discerned a relation between light and music, for he is said to have invented a zither on which colours could be played as well as a notational system specifying which colours should be played when. Around 1725, animated by Newton's comparison between the rainbow's colours and the tempered octave, and by Descartes' theory of light, a Jesuit priest named Louis Bertrand Castel (1688–1757) invented a Colour Organ; in fact, his performances in Paris of Colour Music created with candlelight and cloths were renowned. In his *L'Optique des couleurs* of 1740, he systematically presented details of the intermediate colours produced by mixing the primaries. Castel's ideas about colour contradicted Newton's—Castel identified blue, yellow, and red as the three primary colours from which all others could be derived. He realized that, phenomenologically, there are more distinguishable hues between pure red and pure blue than between blue and yellow, and more still between yellow and red; but he strived to bring theoretical order to the field. By informal experiments he established a colour circle of twelve equally spaced hues: blue, celadon (sea-green), green, olive, yellow, fallow (a light yellowish-brown), nacarat (orange-red), red, crimson, purple, agate, and purple-blue. He then mapped these onto the musical scale, taking blue as the keynote, yellow as the third, and red as the fifth.

But Père Castel is best known as the inventor of the "clavecin oculaire," which consisted of two coloured discs, each divided into twelve parts (corresponding to the twelve semitones in the octave) and connected to a harpsichord, which would then be able to produce colour and sound simultaneously (i.e., both a note and the colour associated with it). Castel believed that a close correspondence existed between the natural scale and the fundamental colours: "There is a base note, which we will call C; it renders a firm, tonic and basic

colour which serves as a foundation for all colours, and that is blue."[26] On this basis he generated a colour scale to match the aural scale. In descending order: B, he suggested, corresponds to dark violet; B-flat to agate; A to violet; A-flat to crimson; G to red; F-sharp to orange; F to golden yellow; E to yellow; E-flat to olive green; D to green; C-sharp to pale green; and C to blue. The composer and musical theorist Jean-Philippe Rameau (1683–1764) was both an associate of Castel and a major influence on him. Rameau's theoretical work was based on his understanding of the physical properties of sound and on his ideas about the relationship between bass and harmony. He was interested, too, in the links between science and art. Against Jean-Jacques Rousseau, a philosopher (as well as a composer of music of quite some interest), who had asserted that the art of music should be close to a natural human being's singing, and so should be fundamentally melodic, Rameau asserted that melody, far from being sufficient for a good piece of music, depends on the rules of harmony—that is, of mathematics (from which it follows that the real guide for every composer is harmony, not melody). This was the central claim of Rameau's theory of music, which he defended in theoretical writings such as *Génération harmonique* (1737). For his part, Castel, in keeping with the tenor of Rameau's thought, understood his project as an effort to understand the *génération harmonique des couleurs* (harmonic generation of colours).[27]

Another composer who engaged Rousseau in debates over the sound/colour analogy was the Belgian, André-Ernest-Modeste Grétry (1741–1813). Grétry defended Castel's invention even though he had not actually seen an operating version of it. In *Mémoires ou Essais sur la musique* (1789), he asserted that lowered or "flatted" tones have the same effects on the ear as gloomy colours have on the eye, and that raised or sharpened tones have effects similar to those of lively, bright colours.[28] He also identified emotions with facial colours: black and purple he associated with fury and rage; purplish-red with anger; pink with modesty; white with candor; and yellow with sustained grief.

In 1740, Père Castel himself described his *clavecin oculaire*, setting out the description more or less in the form of plans. However, for many years the *clavecin oculaire* remained a hypothetical entity, for Castel insisted that he was a *philosophe* and not an artisan. Eventually, attempts were made to build a *clavecin oculaire*: in 1757 a friend of the priest, from London, constructed an Eye-Harpsichord, which was reported to consist of a box with a harpsichord keyboard in front, over which rose a six-foot-square frame containing sixty windows, each covered by a coloured glass shield. Over each of those shields was a curtain on a pulley attached to a specific key. Behind each window was a light so that when the performer pushed a key, one of the sixty curtains opened; as the note sounded, a flash of light emanated from the coloured glass port. High society was dazzled by this invention and flocked to Castel's Paris studio for demonstrations; but Castel wanted more, so a second, improved model

was produced in 1754. It used some five hundred candles and had reflecting mirrors to increase the intensity of the light so that a larger audience could experience the apparatus's effects. Performances must have been smelly affairs and were likely riddled with malfunctions. Still, Castel was optimistic: he predicted that every home in Paris would one day have a *clavecin oculaire* for recreation, and he dreamed of a factory that would build some 800,000 of them. No example of Castel's *clavecin oculaire* has survived.

Georg Philipp Telemann described Castel's *clavecin oculaire* in a note dated 1739, titled "Descriptions of an Eye-Organ or the Eye-Harpsichord Invented by the Famous Herr Pater Castel." Despite the renowned composer's enthusiasm, the very idea of a Colour Organ was controversial. Thus, while Telemann may have approved of the device, Rousseau was critical, arguing that music is an intrinsically sequential art whereas colours should be stable to be enjoyed.[29] In any event, Castel's *clavecin oculaire* never got much beyond the experimental stages.

Whatever adversities Père Castel faced, many painters, composers, and filmmakers since his day have experimented with building a Colour Organ. A similar piano of colours was described again in 1788, this time in *Aufschüsse zur Mage aus geprüften Erfahrungen über verbogene philosophische Wissenschaften und verdeckte Geheimnisse der Natur* (Disclosures of Magic from Test Experiences of Occult Philosophical Sciences and Veiled Secrets of Nature, 1788) by a Bavarian alchemist named Karl von Eckartshausen (1752–1819), the author of *Zahlenlehre der Natur* (Nature's Arithmetic, 1794), *Die Wolke über dem Heiligthum* (The Cloud upon the Sanctuary, 1802), and *Musik der Auge, oder die Harmonie von Farber* (Music of the Eyes, or the Harmony of Colours, n.d.). In 1870 a physicist named Frédéric Kastner built what he called a Pyrophone, an organ with glass cylinders filled with gas that emitted tones when the gas was released. In 1888 an American, Bainbridge Bishop, produced a Colour Organ of some sort; by 1893 he had produced three, each of which was destroyed in a separate fire (a fact that should surprise no one, given the nature of the technology). Bishop's scale matched the order in the rainbow (a symmetry, he suggested, that ensured that the structure of his instrument corresponded to the harmonic order of reality): B corresponded to violet-red; B-flat to violet; A to violet-blue; G-sharp to blue; G to green-blue; F-sharp to green; F to yellow-green; E to green-gold/yellow; D-sharp to yellow-orange; D to orange; C-sharp to orange-red; and C to red. One of his organs, which he deemed the most satisfactory, had mounted over the keyboard a large ground glass about five feet in diameter, framed like a picture, on which the colours were displayed. The instrument had numerous small windows, each glazed with glass of a different colour; and each window had a shutter attached to a key on the organ. When a key was pressed, the shutter was retracted to let in a coloured light. This light was then diffused so that when it reflected on a white screen

behind the ground glass (and onto the glass), it produced a colour that shaded into the tint of the glass; the colour of the bass sound in a chord spread over the entire glass screen, while the colours of the higher tones in the chord were projected onto the bass colour.[30]

In 1894 the British painter Alexander Wallace Rimington (1854–1918) exploited the new possibilities inherent in electricity. His London residence (on Pembridge Crescent, W11) was filled with the results of his experiments with electrically driven gadgetry. His principal Colour Organ was a machine with twelve openings for projecting twelve colours, each analogous to a tone of the musical scale: a performer opened the apertures using a keyboard similar to that of a piano, and the effect of opening any of the apertures was to project a cone of light onto a common surface. Judging from photographs, the machine was an impressive piece of work: it consumed thirteen hundred candlepower; a current of 150 amperes was required to power its light source (arc lamps mainly); it had stops to control the hue, luminosity, and chroma (i.e., purity) of the colours it produced; and the dyes used in its colour filters were the result of much research. Many celebrities came to see it, including Sir George Grove.[31]

In 1920, Adrian B. Klein produced a two-octave controller for a colour projector for stage lighting. His instrument was based on his colour theories, according to which the visible spectrum was logarhythmically organized. His book, *Colour Music: The Art of Light* (London, 1926; reprinted 1937 as *Coloured Light: An Art Medium*), is extremely valuable as one of the early works in the field of colour-music. It offers detailed descriptions of various early colour-music instruments. It begins with a history of colour-music and its relationship to painting, music, and psychology. It then deals with a number of design issues—for example, colour harmony—in a way that still has value. Its two chapters on the theory of colour-music (one examines its similarities to music, the other treats colour-music as an independent art) are impressive as early treatments of the aesthetic of this new field.

As for Rimington, he explained his ideas on the new art form in *Colour Music: The Art of Mobile Colour*. Like so many others of the time, he thought that reality was fundamentally vibration and that sound (music) and colour were both manifestations of that basic reality. In other words, both sound and colour are phenomenal effects of vibrations that stimulate the nerves endings: colour results from the stimulation of optic nerve endings, and sound results from the stimulation of aural nerve endings.[32] Like Castel (and others), he drew up a table of correspondences between colour and tone. In his table, the colour scale corresponding to the major scale with middle C as its tonic ran as follows: deep-red, crimson, orange-crimson, orange, yellow, yellow-green, green, bluish-green, blue-green, indigo, deep blue, violet.

Rimington's Colour Organ formed the basis of the moving lights that accompanied the March 20, 1915, New York premiere of Scriabin's symphony *Prométhée: Le Poème de Feu* (Prometheus: The Poem of Fire).[33] Similar devices were built by Beau and Bertrand-Taillet in France (whose coloured-light piano used electric bulbs and correlated the note C to violet) and by Hermann Schroder in Germany (whose organ correlated C with yellow).

Alexander Burnett Hector (1869–1958), a Scot born in Aberdeen, spent most of his life in Australia and there developed an electronic colour-music instrument. A hometown newspaper, the *Scotland Evening Gazette*, of October 12, 1921, described his invention:

> In some way his colour piano or organ is linked to a multitude of intensely brilliant electric lights—forty thousand candlepower, I fancy. These lights are immersed in many delicately graded aniline dye solutions of exceptional purity, contained in clear glass vessels; when a note on the piano is struck, it makes an electric contact, and the light bulb in connection with that particular note blazes out through the coloured solution surrounding it, carrying that colour with it and throwing it on to the screen and stage of Mr. Hector's pretty little demonstration theatre—an annex-room to his private house.

The Czech artist Zdeněk Pašánek (1896–1965) designed a Colour Harpsichord, which he installed as part of his Czechoslovak Spa Fountain in the Czech Pavilion at the 1937 Paris Universal Exhibition. This device required the operator to control more than one thousand tungsten lamps. Projected patterns of light, utilizing the full potential of almost 250 variations of colour, were recorded on interchangeable rolls of perforated paper, which were then fitted to a type of player-piano mechanism. This light sculture extended work that Pašánek had been doing for some time. Pašánek had in his studio an instrument he called a "kinetic light piano" (consisting of lamps controlled by a keyboard and a screen). On April 13, 1928, he and the extraordinary Czech composer Erwin Schulhof (1894–1942) presented, at the Smetana of the People's House, a synaesthetic concert of music by Scriabin. Alexander László introduced his device, the Sonchromatoscope, in 1925 at the Music-Art Festival in Kiel, Germany. Laszlo's book, *Die Farblichtmusik*, was published the same year. He composed preludes for piano and coloured light that employed a special system of notation. The English light-artist Adrian Bernard Klein (a.k.a. Adrian Cornwell-Clyne, 1892–1969) used a high-intensity carbon-arc lamp for his Colour Projector, which he built in 1921: His machine consisted of a large spectroscope that dispersed spectral lights over a cinema-type screen. These lights were controlled by a keyboard on which Cornwell-Clyne (then still known as Adrian Bernard Klein) performed many concerts of his own improvised music. More than 150 combinations of coloured lights could be generated by his Colour Projector.[34]

Perhaps the best known "colour organ" was Thomas Wilfred's Clavilux. Wilfred (1889–1968) was a Dane who between 1905 and 1911 studied music and art in Copenhagen, Paris, and London. He came to America as a vocalist, but ultimately turned his back on a flourishing performance career to create colour/ light pieces (though he continued singing in order to raise funds for his experiments with light). He had changed course after meeting Claude Bragdon, a Rochester architect, disciple of Gurdjieff, and explorer of the fourth dimension, who contended that just as architecture is geometry made visible, so music is number made visible.

Bragdon had already experimented with large visual-music spectacles. In 1916 he had presented a concert of visual music, the "cathedral without walls," in New York's Central Park. After that, he acquired a patron—Walter Kirkpatrick Brice, who built him a studio on Long Island where Bragdon and a society of Prometheans worked on further developing colour-music instruments. (The Prometheans were colour-music visionaries, inspired by Theosophical ideas, who wanted to create a Colour Organ to demonstrate their spiritual principles.) Wilfred gradually took over the space; in 1921, in close association with Bragdon, he built his first Clavilux, a console instrument for projecting lumia.

The Clavilux consisted of spot and flood lights, rheostats, screens, filters, and prisms, all controlled through an elaborate panel, with units that resembled manuals on a pipe organ.[35] Each unit had a bank of sliding keys, which were in three groups: form keys, colour keys, and motion keys. A beam of white light, of considerable intensity, was intercepted by a number of lenses and shaped into a form through the form keys. The forms were moved rhythmically using motion keys, and one or several colours, seemingly in every possible combination, were introduced using the colour keys. Wilfred's compositions were made up of polymorphous, fluid streams of slowly metamorphosing colour.

Wilfred debuted his Clavilux at the Neighborhood Playhouse in New York City in 1922. Between 1922 and 1929 he made tours and gave concerts of his own music in the United States and Canada. A reporter for the *Louisville Times* (November 20, 1924) described *A Fairy Tale for Orient* (Opus 30) as "an Arabian night of color, gorgeous, raging, rioting color, yet not rioting either ... Jewels were poured out of invisible cornucopias, lances of light darted across the screen to penetrate shields of scarlet or green or purple."[36] In 1925 he appeared in Paris, London, and Copenhagen. The *Manchester Guardian* (May 18, 1925) described *A Fairy Tale for Orient* as a dream of "some unearthly aquarium where strange creatures float and writhe, and where a vegetation of supernatural loveliness grows visibly before the spectator."[37]

Wilfred had even more grandiose plans. In 1928 he proposed a coloured-light spectacle on a massive scale: a "Clavilux Silent Visual Carillon" would be

installed atop a skyscraper. Ever-changing patterns of coloured light would be projected onto the inside of a translucent glass dome and operated either manually or automatically. He would not realize this utopian project. Nonetheless, his interest in coloured-light compositions never flagged: he went on to found the Art Institute of Light in West Nyack, New York, and he continued lecturing, creating, and writing until his death.[38]

Undoubtedly the best-known composer to have proposed an art that synthesized colour and sound, with the goal of triggering synaesthetic effects, was Aleksandr Scriabin (1872–1915). Scriabin was member of the Symbolist circle in Moscow—he participated, for example, in the Society for Free Aesthetics, which, under the leadership of Bely and Bryusov, propagated Symbolist ideas and included the Blue Rose artists (a "group of mystics and obscurantists," as their critics characterized them), as well as Goncharova, Larionov, and Yakulov and the composer Leonid Sabaneiev. (Henri Matisse, Emile Verhaeren, and Vincent d'Indy all spoke at the Society for Free Aesthetics.) Scriabin was an extraordinary figure: from about the age of thirty, around the time he finished his *Third Symphony*, subtitled *Le Divin Poème* (The Divine Poem, 1903), he took it as his mission to save humanity. Deeply influenced by Mme Blavatsky's Theosophy (when he visited London he insisted on seeing the room where she died), his soteriological efforts were typical of Gnostics: he believed that, having struggled with its past and evolved through pantheism, the human spirit could now fuse with the universe, if only it freed itself from sensory delights.

After completing *Le Divin Poème*, Scriabin conceived of a giant mystery play that would include all humanity as its cast and that would fuse all the arts. To bring this project about, in 1908 he issued a one-movement symphony that included three hundred lines of verse. His original title for this symphony was *Poema ognya* (Orgiastic [i.e., Orgasmic] Poem); later he released it as *Poema ekstaza* or *Le Poème de l'extase* (Poem of Ecstasy, 1905–7). This composition was revolutionary, both in its use of atonality and dissonance and in its erotic mysticism—it is reported that the piece could arouse the composer sexually as he listened to it. *Poema ekstaza* depicts the rising journey of the soul, and the work's basic motif sets ascending fourths and fifths (perfect and diminished) against a descending chromatic figure. The use of the number "four" takes on a special, spiritual meaning in this work; Scriabin associated that number with the fourth dimension and with rising above merely physical sensations toward the region of purely abstract ecstasy, of pure intellectual speculation.

In 1909, shortly after finishing *Poema ekstaza*, Scriabin began writing *Prométhée: Le Poème de Feu* (Prometheus: The Poem of Fire; 1910). He thought of the celestial rebel Prometheus as the bringer of colours and light that would grant humankind a higher form of understanding.[39] This symphony recounts an essentially Gnostic story, that of the Creative Principle arising from chaos and ascending through the dance of atoms to form human consciousness,

and then of the human spirit descending to matter. *Prométhée* makes extensive use of a chord built on the interval of the fourth—specifically, on the interval of the fourth in the fourth octave in the overtone series; this chord, often referred to as the Mystic Chord, comprises an augmented fourth, a diminished fourth, another augmented fourth, a perfect fourth, and another augmented fourth. It became one of Scriabin's trademarks. While he worked on this piece, dreams brought the composer to think of a new form of fire—electricity—so he incorporated into his score notes about colours that would be triggered by a "light keyboard" (Alexander Moser's Colour Organ) that might accompany a performance of the composition.[40] Since the Colour Organ part tracks the work's pitch structure, the device would provide a sort of instantaneous analysis of the composition's *Grundbaß* (thorough-bass). Scriabin wanted everyone in the audience to wear white clothes so that the projected colours would be reflected on their bodies and thus possess the whole room.

From *Prométhée*'s score, with its part for a "Light-Organ" (the score contains a line labelled "Luce"), we can easily trace how he integrated his ideas about colour into the harmonic system he had worked out. Like Goethe (at one time), the composer believed there were relationships between specific tones and colours. He associated the twelve tones of the chromatic scale with twelve colours (though his correspondences did not match Goethe's). Scriabin envisaged that performances of *Promethée* would make use of variously coloured lights projected onto the ceiling of a high-domed white hall; since he strived for contrapuntal effects among the different media his composition comprised, the light with which he proposed to flood the concert hall would change colour sometimes in parallel with, and other times in opposition to, the sound (music).

The part for colour light—the "tastiera per luce" part—is presented in the score in a deeply idiosyncratic manner. It is set in traditional musical notation at the top of the score; and, as noted, it plays continuously throughout the piece. Nowhere does Scriabin explain the colour–pitch relations he had in mind—for this, performers have had to rely on Sabaneiev's statements (or those of other Scriabinists). The part generally consists of two pitches (i.e., two colours), which are to interact. One of the "pitches" (colours) generally doubles one of the orchestral parts. Also, one of the "pitches" in the colour part changes metrically with the music, while the other remains constant over very long durations. The latter would seem analogous to organ pedal points (we might think of them as colour-organ pedal points). Scriabin conceived the repeated figures in this line as expressing the breathing in and out of the Cosmic Life Force.

The "tastiera per luce" also has programmatic significance. The opening section depicts chaos, and its colour is blue-green, as though soulless creatures

were drifting about in a vast ocean. Just before humans receive the gift of the *manas* (the Promethean spark), a metallic colour is presented; it is followed immediately by a green glimmering, suggesting the bestowing of fire. Voluptuous passages are associated with dark red and red-purple. In one of the "victorious" climaxes, yellow, the colour of the sun, prevails.

This new synthesis of the arts, Scriabin believed, had the potential to raise humankind to the status of the gods. His lofty hopes were never realized, however: though *Promethée* was performed in London, Paris, Brussels, Berlin, and New York, he never witnessed a performance complete with coloured lights. He did assess a colour-piano that had been built in New York in 1915, but he was disappointed by its failure to produce harmoniously related variegated forms. A performance did take place during his lifetime, in America, using an experimental apparatus for producing coloured light, but that device was inadequate and failed to gain wider acceptance.

A contemporary, Leonid Sabaneiev, gave evidence of an ability to discern the historical significance of Scriabin's project:

> The various branches of the arts have, since the time of their religious interaction in antiquity, become autonomous and have reached a startling perfection independent of each other. Music and the art of words have reached the highest point: however, of late the arts of movement and of the pure play of light—the symphony of colors—have begun to develop. Today we encounter more and more attempts to vivify the art of movements. The methods of many innovators in painting can be called only an approach in painting to the pure play of colors.
>
> The time for the *reunification* of the separate arts has arrived. This idea was vaguely formulated by Wagner, but Scriabin expresses it much more clearly today. All the arts, each of which has achieved an enormous development individually, must be united in one work, whose ambiance conveys such a great exultation that it must absolutely be followed by an authentic ecstasy, an authentic vision of higher realities.[41]

We see here another proposal for a synthetic art as a sort of *Universalpoesie*—he avers that the different arts should be to one another as sisters. There are now two top arts, Sabaneiev asserts: music and the art of words. The arts of movement and the pure play of light have, however, advanced to the point that they will be able to fall under the guidance of the two top arts. From the synthesis would emerge a transcendental art, akin to Schlegel's transcendental poetry, that new art that would unite the individual arts and in so doing would acquire the capacity to fully express the artist's mind. The elements of this new art would act as hieroglyphs of an invisible reality. The artwork fashioned in this new synthesis of the media would be an integral configuration that can incorporate diverse materials, mingles and fuses them, and yet would

not elide, the difference of opposites. It would, in a sense, encourage dissent amongst its parts, to mark the freedom of the artist, but would reconcile them in a harmonious unity that would elevate the mind to higher states. At this point in his polemic, Sabaneiev executes a truly Schopenhauerian turn: he diverts himself to considering the relation of music to the will:

> All the arts are not equal in this unification. The arts that will dominate are those directly passed on impulses of the will, which can express the will directly (music, word, plastic movement). Arts that do not depend upon impulses of the will remain subordinate (light, smell); their purpose is resonance, strengthening the impression of the primary arts. They are still underdeveloped arts that obviously cannot exist independently, without the support of those that are primary.[42]

Schopenhauer had declared that music is the *ottima arte* (the top art) because it alone is able to penetrate to the essence of reality; thus it can express things that language cannot. In *Die Welt als Wille und Verstellung* (The World as Will and Idea, hereafter *WWI*, 1819), he extolled music above all other arts as a "universal language" that is able to express, "in a homogeneous material, mere tone, and with the greatest determinateness and truth, the inner nature, the in-itself of the world." It distinguishes itself from the other arts in not being a "copy of the phenomenon, or, more accurately, the adequate objectivity of will. It is the direct copy of the will itself, and therefore exhibits itself as the metaphysical to everything physical in the world."[43] The composer's experience is different from that of other mortals, in that his or her experience "reveals the inner nature of the world, and expresses the deepest wisdom in a language which his reason does not understand; as a person under the influence of mesmerism tells things of which he has no conception when he awakes" (*WWI* 1:336).

In expounding his view of the noetic importance of music, Schopenhauer makes what might seem a surprising move to some: he avers that only instrumental music enjoys the cognitive powers he ascribes to the art: "It is precisely this universality, which belongs exclusively to it, together with the greatest determinateness, that give music the high worth which it has as the panacea for all our woes. Thus, if music is too closely united to the words, and tries to form itself according to the events, it is striving to speak a language which is not its own" (*WWI* 1:338). This remark—and indeed, Schopenhauer's according to music the status of the *ottima arte*—reflects the Romantic antipathy toward language, which the Romantics accused of reducing perceptual vivacity by turning thinking toward abstraction; of transforming (or tending to transform) thinking into chains of logical deductions; and of reinforcing thereby the divorce of the subject of experience from the experienced object that only the imagination—the faculty that produces not language, but images—

could possibly heal. Note, however, that Schopenhauer's conception of music reflects a specifically modern view—that traditional music was commonly allied with texts and depended for some of its meanings on the meanings of those texts with which it was allied. This points to the anomaly I noted in the preface to this book: On the one hand, Schopenhauer generally accepted the view that there exist rivalries among the Sister Arts, and that in their contest, one of them would finally emerge as the *ottima arte*. On the other hand, Schopenhauer, like many of his time (one might think of Hegel, his archrival), harboured a basic conviction that the task of reason is synthetic: it is to identify the One through whom the Many—engaged in their contests with one another and with their dissent from the whole—might be brought into a dynamic harmony. Thus, while Schopenhauer did not himself do so, some of his followers (including Richard Wagner) advocated the synthesis of the arts, the creation of a *Gesamtkunstwerk*, whose role would be similar to that which Friedrich von Schlegel assigned to transcendental poetry.

In fact, this tension (a topic that appears often in the present volume) results partly from a discord between older, eighteenth-century views of the role of music and the arts and nineteenth-century Romantic views of the same. According to the eighteenth-century view, musical harmony mirrors the harmony that exists among the parts of the cosmos (which is also mirrored in the harmony among the elements of the state, which is mirrored in the harmony among the elements of the soul). Thus, there are correspondences among psychological harmony, social harmony, and cosmic harmony: all involve a co-functioning of different parts, which work toward a common end in what can be characterized as cooperation. (Ugliness, in this view, is a result of disorder.) In the eighteenth century, the arts separate but are still believed to have some common ordering principles; thus, the arts are thought to be in harmony with one another, for all reflect the universal structure of the cosmos. The nineteenth century, a more revolutionary era, accorded a greater role to strife and dissent: its view of harmony was less that of cooperation among elements working toward a common goal than of strife leading to dynamic resolution.[44] In the aesthetic theory of that century, the individual arts were thought to have an impulse to develop and expand until they encroached on one another's territory in what Goethe called an "Andersstrebung" of the arts (the arts' striving to take over one another's territory). This was largely the result of the Romantics' having embraced a metaphysical system that accorded special privilege to "The One." As they thought about the relation between diversity and unity, they were less inclined to see unity emerging from the coordination of fundamentally discrete parts; it was more a matter of unity struggling with contending elements—with elements that contend among themselves and against the unifying impulse of The One itself—until it finally reconciled them, bringing about a dynamic harmony. Thus arose the Goethean

idea of the *Andersstrebung* of the arts (each attempting to take over the functions of the other), and thus arose Schlegel's idea of *Universalpoesie*. As a result, in Romantic writing on the arts one finds affirmation of the principle of differences among the arts (with one art being proclaimed as the *ottima arte*) as well as affirmation of the principle of unification of the arts.

In fact, Scriabin did not follow Schopenhauer all the way on this matter of music as a true transcendental poetry. His melodies and harmonies were not "pure" noumena, but phenomenal forms whose purpose was to raise human consciousness.[45] In this, Scriabin adopted the Symbolist interpretation of the role of music in metaphysical reality, which dissented from the views propounded by German idealist philosophies.

After *Promethée*, Scriabin began work on the even grander piece, *Misteriya* (Mysterium; or sometimes Le Divin Poème [Mysterium]; or for the English, sometimes Mystery Play). This work has a profoundly Symbolist character and displays the usual range of Symbolist obsessions: the Scriptures; the philosophies of Nietzsche and Schopenhauer; the Christian/Sophia religion of Vladimir Solovyov (1853–1900), especially the ideas of *vse-edinstvo* (all encompassing unity) that he put forward in *La Russie et l'Eglise Universelle* (Russia and the Universal Church, 1889); and the Theosophical Doctrine of Mme Blavatsky (1831–1891).[46] Mme Blavatsky and her Theosophist teachings played an especially great role in shaping the piece.[47]

With *Misteriya*, Scriabin intended to unite philosophy with religion in a new gospel that would supplant the present one. He would depict the end of the world and the creation of a new human race. He recorded in his diary, "I am come to tell you the secret of life, the secret of death, the secret of heaven and earth ... I am the *author* of all experiences, I am the creator of the world."[48] *Misteriya* would carry his heterodox interests even further than *Promethée* had. Its introductory section, "Prefatory Action," would focus on the creation of the universe: it would evoke this creation in an essentially Symbolist fashion, as an amalgam of images blending dreams, ecstatic visions, and premonitions of death into a non-discursive form. *Misteriya* would elicit little sense of forward movement and an overall sense of timelessness.[49] The composer's efforts to dispense with forward propulsion (a principal that much tonal music relies on) and to evoke feelings of stasis and timelessness arose from his desire to convey a spiritual ascension from the physical to the astral plane—an ascension described in Blavatsky's Theosophical doctrine. Scriabin's phantasmagoria suggests a sense of the illusory world of appearance, as well as its transcendence. In his writings about *Misteriya*, Scriabin cast himself as both demiurge and guide, as leading his listeners from one plane of reality to another by raising consciousness to a transcendental plane. He intended the work to represent the fulfillment of his life-long quest to spiritualize life; he hoped it would culminate in the world's annihilation and time's cessation.

Misteriya would combine music, colour displays, and architecture. Scriabin meant for it to be performed in a hemispherically shaped temple in India. In his plans for this performance venue, to be built in the Himalayan foothills, he sketched a spherical temple, which, mirrored in a reflecting pool, would form a perfect sphere, a symbol of the Divine. Bells would be suspended from the clouds in the sky to summon spectators from all over the world. Across the reflecting pond from the stage, spectators would sit in tiers across the water, arranged so that they radiated out from the centre of the stage (this would involve circles within circles upon circles), according to their spiritual evolution: the most spiritually advanced would be seated nearest the radial centre. Scriabin would sit right at the centre of the stage, surrounded by hosts of instruments, singers, dancers—a cast of thousands, all of them moving continuously, including the costumed speakers, who would recite *Misteriya's* libretto while engaged in the processions and parades.

The choreography would include glances, looks, eye motions, and movements of the hands. At some point, Scriabin also began incorporating notations for scents and tastes into his score, alongside those for coloured light: odours of both pleasant perfumes and acrid smokes, as well as the aromas of frankincense and myrrh, were to be incorporated in the work. Columns of incense would form part of the scenery. Lighting effects—from fires and constantly changing theatre lights—would envelop the cast and audience throughout the performance. The composer speculated that the sensuous experience provoked by these aromas and sights would raise his listeners to a quasi-religious state of consciousness.

This work, Scriabin believed, would prepare people for their final Mysterium, their ultimate dissolution in ecstasy. "I shall not die," he declared. "I shall suffocate in ecstasy after the *Misteriya*." The piece would last for seven days: bells would summon the audience to the performances; sunrises would serve as preludes and sunsets as codas. Shafts of light and sheets of fire would appear periodically, and ever-changing perfumes, appropriate to the music, would pervade the air. At the end of the seven days, the world would dissolve into bliss.

Earlier, I outlined Schopenhauer's views on the Inter-Arts Comparison. But Schopenhauer's influence was yet more wide-ranging: he influenced other Russian Symbolists as much as he did Scriabin. The Symbolists' belief that music alone has the power to convey the higher reality and that poetry and painting must take on attributes of music if they hope to lift people's minds to a transcendental sphere reflects Schopenhauer's idea that "music is as *immediate* an objectification and copy of the whole *will* as the world itself is ... Music is by no means like the other arts, namely a copy of the Ideas, but a *copy of the will itself*, the objectivity of which are the Ideas."[50] A composer, astrologer, and student of Scriabin's work, Dane Rudhyar, showed how greatly Schopenhauer inspired Scriabin.[51]

But with Scriabin, the conscious foundations of an entirely new and revitalized SENSE of music became patent. He discovered, or rather rediscovered, a New World of music, the America of music; and though the discovery is indeed far from being complete, though a whole continent lies unchartered and uncultivated, yet Scriabin pointed the way and no better foundation can be secured for the new American music which is to be, than a study and comprehension of Scriabin's new sense of music ...

While music is, for the neo-classicists, an assemblage of sound-patterns and esthetic forms, and for the romantic, an emotional projection of human life, for Scriabin it is a magical force used by the spiritual Will to produce ecstasy, that is, communion with the Soul. This characterization of music as magic, of harmonic sound as a magical force directed by the will of the evoker (no longer a composer) for whatever purpose it may be, is the central fact of the new musical philosophy. It means that the essence of music is the energy of sound used by man. The energy of sound—not the form or pattern made by melodies or sequences of more or less abstract notes. Music becomes a problem of spiritual dynamics.[52]

Sabaneiev proceeds to the conclusion that we have been shown a key to Symbolist aesthetics (and, indeed, to much of nineteenth-century aesthetics). He affirms the important role of what I have been calling "dissent": that elements break with the Whole and contend against it, that they engage in strife against the Whole, so that when the Whole once again takes them into itself, they transform the Whole:

With [a chord consisting of E-flat–A–F-sharp–C–G–B-flat] begins the Prometheus poem of the creative spirit which, having already become free, freely creates the world. This is a kind of symphonic synopsis of the mystery, in which the participants are forced to experience the whole evolution of the creative spirit, where they are separated into receiving, passive, and creative human interpreters. This separation is also seen in *Prometheus*: it has the customary form of the symphony, performed by orchestra and chorus.

His "single" harmony has the capacity to include the most diverse nuances, beginning with a mystical horror and ending with a radiant ecstasy and a caressing eroticism [which, under the influence of Solovyov, stands for the state of *vse-edinstvo*, the all-comprehending unity] ...

Another exaltation, and again the orchestra is caught up in a sea of sounds that merge in the final chord.[53]

Of course, I should prefer not to say that a "single" harmony has the capacity to include the most diverse nuances but to say, "Elements depart from that opening harmony, engaging in an act of dissent, which, as those elements are eventually again reconciled to the single harmony, cause it to undergo change as well." Nonetheless, the idea that Sabaneiev is expounding here is a

principle that was already becoming important in cinema; and, as I pointed out in the preface, many twentieth-century artists saw the advent of cinema as both reinforcing its strength and providing scientific (technological) proof of its truth.

Scriabin's *Promethée* and *Misteriya* inspired other composers to create audiovisual *Gesamtkunstwerke* and designers to create audiovisual instruments. Scriabin's follower, Ivan Wyschnegradsky, wrote lengthy manuscripts about his own imagined dome of light, onto which complex geometric patterns would be projected, accompanying music written in a microtonal harmonic system. (Wyschnegradsky was an impoverished Russian exile in France, and unfortunately was unable to raise the wherewithal to realize his artistic dreams.) Another, the Russian painter Baranoff-Rossiné, demonstrated his Optophonic Piano in 1923, in the wake of the enthusiasm for synaesthesia that Scriabin's works unleashed; meanwhile the erstwhile Dada artist Raoul Hausmann worked on his Optophone in Berlin. The Synchromists Morgan Russell (1886–1953) and Stanton Macdonald-Wright (1890–1972) conceived an instrument for realizing their colour/sound analogues, an instrument that would combine moving coloured light with music; indeed, for over twenty years they preoccupied themselves with the idea of a kinetic light machine. Russell wrote to Macdonald-Wright: "As a matter of fact when I left off the synchromies in paint I got to meddling with lights also, but never got funds or encouragement … It was inevitable that synchromies should lead to this." Together, Russell and Macdonald-Wright conceived of several designs for light machines and even came to grasp their limitations (Russell thought that the light from these machines should be accompanied by slow music, because the changing lights would have to be slow or they would blur. He also felt that the music these machines produced should engage in a true dialogue with the lights, and not simply run simultaneously, with one overwhelming the other.) The pair tried to construct a Light-Organ in 1931, but it was damaged by fire (it relied on candles rather than electricity).[54] Their idea was realized only decades later, in the 1960s, when Macdonald-Wright actually built his Synchronous Kineidoscope (an apparatus that could turn any painting into saturated coloured light, whose movements would then induce kinesthesis). And, as we noted earlier, the Swiss artist Charles Blanc-Gatti, a favourite of the great French composer Olivier Messiaen, took out a patent in 1933 on a Chromophonic Orchestra that would produce moving, multicoloured lighting effects on a screen in synchronism with musical sounds.

In 1924, Alexander László, a Hungarian pianist and composer, produced sketches for a projection machine. He commented on what he was trying to achieve: "As coloured light music is a contemporary (abstract) branch of art, so we need an instrument to render its compositions. This we call the coloured light piano (Sonchromatoscope). Basically, four large projectors are used and

four small footlight machines, which are operated from a switchboard. [This makes possible] coloured light musical compositions, in which there appear, on the one hand, the widest possible range of colour variations with an unobtrusive transition from one threshold into another (similar to breakfast or supper) and, on the other, images in geometrical or expressionistic planes, seen in both moving and static states."[55] In 1925, László mounted a Colour Music performance in Leipzig. In the introduction to a monograph, László described his accomplishment this way:

> Color-light music seeks to merge two previously separate art genres, art in notes—i.e. music—with art in colors—i.e., painting—into a higher unity, a new art ... László determines ...the basic color of a musical piece, calls one of them "Preludes for Colored Light and Piano Blue," another "Red," and retains this basic color throughout the entire piece. Depending on the changing musical events, such as dynamic or rhythmical changes, or the appearance of new themes or a new key, the basic color is supplemented by new color hues ... understood by analogy to the rules of musical variation. The colors are in turn occasionally supplemented by parallel phenomena to certain musical figures, plastic configurations such as wavy lines or wedge shapes. It should be emphasized that this new "comprehensive work of art" can not be judged solely either from a musical or a painterly point of view ... The colors are projected on a backdrop on a darkened stage by means of a "color-light piano" consisting of seven different projectors, developed by László himself and manufactured by the Ernemann Company, Dresden; they are controlled from a console by means of a keyboard.[56]

László's performances on the machine went some distance toward realizing what he imagined, but only part of the way. Aware of the limitations of his imagined Sonchromatoscope, as well of his skills and imagination as a visual artist (and likely of his tendency toward *Traumerei*), Lászlo purchased films from Oskar Fischinger and attempted to persuade him to collaborate with him on his research into coloured light-music. Around this time he also wrote curious scores for piano and light projections.

Others attempted to choreograph the movement of coloured light in space as well as in time, to correspond to the dynamics of tone changes (changes in pitch and timbre, including chord changes) in time. The demands of this sort of audiovisual coordination are rigorous, and sometimes the efforts to coordinate the movement of tones in musical space to the movement of light in real space ignore the material differences between the media.[57] For that reason, among others, presentations using the Coloured Light-Organ were only intermittently successful. A closely related practice, similarly aimed at modulating beams of coloured light to aesthetic effect, avoided the difficulties that performances with the Coloured Light-Organ met by avoiding those forms of close audiovisual coordination that are generally so aesthetically deleterious. These

works do not try to connect alterations in the qualities of light with changes in music, nor do they attempt to transpose means for organizing forms in time to forms in space.

The Futurist painter Giacomo Balla, who took a great interest in synaesthesia, created an abstract set design in which moving polychrome sculptures and modulating lights assumed the parts that actors might have played. Two other Futurists, Fortunato Depero and Enrico Prampolini, produced work of this sort as well. Ludwig Hirschfeld-Mack made especially important contributions to the *Lichtspiel*. Some of his works were audiovisual syntheses, but in others he did not attempt to transpose musical forms onto spatial ones. The story of the way he came to understand the potential of the light-play is a charming one: He taught at the Bauhaus, and in the summer of 1922, he and a group of associates were rehearsing a shadow-play, a type of production often presented at the famous art and design academy. In this, they were encouraged partly by the in-depth exploration of the shadow-play that a Bauhaus student, Kurt Schwerdtfeger, had undertaken that year. The acetylene bulbs that Hirschfeld-Mack and his associates were using began to weaken, and he noted that the shadows cast on a paper screen were doubled as a result. This observation prompted him to experiment with acetylene bulbs of different colours. He found that some produced "colder" shadows, others "warmer," and that by using different acetylene bulbs simultaneously, he could produce many shadows of differing qualities. Over the following years, he refined the principle by constructing a special device for creating his light-plays: beams from lamps of many colours were formed by movable stencils and projected onto a screen, allowing observers on the opposite side to watch the changing effects of the light modulations. His apparatus enabled him to present reflected light-compositions set to music he composed himself. Together with Oskar Schlemmer and Kurt Schwerdtfeger, he began to explore its use.

Hirschfeld-Mack's experiments with coloured light grew out of his interest in colour and its psychological/spiritual effects. He was deeply interested in colour, participating in the Bauhaus classes on colour, helping develop Bauhaus colour theories, and taking part in the Bauhäuslers' early experiments in light-art. He developed the Bauhaus colour top (*Farbenkriesel*), a spinning top made of seven variously coloured paper disks. Bauhäusler used these to analyze the qualities and interactions of colours and to illustrate the colour theories of Goethe, Schopenhauer, and Bezold.[58]

Under Kandinsky and Klee's supervision, Hirschfeld-Mack participated in research on the psychological relationship between form and colour. These artists sent out a thousand postcards to a representative sample of the population, asking them to fill in three elementary shapes—the triangle, the square, and the circle—with three primary colours—red, yellow, and blue—using one colour only for each shape. (They found that an overwhelming majority chose

yellow for the triangle, red for the square, and blue for the circle.) Hirschfeld-Mack's work with coloured-light/sound machinery reflects this interest in the harmonies among shape, colour, and sound. For example, his *Reflektorischen Lichtspielen* (Reflected Light Compositions, ca. 1922–23) combined intense, glowing yellow, red, and blue with light, silver-grey colours, which moved at varying tempi on the dark background of a transparent screen. Here, the various colours were associated with different shapes. One moment these bright colours would appear as angular forms: triangles, squares, polygons; the next, they would appear as curved shapes: circles, arcs, and waveforms. Usually the colours joined or overlapped to create intricate blendings.

Hirschfeld-Mack introduced his *Lichtspielen* to the public in 1923 during a film matinee at the Berlin Volksbühne and later in Vienna with Fernand Léger/Dudley Murphy's *Ballet Mécanique*. Other Bauhaus artists followed his lead and created performances, some of them intricately scored, of projected light that moved and changed colour. For example, *The Mechanical Cabaret*, an event organized by the Hungarian Bauhäusler Andreas Weininger, included the piece *Reflektorische Lichtspiel* (Reflectorial Colour Play) by Schwerdtfeger and Hirschfeld-Mack.

Hirschfeld-Mack's apparatus, with its movable stencils, was especially close to cinema. The film strip itself, after all, is a sort of stencil, or coloured filter, that modulates a projected beam. Indeed, film's limitations are what distinguish cinema from Hirschfeld-Mack's device: in film, the beam comes from a single stationary source and has a single colour, and the stencil moves in a single, predetermined direction and at an unvaried, predetermined rate. Hirschfeld-Mack's light-play performances were able to use more gradual transformations in colour and light, since his apparatus blended beams from different sources, which could be varied independently, and more gradually and subtly, than the beam of a motion picture projector could ever be. Furthermore, in theory, changes in light could occur more rapidly than the 1/24 of a second that is the lower threshold of changes to the film's projector beam. Many advantages were on the side of these direct projection light compositions; film had only the advantages that result from known limitations. Nonetheless, these proved decisive, for film provided for replicable performances—and, since it used standardized equipment, for transportable performances.[59]

A unique device for exploring correspondences in the audiovisual domain was suggested by the Dada photomontagist and sound poet Raoul Hausmann's Optophone drawings. In a letter to the sound-poet and explorer of biopsychical vibrations, Henri Chopin, dated June 23, 1963, Hausmann wrote:

> I wanted to draw your attention to the fact that I developed the theory of the Optophone, a device for transforming visible forms into sounds and vice versa, back in 1922. I had an English patent, "Device to transform numbers on

MODERNISM AND THE ABSOLUTE FILM

photoelectric basis," which was a variant of this device and at the same time the first robot. [But] I did not have enough money to build the Optophone.[60]

Another undated text explained how he developed the idea:

> In 1915 I studied Goethe's theory of color, which shows that Newton's theory of color is erroneous. In 1920 I witnessed the experiment with the incandescent arc speaking lamp at the Berlin Postal Museum, and I became aware of Ernst Ruhmer's experiments on transforming sounds into visible signs using a selenium cell. I still have a copy of his book, dated 1905. I later carried out experiments with prisms. In 1920 I came across an article in an illustrated New York periodical about Thomas Wilfred's Claviluz and colored electrical forms that fly freely in space. I continued my theoretical studies of optics and acoustics and in 1922 I published an article in Russian on the Optophone in Ilia Ehrenburg's journal *Wjescht, Objet, Gegenstand*. The same article was published by Kassak and Moholy in the Hungarian language journal *MA*. In this article, I proved that with its six hundred tubes the eye of the bee is an optophonetic organ. In 1926 Moholy sent me a student of his named Brinkmann, who said I was a real fool not to have taken out a patent for the Optophone. He showed me a letter from Albert Einstein saying that the Optophone was very important.
>
> In 1924 I published technical articles on optophonetics in Hans Richter's journal G, and between 1925 and 1932 in Seiwert's *A bis Z*, [based in] Cologne. In 1925 I entered into contact with the German inventors of the talking pictures, Vogt, Masoll and Engel. At the time, I had founded a firm for patents, DIAG, which was officially registered in the trade directory. In the meantime, I had been granted a patent for projection inside corporeal cavities. However, when, after Brinkmann's visit, I requested a patent for the Optophone, the Berlin patents office refused it, saying that it was "technically quite possible, but we cannot see what use it would be."
>
> In July 1931 I published quite a long article about the "Over-Developed Arts" in *Der Gegner*, a journal edited by Franz Jung. In it I showed that the visual arts had reached saturation point and that we needed to develop optophoneticism. In this article I gave a technical explanation of the Optophone. I still have a copy of this issue in my possession.
>
> In 1927 I was visited by the engineer Daniel Broido, who was working on a photoelectric calculating machine for a big electricity company in Berlin, AEG. That was when I changed my conception of the Optophone and made it into a variant on the photoelectric calculating machine.
>
> Together, Broido and I built a demonstration model. But the advent of Nazism forced Broido to emigrate to London and me to Prague. In the end I was granted English patent no. 446.338 for the "Device to transform numbers on photoelectric basis." As I was forced to leave Czechoslovakia because of Hitler in 1938, I sold my patent to Broido for 50 pounds sterling.[61]

The Optophone would never get past the planning stages. It would have used electricity to realize the Symbolist dream of audiovisual correspondence.

"With the appropriate technical equipment the Optophone can give every optical phenomenon its sound equivalent, in other words, it can transform the difference in the frequencies of light and sound," Hausmann proclaimed in 1922.[62] One can see what might have drawn Hausmann to the idea of the Optophone: this apparatus for transforming sound signals into light signals and vice versa was to be, essentially, a technological device for accomplishing automatically the exchange between sound and images that Hausmann had already explored in his letter poems (in which larger letters recorded/scored sounds of greater intensity). Hausmann published three important texts on the Optophone between 1921 and 1923: "PREsentismus" (PREsentism), a manifesto; and the essays "Optophonetics" and "From Talking Films to Optophonetics." These writings, and especially the manifesto, show the influence of the aesthetician Salomo Friedlander (1871–1946, aka Mynona) and the neo-Kantian philosopher Ernst Marcus (1856–1928); Hausmann corresponded with both in the early 1920s. Friedlander, whose doctoral thesis was on Schopenhauer and who together with the Stirnerbund (followers of Max Stirner) founded the Association for Individualist Culture, was a friend of Raoul Hausmann and Johannes Baader; he was the author of many grotesqueries as well as the philosophical text *Schöpferische Indifferenz* (1918). Extending the ideas of Stirner, he critiqued modernity for destroying the "differentiated ego." In *Das Problem der exzentrischen Empfindung and seine Lösung* (The Problem of Eccentric Feeling and Its Solution, 1918) Marcus presented a theory of "eccentric sensoriality" according to whose radical physiological thesis the sense of touch is an extension of all the other senses and haptic sensations are an aspect of all sensation. In his manifesto, Hausmann wrote (using the Marcusian idiolect): "We must convince ourselves that the sense of touch is mingled with all our senses, or rather that it is the definitive basis of all the senses: the haptic sense, whose eccentric emanations are projected into the atmosphere through the six hundred kilometers of the Earth's atmosphere as far as Sirius and the Pleides. We see no reason why this most important of our apperceptions should not be made into a new art."[63]

A letter that Hausmann wrote to Hannah Höch reiterated the expansive idea of sensation that did much to motivate Hausmann's interest in creating the Optophone: "The limits of the body are not those of sensory perceptions but ... by virtue of the eccentric rays, perceptions may take place in the remotest areas."[64] For Hausmann, touch was the primeval sensory modality, and new technology had made it possible to use those primeval sensations to generate both sounds and images: "Thanks to electricity we can transform our haptic emanations into mobile colors and sounds, into new music."[65] A description in "Optophonetika" provided a more technical explanation of the means for producing this audiovisual correspondence:

If one places a telephone in the circuit of an arc lamp, the arc of light is transformed because of the sound waves that are transformed by the microphone in accordance with variations corresponding exactly to acoustic vibrations, that is to say, the rays of light change form in relation to sound waves.

At the same time, the arc lamp clearly reflects all the different variations from the microphone, i.e. speech, singing, etc.

If one places a selenium cell in front of the arc of light in acoustic movement, it produces different resistances that act on the electrical current in accordance with the degree of lighting. One can thus force the ray of light to produce induction currents and transform them, while the sounds photographed on a film behind the selenium cell appear in lines of varying width or narrowness, lightness or darkness, and are transformed back into sound by a reversal of the process.

The optophone again transforms images of luminous induction into sounds with the help of the selenium cell using a microphone in the electrical circuit. What appears as an image in the emitter station becomes a sound in the intermediary stations and, if one reverses the procedure, the sounds become images.[66]

Another letter, to Henri Chopin, citing a text written in 1960, "Libération de l'imaginaire," provides perhaps a clearer commentary:

If one passes the reflection of different sizes of microscopic rays through a sheet of quartz towards a cylinder with slits like a multiplication table, one obtains reflections of colored light of very varied aspect, because of the dispersion of the rays passing through the slits of the multiplying cylinder. And one obtains on a screen colored phenomena deformed by their angle of reflection. This enables us to trigger an automated process of sequences of variable forms of refracted light and to introduce changes into the ordered visual chains, electrically based systems that are analogues for an imaginary process, analogous to the behavior of electrical discharges.[67]

The device Hausmann envisioned, apparently, consisted of a keyboard with scores of keys, each associated with a surface of bichromatized gelatine that had been formed into a pattern that would shape light in a distinctive fashion. When keys were pressed, the corresponding surfaces were activated, and the lights passing through them shaped distinctive images. Also, the keyboard was constructed so that keys could work in combination to generate unique shapes and intensities. The light was then passed through a prism to refract the light into various colour zones.[68] With this device, Hausmann would be able to create the "electric scientific painting" he called for in his "PREsentismus" manifesto. In that manifesto he considered the possibility that electrical signals could be used to transmit images across distances. And he argued that such televisual sensations would be a form of touch radiating across space.

Hausmann predicted that technology would alter our conception of touch to take into account the emerging phenomenon of tele-tactility. Condemning the "superficially understood tactilism" of F.T. Marinetti, who had described enthusiastically the coming-to-be of a new tactility through direct "hands-on" contact with materials, Hausmann proclaimed that a new tactility would have to consider the emerging "second nature" being fashioned by electricity and telecommunications: in this realm, the corporeal limits of the physical body would be overcome, as electricity enabled it to be extended indefinitely. Here, Hausmann was extending Marcus's ideas about ex-centric sensitivity, re-formulating them in "televisual" terms. Marcus had proposed that percep-tions and sensations were not confined to the physical body; rather, sensa-tions occur at the object toward which our attention is directed. According to Marcus, sensations take place "in" the world rather than "in" us. Hausmann saw in this theory the basis for claiming that a new relation between hapticity and opticality was possible—indeed, the distinction between the two would be eliminated by an emerging understanding of tactility, an understanding that would produce a "somatic extension all the way to the stars."[69] That exten-sion would demand a redefinition of bodily presence.

Writing in late 1960s, Hausmann extended this idea of radiating sensory rays into a full-blown effort at rescuing Gnosticism. An unpublished television script titled "À la recherche de Jean Arp à la téléconcretisation" (A Teleconcretized Search for Jean Arp) presents an imaginary interview of the renowned Dada artist Hans (Jean) Arp and a jovial French television host (Hausmann was living at the time in Limoges).[70] This script imagines Arp presenting his views on the nature of art and creativity. Arp believed that the distinction be-tween natural and artificial objects was the product of a philosophical tradi-tion that separates the material body from the "sparks of the spirit," with the result that the material body is understood to be essentially passive, to be a "soma in coma" without "étincelles" (flickering). The idea that the soul is a spark is, of course, Gnostic, and the phrase "soma in coma" is a play on the Gnostic (and Pythagorean) "soma/cema" doctrine (the doctrine that the body ["soma"] is a tomb ["cema"] for the soul). But, as television shows, the sparks (*étin-celles*) belonging to the realm of electrical reality fuse body and soul—as there the material body (the image on the screen) cannot be separated from the flickering sparks of electricity or, ultimately, from light itself (for Gnostics the source of being). Like New Media theorists since, Hausmann foresaw the era when the body would ephemeralize into electricity and in so doing return the soul to its source, in light.

Hausmann, like all Gnostics, invested great intellectual and emotional capital in the idea of light. He criticized Marcus for asserting that an optical image is nothing other than *Schein* (appearance, light). He had to, because in asserting that the image is simply appearance (light), one implicitly accepts the

distinction between appearance and reality. Hausmann could not afford that distinction because his new theory of bodily presence maintained that in the realm of electricity—of energy, the ultimate reality—there is no distinction between image and material body: all bodies are penetrated by light, indeed entirely suffused with light. All bodies are, essentially, light. That is how touch can expand outward to infinite distances from the body. Indeed, Hausmann seems to have accepted the ideas of Johannes Müller (discussed earlier). One can imagine how Hausmann would have interpreted Müller's idea that the reports of the various sensory modalities are all reactions to stimulation of our nerves by energy: light is a form of energy, and energy operates to produce sensation by essentially haptic means. Vision is touch at distance—and virtual images and objects produce similar disturbances of the retina. Hausmann's theory of PREsentismus thus crosses Müller's findings in neurobiology with Gnostic ideas about light/energy.

In his "PREsentismus" manifesto, Hausmann had claimed that the new media would be able to serve up the actual object in its bodily existence. This idea was to occupy Hausmann for most of his remaining years, and in later writings he extended his claims about concreteness and presence. He argued that the beam that transports the televisual image brings about *téléconcretisations* through which a unique original is multiplied; in this way, it allows the original to reach out and touch other spaces and other times.[71] This odd spatio-temporal existence establishes the peculiar ontological status of the televisual image. The multiplication of being through *téléconcretisations* can restore lost time and even return being to the dead; the multiplication of being thus offers the gift of time.

What guaranteed the reality of these televisual images, in Hausmann's view, is that they are available to the sense of touch as well as to sight. In a much earlier (but also unpublished) piece, "Universale Organfunktionalität" (1923), Hausmann presented the fantasy of a technology to come that literally would allow its users to "reach out and touch someone": electrical voices, emanating from a device implanted in one body, would reach out and touch a hearing device, a sort of electric ear, implanted in another body, rather as, in "PREsentismus," he imagined "haptical and telehaptical transmitters."[72] Another fantasy he offered supposed the future transformation of the body by electrical technology (a fantasy that, toward the end of the millennium, would come to haunt the dream life of people in the "advanced" states). An even more startling aspect of this fantasy was Hausmann's prescient redefinition of the presence, to depend on beings' status as the *termini ab quo* and *ad quem* of communication: whatever could be reached through electrical signals must exist. "If the call to a friend is not answered, one will know that he is dead," Hausmann wrote.[73] Thus, in "PREsentismus," Hausmann proposed to revise the concept of bodily presence so that it incorporated tele-presence. Hausmann anticipated McLuhan in understanding how such devices as the telephone,

the conveyor belt, and the airplane would change our conceptions of space, by eliminating spatial divides even while allowing new connections to be established across space. Televisual presence—"télé-presence," in Hausmann's coinage—would carry this transformation to a radical extreme, to the point that all objects and all beings would be immediately present to one another. This was the farthest he took Marcus's theories.

Friedlander's and Marcus's writings were not the only ideas that propelled Hausmann toward his extravagant conception of sensation. Clearly, that conception was linked to the character of the Optophone, and there is no doubt but that device's origins and history swayed his thinking. For Hausmann was not the first to invent an instrument called the Optophone. Others had conceived of the tool, in response to the discovery, in 1818, of the element selenium by the Swedish chemist Jons Jakob Berzelius (1779–1848). Interest in that element over the following years resulted in another key discovery—that selenium is photosensitive. Specifically, it reacts to light in such a way as to vary its conductivity. This discovery generated a great deal of interest, for it seemed to confirm the belief that reality is essentially energy: put another way, that matter responds to energy and (thus many thinkers concluded) that such response by the human body is what sensation essentially is. Sensation is the workings of energy in the human body. The link between sensation and energy attracted speculative thinkers and inventors alike. Thus in 1880 the Scottish-Canadian inventor Alexander Graham Bell created the Photophone, which conveyed speech along a beam of light to a selenium receiver. Later that same year, Perry and Ayrton proposed the idea of "electric vision."

Another person intrigued by selenium was Dr. E.E. Fournier d'Albe, who in 1910 was appointed Assistant Lecturer in Physics at the University of Birmingham. There he set up a laboratory to look into the properties of selenium. It was he who in 1912 coined the word "Optophone." His contraption converted light into sound using a selenium detector; the pitch of sound it generated varied with the intensity of the light falling on the detector. His first application of the Optophone was as a mobility aid for blind people. This application may have contributed to Hausmann's interest in sensation through "eccentric" rays—that is, in expanding proprioceptive space. To be sure, Hausmann's writings do not mention Fournier d'Albe's device, and the idea of electricity as a correlative—even an extension—of sensation was relatively commonplace in this era: there were a few earlier devices, none very well known now, such as the Elektroftalm and the Photophonic Book, that also were supposed to provide prosthetic sensations for people needing them. The Elektroftalm, first created in 1897 by Noiszewski, used a single selenium cell, worn on the forehead, to control the intensity of a sound output; thus it could serve as an electrical sensing device to help blind people move through space (by distinguishing between light and dark areas). The Photophonic Book, which was created

in 1902 by V. de Turine, was designed to help the blind read. The books were specially prepared using a series of transparent squares to represent letters of the alphabet; when the book was passed under a light, the light that passed through the transparent squares fell on a selenium cell, which then varied the electric current that was passed to a speaker.

Fournier d'Albe's first Optophone was similar to the Elektroftalm in that it used selenium cells to distinguish light from dark areas. Though this instrument received a lot of good press, it was criticized by Sir Washington Ranger, a blind solicitor, who said that "the blinds' problem is not to find lights or windows, but how to earn your living." This criticism prompted Fournier d'Albe to stop working on aids designed to help mobilize the blind; instead, in 1913, he developed the Reading Optophone. This device used a vertical row of five spots of light; when the user scanned these lights across the page, the reflection varied according to the intensity of the character: a dark character reflected less light than a bright character. A row of selenium cells detected the reflected light, and the resulting signal was used to modulate the sound output. Each speck of light thus contributed a different component to the resultant musical sound—different configurations produced different tones. Scanning the text resulted in a musical "motif"—a musical phrase far more pleasing to the ear than a progression of unfamiliar sounds. Work continued on the development of the Reading Optophone, and improvements continued to be made. By 1920 there were public displays in which Miss Mary Jameson used the instrument to read at a speed of sixty words a minute (though by most users the rates attained were considerably slower). The Optophone seemed on the verge of success: it was being manufactured in significant numbers and had enjoyed much publicity, even appearing on the cover of *Scientific American* in 1920. Around this time, Francis Picabia produced two canvases, *Optophone I* (ca. 1922) and *Optophone II* (ca. 1921/2, reworked ca. 1924/6). By 1924, however, the Optophone had all but disappeared—the device was just too difficult to operate. The idea of a device that would enable the blind to read by converting visual differences into aural differences would re-emerge in the form of optical character recognition devices coupled with phoneme synthesizers.

Hausmann's was an astonishingly utopian conception of the Optophone. For him, the device amounted to scientific confirmation of the unity of sensory experience: all experience is the result of vibration, and vibrations are what reality is made of—thus, the Optophone extended the domain of hapticity, the primeval sense, to effect immediate contact with the further ranges of vibratory space. In the first issue of *Gegner* (Combatant), founded in Berlin in 1930 by Franz Jung, Hausmann published an extended reflection on the Optophone, "Die überzüchteten Künste: Die neuen Elemente der Malerei und der Musik" (The Overdeveloped Arts: The New Elements of Painting and Music). In the article, Hausmann declared:

It is possible for this keyboard to exploit structurally the tension checks between the optical and acoustic values in such a way that, given the choice of keys for the gelatin plates, one can play on it optical-phonetic compositions of an absolutely new key, regarding which the Patent Office declared "no sort of pleasant effect, in the usual sense, could come out of that."

Dear musicians, dear painters, you will see with your ears and you will hear with your eyes and you will run mad! The electric Spektrophone obliterates your notions of sound, color, and shape; of all your arts there remains nothing, alas, nothing at all.[74]

Interest in light shows and Colour Organs reawakened in postwar America. Mary Hallock Greenewalt (1871–1950) in Philadelphia during the 1940s, and Charles Dockum (1904–1977) in California and New York in the 1950s, continued work on Colour Organs. Hallock Greenewalt's performances were of silent colour-music. She was born in Beirut, (now) Lebanon, and studied piano at the Philadelphia Conservatory and with the Viennese virtuoso Theodore Leschetizky (1830–1915). During her concert career, she performed with the Pittsburgh and Philadelphia symphony orchestras. In March 1920, Columbia Records released a disc of her Chopin: the Preludes in E minor, C minor, and A major as well as the Nocturne in G major.[75] She developed a desire to control the ambience in which delicate music such as Chopin's was performed; this led her to experiment with light modulation. She contrived ways to fade light up and down smoothly, using a rheostat and a liquid-mercury switch (both of which she helped develop).[76] This led her in turn to the Colour Organ, which she called the Sarabet (after her mother, Sara Tabet). She became an electrical engineer in order to realize her conception; eventually, she would register eleven patents for devices that would enable her to create light-music. Of these patents, one was for a non-linear rheostat (USA Patent no. 1,357,773)—a patent that would be infringed by General Electric and other companies.[77]

Hallock Greenewalt named the art she pursued, the art of light-music, "Nourathar."[78] She derived that name from the Arabic words for light (*nour*), and essence (*athar*). Unlike many other composers and inventors of colour-music, she did not draw up a table of correspondences between specific colours and degrees of the scale or specific chords. She argued that these relations were not fixed, but varied according to the performer's temperament and mood:

Light, in its very nature, is an atmosphere, a suffusion, an enveloping medium. To give it the sharpness of short succession, as with the notes of an instrument, is inconceivable. To give it a formful image on the flat, turns it into a kaleidoscope—certainly not a new thing. To play with intensities of light and tint without forcing them out of the groove to which they cling, that will be a new joy for the artist as it once was the Creator's.[79]

Her first efforts at realizing colour-music involved constructing an automated machine that would synchronize changes in coloured lights to the music played on a gramophone. She found the results unsatisfactory, and this disappointment led her to develop the Sarabet.

She continued to perform on the Sarabet, for which she created a special notation for indicating which colours should be displayed, and when, and at what intensity. Her elaborate instrument was operated from a small, table-like console. A sliding rheostat controlled the reflections of seven coloured lights onto a monochromatic background. Her light-concerts emphasized variations in luminosity, which she believed paralleled nuances in musical expression. She treated different chroma as secondary to the intensity of the colours. She also patented a new notational system for works composed for the Sarabet.[80]

She also produced the earliest hand-painted films known still to exist.[81] In a letter to the Historical Society of Pennsylvania, she claimed to have produced the first painted film rolls in 1909–12. (In documents relating to a patent infringement suit, she claimed she had produced them before 1916.) Michael Betancourt, after exemplary research, found no evidence in the Historical Society of Pennsylvania to support her claim for that early a date; he did, though, find patent evidence to support her claim that she had produced hand-painted film rolls before 1925. It is not unlikely that these films were meant to be projected, though it is not clear whether they were to be viewed on a sort of nickelodeon device, or whether they were simply a score for the performer.

These films were not meant to be autonomous works, complete in themselves; rather, they were to be used in the earliest device she constructed to produce light-music—that is, the device for producing light-play accompaniments to recorded sounds. Nonetheless, though not intended to be motion pictures, the means she devised to create her light-plays were ingenious: she used masks, templates, filters, and aerosol sprays, as Len Lye would do in the 1930s. Betancourt has proved that these "films" were not shown to the audience.[82] These "pieces" exist on film rolls, about six inches high and ten inches wide, with lines along the edges. Templates were used to create both biomorphic and geometric shapes, which, when back-lit over a light table, appeared in intensely saturated colours. As Betancourt points out, these film rolls resembled more closely the scroll paintings produced by Eggeling and Richter. They would not have been visible to anyone but the performer—and even the performer would only have seen them as narrow strips passing over an illuminating bar. Their roll film function was to mark time and to indicate something about the mood of the piece. The film was marked along the edge in increments corresponding to 4/4 time in music: every fourth mark was larger than the previous three. The larger marks would have indicated the accented beats, the

smaller ones the unaccented beats. Thus, Betancourt states, these "films" were really scores, not motion pictures.

The central importance of Hallock Greenewalt, however, concerns this: Most early advocates of colour-music believed that music is the "ottima arte," and they aspired to imitate music's greatness. Accordingly, they strived to integrate visual art into a musical structure, which meant, essentially, having the colour-play subservient to the musical development. Hallock Greenewalt, to the contrary, considered that light-play might be the "top art." Her reasons for asserting this involved the familiar Symbolist belief in reality's fundamentally vibratory character as well as the belief that colour vibrations are more subtle and refined than light vibrations: "Did I not unconsciously want and need the rays of light because they went vibrations of sound one better for completing, for pushing still further inwards the messages that sounds portrayed and conveyed? Such a one could well be a next in the order of fine art progress, with all fine art considered as a whole. Musical sounds antedating this, the more recent conception, are rougher in their vibratory effect. Light is still finer. It is still deeper in its infiltration, within the body's tissues."[83]

Both Fischinger and Dockum received fellowships from the Guggenheim Foundation through the Baroness Hilla Rebay, curator of the Guggenheim Museum of Non-Objective Painting, to work on colour-music projects. However, as university deans have been known to do, Rebay stipulated that each grant recipient must spy on the other to make sure that he was working on the project for which he had been funded. Fischinger used his money to produce his films *Radio Dynamics* and *Motion Painting*, while Dockum used his to build a larger and more complex projector that would allow multilayered motion in several directions.

Dockum's MobilColor Projector IV, his version of the Colour Organ (which he perfected in 1950), was to be installed in the Guggenheim Museum. His colour projection apparatus was capable of producing either soft- or hard-edged imagery as well as layered movements of diverse overlapping imagery. It also used prepared image sources that could be modulated in colour and that could be moved. Rebay had wanted a projector for the Guggenheim Museum, since the rival Museum of Modern Art had a Thomas Wilfred Lumia box on display. However, she was shocked to learn that Dockum's device did not operate automatically and that (unlike Wilfred's Lumia) it required one or two people to play it. Dockum himself gave several performances in 1952 (one of which was filmed by Ted Nemeth and Mary Ellen Bute), but only after he returned to California (and his stipend was discontinued). Rebay consigned the projector to storage; then, a few years later, she had it dismantled (the light units were used for track lighting in the galleries; the rest of the mechanism was trashed). Ten years' worth of compositions for a machine that Dockum had

produced were also trashed.[84] Back at his old studio in Altadena, Dockum spent the rest of his life (into the mid-1970s) constructing MobilColor v and composing about fifteen minutes of material that can still be performed on it. He had finished the new machine by the early 1960s, and he would perform on it at various venues in California. He also filmed one sample of three compositions to show Frank Popper when he visited France in the mid-1960s. He began working on a MobilColor vi, which would have incorporated computerized mechanisms that would have enabled it to play continuously without human operators, but it remained unfinished when he died in 1977 and could not be completed by others (the computer elements were obsolete by then, as the computer industry evolved rapidly in the late 1970s and early 1980s).

Dockum's existing compositions present three types of visual forms—geometric forms, vibrating dot patterns, and soft, sensuous trails, with an exquisite intensity of light and a vivacity of glowing colour. The imagery appears silently out of complete darkness, and the saturation of vivid colour forms creates an impressive, living presence.

Several early pioneering filmmakers, including Mary Ellen Bute (1908–1983), took an interest in the Colour Organ. Bute had studied painting in Texas and Philadelphia but felt frustrated by the medium's inability to wield light into a flowing time-continuum. So she became a student of art direction for the theatre (1925–29)—first at the Inter-Theatre Art School in New York, where she served as student art director for a spring dance performance, designing the lighting and visuals; then at Yale University's drama department, where she studied stage lighting under Stanley McCandless; then as a technical director at the theatre aboard the Floating University (a cruise ship that offered courses); and finally exploring modern equipment for the control of light in Germany and Austria. The purpose of all these studies was to gain the technical expertise to create a Colour Organ that would allow her to paint with living light. She also haunted the studios: first (in 1929) that of Wilfred, whose Clavilux projected sensuous, soft, swirling colours; and then that of the electronic genius Leo Theremin. In the early 1930s she applied to the Guggenheim Foundation for support for her work with Theremin. In the application, she stated: "Composing symphonies in light (mobile color) is my primary interest and devotion."[85] Together, in 1932, Bute and Theremin presented a paper, "The Perimeters of Light and Sound and their Possible Synchronization," to the New York Musicological Society. Her prolonged studies, along with her early studies in art history at the Sorbonne, had convinced her "that a kinetic art form of color is to be the contribution of our age to the history of art."[86] That statement encapsulates a key belief in the arts of the twenty-first century—that the coming decades would see the dematerialization of art into the dynamics of light (a notion that makes clear just how important a role the cinema played both in shaping the aesthetic ideals of the century and, reciprocally, in responding

to those ideals). Bute had devoted her career to finding ways to shape light and colour into dynamic patterns with the order of music, and she would continue on that course. Her films include *Synchromy* (1933, unfinished, with Joseph Schillinger and Lewis Jacobs); *Rhythm in Light* (1934, with M. Webber and Ted Nemeth), 5 minutes; *Synchromy No. 2* (1935), 5 minutes; *Dada* (1936), 3 minutes; *Parabola* (1937, with Nemeth), 8.5 minutes; *Ecape—Toccata and Fugue* (1937, with Nemeth), 4 minutes; *Spook Sport* (1939, with N. McLaren), 8 minutes; *Tarantella* (1940, with Nemeth), 4 minutes; *Polka Graph* (1947), 4 minutes; *Color Rhapsodie* (1948), 6 minutes; *Imagination* (1948), 2 minutes: *New Sensations in Sound* (1948), 3 minutes; *Pastorale* (1950), 6 minutes; *Abstronic* (1952), 5.5 minutes; *Mood Contrasts* (1953), 6.5 minutes; and *Passages from Finnegans Wake* (1965), 97 minutes.

Oskar Fischinger also created his own Colour Organs, after his health was severely damaged from painting with oils under hot lights (while making *Motion Painting No. 1*). His *Lumigraph* of 1953 was presented at the groundbreaking show *Art in Cinema* at the San Francisco Museum of Modern Art. His Lumigraph consisted of a taut cloth sheet that could be pressed into from behind, with hands or other prods, to intersect thin sheets of light controlled by foot pedals. Like Wilfred with his Home Clavilux, Fischinger hoped that his device would achieve widespread success, and he took the trouble to patent his invention.

In California, the art of light became something of a movement—albeit a small one, and known primarily to initiates. The best-known California practitioner of the art of light was Jordan Belson, who created Buddhist-inspired "psychedelic" light-shows for his Vortex concerts in San Francisco in the 1950s and 1960s. His work helped popularize the light show among creators of rock concerts and has become a staple of that form since the mid-1960s.

MORE ON VIBRATORY MODERNISM
THE ESOTERIC BACKGROUND TO THE ABSOLUTE FILM

An unrealized proposal from the second decade of the twentieth century provides evidence that film played a central role at the time in forming artists' aesthetic ideas. In a letter to his music publisher, Arnold Schönberg outlined his ideas about filming his second opera, *Die Glückliche Hand* (The Lucky Hand):

> What I think about the sets is this: the basic unreality of the events, which is inherent in the words, is something that they should be able to bring out even better in the filming (nasty idea that it is!) For me this is one of the main reasons for considering it ... And there are a thousand things ... that can be easily done in this medium, whereas the stage's resources are very limited.

MODERNISM AND THE ABSOLUTE FILM

My foremost wish is therefore for something the opposite of what the cinema generally aspires to: I want

The utmost unreality!

The whole thing should have the effect (not of a dream) but of chords. Of music. It must never suggest symbols, or meaning, or thoughts, but simply the play of colours and forms. Just as music never drags a meaning around with it, at least not in the form in which it (music) manifests itself, even though meaning is inherent in its nature, so too this should simply be like sounds for the eye, and so far as I am concerned everyone is free to think or feel something similar to what he thinks or feels while hearing music ...

A painter (say: I, Kokoschka, or II, Kandinsky, or III, Roller) will design all the main scenes. Then the sets will be made according to these designs, and the play rehearsed. Then, when the scenes are all rehearsed to the exact tempo of the music, the whole thing will be filmed, after which the film shall be coloured by the painter (or possibly only under his supervision) according to my stage-directions. I think however that mere colouring [will] not suffice for the "Colour Scene" and other passages where strong colour effects are required. In such passages there would have to be coloured reflectors casting light on the scene.[87]

Two properties of the film interested Schönberg: its insubstantial ephemerality—its being nothing more (or less) than coloured light—and its dynamism. These two properties allow film to escape from everything fixed, stable, and enduring, and thus avoid representation (and meaning) altogether. Accordingly, film could be a spiritual counterpart to music as well as to modern, non-objective painting. Film could serve as the new *Universalpoesie*, for its forms could serve as hieroglyphs of the unknown, to elevate the mind and disclose something of the nature of the higher reality (though holding it forever in the embrace of greater mystery). Sight (relating to *visio*), sound (relating to *verbum*) and colour (relating to their synthesis) would thereby be reconciled.

One of the painters whom Schönberg had in mind as a collaborator for this project also extolled the advantages of a seemingly non-material material. In *Über das Geistige in der Kunst* (On the Spiritual in Art) Kandinsky contended: "An artist who sees that the imitation of natural appearances, however artistic, is not for him—the kind of creative artist who wants to, and has to, express his own inner world—sees with envy how naturally and easily such goals can be attained in music, the least material of the arts today. Understandably, he may turn toward it and try to find the same means in his own art. Hence the current search for rhythm in painting, for mathematical, abstract construction, the value placed today upon the repetition of color-tones, the way colors are set in motion, etc."[88]

Rhythm, abstract mathematical construction, colour repetition, and setting colour in motion: these would be the focus of the makers of Absolute Film. The film medium—a fleeting, ephemeral, insubstantial medium, its stuff

just coloured light, hardly more substantial than coloured shadows—became, indeed, a model of the spiritual in art.

So Kandinsky proposed a spiritual theatre of light: in 1908 or 1909 he conceived of a stage piece, *Der Gelbe Klang* (The Yellow Sound), which, according to Gabriele Munter, he also intended to film. Kandinsky referred to the work he wanted to create as a "Bühnenkomposition," that is, a *composition* for stage. Inspired partly by Scriabin's *Prométhée*, the work was to be a synthesis of components of different sorts: "musical sound and its movement; bodily spiritual sound and its movement, expressed by people and objects; color-tones and their movement."[89]

The argument that Kandinsky used to justify his synthetic approach is fascinating for many reasons, not the least for its deeply Theosophical basis. He starts by acknowledging that every art has its own means, that every art is something self-contained, a realm of its own. Every art possesses distinctive means: sound, colour, or words. He then takes a turn: he declares that the final goal of art making is to extinguish the differences between the means of the different arts, in order to reveal that there is an inner identity among the arts:

> This final goal (knowledge) is attained by the human soul through finer vibrations of the same. These finer vibrations, however, which are identical in their final goal, have in themselves different inner motions and are thereby distinguished from one another.
>
> This indefinable and yet definite activity of the soul (vibration) is the aim of the individual artistic means.
>
> A certain complex of vibrations—the goal of a work of art.
>
> The progressive refinement of the soul by means of the accumulation of different complexes—the aim of art.[90]

All art aspires to produce a complex of vibrations in the soul, a complex of vibrations that produces knowledge. Artists sense the effects that a complex of vibrations has on their souls, and find a means by which the spectators, listeners, or readers, by attending to that means, can experience almost the same complex of vibrations in their souls. About the vibration in the receiving souls, Kandinsky notes:

> First, it can be powerful or weak, depending upon the degree of development of him who receives it, and also upon temporal influences (degree of absorption of the soul). Second, this vibration of the receiving soul will cause other strings within the soul to vibrate in sympathy. This is a way of exciting the "fantasy" of the receiving subject, which "continues to exert its creative activity" upon the work of art. Strings of the soul that are made to vibrate frequently will, on almost every occasion other strings are touched, also vibrate in sympathy. And sometimes so strongly that they drown the original sound: there are people who are

made to cry when they hear "cheerful" music, and vice versa. For this reason, the individual effects of a work of art become more or less strongly colored in the case of different receiving subjects.

Yet in this case the original sound is not destroyed, but continues to live and work, even if imperceptibly, upon the soul.[91]

Kandinsky realizes that the idea that art creates its effects through inducing vibration has another implication: the effects of one art, engendering a particular vibration, can be duplicated using the means of another art (and many artists, he realized, want to do exactly that); and that establishes the possibility for a cooperation among the arts that would avoid redundancy by creating contrasts rather than duplications among effects.

> The internal, ultimately discoverable identity of the individual means of different arts has been the basis upon which the attempt has been made to support and to strengthen a particular sound of one art by the identical sound belonging to another art, thereby attaining a particularly powerful effect. This is one means of producing [such] an effect.
>
> Duplicating the resources of one art (e.g., music), however, by the identical resources of another art (e.g., painting) is only one instance, one possibility. If this possibility is used as an internal means also (e.g., in the case of Skriabin), we find within the realm of contrast, of complex composition, first the antithesis of this duplication and later a series of possibilities that lie between collaboration and opposition. This material is inexhaustible.[92]

Kandinsky then goes on to discuss the nature of the unity into which these different affective means (*Wirkungsmittels*) are combined. He does this partly by commenting on Richard Wagner's use of leitmotifs (phrases the composer generally associates with particular characters in his dramas to tell us something of the character's emotional make-up).

> Of a similar nature is the other kind of combination of music with movement (in the broad sense of the word), i.e., the musical "characterization" of the individual roles. This obstinate recurrence of a [particular] musical phrase at the appearance of a hero finally loses its power and gives rise to an effect upon the ear like that which an old, well-known label on a bottle produces upon the eye. One's feelings finally revolt against this kind of consistent, programmatic use of one and the same form.[93]

The problem with Wagner's approach to combining sound and drama, Kandinsky states, is that the relation between one modality and the other (between music and character) is essentially external (like the relation a label has to the contents of the container to which it is affixed): there is no essential similarity between the inward nature of elements belonging to the different modalities, nothing that unifies elements (e.g., music and movement) in the

ensemble so that we might consider the complex to be a monistic whole. The relation is created only through conditioning (i.e., through repeated association). Kandinsky here connects the externality of the relations between the different modalities to the materialism of the society in which he lives. He is arguing that if artists were to apprehend the spiritual truth contained in the inner natures, they would create relations in which there was true integration of these diverse elements:

> All of the above-mentioned forms, which I call substantive forms [*Substanzformen*] (drama—words; opera—sounds; ballet—movement), and likewise the combinations of the individual means, which I call affective means [*Wirkungsmittel*], are composed into an external unity. Because all these forms arose out of the principle of external necessity.
>
> Out of this springs as a logical result the limitation, the one-sidedness (= impoverishment) of forms and means. They gradually become orthodox, and every minute change appears revolutionary.

<p align="center">* *</p>

<p align="center">*</p>

> Viewing the question from the standpoint of the internal, the whole matter becomes fundamentally different.
>
> 1. Suddenly, the external appearance of each element vanishes. And its inner value takes on its full sound.
> 2. It becomes clear that, if one is using the inner sound, the external action can be not only incidental, but also, because it obscures our view, dangerous.
> 3. The worth of the external unity appears in its correct light, i.e., as unnecessarily limiting, weakening the inner effect.
> 4. There arises of its own accord one's feeling for the necessity of the inner unity, which is supported and even constituted by the external lack of unity.
> 5. The possibility is revealed for each of the elements to retain its own external life, which externally contradicts the external life of another element.[94]

Kandinsky goes on to list the possible means of overcoming each of the deficiencies he has enumerated. All of his remedies depend on the creator's grasping the spiritual (vibratory) potentials within the various *Wirkungsmittel:*

> Further, if we go beyond these abstract discoveries to practical creation, we see that it is possible
> re (1) to take only the inner sound of an element as one's means;
> re (2) to eliminate the external procedure (= the action);
> re (3) by means of which the external connection between the parts collapses of its own accord;
> likewise,
> re (4) the external unity, and

re (5) the inner unity place in our hands an innumerable series of means, which could not previously have existed.

Here, the only source thus becomes that of internal necessity.[95]

ABSTRACT FILM AND ITS EARLIER OCCULT PREDECESSORS

We noted earlier that Castel's *clavecin oculaire* (described ca. 1740) was a precursor to the Absolute Film; now we must consider its occult sources. The idea of the Colour Organ issued from a climate of esoteric speculation that linked Pythagorism with Hermeticism and that manifested itself in Illuminism, as one version of eighteenth-century Gnosticism called itself. We easily forget what Isaiah Berlin once pointed out—that the Enlightenment had an underside, that in the shadow cast by reason's glare, figures such as the Count de Saint-Germain (1701–1784) and Joseph Balsamo (a.k.a. Cagliostro, 1743–1795, the founder of the Egyptian Rite within the Masonic movement) flourished, and that there was a great taste for apparitions and manifestations of every occult variety. This occult speculation produced many Neopythagorean writings—for example, Sylvain Maréchal's *Les Voyages de Pythagore en Egypte* (1799), which expounded the proposition (likely true) that Pythagoras based his teachings on secret Egyptian doctrines (on doctrines to which groups of more recent times such as the Order of the Golden Dawn and Ordo Templi Orientis have also claimed to be privy).

The enthusiasm for synaesthetic experience and for the mystical effects of colour as manifested in the Colour Organ met with another interest: in apparitions and manifestations. Athanasius Kircher was interested in the Colour Organ for spiritual reasons: he believed that the whole universe could be allegorically understood as a great organ on which the Creator played. But Spiritualist interests are also evident in Kircher's writings, especially in his studies of electricity and magnetism. He wrote the most comprehensive work on magnetism of the seventeenth century, *Magnes sive de arte magnetica opus tripartium* (Magnets or the Art of Magnetism: a Work in Three Parts; 1643), the third book of which depicts magnetism as an elemental force of nature.[96] (Mme Blavatsky would later quote extensively from this book.) Kircher's work presents magnetism as one of nature's elemental forces, indeed, as the force that holds the world together. He insisted that an inner bond of unity (*nexum unionemque*) holds together all the things in the universe; that through that bond they become radiant; and their cooperation and mutual attraction can be explained only as a species of magnetic power. Kircher linked this interpretation of the universe's essential cohesion to more ancient teachings about the mysterious fundamental force in nature, exemplified by Plato's "unspeakable power" (*arrhetos dynamis*). Soul, spirit, and physical phenomena all belong in magneticism's sphere, Kircher maintained.

His work laid the foundations for a virtual "theosophic theology of electricity magnetism." A century later, during the Enlightenment, that theology would come to fruition in the work of Friedrich Christoph Oetinger (1702–1782), a leading Swabian pietist, whose work embraced the Theosophy of Jacob Boehme, the Kabbalah, and the visionary revelations of Emanuel Swedenborg. It would also contribute immensely to a theology of electricity in mid-eighteenth century Germany, among Protestant pietist theologians and scientists. This theology of electricity was cast as an esoteric doctrine, one that drew on ideas from cosmology, anthropology, and scriptural exegesis. Besides Oetinger, its leading figures were Johann Ludwig Fricker (1729–1766); Benjamin Franklin, the American Enlightenment Freemason; Prokop Divisch (1696–1765), who knew of lightning before Franklin's writings were published in French (*v.* his *Theoretischer Tractät oder die längst verlangte Theorie von der meteorologische Electricität* [Theoretical Treatise or the Long Required Theory of Meteorological Electricity]); and the renowned Swabian doctor Franz Anton Mesmer (1734–1815), whose findings so intrigued the poet Shelley.[97]

We do well to remember that the earliest producers of two-dimensional moving images were magicians and that their uncanny practices shaped the development of the moving picture. Indeed, the first two-dimensional projected illusions were visions summoned up by sorcerer-priests and were aimed at presenting phenomena beyond the grasp of the human mind. Such conjuring displays predate the Middle Ages. In *Movement in Two Dimensions*, Olive Cook points out,

> Iamblichus informs us that it was the priests, who were also magicians, who were responsible for these appearances, and that they were always accompanied by smoke and vapours; he describes one occasion in particular when a conjuror named Maximus produced a monstrous figure of Hecate who made an overwhelming impression on an audience already trembling with fear by laughing aloud with heaving shoulders and diabolical grimaces.[98]

These proto-cinematic illusions were likely created using mirrors.

In the Middle Ages, wandering entertainers known as tregetours produced spectacles by manipulating mirrors; Chaucer described their tricks in "The Frankeleyn's Tale." Among them were the appearance, in the interior of a hall, of water and a barge, a lion, flowers, a vine, and a castle of lime and stone—all of which vanished as mysteriously as they had appeared:

> For ofte at festes have I wel herd seye,
> That tregetours, withinne an halle large,
> Have maad come in a water and a barge,
> And in the halle rowen up and doun.
> Sometyme hath semed come a grim leoun;

MODERNISM AND THE ABSOLUTE FILM

> And somtyme floures springe as in a mede;
> Somtyme a vyne, and grapes whyte and rede;
> Somtyme a castle, al of lyme and stoon;
> And whan hem lyked, voyded it anoon.
> Thus semed it to every mannes sighte.[99]

He also tells us how there appeared wild deer. Some were seen being slain by arrows and some being killed by hounds. Falconers were seen on the bank of a river, where birds pursued herons and slew them. Knights jousted on a plain. The amazed spectator saw himself dancing with his lady:

> Doun of his hors Aurelius lighte anon, And forth with this magicien is he gon Hoom to his hous, and made hem wel at ese. Hem lakked no vitaille that mighte hem plese; So wel arrayed hous as ther was oon Aurelius in his lyf saugh never noon. He shewed him, er he wente to sopeer, Forestes, parkes ful of wilde deer; Ther saugh he hertes with hir hornes hye, The gretteste that ever were seyn with yë. He saugh of hem an hondred slayn with houndes. And somme with arwes blede of bittre woundes. He saugh, whan voided were thise wilde deer, Thise fauconers upon a fair river, That with hir haukes han the heron slayn. Tho saugh he knightes justing in a playn; And after this, he dide him swich plesaunce, That he him shewed his lady on a daunce, On which him-self he daunced, as him thoughte. And whan this maister, that this magik wroughte, Saugh it was tyme, he clapped his handes two, And farewel! al our revel was ago. And yet remoeved they never out of the hous, Whyl they saugh al this sighte merveillous.[100]

Benvenuto Cellini recounted in his memoirs an encounter with a Sicilian priest, "a man of very elevated genius and well instructed in both Latin and Greek letters," who presented, in the dead of night, in the Coliseum, a spectacle of apparitions.[101] The priest held a pentacle, there were many noxious vapours and so on, and spirits appeared one by one over the entire edifice.

Renaissance artists sometimes created and directed public spectacles: fantastic triumphal parades that often required the construction of elaborate temporary architecture; and allegorical events utilizing multimedia illusions that bordered on total realism. (Earlier, Dante, whose *Commedia* includes everything, alluded to these spectacles in the "Il Paradiso terrestre" canti of *Purgatorio*.) In 1589, Polidoro da Caravaggio staged a mock naval battle in the specially flooded courtyard of the Pitti Palace in Florence; Leonardo da Vinci dressed his performers as planets and had them recite verses about the Golden Age in a pageant titled *Paradiso* (1490; doubtless alluding to Dante's *Paradiso*). The great Baroque sculptor Bernini (1598–1680) was among those most committed to exploring total realism: He staged spectacles for which he wrote scripts, designed scenes and costumes, and built architectural elements. He created a theatre piece in which a curtain fell to reveal an onstage audience

watching another audience watch the stage. In another presentation, he had the scenery catch fire to reveal a garden. In his most ambitious spectacle, *L'Inondazione* (The Inundation of the Tiber, 1638), water burst through a dike, rushed toward the panicking audience, then drained away at the last moment. Bernini understood these spectacles as attempts to provoke a sense of the real; for, in sculpture, he explained, deformations of natural dimensions (e.g., the size of a person's hand) are sometimes required to create the sense of reality. For Bernini, art was a form of trickery.

Athanasius Kircher's important work on the relation between light and music has already been noted. His findings in this field were influenced mainly by the European tradition, but they also came from farther afield. When Jesuit missionaries returned from India, the Far East, and America with their traveller's tales, Kircher, himself a Jesuit priest, was open to accommodating the beliefs and spiritual practices of those lands to the same theory of a *prisca theologia* ("theology of the ancients," the long tradition of religio-philosophical writings that supposedly anticipate Christian theology). He was an enthusiast for all things Egyptian, and for Egyptian hieroglyphs in particular (an interest that began when, as a young man, he first saw some Egyptian writing). Testifying to that enthusiasm is the fact that he produced the *Oedipus Aegyptiacus,* a work of comparative religion before that field had become an established scholarly discipline. At the request of Nicolaus Claude Fabri de Peiresc, the Senator of Provence and a wealthy patron of scholarship (who had heard of Kircher's linguistic skills and of his interest in the Egyptian hieroglyphs), Kircher tried to decipher some Egyptian manuscripts in Peiresc's possession. Peiresc provided him with books depicting Egyptian inscriptions as well as a copy of the Bembine Tablet of Isis.[102] Kircher believed that he had succeeded in deciphering Egyptian hieroglyphs—and though no one today takes his decipherments as adequate, he provided Jean-François Champollion with an important key: that Coptic, the language of Egyptian Christians, was descended directly from the language of the pharaohs. Kircher derived that insight partly from a Medieval Arabic manuscript he had acquired, which provided an introductory grammar to Coptic, to help with the decipherment of the large collection of Coptic manuscripts that the Vatican Library had assembled over the centuries. His first work in this field was *Prodomus Coptus sive Aegyptiacus ... in quo cum linguae, sive Aegyptiacae, quodam Pharaonicae, origo, aetas, vicissitudo, inclinatio, tam hieroglyphicae literaturae instauratio ... exhibentur* (The Coptic, or Egyptian, Forerunner in which Both the Origin, Age, Vicissitude, and Inflection of the Coptic or Egyptian, Once Pharaonic, Language, and the Restoration of Hieroglyphic Literature Through Specimens of Various Paths of Various Disciplines and Difficult Interpretations Are Exhibited According to a New and Unaccustomed Method, 1636). He went on to produce a Coptic–Arabic–Latin dictionary, *Lingua Aegyptiaca Restituta* (The Egyptian

Language Recovered; Rome, 1643), which Champollion kept beside him when he set to work deciphering the Rosetta Stone.[103]

The Jesuit Order's Collegio Romano had devoted much labour to the search for a universal language that it might use to communicate the Gospel to the world; and Egyptian hieroglyphs, with their easily recognizable images, seemed to offer a possible model for a universal script—if only someone could decipher them. Following Plotinus and Iamblichus, Renaissance magi (including Kircher) believed that Egyptian hieroglyphs were essentially images (though Champollion would in fact determine that hieroglyphs were used quasi-alphabetically), and that each image offered a sort of ideal form; thus their deployment might actually create and project meaning, and not simply refer to the extralinguistic world for their significance. (These beliefs helped produce the Renaissance emblem books.) The search for a universal language helped drive another project that Kircher engaged in at the same time he was trying to decipher the Egyptian writing system—that of creating an early symbolic logic, a calculus of thought employing a hieroglyphic notation. Kircher's idea was akin to Leibniz's idea of a *characteristica universalis*; also like Leibniz, he proposed a pasigraphic writing system that would furnish an "alphabet of human thought" (to use that Cartesian phrase).

Kircher's further researches into things Egyptian resulted in the aforementioned two-volume *Oedipus Aegyptiacus*, a remarkable work of early modern scholarship. The founding principle of the theological and philological inquiries the book presents is, "that which is more primal is closer to the truth." This conviction led Kircher to take an interest in the origins of language and religion—specifically, in a supposedly primordial tradition once common to all humankind. He argued, too, that in almost every religio-philosophical tradition an esoteric side coexists with an exoteric side, and that the former is invariably closer to the truth. His broad interests led him to devote fully half of *Oedipus Aegyptiacus* to an exposition of the theosophical systems of Zoroaster, Orpheus, Pythagoras, Plato, and Proclus, and to the Chaldaean and Hebrew Kabbalah. All these he traced from the Egyptian wisdom, which he believed had been handed down by hermetic writings.[104] Kircher's hermetic leanings undoubtedly helped shape his arguments about the origin of the various Middle Eastern belief systems.

Kircher's interests extended to cosmology. He composed *Iter extaticum coeleste* (The Ecstatic Heavenly Journey, 1660), which compares six different models of the solar system: the geocentric, heliocentric, and geo-heliocentric variations, including the model of Ptolemy, followed by five other schemes—the Platonic, Egyptian, Tychonic, Semi-Tychonic, and, finally, the Copernican. *Iter exstaticum coeleste* examined each of the different models of the world system, assessing the strengths and weakness of each. His approach presupposed

that, just as no single religious belief system has an exclusive hold on the truth, so no scientific model comprehensively contains the truth about reality to the exclusion of all other models. His investigations carried him so far that in 1669 he published *Ars Magna Sciendi sive Combinatoria* (The Great Art of Knowing or Combinations). The book was published in Amsterdam by a Protestant press as part of plan to bring out all forty-some volumes of Kircher's writings in lavishly illustrated form. The book's motto Kircher took from Plato: μηδὲν κάλλιον ἡ πάτα εἰδέναι (There is nothing more beautiful than knowing everything). Kircher might well have aspired to know everything: he commanded twenty-three languages; he was the first person to write on bioluminescence; even before there were microscopes powerful enough to show *Yersinia pestis*, he maintained that the plague was caused by a bacillus (and argued for the evacuation of Rome when the plague broke out there in 1656); he developed a theory that parts of the earth migrate (a sort of proto–plate techtonics) to explain the presence of fish fossils far from any body of water; and he wrote one of the earliest science fiction books, the aforementioned and scorchingly amusing *Iter Extaticum Coeleste* (1660), which features a sarcastic guardian angel, Cosmiel, who flies a terrified Theodidactus (Father Kircher) through the universe while offering sharp-tongued asides on Aristotle. (The book also suggests that the universe is infinite—a view the Inquisition might have declared heretical were it not offered in a fictional work.) And in 1660 he published a sequel with a character named Hydriel in it, a runny-nosed little imp who carries a water bucket and who, at one point, plunges Kircher into the belly of a whale.

People interested in proto-philosophical toys are often interested in the nature of consciousness. Kircher certainly was. His *Ars Magna sciendi* (The Great Art of Knowing, Amsterdam, 1669) identified twenty-seven symbols (categories) that Kircher believed could encompass all of human knowing: animal, vegetable, mineral, celestial, angelic, human, numerical, and so forth. He offered what amounted to a visual Esperanto, which his Jesuit colleagues used to convert the infidel to Christ. His symbol system eventually developed into symbolic logic. He and his colleagues also worked to develop a language of gestures that would obviate the need to translate when people from different linguistic groups met; people would then be able to converse without putting their thoughts in words. Deaf children in Jesuit schools were taught with this language; a direct descendant of it is American Sign Language.

The same people who take an interest in illusory images often are also involved in creating synaesthetic displays and automated music. So it was with Athanasius Kircher.[105] Kircher's encyclopedic work about music, *Musurgia universalis* (Universal Music Making, Rome, 1650), describes an early automated instrument (similar to the player piano that would become popular

two-and-a-half centuries later). The programs for this automated instrument were written on paper and then transferred to a metal cylinder called a *cylindrus phonotactus*; Kircher's *Musurgia universalis* also contained a short, three-part ricercar, *Ricercata pro instrumentis automatis*, which he created as an instructive example for those who were interested in learning how to program the automatic organs he described in the book. Because he intended for the ricercar to demonstrate the capabilities of automatic instruments, it made extensive use of syncopations and short note values. Kircher's visionary endeavours took him even further. He likely created his ricercar with the help of another apparatus described in the book, the *Arca Musurgica*, a logic device that could help its user compose or arrange music in both contrapuntal and homophonic settings.

However, among Kircher's projects, the most germane to our topic was the Magic Lantern or "Sorcerer's Lamp." The very names, while not Kircher's own, suggest the project's provenance in esoteric belief systems. Various types of projecting devices have been in use since the Middle Ages (and perhaps even earlier). The best known of these early experiments are the "crystal balls" (i.e., spherical projection lenses, which had a "prodigious sign" painted on them) that the Neapolitan, Giovanni Battista Della Porta (ca. 1538–1615), described in his *Magia naturalis, sive de miraculis rerum naturalium* (Natural Magic, or Concerning the Miracles of Natural Things, Naples, 1558); that work describes the "deviltries"of the *camera obscura*.[106]

Della Porta was a premodern polymath: an author, scholar, member of secret societies, scientist, and organizer. Volume XXVIII of Zedler's *Lexikon* (1741) says this about him: "He did much to help establish the Academie Degli Otiosi, and he held another at his house, which was called the 'Academie de Secreti,' to which only members were admitted who had discovered something new about the natural world. But the papal court prohibited the meetings of the latter because its members allegedly engaged in forbidden arts and studies." Della Porta's most famous work was the previously mentioned encyclopaedia, *Magia naturalis*, the first version of which he wrote in the fifteenth year of his life. The twenty sections of *Magica naturalis* (Della Porta refers to them as "books") describe natural phenomena as presenting material not simply for empirical investigation or imitation, but also for transformation, through the powers of magic and the imagination. In *Magica naturalis*, Della Porta describes magic as "wisdom and perfect knowledge of natural things" (according to the description on the second page of the Nürnberg edition of 1719). *Magica naturalis* is a treatise in biology, physics, chemistry, medicine, and philosophy. It includes observations on the alchemistic transmutation of metals, the artificial production of precious stones, and the preparation of herbal potions, as well as rituals for inducing abortions and for effecting the sex of an unborn

child (if the herb *phyllon* or *mercurialis* is placed "in the natural place," a son will be born). It discusses cooking, secret ciphers, and the uses of artificial fires, and, in book 17, "divers mirrors and lenses," including Della Porta's studies on projection and optical scene creation.

Della Porta's ideas about how the magic lantern might be used were extrordinarily theatrical. In *Magica naturalis* he described how the *camera obscura* could also be used to present dramatic events.

"How in a Chamber you may see hunting, battles of enemies, and other delusions"

Now for a conclusion I will add that, then which nothing can be more pleasant for great men, and scholars, and ingenious persons to behold. That in a dark chamber by white sheets objected, one may see as clearly and perspicuously, as if they were before his eyes, huntings, banquets, armies of enemies, plays, and all things else that one desires. Let there be over against that chamber, where you desire to represent things, some spacious plain, where the sun can freely shine. Upon that you shall set trees in order, also woods, mountains, rivers, and animals that are really so, or made by art, of wood, or some other matter. You must frame little children in them, as we use to bring them in when comedies are acted. And you must counterfeit Stags, Boar, Rhinocerets, Elephants, Lions, and what other creatures you please. Then by degrees they must appear, as coming out of their dens, upon the plain. The hunter must come with his hunting pole, nets, arrows, and other necessaries, that may represent hunting. Let there be horns, Cornets, and trumpets sounded. Those that are in the chamber shall see trees, animals, hunters faces, and all the rest so plainly, that they cannot tell wether they be true or delusions.

And then, right after, as though to confirm my conjectures about the relation between these "real illusions" and the celestial order,

"How you may see the sun eclipsed."

Now I have determined to show how the sun's Eclipse may be seen. When the sun is eclipsed, shut our chamber windows, and put a paper before a hole, and you shall see the sun. Let it fall upon the paper opposite from a Concave-glass, and make a circle of the same magnitude. Do so at the beginning, middle, and end of it. Thus may you without any hurt to your eyes, observe the points of the diameter of the sun's Eclipse.[107]

A later version of an apparatus for projecting images, similar to Della Porta's, appeared in 1646, in the first edition of Kircher's *Ars magna lucis et umbrae* (The Great Art of Light and Shadow), a work on light and optics. In that book Kircher described a projecting device, equipped with a focusing lens and a mirror, either flat or parabolic. This device was obviously an original

construction, and he proudly declared that "this is completely our own invention, and I cannot remember that I ever have read about anything like it." Though this claim was issued later than Della Porta's description, it is likely true, as Kircher usually gave credit to inventors when he knew them. The projector, which Kircher called a "Steganographic Mirror," used sunlight as its light source. (Kircher also produced a brief description of a primitive method for using artificial light for projection.)[108] The 1671 Amsterdam edition of his *Ars magna lucis et umbrae* also includes an illustration of the Smicroscopin, an instrument to be used in recounting tales: with this machine, Kircher presented the story of Christ's passion in eight dramatic tableaus (which he referred to as "simulacra").

Kaspar Schott, Kircher's long-time collaborator, published his own treatise *Magia optica—das ist geheime doch naturmassige Gesicht- und Augen-Lehr* (The Secret yet Natural Science of Face and Eyes) in the same year (1671) that the second edition of the *Great Art of Light and Shadow* appeared. Schott had been Kircher's assistant, so his book presents discoveries his master had developed. He was, in addition, more meticulous than Kircher in presenting the details of his ideas about enhancing vision using artificial prosthetics. In book 6, "Von der Spiegelkunst" (On the Art of Mirrors), Schott reworked Kircher's "Allegorie-Maschine," disassembling its components and experimenting with several possibilities for producing images and for projection.[109] These ideas, we shall see, were fundamental to Baroque art—and to the Absolute Film.

A POSSIBLE EGYPTIAN CONNECTION FOR KIRCHER'S STEGANOGRAPHIC MIRROR

There is one fascinating possibility regarding the provenance of Kircher's Steganographic Mirror—it is, admittedly, only remotely possible, but given his knowledge of things Egyptian (and his ability to read Arabic), nonetheless it should be considered. Shadow-plays have a long and fascinating history in Egypt.[110] Called *khayal al-zill*, they date from the founding of Cairo in the tenth century and reached the height of their popularity in the thirteenth and fourteenth centuries. Shadow-plays were mounted throughout the Nile Delta during this period. Egyptian shadow-theatre is not the earliest known: China, Southeast Asia, Indonesia, and India were all familiar with shadow-play before Egypt was. Perhaps the most famous tradition of shadow-play was the Turkish tradition, called "karagöz oyunu" after its main character, Karagöz.

But it was in Egypt that shadow-plays became especially popular. There they assumed many forms: some were long, some were short; some were simple, some were elaborate; some were serious, some were farcical. Shadow-plays were performed in all manner of dwellings, in palaces and mud homes, and on all sorts of occasions: for weddings and circumcisions and even—indeed,

especially—on evenings during Ramadan. Some plays were witty and mildly bawdy; others were educational, passing on traditional fables and histories; still others satirized political figures. Many were serial tales, so that audiences would return night after night. Seen against the dark of night, these brightly coloured shadow-plays, with their frequently broad and humorously expressive figures, held audiences in a spell.

During Ramadan, after the sun went down, when the day's fast was broken, crowds filled the main streets and squares (*midans*), looking for *iftar*, the quick meals peddled by pushcart vendors. After the *iftar*, many sought out some form of entertainment: tumblers, gymnasts, magicians, storytellers. The most popular entertainment of all, though, was the *khayal al-zill*, which could be found in any neighbourhood in Cairo. Most shadow-plays offered a different show each night during Ramadan. The shadow-plays were mounted on portable stages of wood and canvas, which could be adjusted to fit into large rooms (such as cafés) or used on the street.

Puppets—figures on long wooden rods so that their, arms, hands, and legs could be animated from behind by manipulating the sticks—were used to form the shadows. These puppets were generally about 30 centimetres tall and made of stiff, thin-stretched translucent camel-hide. A strong lantern, placed between the puppets and puppeteers who worked them, projected shadows of the moving figures onto a cloth screen; the audience sat on the other side of the screen.

The *raid al-khayal* (shadow-master) who manipulated the puppets could make them turn somersaults or fight furiously. Shadow-masters would know at least twenty-eight plays, one for each night of Ramadan. Often the *raid al-khayal* could supplement the shadow-play with poetry and song, generally to the accompaniment of drums, tambourines, flutes, and "special effects"—smoke, fire, thunder, rattles, squeaks, thumps. He could imitate many voices: of men, women, and children, and even of animals and birds (though the *raid al-khayal* would often enlist boys to provide female voices). Shadow-masters would perform the entire script from memory while manipulating their puppets.

Scenes in *khayal al-zill* could be extremely elaborate. A scene might depict ships in heavy seas, with an entire navy, decked out with sailors, rowing; nature scenes, complete with prancing animals, flying birds, and swimming fish; and, of course, battles. The scenes were so elaborate that producing them required the skills of many crafts. Productions of successful shadow-plays enlisted workers in wood, rope, and leather, tinsmiths, lantern makers, candle makers, tinkers, and mechanics. But Cairo by the fourteenth century had experienced a four-centuries-long boom, and artisans were available.

The person who made the puppet characters was called the *qassas* (cutter; the term also meant storyteller). The *qassas* cut and stitched camel leather—

and sometimes fish skin; the *qassas*'s skill in his craft was such that he could produce a puppet that the *raid al-khayal* could manipulate easily and that would cast a recognizable, and interesting, shadow on the curtain. Another craftsman, the *megariz*, was responsible for piercing each puppet and attaching it to the manipulating rods. His great chore was to find a way to insert the rods in such a way that the puppet could be controlled and, moreover, would move in a manner befitting the character the puppet represented.

The *khayal al-zill* playwrights were just as talented, and just as highly respected, as other Egyptian playwrights. Among the most famous, and most successful, of the shadow playwrights was Ibn Daniyal. Daniyal was born in what is now Iraq, and by the age of nineteen he had completed his medical studies to become an eye doctor. When the Mongols invaded his homeland, he fled to Cairo. There he became a renowned poet, and in his spare time he wrote and performed original shadow-plays. Three of his texts still exist, all labelled *tayf al-khayal* (phantoms of the shadows); they are the only complete examples of Arabic drama from the Middle Ages that have survived to this day. They were written in rhymed prose, in witty classical Arabic. They contain a great deal of dialogue, and the banter among characters is rich with allusions to Cairo's *haute monde*. In one of them, Ibn Daniyal deals satirically with events that occurred during the reign of the Mameluke sultan, al-Zahir Baybars. It begins with the customary prologue that offers praise to "the Lord God Almighty, the majestic, exalted, above all the world," that blesses "the Prophet and his family," and that prays for "a long life for our Sultan, who alone preserves us from evil." Sultan Baybars had in fact preserved Cairo from "evil," for in 1260 he and his Mameluke armies had dealt the Mongols a historic defeat, thereby saving Cairo from the devastation that had befallen Baghdad and Damascus. But the Sultan had also routed another evil: a comment offered just a moment later in the play refers to a recent order of the Sultan that had the effect of putting "Satan's army to flight." That comment refers not to the Mongols but to the drug peddlers who had recently been expelled from the city. An evil character in Ibn Daniyal's play, Amir Wisal, boasts:

> I am sharper than a lancet,
> I croak better than a frog,
> I can break in like a passkey
> And I'm rougher than a cob.
> I am brighter than the brightest star,
> More crooked than a spiral.
> My capacity is endless
> And I'm dangerous and dire.

Such was the besetting evil that Sultan Baybars helped route.

While the internal features of the shadow plays were highly various, they always had a similar form. They always began with a dance and ended with either a joyful song or a free-for-all battle. A two-part epilogue followed: the first praised God, the Prophet Muhammad, and his descendants; the second presented the credits for the play, naming the shadow-master himself, the people who made and painted the figures, who played the music, and who made other significant contributions. Finally, the shadow-master praised the audience and thanked them for coming, and thanked God for giving him strength to perform.

All *khayal al-zill* had one stock character in common: the *muqqaddin* (presenter, or narrator). The *muqqaddin* almost always appeared wielding a stick, a sceptre with which to command the players. The *muqqaddin* would begin with a dance to get the audience's attention; he then would introduce the characters, with muttered asides that foreshadowed plot developments or derogated their natures. At the end of every performance the *rais al-khayal* would exhort the audience to return the next day.

Though they had long experienced declining public support, not until the twentieth century did Cairo's shadow-plays fall decisively from public favour. Technological changes eclipsed the shadow artisans. For generations they had worked mostly with wood, tin, and leather. As plastics began to displace wood, the woodworker's craft increasingly appeared too expensive as well as labour intensive; so shadow shows were no longer mounted.

Khayal al-zill means "shadows of the imagination." The reference to the imagination alluded to the stories' allegorical nature. The white screen on which the shadow-forms were cast separated the world of physical reality from the world of the imagination: "khayal al-zill" reminded viewers that what they were seeing was not real. The unreal status of the shadow-forms allowed the authorities to grant more freedom to these plays than they would to plays offered by flesh-and-blood actors.

More important for us is that these plays were projections of light: the play of brilliant material stood for God's illuminating and creative power. The religious significance of the shadow-play must be understood against the background of Islamic philosophical ideas regarding the status of the imagination. In much Islamic thought the imagination has special ontological status. In Aleppo, Syria, the "theosopher" Yahya Suhrawardi (d. 1191) founded a school dedicated to fostering illusion (*al-ishraq*); it incorporated ideas and practices from an Iranian mystical tradition predating Islam (a tradition that in recent years has attracted the interest of many religious scholars as a key source of the ideas that went into the making of Christianity).[111] The true philosophy, Al-Suhrawardi taught, would synthesize the knowledge of the *falsafahs* (philosophers) that resulted from the disciplined training of the intellect and the

understanding that results from Sufi practices that transform the heart. Sufi discipline enables people to experience the inner significance of earthly existence. Only mystical understanding provides a context for discerning the meanings of religious myths, inasmuch as the phenomena that myths describe have no reality outside the context of mystical experience. Muslims, Al-Suhrawardi taught, must cultivate the experience of the *alam al-mithal* (the "world of pure images"), a realm intermediate between our ordinary world and God's world. Ordinary people, people not trained in the mystical practices of the Sufi, experience the *alam al-mithal* through dreams or hypnagogic imagery (which we experience when we enter that zone intermediate between waking and sleeping, or in a trance). A prophet or a mystic knows this realm intimately, Al-Suhrawardi maintained. Al-Suhrawardi, who represents the pinnacle of one Neoplatonic strain in Muslim philosophy, was sometimes called the "the Master of Illumination" (*shaykh al-ishraq*), because he expounded an extraordinarily complex hierarchy of lights, in which the Divine and quasi–Divine were seen entirely in terms of light. Thus, God was the Light of Lights (*nur al-anwar*), and from the Light of Lights emanated the First Light, from which emanated the Second Light, and so on, in an elaborate Neopythagorean hierarchy. The whole system of lights was bound into a whole in a three-tier system of Angelic Lights. The doctrine of emanation taught that each rank in the hierarchy of lights (or intellects) had ontological and noetic precedence over lights of lower ranks, but not temporal precedence.

Al-Suhrawardi was executed for his views; yet he was a devout Muslim, and his works are still read as classics of mysticism.[112] So, too, are the works of the renowned Spanish theosopher Muid ad-Din ibn al-Arabi (d. 1240). Ibn al-Arabi urged Muslims to discover the *alam al-mithal* within themselves; the way to God, he taught, is through the creative imagination. Training the imagination provided for those theophanies through which Muslims could see beneath the surfaces of things and discover the sacred presence that resides in everything and everyone (for every person is an unrepeatable revelation of one of God's hidden attributes). The great French authority on Islamic philosophy, Henry Corbin, writes on the topic of the notion of the imagination in esoteric Islam. I quote at length because the language suggests much about the shadow-forms:

> It will first be necessary to recall the acts of the eternal cosmogony as conceived by the genius of Ibn al-Arabi. To begin with: a Divine Being alone in His unconditioned essence, of which we know only one thing: precisely the sadness of the primordial solitude that makes Him yearn to be revealed in beings who manifest Him to Himself insofar as He manifests Himself to them. That is the Revelation we apprehend. We must meditate upon it in order to know *who* we are. The leitmotiv is not the bursting into being of an autarchic Omnipotence, but

a fundamental sadness: "I was a hidden Treasure, I yearned to be known. That is why I produced creatures, in order to be known in them" …

The Creation is essentially the revelation of the Divine Being, first to himself, a luminescence occurring within Him; it is a theophany [*tajallī ilāhī*] …

Thus Creation is Epiphany [*tajallī*], that is, a passage from the state of occultation or potency to the luminous, manifest, revealed state; as such, it is an act of the divine, primordial Imagination. Correlatively, if there were not within us that same power of Imagination, which is not imagination in the profane sense of "fantasy," but the Active Imagination [*quwwat al-khayāl*] or Imaginatrix, none of what we show ourselves would be manifest. Here we encounter a link between a recurrent creation, renewed from instant to instant, and an unceasing theophanic Imagination, in other words, the idea of a succession of theophanies [*tajalliyāt*] which brings about the continuous succession of beings. This Imagination is subject to two possibilities, since it can reveal the Hidden only by continuing to veil it. It is a veil; this veil can become so opaque as to imprison us and catch us in the trap of idolatry. But it can also become increasingly transparent, for its sole purpose is to enable the mystic to gain knowledge of being as it is, that is to say, the knowledge that delivers, because it is the gnosis of salvation …

The intermediary between the world of Mystery (*'ālam al-ghayb*) and the world of visibility (*'ālam al-shadādt*) can only be the Imagination, since the plane of being and the plane of consciousness which it designates is that in which the Incorporeal Beings of the world of Mystery "take body" (which does not yet signify a material, physical body), and in which, reciprocally, natural, sensuous things are spiritualized and "immaterialized." We shall cite examples to illustrate this doctrine. The Imagination is the "place of apparition" of spiritual beings, Angels and Spirits, who in it assume the figures and forms of their "apparitional forms"; and because in it the pure concepts (*ma'ānī*) and sensory data (*mahsūsāt*) meet and flower into personal figures prepared for the events of spiritual dramas, it is also the place where all "divine history" is accomplished, the stories of the prophets, for example, which have meaning because they are theophanies; whereas on the plane of sensory evidence on which is enacted what we call History, the meaning, that is, the true nature of those stories, which are essentially "symbolic stories," cannot be apprehended …

Mystic "cosmography" designates the intermediate world or plane of being specifically corresponding to the mediating function of the Imagination, as the luminous world of Idea-Images, of apparitional figures (*'ālam mithālī nūrānī*). Ibn al-Arabī's first preoccupation is with the connections between visions and on the one hand the imaginative faculty and on the other hand divine inspiration. For indeed, the entire metaphysical concept of the Imagination is bound up with the intermediate world. Here all the essential realities of being (*haqā'iq al-wujūd*) are manifested in real Images; when a thing manifested to the senses or the intellect calls for a hermeneutics (*ta'wīl*) because it carries a meaning which transcends the simple datum and makes that thing a symbol, this symbolic truth implies a perception on the plane of the active Imagination. The

MODERNISM AND THE ABSOLUTE FILM

wisdom which is concerned with such meanings, which makes things over as symbols and has as its field the intermediate world of subsisting Images, is a wisdom of light (*hikmat nūrīya*) ...

The theosophy of Light suggests the metaphor of the mirror and the shadow. But "shadow" must not be taken to imply a dimension of Satanic darkness, an Ahrimanian antagonist; this shadow is essentially a reflection, the projection of a silhouette or face in a mirror. Our authors even speak of a "luminous shadow" (in the sense that color is shadow in the context of absolute Light: *Zill al-nūr* as opposed to *Zill al-zulma*, dark shadow). And that is how we must take the following statement: "Everything we call other than God, everything we call the universe, is related to the Divine Being as the shadow (or his reflection in the mirror) to the person. The world is God's Shadow" ...

Hence [too] "we know the world only as we know shadows (or reflections); and we are ignorant of the Divine Being insofar as we are ignorant of the person who projects this shadow.[113]

Their religious significance explains why these "shadows of the imagination" were never more popular than during Ramadan.

It is not clear whether Kircher was acquainted with the *khayal al-zill*. But he did know Arabic, so perhaps he was. Moreover, *Iter extaticum coeleste* presents an imaginative journey in a fashion traditional among some Islamic thinkers who belonged to the tradition of light metaphysics. In that work he presented his view of the universe as a dream trip guided by the angel Cosmiel. The heavenly guide escorts the Jesuit, represented by Theodidactus, on a trip through the stars and spheres. The cosmology is definitely not in keeping with the science of Kircher's day and seems related to esoteric tradition. (The work fell under the Church of Rome's censorship.) More strikingly, the frontispiece to *Iter extaticum coeleste* shows Cosmiel leading Kircher to a universe that is clearly not that of the Roman Catholic tradition. But he said little of this divergence. (Five years earlier, when preparing *Oedipus Aegypticus* for publication, he had offered the mythological figure of Harpocrates. This boy god holds a finger over his mouth, and the words appear over his head, "Only by this do I reveal secrets." Harpocrates was the Egyptian god of silence.)

Still, imagery associated with Islamic light cosmology would have been available to a European any time after the twelfth-century "orientale lumen." But whether or not Kircher was acquainted with this form of Egyptian theatre, what is beyond question is that his ideas for the Steganographic Mirror have similarities with the Cairo shadow-plays (not the least in the analogical conceptions of *illusio* that underpin the two). And, what is as important—and my purpose for introducing this luminist tradition in Arabic thought—these ideas about light became part of the Western tradition as Arabic philosophy was introduced to Europe through Spain (including, through the so-called

"Theology of Aristotle" and the *Liber de Causis*, Neoplatonic works that we now sometimes call the *Plotiniana Arabica*, and that at the time were mistaken for Aristotelian works). This influence was reinforced through the work of Al-Fârâbî (c. 870–950), Islamic philosophy's "Second Master" (after Aristotle) and an important expositor of Neoplatonic thought, and through the influence that Al-Fârâbî exerted on Ibn Sînâ (980–1039), known in the West as Avicenna, a thinker who had a monumental influence on European philosophy.[114] Even after the Aristotelian revival, these Neoplatonic, luminist ideas were latent in the European tradition, ready for revival by occult practitioners (much as Pythagorean ideas have been latent in the tradition, ready for revival by contemporary New Age thinkers).[115] The art of light that Kircher helped pioneer has deep roots in a profound tradition of thinking about light.

HUYGENS, ROBERTSON, AND THEIR COLLEAGUES
POPULAR MAGIC

Though Kircher's proposals for the Steganographic Mirror were not themselves practical, within fifteen years others had developed his idea into working "Laternae Magicae." Some of this early development was undertaken at the University of Leyden, by two scientists working independently of each other. One was the physicist Christiaan Huygens, who described his version of the lantern in some letters to a friend (but who did not publish a description of his invention). The other was the Danish scientist and engineer Thomas Walgensten, who toured Europe, demonstrating (and selling) his lanterns. Kircher must have remained abreast of this subsequent work, for in a second edition of *Ars Magna Lucis et Umbrae* (1671), he commented on the similarities and differences between his own construction and that of Walgensten and provided a detailed (if in places confusing) description of the new lantern.[116]

Again confirming the Magic Lantern's associations with magic, there is evidence from Samuel Pepys's diary, in an entry dated August 19, 1666: "comes by agreement Mr. Reeves ... [who] did also bring a lanthorne with pictures in glasse, to make strange things to appear on a wall, very pretty."[117] Johannes Zahn invented a table-mounted Magic Lantern, which he used as an automatic wind direction indicator by hooking it to a weathervane on the roof (he described this apparatus in *Oculis Artificialis*, 1685). William Hooper presented a popular exposition of the Magic Lantern in *Rational Recreations* (London, 1774). There were even efforts to dynamize Magic Lantern projections. In *Physicae experimentalis* (Leyden; 1729), Pieter van Musschenbroek, a Dutch mathematician, theorized that overlapping glass plates, when subjected to a beam of light, could show animated movements; he may actually have built such a machine. Eventually the Magic Lantern became a popular entertainment, with many homes owning the apparatus.

Other pre-cinematic illusionistic devices supposedly presented revenants. In the 1770s, Abbé Guyot projected apparitions onto smoke using a Magic Lantern–like instrument, a *camera obscura* that projected the image from below onto the table surface. He described the device in his *Nouvelles récréations physiques et mathématiques* (Paris, 1770). The instrument was about two feet high and its lens two or three inches off the ground. The device was a simple novelty for guests or a conversation piece, though it could also be used for drawing.

In 1781, Philip Jacob de Loutherbourg (who also created the first scenic curtain for theatre) developed the Eidophusikon. Loutherbourg had been a painter of Romantic landscapes; his work was praised by Denis Diderot. He became the youngest person to be elected to the Académie Royale in Paris and was nominated as a *peintre du roi*. In November 1771 he temporarily abandoned his family and moved to London, where, through a letter of introduction from Jean Monnet, director of the Opéra Comique (which described Loutherbourg as "un de nos plus grand peintres"), he met David Garrick. Garrick took him on as his chief stage designer at the Drury Lane Theatre; there, between 1773 and 1789, he worked on at least thirty dramatic productions, first under Garrick and then, after 1776, under Garrick's successor Richard Brinsley Sheridan. These productions included *A Christmas Tale* (1773), *The Maid of the Oaks* (1774), *Selimor and Asor* (1776), *The Camp* (1778), *The Critic* (1779), and *Robinson Crusoe* (1781). For *The Wonders of Derbyshire* (1779), Loutherbourg drew on sketches he had made during a visit there the previous year, creating pictorial effects similar to those of the sublime landscapes he had produced as a painter. His work at Drury Lane became renowned for its integration of scenery, costume, movement, and music; among its cardinal historical importances is that it made pictorial rather than architectural considerations the primary factor in elaborating illusion. (His illusionistic sets were a forerunner of cinema and foreshadowed the effects that cinema would exert on the other arts.)

Loutherbourg installed his "Eidophusikon; or, Various Imitations of Natural Phenomena, represented by Moving Pictures" in Leicester Square and opened it on February 26, 1781. (He later moved it to The Strand.) The original device incorporated a small stage, no more than seven feet wide, four feet high, and eight feet deep. He used his Eidophusikon to present a series of scenic illusions that included movement and that were accompanied by sound effects and music by composers who, in their time, were well known. A typical performance consisted of five picturesque landscapes, each running for around three minutes; dynamic effects were created by lighting, movable filters of coloured silk, painted transparencies, Magic Lantern slides, clockwork automata, and movable three-dimensional models. Viewers were presented with displays of dawn creeping through the mist over the Thames at Greenwich;

Gibraltar shimmering in the noon sun off the port of Tangier; the Bay of Naples animated by the sun and scudding clouds; a moon rising over the Mediterranean; and a storm sinking a ship at sea. The closing of each scene was marked by a Magic Lantern projection of a painted transparency and by music and song. These performances, in the creation of which Gainsborough often assisted, were technically innovative. For example, Loutherbourg darkened the auditorium to increase the audience's receptivity and to bolster the illusion. That was something new to theatre: not until the late nineteenth century did Henry Irving introduce the practice of lighting only the stage during a performance.

Descriptions of Loutherbourg's pictures credit them with a vivid reality. Contemporaries recorded that flashes of lightning struck terror in the spectators and engendered an admiration that approached that which people feel for the numinous. Ceram tells us that the Eidophusikon had a miniature stage that moved its scenery with pulleys to produce the illusion of changing sky effects, clouds, storms, and sunrises and that a moving backcloth of tinted linen was lit from behind by lamps. Loutherbourg called the latter his "movable canvas." Clouds painted on linen attached to large frames were moved diagonally by pulleys and seemed to pass naturally across the sky. Against this moving background, tiny mechanical actors, accompanied by telling sound effects, appeared automatically and re-enacted dramatic scenes: Milton's Satan arrayed his troops on the Fiery Lake, while Pandemonium rose from the deep, to gradually changing colour from sulphurous blue to lurid red to shades that suggested a fiery furnace. Loutherbourg's work had a lasting effect on the London stage and the art of *mise en scène*, for he highlighted the need for lighting and pictorial scenery.[118]

Like so many who dedicated themselves to displaying apparitions, Loutherbourg had a keen interest in the occult. In Paris he had studied alchemy, and after moving to London he had extended his knowledge to comprise mesmerism and Swedenborg's doctrines. In 1786 he met the magician and freemason "Count" Cagliostro, who provided him with further instruction in the occult sciences. In June 1787, when Cagliostro returned to the continent, Loutherbourg followed him—the only time he returned to the continent after leaving it in 1771. Six months later, he and Cagliostro had a falling out and Loutherbourg challenged Cagliostro to a duel. Early in 1788, Loutherbourg returned to London. That same year, he and his wife established a practice as faith healers, working from their house on Hammersmith Terrace, Chiswick, and claiming to deploy for therapeutic purposes the influxes that, according to Swedenborg, flow from heaven to earth. At first they were extremely successful, attracting thousands of patients, but in 1789 a mob attacked their house and their public practice was abandoned, though Loutherbourg continued to use his healing powers in private until at least 1804.

He then worked as illustrator for Thomas Mackin's six-volume edition of the Bible, producing twenty-two plates and approximately seventy-one vignettes over a ten-year period. During this time he became a recluse, studying the Kabbalah and other rare religious texts in his possession. Thus, his illustrations for Macklin include many examples of the apocalyptic sublime (including *The Vision of the White Horse* [1798] and *The Angel Binding Satan* [1792]), influenced by his interest in the occult.[119]

In the 1790s, E.G. Robertson (a *nom professionel* of the Belgian Etienne-Gaspard Robert) produced projections of convincing figures before an audience. He soon put the device to work in ghost shows. He later described these shows in his *Memoires récréatifs, scientifiques et anecdotiques du physicien-aeronaute* (Paris, 1831). Robertson's illustrated show, which he called the Fantasmagoria, was an audiovisual forerunner of cinema. With it he mounted true spectacles, complete with stories, that made elaborate use of *mise en scène*, emotional lighting (including contre-jour and faux daylight), special effects, and sound effects (including those of a ventriloquist) to make the dead speak. In the first decades of the 1800s he travelled throughout Europe with his special shows; about them, he remarked, "I am only satisfied if my spectators, shivering and shuddering, raise their hands or cover their eyes out of fear of ghosts and devils dashing towards them; if even the most indiscreet among them run into the arms of a skeleton."[120]

Robertson referred to his illusionistic displays as *fantômes artificiels*.[121] His phantasmagoria developed out of a childhood interest in magic, conjuring, and optical effects. In his *Memoires* he recalled that in his youth, Kircher's Magic Lantern had fascinated him. He understood the potential for using his "Fantasmagorie" to pseudo-necroromantic ends. A commentator described his *fantômes artificiels* in these terms.

> The members of the public having been ushered into the most lugubrious of rooms, at the moment the spectacle is to begin, the lights are suddenly extinguished and one is plunged for an hour and a half into frightful and profound darkness; it's the nature of the thing; one should not be able to make anything out in the imaginary region of the dead. In an instant, two turnings of a key lock the door: nothing could be more natural than that one should be deprived of one's liberty while seated in the tomb, or as in the hereafter of Acheron, among shadows.[122]

At the end of the spectacle, Robertson would emerge from the gloom to speak to the audience—to offer to conjure up the spirits of their loved ones who had departed the earthly realm. A man in the audience would ask to see Marat. At this, Robertson would pour two glasses of blood and a bottle of vitriol onto a lighted brazier, and add twelve drops of aqua fortis and two numbers of a journal (*Hommes-Libres*), at which point a phantom wearing a red cloak and armed

with a dagger would appear. Then a young man in fancy dress would ask to see the woman he loved, showing a miniature portrait of her to assist the conjurer. The phantasmagorian would throw some sparrow feathers, a few grains of phosphorus, and twelve butterflies onto the brazier, and a beautiful young woman, with one breast uncovered, would appear, gaze at her lover, and smile.

The authorities closed down Robertson's first phantasmagoria, exercising political censorship over the content of his show, and forced him into exile in Bordeaux. When he returned to Paris a year later, he began staging even more elaborate spectacles in the crypt of an abandoned Capuchin convent. There, amidst tombs and effigies, he mounted a spectre-show that was, he said, pervaded by the aura of "les mystères d'Isis." In his *Salle de la Fantasmagorie*, he would open the spectacle with a speech on death and immortality. The two great events for any human, he would say, are one's entry into life and one's departure from it. Those things which lay before the former and after the latter were hidden by a hitherto impenetrable veil; he proposed to lift that veil. He would raise the dead, he promised. He would ask his audience to imagine the situation of a young maiden of ancient Egypt in some dark catacomb who, through necromancy, would attempt to summon the ghost of her dead lover; surrounded with images of death, she would await the appearance of her beloved. Then luminous shapes would rise out of the darkness and flit over the heads of the spectators.

The spectre-shows Robertson presented included "The Three Graces," whose characters turned into skeletons; "Macbeth and the Ghost of Banquo"; "A Witches' Sabbath"; "The Witch of Endor"; and "A Gravedigger." Intercollated with these scenes would be single apparitions from his early phantasmagoria shows, including the figures of Voltaire, Rousseau, Robespierre, and Marat. At the show's end, Robertson would announce: "I have shown you the most occult things natural philosophy has to offer, effects that seemed supernatural to the ages of credulity ... but now see the only real horror ... see what is in store for all of you, what each of you will become one day: remember the phantasmagoria."[123] Then he would relight the torch to illuminate the skeleton of a young woman.

Phantasmagoria became a staple of popular entertainment. In 1897 a German conjurer opened a phantasmagoria show at the Temple of Apollo on The Strand, featuring representations of the raising of Samuel by the Witch of Endor, the ghost scene from Hamlet, and the transfiguration of Louis XVI into a skeleton. Henry Crabb Robinson reported that he saw a pleasing show of spectres, with their eyes and other parts moving, at the Royal Mechanical and Optical Exhibition on Catherine Street. In 1833, De Berar's Optikali Illusio, presented at Bartholomew Fair, showed Death riding a pale horse accompanied by a luminous skeleton. As time drew on, the figures became more clearly drawn: in one renowned show from 1863, Pepper's Ghost (named after the

show's director, Professor John Henry Pepper, Professor of Chemistry at the Royal Polytechnic in the 1860s), presented ghostly figures of actors, projected from below the stage, who mingled with real stage figures.[124] This was not the only intercourse that real figures and phantoms had in his show: by superimposing the image of a skeleton onto the body of an audience member who had been invited to lie down in a coffin, he would give the illusion that the person had changed into a skeleton. Dr. Pepper would present the illusion in the form of the "Knight Watching his Armour." Munro (1863) and Maurice (1865) took out patents for the same illusion, which is still in use today in many Haunted Castle and Dark Ride exhibits throughout the world.

The magic show exercised considerable influence on that marvel of the late nineteenth century, the moving picture. The titles of many early films suggest connections with magic. Consider the film program that was on display in the autumn of 1906 at the Théâtre Robert-Houdin, a house of magic on the boulevard des Italiens: on exhibition were films with such titles as *A Spirtualist Photographer*; *The Enchanted Sedan Chair*; *Tchin-Chao, The Chinese Conjurer*; and *The Magic Lantern*.

SPIRITUALISM AND THE NEW TECHNOLOGY

The taste for the fantastic and the otherworldly (the climate of reception that explains the extraordinary appeal of Spiritualism in America and its European cousin, Spiritisme) was not confined to the theatre. It was also evident in literature. Nathaniel Hawthorne presents the outstanding example. His 1853 novel, *The Blithedale Romance*, presents an oddball professor peddling a variety of mesmerism in the town hall. His earlier *The House of the Seven Gables* (1851) is deeply imbued with Spiritualist and mesmerist interests, including telepathy and telegraphy—which helps explain why its form is a variant of the gothic novel. The Pyncheons live in a two-hundred-year-old house with seven gables, which is haunted by a curse imposed by a seventeenth-century wizard, Matthew Maule, who once owned the property on which the house stands. The Pyncheons' forebear, Colonel Thomas Pyncheon, had vociferously advocated Maule's prosecution for witchcraft, in order to get hold of Maule's property. Just before he was hanged, Maule cursed Pyncheon. As a result, the mansion, thanks to what Hawthorne describes as "a sort of mesmeric process," is fated to contain every image it has ever reflected.[125] The description captures the feeling of magic and mystery, of the supernatural, that photography evoked at the time. The Maules, too, commanded over "the topsy-turvy commonwealth of sleep" (the nether realms) that held the key to this para-photographic record of things—that is, to the domain of memory.[126]

A character who goes by the assumed name of Holgrave, a drifter, a revolutionary, a daguerreotypist, and a mesmerist (note the association between the

daguerreotype and the paranormal again) shows up at the house of seven gables and is taken in as a tenant. Holgrave's interests are in the spirit world, but not the world of darkness; indeed, he uses sunlight and the daguerreotype to capture the hidden truths of the visible world: "There is a wonderful insight in heaven's broad and simple sunshine. While we give it credit only for depicting the merest surface, it actually brings out the secret character with a truth that no painter would ever venture upon, even could he detect it."[127] The daguerreotypist reveals the inner truth of people, the spiritual truth that fate (family history) bequeaths them: the austere, Puritan mien behind Judge Jeffrey Pyncheon's smiling face, and the beautiful smile behind Clifford Pyncheon's public severity. Holgrave also reveals, in one of his tales (recounted in chapter 13 of Hawthorne's book), Matthew Maule's cruelly invasive mesmeric probing of the virginal figure, Alice Pyncheon: "It appears to have been his object to convert the mind of Alice into a telescopic medium, through which Mr. Pyncheon and himself might obtain a glimpse into the spiritual world. He succeeded, accordingly, in holding an imperfect sort of intercourse, at one remove, with the departed personages, in whose custody the so much valued secret had been carried beyond the precincts of earth."[128] Through this paranormal manner of possessing another, a manner that combines mesmerism (control over another's mind) with spiritualism (communication with the dead), Maule takes possession of the Pyncheons' secret. However, he does not share it with them—to do that would be to cede it to them. Instead he keeps it to himself, and in doing so preserves his control over Alice. Wherever she is, she is the plaything of his whims: with the slightest gesture, he can make her laugh at funerals, weep at parties, dance at inopportune moments, or engage in other inappropriate behaviours.

As he reads his tale aloud to Phoebe Pyncheon, by miming Maule's gestures Holgrave mesmerizes Phoebe (for Phoebe, like Alice, was especially sensitive to magnetic sympathy). Holgrave is clearly a double for Maule, as Phoebe is for Alice, but Holgrave is unwilling to follow Maule's course and take advantage of Phoebe.

Clifford Pyncheon, a sensitive young man wasting away under the burden of accumulated family guilt, finally escapes the house and flees by train. During the journey, he becomes virtually enraptured and enthuses to his more sober and sceptical seatmate about the world's growing spirituality. He cites evidence of the spiritual wonders of the contemporary world: mesmerism, rapping spirits and, of course, electricity. He then points out the telegraph lines that run parallel to the railway, remarking that "an almost spiritual medium, like the electric telegraph, should be consecrated to high, deep, joyful, and holy missions. Lovers, day by day—hour by hour, if so often moved to do it— might send their heart-throbs from Maine to Florida."[129] Clifford's remark thus combines the idea of transmitting the soul with the idea of erotic fusion.

He goes on to associate erotic merger with spirit communication (and who has not felt a frisson of the perverted in the idea of being able to arouse the dead, of "the sex-appeal of inorganic," as Walter Benjamin referred to it). "When a good man has departed, his distant friend should be conscious of an electric thrill, as from the world of happy spirits, telling him—'Your dear friend is in bliss!' Or, to an absent husband, should come tidings thus—'An immortal being, of whom you are the father, has this moment come from God!'"[130] An "electric thrill" tells of a procreation! The sort of telegraphic message with which most people were once familiar (messages relayed in Morse code over electrical transmission cables and often bringing news of ultimate matters, of birth and death) was understood as a "spiritual telegraph," as a means of rapturously fusing minds.

Hawthorne's writings represent a key achievement of the discursive regime that composed relations between scientific ideas about the transmission of signals with Spiritualist ideas about spiritual rapport and communication. They convey the impact of the discovery of a medium, telegraphy, that competes with writing as a means for storing intelligence. Sound recordings and film media, both of which, like writing, can capture temporal sequence, would be even more potent competitors. There is something uncanny about hearing voices of the departed or seeing their bodies in movement. Audio and visual recordings detach bodies from the cycle of birth and death and store them so as to preserve them from time. They are, as the film theorist André Bazin realized, the product of the wish to preserve the spirit from death—a wish that manifests itself in the desire to preserve the body and its motions in a realm that doubles ordinary material reality, a realm from whence "the dead," as Eisenstein had it, can "cry out." What is more, both the phonograph and the cinema preserve the appearance without preserving the actual body. They are like memories, cut in one individual's life and retrievable in another's; they therefore resemble thoughts that are transferred from mind to mind. That was how Oliver Lodge thought of memory and the advance that photography marked: it was a means to externalize subjectivity in a physical medium. Or, as the proto-Jenaromantik Johann Gottlieb Fichte described the Spiritualist practices of his day, they were a means to materialize idealism.

So it was that some thinkers came to believe that not just thoughts could be transferred from mind to mind: flesh itself could be transported through mediums and relayed to unsuspecting parties. The weirdest of these materializations was "ectoplasm," a white, viscous substance with an ozone smell. The figure who drew attention to this pseudo-phenomenon was a French medium who went by the name Eva Carrière. Carrière, it was said, could exude the substance from her mouth, nipples, navel, and vagina; other mediums were later presented emitting the material from the nostrils. Spiritualists declared that ectoplasm was evidence of yet another form of action at a distance,

to which they gave the splendid name "teleplasm" (flesh at a distance). During the first two decades of the twentieth century, the Munich physician Baron von Schrenck-Notzing supposedly studied Carrière's abilities in depth. Even today, his massive book *Materialisationsphaenomene: Ein Beitrag zur Erforschung der mediumistischen Teleplastie* (Phenomena of Materialization: A Contribution to the Investigation of Mediumistic Teleplastics) can exert a prurient fascination. In it he presented in apparently meticulous detail the exhaustive scrutiny he claimed to have made of Carrière's nude body, both before and after her sittings (and he provided 225 photographs of what he had observed during his examinations). The book describes the forms that teleplasm took: clouds and mists, whitish hands, pseudopods, heads, fingers, limbs, and fleshy masses in various stages of development. Some people took his claims about teleplastics (and those of other investigators of ectoplasm) as evidence that not only could spirits and intelligences be transported over long distances, but so, also, could the carnal aspect of the human constitution (though, they had to admit, the parturitional process did produce rather grotesque results).

These ideas were central to the belief systems of the late nineteenth and early twentieth centuries and constituted the ideational field in which the arts of the twentieth century developed. A common discursive trope of the late nineteenth century identified electricity with a spiritual and/or cosmic force and the transmission of signals (electrical, telegraphic, radio) with moving the soul through worldly and heavenly spheres. The word *radio* derives from the Latin "radiare" (to emit rays), which itself is associated with the Latin "irradiatare" (to illuminate, to enlighten intellectually); thus, it invokes a notion from the theology of light—that of a source of illumination that moves outwards to the world and the cosmos alike. This conceptual space, the space that notions of spiritual electricity and of the ether inhabit, guarantees that the phenomenon of voice transmission is imbued with the religious and cosmic meaning of the Logos.

In the early achievements in telephonic communication many heard echoes of the Spiritualist desire to reach the other side. Thomas Edison himself experimented with thought transference and communication with the dead.[131] The crystal receivers of the early wireless were understood within a conceptual framework established by the Spiritualists' ideas of the wireless telephone and voice boxing. Even the most hard-headed among present-day thinkers might find themselves admitting that the phenomenon of radio transmission invites such belief. To ensure that no reader should fear he or she is becoming soft-brained by admitting the range of influence these odd ideas exerted, I point out that as cautious a thinker as Rudolf Arnheim could still, decades after Edison, maintain that the intimate radio voice creates a "Stimmung" (atmosphere) associated with the cosy parlour on the one hand and the "Heavenly Father ... unseen, yet entirely earthy," on the other.[132]

Allan Kardec, the founder of a French version of Spiritualism known as Spiritisme, wrote that a spirit informed him of the analogy between spiritual mediums and telegraphy:

"As we have told you, mediums, as such, play but a secondary part in the work of spirit-communication; their action is that of the electric machine which transmits telegraphic dispatches from one point of the earth's surface to another point. Thus, when we wish to dictate a communication, we act on the medium, as the telegraph clerk acts on his machinery; that is to say, just as the action of the telegraphic needle impresses on a band of paper, thousands of leagues away, the signs which reproduce the despatch, so, by means of the medianimic apparatus, we transmit, athwart the immeasurable distances which separate the visible material world from the invisible immaterial world, the communications we are permitted to make to you."[133]

Ideas about the occult character of electrical transmission of sounds continued to resonate in the advanced arts of the twentieth century. Edgar Varèse described his ambition for his unfinished work, *Espace*: he wanted there to be "voices in the sky, as though magic, invisible hands were turning on and off the knobs of fantastic radios, filling all space, criss-crossing, overlapping, penetrating each other, splitting up, superimposing, repulsing each other, colliding, crashing."[134] He offered similar testimony in "The Liberation of Sound," in which he explained that he wanted to create a feeling "akin to that aroused by beams of light sent forth by a powerful searchlight—for the ear as for the eye, the sense of projection, of a journey into space."[135] The ambition to beam sound into space is evident in his unrealized project, *L'Astronome*, which he began in 1928. That work was a projection into the year 2000 and involved the representation of a series of catastrophes caused by "instantaneous radiation."

Antonin Artaud read Varèse's sketch for *L'Astronome* in 1932. It inspired him to write *Il n'y a plus de firmament* (There Is No More Firmament). In Artaud's narrative, a scientist willingly annihilates space through "celestial telegraphy" in order to establish an "interplanetary language"; the result of his efforts is the destruction of the earth.[136] Varèse's *L'Astronome* would have ended in much the same way: in the final scene the protagonist would have been volatilized into interstellar space to the sounds of factory sirens and airplane propellers. Varèse planned to have spotlights beamed into the audience at the moment when the protagonist was volatilized, with an intensity strong enough to blind the spectators, while the "mob" in the drama turned into stone.

LÉOPOLD SURVAGE AND THE ORIGINS OF
THE ABSOLUTE FILM

The Absolute Film emerged from a remarkable confluence of heterodox interests and concern with the specificity of the film medium. We will take up the latter aspect first, pursuing it in the thought of the artist who was perhaps the first to formulate the ideal of the Absolute Film. Léopold Survage (born in Moscow in 1879) was a Russian-French painter who trained at the School of Fine Arts in Moscow; what most impressed him, when he was a young man, were the paintings of Manet, Gauguin, and the Impressionists that he saw in private collections in Paris. The 1905 Revolution left him disillusioned, and he moved to Paris in 1908. An acquaintance of Picasso, Braque, Modigliani, Léger, and Brancusi, he exhibited his paintings for the first time in the Cubist gallery of Salon des Indépendents in 1912. Picasso sketched his portrait in 1912.

In 1914, Survage became the first artist to formulate and expound on the notion of abstract animation. He conceived of this abstract art as "color-rhythm" (*rhythm-colorisé*). In painting, his deepest loyalties were to an abstractionism that developed out of Cubism. These interests led him to imagine the possibility of animating abstract paintings according to rhythmic principles. His ideas were influenced by the ferment of ideas that surrounded Cubism—indeed, it was at the suggestion of his sculptor friend Alexander Archipenko (1887–1964) that he set down his thoughts on colour-rhythm; after he finished this tract, he sent it to Guillaume Apollinaire (1880–1918), a commentator on Cubism as well as a tremendously important poet, who published the piece in the final issue of *Les Soirées de Paris* (July–August 1914).

Survage propounded his ideas about colour-rhythm in strictly modernist terms. He accepted the principle that Kandinsky (and others) proposed and that most modernists accepted: that all arts aspire to the condition of music because music is—at least in its essence—pure pattern and pure form, undistorted by referential proclivities. This conviction provided the grounds for Survage to contend that cinema was the fulfillment of the visual arts, for it allowed the visual arts to develop rhythm in time as well as in space (and rhythm, of course, is the paradigm of a non-referential pattern). Survage did not strive to develop cinematic forms that would illustrate musical pieces—he explicitly abjured those possibilities. Still, he did seek to create forms that would exploit those features of the new cinema that would make it analogous to music:

> Colored rhythm is in no way an illustration or an interpretation of a musical work. It is an art unto itself, even if it is based on the same psychological phenomena as music.

MODERNISM AND THE ABSOLUTE FILM

ON ITS ANALOGY WITH MUSIC

It is the mode of succession in time which establishes the analogy between sound rhythm in music and colored rhythm—the fulfillment of which I advocate by cinematographic means. Sound is the element of prime importance in music ... Music is always a mode of succession in time. A musical work is a sort of subtle language by means of which an author expresses his state of mind, his inner dynamic being. The performance of a musical work evokes in us something of an analogy to this inner state of the author.[137]

Apollinaire, with characteristic insight, realized that efforts to draw the new cinema to music too strictly were misguided and that this new form would have to evolve out of features proper to the cinematic medium itself:

One can compare Colored Rhythm to music, but the analogies are superficial, and it really is an independent art having infinitely varied resources of its own.

It draws its origin from fireworks, fountains, electric signs, and those fairy-tale palaces which at every amusement park accustom the eyes to enjoy kaleidoscopic changes in hue.

We thus will have beyond static painting, beyond cinematographic representation, an art to which one will quickly accustom oneself and which will render its followers infinitely sensitive to the movement of colors, to their interpenetration, to their fast or slow changes, to their convergence and to their flight, etc.[138]

The version of modernism that Survage developed anticipated ideas that Susanne Langer would develop three decades later: that each work of art presents a form that arises from characteristics of its material, and that those forms possess the virtual shape of emotions. Unlike Langer, however, Survage suggested that the artist actually feels the feeling to which the form bears the relation of analogy. Again unlike Langer, he stressed the materialist basis of the form:

The fundamental element of my dynamic art is colored visual form, which plays a part analogous to that of sound in music.

This element is determined by three factors:

1. Visual form—which is abstract, to give its proper label
2. Rhythm—that is, movement and the changes which visual form undergoes
3. Color

FORM, RHYTHM

By abstract visual form, I mean the complete abstraction or geometrization of a shape, an object, within our surroundings. Ultimately, the form of such objects, however simple or familiar—say, a tree, a chair, a man—is complicated. To the degree that we study the details of these objects, they become more and more

resistant to simple representation. To represent the irregular shape of a real body abstractly means to reduce it to a geometric form, whether simple or complex, and these transformed representations or forms will be to the actual world as musical sounds are to noises. But that alone does not suffice to represent a state of mind or to channel an emotion. Immobile, an abstract form still does not express very much. Round or pointed, oblong or square, simple or complex, it only produces an extremely confused sensation; it is no more than a simple graphic notation. Only by putting it in motion, transforming it and combining it with other forms, does it become capable of evoking a feeling … Such a transformation in time erases space; one form converges with others in the midst of change; and they merge together, now advancing in parallel, now sparring with one another or dancing to the measure of the cadence which propels them; and that is the author's mood, his sense of gaiety, his sadness, or the deepest depths of his reflections. At this point there may come an equilibrium. But no! It is unstable, and the transformations begin anew; and through this the visual rhythm becomes analogous to the rhythm of music. In both domains, rhythm plays a similar role. Consequently, in the graphic realm, the visual form of any body is of value only as a means to express or evoke our inner state, and not at all as the representation of the significance or importance which such a body actually has in our daily life. From the point of view of such a dynamic art, visual form becomes both the expression and the effect of a manifestation of form-energy, within our environment. In this, form and rhythm are bound up together inseparably.

COLOR

Whether produced by dyes, by rays, or by projection, color is, at one and the same time, the cosmos, the material world, and the energy-field of our light-sensitive apparatus—the eye. And since what influences us psychologically is not sound or color, in isolation, but the alternating series of sounds and colors, so the art of colored rhythm, thanks to its principle of mobility, augments the alternating layers already present in ordinary painting …

Through this, color in turn is bound up with rhythm. Once it ceases to be an accessory to objects, it becomes the content, or even the spirit, of abstract form.[139]

A startling parallel to these ideas appears in an unlikely source—the writings of Virginia Woolf. In an essay from 1926 titled "The Cinema," she made the perceptive point that the special virtue of cinema is that it challenges the eye—especially "the English unaesthetic eye" that leaves the intellectual faculties slumbering—and summons the brain to its assistance so that it might study the world anew:

Together they look at the King, the boat, the horse, and the brain sees at once that they have taken on a quality which does not belong to the simple photograph of real life. They have become not more beautiful, in the sense in which

pictures are beautiful, but shall we call it (our vocabulary is miserably insufficient) more real, or real with a different reality from that which we perceive in daily life? We behold them as they are when we are not there. We see life as it is when we have no part in it. As we gaze we seem to be removed from the pettiness of actual existence. The horse will not knock us down. The King will not grasp our hands. The wave will not wet our feet. From this point of vantage, as we watch the antics of our kind, we have time to feel pity and amusement, to generalize, to endow one man with the attributes of the race. Watching the boat sail and the wave break, we have time to open our minds wide to beauty and register on top of it the queer sensation—this beauty will continue, and this beauty will flourish whether we behold it or not. Further, all this happened ten years ago, we are told. We are beholding a world which has gone beneath the waves ... The war sprung its chasm at the feet of all this innocence and ignorance, but it was thus that we danced and pirouetted, toiled and desired, thus that the sun shone and the clouds scudded up to the very end.[140]

Reading this, one might be inclined to conjecture that Woolf would go on to argue that this heightened sense of reality affecting us through time forms the basis for cinema's vocation to preserve—to *embalm*—a fleeting reality. She did not. In fact, she went on to point out that this sense of reality makes a mockery of efforts to use cinema to create fictions.

The next step in the argument is mind boggling: she asserts that the reality of movement in cinema—movement that does not represent anything outside the film but that affects us deeply by its luminous reality—is the true source of cinema's capacity. That leads her to advocate a cinema akin to the Absolute Film. She frames her views partly under the impact of pondering the implications of a large piece of dirt being caught in the projector during the screening of a German Expressionist film. She then sets out her conclusions partly by asking cinema what devices are proper to it:

If it ceased to be a parasite, how would it walk erect? At present it is only from hints that one can frame any conjecture. For instance, at a performance of Dr. Caligari the other day, a shadow shaped like a tadpole suddenly appeared at one corner of the screen. It swelled to an immense size, quivered, bulged, and sank back again into nonentity. For a moment it seemed to embody some monstrous, diseased imagination of the lunatic's brain. For a moment it seemed as if thought could be conveyed by shape more effectively than by words. The monstrous, quivering tadpole seemed to be fear itself, and not the statement, "I am afraid." In fact, the shadow was accidental, and the effect unintentional. But if a shadow at a certain moment can suggest so much more than the actual gestures and words of men and women in a state of fear, it seems plain that the cinema has within its grasp innumerable symbols for emotions than have so far failed to find expression. Terror has, besides its ordinary forms, the shape of a tadpole; it burgeons, bulges, quivers, disappears. Anger is not merely rant and rhetoric, red faces and clenched fists. It is perhaps a black line wriggling upon a white sheet ...

Is there, we ask, some secret language which we feel and see, but never speak, and, if so, could this be made visible to the eye? Is there any characteristic which thought possesses that can be rendered visible without the help of words? It has speed and lowness; dark-like directness and vaporous circumlocution. But it also has, especially in moments of emotion, the picture-making power, the need to lift its burden to another bearer; to let an image run side by side along with it. The likeness of the thought is, for some reason, more beautiful, more comprehensible, more available than the thought itself...

Yet if so much of our thinking and feeling is connected with seeing, some residue of visual emotion which is of no use either to painter or to poet may still await the cinema. That such symbols will be quite unlike the real objects which we see before us seems highly probable. Something abstract, something which moves with controlled and conscious art, something which calls for the very slightest help from words or music to make itself intelligible, yet justly uses them subserviently—of such movements and abstractions the films may, in time to come, be composed.[141]

An abstract cinema would present the essential form of thought. This is a visionary insight—one that, over the next eighty years, avant-garde filmmakers would embrace again and again.

Survage attempted to realize the cinema he had imagined. In the years 1912 to 1914 he made nearly two hundred abstract watercolours. His achievements seem all the more remarkable when one considers that he embarked on this project only two years after Kandinsky produced his first non-representational paintings.[142] Apollinaire, who helped sponsor Survage's first one-person exhibition in 1917, wrote that Survage had "invented a new art of painting in motion," one that was about to manifest itself in cinema.

In a manner characteristic of the artists who would be participating in many of the twentieth century's art movements, Survage argued that cinema would fulfill the ideals of modern painting. Abstraction was simply a stepping stone on the way to the art of the future, which also would use movement as a resource:

> Painting, having liberated itself from the conventional forms of objects in the exterior world, has conquered the terrain of abstract forms. It must get rid of its last and principle shackle—immobility—so as to become as supple and rich a means of expressing our emotions as music is. Everything that is accessible to us has its duration in time, which finds its strongest manifestation in rhythm, action and movement, real, arranged, and unarranged.
>
> I will animate my painting, I will give it movement, I will introduce rhythm into the concrete action of my abstract painting, born of my interior life; my instrument will be the cinematographic film, this true symbol of accumulated movement. It will execute the "scores" of my visions, corresponding to my state of my mind in its successive phases.

I am creating a new visual art in time, that of colored rhythm and of rhythmic color.[143]

Blaise Cendrars, who wrote about cinema as enthusiastically as Apollinaire himself, produced a text he considered a poetic equivalent to Survage's *Coloured Rhythm* series. It proceeds by offering a series of analogies to living organisms:

A blue streak appears which widens and grows rapidly, from above and below. Frondlike, this blue extends its branches in all directions and grows little trembling leaves on the red, wedge-shaped like the leaflets of the maidenhair fern. The red scales and the blue leaflets now alternate two by two, quiver, turn gently, disappear. There remain on the screen only two large bean-shaped spots, one red, the other blue, facing each other. One could call them two embryos, masculine and feminine. They approach each other, join together, divide, reproduce by cells or by groups of cells. Each spore, each tiny spore is surrounded by a fine violet line which soon grows larger, swells and distends like a pistil. This pistil becomes plump, its head grows larger as you watch it.[144]

Though he attracted hugely influential supporters (from Apollinaire to Cendrars), Survage was never able to film his series paintings. In that respect, his project shared a fate with more avant-garde film projects to come than one might wish.

WALTHER RUTTMANN AND THE ORIGINS OF THE ABSOLUTE FILM

However important a precursor Survage may have been, Walther Ruttmann was the first to develop a clear, adequately elaborated idea of the Absolute Film. Like many painters of his time, the young artist Walther Ruttmann was much concerned with movement, with recreating the sensation of dynamism that has been so prominent a feature of life since at least the late nineteenth century. Ruttmann had trained as an architect and was a self-taught painter and avid amateur violinist. This particular combination of interests would begin to affect his painting just before the First World War and eventually steer him toward filmmaking. His undated and untitled seascape (but probably from 1913 or 1914) is clearly related to his *Lichtspiel Opus Nr. 1* (Lightplay Opus No.1), both in the contrapuntal rhythm of red and blue contrasts and in the wave-like form.[145] A large abstract work of 1918, also untitled (but referred to by Ruttmann scholars as *Letztes Bild*, Last Picture), is similarly a dynamic piece—it contrasts the more solid red and white arcs in the lower-right half of the canvas with the blue and white areas in the upper-left half.[146] The blue forms seem to lift themselves above the more solid red forms and to float up-

wards and backwards in space. Standish Lawder reports that when Ruttmann finished this painting, he remarked to Albrecht Hasselbach, a close friend of Ruttmann who purchased the painting from him, that "it makes no sense to paint any more. This painting must be set in motion."[147]

In a remarkable text on cinema, written sometime between 1913 and 1917, Ruttmann declared:

> I'm in love with the flickering muse, and I share the fate of many men in love: I love her not as she is, but as I would like her to be. For I believe in art in the cinema. But I doubt whether a work of cinematic art has so far ever been made.
>
> You can't cure a sick man by painting his cheeks in fresh colors. And you can't turn a film into a work of art by augmenting and exalting it with "quality." You can gather together the best mimes in the world, you can let them perform in the most exquisite paradise, you can adorn the programs of your film dramas with the names of the most eminent poets—art will never result that way. A work of art will result only if it is born of the possibilities and demands of its material.[148]

Ruttmann realized that he was presenting ideas that had already found some measure of acceptance, at least in vanguard circles. But he also knew that no one had yet applied these ideas to the cinema—for what was being hailed as cinematic art was not cinematic at all, as its value derived from the other arts:

> That's nothing new. But who has drawn the consequences for cinematic art? People are satisfied with justifying the film artistically by pointing to the pantomime. And they're making a big mistake. For—the reproduction of a work of art is by far not the same thing as self-contained art.
>
> Record the achievements of a Bassermann or a Wegener cinematographically, and then compare the impression made by the film to that made by their art on the stage—it is the comparison of an original with a reproduction![149]
>
> But no one has ever gone beyond reproduction. At most there have been attempts to create independently with a few external peculiarities of the medium of film.
>
> So people have tried to seek salvation in the grotesque, a grotesque which is possible only on film—not on the stage (The Student of Prague). They have overlooked the fact that they were exploiting only a secondary possibility of the material, and were otherwise remaining nice and literary.
>
> But literature doesn't have anything to do with film![150]

The films to which he was referring, films like *Der Student von Prag* (1926), were films that used optical and geometric distortions to convey a sense of alienation from reality, of reality having gone awry—films that many historians call "German Expressionist" (but in fact have only a little to with German Expressionist literature and painting). Such works, Ruttmann granted, traded

in experiences that only the cinema could create *einer Groteske, deren Darstellung nur dem Film—nicht der Bühne—möglich ist* (a grotesque, whose representation is possible only for film, not the stage).[151] Ruttmann did not expand on what he meant by saying that such effects, while attainable only by using the materials of cinema, nevertheless exploit "nur eine sekundäre Möglichkeit des Materialcharakters" (only a secondary possibility of material), but one might infer (especially in light of what Ruttmann proceeded to set out as the basic potentials of the film medium) that the distortions of the spatial field characteristic of the Grotesque missed what is primary, and that is the fact that cinema, like music, is an art of time (and only secondarily an art of space). Furthermore, as Ruttmann went on to say, such constructions are literary devices—they serve the story the film tells. However, film has nothing to do with storytelling, or with any literary form. The distortions are merely decorative (albeit cinematic) appurtenances to the author's literary tale.

Ruttmann worked out this idea in a fascinating if characteristically modernist fashion, by contrasting visual and verbal forms (visio and verbum).

> The content of every film drama is conveyed to us through the eye and can therefore become an artistic experience only if it has been conceived optically. But the art of the poet does not use experiences of the eye as its base, and when a poet gives shape to his work he does not address himself to our eye. So his creativity lacks the most fundamental requirements for film. And in this lack lies the main reason for the painful disappointments which every new "author's film" produces. People have gotten stuck in the wrong direction; in search of art they have contented themselves with artistically costuming and preening up the cinema, instead of creating something self-contained by proceeding from its essence. The fact that up to now nothing has been achieved is the result of a thorough misunderstanding of this essence![152]

Ruttmann went on to specify the primary visual character of film, the character that the so-called Expressionist Film missed. That character is the temporal organization of visual form:

> For cinematography belongs to the group of visual arts, and its laws are most closely related to those of painting and the dance. It uses the following means of expression: forms; surfaces; brightnesses and darknesses with all their inherent moods; but above all the movement of these optical phenomena, the temporal development of one form out of the other. It is visual art with the novelty that the root of the artistry cannot be found in a final result, but in the temporal growth of one revelation out of the other. The main task of the creator of films lies therefore in the work's total optical composition, which for its part also makes quite specific demands in the treatment of the individual links. And just about everything that up to now has been rejected as unessential is essential for the aesthetic value of the work. For example: the conscious imparting of a cer-

tain expression by having a dark section of film follow a bright one; a crescendo of the plot through an intensifying rhythm in the sequence of individual sections of film, through a progressive shortening, lengthening, darkening or brightening of these sections, through the sudden introduction of an occurrence with a completely different type of optical character, through the development out of a resting mass to restless, wild movement, through a pictorially composed unity between human beings and the forms of nature which surround them—and through a thousand related possibilities of changes between light and dark, between motionlessness and movement. The formal possibilities are not merely cosmetic, decorative elements of cinematic art. Just as the artistic content in painting is identical with the formal aspects of the work—in such a way that the carriers of the actual spiritual content are to be found in the energies of colors, surfaces, directions of movement, and the like, with the representational aspect playing only a subordinate role—so can the core of the artistic in a work of film-making lie only in the above-mentioned characteristics and possibilities of the cinema.[153]

Ruttmann's identification of the aesthetic with the formal ("Just as the artistic content in painting is identical with the formal aspects of the work... so can the core of the artistic in a work of filmmaking lie only in the above-mentioned characteristics and possibilities of the cinema") is characteristic of the modernist doctrine on aesthetic value. The remark, which most commentators today would likely take as a piece of modernist orthodoxy, brackets another, which is just as deeply embedded in European modernism (though that this view was once orthodox is hardly recognized, as Clement Greenberg drove it into obscurity). The remark reads: "Die eigentlichen Träger des seelischen Gehaltes in den Energien der Farben, Flächen, Bewegungsrichtungen u.s.f. und nur untergeordnet in dem Gegenständlichen zu suchen sind." (The carriers of the actual spiritual content are to be found in the energies of colors, surfaces, directions of movement, and the like, with the representational aspects playing only a subordinate role.) The statement that a work of art's energy conveys its "seelischen Gehaltes" (spiritual content) is especially startling coming from a pioneer of abstract art, for it suggests that Ruttmann's ideas and practices were rooted in a spiritual conception of such works.[154]

So, Ruttmann offered one of the earliest statements of the ideal of the Absolute Film. In addition to this, he was the first to *make* an Absolute Film. He realized his first film, *Lichtspiel Opus Nr. 1* (Lightplay Opus No. 1), between 1919 and 1921. This film, which had a musical accompaniment composed by Max Butting (who worked closely with Ruttmann on the piece), was first shown in Frankfurt, then in Berlin on April 27, 1921. Ruttmann made a single hand-coloured print of it, which had been lost (or preserved only in part, for the print found in the Moscow archive may represent what remains of that single hand-coloured print). In *Lichtspiel Opus Nr. 1*, forms,

sometimes geometric and sometimes organic, enter into various exchanges with one another: one form metamorphoses into another in virtual space, and the movements of forms seem to respond to one another or to move in corresponding rhythms at a light-hearted pace. Today the work is generally presented in black and white; as noted earlier, however, Ruttmann showed a hand-coloured print that juxtaposed colour sections with expanses of solid black; furthermore, short monochrome (tinted) passages undergo changes in hue and saturation that result in changes in the sculptural properties of the animated forms.[155] The film was recently restored (in part) and when one sees the restored colour print, one notices that *Lichtspiel Opus Nr. 1* does not make use of the illusion of depth. It gives no impression of objects (not even of idealized objects) moving in three-dimensional space. Its constructive principles are clearly more closely allied with painting than with the photographed cinema. It resembles what Ruttmann wanted it to resemble: a painting that moves. A dramaturgical conception lies at the heart of the film: the frame is handled like a proscenium, with abstract forms entering and existing from the (flat) space it encloses. Conflicts arise between round forms and pointed forms; colour heightens the conflicts between shapes (especially when two shapes have different colours or when shapes' similar colours focus our attention on their contrasting movements); and, moreover, the shapes' movements often suggest characters in conflict (e.g., sensuous forms pitted against aggressive forms). This Expressionistic dramaturgy is structured according to musical principles (for the music, too, is Expressionist). *Lichtspiel Opus Nr. 1* has three movements with intervals of black (optical silence) separating them. Different passages often have a different mood (as passages in a musical composition often do), and these passages are often defined by their colour (as the passages of a musical composition are often defined by their tonal and harmonic colour). Thus, in the second movement, a rapid, yellow passage follows a long, blue-toned section with slower movements.

Even at its first exhibition it made people realize that here was something new in the world of film, that film is really light and colour(!) articulated according to pure formal principles. Bernhard Diebold, reviewing the film in *Frankfurter Zeitung* in a piece titled *Eine neue Kunst: Die Augenmusik des Filme* (A New Art, The Vision-Music of Films, April 2, 1921), reported that both he and a young friend named Oskar Fischinger were "greatly impressed with this work."[156] Herbert Ihering reviewed the film in *Berliner Börsen-Courier* on May 6, 1921:

> This joint effort of the painter Walther Ruttmann and the musician Max Butting is one of the most interesting that I have seen in the world of film. It means nothing less than the rendering of light and color as sound and the transformation of music into visible motion. Colored triangles do battle with swelling and shrink-

ing colored circles. Rays of light swing, and suns go around in circles. There is only one law which propels them against each other and out of one another and per-mits the forms to increase and decrease—and that law is rhythm. A motion play of rare purity. Indeed film in its original form (which here first came to a late fruition): presenting shapes in rhythmical motion and without the material bur-dens and restrictions. Visible music, audible light. This film was not photographed. It was painted. And it was recorded directly. It was an experiment, that now re-mains only a special case (apparently without connection with the course of de-velopment). And yet perhaps of decisive importance to the development of a new genre: of "lightplays," that will be nothing other than the play of light.[157]

Herman G. Scheffauer wrote an ecstatic commentary on the piece when it was shown in Berlin. His commentary makes it clear that Ruttmann's really was a piece whose structures and dynamics were based on analogies to musi-cal compositions, as Oskar Fischinger's later films also were:

The visible symphony was recently performed in Berlin before a small group of artists, musicians, and film adepts. Expectancy and skepticism were in the air ... The opening notes of the symphony—iridescent atmospheres surcharged with an intense, vibrant light, burned and dissolved upon the screen. These served as backgrounds, melting and flowing into one another—dawnlight and sunburst and twilight, infinite reaches of space, and the caroling blue of morning or the dark saturated stillness of the night sky with a gray *terror vacui*.

The separate notes and cadences of the symphony darted and floated into these luminous fields, as though the notes of the composition had shaken off their schematic disguises of black dots and lines and broken through the bars of the score and the sound waves of the instruments, and converted themselves into a river of flamboyant color ...

Some of the forms these colors assumed were already familiar to us in the restless paintings of the Cubists and expressionists—triangles, trapezoids, cubes, circles, spirals, squares, disks, crescents, ellipses—all the usual fragmentary and activist geometry. But here the writhing, shifting, interlacing, interlocking, in-tersecting elements were fluent and alive, moving to the laws of a definite rhythm and harmony, obedient to an inherent will and impulse ...

Bubbles and foams of color danced and wallowed across the screen, foun-tains and jets of light and shadow shot into infinity, waves—great thundering beach-combers of brilliant sound—came galloping on, heaving, palpitating, ris-ing to a crescendo, throwing off a serpentine of pearls or a thin glittering spray that floated away like some high note, piercing, sustained, ecstatic. Globes and disks of harmonious colors came rolling into the field, some cannoning furiously against others, some buoyant as toy balloons, some kissing or repulsing or merg-ing with one another like white or red blood corpuscles. Triangles sharp as splin-ters darted across the rushing torrent of forms. Clouds rolled up, spread, dis-solved, vanished. Serpents of flame blazed through this pictured music, a colored echo, no doubt, of some dominating note.

From time to time, flickering and wavering in and out, over and under this revel of *Klangfarbe*, or sounding color, the *Leitmotif* appeared in playful, undulant lines, like lightning over a landscape or a golden thread through a tapestry. Then the color equivalents of the strong, clear finale poured themselves like a cataract upon the scene—masses of oblongs and squares falling crashingly, shower upon shower. The silent symphony was over.[158]

Scheffauer's review makes it clear that Ruttmann's film, unlike those of Richter and Eggeling, was an effort to realize, in the twentieth-century technology of film, the nineteenth-century ideal of the *Gesamtkunstwerk*. Eggeling accepted the uniqueness of each of the arts, that no counsel such as "non erit dissimilis pictura ars musica" (let picture be not dissimilar to the art of music) captured the truth concerning the characteristics of the two media and their idea relation. His *Diagonal-Symphonie*, to take that example, was not a piece whose dynamics could be matched to any musical composition. He did not attempt to transpose musical to spatial form, and as a result *Diagonal-Symphonie* possesses a wholly autonomous structure, one that unfolds according to laws unique to the cinema—that is, its formal evolution cannot be matched point by point with the structure of any plausible musical composition. Even so, visual art and music can be seen as Sister Arts, when one understands the basis of that relationship. Eggeling and Richter used musical structures as models for analyzing dynamic and contrapuntal relations, for understanding the axiomatic structure of a form that can evolve through time; but once they had identified those fundamental principles, they did not try to create dynamic visual forms that corresponded point by point with musical forms. Thus, the important differences (discord, dissent) between sound and image were reconciled in a harmony belonging to a higher order. For Ruttmann and later for Fischinger, however, the Inter-Arts Comparison ended with their accepting the essential identity of sound and image.

Leonhard Adelt commented on Ruttmann's *Lichtspiel Opus Nr. 1* in *Berliner Tagblatt* (though it gives *Opus Nr. 1, Symphonie in Drei Teile* as its title). His remarks give a good sense of its colour properties and their musical organization:

> The gentle hues of the planes—sky-blue, dusk-red, dawn-green—playing according to rhythmical laws, are changing into geometrical forms, uni-colored and two-dimensional: angles, squares, circles, wavy lines. Fiery tongues, stinging, the sun's disk glowing fiery-red, then disappearing; stylized clouds lowering and moving away, colored balls rolling like children's balloons, white waves rearing into a crescendo with foamy paws like polar bears, overlaid with a leitmotif of dolphin-like arabesques. In the final movement squares rush by like letters in a sorting machine at a post-office. The concepts of sound painting or tone color seemed literally to fulfill their meaning; content and character of the musical piece express themselves, silently moving in the forms and colors of the continuous motion picture.[159]

He went on to expound on what the development of this sort of film meant for the visual arts; in doing so, he hit on some of the ideas that would make the cinema a paradigmatic art form for many art movements of the twentieth century:

> That an artist with the means of his art achieves effects in the field of another art is not without example; dance and opera also, silently or eloquently, are able to express musical values. Not so, the fine arts. If a painter wanted to represent the effects of music, he could do it only indirectly by showing a circle of listeners seemingly moved by a Beethoven sonata, with the master's death-mask in the background so there would be no misunderstanding as to the meaning of the picture. The obstacle to a direct presentation was that fine arts remain closely tied to frozen form. Music, however, as a rhythmical sequence of sound, is movement, so that these two media are mutually exclusive. This antithesis is now bridged through the moving picture of the music-painter Ruttmann.[160]

Adelt continued by arguing that the cinematic medium overcomes the limitations of representations by overcoming the limitations that its photographic basis imposes on it. He maintained that Ruttmann had bridged the antithesis between frozen form in the visual arts and rhythmical sequence using the film medium, but

> mind you, not through film *per se*. The film *per se*, which does nothing but photograph continuously, is totally without art; only by transcending its automatic naturalism will it become the servant of the arts, will it serve the poetic imagination, the dramatic *mis-en-scène*, the mimic presentation, and in animated film the graphic inspiration. Even then film is not an art in itself, but just its technical medium of expression, thus not to be equated with poetry and painting but only with the scenic frame and the canvas which only creative imagination can fill with the figments of its pre-destined art form.
>
> The painter Ruttmann, who sees music as a painterly movement of form, just as other people might perceive it as an emotional experience or a law of harmony, technically continues the tradition of the animated film in order to find an immediate expression for his vision. His technical production procedure is very painstaking: with seemingly microscopic exactness, the painter must produce a series of many thousands of drawings and then color them. This continuing pictorial sequence, like music—that is the bridging element between the two— is basically an element of eurhythmy, moving form whose rhythm fulfills itself according to the laws of harmony of the presented symphony.[161]

Adelt's next point concerns an important question about Absolute Film— one that arises with special insistence in discussions of Fischinger's films: In what sense are Ruttmann's films not mere illustrations of musical structures? Adelt answered this question rather craftily, by pointing out the difference between the rhythm and dynamics of Ruttmann's visual forms and the rhythm

and dynamics traced by the baton of the conductor who describes invisible forms and lines in the air:

> Ruttmann, as an artist who aims for direct expression of experience, is an expressionist, which means that in place of traditional schemes of communication he substitutes a completely subjective expression. He therefore maintains this free interpretation, which is the individuality and downfall of expressionism, in contrast to the strict commitment of the conductor (who is not so free to form whatever dynamic lines he wishes with his baton, because he is constrained by the score). For expressionism, at best, realizes only one postulate of art, namely, to form the individual experience—but more or less deprives itself of the other, that is, letting others share in this experience. The moving picture offers an exit from this impasse—not intellectually like the score—but out of his just feeling for rhythm and harmony, Ruttmann's painterly paraphrase of the score, full of imagination and on the wings of his fantasy, conjures up musical associations, thus communicating his experience in a painterly as well as a musical way, just like the dance, whose two-dimensional companion-piece the music-film is.[162]

The visual dynamics, then, offer an individual's response to the music, including flights of fancy; so, the visual dynamics do not imitate the dynamics of the accompanying music.

Diebold's review of *Lichtspiel Opus Nr. 1* was genuinely enthusiastic; even so, he suggested a shortcoming: "This work is marked by a decorative, 'Arts and Craft' [Kunstgewerbe] taint, despite its inner will." Alfred Kerr's commentary on the film in the *Berliner Tagblatt* of June 16, 1921, while not nearly so insightful as Diebold's, did identify a troubling bent toward cuteness that the Absolute Film has always had to work at avoiding:

> a strange kind of violet worm transforms into a bent cob of corn; rolls itself into an Edam cheese; into a moon; a small orange. Fish-like, or like magical beasts, all kinds of colorful forms slide soft as ribbons in elegant curves over the flickering surface ...A sunbeam, lemony, sweeps left and right like a broom, pales, fades away. A yellow triangle shoots up, relaxes its form and disperses.

Such a reading, of course, is far too literal, far too Expressionistic. It does, however, foretell the criticism of the Absolute Film that the Surrealists Luis Buñuel and Salvador Dalí would soon offer. Stark architecture and complex musical structures make later films by Ruttmann, *Opus Nr. III* and *Opus Nr. IV*, entirely free of this decorative *Kunstgewerbe* "taint"; their sensuous beauty is of an altogether purer order.

What techniques did Ruttmann use to produce his pioneering works? The question has long been debated. Lotte Reiniger, who knew the artist, says that he produced his films by painting with oil on a small glass plate on an animation stand beneath the camera. He shot a frame after each brush stroke (or

alteration); and since the paint was still wet, he could wipe it away and modify the form. According to Hans Richter, Ruttmann skewered a blob of plasticine on a stick, moulded it, then fixed the stick in front of the camera and turned it slowly while filming frame by frame. Reprints of frames from *Lichtspiel Opus Nr. 1* lend credibility to Richter's claim. Furthermore, a contemporary photograph of the artist confirms Richter's description of Ruttmann's methods, for we see on a shelf a frame holding five horizontal sticks on which, shaped into an undulating form, are what could be plasticine.[163] There is one further possibility: Fischinger sold Ruttmann a version of his wax-cutting machine, and Ruttmann's experiments with wax forms may have evolved into the technique that Richter described (using wax, not plasticine).[164]

Ruttmann likely used both techniques: the ones that Reininger and Richter described. Whatever the case, his abstract films have a character different from what his Berlin colleagues were producing as they spearheaded the development of abstract film (or Absolute Film). The visual forms that Eggeling and Richter incorporated into their films are more strictly geometric—they are graphic forms reduced to rectilinear lines and simple curves (in Eggeling's case) or simple geometric forms bounded by straight lines (in Hans Richter's case)—and both artists hold the rhythms that govern the development and variation of these geometric forms to strict metres. Richter's forms reveal his Constructivist leanings, for they consist of simple squares and rectangles and their dynamic properties are influenced by the scroll sequences that were their origin—they develop in steady increments, as though the camera were being moved at a constant rate along a long, thin strip, along which all visual developments are evenly spread out (occurring by increments determined by dividing the distance a given movement will traverse by the number of stages used to represent that movement). By comparison, Ruttmann's visual forms are less strictly geometrical, their dynamics more subtle and more dance-like. His films are altogether lighter and more Impressionistic. Richter, speaking as an artist who had absorbed many of Constructivism's ideals, criticized the lack of scientific seriousness of Ruttmann's films. From the perspective of a Constructivist, he was right to do so. Ruttmann's films, however, grew out of a different set of ideas.

HANS RICHTER AND VIKING EGGELING
THE ABSOLUTE FILM AS THE FULFILLMENT OF MODERN ART MOVEMENTS

In the mid-1950s, Hans Richter was living in New York City and teaching at the City College. A new independent American cinema was emerging then, and many young people, enthusiastic to discover new models for cinematic

production, looked to Richter as a predecessor and mentor. So it was that Jonas Mekas asked Richter to contribute to the first issue of the film magazine he had founded, *Film Culture*, which quickly became the unofficial house organ of the New American Cinema movement. Richter's essay, "The Film as an Original Art Form," was a reflection on his accomplishments during the early years of Absolute Film:

> The main aesthetic problem in the movies, which were invented for *reproduction* (of movement) is, paradoxically, the overcoming of *reproduction*. In other words, the question is: to what degree is the camera (film, color, sound, etc.) developed and used to *reproduce* (any object which appears before the lens) or to *produce* (sensations not possible in any other art medium)? ... In the words of Pudovkin: "What is a work of art before it comes in front of the camera, such as acting, staging, or the novel is not a work of art on the screen."
>
> Even to the sincere lover of the film in its present form it must seem that the film is overwhelmingly used for keeping *records* of creative achievements: of plays, actors, novels, or just plain nature.[165]

The interest in sensations that are unique to the film medium—sensations that could not be produced but through the film medium—is pure modernism. So, too, is the idea that film becomes film—film becomes an original art form—by purifying itself of any contaminating influence from adjacent media and becoming truly (purely) film. This, Hans Richter claimed, is what documentary cinema accomplished:

> With the documentary approach, the film gets back to its fundamentals. Here, it has a solid aesthetic basis: in the free use of nature, including man, as raw material. By selection, elimination, and coordination of natural elements, a film form evolves that is original and not bound by theatrical or literary tradition. That goes, of course, as much for the semidocumentary fictional film (*Potemkin, Paisan*), as for the documentary film itself. These elements might obtain a social, economic, political, or general human meaning, according to their selection and coordination. But this meaning does not exist a priori in the facts, nor is it a reproduction (as in an actor's performance) ... It has come to grips with facts— on its own original level.[166]

Here Richter offered the semiotic proposition that the documentary (and semidocumentary) film is art because it is productive—it *makes* meaning rather than recording pre-established meanings. It does this through configuring relations that do not pre-exist the film's making.

However, he went on to say that relations in a documentary film elicit a rational response, because in documentary films the relata have a factual character. There is another type of film that can elicit a response of a different order:

[The documentary film] covers the *rational* side of our lives, from the scientific experiment to the poetic landscape-study, but never moves away from the factual. Its scope is wide. Nevertheless, it is an original art form only as far as it keeps strictly to the use of natural raw material in rational interpretation ...

The influence of the documentary film is growing, but its contribution to a filmic art is, by nature, limited ... Since its elements are facts, it can be original art only in the limits of this factuality. Any free use of the magic, poetic, irrational qualities to which the film medium might offer itself would have to be excluded *a priori* (as nonfactual). But just these qualities are essentially cinematographic, are characteristic of the film and are, aesthetically, the ones that promise future development.[167]

Richter did not explain why he believed that irrational, poetic, magical qualities are essentially cinematic. But one might conjecture what led him to that conviction: dynamism exerts a spell, a sort of magical charm. That charm is cinema's real strength; but documentary cinema restricts its effects by shackling its dynamism to the order of facts. Avant-garde cinema, by contrast, unfetters dynamism and allows cinema's capacity to charm to achieve its full potential—to become mysterious:

There is a short chapter in the history of the movies that dealt especially with this side of the film. It was made by individuals concerned essentially with the film medium. They were neither prejudiced by production clichés, nor by necessity of rational interpretation, nor by financial obligations. The story of these individual artists, at the beginning of the 1920's, under the name of "avant-garde," can be properly read as a history of the conscious attempt to overcome reproduction and to arrive at the free use of the means of cinematographic expression. This movement spread over Europe and was sustained for the greatest part by modern painters who, in their own field, had broken away from the conventional: Eggeling, Léger, Duchamp, Man Ray, Picabia, Ruttmann, Brugière, Len Lye, Cocteau, myself and others ...

These artists discovered that film as a visual medium fitted into the tradition of the art without violation of its fundamentals. It was there that it could develop freely: "The film should positively avoid any connection with the historical, educational, romantic, moral or immoral, geographical or documentary subjects. The film should become, step by step, finally exclusively cinematography, that means that it should use exclusively "photogenic elements." (Jean Epstein, 1923)[168]

This insight led Richter to assert: "Problems in modern art lead directly into the film. Organization and orchestration of form, color, the dynamics of motion, simultaneity, were problems with which Cézanne, the cubists, the futurists had to deal."[169] He continued by relating the reasons for his own early involvement in Absolute Film to the issues being dealt with in visual arts of the time:

Eggeling and I came directly out of the structural problems of abstract art, volens-nolens into the film medium. The connection to theater and literature was, completely, severed. Cubism, expressionism, dadaism, abstract art, surrealism found not only their expression in films but also *a new fulfilment on a new level*.

The tradition of modern art grew on a large front, logically, together with and into the film: the orchestration of motion in visual rhythms—the plastic expression of an object in motion under varying light conditions, "to create the rhythm of common objects in space and time, to present them in their plastic beauty, this seemed to me worthwhile" (Léger)—the distortion and dissection of a movement, an object or a form and its reconstruction in cinematic terms (just as the cubists dissected and rebuilt in pictorial terms)—the denaturalization of the object in any form to recreate it cinematographically with light—light with its transparency and airiness as a poetic, dramatic, constructive material— the use of the magic qualities of the film to create the original state of the dream—the complete liberation from the conventional story and its chronology in dadaist and surrealist developments in which the object is taken out of its conventional context and is put into new relationships, creating in that way a new content altogether. "The external object has broken away from its habitual environment. Its component parts had liberated themselves from the object in such a way that they could set up entirely new relationships with other elements."—André Breton (about Max Ernst)[170]

Richter expanded on Breton's remarks on the role of the external object in Max Ernst's art (and Ernst's art is a magical art if ever there was one) by relating it to the shaping role the external object has had in the experimental cinema:

The *external object* was used, as in the documentary film, as raw material, but, instead of employing it for a *rational* theme of social, economic, or scientific nature, it has broken away from its habitual environment and was used as material to express *irrational* visions. Films like *Ballet Mécanique, Entr'acte, Emak Bakia, Ghosts Before Breakfast, Andalusian Dog, Diagonal Symphony, Anemic Cinema, Blood of a Poet, Dreams that Money Can Buy*, and many others were not repeatable in any other medium and are essentially cinematic.[171]

The claim that twentieth-century artistic movements had not just found expression in film, but "a new fulfilment on a new level," goes a distance in describing the relation between film and vanguard art in the first half of the twentieth century. However, it leaves out of account an unrecognized fact: that these arts found their fulfillment in film because cinema helped form their artistic ideals. Before commenting further on that, however, we must seek some clarification about what Richter had in mind when he proposed that truly filmic forms would emerge not from literature but from "the orchestration of motion in visual rhythms."

THE LANGUAGE OF ART
CONSTRUCTIVISM, REASON, AND MAGIC

However magical this new cinema would be, it would still have a regulative basis.[172] Between around 1800 (roughly the time when electricity began to attract close attention) and, say, 1950, thinker after thinker proposed that science would show how wondrous natural processes are. Reason, it was postulated, would uncover the laws that account for the wonder of art. Hans Richter was involved in the international Constructivist movement, and his contribution to the theory of form building emerged partly from the ideals of that movement. Constructivism strived to generalize the principles of form and sought a supra-individualist basis for artistic construction. It attempted to discover a lawfulness in the making of art. Some of his visual art of the mid-1920s, such as *Farbenordnung* (1923), shows the influence of Lazar Markovich ("El") Lissitzky's work, especially in its use of trapezoidal forms to suggest perspectival foreshortening.[173] The influence was more than indirect: Lissitzky had arrived in Berlin in late 1921 or early 1922, on behalf of Anatoly Vasilievich Lunacharsky, specifically to engage German artists in a dialogue about artistic production in the Soviet Union. He was there, in effect, to serve as a conduit for introducing Constructivist ideas to Central and Western Europe. He quickly became friends with Theo van Doesburg and established contact with the De Stijl artists Vilmos Huszár and J.J. Oud.[174] In late May 1922, Richter and his friend and fellow painter/filmmaker Eggeling went to Düsseldorf for the Erst Kongress der Internationale fortschrittlicher Künstler (First International Congress of Progressive Artists). Lissitzky was also there, representing *Veshch'/Gegenstand/ Objet*; Richter and Eggeling represented *De Stijl* and "the Constructivist groups of Romania, Switzerland, Scandinavia and Germany."[175] On the second day of the conference, differences arose among the conference participants. This clash resulted partly from conflicting notions about the organization's goals: most of those attending wanted it to focus on practical economic concerns and not to concern itself unduly with intellectual or artistic matters. Van Doesburg, Lissitzky, and Richter disagreed, and established their own Internationale Faktion der Konstrucktivisten (International Faction of Constructivists). The Faktion's declaration offered another reason for the schism (besides the Faktion's intellectual thrust):

> We define the progressive artist as one who fights and rejects the tyranny of the subjective in art, as one whose work is not based on lyrical arbitrariness, as one who accepts the new principles of artistic creation—the systemization of the means of expression to produce results that are universally comprehensible...
> THE ARTISTS OF THE CONGRESS HAVE PROVED THAT IT IS THE TYRANNY OF THE INDIVIDUAL THAT MAKES THE CREATION OF A PROGRESSIVE AND UNIFIED INTERNATIONAL IMPOSSIBLE WITH THE ELEMENTS OF THIS CONGRESS.[176]

MODERNISM AND THE ABSOLUTE FILM

The Faktion's declaration echoed Soviet Constructivists' desire to assimilate the labour of artists with that of other workers in other sectors of society: "Art is a universal and real expression of creative energy, which can be used to organize the progress of mankind; it is the tool of universal progress." Emphasizing their anti-individualist convictions, van Doesburg, Lissitzky, and Richter declared that the time had come to form a group that "denies and attacks the predominance of the subjective in art, and builds artistic works not upon lyrical whim, but rather on the principle of the *Gestaltung* by organizing the means systematically into an expression intelligible to all."[177] The manifesto was a radical, vanguard attack on the prevailing artistic ethos, for it also condemned Expressionists and "Impulsivists" for their individualism. Two years later, in 1924, Richter commented on the appropriation of the term "Constructivism":

> The word "Constructivism" emerged in Russia. It describes an art which employs modern construction materials in the place of conventional materials and follows a constructive aim. At the Düsseldorf Congress of May 1920 [actually 1922] the name Constructivism was taken up by Doesburg, Lissitzky and me as the Opposition, in a broader sense. Today, what passes by this name has nothing more to do with … elementary formation, our challenge at the Congress. The name Constructivism was in those days borrowed as a slogan which was applied both against the legitimacy of artistic expressions [present there] and as an efficient temporary communication—against a majority of individualists at the Congress.[178]

Richter correctly identified the use of modern (industrial) materials as a defining feature of Constructivism. Indeed, the use of those materials characterized those exemplars of the Constructivist ideal, the laboratory works produced by Rodchenko and his colleagues in OBMOKhU (Obshchestvo molodykh khudozhnikov; Society of Young Artists) for their Moscow exhibition that opened on May 22, 1921.[179] Richter also pointed out, meticulously, that he and his colleagues used the term "Constructivism" in a somewhat different sense: as a movement that concerned "elementary formation," which they conceived as an antidote to impulsivism and individualism.

Lissitzky, Richter's comrade in the battle against individualism, perhaps influenced Richter's understanding of Constructivism. In Berlin in the winter of 1922–23, some eight months after the founding of the Faktion, Lissitzky characterized the emergence of Constructivism in an unusual way:

> Two groups claimed constructivism, the Obmoku and the Unovis.
> The former group worked in material and space, the latter in material and a plane. Both strove to attain the same result, namely the creation of the real object and of architecture. They are opposed to each other in their concepts of the practicality and utility of created things. Some members of the Obmoku group…

went as far as a complete disavowal of art and in their urge to be inventors, devoted their energies to pure technology.

Unovis distinguished between the concept of functionality, meaning the necessity for the creation of new forms, and the question of direct serviceableness. They represented the view that the new form is the lever which sets life in motion, if it is based on the suitability of the material and on economy. This new form gives birth to other forms which are totally functional.[180]

It is not difficult to see which side Lissitzky was on: UNOVIS (Utverditeli novogo iskusstva; Affirmers of the New Art) had been organized by Kazimir Malevich and reflected his spiritual interests in elementary constructions.[181] Lissitzky's gesture of taking the term "Proun" (Proekt utverzhdeniia novogo; Project for the Affirmation of the New) to refer to his own work of the period aligns him with the work of UNOVIS. Lissitzky was more strongly committed to Suprematist spiritual elementarism than to the Productivism toward which most Constructivists inclined.[182] Embracing such spiritual convictions in the Soviet Union was an idiosyncratic gesture; though Malevich's abstractions influenced the new artists associated with OBMOKhU, the "affirmers" associated with UNOVIS, unlike Lissitzky, did not claim Constructivism as their cause. OBMOKhU artists rejected Malevich's spiritual concerns, the very basis for his new art, in favour of Marxist principles. But in Europe, Lissitzky's idiosyncratic redefinition of Constructivism (a redefinition that aligned the movement with Malevich's elementarist spirituality and that minimized OBMOKhU's Marxist/materialist commitments) took hold, and this redefinition influenced Richter's understanding of Constructivism as an elementarist art of much the same sort as De Stijl advocated. Thus, Richter advertised *G: Material zur elementaren Gestaltung* (Material for Elementary Organization/Deign) in *De Stijl* as "the organ for the constructivists in Europe."[183] Lissitzky's redefinition was the view of Constructivism that *Veshch'/Gegenstand/Objet* propounded.[184]

There were grounds for Lissitzky to appropriate the term "Constructivism" for his project, which used simple geometric art to convey spiritual feelings (and kept its distance from Marxism), which he tried to spread among vanguard artists of Central and Western Europe.[185] He noted the similarity between the geometric forms of De Stijl artists and those of contemporary Russian artists; and he noted the correspondence between van Doesburg's artistic radicalism, which proposed to poeticize reality, and the Russian Constructivists' interest in integrating art and life.[186] He would have noted, too, the spiritual interests of the Neo-Plasticists and their affinity with the pneumatic concerns of the Suprematists. It was his nature to recognize similarities in people's beliefs that might allow them to make common cause with him in transforming reality, so he developed a unique understanding of Constructivism: for him, it was an art movement concerned with elementary principles and sympathetic to spiritual concerns. Furthermore, in this effort

to internationalize the avant-garde, Lissitzky faced the difficult task of reconciling the rational interests of the Constructivists ("rational" in the sense that Marx understood reason) and the spiritual interests of the Suprematists. The Neo-Plasticists' Hegelian leanings allowed him to discern how the strife between Reason and Spirit might be resolved.[187]

The drive to uncover the universal laws of art making fuelled Eggeling and Richter's research into what they called a *Universelle Sprache* (universal language) of art. Richter, in fact, assumed the task of identifying the scientific principles of art as Constructivism's defining ambition. At the Düsseldorf conference he declared that Constructivist artists had "overcome our own individual problems and reached the fact of an objective issue in art. This objective issue unites us in a common task. This task leads us (through the scientific investigation of the elements of art) to want something other than just a better image, a better sculpture: it leads us to reality."[188]

The Faktion founded at Düsseldorf later renamed itself the Konstruktivistische internationale schöpherische Arbeitsgemeinschaft (Constructivistic International Creative Workshop, KisA) and expanded its membership to include, besides the original trio, Karel Maes and Max Burchartz. KisA associates included Werner Graeff, Raoul Hausmann, Hannah Höch, Erich Buchholz, László Moholy-Nagy, and Cornelis van Eesteren. Richter played a central role: a second manifesto of the group, published in *De Stijl* 5, no. 8 (1922), gave Richter's address as the group's office address. Visitors to KisA meetings included Hans Arp, Tristan Tzara, and Kurt Schwitters. Gert Caden, an observer of a second congress—convened by the KisA along with some erstwhile Dadaists—observed how closely the ideas of Richter, Lissitzky, van Doesburg, and Moholy-Nagy all meshed.[189] What he wrote about this reflects Eggeling and Richter's ideas on the *Universelle Sprache* and its relation to International Constructivism and Neo-Plasticism:

> Not the personal "line"—what anyone could interpret subjectively—is our goal, but rather the work with objective elements: circle, cone, sphere, cube, cylinder, etc. These elements cannot be objectified further. They are put into function; the painting also consists of complementary tensions in the color-material and the oppositions of vertical, horizontal, diagonal ... Thus a dynamic-constructive system of force is created in space, a system of innermost lawfulness and greatest tension ...That is the formal side of our efforts. More important, however, is the ideological side: that these things agitate for a clear, simple plan for life, one of inner necessity with an exact balancing of forces. Here our goal meets the goals of the social revolution. So seen, our task is not party-political, it is rather a task of cultural politics.[190]

So Caden cast the ideas of Richter, Lissitzky, van Doesburg, and Moholy-Nagy, in a way that echoed Piet Mondrian's ideas about dynamic equilibrium and

inner necessity. Mondrian's political affiliations were perhaps different from those that Caden sets out here, but he and KisA shared a fundamental understanding of *Gestaltung*. Mondrian would even have agreed that the goal of art is to balance the forces that act on human life. The coincidence makes it easy to understand how, their revolutionary proclivities notwithstanding, Marxist-Constructivist arts could be committed to spiritual amelioration.

Eggeling and Richter proposed to apply formal principles of *Kontrast-Analogie* (contrast-analogy) to reconfigure artistic form, to make artistic forms (i.e., works of art) consistent with the materials in which they are realized. This ambition was among the reasons Richter set to work making abstract films: the abstract film would be the true art of cinema, cinema that is true to its own nature, not that of literature or theatre. Richter's views about recasting the arts took many forms: sometimes he sided with Dadaists, sometimes with Surrealists, and sometimes with Constructivists/Neo-Plasticists. He emphasized his Constructivist/Neo-Plasticist leanings in a 1924 article that first appeared in the journal he and Werner Graeff edited, one of the first journals of avant-garde art, *G—Zeitschrift für elementare Gestaltung* (G—Journal of Elementary Formbuilding). Titled "Die schlecht trainierte Seele" (The Badly Trained Sensibility), that article was illustrated with reproductions of film frames, most of them from *Rhythmus 21* (though there is one from *Rhythmus 23*).[191] These images, presumably, were intended to indicate ways in which the poor training alluded to in the article's title might be undone.[192]

"The Badly Trained Sensibility" foreshadowed many of the ideas that structural filmmakers of the 1960s would propound. The article starts out by attacking the contention that feelings are without form:

> They say feelings are conceived in sleep and, hatching themselves out, just appear! It is simply not true. Feeling is just as precisely structured and mechanically exact a process as thinking: it is just that our awareness of this process, or rather its IDENTITY, has been lost. So modern man is excluded from a whole sphere of perception and action.[193]

The idea that feelings are formless served as the basis for an intuitive approach to creation that valued sincerity over structure. Richter proposed to combat this tendency by according primacy to rhythm organized by universal sensory laws:

> Still without a well-defined aesthetic, it does not understand that creative form [*schöpferische Gestaltung*] is the control of material in accordance with the way we perceive things. Not knowing how our faculties function film does not realise that this is where its job really lies. Instead, the screenplays of today strain for theatrical effects.
>
> By film I mean visual rhythm, realised photographically; imaginative material coming from the elementary laws of sensory perception.[194]

Richter claimed that the form of *Rhythmus 21* followed the shape of feelings.[195] This required eliminating recollection and bringing the time of the film entirely into the compass of the present.[196]

> This film gives memory nothing to hang on. At the mercy of "feeling," reduced to going with the rhythm according to the successive rise and fall of the breath and the heartbeat, we are given a sense of what feeling and perceiving really is: a process—movement. This "movement" with its own organic structure is not tied to the power of association (sunsets, funerals), nor to emotions of pity (girl match-seller, once famous—now poor—violinist, betrayed love), nor indeed to "content" at all, but follows instead its own inevitable mechanical laws.[197]

In this article, Richter sketched out the background to his work in Absolute Film—and to the efforts he and Viking Eggeling were making to develop a *Universelle Sprache*. His commentary took a dialectical form. He proposed that form building (*Gestaltung*) relies on the following: relations of maximal contrast between elements (as examples of the attributes that might enter into relations of maximal contrast, he cited position, proportion, and light distribution); relations between most nearly identical elements; and relations that modulate the contrast between elements. Regarding this last, the examples he offered focused on movement; he devoted much thought to the ways in which movements could be more or less similar, and the article offered several attributes in respect of which different movements could be more or less similar or more or less contrasting—could resolve, to a greater or lesser extent, the tension between otherwise contrasting elements. He argued that film is visual rhythm created using photographic technology and that rhythm and technology serve as building blocks for the imagination, which creates by drawing on the medium's material attributes and on laws governing the senses.[198] Extending Eggeling's ideas of contrast to montage, he asserted that perception involves opposition: unless a thing is differentiated (i.e., unless it has borders), it cannot be perceived; but though separation is necessary (so that the object can be perceived as having boundaries), recognizing affinities among things is required to place the perceived object in a context. The important principle of unity-in-difference (Kontrast-Analogie) applies in the theory of sensations just as well as it does in aesthetics.

The role that contrast between elements can play in giving shape to a work of art had been one of Richter's fundamental interests since 1917.[199] The method of creating works by articulating contrasts and similarities allowed Richter to be prodigiously productive, producing sometimes three or four visionary portraits in a day. In late 1917 he became disenchanted with this spontaneous method and the results it produced. He conceived the desire to create more structured abstract works in which a single rhythmical effect would unify the pictorial elements. "The completely spontaneous, almost automatic process by

which I painted my 'visionary portraits' no longer satisfied me. I turned my attention to the structural problems of my earlier Cubist period, in order to articulate the surface of my canvases" (ibid., p. 61). The works that resulted were his *Dada-Köpfe*. These Dada-inspired portraits, which became increasingly abstract, show that even this early, Richter was concerned less with the sitter's psychology than with formal relationships—with working out contrasts in which blacks and whites traded roles in defining volume and space. These portraits concern figure–ground relationships, which Richter articulated using contrasting black and white areas that, depending on the areas the tone covered and the relation of those areas to areas in other tones, traded roles in representing form and space. Viola Kiefer wrote of them: "What was strived for was not a choice for or against some position, but a synthesis of polarities, the harmonization of opposites, order and chance, logic and intuition, consciousness and unconsciousness, objectivity and abstraction."[200] Some of Richter's other drawings from the period, for example, *Häuser* (1917) and *Musick-Dada* (1918), work on similar principles.[201]

EGGELING'S INTEGRITY

By the time he met Richter, in Zürich early in 1918, Eggeling had already started work on his scrolls, which became the basis of his film experiments. He had begun these experiments as early as 1915–17. He had also already been working systematically on a survey of elementary forms in an effort to frame a set of syntactical principles that governed their relations. Richter quickly noticed Eggeling's fanatical dedication, which was evident in the systematic manner in which he pursued the study of contrasts. Richter wrote about their meeting forty-five years later:

> One day at the beginning of 1918 … Tristan Tzara knocked at the wall which separated our rooms in a little hotel in Zurich and introduced me to Viking Eggeling. He was supposed to be involved in the same kind of esthetic research. Ten minutes later, Eggeling showed me some of his work. Our complete agreement on esthetic as well as on philosophical matters, a kind of "enthusiastic identity" between us, led spontaneously to an intensive collaboration, and a friendship which lasted until his death in 1925 …
>
> Eggeling's dynamics of counterpoint, which he called *Generalbaß der Malerei*, embraced generously and without discrimination every possible relationship between forms, including that of the horizontal to the vertical. His approach, methodical to the degree of being scientific, led him to the analytical study of the behavior of elements of form under different conditions. He tried to discover which "expressions" a form would and could take under the various influences of "opposites": little against big, light against dark, one against many, top against bottom, and so forth.[202]

Having realized that their interests overlapped, Richter invited Eggeling to return with him to his parental home. There they worked together on formal exercises; then, in 1920, they began to experiment with film. Though the two worked closely for a time, Eggeling's work clearly differed from Richter's. Eggeling's drawings in the Yale University Library reveal that the abstract shapes in which he took an interest evolved from natural forms: he was preparing what were essentially notations for sets of natural forms, and then (as Goethe's scientific method prescribed) putting them through an evolution that proceeded according to visual laws.[203] Experiencing these evolutionary dynamics can enhance the senses and can (as Goethe suggested) lead us to grow new organs of perception. The forms Eggeling evolved out of the elementary shapes he was studying are organic, yet they have something of the character of ideograms (as do the shapes in his well-known *Diagonal-Symphonie*). The syntax that Eggeling strived to work out would be based on oppositions between pairs of attracting or repelling forms. His fundamental task, then, was to identify certain elementary forms and to determine their affinity for, or antagonism toward, other elementary forms (to identify the "Elementaren und Gesetzmässigen" [elements and basic laws] of art).

When he met Richter, Eggeling was working on ideas about orchestrating lines that would eventually form a part of the general theory of painting that Richter alluded to in the passage cited above, a theory he referred to as the "Generalbaß der Malerei" (a topic to which we shall soon turn).[204] In 1917, Eggeling learned about the Dada movement, and while he did not share their anti-artistic animus (or their politics), he found liberating the Dada idea that the conventions of traditional art had grown stifling. In 1918 he moved to Germany, where Dada had taken hold. He had already organized the geometric possibilities of the line into themes. He had also found the means to orchestrate the line, and he would soon anthologize these ideas in his (likely uncompleted) film, *Horizontal-Vertikal Orchester* (1923). These means relied on principles similar to those of counterpoint in music—that is, on creating a play of contrast (using opposing features) and analogies (using similar features). Drawing partly on Hans Arp's "The Rules of Plastic Counterpoint," but mostly working on his own through empirical and practical study, he developed his ideas systematically. Over long years, with exacting thoroughness, he drew up models of formal classification, organizing them according to similarities and contrasts. From Richter he drew the idea of harmonizing tonal masses, incorporating Richter's idea of counterpointing positive and negative areas into his structural system (which to that point had focused on counterpointing contrasting linear elements).[205] He soon discovered that by using contrast and analogy he could develop any formal element, not just vertical and horizontal lines (as Mondrian was doing). Still, for Eggeling, the origin of all artistic forms was the line.

This investigation carried Eggeling beyond traditional art media. He began, partly under the influence of Bergson, to explore time in the visual arts, and this led him to his scroll painting (and his work on the film *Horizontal-Vertikal Orchester*). He was led to this interest in time partly because he had experienced difficulty incorporating motion into his visual language (though he had managed to create a dynamic effect by using diagonal lines and curves, as well as forms oriented along diagonals).[206] After he began collaborating with Richter, he decided that a better way to create a dynamic effect was to extend his work into the dimension of time. His and Richter's first attempts at this took the form of laying out a sequence of constructions on a long scroll of paper: the viewer was required to scan the length of the scroll (i.e., view it through time), since the constructions could not all be seen at once. However, this approach left them dissatisfied: scroll paintings implied movement more strongly than did the diagonalization of form in traditional painting, but they did not present actual movement. They next experimented with an elastic canvas (very thin sheets of rubber) that could be stretched horizontally and vertically to create a sort of movement. When even this left them dissatisfied, they found themselves exploring film.

TOWARD A *GENERALBAß DER MALEREI*

Richter, when he met Eggeling, was already interested in the analogy between music and painting. Soon after they met, he explained to Eggeling that he wanted to paint completely objectively, following the principles of music, with long and short note values (a double ambition that would later animate the work of Peter Kubelka). This is not to say that Richter—or Eggeling for that matter—wished to create visual forms that mirrored specific musical compositions, as Ruttmann and Fischinger would later do; rather, they wanted to pattern their work after the lawfulness of musical structure. Eggeling played the leading role in conceiving the core notions of their *Generalbaß der Malerei* and in working out its basic principles. He was a brilliant theoretician and artist whose intensity deeply affected those who met him. Hans Arp described meeting Viking Eggeling:

> I met him again in 1917 in Zürich. He was searching for the rules of a plastic counterpoint, composing and drawing its first elements. He tormented himself almost to death. On great rolls of paper he had set down a sort of hieratic writing with the help of figures of rare proportion and beauty. These figures grew, subdivided, multiplied, moved, intertwined from one group to another, vanished and partly reappeared, organized themselves into an impressive construction with plantlike forms. He called this work [his *Diagonal-Symphonie*] a "Symphony."[207]

Richter and Eggeling together tried to work out a theory to ground visual compositions in the formal principles that music had uncovered. Richter explained why he assumed that a syntax regulating the interplay (counterpoint) of visual elements could be modelled on music:

> In musical counterpoint, we found a principle which fitted our philosophy: every action produces a corresponding reaction. Thus, in the contrapuntal fugue, we found the appropriate system, a dynamic and polar arrangement of opposing energies, and in this model we saw an image of life itself: one thing growing, another declining, in a creative marriage of contrast and analogy [this combination of terms will soon become highly significant]. Month after month, we studied and compared our analytical drawings made on hundreds of little sheets of paper, until eventually we came to look at them as living beings which grew, declined, changed, disappeared—and then were reborn …
>
> It was unavoidable that, sooner or later in our experiments, these drawings, which were spread about on the floor of our studio, would begin to relate systematically to each other. We seemed to have a new problem on our hands, that of continuity, and the more we looked, the more we realized that this new problem had to be dealt with … until, by the end of 1919, we decided to do something about it. On long scrolls of paper Eggeling developed a theme of elements into *Horizontal-Vertical Mass*, and I developed another into *Praeludium*.[208]

The history of *Film ist Rhythmus* seems to be this: In late 1920 or early 1921, Richter and Eggeling had studio technicians shoot tests of their scroll drawings. Richter's test strip, which he presented under the title *Film ist Rhythmus*, was about thirty seconds long (at silent film speed)—so short, in other words, that on one occasion, when it was presented in Paris, a critic missed the work because he took off his glasses to clean them. The footage was not entirely satisfactory, in part because Richter was still learning about the medium. Werner Graeff tells us that as late as 1922, Richter still did not know that a film frame has a horizontal format, not a vertical one. Richter shot an additional thirty seconds of footage, which he added to *Film ist Rhythmus*; this minute of film is what he showed at the matinée of Absolute Film in May 1925. By 1927, with Erna Niemeyer's help—Niemeyer was now his wife, having worked with Eggeling on *Diagonal-Symphonie* (which she finished animating in the fall of 1924)—he had produced another thirty seconds of film. This ninety-second piece of film Richter came to call, simply, *Rhythm*; it constitutes the middle section of the misleadingly titled *Rhythmus 23*.[209]

What Richter offered this enterprise was a theory about form building. Artworks should evoke feeling through form, he proposed: through its form, an artwork elicits and resolves tensions. The tensions appropriate for artworks to modulate are those which arise from creating and resolving contrasts among features that are essential to that medium (features that all works realized in

that medium have without exception). Every frame is a distribution of light and dark—and filmmaking is essentially the art of modulating the distribution of light. Thus, it is fitting for film form to modulate tension by varying the contrasts among dark and light areas.

Constructing forms that modulate tension by varying the contrasts among features essential to the medium brings those forms into alignment with the nature of the materials in which it is realized. But this approach does even more than that. The emotional associations that individuals have with particular representational images are unpredictable. They are loose, or, to use Richter's word, "flabby." By contrast, people's responses to forms rooted in the actual materials of the medium do not depend on the twists in individual viewers' life experiences; the response is common to all and therefore predictable. It should be possible, then, to work out a scientific basis for developing such forms. And once that basis had been worked out, the problems of creating artistic form would not engage with the vagaries of an individual's make-up; instead, artistic form would be rooted in the common constitution of humankind.[210]

From the way the two aspects of contrasting and relating depend on each other, their mutual interaction, comes feeling. This is the way of the creative process ...

What flourishes today as "feeling" is easy submission to uncontrollable emotions about the hero, chaste maiden, and smart businessman ... This sensibility, some kind of mad thing made up of feelings preserved from past, and unreal, centuries, dominates and distorts our vision of the world.

Our perceptive faculties have become flabby, our breathing has become restricted; our sensibility—unable to develop—has become more a weakness than a strength ...

The development of such a soundly based approach ... touches at the root of basic questions about the evolution of the psyche, which originally had a certain "thinking power" now lying fallow. This "thinking power" enables the sensibility to exercise its powers of judgment and of action. It provides the whole man with powerful means of action indispensable to his general sense of direction.[211]

Elsewhere, Richter explained the connection between Eggeling's theory of *Kontrast-Analogie* and counterpoint:

[a] principle of dynamic relations as in counterpoint, [it] comprehended every possible relation among forms without discrimination, including the horizontal-vertical relationship ... Its almost scientific method led him [Eggeling] to analyze how elements of form "behaved" under various conditions. He tried to discover what expression a form would assume under the influence of different kinds of "opposites": small versus large, light versus dark, one versus many, above versus below, etc. In that he intimately combined external contrasts with

analogous relations of form, which he named "analogies," he could produce an endless variety of relations among forms. Opposing elements were used to dramatize, to tighten the form complex; analogies were used to relate them again to each other.[212]

The theoretical foundations of Richter's work developed out of a search for a "Generalbaß der Malerei." *Generalbaß* is the German word for "thoroughbass," a seventeenth- and eighteenth-century term denoting the *basso continuo* part (so called because an independent bass part plays throughout the composition). Most European compositions from 1600 to 1750 (including most of J.S. Bach's compositions) make use of a *continuo* part—those that used a *basso continuo* were so preponderant among all the compositions of the period that that era is often referred to as the thorough-bass era. The *basso continuo* part was written as a bass line with numbers (called "figures"—thus a German synonym for *Generalbaß* is *bezifferter Baß*) under or over or beside the bass notes, to indicate which chords (harmonies) to play. The numbers indicated the interval above the bass note that should be played (as Roman numerals indicate intervals in harmonic analyses); however, the pitches could be played in any register and freely doubled (though the general principles of voice leading had to be observed). Converting the numbers into chords (to create a complete musical texture) musicians referred to as "realizing a figured bass"; realizing a figured bass and deciding how to play these chords took real interpretative skill, as it demanded that the performer create an "accompaniment" part from a composed bass part by playing the notated pitches and improvising harmony above them (sometimes using note doubling, sometimes not; sometimes using dissonances, sometimes not—though the principles of voice leading quite often led to dissonance). Though the bass line itself could not be modified, the player who realized the harmonies had considerable freedom. The player was not bound by the rhythm of the bass line or to use the simplest forms of the specified harmonies—a chord might be played in root position or not (the choice depending on a complex set of factors). Bach was extremely adept at extemporizing, and the music he could produce by sight reading from these general instructions sounded like rehearsed, thoroughly notated compositions. He even wrote a text explaining these skills.

The concept of the *Generalbaß* was embedded in a broader understanding of the nature of art, according to which art's powers—aesthetic, pneumatic, and noetic powers alike—derived from the fact that the learned earthly composer was replicating in his music the celestial harmony whereunder God had framed His creation; in this way, the earthly composer re-enacted the original Creation. The principles that God had devised to frame His Creation were those which Pythagoras had revealed to the world with the claim that "all things are num-

ber"; in other words, to know the nature and symbolism of the key numbers is to unlock the mystery of the harmony of the cosmos and the norms that should guide the good life (since, as ethical theory from the time of Plato has posited, the good life is one that conforms to the order of things). The fundamental mystery for the composer to solve (much as the alchemist strived to "solve" nature) was how to braid musical themes into a counterpuntal composition so as to convey metaphysical revelations into the order of being.

Indeed, now that the architecture of the Gothic cathedral had made the placing of note against note (*punctum contra punctum*) an exhilarating practice—earlier churches had required a single chanted line, since otherwise the sounds would interfere with one another—composers began investigating the relations between musical lines, and theorists began elaborating codes and principles to guide these practices. The strictest forms of part writing were the canon and the fugue, collectively known as "learned counterpoint." The term "learned" suggested the profundity of the wisdom that accrued to the composer as a result of acquiring the principles of counterpoint—indeed, the principles were passed down from *artifex* to *artifex* just as were the principles of alchemy.[213]

Among the most prolific and influential musical theorists of the Baroque era was the Central German organist Andreas Werckmeister; his 1702 treatise on composition, *Harmonologia musica*, was widely read. In it he writes of the wonderful powers of double counterpoint and its mysterious properties, which are nearly beyond the powers of human understanding (*Verstand*). He accounts for those powers through an allegory that compares the movement of voices in invertible counterpoint to the motions of the planets:

> The heavens are now revolving and circulating steadily so that one [body] now goes up but in another time it changes and comes down again …We also have this mirror of heaven and nature [*Himmels- und Natur-Spiegel*] in musical harmony, because a certain voice can be the highest voice, but can become the lowest or middle voice and the lowest or middle can again become the highest. One voice can become all other voices and no other voice must be added and at the very least … Four voices can be transformed in different ways in good harmony.[214]

Again, in the appendix, Werckmeister deliberates on the relation between invertible counterpoint and cosmic order, suggesting that the perfection of inversion ("replica") serves as "ein Spiegel der Natur und Ordnung Gottes" (a mirror of nature and God's order).[215] He suggests there, too, that successive permutations of the *replica* can eventually return the theme to its original state and thereby mirror the cycles of the planets. The constant, regular motions of the planets in the heavens, then, serve as a model for the revolution of parts in a well-constructed piece of double counterpoint, whose perfection provides humans with a glimpse of the splendour of God's created order. In fact,

the relation was not understood simply as that of model to reflection: the musical work embodied the very principles that God had used when he framed the heavens; therefore, a musical work could aspire to belong to the same spiritual order as the beings that populate the heavens. These ideas had achieved the status of doctrine by Werckmeister's time: Plato, Augustine, and Boethius all contended that the universe had been built on a series of divine ratios and proportions. Thus, the ratios and proportions in musical structures could reflect a similar kind of divine order. Thus, the composer who understood that order would be able to take instruction from *il miglior fabbro*.[216]

Martin Luther insisted on the spiritual/reformist importance of the ability to hear the harmony of the spheres. He maintained that that capacity made it possible for people to appreciate the splendour of God's creation: "We do not marvel at the countless other gifts of creation, for we have become deaf toward what Pythagoras aptly terms this wonderful and most lovely music coming from the harmony of the motions that are in the celestial spheres."[217] The role of music in the *cultus dei* was to overcome reason's pernicious effects: "Reason sees the world as extremely ungodly, and therefore it murmurs. The Spirit sees nothing but God's benefits in the world and therefore begins to sing."[218] Indeed, Luther believed that the most nearly perfect music (the music of utmost artistic excellence) would allow listeners to sense ("taste," in Luther's term) God's perfect wisdom—the wisdom manifest in the music (harmony) of his creation: "When [musical] learning is added to all this and artistic music which corrects, develops, and refines the natural music, then at last it is possible to taste with wonder (yet not to comprehend) God's absolute and perfect wisdom in his wondrous work of music."[219] The Calvinist tradition utterly excluded art music from corporate worship service, restricting music used in services to simple congregational psalmody; the Lutheran Reformation, based on Luther's understanding of music as the creation and gift of God, encouraged the liturgical use of art music of the most highly developed sorts. Luther:

> I truly desire that all Christians would love and regard as worthy the lovely gift of music, which is a precious, worthy, and costly treasure given to mankind by God. The riches of music are so excellent and so precious that words fail me whenever I attempt to discuss and describe them ... In summa, next to the Word of God, the noble art of music is the greatest treasure in the world. It controls our thoughts, minds, hearts, and spirits ... Our dear fathers and prophets did not desire without reason that music be always used in the churches. Hence, we have so many songs and psalms. This precious gift has been given to man alone that he might thereby remind himself that God has created man for the express purpose of praising and extolling God. However, when man's natural musical ability is whetted and polished to the extent that it becomes an art, then do we note with great surprise the great and perfect wisdom of God in music, which is, after all, His product and His gift; we marvel when we hear music in which

one voice sings a simple melody, while three, four, or five other voices play and trip lustily around the voice that sings its simple melody and adorn this simple melody wonderfully with artistic musical effects, thus reminding us of a heavenly dance, where all meet in a spirit of friendliness, caress and embrace. A person who gives this some thought and yet does not regard music as a marvellous creation of God, must be a clodhopper indeed and does not deserve to be called a human being; he should be permitted to hear nothing but the braying of asses and the grunting of hogs.[220]

Thus there developed within the Lutheran tradition a treasury of congregational music (for choir, with and without accompaniment of organ and other instruments) of astonishing richness and depth. Bach's music is the surpassing example. The wealth of that tradition ensured that the notion that in composing art music composers frame their works in such a way as to embody the same principles God used in joining His creation—that art music is education—that it elevates the souls of listeners so they might apprehend with joy the wondrous splendour of His creation—would have a long life indeed. This conception of the nature and value of art making is the provenance of Richter's lament that poor (visual) art had produced a badly trained soul and that a *Generalbaß der Malerei* was necessary in order to instruct visual artists on the true principles of creation, thereby to heal this malformed soul.

Extending the idea of *Generalbaß*, one could describe it as a method for creatively elaborating musical works that proceeds according to well-established principles. It is in this sense that Goethe used the word: in a conversation with Riemer (May 19, 1807), he accused painting of lacking any *Generalbaß*, that is, any accepted theory for creating forms by following established principles. In proposing a *Generalbaß der Malerei* (a thorough-bass for painting), Eggeling and Richter were proposing to fill the lack that Goethe had noted and to provide a rules-guided but nonetheless creative approach to making a painting: in making a painting (or any visual artwork), the imagination would follow demonstrated principles.

Richter's Dada experiences had led him willy-nilly to consider the analogy between visual art and music. As I have noted, just before embarking on his effort to develop a *Generalbaß der Malerei*, he had been working on his *Dada-Köpfe*, which, as we have noted, set black elements against white elements to represent volumes against space or spaces against volume according to the positions and relative sizes of the black and the white forms. In January 1918, in Zürich, Richter met the Italian composer and musicologist Ferruccio Busoni (1866–1924).[221] Busoni saw in this alternation of black and white a set of relations analogous to the play of voices in a contrapuntal composition, and proposed to Richter and Eggeling that they undertake a systematic study of these relations by examining J.S. Bach's 1725 *Klavierbüchlein für Anna Magdelena*

Bach (Little Piano Book for Anna Magdelena Bach). This was just around the time that Richter met Eggeling, and Richter passed Busoni's recommendation on to him. Busoni's recommendation resonated in Eggeling, who had already undertaken a systematic study of the elementary syntax of form relations (and had already begun to ponder the analogy between music and visual art).

We don't know exactly what connection Busoni drew between Richter's black-and-white drawings and the thorough-bass practices of the seventeenth and early eighteenth centuries. But we can conjecture: Baroque music often exhibits a homophonic texture, with a melody playing against a bass line that has strong harmonic implications; Busoni may have viewed this polarity between the soprano and bass lines as a formal parallel to the contrasts between black and white in Richter's *Dada-Köpfe*. Furthermore, with the beginning of the thorough-bass era (that is, around 1600), this soprano–bass polarity developed into a more complex form, with the inner parts of the composition improvised against the *basso continuo*. Busoni quite possibly saw a parallel between the foundation of the bass and its implied harmony and one or more supported melodic parts, on the one hand, and, on the other, Richter's complex, shifting relation between foreground and background (as sometimes the middle parts in a performance of a thorough-bass composition seem to come to the fore and become almost another melody).[222]

Richter and Eggeling presented the results of their study of the syntax of form relations in their eight-page pamphlet *Universelle Spache* (Universal Language, 1920), which they mailed to a number of influential people (including Albert Einstein). Among their purposes for the document was to persuade UFA to support their work in experimental film. No copies of the pamphlet are known to exist, but an outline for it can be found in Stephen C. Foster's *Hans Richter: Activism, Modernism and the Avant-garde*. Also, a statement of what were likely some of its central ideas appears in Eggeling's hardly known essay of 1921, "Elvi fejtegetések a mozgómüvészetrö" (Theoretical Presentation of the Art of Motion), as well as in Richter's much better known, and nearly identical, essay of the same year, "Prinzipielles zur Bewegungskunst" (Principles of Movement Art).[223]

The purpose of Eggeling and Richter's study of the *Generalbaß der Malerei* was to uncover the basic principles of forming (*Gestaltung*). Their goal was to offer a new universal language—universal both in the sense that it applied to all visual media and in the sense that it applied to all cultures (notwithstanding their different natural languages). They wanted to develop a system of communication based on the visual perceptions, whose mechanisms, they were certain, were universal. "Every person would have to react to such a language and for the very reason that it was based on the human ability to see and record," Richter wrote.[224] Some years after the pamphlet was issued, Richter outlined the thesis the *Universelle Sprache*:

This pamphlet elaborated our thesis that abstract form offers the possibility of a language above and beyond all national language frontiers. The basis for such a language would lie in the identical form perception in all human beings and would offer the promise of a universal art as it had never existed before. With careful analysis of the elements, one should be able to rebuild men's vision into a spiritual language in which the simplest as well as the most complicated, emotions as well as thoughts, objects as well as ideas, would find a form.[225]

Though all visual media could use this language, Eggeling and Richter believed that film would take it to a higher level. (In "Elvi fejtegetések a mozgó-müvészetrö," Eggeling proposed that "beyond all doubt the film will soon be taken over by the artists as a new field for their activity.")[226] The Constructivist notions at the heart of Eggeling and Richter's research advocated a comprehensive reorganization of life that could be initiated solely by reason. In an interview, Richter stated: "My driving desire, to control the means of expression and to pair inspiration with understanding, let me first point to a geometric scale as a point of departure. Objectivizing gestures are a universal language."[227]

Eggeling and Richter's *Universelle Sprache* was a grammar for combining forms into pairs based on mutual attraction and repulsion; the constellation of opposing pairs would create a sort of counterpoint. *Universelle Sprache* theorized that polarities between opposites were the elemental relations from which forms were created: positive and negative; black and white; above and below; curved and straight; empty and filled; intersecting and not intersecting; horizontal and vertical; parallel and counterpoint; simple and complicated; dark on light and light on dark; single and multiple; internally linked and separated. It was a language whose elements, then, were not individual forms but their relations to one another.

Eggeling and Richter's research sought to identify especially the key features of spatial relations. The idea that there might be a grammar of spatial relations was a fundamentally Constructivist one (especially if we take the term "Constructivism" in the expanded sense in which Lissitzky—and Richter—used it). Moholy-Nagy wrote of the need to "apprehend the elements of optical expression" and of the need to develop a "standard language of optical expression."[228] And he, too, believed that this language—which would be universal since it would be internationally understandable—should be immediately standardized (i.e., simplified, purified, and democratized). Moholy-Nagy, Eggeling, and Richter were all utopians—all three wanted to establish a new system of visual communications for a new society, as they were all appalled at the conditions around them.[229]

Eggeling and Richter believed that this new universal language of visual art would help shape the new human who would arise out of the blighted world. This universal language would not only concern itself with the self-realization

of the "universal man" but also be the means for realizing universal life, life without political or ethical limitations. In this way, Eggeling and Richter's advocacy reflected utopian aspirations that were in the air in this era. In those decades, many thinkers and artists felt that the culture of their time had become weak, superficial, impoverished, and that European civilization had entered a phase of crisis: the outrages that humans perpetrated on other humans were evidence of that. It was art's responsibility to renew European civilization, and to achieve this it would have to become more spiritual—it would have to become, in Eggeling's phrase, "signs of communication" between people. The old artistic forms were no longer able to render communication spiritual; the most important task that artists confronted, therefore, was to create a new, universal language, one that all would be able to understand, a language not burdened with outmoded associations carried forward from a now decadent civilization encumbered by national differences. Its idiom would be pure, simple, and abstract, for only non-figurative art could do what was essential— that is, revive culture by creating a new instrument with which all people could communicate.

This language was not to be simply a means of communication that duplicated the languages now in use. It would be an objective language—that is, its grammar would give instruction on the correct ordering of forms. Its first concern would be with structure, not personal expression. Expressionist values had dominated German art for two decades, and though Richter's early drawings were influenced by such German Expressionists as Ludwig Kirchner, Richter (and Eggeling, too) had come to see Expressionism as a dimension of the culture that must be opposed. Excessive feeling, especially feeling unconstrained by the bounds of formal, constructive imperatives, can deform art (just as unbridled feeling, feeling unconstrained by the ideals of the Socialist utopia, can wreak havoc on society). Eggeling and Richter saw the elimination of subjective expression as a purifying process; they envisioned *Universelle Sprache* as an immaterial pneumatic language that would allow an ascetic and disciplined presentation of a subject and ensure that reason would rise above personal feeling. It would produce a new terrain outside language's communicative domain, a metalanguage that would help foster a new reality; as the product of ideal order, the language of this new reality would be spiritualized.[230]

The belief that *Universelle Sprache* would allow the ascetic and disciplined presentation of the subject, so that reason would triumph over feeling, led Eggeling to a belief in the transcendental character of art. He proposed that visual art could become the ideal form of expression and might even supplant ordinary language in many of its uses—that it could become the embodiment of the perfection that humans heretofore had been able to conceive but unable to realize (because of the hold that the concept of representation had on

earlier mentalities). All in all, he was skeptical of representation, maintaining that representations could not directly communicate a particular state of mind to an audience, since viewers' responses to them were inevitably contaminated by preconceived notions. He searched for a way for artists to convey a precise quality of experience (so precise that artists could think of it as impersonal, objective, and universal). His practical program for freeing the visual arts from biased perceptions led him to abstraction; for he believed that, to achieve direct communication, visual constructions must be freed from the concepts we associate with particular objects. To this end, he began to study pure visual phenomena: line thickness, orientation, curvature, texture, and so on; he also began to explore systematic variations of these attributes in constructions that used lines and curves as well as simple derivations of them (e.g., semicircles, triangles, and quadrilaterals). By limiting his elements to forms belonging to this set, by avoiding representation, and by working only with neutrals, he strived to discover the means to preserve the purity of the message transmitted to the viewer.

Richter maintained similar beliefs. In his essay "Prinzipielles zur Bewegungskunst" (Principles of Kinetic Art), he set out the following precepts concerning the essential attributes of art:

- Art is a human language that requires definite elements as an "alphabet."
- It consists of an abstract "form-language" (*Form-Sprache*) through which the pure relations that forms bear to one another can be investigated.
- It is not the identifying characteristics of the natural objects that are of interest, but the pure material of artistic forms.
- A composition arises dialectically, as a constructive process based on polarities that evoke tension and release.
- A work of art contains relations based on contrast, which are visible, and relations based on analogy, which can be experienced only pneumatically.
- A work of art strives for a synthetic solution of rhythmic unification (*rhythmische Einheitlichkeit*).[231]

In "Demonstration der universalen Sprache," Richter proposed that both organic and inorganic elements in "analogic" relations (i.e., relations between elements that are similar in some respect or another) are stipulated by metaphysical laws or truth of a higher order. When, through intuition, artists apprehend these metaphysical truths, their artistic production falls into conformity with universal principles that apply to all arts.[232] "Art serves as a realization of a higher unity," he wrote, "the completion of individuality in a higher form of organization." Like Eggeling, he described artworks as having a transcendental function, for an artwork detaches itself from the natural object in order to approach, through humans' determined striving, the further

side of awareness and experience. With the help of universal principles, the standardized language would speak to a higher form of organization, a harmonized and conflict-free condition, an effectively static and non-human condition.

Art brings about a synthesis of intuition and rational will, chaos and order; this synthesis allows "the truth of the chaotic to be expressed ... but it is controlled by will: the manifest law—as far as it really expresses just that, is not improvised."[233] When artists intuit these laws or truths, a will for displaying what they experienced supervenes. This will commands a rhythmic structure, which then serves as a higher law for the material the artist shapes. When artists form material in conformity with a rhythmic structure, the material produces apt results—and the work is therefore full of sense.

Film played an important role in shaping these ideas. Evidence of that can be found in a key passage in which Richter singled out kinetic art as the art of the future (for kinetic art promised a new cultural reality, in which movement would be identified with progress). Through artists' efforts, kinetic art would be reoriented: instead of concerning itself with what is effective (i.e., instead of being directed toward producing particular emotions), it would aim at bringing about transcendental experience. In the new cultural reality brought about by kinetic art, humankind would be functionally integrated in a superindividual collective that would negate (to use that dialectical term) the singular beings of individual persons.

Richter marked the universality of the objectivizing gestures that constituted this language by expelling from them all intelligible verbal and visual signs and so as to rely solely on elementary geometric forms. Because the elements of this language were without intrinsic significance, no preconceptions were invoked—the syntax of the *Universelle Sprache* had to itself the task of combining these elements into rhythmic compositions and thereby drawing the elements into a higher domain. Rhythm would do the work of fusing the elements into a unity: the principle of polarity inherent in the rhythm would sublate the contradictions among elements, rendering them comprehensible.

Richter's idea of rhythm was expansive: "The rhythm of a work is identical with the idea of the whole. Rhythm is that which conveys ideas, that which runs through the whole: its meaning = principle, from which each individual work derives its significance. Rhythm is not a definitive, regular sequence of time and space; it is the unity which ties all the parts into a whole."[234] By rhythm, here he meant the metaphysical domain of belief and truth. We experience rhythm intuitively. Rhythm is inwardness. Rhythm is the power of nature. Rhythm it is that forms and animates incommunicable ideas; through rhythm we are bound to the elementary forces of nature.[235]

Because the forming process depends on unifying contrasting forms through rhythm, the will-to-form is grounded in emotions as well. "The emo-

tional power of form leads to rhythm as the essence of emotional expression," Richter stated (referring, of course, to the form of expression concerned with supra-individualistic, transcendental feeling).[236] In the end, though, the purity of rhythm draws artistic form into a higher, transindividual domain. The inner sense of a linguistic form cannot be grasped literally or symbolically; we can only experience it in process. This conviction was Richter's basis for arguing that rhythm, though it does not contradict reason, belongs to a domain beyond the rational. "Rhythm expresses something different from thought," he stated.[237] Thought coheres on an intellectual/conceptual plane of communications and ideas; strict semiotic practices are its proper territory. Rhythm coheres on a more rudimentary plane.

GOETHE AS PRECURSOR

Goethe was responsible for pointing out the need for a *Generalbaß der Malerei*; furthermore, his *Zur Farbenlehre* (Theory of Colours, 1810) provided a model for working out its form.[238] There are several parallels between Eggeling/ Richter's ideas about form generally—in particular, between their ideas about colour contrast and colour harmony—and Goethe's ideas on the same. Goethe challenged Newton's assumption that colour is an intrinsic property of light; against Newton, he contended that colour emerged as a condition of light's environment. Coloured light seems darker than colourless light, and Goethe refused to deny his intuitive sense that an amalgam of darker luminous materials cannot make a lighter one.

Goethe's science, which the Theosophist/Anthroposophist Rudolf Steiner did so much to restore to public attention, was empirical—but empirical in an extended sense of that term: he assumed that experience can reveal what brings forth the phenomenal realities that belong to the visible world of ordinary experience. He outlined the conditions under which observation might produce insight, recommending "exakte sinnliche Phantasie" (exact sensorial imagination) as a means to participate actively and deeply in the phenomena: there should be no addition, no speculation, and no agenda or desire to adjust observations to represent them as being other than close scrutiny reveals them to be. Like Galileo and Newton, Goethe looked for experimental procedures that would allow him to examine natural phenomena systematically. He did not assume, however, that only the quantifiable attributes of phenomena are germane to the construction of scientific theories. His science, in keeping with the spirit of his times (the spirit that also produced the philosophies of Schelling, Herder, and Hegel), was a science of generative processes—in other words, to discover the inward truth about natural processes and the forms they produce, one had to look for means to explore the generative process that produces a variety of observed forms, all of which, these

philosophers assumed, are different expressions of that process's underlying nature.[239]

Thus, in one famous section of his scientific writings—a section that reveals much about his method and the beliefs undergirding it—Goethe considered the process by which one comes to understand the development of leaf forms. To comprehend this process, we lay out samples of the leaf's development in a temporal sequence, from the oldest, most basal leaves to the newest, most apical leaves. Examining the sequence carefully, we see that the various leaves differ markedly; however, mental sight enables us to link the forms of several different leaves (their different morphotypes) into a smooth, continuous metamorphosis that takes us from one form to another. As our attention passes from leaf to leaf, we realize that there is no single representative leaf (the ideal leaf, a standard against which other leaves will be compared); rather, there is a fluid spectrum of shapes. The sequence of forms constitutes an integral process characterized by necessity: this wholeness would be disturbed if we were to change the order in which the leaves were displayed. We begin to experience the dramatic movements of plant growth by entering into our imaginations. Goethe understood *exakte sinnliche Phantasie* as an active process that, as understanding develops, results in our merging ourselves with the phenomenon being studied. Through the imagination, one can intuitively and non-invasively come to an understanding of how the plant grows.[240] This experience reveals a unique "gesture," a movement characteristic of the plant, telling us "who" it is as it dances its way into being (Theosophists would say that this experience attunes us to the "deva" of the plant).

Goethe emphasized that one must start with the actual phenomenon; in opposition to the dominant scientific methods of his time, he asserted that one cannot distance oneself from participation in nature if one wants to uncover its underlying truth. His approach to science seeks to participate in this gesture of organisms, and it is this experience that shows us the "inner necessity" of the growing plant. (Likewise, to fully experience the morphological transformations in, say, Eggeling's *Diagonal-Symphonie*, we must experience the inner necessity that is generating the transformations. This is the significance of the reference to the unconscious in this remark, taken from the "Zweite Präsentistische Deklaration" [Second Presentist Declaration], co-authored by Eggeling and Raoul Hausmann: "Our attachment to physiology and to the physical approach to formal function sets us in opposition to the techniques and arts that have existed until now; for we observe that no field of human work or behavior is there of itself: it is, in fact, linked in each of us to an analytical process at the subconscious level, beyond the inadequacies and functional inhibition of human psychology.")[241]

Goethe's inquiry into colour remained true to his principles about scientific investigation. He observed, first, that the experience of one colour can call

forth its complementary: a colour creating its complement is also known from coloured shadows. These observations led him to conclude that all colours spring from the polarity of light and dark—against Newton, then he contended that colour is not present in a beam of white light (no combination of darker-toned materials can make a lighter one). He asserted instead that light is perfectly colourless. A vague or dim form (he refers to this dim form as a *Trübe*—literally referring to a cloud and, by extension, to a nebulous or cloud-like material)—for example, smoke or milkwater—placed before a dark background, shows bluish colours when lit from aside. The thinner this *Trübe* the more blue the colours appear, until they finally become purple. We see this in the bluish appearance of the atmosphere that enwraps the earth as a *Trübe*, set against the dark background of the universe. The sky seems light-blue at the horizon, for here the light has to pass through the thickest mass of air; right above our heads, or standing on top of a mountain, the atmosphere looks purple. The atmosphere can also evoke orange and yellow colours, and, when it does, the thinner areas evoke lighter yellow colours. At the thickest part, the atmosphere looks orange-red: we see this with the light orb of the sun just above the horizon. That a semitransparent medium can evoke yellow and blue colours led Goethe to postulate that blue and yellow were of key importance.

As concerns colour experience, Goethe happened on an experiment that allowed him to study colour systematically. This experiment involved examining the spectrum produced by a prism held up to a horizontal boundary dividing a light area from a dark area. When he held the prism with a corner up, against a boundary dividing a dark area above from a light area below, he could see colours from the blue range of the spectrum: from the top down, the colours were violet, indigo, and blue. If he reversed the prism so that a side was at the top, he saw something different: the dark area and the light area were reversed (so that there was a light area above and a dark area below) and there was a complementary range of colours: from the top down, the colours were yellow, orange, and red. Moreover, no green occurred in either experiment.

On the other hand, when he placed two black cards on a white card, one card over the top part of the white card, the other over the bottom part, and positioned them so as to form a horizontal slit of white between the black areas, and viewed this through a prism positioned with a corner at the top, then he could see colours from violet to red, with green in the middle; and when he placed two white cards on a black card, leaving a strip of black between the white surfaces, he saw a reversed series of colours, with yellow at the top and blue at the bottom. He looked for a pattern in these phenomena and noted that the warm colours (red, orange, and yellow) appeared at dark borders on a light background and that the cold colours (blue, indigo, and violet) appeared at light borders on a dark background. These observations

are difficult to explain using Newtonian principles (as is the failure to see green in the first pair of trials).

Like the philosophies of Kant, Schelling, and Hegel, Goethe's science was one of polarities: for Goethe, the visible and invisible world, light and dark, spirit and matter, were the interacting constituents of a single reality. His *Zur Farbenlehre* also posited certain polarities as fundamental to the experience of colour; and of these, the polarity of black and white was most important, since black and white strips could form all the colours of the spectrum. Goethe noted that when one looked at a clear white surface or a clear blue sky through a prism, one did not see a spectrum of light. However, if a slight spot interrupted the white surface or a cloud appeared in the sky, then one saw a burst of colour. From this, he concluded that it is the interchange of light and shadow that causes colours to be seen. But how does a shadow produce colours?

Against Newton's idea of the spectrum, Goethe noted first that colour appears only when light and dark come together. Newton maintained that the appearance of colour depends on chemical pigmentation and that the absence of light alone causes colour to appear—darkness, in Newton's theory, is simply the absence of light. According to Newton, bodies absorb light according to their pigmentation; he believed this explained why it is impossible to mix colours on a palette to produce white. Goethe asserted, to the contrary, that colour is produced by the interaction of light and dark and that both the source of light and the source of darkness are real phenomena; thus, colour is really "troubled light" (or, as that other great, anti-Newtonian poet, William Blake, had it, "Colours are the wounds of light").[242] Goethe considered the appearance of colours at the borders between dark and light to be simply the effect of darkening areas of light (at this interface the warm colours emerge, just as during a sunset as the light grows dark) and of lightening areas of dark (here the cold colours emerge).

One of Goethe's principal concerns in formulating his theory of colour was to develop a consistent understanding of our subjective responses to colour, of the feelings we experience from different colours—of what he called the "sinnlich–sittliche Wirkung der Farbe" (sensual–moral effects of colour), whose effectivity he explained by considering colour mainly as sensual qualities within the contents of consciousness. His interest in these effects reflected his belief that mind and matter develop out of the same matrix. The mind is active in perception, he maintained: it does not simply record visual sensory input; in fact it helps shape perception; the imagination (by which he meant a faculty for the inner re-creation of the phenomenon, not for engendering a fantasy about it) plays a role in forming the perception. His analysis of colour thus straddled the domains of physics and psychology.

Goethe believed that there is a consistent relation between the dynamic in nature that produces colours and our experience of colours' feeling qualities;

therefore, these experiences are the basis of a reliable knowledge about the process that forms the phenomenon. Experience arises from the whole process, which goes on within us and beyond us and which includes both outer circumstance and its inner resonances. (Richter reiterated this when he proposed the idea that grounded his belief in the universality of the *Universelle Sprache*— that "nature + mind are not opposites. The one completes itself in the other. The law lies above them.")[243] The consistent relationships that organisms have with their environments reflect reality; from this, it follows that consistent emotional responses to physical processes are unlikely to be arbitrary, and this recognition provides a reason for taking these "inner" responses and qualitative experiences to be indicators about the process experienced.

In "Über die Einteilung der Farben und ihr Verhältnis gegen einander" (On the Order of Colours and Their Relationship to Each Another), Goethe attempted to show that only yellow and blue are totally pure colours: that yellow has the effect of brightness (of being "next to light") and blue the effect of darkness (of being "next to blackness"), and that all other colours can be grouped between these. This led the poet-scientist to the idea that colours can be organized in a circle. First, he set blue and yellow at the opposite ends of a diagonal. He noticed that these colours could be intensified by being combined with red, so, at 45 degrees above these colours he placed the intensified forms of these basic colours—that is, these colours augmented with a red tint. Yellow thus became orange, and blue became purple. At the top, he placed pure red (which he referred to as "Purpur"). Goethe thought of this pure red as being above the two basic colours: among the colours, it has the highest value—so he maintained— because it has liberated itself from the boundaries of light and darkness. Green he placed diametrically opposite red, as having the lowest value.[244]

The Newtonian understanding of colour draws a cardinal distinction between additive and subtractive relations among tones: pigments have subtractive relations—pigments absorb light, reflecting only the colour you see. For example, when you mix blue and yellow pigments together, you are mixing compounds that absorb blue light (leaving yellow and red, which basically looks like yellow) and that absorb red (leaving blue). The combination absorbs both the blue and the red light at both ends of the spectrum, leaving only green (the middle of the spectrum) to be reflected. Mixing light, however, is a different matter: the relations among different colours of light are additive—when you combine blue and yellow lights, you see both the blue and the yellow, which is composed of different wavelengths than the colour reflected from the mixed pigments. In the preface to *Zur Farbenlehre*, Goethe propounded the view that the same principles that apply to coloured light apply to paint (a view that doubtless appealed to artists).

We have noted that Goethe's science was dialectical. His colour circle confirms this: his tendency to think in polarities—a tendency that we noted with

regard to his conviction of the importance of the interplay of light and darkness—appears again in his ideas about opposing colours. Complementary colours lie directly opposite each other on the colour wheel; there are also two triangles, formed by the characteristic colours (i.e., those which are not complementary and not adjacent to each other in hue). By using these complementary colours, we can intensify blue to make purple, and yellow to make orange-red. Red and purple together produce magenta (which epitomizes the strong side of colours), whereas yellow and blue together produce green (which epitomizes the weak side of colour). Goethe maintained that the purest and most intense red, even with paints, is produced through the interactions of the two extremes of the yellow-red and the blue-red (though there is a red that is not produced through this interaction).

Goethe also thought of the colours as having opposing spiritual values: as we have noted, red (or purple) is the highest augmentation of colours leading from yellow to blue; whereas green, which results from the mixing of yellow and blue, lies opposite it on the circle. The circle is completed by orange on the ascending side and by blue-red (violet) on the descending side. Goethe suggested that there is a systematic order to the effects of colours that can be revealed by sectioning a number of triangles out of the colour circle. Among the triangles he identified were a triangle of primaries (red, yellow, and blue) and a triangle of secondaries (purple, green, and orange). Perhaps the most important triangle, however, was the one that related to the emotional effects of colour: he held that colours can be arranged on the basis of their sensual-moral effects into a triangle whose vertices are marked by force, sanguinity, and melancholy. Red is arousing and passionate (as red reflects our own fires being lit as external light darkens); blue is uplifting, calming, peaceful, and contemplative (for blue represents the lightening of darkness—lightening the mood to feelings of serenity) and also gives a feeling of coldness; yellow has a splendid and noble effect, making a warm and comfortable impression; and green is alive and vibrant.[245] Red, Goethe also noted, results from a darkening of light—thus, the sun's light is darkened by the increasing depth of atmosphere through which its light travels as the sun sinks in the evening, while the blue of the sky results from the effect of sunlight being scattered by the earth's atmosphere, which scattering lightens the darkness of space. The part of the circle that runs from yellow through orange to red Goethe referred to as the plus side and its continuation through green and purple into blue he referred to as the minus side. There are, accordingly, three basic pairs of opponent hues: red/green, orange/blue, and yellow/purple. Generally, the colours on the plus side of the circle from which the triangle is excised induce an exciting, lively, aspiring mood, whereas the colours on the minus side "create an unsettled, weak, and yearning feeling." Those familiar with Steiner's writings on colour will note that Goethe's commentary on the

sensual–moral effects of particular hues is at variance with those of Rudolf Steiner and the Theosophists, who, for example, considered blue the most spiritual colour.

Goethe's interest in the "subjective," sensual–moral effect of colour seems to clash with his desire to create a science of colour (indeed, for most readers, this aspect of Goethe's colour theory probably seems more like poetry than science), in that we usually consider subjective associations to be individual and idiosyncratic and, therefore, unreliable as indicators of the real character of physical processes. Yet these sensual–moral effects of colour were a primary concern of Goethe's colour theory, and many people believe that studying the effects of individual colours "on the sense of the eye ... and the eye's imparting on the mind" was *the* main purpose of Goethe's study of colour. His analysis of the sensual–moral properties of colour was an attempt to bring order to colour's more chaotic, aesthetic aspects (in the same way, Eggeling and Richter attempted to bring order to the chaotic, aesthetic aspects of visual form). Colour could be powerful or gentle or radiant; if yellow, yellow-red, and purple predominate, one will experience a sensation of power; if blue or its neighbours predominate, the experience will be of something gentle; while if all colours are in equilibrium, a harmonious coloration will arise that can produce radiance and pleasantness. Wittgenstein maintained in *Bemerkungen über die Farben* (Remarks on the Colours) that "[er zweifelte] daß Goethes Bemerkungen über die Charaktere der Farben für einen Maler nützlich sein können. Kaum für einen Dekorateur." (One doubts that Goethe's comments on the nature of colours can be of any use to a painter. Scarcely even for a decorator.) Yet Goethe did offer artists advice about using colour combinations (either characteristic combinations, harmonic combinations, or complementary colours). For example, he recommended that set designers use complementary colours to separate costumes from scenery.[246] The practical thrust of Goethe's colour theory was probably an inspiring example for Eggeling and Richter in their efforts to develop a scientific theory of visual form.

Kandinsky's theory of colours was modelled on Goethe's momentous *Zur Farbenlehre*. Kandinsky's approach was similarly methodical—he asserted that when one concentrates on colour in isolation, and allows oneself to be affected by single colours, one is able to couch questions about colour in the simplest possible terms.

> The two great divisions, which at once become obvious, are:
> 1. warmth or coldness of a color.
> 2. lightness or darkness of a color.
>
> In this way, for every color there are four main sounds [*vier Hauptklänge*]: (1) warm, and either (1) light, or (2) dark; or (11) cold, and either (1) light, or (2) dark ...

In the most general terms, the warmth or coldness of a color is due to its inclination toward yellow or toward blue. This is a distinction that occurs, so to speak, within the same plane, whereby the color retains its basic tonality, but this tonality becomes more material or more immaterial. It is a horizontal movement, the warm colors moving in this horizontal plane in the direction of the spectator, striving toward him; the cold, away from him …

The second great contrast is the difference between white and black, i.e., those colors that produce the other opposing pair, which together make up the four main possibilities of tone: the inclination of the color toward light or dark. These also have the same movement toward or away from the spectator, although not in dynamic, but in static, rigid form.[247]

Kandinsky had set out (just as Eggeling and Richter had) to develop a grammar for visual art that cast syntax as the arbiter of meaning. In Kandinsky's formal syntax, the concept of opposition plays the key role, similar to the role played by *Kontrast-Analogie* in Eggeling and Richter's *Universelle Sprache*. For Kandinsky, the fundamental polarity is between the circle and the triangle: their interaction creates a mysterious pulsation. In this opposition, the triangle plays the role of an active or aggressive element, while the circle plays a role that suggests interiority and spiritual depth. Mediating between the triangle and the circle is a third elemental form, the square, which evokes feelings of peace and calm. The circle brings together opposing characteristics—for example, the concentric and the eccentric—in a dynamic equilibrium. When this union of opposites goes to its furthest extreme and the opposites are brought together in an absolute identity, the circle becomes a point, the *Indifferenzpunkt* (point of indifference) of Schelling's philosophy of identity, where the invisible becomes visible. "In geometry, the point is an invisible entity. It must, therefore, be defined as a nonmaterial being. Thought of in material terms, the point resembles a nought … Thus, the geometrical point is, in our imagination, the ultimate and most singular combination of silence and speech."[248] Speech, too, Kandinsky understood as form, and silence as formless; in asserting that the point marks the identity of speech and silence, he was suggesting that art emerges at the point where (artistic) form passes over into, or fuses with, formlessness; at the point where it becomes possible for an artistic form to articulate what lies beyond form; at the point where vibrations become still.

The directions in which artist and Bauhaus teacher Johannes Itten took Goethe's colour theory tell us much about what the early abstract filmmakers (and, generally, avant-garde artists of the early twentieth century) must have found in the great writer's scientific work. Itten developed a twelve-part colour wheel that, because it was practicable and rational, won wide acceptance among both teachers and practising artists. Itten hoped to find a way to harness the richness of the rainbow, with its inestimably broad range of colours—to use

it to extend the restricted and more controlled palette of traditional pigments. He explored colour mixtures as well as some of the optical effects that had intrigued Goethe. Itten's colour system also served as a colour-music code whose character reflected his Mazdaznan beliefs. (The Mazdaznans are a religious group that draws on Christian and Zoroastrian elements, along with vegetarianism and yogic breathing to cultivate good health.) Instead of using Newton's spectral progression of ROYGBIV, Itten used the painter's standard colour wheel: the primaries (red, yellow, and blue) and the secondaries (orange, green, and purple, or violet) were supplemented by six intermediate hues to form a system of twelve colours—one for each of the semitone notes of the musical scale. Like so many other vanguard artists of the time, Itten believed that different colours have different spiritual values.[249] Accordingly, he offered moral equations for colour mixtures: thus, the mix of red and blue that gave violet was equivalent to the combination of love and faith needed for piety.

Itten's teaching steered other artists toward visual music. The pioneer of twelve-tone music, Josef Matthias Hauer (1883–1959) lectured on music's relation to colour in Vienna between 1918 and 1920, drawing on ideas from Goethe's teachings on colour, from the Christian existentialist philosopher Ferdinand Ebner (1882–1931), and from Itten. Ebner had been a fellow student with Hauer at the Teacher's College in Wiener Neustadt and had worked with the composer on the text *Über die Klangfarbe* (On Tone-Colours, 1918). Ebner's philosophico-theologial work *Das Wort und die geistigen Realitäten* (The Word and Spiritual/Mental Realities) affected Hauer deeply—Hauer claimed that it did much to inspire his discovery of the "twelve-tone law" in August 1919. Ebner had argued that art falls short as revelation, for an artwork really reflects the artist himself: it embodies an I–I relationship (the artist's relationship to him/herself) rather than a true I–Thou relationship (a relationship of the self to the Ultimate Other). Hauer accepted Ebner's view that music in the European art-music tradition was the personal expression of the composer's feelings. Unlike Ebner, though, he thought of music as a means of spiritual contemplation. He believed that when he discovered the principle of twelve-tone composition (i.e., the principle of constantly and systematically circulating all twelve notes), he had discovered the means by which music could transcend the personal realm and attain a transpersonal spiritual reality. Thus, though Schönberg held Hauer's ideas in high regard in the early and mid-1920s, and though Hauer's music was performed in Schönberg's Verein für musikalische Privataufführungen (Club for Private Musical Performances), Hauer's conception of the ideal composer differed sharply from that of Schönberg and his followers. Schönberg, Berg, and Webern continued to embrace the traditional idea of the composer as expressive artist. Hauer, to the contrary, argued that the ideal composer would suppress any will to personal expression in music and work only at conveying the pneumatic truth inherent in the

twelve notes themselves. (He eventually went so far as to reject the title of composer, thinking of himself, rather, as an "interpreter of the twelve tones.") The parallels with Eggeling and Richter's *Universelle Sprache* are striking.

Behind Hauer's interests in music form and colour was Goethe, the same thinker who was exerting such a massive influence on Eggeling. Time and again in his writings, Hauer grounds his technical discussions in his belief in the spiritual strength of atonal music (partly on the basis that perfected forms in twelve-tone music employ all twelve notes in equal proportion), and justifies those claims by appealing to the authority of Goethe's colour theory— and to the spiritual traditions embodied in Eastern philosophy. He often alludes to Chinese philosophy; in that regard, it is worth noting that his duodecaphonic technique relied on the use of paired hexachords, conceived as stacks of pitches rather than as linear progressions of melody, probably by analogy to the *I Ching*'s hexagrams. Hauer's son, Bruno, tells us that the *I Ching* was the only book that Hauer kept when he dispersed his library (so as not to be influenced by traditional conceptions of art and music). Like the *I Ching*'s hexagrams, Hauer's hexachords, which he called *Konstellationen*, were aggregate symbols whose elements could be internally reconfigured; and those reconfigurations invited a variety of interpretations (indeed, the composer divined truths by reconfiguring his *Konstellationen*). There were forty-four of these *Konstellationen*, or tropes (by way of comparison with the much more elegant sixty-four hexagrams of the *I Ching*). Sets of twelve notes were grouped into two hexachords, that is, collections of six notes. The tones of each half of these tropes could appear horizontally or vertically, in any order, so long as each remained in its half of the upper or lower part. (One could think of the composition as being generated from a set of twelve distinct objects, representing notes. These objects are placed on a board, which is divided in half vertically. The analogy to a game board is not inappropriate, as Hauer referred to his compositions as *Zwolftonespielen* [games with twelve tones], or, later, *Zwolftonspienen* [twelve-tone games]. The composition is produced by reorganizing the objects on the top half of the board, and the objects on the bottom half; one cannot, however, move an object from the top half of the board to the bottom.) Clearly, one can draw an analogy between the hexachords of the *Konstellationen* and the trigrams of the *I Ching*'s hexagrams—and can draw comparisons to various traditional conceptions of the upper and lower realms.

Hauer's *Vom Wesen des Musikalischen* (Concerning the Essence of Musicality, 1920) is a revised version of his 1918 theoretical study *Über die Klangfarbe*. The revisions largely reflect the influence of his Mazdaznan friend, Johannes Itten, whom he got to know in Vienna in 1919. *Vom Wesen des Musikalischen* argues for music's superiority over language as a mode of arriving at pneumatic truth. Hauer's affinity with Itten can be explained by the fact that both believed that colour perception and picture division, like music, are derived from

proportions, that is, from the relations among numbers. Itten interpreted the divisions of Goethe's colour circle as a mathematical allocation scheme for music and painting (cf. Richter's interest in the divisions of the frame/canvas).

Itten's interest in divisibility and proportion impelled Hauer to revise his understanding of pitch and its relation to colour. In the earlier version Hauer posited that musical intervals can elicit particular colours; in the revised version he placed increasing emphasis on harmonic spans. Also, in the revised version he begins by assuming that the relation between black and white is equivalent to the acoustic proportion of one octave. His interest in tone colour (and its analogy to colour) is reflected as well in such pieces as *Studies of Sound Colour, for piano, Op. 16*.

Hauer's writings refer time and again to Goethe's scientific theories (likely by way of alluding to Steiner's interpretations of those doctrines). He maintains that the twelve equal-tempered notes do not arise naturally in nature (following Goethe's argument that the entire colour spectrum does not exist in nature); the twelve equal-tempered tones are, rather, the result of a "spiritualization" of what nature provides—a means of transcending the given realm of coarse matter and attaining the perfect realm of the spiritual. Twelve-tone music elicits "intuitive hearing," by which one can apprehend the spiritual realm. Yet again, one can detect here the influence of Schopenhauer's musical aesthetics, read through Steiner's esoteric interpretation of Goethean science.

While Hauer avoided the fixed sequence of pitches that was the basis of Schönberg's system, he did sometimes employ a *Reihe* (tone row). However, he used it as a sort of *cantus firmus*: this row was repeated, unchanged, throughout the composition, embedded in the individual phrases of a composition. Like the *cantus firmus*, this provided a harmonic foundation and structural framework for the composition. The continual repetition of a complete overtone series (*Obertonreihe*), which provided the basis for the *Reihen* he used, symbolized the constancy and totality of the cosmos (that is, of the *Kontinuum*).

In a manifesto housed in the Hauer archive, the composer wrote:

From all eternity God has created absolute music once for all, in all perfection. We human beings are trying within one aeon to learn this divine language of the Father.

The twelve-note system regulates the psycho-physical pre-conditions for pure intuition which alone enables us to hear the unchangeable, absolute music as a revelation of world order.

Absolute, cosmic music permits the deepest insight into universal order. The tones with their overtones are suns with their planets. The sun systems "temper" each other, their tensions inevitably create all spheric harmony. Twelve-note pieces contain functions of the Milky Way, systems which are motoric formation centres of organic processes. The twelve-note "play" is at the same time

MODERNISM AND THE ABSOLUTE FILM

an oracle "play" as it is recorded in the ancient Chinese book of wisdom, the Iging.[250]

Another document in the same archive from 1937, reads:

Twelve-note music is supreme art, purest music.
 Twelve-note music is supreme science, purest mathematics.
 Twelve-note music is the most sacred, most spiritual, most precious gift on earth.
 Twelve-note music is the revelation of world order, religion in its truest sense, the only one there is and the only one there can be.
 Twelve-note music offers the deepest insight into cosmic order.
 Twelve-note music cannot deceive, cannot lie.
 Twelve-note music is the unchangeable sacred scripture, the eternal language of the universe.
 Twelve-note music is the spiritual reality.
 Twelve-note music is the starting-point of the twelve-note culture which will extend all over the earth and will regulate man's basic necessities of life.

We are back on Bach's terrain, the ground of Eggeling and Richter's *Generalbaß der Malerei*.

KANDINSKY, EGGELING, AND RICHTER
COLOUR AS FEELING, RHYTHM AS FORM

Eggeling and Richter's ideas about colour and form were influenced by Blavatsky, Steiner, Leadbeater, and, above all, Kandinsky (especially by Kandinsky's version of Goethe's colour theory). Indeed, Richter embarked on the project of understanding, and developing, Goethean ideas about colour before embarking on his final rhythm film, *Rhythmus 25*. Like Goethe, he understood colour as the product of interacting opposites and maintained that only a single pair of primary colours exists: red and green: "The scientifically denominated elementary colors, blue, red and yellow, do not have, esthetically speaking, an absolute distance from each other. Red and yellow are nearer (warm); blue is the opposite of yellow as well as of red, whereas green and red are incomparably unequal to each other. And if you want to use technical measure, green and red are together, black. All other colors I consider more or less variations."[251]

Rhythm in painting was often understood as a temporal form—Richter himself did not propose that view, but some of his contemporaries did. They also linked rhythm to colour. The American Synchromist Morgan Russell (1886–1953) remarked: "In order to solve the problem of a new painterly structure, we have considered light as tightly linked chromatic waves and devoted closer study to the harmonic combinations among the colors. These 'color

rhythms' lend a painting a temporal dimension; they create the illusion of the painting developing over a period of time, like a piece of music."[252]

Around 1925 (i.e., just a short time after Richter began working on scrolls), Karl Büchheister (1890–1964), one of Richter's Constructivist/Dada colleagues, was producing elongated, almost scroll-like paintings whose titles identify both music and visual art (e.g., *Konstruktive Komposition mit Dreiklang Gelb-Rot-Blau* [Constructive Composition with Three Sounds Yellow-Red-Blue]). A few years later, in 1929, Büchheister offered this observation: "Rhythm is the essence of abstract artworks ... A good abstract image is born out of inner necessity [note the echo of Kandinsky], the rhythmic structure of a good abstract image is in harmony with the rhythmic events of nature. It is a layperson's task gradually to make itself familiar with the inner necessity of abstract images sensed through the exercise of the rhythmic feelings."[253] Rhythm, then, experienced through *exakte Phantasie* (exact imagination, to use Goethe's term for the sort of sensory/imaginative participation in the inner life of the object apprehended), allows us to apprehend the unifying force of inner necessity, a force that pervades the artwork and the cosmos alike. Kupka maintained a similar view—so he created a "two-part composition," one part in red, the other in blue, whose parts converge and diverge (i.e., they develop through time) as the parts of a fugue do. The effect Kupka desired was to present the dance of cosmic rhythms.

By the beginning of the twentieth century the relations among painting, music, and time had become a key issue for artists. Richter's interest in rhythm can be associated with similar ideas about vibration. Standish D. Lawder, following up Richter's remarks, commented as follows on *Rhythmus 21*:

> Richter's first film, *Rhythm 21*, was a kinetic composition of rectangular forms of black, grey, and white. Perhaps more than in any other avant-garde film, it uses the movie screen as a direct substitute for the painter's canvas, as a framed rectangular surface on which a kinetic organization of purely plastic forms was composed. For, normally, the movie screen is perceived as a kind of window, more or less arbitrarily circumscribed, and behind which an illusion of space appears; in *Rhythm 21*, by contrast, it is a planar surface activated by the forms upon it. Thus, its forms, like those of an abstract painting seem to have no physical extension except on the screen, nor do we sense their lateral extension beyond the limits of the screen as is usually the case in images created by camera vision. The film is a totally self-contained kinetic composition of pure plastic forms.[254]

In the final two sentences of this passage, Lawder is interpreting the significance of Richter's recasting the role of the screen surface in an orthodoxly modernist fashion (hence the allusion to De Stijl with the use of the phrase "pure plastic forms"). He is not wrong in staking this claim: some years after making *Rhythmus 21*, Richter made a similar point:

The simple [square] of the movie screen could easily be divided and orchestrated by using the rectangle of the cinema-canvas as my field of pictorial vision. Parts of the screen could then be moved against each other. [This of course is the contrapuntal principle.] Thus it became possible on this cinema-canvas to relate (by both contrast and analogy) the various movements to each other. So I made my paper rectangles and squares grow and disappear, jump and slide in well-articulated time-spaces and planned rhythms.[255]

But there is more to Richter's recasting of the role that the screen surface plays than either Richter or Lawder allows: the screen is treated as it is because Richter conceived of it as a surface that could be set into dynamic motion—that could be made to pulsate and vibrate.

RHYTHMUS 21 AND THE GENERALBAß DER MALEREI

The *Generalbaß* provided Richter with a schema for understanding the relations between music and painting. His first film, *Rhythmus 21*, involved expanding and contracting forms on a black or white background in a contrapuntal interplay. Much of the tension of the film results from the way that background forms develop into foreground figures and that foreground elements turn into background (much as the lines in a polyphonic composition do). Richter, following Eggeling, used the term *Kontrast-Analogie* to explain this ambiguity of the spatial illusion. Using both negative and positive footage heightens that ambiguity: in the negative footage a dark shadow form—a form that suggests that one figure is raised above the other—sometimes marks the edges of figures. As in the other *Rhythmus* films, in this work Richter created a distinctive abstract genre: as Richter and Lawder noted, in these films the cinema screen is treated like a painter's canvas that is activated by the white, black, and grey geometric shapes projected on it. As are the other *Rhythmus* films, this work is an autotelic kinetic composition of pure plastic forms. Lines turn into oblong shapes that collide with squares that grow out of darkness, and curves become circles. Individual forms wax and wane, expand and shrink. Their movements create a sense of spacial ambiguity.

The film's fundamental structural principle is the counterpointing of contrasting pairs. Wipes from black to white are answered by wipes from white to black, and similar forms move in contrasting vertical or horizontal or diagonal direction according to regulated rhythm, a rhythm that is less that of regular succession in time than of the coordinated movement of parts. For Richter, artistic form reflects the fact that the universe manifests itself in harmonic configurations and rhythmically organized compositions. The fluidity of the movements and their precise coordination create a remarkable harmony.

Richter embraced the fundamental tenets of *Universelle Sprache*. Yet his conviction that principles relating to contrasting elements hold in all visual media

(including painting and film), and his experience in filmmaking, led him to conclude that additional laws—laws not applicable to painting—also play a role in filmmaking. The differences between the two media, he determined, result from the regulated, physically precise determination of the time over which the events in a film unfold; whereas with painting, movement and rhythm are the result of the spectators' attention moving from point to point, and those shifts of attention occur in a less regulated time and in an order that is not invariant from one spectator to another. Furthermore, in film, single forms have hardly any importance: all that matters is the relation of one form to another in time. Time has a different character in film, and it is time, Richter realized, that must govern the forms of film.[256]

THE END OF THE ABSOLUTE FILM

These ideas produced a body of work of remarkable resonance, works that continue to command fascination and delight. The first major public screening of Absolute Film was held at Berlin's UFA-Palast, during a matinée, on May 3, 1925, under the title "Der absolute Film." The films were presented by the Novembergruppe, which the Berlin Expressionists had founded in 1919 as their response to the Great War, the humiliations of the Treaty of Versailles, and the October Revolution in Russia.[257] It was spearheaded by such artists as Max Pechstein and Rudolf Belling, who wanted to link art to the Revolution. Artists who joined the cause included the painter Emil Nolde, the playwright Bertolt Brecht, the composers Paul Hindemith and Kurt Weill, the architects Walter Gropius and Erich Mendelson, and an art dealer Alfred Flecheim. The Novembergruppe's purpose was to unite all revolutionaries of the spirit—Expressionists, Cubists, and Futurists—to rally them at a crucial moment when the gravity of the hour and the future of art required their collective effort. One of the wildest and most destructive eras in human history would find expression in their work; they would work with bitterness and intensity and out of their efforts would come a new unity of art and life. They would bring forth a new utopian art.[258]

The following films were shown at the matinée that afternoon: *Dreiteilige Farbensonatine* (Three-Part Colour Sonatine) by Hirschfeld-Mack (likely a *Lichtspiel* created with the apparatus he had developed); *Film ist Rhythmus* (Film is Rhythm), which is part of the middle section of the (misleadingly titled) *Rhythmus 23*; *Symphonie Diagonale* (the publicity flyer used the French title) by Eggeling; *Opus 2, 3 und 4* by Ruttmann; *Images mobiles* (Mobile Images; an earlier version of the film that its makers came to call *Un Ballet Mécanique*) by Fernand Léger and Dudley Murphy; and *Entr'acte* (for which the credits, even on the German-language flyer, were "Scénario de Francis Picabia, adapté et réalisé par René Clair"). Meant to celebrate the Absolute Film, this

screening actually marked the end of the movement. Neither Ruttmann nor Richter made another abstract film after this screening. Only Fischinger, whose first abstract film, *R1 Ein Formspiel*—a three-screen work of extraordinary intricacy and staggering beauty—was made around 1927, would carry the torch for German avant-garde film. When Fischinger and his wife Elfriede moved to the United States in 1936, the abstract film moved with them, and became known in artistic circles through the support of Hilla Rebay.[259] The next major Absolute Films would be made in the United States, by Dwinell Grant, Mary Ellen Bute, James and John Whitney, and Jim Davis.

What caused the rapid decline of the Absolute Film? A few factors: *Un Ballet Mécanique* and *Entr'acte*, the two French films included in the Absolute Film matinée, used photographic imagery to do some of the same things the Germans had done with animation, and that likely opened German filmmakers to possibilities for a non-narrative cinema quite different from the abstract cinema they had been creating. Also, shortly after the matinée, a film appeared that would drastically alter the face of cinema: Eisenstein's *Bronenosets Potyomkin* (Battleship Potemkin, 1925). That film, along with *Images Mobiles* (*Ballet Mécanique*) and *Entr'acte*, must have convinced German avant-garde filmmakers that they had overlooked one formidable potential of the medium: montage. Thus, Richter's next film would continue the goals of abstract film but with photographed images and montage. That project was *Filmstudie* (1926), which, though based partly on the "universal language of forms" (the basis of his work in the Absolute Film), referred to natural objects: a woman's face, birds, eyeballs, a man hammering, and so on. *Filmstudie* is based partly on abstract rectangles and disks and partly on shots of real objects, photographed to highlight their geometric shapes.[260] The affinity that *Filmstudie* has to the cinematic works of the French avant-garde is evident especially in the use of surrealist motifs such as glass eyes, birds, and mask-like faces. The work straddles the boundary between the earlier, pure, abstract film and the second-wave of German experimental film, which is based on the montage of referential forms. Partly a photographed "montage film," partly an abstract animation, *Filmstudie* investigates the thresholds between the two artistic modes, highlighting some of the features that separate the two and minimizing others. Richter employs devices (e.g., multiple exposures and negative images) that draw attention to the technical specificity of photography; he then fuses these with graphic elements.

The deeper issue concerns the role of the object in the new art. Regarding the universal language of forms that Eggeling and Richter worked out between 1918 and 1920 and Richter's brush drawings titled *Dada-Köpfe* that were the first result of their study of the principles of counterpoint, Richter wrote: "What I tried to find was not chaos but its opposite, an order in which the human mind had its place but in which it could flow freely ... It allowed me also to

discard objects (subject matter) altogether and articulate free abstract parts on a given plane against and with each other. It came to be a kind of musical as well as visual articulation."[261]

Discarding objects, freeing visual form from any correspondence to the natural object, changed painting, as it allowed painted forms to become pure plastic elements that the artist could freely shape.[262] It also offered filmmakers real advantages: it allowed them to develop pure plastic relations among the visual elements of an Absolute Film, to treat visual elements as forms interacting in contrapuntal relations. *Images Mobiles/Ballet Mécanique* exposed the limits to the Germans' approach. That film is based on a different conception of the relationship between the artwork and the natural object. In "A New Realism—the Object" (1926), written not long after he and Murphy had finished their film (*Images Mobiles/Ballet Mécanique* was made in 1923–24), and seemingly a deliberation on what he had learned from his involvement with film, Léger stated:

> Every effort in the line of spectacle or moving-picture, should be concentrated on bringing out the values of the object—even at the expense of the subject and of every other so-called photographic element of interpretation, whatever it may be.
>
> All current cinema is romantic, literary, historical expressionist, etc.
>
> Let us forget all this and consider, if you please:
>
> A pipe—a chair—a hand—an eye—a typewriter—a hat—a foot, etc., etc.
>
> Let us consider these things for what they can contribute to the screen just as they are—in isolation—their value enhanced by every known means ...
>
> The technique emphasized is to isolate the object or the fragment of an object and to present it on the screen in close-ups of the largest possible scale. Enormous enlargement of an object or a fragment gives it a personality it never had before and in this way it can become a vehicle of entirely new lyric and plastic power.
>
> I maintain that before the invention of the moving-picture no one knew before the possibilities latent in a foot—a hand—a hat.
>
> These objects were, of course, known to be useful—they were seen, but never looked at. On the screen they can be looked at—they can be discovered—and they are found to possess plastic and dramatic beauty when properly presented ...
>
> I propose to apply this formula to the screen and to study the plastic possibilities latent in the enlarged fragment, projected (close up) on the screen, specialized, seen and studied from every point of view both in movement and immobile ...
>
> I repeat—for the whole point of this article is in this: the powerful—the spectacular effect of the object is entirely ignored at present.[263]

Léger's film gave the object central place: in its own way so did *Entr'acte*. The matinée screening at UFA-Palast must have impressed on the German

filmmakers various potentials of the medium that they had overlooked. It must have convinced Ruttmann and Richter that film was not destined to be a non-objective art (*gegenstandlose Kunst*). Rather, film's special virtue was to lead us to discover the plastic possibilities inherent in natural objects when they were presented in isolation or from unusual vantage points. Richter's *Filmstudie*, as we have noted, turns toward presenting figurative elements in a nearly Surrealistic fashion. This was a surprising turn in direction, since throughout his years as a Dadaist painter, he had laboured to expel the natural object from his paintings (his breakthrough on this front had occurred between 1918 and 1920 when, with Eggeling, he had developed his ideas about *Universelle Sprache* and *Generalbaß der Malerei*). Perhaps surprisingly, Richter now continued in this direction: by 1928, he had embarked on such projects as *Rennsymphonie* (Race Symphony, 1928) and *Zweigroschenzauber* (Tuppence Magic, 1929), which incorporated photographic imagery. By 1929, he and Werner Graeff had reformulated the theoretical basis of filmmaking. In "Filmgegner von Heute—Filmfreude von Morgen" (Film's Enemies of Today—Film's Friends of Tomorrow), a text prepared for the famous Internationale Ausstellung des Deutschen Werkbundes "Film und Foto" (International Film and Photo Exhibition of the German Werkbund) in Stuttgart, Richter commented on the potentials of the natural object in cinema. He would repeat those comments later, in "Easel-Scroll-Film": "The scope of the experimental film has grown. The principles which we followed with our first abstract film are not limited to the articulation of lines or squares alone. The rhythm of a swing or a clock, the orchestration of hats or legs, the dance of kitchenware or a collar—could become expressions of a new sensation. The experimental film has at last come into its own."[264] Richter was arguing, then, that it is possible to create an art that respects the principles of abstract *Bewegungskunst* but that does not eschew the object (and that furthermore, such an art would be more true to the nature of cinema).

The shift in artistic approach that the UFA-Palast showing encouraged among abstract filmmakers was part of a broader change taking place among German artists. The mid-1920s saw a shift in how photography was generally understood. That medium had played almost no role during the Bauhaus's Weimar years (1919–25) and was generally in disrepute among artists—dismissed as a means of mechanical reproduction. Then in 1921, Paul Citroen produced a Cubist-inspired photomontage of urban elements, to convey something of the new urban experience. That same year, Georg Munche produced some abstract photo-compositions. Around the same time, Moholy-Nagy explored radical means of presenting the natural object in photography. He rejected the view that photography is reproduction: in *Malerei, Fotographie, Film* (Painting, Photography, Film) he pointed out that Constructivist principles could be extended to photography as well—that they could be applied in ar-

ticulating rhythm, form, and movement, and, above all, that distortions result-ing from extreme vantage points also had applications (examples: from above, assuming the bird's-eye; or from below, assuming the frog's vision; or diago-nally from the side). Such distortions were capable of separating the forms in a photograph from the appearances of the everyday world. The camera did not and need not copy the eye's way of seeing—rather, it represented a *new* way of seeing ("Neues Sehen" [New Vision]).

These observations helped launch a revolution in photography: the ro-manticized Impressionism of the Pictorialists could now give way to a cool ob-jectivity. An exhibition titled Kipho, mounted by the German film industry in 1925, exemplified this shift in attitude, which was also reflected in German avant-garde film's rejection of the Absolute Film. Guido Seeber, a camera op-erator in the film industry with a reputation for special-effects cinematogra-phy and for ingenious approaches to photography, was contracted to make a short film to advertise the event. The result (inspired by *Un Ballet Mécanique*) was a considerable success. The terms in which commentators couched their praise tell us much about the emerging conception of the art of film: "It is not a film in the Absolute Film vernacular, but one concerned with a concrete subject—the nature of cinema and photography. And done in an entertaining manner as well."[265]

NOTES

1 Wulf Herzogenrath, "Light-play and Kinetic Theatre as Parallels to Absolute Film," in Phillip Drummond, ed., exhibition catalogue: *Film as Film: Formal Experiment in Film, 1910–1975* (London: Arts Council of Great Britain/Hayward Gallery, 1979), pp. 22–26.

2 Moholy-Nagy had no interest in Man Ray's automatist practices (the heuristic value that Ray praises when he tells us that he stumbled onto the technique of the Rayogram by accident).

3 In gauging the importance of this sort of work, consider its analogies with Alexander Calder's mobiles. Clearly, the drive to create kinetic forms was strong.

4 Herzogenrath, "Light-Play and Kinetic Theatre," p. 24.

5 Robert Delaunay, "Light, 1912"; reprinted in Herschel B. Chipp, ed., *Theories of Modern Art: A Source Book by Artists and Critics* (Berkeley: University of California Press, 1968), p. 319. Italics in Chipp's printing of the document.

6 John Golding, *Cubism: A History and An Analysis, 1907–1914* (Cambridge, MA: Belknap Press of Harvard University Press, 1988), p. 185. The reference Golding makes is to Michel-Eugène Chevreul (1786–1889), a chemist who studied colour and who published, in 1839, a book titled *On the Law of the Simultaneous Contrast of Colours*.

7 So it shouldn't be surprising that Malevich attempted to create films—the films he pro-posed to make would have resembled German Absolute films (and were conceived partly in response to visiting Germany). Kazimir Malevich first met German filmmakers in 1927. He had been the director of the Institut khudozhestvennoi kul'tury (Institute for Artistic Culture, or INKhUK) in Leningrad since 1923. In 1927 the institute was closed down; only then was he given permission to travel outside the Soviet Union. At that

point he went to Germány, hoping to start a new career there. He set off from Leningrad in early March, with several enormous crates containing about seventy paintings, works on paper, and architectonics, as well as his teaching materials. He also took with him manuscripts, which he hoped to have published in Germany. He stopped in Warsaw on his way to Berlin; there he was met by two former pupils of the Smolensk branch of UNO-VIS, Katarzyna Kobro and Wladislav Strzeminsky, along with other members of the Polish avant-garde attached to the art magazine *Praesens*. They organized an exhibition of his work at the Hotel Polonia (the exhibition hung from March 18 to 28, 1927). In Warsaw he befriended Tadeuz Peiper, the young editor of the magazine *Zwrotnica*; Peiper decided to join Malevich on his Berlin adventure.

Peiper and Malevich arrived in Berlin on March 29. Malevich stayed with the family of the engineer Gustav von Riesen, whom he knew from prerevolutionary days in St. Petersburg. With El Lissitzky's help, he made contact with the Novembergruppe, an association of progressive artists, who arranged for his participation at the Grosse Berliner Kunstausstellung. Malevich was offered a personal retrospective (which lasted from May 7 to September 30) and was allocated a separate gallery space.

The show garnered an extremely favourable response among Berlin's critics, artists, and gallerygoers. Malevich began to feel that Suprematism had won a major victory over other modernist movements such as Constructivism. The art writers Paul Westheim, Wilhelm Hausenstein, Artur Holitscher, and Adolf Behne were especially enthusiastic about Malevich's Suprematist work. Malevich also became close to the architect Hugo Häring, a proponent of organic architecture. (Häring would later play a key role in saving the artist's work from the Nazis, by hiding many of Malevich's paintings and writings in his home in Biberich.)

Peiper served as Malevich's translator when the Suprematist visited the Dessau Bauhaus in early April. There he met Walter Gropius. The meeting was a disappointment for the Suprematist master, for nothing came of his hope that he would be asked to join the faculty. However, he did meet László Moholy-Nagy, who one year later would publish *Die ungegenständliche Welt* (The Non-Objective World) in a series of the Bauhaus books. (The book was translated into German by Alexander von Riesen in consultation with Malevich.) Moholy-Nagy wrote a preface in which he carefully distanced himself from key Suprematist theses and advanced his own theory of Functionalism (then the prevailing view at the Bauhaus). Moholy-Nagy did not acknowledge the affinities of their views.

Of all the people he met in Berlin, he grew closest to the artist and filmmaker Hans Richter, a man ten years his junior but already well established in international avant-garde circles. Richter was extremely well connected: with the leading European Constructivists; with El Lissitzky and Moholy-Nagy; and especially with Theo van Doesburg, the leader of De Stijl. Between 1923 and 1926, Richter had published a magazine promoting German Constructivism, *G— Zeitschrift für elementate Gestaltung*, which had included several articles by Malevich. Richter introduced Malevich to the current trends in German experimental film production by showing him German abstract films.

This experience must have strengthened Malevich's resolve to relate Suprematism to film. He composed the script for an "artistic-scientific film" that marked "the emergence of new plastic system of architecture." (The script can be found in Malevich, "Art and Problems of Architecture: The Emergence of New Plastic System of Architecture. Script for a Artistic-Scientific Film," in *The White Rectangle: Writings on Film*, ed. O. Bulgakowa [Berlin and San Francisco: Potemkin, 2002], pp. 51–58:) Several factors influenced Malevich's interest in the cinema: He was well aware that his *oeuvre* progressed according to

an evolutionary logic—he recognized that his paintings belonged to an evolving series depicting the stages of his development (and the development of Mind) toward the fulfillment of the Suprematist system. Hence, photographs of the Last Futurist Exhibition, *0,10*, held in St. Petersburg in 1915/16, reveal that Malevich hung them in a manner that suggests they belong to linear progression, a continuous series: like some later shows, this show started with a point in the black square, the prototype of the Suprematist elements, and extended it into sequences and clusters. The sequence of works Malevich's UNOVIS publication of 1920, *Suprematism: 34 Drawings*, implies time and movement, a succession of elements, at first simple, that aims at their absorption and transfiguration in complex compositions. Malevich's essay "From Cubism and Futurism to Suprematism" (1915), proposed that in working toward Suprematism, he had gained an insight into the universal law underlying the evolution of art: depicting quotidian matter was an affair of the past—the New Art would concern a spiritual reality that belonged to the artist's mind. Suprematist forms, "constructed out of nothing," are the product of the intuitive reason of the artist, who gave them the right to individual existence, independent of extrapictorial reality. The elements would be composed not on the basis of interrelation of form and colour, but on the basis of weight, speed, and the direction of movement. Malevich developed these kinetic notions even further in "Suprematism, the Supremacy of Pure Non-Objective Art with Ideal Material and Imagery, the Phases of its Development," in 1923, and these ideas led to the 1927 film outline. In 1925, in "And Visages Are Victorious on the Screen" Malevich argued against Eisenstein and Vertov's idea of film (though he later acknowledged that Eisenstein at least understood the law of contrasts), propounding the view that film must reject all traditional representation (he contended that the cinema of his time was enslaved by the traditions of figurative painting, studio photography, and the pathos of theatre); to counter that hidebound idea of cinema, Malevich declared that cinema must find its specific form and content through "non-objectivity." He even argued against the idea of "the object," which became so important in avant-garde art at this time. In his 1926 article "The Artist and Film," Malevich lamented the technical limitations and conventional thinking, which stood in the way of the revolutionary "dynamic" artist: new kinds of subject matter, innovative camera positions, and electric light would eventually transform, even pulverize, the object. He recognized that in the West, important artist-painters were beginning to work with purely abstract elements, and that the entry of the contemporary painter into cinema would give artists a new means for showing the masses their new life. In the 1926 article he imagined transforming the cinema into a non-objective kinetic event in which the Suprematist elements would move weightlessly in a colourless space, according to a timing and rhythm determined exclusively by the artist. He envisioned a new kind of artist, the film painter of dynamic pictures, the creator of a spiritually oriented cinematography.

The script itself relies on the dynamic power of the particular Suprematist elements set in what Malevich conceived as a space-time continuum. The genesis and transformation of these elements was the film's theme. The film was to be in three parts, but only the first, "Development of Suprematist Elements," was fully developed. Its basic element was the black square, and all other visual forms would evolve from this basic element by transmutation: the revolving square would turn into a circle; the division of the square would produce a cruciform element. The second section, "Architectonisation as Problem," offered a series of spatial developments of the cruciform element, which would attract, as satellites, a variety of Suprematist elements. The third section, "Architecture in Life," would show how two-dimensional Suprematist elements on the plane can form the

basis for a three-dimensional architectural system. This section would likely have contained documentary components.

The analogies with Malevich's Suprematist paintings/compositions are obvious: Malevich intended to treat the cinema screen rather as he treated the bare white space that always formed the ground of Suprematist compositions. The volume of the space surrounding the forms would have been as elusive and ambiguous as in his paintings (for the white ground/cinema screen seems both to recede from and advance toward the viewer)—as a result, as in his paintings, seemingly immaterial geometric elements would have hovered in a colourless and weightless cosmic space.

Malevich probably recognized that while Walther Ruttmann employed rounded organic shapes, Richter, in his films *Rhythmus 21* and *Rhythmus 23*, worked strictly with black and white squares—that is, with those basic forms that Malevich saw as the expression of Intuitive Reason. (Richter constructed his films as sets of rhythmic expansions and compressions of a square, and unlike Ruttmann, he only manipulated cut-out squares of different sizes on a black plane and did not draw any forms, as Ruttmann did. Richter, in fact, worked with space as well as a form of dynamism that creates a tension between surface and space. So Malevich hoped that Richter would help him realize the script. Richter's lack of interest in abstract film at this time almost certainly contributed to Malevich's film's never being completed. Richter's new-found interest in incorporating referential images must not have sat well with Malevich: in 1925, the painter had published an article in *Kinozhurnal ARK* 10 (as a contribution to the discussion of a polemic between Dziga Vertov and Sergei Eisenstein) that decried filmmakers' inability to allow film to fulfill its destiny. The polemic proposed that modern art is based on dynamism and abstraction and that film could continue these means but had not really been allowed to do so. In particular, Malevich criticized Eisenstein for practising the traditional aesthetic of the realist itinerant painters. So it must have disturbed him to see Richter moving in that direction. (Malevich's article can be found in translation in "And Visages Are Victorious on the Screen," in Bulgakowa, *The White Rectangle*, pp. 37–44.)

The original Russian title for "And Visages Are Victorious on the Screen" is wonderfully sly. Malevich glossed the title with this remark: "'Likuyut' [translated here as "victorious"] should be understood: making, writing." So the title, read according to his recommendation, would be "And Visages on Screens [and Malevich, despite the translation, did use the plural] Are Making [i.e., active]." But *likuyut* is much more commonly used to mean "triumphant," not "making," so a Russian reader would first read the title as "And Visages on Screens are Triumphant"; only later, on reading Malevich's recommendation, would they accept the alternative reading. Malevich's note is omitted from the English translation.

8 Blaise Cendrars, *Inédits secrets* (Paris: Denoël, 1969), p. 385.

9 From a letter of Georg Schmidt, probably to Werner Graeff, and cited in Herzogenrath, "Light-play and Kinetic Theatre," p. 24.

10 An example of a film that works with this peculiar temporal constitution is Michael Snow's *Wavelength*; regarding the temporal attributes of that film, see my *Image & Identity: Reflections on Canadian Film and Culture* (Waterloo: Wilfrid Laurier University Press, 1989). But the best exfoliation of the aesthetic implications of film's paradoxical temporal constitution is in Paul Sharits, "Words Per Page," *Film Culture* 65/66 (1978): 29–42.

11 Hans Richter, *Monographie*, ed. M. Joray (Neuchâtel: Editions du Griffon, 1965), p. 29. Quoted in Bernd Finkeldey, "Richter and the Constructivist International," in *Hans Richter: Activism, Modernism, and the Avant-garde*, ed. S.C. Foster (Cambridge, MA: MIT Press), p. 96.

12 Hans Richter, *Köpfe und Hinterköpfe* (Zurich: Arche, 1967), p. 117. Cited in Finkeldey, "Richter and the Constructivist International," p. 96.

13 The Grand Secretary, "The Relationship of Color to Sound: AMORC Achieves a Marvelous Scientific Victory in Its New Color Organ," *Rosicrucian Digest* (February 1933): 7.

14 Ibid., p. 9.

15 "Unusual Demonstration of Color Organ," news release from the headquarters of the Rosicrucian Order of North America, San Jose, December 31, 1932, pp. 1–2.

16 Ibid., pp. 2–3.

17 Goethe's later view of the matter:

> Before we proceed to the moral associations of colour, and the aesthetic influences aris-
> ing from them, we have here to say a few words on its relation to melody. That a certain
> relation exists between the two, has been always felt; this is proved by the frequent com-
> parisons we meet with, sometimes as passing allusions, sometimes as circumstantial par-
> allels. The error which writers have fallen into in trying to establish this analogy we would
> thus define:
>
>> Colour and sound do not admit of being directly compared together in any way, but
>> both are referable to a higher formula, both are derivable, although each for itself, from
>> the higher law. They are like two rivers which have their source in one and the same
>> mountain, but subsequently pursue their way under totally different conditions in two to-
>> tally different regions, so that throughout the whole course of both no two points can be
>> compared. Both are general, elementary effects acting according to the general law of
>> separation and tendency to union, of undulation and oscillation, yet acting thus in wholly
>> different provinces, in different modes, on different elementary mediums, for different
>> senses (*Theory of Colours*, trans. Charles Locke Eastlake [London: John Murray, 1840],
>> pp. 298–99nn748–49).

18 Newton's thoughts on colour and sound represented a revival of Aristotle's theories of the resemblances between light and sound, though Newton's efforts were far more elaborate and mathematical. Newton divided the visible light spectrum into seven colors (in a fashion that, though admirably mathematical, was nonetheless rather arbitrary). Then, noticing that the mathematical relationships of these seven colors were similar to those of the musical scale, he created his table of correspondences.

19 A chronology of composers and art theorists who have proposed correspondences between pitches and colours would include the following: George Field (1816, *v.* Klein, *Colour-Music: The Art of Light* [London: Crosby Lockwood and Son, 1930], p. 69); D.D. Jameson (1844, *v. Colour Music* [London, 1844], p. 12); Hermann von Helmholz (1867, *v. Treatise on Physiological Optics*, vol. 2, 1962, p. 117); Bambridge Bishop (1877, *v. A Souvenir of the Colour Organ*, 1893); Theodore Seemann (1881, *v.* Klein, *Colour-Music: The Art Light*, 1927, p. 86); A. Wallace Rimington (1892, *v.* Rimington, *Colour-Music: The Art of Mobile Colour* [New York: Frederick A. Stokes, 1911]); Alexander Scriabin (1911, *v.* Thom Douglas Jones, *The Art of Light & Color* [New York: Van Nostrand Reinhold, 1972]); Adrian Bernard Klein (1920, *v. Colour-Music: The Art of Light* [London: Crosby Lockwood and Son, 1927]); August Aeppli (1940, *v.* Karl Gerstner, *The Forms of Color: The Interaction of Visual Elements* [Cambridge, MA: MIT Press, 1986], p. 169); Ira. Jean Belmont (1944, *v.* Belmont, *The Modern Dilemma in Art: The Reflections of a Color-Music Painter* [New York: Bernard Ackerman, 1944], p. 226); and Steve Zieverink (2004, *v. Twelve + Twelve* [Cincinnati: UnMuseum, Contemporary Arts Center, 2004]).

A chronology of other theorists who have written on the correspondence of pitch and colour would include the following: David Ramsay Hay, *Laws of harmonious colouring, adapted to interior decorations, with observations On the practice of house painting*

(Edinburgh, London: W. Blackwood & Sons, first ed. 1828, sixth ed. 1847; M.W. Dro-bisch, *Über musikalische Ton-Bestimmung* (Berlin, 1852); C.A. Huth, *Farbiqe Noten* (Hamburg, 1883); F.J. Hughes (grand-niece of Charles Darwin), *Harmonies of Tone and Colours, Developed by Evolution* (London: M. Ward & Co., 1883); M.L. Favre, *La musique des couleurs et les musiques de l'avenir* (Paris, Schleicher frères, 1868); Bainbridge Bishop, *A Souvenir of the Colour Organ, with some Suggestions in Regard to the Soul of the Rain-bow and the Harmony of Light* (New Russia: Devinne Press, 1893); E.G. Lind, *The Music of Colour* (Baltimore: unpublished manuscript, 1894); A. Cozanet (pseudonym, Jean d'Udine), *L'orchestration des couleurs, analyse, classification et synthèse mathématiques des sensations colorée. Correlation des son et des couleurs* (first ed., 1897) (Paris: A. Joanin, 1910); H. Schrodez, *Ton und Farbe* (Berlin, 1906); F.E. Hughey, *Color Music for Children* (New York, 1912); H.B. Brand, *Der Akkord und Quintenzirkel in Farben und Tonen* (Munchen, 1914); Edward Maryon, *Marcotone: The Science of the Tone-color* (first ed., 1919)(Boston: C.C. Birchard & Co., 1924); S.H. Sinnot, *Tone Bow: Application of Color to Music* (New York, 1939); D.D. Lune, *Color Music Book for Children* (New York: Musette, 1942); Mary Hallock Greenewalt, *Nourathar: The Fine Art of Light Color Playing* (Philadelphia: West-Brook Publishing, 1946); R. Hunt, *The Seven Keys to Colour Healing: A Complete Out-line of the Practice* (first ed., 1948; eighth ed., Ashingdon: C.W. Daniel Co.; new ed., Saf-fron Waldon: C.W. Daniel Co., 1968); idem, *Fragrant and Radiant Symphony: An Enquiry into the Wondrous Correlation of the Healing Virtues of Colour, Sound and Perfume, and a Consideration of their Influence and Purpose* (London: C.W. Daniel Co., 1937); J.L. Kel-log, *Color; the Analog between Color and Music. The Kellog System* (Palo Alto: J.L. Kel-logg, 1949); Danton Adams, *Musical Colour: A New and Revolutionary Method of Cre-ating Colour Schemes for the Artist* (London: Douglass & Gilson, 1962); Corinne Dunklee Heline, *Healing and Regeneration through Color* (Santa Barbara: H. Huber, 1944); idem, *Color and Music in the New Age* (Los Angeles, 1964); Forian I. Yuriev, *Music of Light* (Kiev, 1971 [in Russian]); idem, *On Colour, Music of Colour, and Colour Music of Word* (Moscow: Diafilm, 1980 [in Russian]; and K. Loef, *Farbe-Musik-Form* (Goettigen, 1974).

20 *A nomenclature of colours applicable to the arts and natural sciences to manufactures and other purposes of general utility*, second ed., improved (Edinburgh and London: William Blackwood & Sons, 1846). Hay was interested in wedding colour and geometry—this is reflected in his *The principles of beauty in colouring systematized* (Edinburgh and Lon-don: William Blackwood & Sons, 1845).

21 George Field (1777?–1825, *Chromatics; or, an Essay on the analogy and harmony of colours* (London: Newman, 1817); idem, *Chromatography, or, A treatise on colours and pigments, and of their powers in painting* (London, 1835); idem, *Rudiments of the Painter's Art, or A Grammar of Colouring*, London, 1850).

22 Sir David Brewster was the author of *A Treatise on optics* (London: Longmans, &c., 1831). This was an extremely important contribution to the literature of colour theory, for it influenced J.W. Turner. Brewster's importance for Turner was that he provided the artist with a fully scientific argument for the three primaries (which he did from the standpoint of admiration for Newton); Brewster's *Optics*, however, offered a sustained, measured, and precise challenge to the Newtonian conception of colour.

Georges-Louis-Leclerc de Buffon (1707–1788) was a physicist whose mediocre abili-ties did not prevent him from garnering considerable influence. He is perhaps best re-membered as the man who challenged Newton's idea of molecular attraction.

23 Sir John Herschel considered the whole compass of the scale of visible colours to cor-respond only to the interval that musicians call a minor sixth. In the case of a minor sixth there is only one harmonic ratio—thus, though a given note in music may harmonize

with many others (the third above and below it, the fifth above and below it, the octave above or below it, the twelfth above or below it, etc.), a given colour in the spectrum can only have one harmonic, viz., that vibration which in music would be called the third. Accordingly, between the vibrations of two colours that harmonize, there is always the same ratio as between the two nearest musical vibrations that harmonize (i.e., the ratio of the frequencies of their vibrations is 4:5). Thus, a Pythagorean relation is established, but only a single relation.

24　In *Concerning Sounds and Colours*, Blanc-Gatti says that Walt Disney came to an exhibition of his paintings in Paris during the early 1930s, and that he spoke to Disney about his ambition to make a feature-length musical animation film. When *Fantasia* was finally released in Europe after the war, Blanc-Gatti became outraged and attempted to sue Disney for stealing his idea. (Oskar Fischinger, who was an old friend of Leopold Stokowski, with whom he had discussed plans for an animated musical feature in 1934, thought of doing the same.)

25　Kandinsky, "Rückblicke," *Der Sturm* (Berlin: Sturm Verlag, 1913); English translation: "Reminiscences," in K.C. Lindsay and P. Vergo, eds., *Kandinsky: Complete Writings on Art* (New York: Da Capo, 1994), p. 364.

26　In Herzogenrath, "Light-play and Kinetic Theatre," p. 22. Herzogenrath does not cite the source of his quote, though it is likely from Alexander Lázló's *Coloured Light Music* (Leipzig, 1925).

27　In fact, the influence was mutual: Castel, in reviewing Rameau's *Traité de l'harmonie réduite à son principe naturel* (1722), alerted the composer to the existence of higher overtones emitted by vibrating strings (a phenomenon that would eventually undermine the Pythagorean understanding of harmony that had been so widely accepted for so very long); as a result, Rameau's *Nouveau système de musique théorique* (1726) took into account Sauveur's acoustical discoveries and asserted even more forcefully than the original *Traité* that all musical form is derived from the natural actions of a vibrating body and its first overtones (which establish the intervals of the octave, the third, and the fifth).

28　An excerpt from *Mémoires, ou, Essais surs la musique* can be found, translated, in Sam Morgenstern, ed., *Composers on Music: An Anthology of Composers' Writings from Palestrina to Copland* (New York: Pantheon, 1956), pp. 74–75.

29　Of course, Rameau's criticisms of Rousseau's ideas about music were reflected in the controversy.

30　For a description of Bainbridge Bishop's work on Colour Organs, see his memoir, *A Souvenir of the Color Organ, with Some Suggestions in Regard to the Soul of the Rainbow and the Harmony of Light with Marginal Notes and Illuminations by the Author* (New Russia: De Vinne, 1893).

31　Rimington's description of his device, and its aesthetic implications, are laid out in a paper read at St. James's Hall on June 6, 1895, which was published in pamphlet form by Messrs. Spottiswoode & Co., New St. Square, June 13, 1895; the paper is reprinted in A.B. Klein, *Colour Music: the Art of Light* (London: Lockwood, 1930), pp. 256–61. Among the points that Rimington made in this presentation was that prior to the colour organ, there had not been an art that dealt with colour alone; and that mutability of colour introduced problems concerning Time, Rhythm, and Instantaneous Combination—and the fact that those are key problems of the new art justifies calling the new art Colour Music.

32　Interest in the estoeric realm of cosmic reality is often associated with a fondness for the Medieval world, and so it was in Rimington: he claimed that Britons had lost that fine

sense of colour they possessed in Medieval times. Moreover, people's daily affairs had rendered most of them so inartistic as to prohibit the true appreciation of colour. Rimington proposed Colour Music as a possible remedy for this condition, as it could act as a bridge between the quotidian world and the higher realm. As Annie Besant would later, he proposed that psychological medicine might avail itself of insights derived from Colour Music.

33 There appear to have been problems with the performance. Possibly this was because Scriabin did not clearly map his beliefs about the correspondence of pitch and colour (he seemed to have believed that C-sharp corresponded to purple, F-sharp to bright-blue or violet, B to blue, E to sky-blue, A to green, D to yellow, G to orange, C to red, F to deep red, B-flat to rose or steel, E-flat to flesh, A-flat to violet, D-flat to purple (same as C-sharp), and G-flat to bright blue or violet (same as F-sharp); lacking this information, the performance relied on Rimington's conception of the colour scale (deep red, crimson, orange crimson, orange, yellow, yellow-green, green, bluish green, blue green, indigo, deep blue, and violet). Moreover, Modest Altschuler treated Preston S. Millar's "chromolo" (a version of Rimington's device, specially constructed for performances of Scriabin's work) as just one more instrument in the orchestra, playing just one instrumental line, rather that responding to the combined effects of the massed instrumental and choral voices, as Scriabin had intended. In any event, the show seem to amount to not much more than a "pretty poppy show," as one critic described it. Moreover Scriabin held that for every mode there was a corresponding shade of colour, and for each modulation, a nuance of this shade. Changes from the major into the minor should be underlined by strong visual and chromatic contrast. Scriabin's imagination had been fired by his readings in Theosophical literature, and he dreamed of illuminating the entire concert hall with the colours corresponding to the music being played. In practice the performances of *Prometheé* did not live up to these ambitions: colours were projected onto a small screen placed behind the orchestra, and they made very little impression on the audience.

An earlier, private presentation of *Promethée*, with Chromolo, was apparently more successful. This presentation took place "about February 10th" (according to the *New York Times Magazine*) at the Century Theater and was attended by Isadora Duncan, Anna Pavlova, and Mischa Elman. That presentation utilized the entire stage for its colour effects, for Millar draped panels of gauze from the proscenium back to the rear wall of the theatre, and the loose gauze was kept moving gently by fans placed at a considerable distance.

34 This machine is described in Adrian Bernard Klein (Adrian Cornwell-Clyne), *Coloured Light: An Art Medium* (London: Technical Press, 1937).

35 In this early period Wilfred's pieces often had Bragdonian titles, for example, *Multidimensional Sequences in Space*. Later he seems to have taken a more entrepreneurial tack: he went on to develop a "home clavilux," a cabinet-mounted device whose purpose was to allow people to light performances in their home.

36 In Kenneth Peacock, "Instruments to Perform Color-Music: Two Centuries of Technological Experimentation," *Leonardo* 21 (1988): 397–406 at 405.

37 In Peacock, "Instruments to Perform Color-Music, 405.

38 Thomas Wilfred produced two important theoretical statements concerning his interest in Light Music. One of them, "Light and the Artist," appeared in *Journal of Aesthetics and Art Criticism* 5 (June 1947): 247–55. In this piece Wilfred offered a potted history of the emergence of a new art of light, then set out the features that the lumianist worked with: light, he proposed, possesses the attributes of form and colour. The features of form the lumianists are concerned with are location, volume, shape, and character. The

features of colour the lumianists are concerned with are hue, chroma, value, and intensity. Coloured forms must be set in motion—and the features of colour motion can be described in terms of orbit, tempo, rhythm, and field. Wilfred was waiting for the first Johann Sebastian Bach of lumia to appear. On the whole, the article was characterized by an infectious optimism.

In the *Journal of Aesthetics and Art Criticism* 5, no. 4 (June 1947), Wilfred published "Light and the Artist" (pp. 247–55). His second statement, "Composing in the Art of Lumia," appeared in *Journal of Aesthetics and Art Criticism* 7 (December 1948): 79–93. In that piece he set out several principles that he believed should guide lumia compositions. One principle he referred to as "visual anchorage": when all of the elements move in one direction, they should not (except perhaps momentarily) exceed a critical velocity, unless a relatively stable visual anchor be provided. He also distinguished between composing for and performing on the lumia, and composing and performing music. The two arts were so different, he insisted, that efforts to construct lumia instruments in imitation of musical ones would prove utterly futile, as would attempts to write lumia compositions following the rules laid down for music. Wilfred also argued that the design principles governing static composition and colour harmony do not apply to form and colour in motion: as I have argued so often regarding the composition of film images, Wilfred pointed out that if a lumia composition were to be arrested at any point, the static form might well seem unbalanced from the painter's point of view. Thus, he suggested, the lumianist must abandon the old ways and blaze new trails.

39 Scriabin was not alone among Russian composers in proposing correspondences between sound and light: his older contemporary, Nicolai Rimsky-Korsakov, a precursor of Symbolism (1844–1908), proposed a table correlating pitches and colours:

B major	gloomy, dark blue with steel shine
B-flat	darkish
A major	clear, pink
A-flat major	greyish-violet
G major	brownish-gold, light
F-sharp major	green, clear (colour of greenery)
F major	green, clear (colour of greenery)
E major	blue, sapphire, bright
E-flat major	dark, gloomy, grey-bluish
D major	daylight, yellowish, royal
D-flat major	darkish, warm
C major	white

40 Moser's Colour Organ consisted of a keyboard-controlled implement, a "tastiera per luce" (according to the published score), with coloured light bulbs mounted on a wooden base.

41 Leonid Sabaneiev, "Scriabin's *Prometheus*," in Kandinsky and Franz Marc, eds., *The Blaue Reiter Almanac*, documentary edition, ed. and intro. K. Lankheit, trans. H. Falkenstein with M. Terzian and G. Hinderlie (Boston: MFA, 2005), pp. 130–31. The article appeared in *Der Blaue Reiter* in 1912. Sabaneiev was very close to Scriabin and could almost be considered his amanuensis.

42 Ibid., p. 131.

43 Arthur Schopenhauer, *The World as Will and Idea*, trans. R.B. Haldane and J. Kemp, 4th ed. (London, 1896), vol. 1, pp. 339–40. References to this work are abbreviated.

44 Of course, eighteenth-century theorists of art and music acknowledged the role of discord. For example, Charles Burney (1726–1814), in *The Present State of Music in France*

and Italy (London, 1771), wrote that discord is necessary in music because "it seems as much the essence of music, as shade is of painting" (p. 152). However, the music and art theorists of the age really made very little of the role of discord and dissent—and especially of the importance of strife between the Many and the One in the cosmic order, the social order, or in the aesthetic realm (that strife I have termed "dissent").

45 Phenomenal forms are the forms revealed in experience, forms that belong to a world shaped by the categories of space, time, and causality, which the mind imposes on experience as a condition of its possibility. The noumenal realm is the real: it is the realm that conditions experience but lies beyond experience. Schopenhauer was among the first Western philosophers to take a deep and scholarly interest in the philosophers of India. He was a passionate reader of *Upanishads*, and he largely agreed with its Advaita (nondualist) position. Thus, he sometimes referred to the phenomenal realm as the realm of *maya*; presumably the noumenal realm, the realm of will (constant striving) played a similar role in his philosophy that the notion of Brahman did in Advaita philosophy.

46 Solovyov believed that an all-comprehending unity (*vse-edinstvo*) works toward the salvation of all things. Taking down the barriers that prevent humans from granting one another the full measure of their inherent individuality is the real goal of *vse-edinstvo*; Solovyov believed that when that goal is achieved, the historical process will be brought to an end. What thwarts humans in their efforts to realize this goal, according to Solovyov, is egoism: egoism has the effect of excluding all others. It can be overcome by learning to give oneself wholly over to another and creating a union of the two lives. In sacrificing one's egoism, one affirms the other's individuality and helps make it possible for the other to realize him- or herself. This sacrifice requires love, a love that must be a complete and continuous exchange, an affirmation of the mutual self-realization of the self and the other.

It is not possible in this world to achieve such a unity—that would only be possible in an ideal, divine realm. The physical union of sexual acts provides a mirror of the ideal (impossible) union with the Divine, the complete merging with God. To use the terms so beloved by Solovyov's Symbolist colleagues, physical love serves as the *realia* (that which belongs to the external reality of the phenomenal world) through which we can glimpse the *realiora* (the highest reality); cf. the occult ideas of the *inferiora* and the *superiora*—that is the ultimate goal of being merged with the Divine. Thus, the sexual act unites flesh and thus brings humans closer to God. To achieve that complete and saving unity of all things (the *vse-edinstvo*) would require the elimination of the distinction between male and female.

47 Scriabin learned of Mme Blavatsky's work in 1905 while he was living in Paris. In 1908, while residing in Brussels, he enrolled in the Belgian Sect of the Theosophical Society; living in Moscow in 1911, he subscribed to three Theosophical journals: *Le Revue Théosophique Belge*, that of the Italian Societa Theosofica, and the Russian *Vestnik teosofi*, a St. Petersburg publication.

48 In W. Bruce Lincoln, *Between Heaven and Hell: The Story of a Thousand Years of Artistic Life in Russia* (London: Penguin, 1999), p. 298.

49 Scriabin dispenses with the sense of forward propulsion by creating a system of chromatic associations that serve no functional (in the Schenkerian sense) harmonic roles—thus, they do away with teleological progression (again in the Schenkerian sense). He accomplishes this in part by relying for his harmonies on the cycle of fifths.

50 Schopenhauer, *The World as Will and Representation*, trans. E.F.J. Payne (New York: Dover, 1969), vol. 1, p. 257.

51 At the time, the sentiment that Scriabin was at least as important a composer as Stravinsky was widespread. George Antheil offered a humorous anecdote that makes the point.

In 1932, Stravinsky and Antheil found themselves together in war-torn Berlin; they passed many hours talking. During one of their meetings, Stravinsky's mother, an admirer of Scriabin, had a prolonged argument with her son concerning the mystical composer. At the end of it, she exclaimed, "Now, now, Igor! You have not changed one bit all these years. You were always like that—always contemptuous of your betters!" The story is recounted in Charles Amirkhanian, "An Introduction to George Antheil," *Soundings* 7–8 (July–October 1973): 177.

That Rudhyar should trumpet Schopenhauerian ideas gives a clue to the way Schopenhauer was read at the time. Rudhyar's modernism was rooted in spiritual convictions: he considered much of the advanced music of his day to be metaphysically aimless and called on composers to develop a new soul and a new faith. "Dane Rudhyar" was not the name the composer-to-be had been given at birth: he was named Daniel Chennevière, but adopted the name "Dane Rudhyar" because of its Sanskrit roots (for "dynamic action"), and because it was cognate with the Indo-European word for the colour red (because his zodiac sign, Aries, is associated with the red planet, Mars). Rudhyar (1895–1985) explored Rosicrucianism, Buddhism, alchemy, and the Baha'i Movement at the New York Public Library (he also studied Asian music there, a study he continued in California and in Bryn Mawr, Pennsylvania; in 1926 he wrote *The Rebirth of Hindu Music*, which was published two years later by the Theosophical Publishing House in Madras). He explored Theosophy in depth in the winter of 1917–18 while living in Toronto (with the Scriabin disciples Madame Djane Lavoie-Herz and Siegfried Herz). Rudhyar also took a great interest in the writings of Bergson, whose works were embraced by members of various esoteric circles (for their emphasis on process and flux, and for the openness to cognitive modalities other than scientific reason). Rudhyar admired Scriabin greatly, considering him the necessary corrective to reactionary Latin music as represented mainly by Igor Stravinsky, and to the rules-ordained music of Schoenberg and his disciples. Scriabin's corrective was the result of his having turned to the Eastern traditions, to the Gnostics, Alchemists, Rosicrucians, and Freemasons, to the Hermetic tradition, and to the early Templars and the Albigensians. Three utterly remarkable books by Rudhyar, *The Planetarization of Consciousness* (1970), *Rhythm of Wholeness—A Total Affirmation of Being* (1982), and *The Fullness of Human Experience* (1985) present his philosophy of life: even at their late date, they are still thoroughly Theosophical texts. And his *The Magic of Tone and the Art of Music* (1982) presents his philosophy of music in similarly Theosophical terms.

52 Rudhyar, "A New Philosophy of Music," reprinted in *Soundings* 6 (Spring 1973): 55–56.

53 Sabaneiev, "Scriabin *Prometheus*," pp. 136–40.

54 More information on these endeavours can be found in Marilyn S. Kushner, *Morgan Russell* (New York: Hudson Hills, in association with the Montclair Art Museum, 1990).

55 Cited in Herzogenrath, "Light-play and Kinetic Theatre," p. 23.

56 Alexander László, *Colour-Light Music* (Leipzig, 1926), in Karin von Maur, *The Sound of Painting: Music in Modern Art* (Munich: Prestel, 1999), p. 91.

57 Indeed, for some, rejecting claims that the media have significant differences was the very point of the endeavour. But to acknowledge that ambition should not require that one agree with the claim.

58 Newton, of course, had used a colour wheel to illustrate the relations between the differently "refrangible" colours he had separated out of white light using a prism. Also, he realized that a prism, when the divisions of the circle were coloured in and a spindle was inserted through the centre, could become a top. Then, spun fast enough, its colours would blur together to produce something like the white light from which they had been derived. In a famous, provocatively written letter to *Philosophical Transactions* protesting

comments that Robert Hooke had made about Newton's theory of light, the great scientist revealed his disappointment with this experiment: spinning a "Top (such as Boys play with)" that had been painted "divers colours," he could only achieve a greyish "dirty colour," not a pure white. In fact, by Newton's time the spinning top already had a long history in the investigation of colour: Pliny and Ptolemy had both described its use in antiquity. The nineteenth century also made much use of the colour top. James Clerk Maxwell used a calibrated version to investigate normal colour vision as well as colour blindness—he also treated children to displays of magically changing colour. Shortly after Maxwell, Hermann von Helmholtz balanced opposing colours on a rotating disc; his experiments with this "colour-top" led to radical refinements to Newton's diagram— as a result of his experiments, the circular geometry of colour relations was modified to the familiar tongue shape of contemporary chromaticity diagrams.

59 Ludwig Hirschfeld left the Bauhaus in 1925, when it moved to Dessau, and taught at the Free School Community at Wichensdorf in Thuringa. In 1933 the National Socialists closed the famous art school (which had, by then, briefly relocated to Berlin). Hirschfeld felt compelled to leave the country. In 1936 he moved to England, where he taught unemployed Welsh miners for several years. He then moved to London, where he worked on "screen art devices," applying the principles of his *Reflektorischen Lichtspielen* to serve stage lighting. In 1938 he was invited to participate in "The Bauhaus, 1919–1928," an exhibition at the Museum of Modern Art in New York. When France fell to the Nazis in 1940, all Germans living in England were interned. Hirschfeld was among internees deported to Australia. While confined at internment camps near Hay, Orange, and Tatura, he came to the attention of Dr. James Darling, the principal of Geelong Grammar, who intervened and had him released and appointed art master at the school (1942–57). He painted many fine abstract works in Australia. He visited Europe in 1964 at the invitation of the Bauhaus Archive, at Darmstadt, to reconstruct his colour light apparatus and demonstrate his *Reflektorischen Lichtspielen*. Hirschfeld died in Sydney on January 7, 1965.

60 Raoul Hausmann, letter to Henri Chopin, in Archives Henri Chopin (unpublished); in Jacques Donguy, "Machine Head: Raoul Hausmann and the Optophone," *Leonardo* 34, no. 3 (2001): 217.

61 Hausmann, another letter to Henri Chopin, in Archives Henri Chopin (unpublished), quoted in ibid.

62 Hausmann, "Optophonetika," in *Veshch'-Gegenstand-Object* 3 (May 1922). Text reprinted in Hungarian in *MA* 1 (October 1922). Cited passage quoted in Marcella Lista, "Raoul Hausmann's Optophone: Universal Language and the Intermedia," in Leah Dickerman, with Matthew S. Witovsky, *The Dada Seminars* (Washington: National Gallery of Art, 2005), pp. 82–101 at p. 84. Lista's article provides valuable information on the Optophone; however, I could not disagree more fundamentally with her remarks on Symbolism and Futurism or with the import of Hausmann's disagreement with Marinetti.

63 Raoul Hausmann, "PREsentismus: Gegen den Puffkeismus der teutschen Seele" (February 1921), *De Stijl* 4, no. 7 (1921): 121; in Lista, "Raoul Hausmann's Optophone," p. 85.

64 In ibid., p. 85.

65 Hausmann, "PREsentismus," p. 141, cited in ibid., p. 88.

66 Hausmann, "Optophenetika," in Donguy, "Machine Head," pp. 218–19.

67 Hausmann, letter to Henri Chopin, October 10, 1963, in ibid., p. 219.

68 In this passage I am describing a device conceived by Raoul Hausmann that anticipated the work that he and Daniel Broido would do together. Hausmann: "That was when I changed my conception of the Optophone and made it into a variant on the photoelectric calculating machine. Together, Broido and I built a demonstration model" (from a

letter to Chopin, cited above, note 67). Some of the other descriptions I have given apply to the device that Hausmann and Broido worked on together. It is not clear exactly how much the two devices had in common. I am assuming that the two devices had much in common, but there is no way to verify this.

69 In Ina Blom, "The Touch through Time: Raoul Hausmann, Nam June Paik, and the Transmission Technologies of the Avant-Garde," *Leonardo* 34, no. 3 (2001): 212.

70 Hausmann's unpublished text is discussed in ibid., 209–15.

71 Consider that in the late 1960s pseudo-interview, probably written just after the actual Hans (Jean) Arp died, the character Arp announces ideas that had circulated among the circles the real Hans Arp involved himself in the 1920s; moreover, the title "À la recherche de Jean Arp ..." inevitably calls to mind Proust's *À la recherche du temps perdu*. The idea of the transmission of reality through time is clearly a theme of this imaginative piece of writing.

72 In ibid., p. 211.

73 In Blom, "The Touch through Time," p. 211.

74 Hausmann, "Die überzüchteten Künste: Die neuen Elemente der Malerei and der Musik," *Gegner* 1 (1931, June 15): 17, in Lista, "Raoul Hausmann's Optophone," p. 94.

75 She became relatively well known; Thomas Eakins painted her portrait.

76 So when other people (including Thomas Wilfred) infringed on her patents by adapting the rheostat-and-mercury switch, she attempted to sue; however, a judge ruled that these electric mechanisms were too complex to have been invented by a woman, and denied her case.

77 Mary Hallock Greenewalt successfully sued these companies for patent infringement in 1934.

78 She described this visual music in a talk that she gave in 1942 and turned into a book in 1946: Mary Hallock Greenewalt, *Nourathar: Talk on the Fine Art of Light–Color Play. Delivered before the Women's Club of Washington, New Jersey, Hotel du Pont, Wilmington, Delaware. March 24, 1942* (Philadelphia: Westbrook, 1946). This book deals with a range of topics, including how rooms should be furnished and arranged for light performances, along with a notational system for recording them. It includes a light score for the first movement of Beethoven's *Moonlight Sonata*, which the author claims is the first light-play score in history. The book describes her several patents, lays out her approach to playing, offers ideas about colour, and proposes how the field of Colour Music should develop.

79 Mary Hallock Greenewalt, *Light: Fine Art the Sixth. A Running Nomenclature to Underlay the use of Light as a Fine Art* (Philadelphia, 1918), p. 10. This monograph was originally presented as an address before the Illuminating Engineers' Society, Engineers' Club, Philadelphia, April 19, 1918.

80 Greenewalt's "Notation for Indicating Lighting Effects" (US Patent 1,385,944, July 26, 1921). Her notation was written left to right on a row of dots, one per beat of the light score.

81 Futurists Bruno Corra and Alberto Ginna, in 1909, produced abstract films by painting directly on clear leader.

82 Michael Betancourt, "Mary Hallock-Greenewalt's Abstract Films," *Millennium Film Journal* 45/46 (2006): 52–60.

83 Greenewalt, *Nourathar*, p. 45.

84 Mary Ellen Bute shot a reel of documentary footage that preserves about ten minutes of short excerpts from Dockum's performance on the Guggenheim MobilColor, enough to show that it really did create complex, layered imagery.

85 In Kit Basquin, "Mary Ellen Bute: Energy in Motion," in *Mary Ellen Bute: Pioneer American Filmmaker: A Guide to the Collection at the Golda Meir Library, University of Wisconsin–Milwaukee* (Milwaukee: Golda Meir Library, University of Milwaukee, 1998), p. 5.

86 Ibid.

87 Arnold Schoenberg, *Letters*, ed. E. Stein, trans. E. Wilkins and E. Kaiser (London: Faber and Faber, 1964), pp. 43–44.

88 Kandinsky, "The Pyramid," in *Complete Writings on Art*, p. 154.

89 Kandinsky, "On Stage Composition," in *Complete Writings on Art*, p. 264.

90 Ibid., p. 257.

91 Ibid., p. 258.

92 Ibid., pp. 258–59. This idea resembles Sergei Eisenstein's idea of the monistic ensemble.

93 Ibid., p. 261.

94 Ibid., pp. 262–63.

95 Ibid., p. 263. The word "particular" introduced by Lindsay and Vergo.

96 Note that Kircher was skeptical of alchemy, whereas other scientists of the time (including Newton and Boyle) were believers.

97 In his introduction to Divisch, *Theorie von der meteorologischen Electricité*, Oetinger laid out an interpretation of the first chapters of Genesis. He asked himself what the light of this first day of Creation could have been, since it could not have been the light of the sun (the Genesis creation story tells us that the sun was not created until the fourth day). Oetinger answered his rhetorical question by telling us that the first light of the first day was an "electrical fire" that spread out over chaos and acted as a warming and form-giving life principle. As a life principle, it penetrated all matter and fused with matter itself. Nature's electrical fire of nature, suffusing all matter, is the life principle that again and again rushes into new forms, for it is animated by the urge to manifest itself again and again in new living shapes. It serves as a seed, planted by God Himself, and it embodies the principles of all subsequent life forms.

On the topic of the idea of electricity among Swabian Pietists, *v.* Ernst Benz, *The Theology of Electricity: On the Encounter and Explanation of Theology and Science in the 17th and 18th Centuries*, trans. W. Taraba (Allison Park: Pickwick, 1989), pp. 27–44.

By the way, in other writings Kircher referred to "anemic machines," using the term "anemic" in a sense that pertains to the etymology of "breath" and "soul." This idea of an "anemic machine," and the presence in Kircher's writings of diagrams of rotating celestial wheels, complete with inscriptions, probably influenced Marcel Duchamp's film *Anémic Cinéma*; *v.* Maurizio Calvesi, "Duchamp und die Gelehrsamkeit," in exhibition catalogue: *Marcel Duchamp* (Köln: Museum Ludwig, 1984), pp. 61–69.

The identification of electricity gave shape to a fascinating work by the French genre painter Louis-Léopold Boilly, *L'Étinvelle Électrique* (Electric Shock, 1791; the word "étinvelle" also suggests a bright glare), from 1791, which depicts lovers embracing as they prepare to experience an electric current in an alchemist's laboratory.

98 Iamblichus, in Olive Cook, *Movement in Two Dimensions: A Study of the Animated and Projected Pictures Which Preceded the Invention of Cinematography* (London: Hutchinson, 1963), p. 13.

99 Geoffrey Chaucer, "The Franklin's Tale," *Chaucer's Canterbury Tales: An Interlinear Translation*, trans. V. Hopper (New York: Barron, 1948), ll. 414–23.

100 Ibid., ll. 455–78.

101 Benvenuto Cellini, *The Autobiography of Benvenuto Cellini*, trans. J.A. Symonds (New York: Garden City, 1927), p. 117.

102 Peiresc and Kircher had to abandon this work temporarily when, over Peiresc's strong protests, Kircher was called to succeed Johannes Kepler as the mathematician to the Hapsburg court. In 1633, Kircher set out for his new post, only to discover on being shipwrecked near Rome in 1635, after an extended, hazardous, and calamity-filled journey, that Pope Urban VIII and Cardinal Barberini had at last responded to Peiresc's petition and gave Kircher a position in Rome, so that he would not have to accept his transfer to Vienna. So Kircher resumed his work in Rome, where for the next eight years he worked at deciphering Egyptian hieroglyphs and studying other "Oriental" languages.

Kircher's work on the Bembine table and his theory of hieroglyphs are discussed in Daniel Stolzenberg, *Egyptian Oedipus: Antiquarianism, Oriental Studies & Occult*, chap. 5 of "Philosophy in the Work of Athanasius Kircher" (PhD diss., Stanford University, 2004).

103 Jean-François Champollion's copy of Kircher's dictionary, with many comments written in the margins, is kept in the Bibliothèque Nationale in Paris.

104 A key influence on his understanding of hermeticism was Juan Eusebio Nieremberg's (1595–1658) *Curiosa filosofia* (pt. 1, Barcelona, 1630; pt. 2, Barcelona, 1645), which are writings on "occult philosophy" and on aspects of natural magic such as the sympathy and antipathy of objects.

105 There is a Neoplatonic dimension to this interest in automated composition. Thus, Kircher's interests in automated composition and in synaesthetic chromatic effects accord with each other. A further indication of his esoteric proclivities is that he titled a musical composition *Musica Pythagorica*.

The Neoplatonic background to the interest in automated composition can be explained with an anecdote concerning Charles Babbage, the inventor of the analytical engine (the first computer). The Earl of Bridgewater left a bequest to pay for the publication of books on the power, wisdom, and goodness of God as manifested in the Creation. When Babbage found that he was not one of the eight writers selected by the committee, he wrote and published his own book—*The Ninth Bridgewater Treatise*—in which he presented God as a kind of programmer and miracles as unexpected results computed by design after very long intervals of predictable behaviours.

His *Organum Mathematicum* (Mathematical Organ, 1668) described such an instrument, of which an example survives in Florence's Museum of the History of Science. Clearly, he believed that mathematics and music are intimately linked. Indeed, his purpose was not primarily to create a music-composing apparatus; rather, he designed this device to contain all of the mathematical knowledge required by the young Archduke Karl Josef of Austria. The device would allow the operator to perform simple arithmetical, geometrical, and astronomical calculations by manipulating the wooden rods in the box. It could also be used to encrypt messages, design fortifications, calculate the date of Easter— and compose music. Kircher indicated that his goal was to make the acquisition of mathematical knowledge nearly effortless. He hardly succeeded: the instruction book, by Kircher's disciple Gaspar Schott, was more than 850 pages and included many long Latin poems (as *aides-memoire*), which the operator was required to memorize.

106 Parabolic mirrors with pictures painted on the surface were known in della Porta's time and were used in "hole" projectors and lanterns that produced shadows on walls; these, too, may have been among the devil's devices with which della Porta was acquainted.

107 Giambattista della Porta, *The Book of Natural Magick*, bk. 17, chap. 6, transcribed from 1658 English Editon, Printed for Thomas Young and Samual Speed, at the Three Pigeons, and at the Angel in St Paul's Church-yard; http://homepages.tscnet.com/omard1/jportat2.html.

108 The Magic Lantern was not the only one of Kircher's inventions that presaged the cinema. In *Iter exstaticum coeleste* (Würzburg, 1660), Kircher employed a narrative device—that of a fantastic voyage through space—of remarkable similarity to the science fiction film in order to discuss his theories of the solar system. The two protagonists, Theodidactus and Cosmiel, travel through the void accompanied by the "music of the spheres," and reach other worlds where they converse with the intelligent life forms they find there.

109 A methodological note is in order. Magic Lanterns are often grouped together with microscopes and telescopes as evidence of an interest in optical devices as protheses for vision. Including mirrors in that group is partly appropriate. But one implication of this classification is clearly wrong: often the Magic Lantern was presented along with the *camera obscura* as one in a number of devices that would lead to a photographic realism the function of which was to reveal details of the visible world. But to interpret the importance of the Magic Lantern in this way is to commit the historical error of reading later historical developments into the character of previous events, casting them as mere transitory stages that anticipate later occurrences. The term "steganographic" suggests how wrong this approach is: those who presented Magic Lantern shows did not conceive of their enterprise as making details of the visible world evident. Rather, they were making a hidden reality apparent. Should we conclude then that grouping these projection devices together with lenses and photographic paper is entirely wrong—that Magic Lantern shows served the interests of magic or fantasy, while the projection of photographic images would have served the interests of revealing reality? I really don't think so. I believe that all were understood as presenting a hidden reality of imagination, fantasy, and dream. In fact, in late modernity it was no longer possible to map the distinction between the real and the unreal onto the distinction between the visible and the invisible: the real joined imagination, fantasy, and dream in the night world—the night world with which projected images had an affinity.

How do the Magic Lantern, the *camera obscura*, and other projection devices relate to the telescope and other optical devices in the paradigm of Renaissance and Baroque thought? I believe that the answer can be discerned by considering the telescope and the solar projection of meridian lines, both of which are a common feature of Baroque churches. The connection is fascinating—as I will show, the Renaissance and Baroque eras saw a revival of the Pythagorean idea that the world is ordered best when it reflects a cosmic order. Texts such as the Jesuit astronomer Christoph Scheiner's seventeenth-century treatise on sunspots, the *Orsini Rose, or the Sun shown to be changeable by the marvellous phenomenon of its flares and stains and shown to be Mobile about its own centre and fixed axis from West to East in annual rotation, and to be rotated around another mobile axis from East to West on an approximately monthly basis, about its own poles, demonstrated in four books* (1626–30) reflects this belief. The *Orsini Rose* includes an allegorical frontispiece of Scheiner's work that places the projected image of the sun obtained by means of a telescope (a projected image that one can easily relate to those solar projections on the meridian line) within a hierarchy of sources of reliable knowledge: sacred authority (labelled "Auctoritas Sacra" in the illustration), reason (labelled "Ratio" in the illustration), sense ("Sensus"), and profane authority ("Auctoritas Profana"). *Ratio* and *Auctoritas Sacra* produce, by themselves, beautifully clear sunspot images. *Sensus*, however, is represented by a telescopic projection of the sun—the projecting instrument figures as a direct extension of the senses. *Auctoritas Profana* is merely a dim lantern.

Scheiner's text presents an attack on Aristotelian cosmology, for it asserts that the sun is corruptible and that the heavens are fluid (and not nested solid spheres, as Aristotle

claimed). He attacked Aristotle using citations from the Patristic Fathers and from the Jesuit authorities (including Robert Ballarmine). He also used devices for amplifying the senses—in fact, the teachings of Church authorities are seen to confirm the reports of the senses. (This coincidence of the views of the Church authorities with the information the senses provide was a radical view, for often the word of the authorities was presented in order to contradict sensory reports—and when they were used in this way, sensory reports were rejected as illusory.)

What is important to us is that the telescope was seen as a device for observing the order of the heavens and that the information the telescope provided was seen as veridical. Remember, too, that in 1607, Kepler had used a *camera obscura* to observe Mercury's transit. In fact, the telescope and the *camera obscura* were linked as devices for investigating the heavenly order. Like the solar projection on meridian lines in Baroque churches, these devices were used to explore the relation between the heavenly order and earthly one—so that the earthly order might be brought into conformity with the heavenly order. A Magic Lantern works by projecting light onto a surface—by its nature, then, it reflects the process by which the light of the sun illumines the earth and manifests its celestial truths in the here-below.

110 Much of my information regarding shadow plays in Arabic culture—though not the information about Islamic conceptions of the imagination—comes from John Feeney, "Shadows of Fancy," *Aramco World* 50, no. 2 (March–April 1999): 14–20.

111 For example, the Magi, who come to see the infant Jesus, represent this Persian illuminist tradition; their presence symbolizes both the incorporation and the overcoming of these illuminist ideas in Christianity.

112 Shii thinkers who continued the tradition of Yahya Suhrawardi included Mir Dimad (d. 1631) and Mulla Sadra (d. 1640), who founded a school of mystical philosophy at Isfahan. Like Suhrawardi, they strived to link philosophy with mysticism in religious and daily life. Both agreed that the philosopher must be as rational as Aristotle but must also be imaginative and intuitive in order to approach the truth. To foster the latter, they developed means for training their disciples to acquire a sense of the *alam al-mithal*. In his magnum opus, *Al-Afsan al-Arbaab* (The Fourfold Journey), Mulla Sadra offered instruction on how one might divest him- or herself of ego so as to receive illumination and the mystical apprehension of God. Ayatollah Ruhollah Khomeini (1902–1989), the spiritual leader of the Islamic revolution against Iran's Pahlavi regime (and from 1979 to 1989 the Supreme Faqih of Iran), was deeply influenced by Mulla Sadra's teachings. His final address to the Iranian people urged them to continue the study of *irfan* (the Islamic mystic tradition), since there could be no true Islamic revolution without a spiritual revolution.

113 Henry Corbin, *Alone with the Alone: Creative Imagination in the Sufism of Ibn al-Arabi* (Bollingen Series 91) (Princeton: Princeton University Press, 1997), pp. 184–91. Originally titled *Creative Imagination in Sufism of Ibn al-Arabi*.

114 There are two emanationist traditions in Islamic philosophy, one epitomized by the philosophy of Al-Suhrawardi, an emanationism of lights, the other by the philosophies of Al-Fârâbî and Ibn Sînâ, an emanationism of intellects. I have stressed Al-Suhrawardi to highlight how Islamic emanationism affected Western light metaphysics. Despite this difference between the two strains of emanationism, their common Neoplatonic basis allowed the two strains to reinforce each other.

115 Even a cursory reading of Western philosophers who expound a metaphysics of light will reveal the extraordinary influence of the tradition. Robert Grosseteste (1168–1253), for example, is a key figure in that tradition, and Grosseteste prepared translations from

Arabic works. Even Bonaventure (1221–1274) speaks of God as a sun from which flow rays of light. He distinguishes among lights that participate in this: an external light, or the light of mechanical art; a lower light, or the light of sense knowledge; an inner light, which is the light of philosophical knowledge; and a higher light, which is the light of grace and of Sacred Scripture. Plato, of course, is the ultimate source, but the Neoplatonic tradition certainly played a shaping role—and Islamic philosophy reinforced the influence of the Neoplatonic tradition.

116 That Kircher invented the Magic Lantern (so he claimed) is not a done deal. Others might perhaps be credited: Pierre Fournier (France, 1515); Giovanni Battista della Porta (Italy, 1589); Christiaan Huygens (Holland, 1659); Rasmusser Walgertsen (Denmark, 1660); and Claude Millet (France, 1674). Indeed, the earliest existing drawing of a Magic Lantern appeared in a sketchbook of Johannes de Fontana, dating from 1420. Confirming our thesis concerning cinema's relation to occult and magical ideas, the sketch shows a monk holding a Magic Lantern with a small, translucent window in its side; through the window we can see a devil holding a lance. It was this image, drawn on a translucent sheet of bone, that the flame inside the Magic Lantern projected onto the wall. The lantern's purpose, we are told, was to frighten people with the grotesque shadows of the demonic shapes painted on the horn window. However, without a lens the image would have been very blurry. It would be two more centuries before the lantern acquired the magical power to present, through conjuring, a precise, detailed rendition of the devil's person.

117 Diary of Samuel Pepys, transcribed from the shorthand manuscript in the Pepysian Library, Magdalene College, Cambridge, by the Reverend Mynors Bright (New York: Random House, 1946), pp. 274–75.

118 C.W. Ceram, Archaeology of the Cinema (New York: Harcourt, Brace and World, 1964), pp. 61–63.

119 Loutherbourg also produced plates for John Bell's edition of Shakespeare's plays (1786–88) and the publisher Robert Bowyer's edition of David Hume's The History of England (1806). He published two collections of engravings, The Picturesque Scenery of Great Britain (1801) and The Picturesque and Romantic Scenery of England and Wales (1805).

120 Robertson, Memoires récréatif, scientific et anecdotiques da physicien-aeronaute (Paris: by the author and Librarie de Wurtz, 1831). Passage quoted appears in original Volume I, p. 129, and is cited in Terry Castle, "Phantasmagoria: Spectral Technology and the Metaphysics of Modern Reverie," Critical Inquiry 15, no. 1 (Autumn): 34.

121 "Robertson" was a true eccentric. He attracted considerable attention in 1796, when he proposed to the French Directoire a plan to construct a gigantic Miroir d'Archimede, a vast assembly of huge mirrors capable of focusing solar rays on distant objects, causing them to ignite; he proposed to incinerate the British fleet in this manner. He experimented with galvanism in 1790s, and in the 1800s he took up ballooning. Information on "Robertson" can be found in Castle, The Female Thermometer.

122 Etienne-Gaspard Robertson, Mémoires récréatifs, pp. 146–47.

123 Ibid., p. 149.

124 The illusion was created by merging live actors with reflected ghost images of hidden backgrounds or other actors. The technique had several variations; however, all used an angled sheet of glass that separated the audience from the illusion.

125 Nathaniel Hawthorne, The House of Seven Gables: An Authoritative Text, Backgrounds and Sources, Essays in Criticism, ed. S.L. Gross (New York: Norton, 1967), p. 21.

126 Ibid., p. 26.

127 Ibid., p. 91.

128 Ibid., p. 206.

129 Ibid., p. 264.

130 Ibid., pp. 264–65.

131 V. Thomas A. Edison, *The Papers of Thomas A. Edison: From Workshop to Laboratory*, vol. 2, June 1873–March 1876, ed. R.A. Rosenberg, P.B. Israel, K.A. Nier, and M. Andrews (Baltimore: Johns Hopkins University Press, 1991), in Paul Israel, *Edison: A Life of Invention* (New York: Wiley, 1998), pp. 111–12. Further documentation for Edison's involvement with the Spiritualist Movement can be found in Henry Olcott, *Old Diary Leaves: The True Story of the Theosophical Society* (New York: G.P. Putnam's Sons, 1895), p. 467.

132 Rudolph Arnheim, *Radio* (New York: Da Capo, 1972), p. 76.

133 Allan Kardec, *The Mediums' Book*, trans. A. Blackwell (Rio de Janiero: Federaço Espírita Brasileira, 1986), pp. 262–63.

134 Fernand Ouellette, *Edgard Varèse*, trans. Derek Coltman (New York: Orion, 1968), p. 131.

135 Edgar Varèse, "The Liberation of Sound," in Elliott Schwartz and Barney Childs, *Contemporary Composers on Contemporary Music* (New York: Holt, Rinehart and Winston, 1967), p. 97.

136 Artaud exclaimed: STUPENDOUS DISCOVERY. SKY PHYSICALLY ABOLISHED. EARTH ONLY A MINUTE AWAY FROM SIRIUS. NO MORE FIRMANENT. CELESTIAL TELEGRAPHY BORN. INTERPLANETARY LANGUAGE ESTABLISHED. V. Antonin Artaud, "There Is No More Firmanent," in *Antonin Artaud: Collected Works*, vol. 2, trans. Victor Corti (London: Calder and Boyars, 1971), p. 85.

137 Léopold Survage, "Le Rhythme coloré," originally published in *Les Soirées de Paris* 26/27 (July–August 1914): 426–27. The article appears in translation in Richard Abel, ed., *French Film Theory and Criticism: A History/Anthology, 1907–1929*, vol. 1 (Princeton: Princeton University Press, 1988), pp. 90–92 (quoted passage at p. 90).

138 Guillaume Apollinaire, "Colored Rhythm," originally published in *Paris-Journal*, July 15, 1914, reprinted in Robert Russett and Cecile Starr, eds., *Experimental Animation* (New York: Da Capo, 1976), p. 38.

139 Ibid., pp. 90–92.

140 Virginia Woolf, "The Cinema," first published in *Arts*, June 1926, and collected in Woolf, *The Captain's Deathbed and Other Essays* (New York: Harcourt, 1950), and more recently in *The Crowded Dance of Modern Life—Selected Essays*, vol. 2, ed. and intro. R. Bowlby (London: Penguin, 1993), p. 55.

141 Ibid., pp. 56–57 (in *The Crowded Dance*).

142 Of these, fifty-nine are now in the possession of the Museum of Modern Art in New York City; twelve are owned by Cinémathèque Française; and most of the others are owned by Survage's family and descendants of friends.

143 Leopold Survage, "Color, Movement, Rhythm," sealed document (no. 8182) deposited on June 29, 1914, at the Academy of Sciences of Paris; published in Robert Russett and Cecile Starr, eds., *Experimental Animation: An Illustrated Anthology* (New York: Van Nostrad Reinhold, 1976), p. 36.

144 Blaise Cendrars, "The Birth of the Colors," originally published in *La Rose Rouge*, July 17, 1919; printed in translation (translator not acknowledged) in Russet and Starr, *Experimental Animation*, p. 39.

145 The painting is reproduced on page 11 of Jeanpaul Goergen's *Walter Ruttmann: Eine Dockumentation* (Berlin: Fruede de Dertschen Kinemathek, 1989). Goergen is an expert on Dada art, and his commentaries and his compilation of documents pertaining to Ruttmann are contributions of the highest order to scholarship in the field.

146 This painting is reproduced on page 13 of Goergen, *Walter Ruttmann*.

147 Reported by Albrecht Hasselbach, one of Ruttmann's close friends, in Standish Lawder, *The Cubist Cinema* (New York: NYU Press, 1975), p. 57.

148 From Ruttmann, "Kunst und Kino" (Art and Cinema). This text was enclosed with an undated letter that Ruttmann wrote to a female friend in 1917. It must have been written sometime during or after 1913, because it refers to films from 1913. In fact, it is likely from that year. That seems likely, first, because Ruttmann was probably referring to contemporary films (to give his comments some edge), and second, because it is known that before the First World War, he wrote a number of short pieces on experimental film and sent them to newspapers, the editorial boards of which (in a fashion that was to foreshadow the subsequent history of avant-garde cinema) rejected all his commentaries. The text, and this information about its background, appears in Walter Schobert, exhibition catalogue: *Der Deutsche Avant-Garde Film der 20er Jahre/The German Avant-Garde Film of the 1920s*, ed. A. Leitner and U. Nitschke, trans. J. Roth, S. Praeder, and T. Schwartzberg (München: Goethe-Institut, 1989), p. 6 (English), p. 7 (German). The letter itself can be found in the archives of the Deutsches Filmmuseum, Frankfurt-am-Main.

 The letter from which Ruttman's remarks have been drawn is important in several ways. First, it makes explicit the modernist background against which the idea of the Absolute Film took shape. This is important, partly because of certain confusing factors that surround its origin. For example, some of the earliest Absolute Films were made by Hans Richter and Viking Eggeling, whose principal involvements at the time were in Dada activities (this is especially true of Hans Richter); and Richter's own writings frequently—though not with complete consistency—associate his early filmmaking with Dada.

 Ruttmann's letter makes it clear that his earliest ideas about cinema, at least, were based on orthodox modernist ideas of mediumistic purity. The document, which is the earliest statement on record of the conception of the Absolute Film—or what Ruttmann called "Malerei mit Zeit" (painting with time), Eggeling called "Bewegungkunst" (art in movement), Diebold called variously "Augenmusik" (music for the eyes), "Lichttonsymphonie" (symphony of light and sound), and "zeitraumliche Eurythmie" (eurythmics in space and time), and Yvan Goll called "Kinomalerei" (cinema painting)—also makes it clear that Ruttmann has a strong claim to having been the first to work out the idea with any clarity and thoroughness.

 To be sure, Ruttmann had competition. Hans Stoltenberg published a brochure, "Reine Farbkunst in Raum und Zeit" (Pure Colour Art in Space and Time), that expounded the core principles of the Absolute Film with even greater thoroughness than Ruttmann. Stoltenberg claimed to have written this piece in 1909 (which, if true, would give him priority). However, the date of the article's composition is difficult to confirm, for it was not published until 1920. The Italian Futurist Bruno Corra also published an early statement outlining the idea of an abstract cinema in which colour would be animated according to musical principles; he even claimed to have conducted film experiments along these lines. Furthermore, as noted earlier, Survage had created in 1914 a series of paintings that he hoped to film, and he had explained their principles in a journal article published in 1914.

149 Paul Wegener (1874–1948) joined Max Reinhardt's Deutsches Theater in 1906 and established himself as a stage actor while still a member of the company. Many other actors of his generation were leery of the cinema; Wegener, though, welcomed the challenge of the new medium. He made his screen debut in *Der Student von Prag: Ein Romantisches Drama* (1913). Then in 1914 he adapted the tale of the Golem (he was interested in the

writings of E.T.A. Hoffmann and Edgar Allan Poe), in which he played the title role. Albert Bassermann (1867–1952) was another member of Reinhardt's company—indeed, he was one of the great theatre actors of the late nineteenth and early twentieth centuries. He began accepting roles in the silent cinema when other actors deemed the medium unworthy, and by the late 1910s he had become a ubiquitous screen presence. By then, Bassermann had appeared in the following films (in chronological order): *Der Letzte Tag* (1913); *Der Andere, Der König*, and *Urteil des Arztes* (1914); *Herr und Diener* (1917); *Der Eiserne Wille, Du sollst keine anderen Götter haben*, and *Lorenzo Burghardt* (1918); *Vater und Sohn* (1918); *Die Brüder von Zaarden* (1918); *Dr. Schotte, Das Werk seines Lebens* (1919); and *Der Letzte Zeuge* and *Eine Schwache Stunde* (1919). He went on to act in, among other films, *Das Weib des Pharao* (1921), *Lucrezia Borgia* (1922), *Der Mann mit der eisernen Maske* (1922), and *Alt–Heidelberg* (1923).

150 From Ruttmann, "Kunst und Kino," in Schobert, *Der Deutsche Avant-Garde Film*, pp. 6, 7.

151 Ruttmann's conclusions about film were quite advanced. His use of the term "Grotesk" was polemical—from the late 1870s until the late 1920s, the Comic Grotesque was a significant movement in German art that had inestimable influence on successive avant-garde movements, including Dada and Neue Sachlichkeit. Lovis Corinth, Paul Klee, Max Klinger, Otto Dix, Alfred Kubin, Kurt Schwitters, Emil Nolde, Hannah Höch, and Max Ernst were all decisively influenced by it. Nor was it just the feature cinema that looked to the Grotesk to validate its claims to be an art: several years after Ruttmann issued forward-looking claims, Richter published *Filmgengner von heute—Filmfreunde von morgen* (Berlin: Hermann Reckendorf, 1929), which offers a compendium of *Grotesk* effects (and montage devices) as evidence of the medium's creative potential.

152 Ruttmann, "Kunst und Kino," in Schobert, *Der Deutsche Avant-Garde Film*, pp. 6, 7.

153 Ibid., pp. 6–8 (German), 7–9 (English).

154 Ruttmann's colleague in the Absolute Film movement, Richter, offered a similar remark about abstraction: "It is obvious that to get to the spirit, the idea, the inherent principle and essence one has to <u>destroy</u> the appearance. Not in a physical way as much as in one's own eye. To forget about the leaf and to study the oval; to forget about its color and to experience its sensation" (*v.* Hans Richter, *Hans Richter by Hans Richter*, ed. C. Gray [New York: Holt, Rinehart and Winston, 1971], p. 60).

155 William Moritz, an authority on Fischinger's life and art and the principal authority on abstract film, reports that *Lichtspiel Opus Nr. 1* was "not only the first abstract film to be shown in public, but also a film hand-tinted in striking and subtle colours, with a live, synchronous musical score composed especially for it."

A partial print of *Lichtspiel Opus Nr. 1* was found in the late 1970s in Moscow, on a reel that included fragments of Ruttmann's other *Opus* films (as well as some advertising films). The print of *Opus Nr. 1* was a positive release print that had been tinted (though the tints were faded, either by time or by repeated copying), toned, and then hand-coloured frame by frame. As a result, sometimes a single frame would have three or four colours. The projection print that the Moscow archive possessed would have to have been assembled from prints tinted different colours—and probably every print of the film (presuming that there was more than one print, something that is not certain) would have to have been put together in the same way. Prints of *Opus Nr. 1* would have been very rare (possibly there was only one print) and rather fragile. Perhaps that is why the film was not shown at the May 25 Filmmatinée (and not because, as is sometimes said, the film was too rudimentary and primitive).

The Russian copy was short of the original running time by about three minutes (a fact we know from Ruttmann's meticulous metronome and timing markings on Butting's

film score). However, because Ruttmann had also drawn colour illustrations for the musicians, William Moritz was able to determine that no type of image was missing—that only repetitions of images (often in different colours) were missing. These notes allowed Moritz to reconstruct *Lichtspiel Opus Nr. 1*; and his reconstruction is truly a splendid achievement.

156 In Russett and Starr, *Experimental Animation*, p. 40. Source not given.

157 In Schobert, *Der Deutsche Avant-Garde Film*, p. 80 (English), p. 81 (German). I have altered considerably the English translation given in the text.

158 Herman George Scheffauer, *New Vision in the German Arts* (New York, 1924), pp. 145–47, in Lawder, *The Cubist Cinema*, pp. 60–61.

159 Leonard Adelt, "The Filmed Symphonie," *Berliner Tagblatt*, April 21, 1921, trans. P. Falkenberg, in Russett and Starr, *Experimental Animation*, p. 41.

160 Ibid., p. 42.

161 Ibid., p. 42.

162 Ibid., p. 42.

163 The photograph is reproduced in Russett and Starr, *Experimental Animation*; however, the authors do not seem to recognize this significance.

164 The bill of sale can be found in the Iota Center, Los Angeles.

165 Richter, "The Film as an Original Art Form," first published in *Film Culture* 1 (January 1955), and reprinted in P. Adams Sitney, ed., *The Film Culture Reader* (New York: Praeger, 1970), pp. 15–16.

166 Ibid., p. 17.

167 Ibid., pp. 17–18.

168 Ibid. By photogenic elements, Jean Epstein meant, essentially, elements that elicit strong sensations (Benjaminian shocks).

169 Ibid., pp. 18–19.

170 Ibid., p. 19.

171 Ibid. Emphases in original.

172 Malcolm Turvey, in "Dada Between Heaven and Hell: Abstraction and Universal Language in the Rhythm Films of Hans Richter," in *October* 105 (2003): 13–36, makes much of the balancing of reason and spontaneity (or, to put it differently, of reason and magic) in Richter's thought. I am in fundamental agreement with Turvey about this; but I think that he claims too much when he argues that Richter's *Rhythm* films are Dada works— I believe that Richter's assertion that these were Dada works was a later interpretation he gave, when he wanted to portray a consistency in his development as a (Dada) artist. As we will see, at the time he was working on these films he made much of his break with Dada "subjectivism."

173 *Farbenordnung* now is known only through a black-and-white photograph; the original has been lost (most likely destroyed after being shown at the infamous Entartete Kunst exhibition).

174 One should probably say that he introduced his own, highly idiosyncratic idea of Constructivism to Middle and Western Europe.

175 As they stated in the September 1922 manifesto of the Konstruktivistische Internationale schöpferische Arbeitsgemeinschaft. V. Max Burchartz, Theo van Doesburg, El Lissitzky, Karel Maes, and Hans Richter, "Erklärung der Internationale Fraktion der Konstruktivisten des ersten internationalen Kongresses der fortschrittlichen Künstler," *De Stijl* 5, no. 4 (1922); translated as "Statement by the International Faction of Constructivists," in S. Bann, ed., *The Tradition of Constructivism* (London: Thames and Hudson, 1974), pp. 68–69.

176 Ibid., pp. 68–69.

177 Ibid.

178 H.R. [Hans Richter], "An der Konstructivismus," *G: Zeitschrift für elementare Gestaltung* 3 (1924): 72. The passage appears, in translation, in Christina Lodder, "El Lissitzky and the Export of Constructivism," in *Situating El Lissitzky: Vitebsk, Berlin, Moscow*, ed. N. Perloff and B. Reed (Los Angeles: Getty Research Institute, 2003), p. 31.

179 Ideals exemplified, too, in Tatlin's plans for his *Model' proiekta Pamiatnika Trietemu Kommunisticheskomy Internatsionalu* (Monument for the Third International, 1919).

180 El Lissitzky, "The New Russian Art: A Lecture (1922)," in Sophie Lissitzky-Küppers, *El Lissitzky: Life, Letters, Texts*, trans. H. Aldwinckle and M. Whittall (London: Thames and Hudson, 1980), p. 340.

181 The group was first established in January 1920 by students at the academy, under the name MOLPOSNOVIS (*MOL*odye *POS*ledovateli *NOV*ogo *IS*kusstva [Young Followers of the New Art]). It soon included a number of the school's professors, thus the name was changed to POSNOVIS (*POS*ledovateli *NOV*ogo *IS*kusstva [The Followers of the New Art]). POSNOVIS was dedicated to introducing "new forms into all types of creative endeavors," and to that end it engaged in a wide range of experiments and worked in many media. Under Malevich the name was changed (on February 14, 1920) to UNOVIS (*U*tverditeli *NOV*ogo *IS*kusstva [The Affirmers [or Champions] of the New Art]). Malevich transformed UNOVIS into a highly structured organization, led by the UNOVIS Council. The artistic theory the group promulgated became more developed as it was worked out and reworked by Malevich and his star pupils, who included El Lissitzky, Nikolai Suetin, Ilia Chashnik, Vera Ermolaeva, Anna Kagan, and Lev Yudin. Malevich at the time was dedicated to the pursuit of a style freed of all objectal and figurative allusion, and the members of UNOVIS followed his lead on this. The group's central objective was now to introduce Suprematist designs and constructions into all aspects of Russian society. The UNOVIS Council proclaimed its commitment to break from historic academic preferences for painting and sculpture and to experiment and innovate in all art media: "organization of design work for new types of useful structures and requirements, and implementation; the formulation of tasks of new architecture; elaboration of new ornamentation (textiles, printed textiles, castings and other products); designs of monumental decorations for use in the embellishment of towns on national holidays; designs for internal and external decoration and painting of accommodation, and implementation; creation of furniture and all objects of practical use; creation of a contemporary type of book and other achievements in the field of printing." The group also advocated collective creation and creativity carried out according to a defined system or plan, and it denounced individualism. The group disbanded in 1922.

182 Yves-Alain Bois is an example. V. "From –4 to 4: Axonometry, or Lissitzky's Mathematical Paradigm," in Jan Debbaut et al., exhibition catalogue: *El Lissitzky, 1890–1941: Architect, Painter, Photographer, Typographer* (Eindhoven: Stedelijk Van Abbemuseum, 1990), pp. 27–33; Y.-A. Bois, "El Lissitzky: Radical Reversibility," *Art in America* 76, no. 4 (1988): 160–81; and idem, "Lissitzky, Malevich, and the Question of Space," in exhibition catalogue: *Suprématisme* (Paris: La Galerie, 1977), pp. 29–48.

183 V. Bann, ed., *The Tradition of Constructivism*, p. xxxiii. One should not underestimate the importance of spiritual concerns to Richter's thought at this time. It is well known that Hugo Ball and Hans Arp's Dada writings often declared spiritual interests. Richter harboured similar commitments. In *Dada Art and Anti-Art* (1964), in the section "The Language of Paradise," Richter stated: "By casting doubt on the claims of the spoken, unspoken or written word to priority, Ball the poet revealed the deeper causes which made

the Dada writers, despite all their anti–art declarations, finally unable to arrest their *pro-art* tendencies within the movement. Our search, as visual artists, for the 'true language of Paradise' went much deeper than the wild anti-art propaganda of the movement's published statements, which was based on social, moral, and psychological arguments. If Ball, whose chosen medium was words, could feel this to be true, we as painters, whose medium was the 'paradisal' language of signs itself, were necessarily even more conscious of it." Richter, *Dada Art and Anti-Art*, trans. D. Britt (London: Thames and Hudson, 1997), p. 49.

Later (p. 59), in the section "Chance and Anti-Chance," Richter offered the following comment on discussions he had had with Hans Arp, the great Dada proponent of chance: "The adoption of chance had yet another purpose, a secret one. This was to restore to the work of art its primeval magic power, and to find the way back to the immediacy it had lost through contact with the classicism of people like Lessing, Winckelmann, and Goethe. By appealing directly to the unconscious, which is part and parcel of chance, we sought to restore to the work of art something of the numinous quality of which art has been the vehicle since time immemorial, the incantatory power that we seek, in this age of general unbelief, now more than ever."

In his later years, Richter took part in the Jungian *Eranos* conferences at Ascona; he connected Jungian psychology (which is rooted in ideas about the reconciliation of opposition) to the antithetical desires that had ruled his life since 1917: the desire for anarchy, chaos, spontaneity, and chance and the desire for order and structure. V. Cleve Gray, ed., *Hans Richter on Hans Richter* (New York: Holt, Rinehart and Winston, 197), p. 67.

184 Christina Lodder emphasizes this in "El Lissitzky and the Export of Constructivism," in Perloff and Reed, *Situating El Lissitzky*, pp. 27–46. Lissitzky's influence might have been even more profound. The Russian critic Nikolai Khardzhiev contends that as early as 1922 (i.e., around the time that, according to some accounts, Richter and Eggeling began making films), Lissitzky was contemplating animating his Suprematist compositions. He described Lissitzky's book *Suprematicheskij skaz pro dva kvadrata v shesti postroikakh* (About Two Squares: A Suprematist Tale in Six Constructions) as "an animation … where all the 'stills' are connected by an undisturbed movement of simple, equivalent figures within a time sequence which is finalized with the triumph of the Red square." He also asserted that Lissitzky planned to resolve "the problem of the formal arrangement of the movement … with the aid of a camera" ("El Lisitskii—konstruktor knigi" [El Lisitskii—Constructor of the Book], in Andrei Sarabianov, Rudolf Dyganov, and Ivrii Arpishkin, eds., *N.I. Khardzhiev: stat'i ob avangarde* [N.I. Khardzhiev: Essays about the Avant-garde], vol. 1 [Moscow: RA, 1997], p. 155, in Margarita Tupitsyn, "After Vitebsk: El Lissitzky and Kazimir Malevich, 1924–1929," in Perloff and Reed, *Situating El Lissitzky*, p. 183). Thus he shared with Malevich the ambition to turn Suprematism into *kino-forma*. Tupitsyn's article drew to my attention El Lissitzky's interest in the cinema. Tupitsyn has done much to make art historians aware of vanguard Soviet artists' interest in the cinema: she had a computer animation of Lissitzky's *Suprematicheskij skaz pro dva kvadrata v shesti postoikakh* prepared for an exhibition, *Malevich and Film*, that she curated for Fundação Centro Cultural de Belém, Lisbon, Portugal (May 17 to August 18, 2002) and Fundación "la Caixa," Madrid (November 31, 2002 to January 13, 2003).

There is more to be said: Maria Gough does a fine job of proving that Lissitzky considered his *Proun Room* (Berlin, Grosse Berliner Kunstausstellung, 1923), his *Raum für konstuktive Kunst* (Dresden, Jubiläums-Gartenbau-Austellung, 1926), and his *Kabinett der Abstrakten* (1927–28) for Hannover to unfold a reasoned argument (as Sergei Eisenstein believed montage was capable of doing)—that is why he referred to these projects

as *Demonstrationsräume*. These works are essentially paracinematic works, Gough shows; like Eisenstein, Lissitzky formulated means to transform the spectator from a passive consumer into an active participant—where Eisenstein used cinematic means, Lissitzky used paracinematic means (*v.* Maria Gough, "Constructivism Disoriented: El Lissitsky's Dresden and Hannover *Demonstrationsräume*," in Nancy Perloff and Brian Reed, eds., *Situating El Lissitzky* [Los Angeles: Getty Research Institute, 2003], pp. 77–125).

185 But not sufficient grounds that a good art historian would be comfortable identifying the different versions of Constructivism that developed in the West and the Soviet Union.

186 At the Kongress der Internationale fortschrittlicher Künstler, Lissitzky described Russian thinking as characterised "by the attempt to turn away from the old subjective, mystical conception of the world to create an attitude of universality–clarity–reality. That this way of thinking is truly international may be seen from the fact that during the seven-year period of complete isolation from the outside world, we were attacking the same problems in Russia as our friends here in the West, but without any knowledge of each other" ("Statement of the Editors of *Veshch'/Gegenstand/Objet*, in Bann, *The Tradition of Constructivism*, p. 63; the declaration was largely written by Lissitzky).

187 Richter's interest in using reason to the ends of magic rehearsed the same problematic.

188 In Bernd Finkeldey, "Hans Richter and the Constructivist International," in Stephen C. Foster, ed., *Hans Richter*, p. 97. Richter's Constructivist interests led him to enthuse over things Russian. His anti-individualism echoed that of Ivan Puni, one of Richter's expatriate Russian friends, who lived near Nollendorfplatz, then the centre of the Russian artistic community in Berlin. In his "Aufruf zur elementaren Kunst" (Call for Elementary Art), Puni, together with Molohy-Nagy, Hans Arp, and Raoul Hausmann, summoned the world's artists to help bring forth a new art that would build on the character of the media with which they work and on the attributes of simple formal elements. Richter also praised a trilingual journal that Lissitzky had founded with Ilya Ehrenburg, *Veshch'/Gegenstand/Objet* (two issues of the magazine appeared, one in March–April 1922, the other in May 1922), for being a journal "that confronted the problems of our modern art and underscored the affinity between our artistic efforts and those in Russian art" (Richter, *Köpfe und Hinterköpfe* [Heads and Backs of Heads], in Finkeldey, "Hans Richter and the Constructivist International," in Foster, ed., *Hans Richter*, p. 97).

189 One thing that members of the Arbeitsgemeinschaft did not agree on was their politics: van Doesburg clashed with Lissitzky and Moholy-Nagy over Constructivism's political commitments—a clash that Richter tried to mediate.

190 Undated letter from Gert Caden to Alfred Hirschbroek in the Sächsische Landesbibliotek, Dresden: Handschriftensammlung, Nachlaß Caden (Provincial Library of Saxony, Collection of Hand-written Materials, Caden File). In Finkeldey, "Hans Richter and the Constructivist International," p. 105.

191 The typesetting of the original article, which was rather elaborate, was subsidized by Mies van der Rohe. An English translation of the article, by Mike Weaver, appears in P. Adams Sitney, ed., *The Avant-garde Film: A Reader of Theory and Criticism* (New York: New York University Press, 1978), pp. 22–23, as "The Badly Trained Sensibility" (though I should have preferred to see it called "The Badly Trained Soul"). My quotations in the following section of the text all come from this source.

192 This article is not the only instance when Richter apparently distanced himself from the Dada movement with which his name is so frequently associated. As we have noted, Richter praised Lissitzky and Ilya Ehrenburg's *Vershch'/Gegenstand/Objet*. The first editorial declared that the time for the "negative tactics of Dada" was now past and that "the fundamental feature of the present age is the triumph of the constructive method. We

find it just as much in the new economics and the development of industry as in the psychology of our contemporaries in the world of art. *Objet* will take the part of constructive art, whose task is not to adorn life but to organize it." Lissitzky and Ehrenburg, "Die Blockade Russlands geht ihrem Ende entgegen," *Veshch'/Gegenstand/Objet* 1/2 (1922): 1–2, translated by Bann as "The Russian Blockade Is Coming to an End," in Bann, *The Tradition of Constructivism*, p. 55.

193 Richter, "The Badly Trained Sensibility," in Sitney, *The Avant-Garde Film*, p. 22.

194 Ibid. The phrase translated as elementary laws is "Elementaren und Gesetzmässigen," which I would prefer to translate as "elements and laws."

195 A notion that relates to Susanne Langer's idea that artistic forms have the virtual shape of emotions. The article gives expression to Richter's Neo-Plasticist leanings: Richter became associated with van Doesburg's De Stijl movement in 1921, and from 1923 to 1926 served as editor of *G.*, which, though not exactly the movement's house organ (there was an official publication, *De Stijl*), was closely aligned with the De Stijl movement. The films Richter made in this period, *Rhythmus 21*, *Rhythmus 23*, and *Rhythmus 25*, are all deeply influenced by Neo-Plasticist ideals, whereas the films made after Richter's intensive involvement in that movement—*Filmstudie* (1926), *Inflation* (1927–28), *Rennsymphonie* (1928), *Vormittagsspuk* (1927–28), *Zweigroschenzauber* (1928–29), *Alles dreht sich, alles bewegt sich* (1929), *Everyday* (1929) *Dreams That Money Can Buy* (1947), *8 x 8* (1956), *Chesscetera* (1956), and *Dadascope I and II* (1956–57)—have a different character. They all incorporate cinematographic images of everyday objects. *Filmstudie* is a transitional work that incorporates both passages of geometric abstraction in the style of the *Rhythmus* films and impressionistic photographically based images, produced using prisms. *Vormittagsspuk*, inspired partly by the physical comedy of the American popular cinema, portrays a revolt of objects—they come to life, gain independence, and rebel against people and their (people's) daily routine. The result is a surfeit of sight gags whose dynamism is structured by musical rhythms. The filmmaker appears in the film, along with such artist friends as Werner Graeff, Darius Milhaud, and Paul Hindemith; Hindemith also composed music for the film (though his composition, together with the film negative, was destroyed by the Nazis as "Degenerate Art"). Subversive gestures from Richter's Dada past are redeployed, though in this work their antibourgeois shock effect is lessened. Unlike *Filmstudie*, *Vormittagsspuk* possesses a rudimentary narrative—however, since the plot suggests the anarchistic dissolution of causal laws, the narrative is associatively developed and not overbearing. *Inflation* is one of the earlier examples of the "essayist film"—a form that recently Craig Baldwin has capitalized on (if not altogether successfully) in works such as *Tribulations 1999* and *Spectres of the Spectrum*. *Filmstudie* (like essayist films in general) combines the possibilities of documentary and experimental film and gives visible form to the invisible world of thoughts and ideas; thus it is free to leap about in space and time and shift modes from, for example, realistic documentary footage to fantastical allegory and to use anything that can be seen or can be imagined (its Dada-inspired form presages the postmodernist use of pastiche). *Zweigroschenzauber* was a commercial trick-film, advertising an illustrated tabloid. *Alles dreht sich, Alles bewegt sich*, Richter's first sound film, presents a extraordinary, intricate Constructivist montage of images and sounds from a day at an amusement park. *Everyday* portrays the routine of an office worker, from morning, through rush hour and the working day, to the end of workday and the evening's entertainments, then returns da capo, to the morning again (in accordance with Richter's ideas about the essayistic film, it offers a steady accelerando that evokes a hectic but meaningless round of repeated activities). *Dreams That Money Can Buy*, *8 x 10*, *Dadascope I and II*, and *Chesscetera* are

all late Dada works made while Richter was living in the United States. Like *Vormittagsspuk*, they were inspired by the physical comedy of the popular American film.

196 This temporal feature distinguishes Richter's films from those of his structuralist successors.

197 Richter, "The Badly Trained Sensibility," p. 22.

198 A still relatively novel theory about colour vision in Richter's time was Ewald Hering's (1834–1918) "opponent process" theory. Hering argued that the "trichromatic theory," the Young-Helmholtz theory that the receptors in the eye are only responsive to three primary colours (or that the receptors are maximally responsive only to the wavelength of one of the primaries), could not explain the phenomenon of afterimages—of negative-coloured images seen after viewing a coloured object for a long time (e.g., a red afterimage of red seen after staring at a green object for a prolonged period, or a yellow afterimage seen after staring at a blue object for a prolonged period). Hering's work has a phenomenological cast; he asked why certain colours, such as bluish-yellow and reddish-green, can never be seen or even described.

He proposed that the visual system generates signals in opposing pairs (i.e., yellow/blue, red/green, white/black). Neural experiments conducted in the twentieth century proved him correct on that one. The idea that sensation depends on contrast—that contrast is built into the very fibre of experience—was much discussed in the 1910s and 1920s.

199 Between 1912 and 1917, his first years as a painter, Richter had painted sometimes in a more Cubist manner and sometimes in a more Expressionist manner. During 1917, after moving to Zurich in late August or early September 1916 and coming under the influence of Dada, he began painting what he called "visionary portraits," intensely colourful and extraordinarily vibrant ever-more-abstract paintings, executed by adopting a spontaneous, free-associative method: "For my own part, I remember that I developed a preference for painting my [visionary portraits] in the twilight, when the colours on my palette were almost indistinguishable. However, as every colour had its own position on the palette my hand could find the colour it wanted even in the dark. And it got darker and darker … until the spots of colour were going on to the canvas in a sort of auto-hypnotic trance, just as they presented themselves to my groping hand. Thus the picture took shape before the inner rather than the outer eye" (Richter, *Dada Art and Anti-Art*, p. 55).

200 Viola Kiefer, "Analogien in Malerei und Filmbild," in H. Gehr and M. von Hofacker, eds., *Hans Richter: Malerei und Film* (exhibition catalogue as *Kinematograph* Nr. 5, 1989) (Frankfurt: Deutsches Filmmuseum, 1989), p. 64. Translation mine.

201 Similar means of creating stark contrasts of black and white, either of which may represent a volume or a void depending on its position and area, characterizes Richter's first film *Rhythmus 21*. In the film's opening sequences especially, but in some measure in the rest of the film as well, the spatial relations among the various figures are ambivalent and undergo continual transformation. It is sometimes difficult to state whether the white areas on the screen are foreground or the background areas, and even when you can identify them, the foreground elements may soon transform themselves into background elements. Incorporating negative film enhanced this ambiguity. Richter's concerns with the harmonization of polarities led him to search for the foundations of visual art, for a *Generalbaß der Malerei*.

202 Richter, "Easel—Scroll—Film," *Magazine of Art*, February 1952, p. 79.

203 Like Mondrian, then, Eggeling worked with an unvanquishable persistence to distill a vocabulary of elementary forms from nature.

204 Eggeling was born in Sweden in 1880, one of twelve children. He became a bookkeeper and in 1911 moved to Paris, where he took up painting. He had had little formal training, and until 1911 his paintings and drawings had consisted largely of landscape and figure studies. The museums and galleries he visited, the analytical discussions he engaged in, and the work he did in Paris opened up many of the issues that would later preoccupy him. People concerned with advanced art in Paris at the time were under the sway of Cubism, and Eggeling took an interest in the Cubists' formal experimentation. As a result, his Paris paintings show an interest in analyzing and simplifying forms into geometrical figures.

205 The difference in concerns would last into the era when the two artists took up filmmaking. Though both Eggeling and Richter attempted to resolve visual form into elementary units, Richter's film work (like that of the Neo-Plasticist painters) was concerned with the interplay of rectangular areas, which are differentially defined as lighter and darker; whereas Eggeling was more concerned with revealing linear developments through time. Thus, Eggeling's *Diagonal-Symphonie* is essentially a work of morphological transformation (understood as Goethe understood that process).

206 Eggeling's interest in dynamizing form through the use of diagonals is evident in *Diagonal-Symphonie* as well.

207 *XX^{ième} Siècle*, 1 (1938), reprinted in *XX^{ième} Siècle*, 21, no. 13 (1959): p. 25, in Lawder, *The Cubist Cinema*, p. 39.

208 Richter, "Dada and the Film," in Willy Verkauf, ed., *Dada—Monograph of a Movement* (Teufen, 1957), in Lawder, *The Cubist Cinema*, p. 43. The scroll that Richter refers to as the *Horizontal-Vertical Mass* is usually referred to as *Horizontal-Vertikal Orchester*. Erna (Ré) Niemeyer, Eggeling's girlfriend at the time the artist produced this scroll (and later, 1927–29, Hans Richter's wife, and still later the wife of the great Surrealist poet Philippe Soupault), reveals that in 1923 she worked with Eggeling on a film of the same name and based on the scroll. No copy of Eggeling's film is known to exist, and it is likely that, owing to some dissatisfaction with it, he did not screen it to the public. Art critic Ernst Kállai commented on the film: "The aesthetic perspective, recalling Gabo's kinetic constructions, is revealed also in Viking Eggeling's abstract film (sketched in 1919) which the artist calls *Horizontal-Vertical Orchestra*. The name indicates two fundamental traits of the work. The film is a trial of strength in which take part the polar and analogous [recalling the terms "Kontrast" and "Analogie"] relations of form, proportion, rhythm, number, intensity, position and temporal quality. [This provides what is likely a comprehensive list of the feature domains that Eggeling considered in his theory of *Kontrast-Analogie*.] The time factor is experienced immediately, through the spatial-optical course of the movement and indicates the connection with music ... In their films where movement of light is presented in square forms, Eggeling's disciple and former collaborator, Hans Richter, and also Werner Graeff, have followed the principles formulated by Eggeling concerning polarity and analogy, and the influence exerted by these two concepts on each other." Kállai, "Konstruktivismus," *Jahrbuch der jungen Kunst* (Leipzig, 1924), p. 380.

The information in the above paragraph, and the quotation from Kállai, which does so much to elucidate the relation between Eggeling and Richter, is drawn from Louise O'Konor, "The Film Experiments of Viking Eggeling," *Cinema Studies* 2, no. 2 (1996): 27–28.

Erna Niemeyer-Soupault also claims that she photographed *Rhythmus 21* and *Rhythmus 23* in 1925 and 1926, and that these films were based on visual designs that Eggeling had laid out. Contradicting hers are two other assertions. First, Werner Graeff (who cer-

tainly doesn't hold Richter blameless in his treatment of collaborators) claims that he worked on *Rhythmus 23* (which, when he met Richter, was called *Fuge in Rot und Grün*) and that it was completed in 1922. Second, Marion von Hofacker states (without giving the evidence) in her "Chronology" of Richter's career (in Foster, *Hans Richter*) that *Film ist Rhythmus* was shown at the final Dada soirée, Soirée du coeur de barbe. Against Graeff's claim is the fact that the publicity flyer for Novembergruppe's Filmmatinée, for May 3, 1925, lists only one film by Richter, *Film ist Rhythmus*. Given Richter's support for causes like those espoused by the Novembergruppe, it is hard to imagine that *Rhythmus 23* would not have been shown if it had been finished. And Hofacker's misidentification of *Film ist Rhythmus* as *Rhythmus 23*—actually, the test strip that Richter showed under the title *Film ist Rhythmus* is only a part of the middle of *Rhythmus 23*—weighs against the authority of her assertions.

209 The information in this paragraph comes largely from William Moritz, "Restoring the Aesthetics of Early Abstract Films," presented at the Society of Animation Studies Conference, Los Angeles, October 1991, and printed in Jonas Mekas, ed., *Swedish Avantgarde Film 1924–1990* (New York: Anthology Film Archives, 1991).

210 The analogies to Eisenstein's ideas about developing forms on the basis of Pavlovian conditioning are striking.

211 Richter, "The Badly Trained Sensibility," p. 23.

212 Richter, *Köpfe und Hinterköpfe* (Zurich: Arche, 1967), pp. 11–12, in Finkeldey, "Hans Richter and the Constructivist International," trans. C. Scherer, in Foster, *Hans Richter*, p. 95.

213 "Artifex" is the Medieval term for alchemist, but Heinrich Bokemeyer used the term in *Die Canonische Anatomie* to refer to the composer of counterpoint. I use the term here to reinforce the point that the counterpointist was thought to possess esoteric knowledge.

214 Andreas Werckmeister, *Harmonologia musica* (Quedlingburg, 1707, reprinted Hildesheim, 1970). The passage is quoted in David Yeardsley's spendid *Bach and the Meaning of Counterpoint* (Cambridge: Cambridge University Press, 2002), p. 19 (whence I have taken it).

215 In Werckmeister, *Harmonologia musica*.

216 Architecture also could, and should, reflect divine ratios—indeed, an intimate relation between musical architecture and building science was a cornerstone of counterpuntal music. Thus a famous motet by Ghiam du Fye, the piece written for the consecration of Florence cathedral, "New Parisar un Flores," is built on a proportion 6 to 4 to 2 to 3. Scholars generally believed that those relationships mirrored the proportions of the Florentine cathedral. Unfortunately, this is not so, for du Fye counted out the spaces of the cathedral incorrectly, so the motet does not match its proportions.

217 Martin Luther, "Lectures on Genesis" (1535/36), 1:126, in *Luther's Works*, 55 vols., various translators (St. Louis and Minneapolis: Concordia Publishing and Fortress Press, 1957–86).

218 Luther, "Lectures on Isaiah, Chapters 40–66" (1527–30), *Luther's Works*, 17:356.

219 Luther, "Preface to Georg Rhau's *Symphonia iucundae*" (a collection of chorale motets published in 1538), *Luther's Works*, 53:324.

220 Ibid., in Walter E. Buszin, "Luther on Music," *Musical Quarterly* 32, no. 1, reprinted in *Luther on Music*, ed. J. Riedel (St. Paul: Lutheran Society for Worship, Music and the Arts, 1958), pp. 5–6. Dietrich Bartel, *Musica Poetic: Musical-Rhetorical Figures in German Baroque Music* (Lincoln: University of Nebraska Press, 1997), p. 4. Note that the idea of the cosmic dance is one whose provenance lies in Pythagorean ideas about cosmic order

(and the possibility of sublunary forms embodying those patterns) similar to those presented in this passage. (On the historical importance of the idea of the cosmic dance, see James Miller's brilliant *Measures of Wisdom: The Cosmic Dance in Classical and Christian Antiquity*, 1986.) E.M.W. Tillyard, in his short and very, very rich book *The Elizabethan World Picture: A Study of the Idea of Order in the Age of Shakespeare, Donne, and Milton* (London: Chatto and Windus, 1943, current ed. New York: Vintage, 1956), states this about music's privileged place: "Ever since the Greek philosophers creation had been figured as an act of music" (p. 123; I am fully aware that Tillyard's book has been much attacked by the New Historicists). According to this view, human being, as part of the creation, is in some sense the product of music and indeed a musical being in the deepest sense. John Dryden's (1631–1700) famous *Song for St. Cecilia's Day* (1687) opens with these lines:

> FROM harmony, from heavenly harmony,
> This universal frame began:
> When nature underneath a heap
> Of jarring atoms lay,
> And could not heave her head,
> The tuneful voice was heard from high,
> 'Arise, ye more than dead!'
> Then cold, and hot, and moist, and dry,
> In order to their stations leap,
> And Music's power obey.
> From harmony, from heavenly harmony,
> This universal frame began:
> *From harmony to harmony*
> *Through all the compass of the notes it ran,*
> *The diapason closing full in Man.* [Emphasis mine]

Two hundred and fifty years later, the philosopher and novelist Olaf Stapleton (1886–1950), writing in one of the most influential science fiction books of the century, and under the influence of the new astronomical discoveries, concluded that "Man himself ... is music, a brave theme that makes music also of its vast accompanying matrix of storms and stars" (*Last and First Men: A Story of the Near and Far Future* [London: Methuen, 1930; Penguin edition, 1963, p. 32]). The example of Stapleton shows that for some in the early twentieth century, this conception of the relationship between creation and music was very much alive. The created universe was simply a piece of music or a cosmic dance. Therefore, future music will engender a new creation—and a new "man" (to allude to one of the themes of the second part of this book).

The Dryden poem was set to music by George Frederick Handel (1685–1750) in *An Ode for St. Cecilia's Day*, which is further evidence of how alive these ideas were to artists in Bach's time—and in Handel's time—and of how available those ideas were to artists of the early decades of the twentieth century who possessed a passing acquaintance with key ideas in the history of art and music.

221 Busoni had a profound interest in counterpoint. His monumental *Fantasia Contrappuntistica* of 1910, which he composed just a few years before Richter met him, was greatly influential. He also produced an important edition of Bach's music, starting with the *Inventions* (1890), followed by the first book of the forty-eight preludes and fugues of the *Well-Tempered Clavier*. He would go on to publish a complete edition comprising twenty-seven volumes, some of these in collaboration with Egon Petri and Bruno Mugellini. He

was well-regarded in avant-garde circles—Filippo Tomasso Marinetti was enamoured with Busoni's music.

In the text I offer some conjectures concerning the parallels between Richter's *Dada Köpfe* and counterpoint. But Busoni may have re-enforced another of Richter's interests: Busoni's magnum opus is generally considered to be *Doktor Faust*, which he began in 1916 and which remained unfinished at his death. (Thus, he would have been working on *Doktor Faust* when Richter got to know him.) *Doktor Faust* is full of the mystical passion that was so much a part of Busoni's music—and of Richter's writings of the early 1920s.

Busoni was also a brilliant theorist; his ideas, though, differed considerably from those that Eggeling and Richter propounded. Busoni developed his aesthetic vision across a series of essays and articles, which culminated in a short pamphlet, *Entwurf einer Neuen Aesthetik der Tonkunst* (Outline of a New Aesthetic of Music, 1907), that established Busoni as important figure in the avant-garde). Among those whom the pamphlet influenced were Edgar Varèse and Luigi Russolo. It was a brilliant, prophetic piece of writing on music, certainly one of the strangest pieces of writing about music to come out of that era. In it, Busoni attempted to expound and defend his idea of "absolute music"—an idealized, celestial music of which Bach and Beethoven's music have given us only in an inadequate and distanced understanding. (He also believed that the music of the First Nations people of North America was a closer approximation of the celestial music of the future, so he wrote *Indianische Fantasie* and *Indianische Tagebuch*.) His *Entwurf* claimed that this idealized, celestial music was too often occluded by our earthly attention to musical laws and forms. In passages reminiscent of Nietzsche's *Also Sprach Zarathustra* (especially the "Vom Geist der Schwere" section), he praised the true creative artist as one who does not follow the received laws but instead creates new ones. Busoni went on to propose new divisions of scales into microtones; he even suggested a new method for notating them.

There are closer correspondences between the ideas of Busoni and those of Eggeling and Richter. In the *Entwurf*, Busoni offered a concept of "Universal Music," and much of that pamphlet is an effort to define that concept. Like Eggeling and Richter, Busoni imagined a music of universal appeal, a music that would transcend all boundaries and differences to affect all alike. This statement appears at the beginning of the treatise: "I wish for the Unknown! what I already know is limitless. I want to go still further."

His tributes to Bach display a sort of universalist ambition. For one of his Bach tributes (among many), the *Fantasia Contrappuntistica*, Busoni followed Bach's practice of realizing a piece of pure music structure, avoiding considerations of the instrument on which it would be played: thus he published versions for pianoforte solo and for two pianofortes; he also allowed Middelschulte to arrange it for organ, and Frederick Stock to orchestrate it for the London Philharmonic (though at the rehearsal, Busoni found some parts of Stock's work unsatisfactory and requested alterations, which prompted the orchestra's directors to cancel the performance).

222 There are many repeating patterns in Richter's *Dada Köpfe*, so I wonder whether Busoni didn't connect this aspect of the works to the traditions of the ground bass and of "divisions on a ground."

223 Eggeling's essay was published in *MA* 8 (Vienna, 1921): 105–6; Louise O'Konor is responsible for bringing it to the attention of film scholars. V. Louise O'Konor, "The Film Experiments of Viking Eggeling," *Cinema Studies* 2, no. 2 (1966): 26–31. Richter's essay was published in *De Stijl* 3, no. 7 (1921): 109–12.

224 Richter, *Monographie*, p. 24, in Justin Hoffmann, "Hans Richter: Constructivist Filmmaker," in Foster, *Hans Richter*, p. 75.

225 Richter, "My Experience with Movement in Painting and Film," in *The Nature and Art of Motion* (New York: Braziller, 1965), p. 144, in ibid., p. 76.

226 Eggeling, "Elvi fejtegetések a mozgómüvészetrö," in *MA* 8 (Vienna, 1921), in Louise O'Konor, "The Film Experiments of Viking Eggeling," p. 28.

227 From an interview between Richter and Friedrich Bayl, in *Art International* 3, nos. 1/2 (1959): 55, in Eva Wolf, "Von der universellen zur poetischen Sprache," in H. Gehr and M. von Hofacker, eds., *Hans Richter: Malerei und Film* (Frankfurt: Deutschen Filmmuseums, 1989), p. 16 (translation mine).

228 "Vom pigment zu licht" in *telehor* (Brno, 1936), p. 119; "Ein Fragment über den Elementarismus von van Doesburg," *De Stijl* 13, no. 7 (1926/27): 82–87; both quoted in Wolf, "Von der universellen," in Gehr and von Hofacker, *Hans Richter*, p. 16 (translation mine).

229 Recall the horrifying images of suffering in the slums that Käthe Kollwitz produced around this time; Meidner's depictions of urban existence as a veritable terror; Kirchner's images of menacing prostitutes preying on the city; Otto Dix and Georg Grosz's grotesque visions of black market racketeers, sex murderers, disabled veterans, and Freikorps assassins; and John Heartfield's (Johann Herzfeld) photomontages, replete with coffins and death masks.

230 In what follows, I outline the logical structure of the process that drove Eggeling and Richter toward their *Universelle Sprache*. Of course, this construal is an art historian's artifact and differs from what the participants would have experienced. Their experience would have been much closer to the concrete economic realities that most artists have to contend with. For them, a key purpose of *Universelle Sprache* was to make it possible for the two artists to make a film.

In 1919 Eggeling and Richter began working on scrolls—Eggeling on *Horizontal-Vertical Mass* and Richter on *Präludium*. In making these works, they developed a form in which the pictorial elements led the eye through the composition. In this regard, the scrolls were like films, and this similarity engendered in the painters a desire to work in film. A wealthy backer who lived in their neighbourhood offered to give them DM 10,000—a large sum, but not enough to make the film. What is more, neither knew any of the technical rudiments of filmmaking. So they started a campaign to persuade UFA (Universum-Film, A.G.) to produce their film; they had the idea of producing, as part of this campaign, a pamphlet, *Universelle Sprache*, that would set out their ideas about a language of elementary pictorial elements and of sending out copies to people with influence (including Albert Einstein). Their campaign succeeded: UFA provided them with a studio and a technician. In the end, however, the technician and the artists did not get along and the resulting collaboration was a disaster.

To be sure (and despite what Richter has written on the topic), Eggeling's first UFA animation tests (1920/21) seemed so unsatisfactory that he would not show them in public. Eggeling and Richter worked together on creating a film of the *Horizontal-Vertikal Orchester* for about a year, then Richter abandoned the project. Eggeling attempted several more animation tests during 1922 and 1923, but they, too, struck him as inadequate. In 1923 a young Bauhaus student, Erna Niemeyer, undertook to animate his *Diagonal-Symphonie* scrolls; at that point, Eggeling abandoned the *Horizontal-Vertikal Orchester* entirely. Niemeyer and Eggeling, working in appalling poverty, finished the *Diagonal-Symphonie* in 1924 and showed it, first privately, to family and friends, and then publicly. Eggeling was already hospitalized when the public première took place; a few days later he died of syphilis.

An influential Berlin critic, Dr. Adolf Behne, saw early on the experiments that Richter and Eggeling were engaged in, and he wrote enthusiastically about them. His report was

read by Theo van Doesburg, who sent Richter a telegram informing him that he wanted to pay them a visit in Klein-Koelzig. He arrived for a three-day stay and remained for three weeks. He recognized, of course, their affinity with the works of the De Stijl movement, which was already underway in the Netherlands.

The idea of a *Generalbaß* of painting has similarities with Kandinsky and Mondrian's notion of inner (or internal) necessity (a notion both painters often mentioned but explained none too clearly). In one of his more lucid statements of the idea, Kandinsky wrote: "Thus it is clear that the harmony of forms can only be based upon the purposeful touching of the human soul. This is the principle we have called the principle of internal necessity." Or, making the same point, when discussing colour harmony: "The artist is the hand that purposefully sets the soul vibrating by this or that key. Thus it is clear that the harmony of colors can only be based upon the principle of purposefully touching the human soul. This basic tenet we shall call the principle of internal necessity." It appears, then, as the principle that a work of art should be so constructed as to move the soul toward some good (a principle that Eisenstein was to reformulate in materialist terms with the help of Pavlov Bechterev and Sechenov's psychology).

In the context of his discussion of internal necessity, Kandinsky, too, referred to the Goethean concept of *Generalbaß*. Kandinsky thought of the *Generalbaß* as a worked-out, reasoned, and conscious mode of composing colours and forms that would ensure that they stirred the spectator's soul toward the good the artist had in mind. It was just this belief that led Kandinsky to conclude *Über das Geistige in der Kunst* (On the Spiritual in Art) (Munich: Piper, 1912) with this paragraph: "In conclusion, I would remark that in my opinion we are approaching the time when a conscious, reasoned system of composition will be possible, when the painter will be proud to be able to explain his works in constructional terms (as opposed to the Impressionists, who were proud of the fact that they were unable to explain anything). We see already before us an age of purposeful creation, and this spirit in painting stands in direct, organic relationship to the creation of a new spiritual realm that is already beginning." One sees that in Kandinsky's mind, too, the opposition between reason and the spirit (magic) is not one of stark antithesis.

231　By relations of analogy Richter meant relationships between organic (i.e., plurisemic) elements and inorganic (i.e., univocal) elements. On organic elements being, and inorganic elements not being, plurisemic, *v.* "Demonstration of the 'Universal Language,'" in Foster, *Hans Richter*, p. 209.

232　This interest in the conformity of artistic products with universal metaphysical principles is evidence of how closely aligned European Constructivism and De Stijl were. It is also evidence of how strongly influenced by Suprematism (UNOVIS) European Constructivism was.

233　Richter, "Demonstration of the 'Universal Language,'" p. 209.

234　Richter, "Rhythm," *Little Review* (Winter 1926): 21, in Karin von Maur, *The Sound of Painting*, p. 57. (Von Maur inaccurately identifies the quote as being from 1971.)

235　Richter, "Rhythm," p. 21, in Wolf, "Von der universellen," p. 19 (translation mine).

236　Ibid.

237　Richter, "Von der statischen zur dynamischen Form," in *Plastique* 2 (1937): n15, in ibid.

238　Goethe's *Theory of Colours* was written in phases: *Beiträge zur Optik I* (1791) and *II* (1792), then *III. Von den Farbigen Schatten* (written in 1792, unpublished), *Didaktischer Teil* (1808), and finally, in 1810, *Zur Farbenlehre*, which included the *Didaktischer Teil: Entwurf einer Farbenlehre* and the *Polemischer Teil: Enthullung der Theorie Newtons* and the *Historischer Teil: Materialien zur Geschichte der Farbenlehre*. Charles Lock Eastlake,

a friend of John Turner, translated *Didaktischer Teil* and published it in 1840 as *Goethe's Theory of Colours.*

239 Richter counselled himself: "Do not show the outer but the inner sequence.—Not biologically: how something emerges (materialistically) but rather logically = the sequence corresponding with the meaning, the law." Richter, "Demonstration of the 'Universal Language,'" p. 217. Admittedly, Richter's world view was modelled on mechanical processes, not on biological processes as Goethe's and Hegel's were; but Eggeling's input into the *Generalbaß der Malerei* would have taken care of that difference.

240 Drawings in the library at Yale University suggest what Eggeling was attempting to do.

241 In Lista, "Raoul Hausmann's Optophone," in Dickerman with Witkovsky, *The Dada Seminars,* p. 98. I wish to add that I couldn't disagree more basically with Lista's remarks on Elementarism, Dada, and the relation of Elementarism and Dada, or with her remarks on Richter and on the *Universelle Sprache.*

242 The Neo-Plasticist Mondrian—whose work resembles Richter's scrolls and films—alludes to this idea. V. Piet Mondrian, *The New Art—The New Life: The Collected Writings of Piet Mondrian,* edited by Harry Holzman (New York: Da Capo, 1993), p. 36. Stan Brakhage suggests a similar view—that what we see on the screen is muddying of pure white light.

243 Richter, "Demonstration of the 'Universal Language,'" p. 209.

244 Readers will know that the Neo-Plasticists avoided using green: that the Theosophists adopted Goethe's colour theory helps explain why.

245 Goethe's description of the sensual–moral effects of particular colours is quite at variance with those of Steiner and the Theosophists, who considered blue (for example) the most spiritual colour.

246 Wittgenstein was even more dismissive of Goethe's *Farbenlehre* than the remark just cited suggests: "It really isn't a theory at all. Nothing can be predicted with it. It is, rather, a vague schematic outline of the sort we find in James psychology. Nor is there any *experimentum crucis* which could decide for or against the theory."

247 Kandinsky, "The Language of Forms and Colors," in *On the Spiritual in Art,* in *Complete Writings on Art,* p. 177–79.

248 Kandinsky, "Point," in *Point and Line to Plane* (Munich, 1926), reprinted in *Complete Writings on Art,* p. 538.

249 This belief that colours have spiritual values was common in the late nineteenth and early twentieth centuries. Miss Georgina Houghton, for example, claimed that spirits worked through her to choose her colours according to their meanings. The catalogue of her painting exhibition of 1871, in London, laid out their meanings: she started her list with the primaries red, yellow, and blue, which she claimed stood for the Father, the Son, and the Holy Ghost. From there she went on to offer other precise, if extravagant, associations: burnt sienna, for example, represented clearness of judgment.

250 Hauer "authorized" the text with a rubber stamp, which he used to sign all documents he issued after 1932. Its impression reads, "Josef Matthias Hauer The spiritual father and (in spite of many imitators!) still the only true master and connoisseur of twelve-note music." Needless to say, by 1932 he had decided that Schönberg had betrayed him.

251 Richter, *Hans Richter by Hans Richter,* ed. C. Grey (New York: Holt, Rinehart and Winston, 1971), p. 85.

252 Morgan Russell, in the catalogue to the Synchromist exhibition, Paris, 1913, in Maur, *The Sound of Painting,* p. 48.

253 In Maur, *Vom Klang der Bilder* (Munich: Prestel, 1985/96), p. 148 (translation mine). Note that in the original publication, all words except the first appear in small letters—not even

the nouns (which are usually capitalized in German) or the initial letters of sentences are capitalized. I have not capitalized the beginning of sentences, but there is nothing I could think of doing that conveys the deviation from standard German orthography of not capitalizing the first letter of nouns.

254 Lawder, *The Cubist Cinema*, p. 49–50.

255 Richter, *Monographie*, p. 29, in Foster, *Hans Richter*, p. 256.

256 Suppose, however, as I believe is the case, that film—or if not film, then at least the medium that film foreshadowed—represented an exemplary art form for the artists involved in several vanguard movements, in Futurism, Constructivism, and (to a lesser degree) Cubism, and helped them formulate the ideals of their artistic movements. Richter's acknowledging the differences between film and the other arts brings exactly this assertion into doubt. For here, after all, is an artist who contributed much to Dada, arguing that different principles inform his work as a (Dada) painter and his work as a (Constructivist) filmmaker. In response to that objection, one should recall that the painter Richter, like many other visual artists of his time, thought that paintings embody rhythms that unfold through time—that is what made it possible to consider painting and music as analogous forms and to work out the principles of his *Generalbaß der Malerei*. So when he stated that the rhythmic forms of film are governed by different laws than those which regulate painting, he was not pointing to an absolute difference.

257 And by UFA—the publicity flier read: "veranstaltet von der Novembergruppe in Gemeinschaft mit der Kulturabsteilung der UFA."

258 Though much of the work of the Novembergruppe was dark, menacing, saturnine.

259 See William Moritz, catalogue: *The Importance of Being Fischinger* (Ottawa: International Animated Film Festival, 1976), p. 2. Hilla Rebay's support for abstract film was a mixed blessing, to say the least. Certainly Fischinger relied on her financial support, but her letters to him often treated him with an insolence that is simply astonishing.

260 Richter persistently gave 1926 as the date for *Filmstudie*. That date is open to question. London Film Society notes from October 21, 1928, indicate that the film was completed after the "less finished work" that he had shown the previous year (*Film*, the ninety-second film composed of the sixty-second piece he had shown at the May 1925 Filmmatinée, along with additional thirty seconds that Erna Niemeyer had shot).

261 In Richter, *Hans Richter by Hans Richter*, p. 68. Parentheses in original.

262 The title of Richter's periodical, remember, made reference to *Gestaltung*.

263 Fernand Léger, exerpt from "A New Realism—The Object," *Little Review* 11, no. 2 (1926), pp. 7–8, as reproduced in Chipp, *Theories of Modern Art*, pp. 279–80. Emphases in original.

264 Richter, "Easel-Scroll-Film," pp. 85–86.

265 Anon, "Wissenshaft und Technik," *Film* 3 (1925), in Hofacker, "Richter's Films and the Role of the Radical Artist 1927–1941," in Foster, *Hans Richter*, p. 130.

PART TWO

MODERNISM AND REVOLUTION

CONSTRUCTIVISM BETWEEN MARXISM AND THEOLOGY

SPIRITUAL INTERESTS IN LATE
NINETEENTH-CENTURY AND EARLY
TWENTIETH-CENTURY RUSSIA

SYMBOLISM, THEOLOGY, AND OCCULTISM

Russia at the beginning of the twentieth century was a cauldron of political and artistic causes. Ferment had been developing on all fronts since the middle of the previous century. Aileen Kelly, introducing Sir Isaiah Berlin's exemplary writings on the Russian political philosophy of the nineteenth and twentieth centuries, provides the ideal opening onto the scene: Bertrand Russell's attempt to explain the Russian Revolution to Lady Ottoline Morel. Russell pointed out to her that, however appalling Bolshevik despotism might be (and from the time he visited the Soviet Union in the 1920s, Russell had been a trenchant critic of the Bolshevik polity generally and of Lenin's character in particular), nonetheless it was probably the sort of regime the Russians required: "If you ask yourself how Dostoevsky's characters should be governed, you will understand," he said.[1] His remark exposes an uncomfortable truth.

Dostoevsky had glimpsed the emptiness of the secular world, a world presided over by science but devoid of human truths, and had spent the 1870s endeavouring to open new paths to religious faith. For his part, Tolstoy strived to find God in the world of the Russian peasants. Russian thinkers occupied themselves with pondering how to escape the dehumanizing effects of the Industrial Revolution—and, especially, with contemplating the soteriological/

eschatological question whether salvation was possible in a world ruled by technology.

Kelly further states: "In the degree of their alienation from their society and of their impact on it, the Russian intelligentsia of the nineteenth century were a phenomenon almost *sui generis*. Their ideological leaders were a small group with the cohesiveness and sense of mission of a religious sect. In their fervent moral opposition to the existing order, their single-minded preoccupation with ideas, and their faith in reason and science, they paved the way for the Russian [Bolshevik] revolution, and thereby achieved major historical significance."[2] Their drive was intense, so much so that the years 1900 to 1914 brought forth an extraordinary number of fervent poetic voices offering daring poetic visions—so many that this age has become known as Russia's Silver Age. The artists of the Silver Age, children of "Russia's terrible years" (so they described themselves), felt that they could not find the key to the future in the past, either the past of their nation or the past of the West. Accordingly, they proclaimed that it was necessary to create a new art based on new aesthetic, moral, and religious values. The great philosopher of Russia's Silver Age, Nikolai Berdyaev, maintained that "the end of the old age seemed to coincide with a new era which would bring about a complete transformation of life."[3]

The religiosity so fundamental to the Russian tradition not only heightened the zeal that ferment aroused, but also added to it a special Russian flavour. Major thinkers of the era preceding the birth of the Constructivist movement had renewed the religiosity of traditional Russian culture. Pre-eminent in this regard was Vladimir Sergeyevich Solovyov (1853–1900), the most original, far-reaching, and influential Russian philosopher of the nineteenth century and the first Russian to develop a comprehensive philosophical system. Solovyov explored systematically the implications of a series of his religious experiences; consequently he became a key thinker for the earliest Russian avant-garde, the Russian Symbolists.

The first of these experiences occurred during a service in the chapel of Moscow University: Solovyov had a vision of a beautiful woman he came to call Sophia.[4] Sophia appears in the Bible—hers is the voice of feminine wisdom in *Proverbs*.

> The LORD possessed me in the beginning of his way, before his works of old. I was set up from everlasting, from the beginning, or ever the earth was. When there were no depths, I was brought forth; when there were no fountains abounding with water. Before the mountains were settled, before the hills was I brought forth: While as yet he had not made the earth, nor the fields, nor the highest part of the dust of the world. When he prepared the heavens, I was there: when he set a compass upon the face of the depth: When he established the clouds above: when he strengthened the fountains of the deep: When he gave to the sea his decree, that the waters should not pass his commandment: when he appointed

the foundations of the earth: Then I was by him, as one brought up with him: and I was daily his delight, rejoicing always before him; Rejoicing in the habitable part of his earth; and my delights were with the sons of men. Now therefore hearken unto me, O ye children: for blessed are they that keep my ways. Hear instruction, and be wise, and refuse it not. Blessed is the man that heareth me, watching daily at my gates, waiting at the posts of my doors. For whoso findeth me findeth life, and shall obtain favour of the LORD. But he that sinneth against me wrongeth his own soul: all they that hate me love death. (Proverbs 8:22–36, KJV)

Though the Western ecclesia has not made much of this passage, in Russia and other Eastern Orthodox countries, the greatest church buildings have always been dedicated to Sophia, who provided the vision for the universe. Furthermore, this ecclesiastic interest in Sophia engendered in Russia a theological/philosophical interest in the ethical, cognitive, and metaphysical implications her figure represents. Wisdom has represented a special value in Russian philosophy, and Russian philosophers since Solovyov have testified to a sense that the Divine Sophia participates in the affairs of this world. Sophiology has become, since Solovyov, a specific and important school of Russian philosophy. Almost all the major sophiologists were professors or private lecturers at Moscow State University. Besides Solovyov, they included Sergei Bulgakov (1891–1940) and his brother Alexei Losev (1893–1988) along with Nikolai Berdyaev (1874–1948), who incorporated sophiological themes into his Christian existentialism.

Solovyov's interest in the beautiful woman of his vision in the chapel took on an undeniably erotic and ecstatic cast; indeed, in *Smysl liubvi* (The Meaning of Love, 1894) he proposed the idea, akin to that of the troubadours, that love offers a non-rational glimpse of an ideal being who, through pleasure, leads us toward self-transcendence as it obliges us to see in another the absolute value we accord to the self.[5] Solovyov believed that the Beautiful Lady, who symbolized both divine wisdom and eternal womanhood, held the key to human history, the goal of which was to develop humankind so that it might better serve its role as the link between nature and God. .

The woman appeared to Solovyov at least twice more in his lifetime: in 1875, at the British Museum, she revealed herself to him and urged him to go to Egypt (which he promptly did); and once in Egypt, he saw her again in a desert at dawn. She presented herself to him there as the transfigured Earth, as the seas and rivers, forests and mountains that had taken on female form; the experience gave him an overwhelming feeling of the unity of all existents. His poem "Tri Svidaniya" (Three Meetings, 1899), often quoted by Symbolist poets, describes his visions of Sophia and asserts the divine unity of the universe.

Solovyov was aware that these visions could be considered hallucinations; but, he argued, their having that status was no reason to discount them. The task of the thinker, he averred, is to discern the meaning of these phenomena. His philosophical writings are a highly original synthesis of ideas from Kant, Schelling, Hegel, Schopenhauer (an especially important influence), the Neo-platonists (both of the genuinely philosophical variety and of the variety that today we would call "New Age"), Gnosticism, Spiritualism, and Scholasticism, and later (increasingly) Buddhism. (Schopenhauer himself was influenced by the religious and philosophical traditions of India). All of these strains he combined with his own original insights.[6]

Solovyov presented the first systematic formulation of his ideas on episte-mology, metaphysics, and social theory in a series of public lectures that were attended by many of Moscow's most prominent intellectuals. The content of these lectures appeared in book form in his *Chteniia o bogochelovechestve* (Lectures on [or Readings About] Godmanhood or Lectures on Divine Human-ity, 1878). He elaborated on that's book's epistemological ideas in the highly metaphysical treatise *Filosofskie nachala tsel'nogo znanija* (The Philosophical Foundations [or Principles] of Integral Knowledge), most of which he wrote in 1877 but which he never completed); and in what became his doctoral the-sis, *Kritika otvlechennykh nachal* (A Critique of Abstract Principles, 1880). *Fiosofskie* and the *Kritika* were originally intended to consist of three parts, one each covering ethics, epistemology, and aesthetics; he did not compose the final work in the trilogy, however. Those works he did complete propound an evolutionary process-metaphysics that, in extolling the Incarnation (the mys-tery through which "God-man" was created) as a central event in the cosmic process, was akin to that which Rudolf Steiner would develop only slightly later. And, like Steiner's, Solovyov's evolutionary metaphysics was Christian, for it gave central place to the story of the Fall and the recovery from the Fall. Solovyov construed the Fall as the falling away of the world of nature, includ-ing human being, from the integrity of the Divine Absolute; thus he proposed that the goal of the evolutionary process was to reunite all nature with the Di-vine. For almost a decade after 1880, he turned his attention to topical matters. In 1890, when he returned to philosophy—an interest rekindled while prepar-ing a second edition of his *Kritika*—he realized that his views had altered, and he reformulated his position in an new system, presented in *Opravdanie dobra* (The Justification of the Good).[7]

As the title of his 1878 book, *Chteniia o bogochelovechestve* (Lectures on Godmanhood), suggests, the central notion of Solovyov's philosophy is that of the Incarnation—a concept he associated with Sophia, the figure he saw in his visions. For in his philosophy, Sophia refers to the personification of God's wisdom (i.e., "Wisdom"), the Bride of Christ, the female "Principle of Creation," the "World Soul," the universal church, and Kingdom of God. Listing the at-

tributes of his "Shekkinah" makes evident that the cluster of notions that he included under the rubric of Sophia are related to one another, though they cannot be identified fully with one another through that figure. The key to their relation is the idea of the Incarnation. In Solovyov's theological metaphysics, the Incarnation is the prelude to the Sacrifice of the Son, through which all creation is sanctified and all humanity is saved. Through the Incarnation, all reality is made one.

The God-man exemplified humankind's belonging to God; thus the Incarnation was not an act of atonement for humanity's sin (a conception of the Incarnation that Solovyov called the "legastic theory of redemption") but rather the practical revelation of the Kingdom of God in humanity. The God-man also typified the unity of purpose served by the heavenly *and* earthly kingdoms. He saw in modern polities nothing but strife and discord, as humans attempted to serve two masters: politics and morality. The God-man pointed to the possibility of theandric integration through which all humanity would be deified and the primal unity recovered.

Though it affirms the sacred character of reality and celebrates the Incarnation, Solovyov's philosophy is not one of mystery. Indeed, the synthetic bent of his thinking leads him to argue that ultimate reality, disclosed through the Incarnation, can be known through reason. Nonetheless, in common with most philosophies that have the goal of systematizing religious experience, his distinguishes among various types of knowledge so as to accord a role to faith proper. Knowledge is furnished either by experience, or by reason, or by intuition, and so is of three different sorts: empirical knowledge, rational knowledge, and faith. The first two types are limited; faith alone—that is to say, the intuition of the Absolute—is complete. Intuiting the Absolute leads to union with the Absolute; and the Absolute, as an object of knowledge, gives content to reason and form to experience.[8] Intuition does not provide knowledge of the sort that can be expressed in propositional form: through intuition we can know *that* God exists, but we cannot learn about His nature. Insight into His nature comes only through reason and experience.

Solovyov explains the Christian concept of the Trinity dialectically, through the relation between intuition and reason. God, as the All-in-All, must be actual; and, as actual, He must have a definite content. This definite content is something different from His being (i.e., His actuality). So this content is a Secondness to His Firstness, which is His being. In *Lectures on Godmanhood*, he writes:

> God is that which is; i.e., to Him belongs being ... [but] being can be conceived only as a *relation* of that which is to its objective essence or content—a relation in which this content or essence is asserted, posited, or manifested. Indeed, if we were to suppose an entity which in no way asserted or posited any objective

content, which did not represent anything, and was not anything either in and for itself or for another, we could not logically admit that such an entity had any being at all ...

Should we wish to find an analogy for this relation [the absolute's positing of its content or essence] in the world of our own experience, the most appropriate one would be the artist's relation to the artistic idea in the creative act. The artistic idea is certainly not anything alien or external to the artist; it is his own inner essence, the center of his spirit and content of his life, that which makes him what he is. In striving to actualize or embody this idea in an actual work of art, he wants merely to have this essence, this idea, not only in himself, but also for himself, or before himself as an object. He wants to represent what is his own as an "other" in some specific form.[9]

The recognition that this content (this Secondness) is really at one with His being (His Firstness) results in a Third, a positing of the divine.[10] Thus, the Trinity derives from God's unity. Somewhat after the fashion of Hegel, Solovyov identifies this second positing, which is content apprehended through reason, with the Logos (i.e., Christ):

We thus have three relations, or *positings*, of that which absolutely is, positings through which it determines itself with respect to its own content. First, it posits itself as possessing this content in immediate substantial unity, in non-differentiation, with itself; it posits itself as a single substance which essentially includes all things in its absolute power. Second, it posits itself as manifesting or actualizing its own absolute content, opposing the latter to itself, or separating it from itself, by an act of self-determination. Third, and last, it posits itself as maintaining and asserting itself in its own content, or as actualizing itself in an actual, mediated, or differentiated unity with this content or essence, i.e., with all things— in other words, as finding itself in its other, as eternally returning into itself, and remaining "at home with itself."[11]

Solovyov explains the intermediary role that the Christian faith attributes to Christ though his nature as Logos. Christ, as Logos, is associated with reason, and the goal of reason is to discover unity among seemingly disparate phenomena; so Christ is the active principle of the Divine Unity. Through His actions, Christ posits a passive reflection of His active principle, a passive unity, which Solovyov identifies with the ideal of humanity, whom he calls "Sophia." Christ, the Logos, is the active principle that creates the world, while Sophia is the passive principle that Christ produces, which reflects his nature. As its spiritual ideal, Sophia is the soul of the world. Since Sophia is a product of Christ's actions, Christ inheres in Sophia's nature (as a cause inheres in an effect); so Christ must have human attributes.

Solovyov's philosophy, then, overall presents the following picture. The Godhead itself is triune. Through the actions of the Godhead, and specifically

through the actions of Christ the Logos, a Divine world comes into being. This world, *qua* Divine, has a soul, and that soul is the reflection of—is the Other for—the Logos, and indeed for the triune Godhead itself. Having arrived at this point in developing his *Weltbild*, Solovyov makes his most Hegelian gambit: just as Hegel proposed that Spirit alienates itself in matter to begin the saga of self-reappropriation, self-discovery, and self-realization, so Solovyov argues that Christ, as God's love, gives the world-soul its independence, so that God will have an object for His love. As the world-soul acts on its independence, it produces various images of itself, as individual souls. With the plural content of the world-soul, a second dialectical triad is completed (following on the evolution of the triune Godhead), for we now have the Godhead (the All-in-All), which, though triune, is nonetheless a perfect unity (for it is a Three-in-One); the plural content of the world-soul; and, intermediary between them, Christ, the Logos.

As the Godhead itself is a triune being, and as God's relation to the world has a triadic structure, so too our own spirit displays a similar triadicity:

> First, there is our primordial, indivisible, and integral subject. This subject, in a sense, contains the peculiar content of our spirit, our essence or idea, and this in turn determines our individual character. If such were not the case, i.e., if this idea and character were no more than products of our phenomenal (manifested) life, or depended on our conscious actions and states, we could not explain why we do not lose that character and idea when we lose our vital consciousness [i.e., when we are asleep]; why our conscious life, in renewing itself each day, does not provide us with a new character, a new life-content. In fact, the identity of our fundamental character, or individual idea, amid the flux of conscious life clearly shows that this character and idea are contained in a primordial subject which is deeper than, and prior to, our conscious life. Of course, it is contained only substantially [i.e., potentially], in immediate unity with [that subject] as its inner idea, an idea as yet undisclosed and unembodied.
>
> Second, we have our differentiated conscious life—the manifestation or disclosure of our spirit. Here our content or essence exists *actually*, in a multiplicity of differing manifestations, to which it lends a determinate character, disclosing its own peculiar quality in and through them.
>
> Third, and last, since these manifestations, for all their multiplicity, disclose a *single* spirit equally present in all of them, we can reflect upon, or return into, ourselves out of these manifestations or disclosures, asserting ourselves as actual, as a single subject, a determinate "I," the unity of which is not only not lost through its differentiation and manifestation in a multiplicity of states and acts of conscious life, but, on the contrary, even more firmly posited. This return into oneself, this reflection upon oneself, or assertion of one's self in its manifestations, is precisely what is called "self-consciousness." It appears whenever we not only experience certain states—feeling, thinking, etc.—but also linger over these states and, by a special kind of inner act, assert ourselves as the subject which

experiences these states—which feels, thinks, etc. We inwardly declare: "I feel, I think, etc." In its second positing, our spirit manifests or discloses its content, i.e., separates that content from itself as other. In this third positing, in self-consciousness, our spirit asserts its content as *its own,* and by the same token asserts itself as that which has manifested this content.[12]

The world emerges through the world-soul's self-assertion. That the world-soul acts independently of God explains why the world's coming into existence results in the Fall: the Fall is the result of souls' separation from God. Salvation is achieved through striving for the unity that is still manifest in all created things, especially in human being. The name of this striving is "love"— love impels humans to create ever more encompassing forms of unity. The history of the world, Solovyov proposes (in a particularly Hegelian turn), is the evolution of ever more comprehensive unities:

> Love discloses what we are at the same time as it pursues its object, which is knowledge of the all.
>
> When we plunge into the mute and motionless depths from which the turbulent stream of our actual existence originates, being careful not to disturb its purity and peace, we come into inward contact, in this generic source of our own spiritual life, with the generic source of universal life. We come to know God essentially as the first principle or substance of the all.[13]

As in Hegel's philosophy, so in Solovyov's the adventure of being is the quest for ever higher unities. Therefore God, as *entissima,* must be entirely a unity, even while being triune. The being of such a "Three-in-One," Solovyov admits, is unfathomable to reason. But this intractability to reason is not restricted to the Divine Being: any being, no matter which, resists all efforts of reason, no matter whose, to apprehend its nature—this is so due to the nature of reason and the nature of being:

> But, clearly, *this* kind of unfathomability—which springs from the very nature of reason as a formal faculty—cannot be charged to any limitation of human reason. Any reason, no matter whose, is limited, qua reason, to grasping the logical aspect of what exists, its concept (λογος), its universal relation to all else— not the existent itself in its immediate, singular, and subjective actuality ... It is not just the life of the Divine being that is unfathomable in this sense, but the life of any being whatever. For no entity is, as such, exhausted by its formal, objective side, by its concept. As an existent it necessarily has its inner, subjective side, which constitutes the very act of its existence. As an existent it is something absolutely singular, unique, and wholly inexpressible. This side of the entity is always something "other" for reason, something which cannot enter the sphere of rationality, something irrational.
>
> Thus, God in Heaven and the least blade of grass on earth are equally unfathomable, and equally fathomable, for reason.[14]

Solovyov's Divine is not a static structure, however—it is an evolving organism. The character of socio-political crisis that formed the intellectual and spiritual ambience in which Solovyov lived was evident in the willingness of many Russian thinkers and artists to proffer visions of the Nietzschean *Übermensch* who could overcome existing conceptions of good and evil or, indeed, of an Antichrist who could reverse "good" and "evil."

In 1899, Solovyov again travelled to Egypt, and it is likely that while he was there he had another vision. This vision was not so affirming as the vision of the beautiful Sophia had been. When he returned from Egypt his hopeful beliefs about free theocracy had been dashed—earlier he had hoped that a new social order might arise by bringing science and religion into a closer harmony, and that this harmony would find political expression in a theocracy presided over by the Czar. By the time Solovyov returned to Egypt, his thinking had taken an apocalyptic turn; his final book, *Tri razgovora o voine, progresse i kontse vsemirnoi istorii, so vklycheniem kratkoi povesti ob antikhriste* (Three Conversations on War, Progress and the End of Universal History, with the Short Tale of the Antichrist, 1899) is an inquiry into the nature of evil and propounds the view that evil will be overcome only with the final revelation that will end history. This work takes the fictional form of three dialogues among five Russians vacationing on the Mediterranean: a General, who represents a traditional Orthodox perspective; a Politician, who believes in Western cultural progress; the Prince, a stand-in for Tolstoy; Mr. Z, a mysterious gentleman who takes an uncompromisingly religious view of all questions; and a Noblewoman, who facilitates the conversations and occasionally interjects pertinent questions and comments. Solovyov uses this dialogue genre to explore eschatological themes he had not treated previously and to call into question his faith in human progress. He suggests that he agrees with the views of Mr. Z, but that he also acknowledges the relative (partial) truth of the General's and the Politician's positions. The preface makes it clear that his purpose is to take his polemic against Tolstoy (who is not mentioned by name) to a new level and to expose Tolstoy as a fraud. Solovyov was offended that Tolstoy and his followers identified themselves as Christians; he maintained that Christianity's central dogma was the Incarnation, which taught the Divinity of Christ, and that Tolstoy denied Christ's divinity—Tolstoy, therefore, could not be considered a Christian. Solovyov believed that Tolstoy's followers needed a religious tradition with which to associate and that they should choose Buddhism, for Buddhism expounded similar principles of non-resistance to evil, inactivity, sobriety, and especially emptiness, as Tolstoy did.

Solovyov's polemic against Tolstoy in *Three Conversations* focuses on the problem of evil in history. In the first dialogue, the General and Mr. Z debate the morality of violence with the Prince; that dialogue is constructed to invite readers to decide that the Prince is wrong in propounding non-violence,

MODERNISM AND REVOLUTION

as violence is justified if undertaken to stop evil actions. In the second dialogue, the Politician argues that the spread of European civilization will bring international peace, while Mr. Z expresses doubts about progress: humanity, Mr. Z suggests, is too old and too feeble to be improved. In the third dialogue, Mr. Z argues that both the ideology of progress and the Prince's (i.e., Tolstoy's) phony Christianity fail to acknowledge death's ultimate power, which in turn confirms the ultimate strength of evil. Only the universal resurrection of all men, which Christ has promised will overcome evil, will bring the true Kingdom of God into being.

The final section of *Three Conversations* is especially interesting. In it, Solovyov explains his views on the end of history and the Antichrist. Mr. Z reads a manuscript, titled "Short Tale of the Antichrist," supposedly given to him by a monk named Pansophius. The tale takes place in the future: In the twentieth century, the last great war in human history is fought when the Pan-Mongolist movement (i.e., the Asian nations led by Japan) conquer Europe. The Europeans rebel against the invasion and found the United States of Europe. A remarkable man then comes to power whom many call a superman, a man who claims to believe in the good, God, and the Messiah but who really loves only himself. This "superman" brings the whole world under his sovereign authority and keeps power by amusing the masses with bread and circuses. In an effort to bring all people under his authority, he calls Catholics, Orthodox, and Protestants to a congress, hoping to unify them. Most of the assembled pledge their loyalty to him; however, three religious leaders—the Pope, a famous Orthodox *starets*, and a Protestant theologian—recognize him as the Antichrist. These three, and a few of their followers, flee to a desert and there agree to unite all true Christians under the Pope. These opponents seem to win the day—just as the matters are at their darkest and it looks as if the Antichrist is about to establish himself for all time, the Jews come to the aid of the Christians by exposing the Antichrist, who is deposed after a huge battle. The true Christ then descends to earth, and Christians and Jews rise from the dead and rule with Christ for one thousand years. In a wonderful satirical turn, at the end of Mr. Z's tale, Solovyov has it come to light that the Prince fled during the reading of the manuscript, at precisely the moment when the true Christians had unmasked the Antichrist.

A real fear of Asia is evident in this work. Anxiety about Asia and the Mongols was nothing new in Solovyov's writing: he had long been convinced that a great war was coming between Christian Europe and the united Asian nations (Pan-Mongolism), and in *Three Conversations* he warned that a new Mongol horde was forming in the East, in preparation for a final clash, which was at hand. This clash would be a turning point in history: a conflict between Good and Evil that would ignite fires that would sweep away the old world and

give birth to a new order. Solovyov's fear of the East had dual aspects. Certainly, it expressed the attitude of many Europeans toward any native resistance to their imperialist efforts. At the same time, though, Solovyov was not simply concerned about the rise of the non-Christian East; he was also deeply worried about the decline of the Christian West, including Russia. He feared that Christian culture was being weakened by pseudo-Christians (either believers who thought that mere external conformity was enough, or Tolstoyan pretenders to Christianity, who lacked real faith, for they did not accept the great mystery that was Christianity's central dogma). This fear led him to doubt that the Church could fulfill its universalizing mission in world history. A spiritually strong (and fidestically resolute) Christian West would have nothing to fear; but its continuing decline was exposing it to retribution.

Thus, *Three Conversations* can be read as a cautionary tale, warning of what might happen if complacency allowed Christianity to weaken further; thus arose Solovyov's conviction that Tolstoy's non-violent resistance to evil was the ultimate in complacency. A feature that appeared in Solovyov's thought for the first time with *Three Conversations* was a consequence of his having repudiated his optimistic belief that secular progress was preparing the way for the Kingdom of God: in his last years, he, like many Europeans just before the Great War, was struck by a great foreboding. He renounced his faith in progress—an aspect of the liberalism he had embraced. But he never disowned Christian politics, nor did he ever cease advocating for Christianity. To the end, he never repudiated his core belief that Christians, Christian states, and Christian nations were responsible for God's work on earth.

Solovyov's influence was so pervasive that an Apocalyptic tone would be evident in the writings of many of the Symbolists who followed him. That tone reached its apogee in Andrei Bely's astonishing *Petersburg* (1922), with its dream vision of conflict, thunder, and earthquakes; of Asiatic hordes staining the fields of Europe with oceans of blood; of that most perverse of all of Satan's dens, St. Petersburg, with its greenish-yellow murk and its spectral inhabitants toiling in factories for a few kopeks a day as its dank, viral life fell to pieces.

Solovyov presided over those developments—indeed, the title of his final work, *Kratkaia povest' ov Antikhriste* (A Short History of the Antichrist), suggests his role in fostering the sentiment that the Apocalypse was at hand. As he became increasingly despairing of Christianity's potential as a unifying force that might reconcile the forces that were sundering the world of modernity and that in the process were defiling civilization (which he saw as having reached its peak of integration in Medieval times), he supplemented his Christian theology with increasing measures of spiritualism, occultism, and demonism. Demonism assumed a larger and larger place in his outlook: between 1898 and 1900 he experienced visions of devils and demons and came

to believe that he had come face to face with Satan. Satanism would not be uncommon in Russia in the years after Solovyov's death.

SOLOVYOV'S INFLUENCE

Solovyov's distinction between objective being (which can be apprehended under the formal categories of λογος), and subjective being (characterized as recessive and "irrational," since reason cannot understand it) is signal. So, too, is his proposition that mystery pervades all existence: it encapsulated the central tenet of the Russian *Weltbild* and was to affect subsequent thinkers enormously. The poet Zinaida Gippius and her husband, the poet, novelist, and critic Dmitry Merezhkovsky, along with the younger and more aggressively modern poet Valery Bryusov, explored an issue that Solovyov had made central to his philosophy: the significance of sexual and artistic experience. Inspired by Solovyov's conception of humankind as the meeting point of nature and the Divine, Merezhkovsky, for example, contended that physical love is a means to experience God's earthly presence and that sex made it possible for humans to communicate with God and to be saved by Him. However, sex could be holy only if both partners remained aware of Christ's presence: physical love, enacted without consciousness of Christ's presence, was a dreadful sin—indeed, the greatest of sins, tantamount to confusing the Blessed Virgin with the Whore of Babylon.

Contemporaries considered Merezhkovsky's wife, Zinaida Gippius, a far better poet than her husband. Her thought developed the trinitarian core of Solovyov's system. Gippius strived to develop a new religious consciousness that had as its basis the trinities of life, love, and death, and of God the Creator, Christ the Son, and the Holy Spirit, whom she identified as the Eternal Woman-Mother. Solovyov had come to argue that the progress of history is the gradual revelation of the Kingdom of God in the life of humankind and that the task of the true Christian was to transform social institutions to make them compatible with the Kingdom of God. Similarly, Gippius argued that the new century required that advanced thinkers and artists work to bring forth the Kingdom of God on earth by integrating life and religion in a higher form of freedom. This required, inter alia, that artists create new artistic forms.

Aleksandr Blok discovered the writings of Solovyov during the summer of 1898, just after he turned eighteen, the same summer he met and fell in love with Lyubov Mendeleeva. Theirs was not the easiest courtship—they did not marry until 1903, for their relationship was made more difficult than most by his tendency to identify Lyubov with Solovyov's Beautiful Lady, Sophia. Recognizing this, Lyubov accused Aleksandr of treating her like an abstract idea—like fiction of his imagination and not a flesh-and-blood woman with a living soul; she despaired over his notions about endowing earthly love with a celes-

tial chastity. Blok's tendency to identify Mendeleeva with Sophia did not stop with their wedding: their marriage remained unconsummated for a year, when Mendeleeva finally devised the means to "weld them together." The feelings Mendeleeva inspired in Blok resulted in his book, *Stikhi o prekrasnoi dame* (Songs about the Beautiful Lady, 1904).

One can trace Solovyov's influence not only on Russia's artistic community, but among philosophers as well. For example, one sees his influence in the philosophical system of Simon Lyudvigovich Frank (1877–1950), the foundational principles of which were worked out just at the time the principles of the revolutionary artistic movements of early Soviet art were in the making. Like Solovyov's, Frank's philosophy is "spiritual": in fact, he was among the one hundred or so intellectuals the government felt required to expel from the Soviet Union in 1922. On his expulsion, he settled in Berlin, where he served as Nikolai Berdyaev's assistant, and joined with Berdyaev in organizing the Academy of Spiritual Culture.[15]

Frank's epistemology consists in a critique of positivism and empiricism and, as Solovyov's did, takes as basic the distinction between abstract cognition and concrete being. Furthermore, like Solovyov, Frank maintained that concrete reality can be grasped inwardly, through an immediate intuition of the world of (what Frank called) "absolute reality." His belief in the importance of the inward apprehension of spiritual reality led him to turn his attention to the analysis of consciousness, or what he calls "the spiritual reality of primary thinking." Frank's philosophy, in fact, presents the *cogito* as a more fundamental reality than the "objective" reality of the "world of fact." This is the gist of his argument against the positivists:

> The peculiar reality of man's inmost self-consciousness, revealed in the "spiritual life"... is qualitatively or, more exactly, categorically distinct from all objective existence and yet it is not less, but rather more, real than it ... The reality of the subject himself is not "subjective"; though not forming part of the world of objects, it is an actual and in a sense self-subsistent, stable, and primary reality. That reality is far more serious and significant than the world of objects. I can to a certain extent "shut my eyes" to the world of objects, draw away, detach myself and lose touch with it, but I can never and in no way escape from the inner reality of my own self: it is the very essence of my being and it remains in me even when I do not notice it. It is precisely in this sense that both religion and philosophy have always taught that a man's "soul" or life is of more importance and value to him than all the riches and kingdoms of the world. Everything external and objective has significance for me only insofar as it is related to this basic and immediate being of my own self. The external world is a comparatively unimportant accompaniment of our true being which reveals itself in the primary, unmediated reality of personal inner life.[16]

Like Solovyov's, Frank's philosophy makes unity its central idea. The Absolute Reality, which we know through a form of experience that Frank characterizes as "inner" (i.e., mystical) experience, is the "Total Unity," the ground of all being, the Real par excellence, the *ens realissima*. In characterizing the Real as it is in itself, Frank uses the language of Plotinus and Nicolas of Cusa; when he writes of the Real's relation to human being, on the other hand, he uses Solovyov's "sophiological" language.

In describing the limits of reason (the boundaries of which coincide with those that Solovyov mapped out), Frank takes on the claims of the Pseudo-Aereopagite:

> Accordingly, in order to apprehend the truly transcendent and absolutely unique nature of God, simple negation in its customary logical sense is useless: the categories of earthly existence must be overcome in a special, *supra-logical* way. This can only be done by going beyond the law of contradiction, i.e., the incompatibility of affirmative and negative judgements. Only thus can we really rise above everything particular, "earthly," and subordinate; only by embracing and including it can we reach the sphere that lies above it …
>
> Let us now apply this consideration to the general problem of reality. In what exact sense must we pronounce it to be "unfathomable," and what follows from this definition if rightly understood?
>
> Reality is unknowable insofar as we mean by knowledge immediate apprehension of the nature of the object in a *conceptual* form. For reality is essentially different from any particular content apprehended through concepts; its nature lies precisely in its complete, self-contained, and self-sufficient concreteness, as opposed to any abstract content in which the object of thought is determined as something particular by distinguishing it from all else and discriminating its relation to that "else"…
>
> But how is it possible to have something in mind except as a definite particular content, i.e., as an abstract concept? The argument of the preceding chapter started with the admission that our experience is wider than our thought. This of course is indisputable and in virtue of it we can come into touch with that which eludes the conceptual form.[17]

If God's being—or even being in general—can be known only in inner intuition, if it eludes the grasp of logic, is it therefore utterly inexpressible? Considering this question leads Frank to recognize the role of art, and specifically the art of poetry:

> But must such experience remain dumb and inexpressible and therefore unconscious, and utterly inaccessible to thought? There is at least one actual testimony to the contrary—namely, art, and in particular poetry as the art of the word. Poetry is a mysterious way of expressing things that cannot be put in an abstract logical form. It expresses a certain concrete reality without breaking it

up into a system of abstract concepts, but taking it as it actually is, in all its concreteness. This is possible because the purpose of words is not limited to their function of designating concepts: words are also the means of spiritually mastering and imparting meaning to experience in its actual, supra-logical nature. The existence of poetry shows that experience is not doomed to remain dumb and incomprehensible, but has a specific form of expression, i.e., of being "understood" just on that side of it on which it transcends abstract thought.[18]

Poetry, then, is given the responsibility of articulating our inward apprehension of Absolute Reality. Does this mean poetry has a higher mission than philosophy, which evidently is the product of humans' reasoning faculty? Frank denied that this is so, and the reasons he sets out for denying this too-ready inference are interesting. Their grounding conviction is the belief that words can have two functions: one type of meaning, "purely rational, abstract meaning," is implicated in a logical analysis of reality; another type of meaning depends on words' ability to present reality in another fashion—to present a concrete description of reality in its concreteness.

Most of Frank's writing has an admirable lucidity, but his remarks on meaning and language fall below his usual standards. He acknowledged the importance to poetry of the sonic properties of words and their combinations, but he did not argue that this is something that prose can share with poetry or that sound is the basis for the distinction between literary and ordinary language. Rather, he argued, the attribute that distinguishes literary language from ordinary language—an attribute philosophical writing can share—is the evocation of precisely rendered scenes that so affect us as to elicit, in all their concreteness, the feelings and thoughts (the inner realities) to which they refer:

> If poetry is the highest and most perfect way of using the supra-rational, immediately expressive function of words, this means—as linguists have observed long ago—that all speech to a certain extent partakes, or can partake, of the nature of poetry and that the difference between poetry and prose is not absolute, but relative. All that we call "expressiveness" in speech is the poetical element in it. True, poetry in the narrow and specific sense of the term utilizes the expressive power of the purely irrational aspect of words—of the involuntary associations of ideas, images, emotions connected with the nuances of meaning and even with the actual auditory texture of words, so to speak with their "aura." But poetry also includes another aspect of expressiveness, accessible to prose as well: thoughts and concepts expressed by words are in poetry so combined that their purely rational, abstract meaning is transcended and they convey concrete reality precisely insofar as it rises above concepts and differs from them in principle. This is the meaning of what may be called the *description* of concrete reality in contradistinction to the logical analysis of it. Accordingly, such description is possible for philosophy as well.[19]

The Russian philosopher of this era who is best known in the West is Nikolai Berdyaev. His philosophy is generally discussed as a Russian version of existentialist thought, but it really relates more closely to the Symbolist movement in Russia than to French or German existentialism. Like Solovyov's and Frank's, Berdyaev's philosophy took the distinction between the objective and subjective as a cardinal distinction (he describes the distinction as "the very core of [his] thought") and, again like Solovyov and Frank, he considered the subjective to be primary. The special character of Frank's philosophy develops from his root conviction—which Kant's philosophy (in particular, *Kritik der Urteilskraft* [Critique of Judgment]) helped him arrive at—that aesthetic experience reveals the spirit's freedom and its power to transcend the lawfulness of the objective domain. The special character of Berdyaev's thought, on the other hand, results from his belief—which also has Kantian provenance (especially in *Kritik der praktischen Vernuft* [Critique of Practical Reason])—that ethical behaviour reveals human being in its noumenal form. Berdyaev wrote:

> What are the marks of objectification, and the rise of object relations in the world? The following signs may be taken as established: (1) the estrangement of the object from the subject; (2) the absorption of the unrepeatably individual and personal in what is common and impersonally universal; (3) the rule of necessity, of determination from without, the crushing of freedom and the concealment of it; (4) adjustment to the grandiose mien of the world and of history, to the average man, and the socialization of man and his opinions, which destroys distinctive character. In opposition to all this stand communion in sympathy and love, and the overcoming of estrangement; personalism and the expression of the individual and personal character of each existence; a transition to the realm of freedom and determination from within, with victory over enslaving necessity; and the predominance of quality over quantity, of creativeness over adaption. This is at the same time a definition of the distinction between the noumenal and the phenomenal world.[20]

He again affirmed the primacy of the spirit, of that which lies within us:

> My inward spiritual experience is not an object. Spirit is never object: the existence of that which exists is never an object. It is thought which determines the objectified phenomenal world. The primacy of the mind over being can be asserted. But this is not the final truth. The mind itself is determined by the noumenal world, by the "intelligible freedom" (in the Kantian sense) of that primary world. What also needs to be asserted is the supremacy of the primarily existent, of that which initially exists, over the mind. Idealism passes into realism.[21]

Berdyaev argued, as Solovyov and Frank did, that being, because it is concrete, dynamic, and particular, cannot be grasped by reason, which employs abstract categories that, like Plato's universals, are unchangeable and universal.

His ideas about being resemble Bergson's ideas about the *élan vital*, so it is perhaps not surprising that he argues that being is grasped through a form of intuition through which we participate in the life of the entity we know:

> When, in opposing the subject and the object, philosophical theory abstracts them both from Being, it makes the apprehension of Being impossible. To oppose knowledge and Being is to exclude knowledge from Being. Thus the knowing subject is confronted with Being as an apprehensible but abstract object with which no communion is possible. The objective state is itself the source of this abstraction, which excludes any communion or, as Lévy-Bruhl puts it, any "participation" in the object, although concepts may be formed about it. The nature of the object is purely general; it contains no element of irreducible originality, which is the sign of the individual.[22]

Berdyaev depicted the fall into abstract thinking as the original sin of humankind; redeeming humankind from this error, by transforming knowledge back into a form of communion with (participation in) that which humans know, became his essential goal. Art had an important role to play in reconnecting humans with life. He believed that the arts are of a temple, cultist origin—that they arose from a unity in which all the parts were subordinate to a religious centre. The arts, it followed, were a vestige of the time when religion dominated humans' outlook; consequently, the arts would play a vital role in restoring that outlook.

An interest in matters of the spirit was widespread in Russia in the decades before the Bolshevik Revolution. Russia itself underwent something of a spiritual regeneration between the late 1890s and 1910, and many philosophers propounded theological systems. The idea that Moscow would be the New Jerusalem, or the New Rome, was much discussed. These spiritual interests, fostered by the important role the Orthodox church played in lives of the Russian people, did not disappear when the Bolsheviks took power; they simply went underground. Thus Lev Vasilievich Pumpiansky stated that the goal that he and Mikhail Bakhtin shared was reformulating the categories of modern thought in terms of the Russian Orthodox tradition. Of course, neither Pumpiansky nor Bakhtin understood the Russian Orthodox tradition in a traditional way—both thinkers were products of religious revival among those early twentieth-century Russian intellectuals who strove to develop a new understanding of the Orthodox heritage that would make it relevant to the twentieth century. The Russian thinkers associated with this revival aspired to that synthetic understanding of the world trumpeted by such German Idealists as Fichte and Schelling. Their goal was to bring all human knowledge within a single compass—their concerns comprised not only various forms of religious experience, but also information from many fields of inquiry. So, like Eisenstein's, their thinking had a polymathic cast. Indeed, some of the principal theologians of this

movement shared with Eisenstein a training in the sciences: G.V. Florovsky was a physicist and mathematician; S.A. Askoldov (S.A. Alekseev) was a chemist as well as a philosopher; and A.A. Ukhtomsky trained first as a theologian and then became a physiologist.

NOTES

1 Aileen Kelly, "Introduction: A Complex Vision," in Isaiah Berlin, *Russian Thinkers*, ed. H. Hardy and A. Kelly, intro. A. Kelly (London: Penguin, 1979), p. xiii.

2 Kelly, *Toward Another Shore: Russian Thinkers Between Necessity and Chance* (New Haven: Yale University Press, 1998), p. 15.

3 Nicolai Berdyaev, *Dream and Reality: An Essay in Autobiography*, trans. Katherine Lampert (New York: Macmillan, 1950), p. 141.

4 Under the influence, no doubt, of Boehme, for whose work there was much enthusiasm in Orthodox seminaries, and Schelling, whose Romanticism had been avidly taken up by many nineteenth-century Russian intellectuals, both of whom exalted Sophia.

5 And in this he anticipated the views of the Russian Symbolists. Andrei Bely (1880–1934) wrote: "To consider a woman as creature, deprived of creativity, is deplorable. A woman creates a man not only by the very fact of physical birth, but by the act of nurturing spirituality in him as well. A woman fertilizes the creative works of a genius—remember woman's influence upon Goethe, Byron, Dante. What would have become of Dante without Beatrice?!" From Bely, "Weininger about sex and character."

6 The influence of Spiritualism should not be overlooked—both Vladimir and his brother Vsevolod (1849–1903) were interested in Spiritualism and in the Russian Spiritualist journal *Rebus*. After 1850, following its spread in Anglo-Saxon countries, Spiritualism spread rapidly in the Czar's Empire. At first it was restricted to tiny groups, but it soon spread to the salons of Count Kushelev-Bezborodko, a personal friend of the medium Daniel Dunglas Home (1833–1886), who married a god-daughter of the Czar (with Alexandre Dumas as best man in a wedding that set St. Petersburg talking). Spiritualism also interested the brothers Tolstoy.

7 Likely Solovyov intended to follow up the ethical investigations he presented there with treatises on epistemology and aesthetics; however, he died after completing only three brief chapters of the epistemological treatise.

8 The ideas that reason is pure form and empty of content (and so has need of an object to give it content), and that experience in itself is amorphous content and needs reason to give it form, highlight the influence that Kant's philosophy exerted on Solovyov. Of course, in claiming that the Absolute can be an object of knowledge for reason, and that the form of experience derives from the Absolute, and not from the mind itself, Solovyov disagreed with Kant's conclusions; we might see these disagreements, however, as indicating the extent of his engagement with Kant's philosophy.

9 Vladimir Solovyov, "Lectures on Godmanhood," trans. G.L. Kline, in J.M. Edie, J.P. Scanlan, and M.-B. Zeldin, eds., with the collaboration of G.L. Kline, *Russian Philosophy. Vol. III: Pre-Revolutionary Philosophy and Theology; Philosophers in Exile; Marxists and Communists* (Knoxville: University of Tennessee Press, 1976), p. 62. The interpolated text is included in this edition. Note that both the philosophical content (including the idea that the Spirit alienates itself in matter, so that it might come to fuller self-understanding) and the lexical aspects of the passage confirm that Hegel exerted enormous influence on Solovyov.

10 This threefold process reflects the Kantian conception of the antinomies and, even more markedly, the Hegelian conception of the dialectic.

11 Vladimir Solovyov, "Lectures on Godmanhood," in Edie et al., p. 63.

12 Ibid., pp. 63–64. The self thus exhibits the same triadic structure as the Godhead: a singular form (whose being constitutes the *first* moment of this triadic dialectic), whose actuality contains other forms that exist only in potentiality, and that through its own actuality actualizes the potentials of those, and in doing so produces a multiplicity (whose being constitutes the *second* moment of this dialectical process); and then (as the *third* moment in this dialectical process) discovers the unity that unifies the seemingly disparate particulars realized in the dialectic's second moment.

13 Solovyov, "Lectures on Godmanhood," p. 62.

14 Ibid., p. 67.

15 S.L. Frank, the son of a Russian Jewish doctor, was driven out of Berlin in 1937 during Hitler's persecution of the Jews. He moved to Paris; then, after the Second World War, he moved again to London, where he died in 1950.

16 From Frank, *Reality and Man* (New York: Taplinger, 1965), trans. N. Duddington, in Edie et al., pp. 289–90.

17 Frank, from *Reality and Man*, in Edie et al., pp. 298–300.

18 Ibid., p. 300.

19 Ibid., pp. 300–1.

20 Berdyaev, "Objectification," in Edie et al., pp. 196–97.

21 Ibid., p. 193.

22 Berdyaev, "Existentialism" (from *Solitude and Society*), in ibid., p. 182.

SYMBOLISM AND ITS LEGACIES

SYMBOLISM, THE SPIRITUAL IDEAL, AND THE AVANT-GARDE

olovyov's and Berdyaev's ideas have parallels in Russian Symbolism, a movement that interested most of the artists who would take part in the Suprematist, Futurist, Cubo-Futurist, Neo-Primitivist, Constructivist, and Cubo-Constructivist movements. The parallels run deep: for example, like the Symbolists, Solovyov believed that symbols were not illusions but higher forms of reality; so, too, he considered the domain of everyday objects to be the pale reflection of a more vital reality. He implored artists to explore the harmonies that revealed this higher reality. The Symbolist Andrei Bely (among others) responded to Solovyov's appeal: Bely, like Solovyov, maintained that the symbol is the site where the eternal meets the transitory.

Through the Symbolists, Solovyov's and Berdyaev's ideas had much influence on Russian and Soviet vanguard movements. The Symbolists of Russia's Silver Age founded *Mir Iskusstva* (The World of Art) to serve as their mouthpiece, and that journal played a key role in creating Russia's first avant-garde movement. *Mir Iskusstva* urged artists to abandon the realism of Repin and Peredvizhniki; it called on artists to cleave to beauty and the creative power of the human soul and to do all they could to raise humanity above the obsession with quotidian utility.[1]

Viktor Gofman's introductory essay in the first issue of *Iskusstvo* (Art), one of a series of publications by Russian Symbolists, established the magazine's general outlook. In that article, "Chto est iskussvo" (What Is Art), he proposed that Symbolism is fundamentally the science of the subjective realm, of "I," of "mystical intimatism," and argued that Symbolism was a significant aesthetic and theurgic force. A number of Russian artists who were strongly influenced by Symbolism—including Kandinsky and Petrov-Vodkin—along with other post-Symbolist artists such as Kulbin, Matyushin, Filonov, and Malevich, took some measure of interest in Theosophy (which, after all, is a theurgic practice); and all were persuaded, for some time at least, by the ideas expounded by the Theosophist leaders Mme Blavatsky and Annie Besant, by the Anthroposophist Rudolf Steiner, and by the Symbolist theorists Bely, Blok, and Ivanov, that the artist is a clairvoyant. Many of these artists and thinkers embraced the doctrine that all art has affinity with cosmic music and that the "music of the spheres" can be heard in the sounds of nature; many also accepted that there is an organic parallel between sound and colour.[2] Russian Symbolists were also interested in the arts of Japan and Mexico (an interest especially important to Eisenstein, who generally took an interest in liminal spaces where the old and the new confronted each other): *Iskusstvo* included an article devoted to Japanese and Mexican art: seventeen photographs of Japanese paintings and twenty-three of Mexico by the Symbolist poet Konstantin Dmitrievich Balmont (1867–1941), the appearance of which evidenced a growing tendency in Russia to document fairly "primitive" and oriental cultures instead of treating them merely as exotic phenomena (as Western Europeans of the period so often did).[3] Russian artists such as Kulbin turned toward the East (specifically, in Kulbin's case, toward Buddhism); Goncharova and Liarionova became interested in Eastern art; and Yakulov began his Simultaneist experiments with light and space based on his experiences in Manchuria in 1904–5. A manifesto of the Neoprimitivists, successors of the Symbolists, declared: "[We] aspire toward the East ... [and] protest against servile subservence to the West."[4]

Russian Symbolism, in its formative years, was identified with the Decadent movement (as the Symbolism movements in France and England were), and the terms "Symbolist" and "Decadent" were often used interchangeably. Thus, one of the earlier Russian converts to French Symbolist poetry was a Decadent, Aleksandr Dobroliubov, a doom-ridden devotee of Poe and Baudelaire, who wore only black, lived in a windowless, black-walled room festooned with satanic emblems, and was greatly enamoured of opium. He became a poet at seventeen years after being tossed out of high school for preaching suicide. Like another great Symbolist, Rimbaud, he soon abandoned verse; he then started a religious cult, and took to travelling around Russia with his body encased in iron hoops. His followers took up the peculiar custom of responding to any question only after a year had passed—a practice that some-

·what isolated them. Dobroliubov's conversation, when it did not concern French poetry or drugs (his enthusiasm for which he justified by his reading of Baudelaire), centred on the topics of demonism and magic. His poetics were founded on the irrationality of the higher order and asserted the impossibility of using rational forms of discourse to speak of irrational matters.

SYMBOLISM
THE CRUCIBLE OF THE RUSSIAN AVANT-GARDE

Several tendencies in Russian art of the immediate pre- and post-revolutionary periods led to non-objective painting: the "expressionism" of Kandinsky (though he was already living in Munich when he did his first non-objective canvases), the Suprematism of Ivan Kliun and Kazimir Malevich, the architectonic paintings of Lyubov Popova, the Painterly Formulae of Pavel Mansurov, and the Constructivist paintings of Aleksandr Mikhailovich Rodchenko (1891–1956). All of these tendencies developed in the wake of Symbolism and partly under Symbolism's aegis. All of these artists embraced Symbolism's spiritual concerns. Furthermore, an anxious, *fin de siècle* mood had shaped the sensibilities of many of these artists and continued to exert an influence on them even after the revolution (sometimes by establishing an emotional tenor against which the more optimistic feelings of the twentieth century's second and third decades could be contrasted). Moreover, many Russian artists of the time were devoted francophiles, and the years that led up to the Bolshevik Revolution saw a lively occult revival in France. Kandinsky was an avid student of matters occult, as was Pavel Filonov, who in 1915 founded World Flowering, an artistic group that took its name in anticipation of a future time when the world would blossom and the unity of the cosmos would be become evident to all. Filonov strived to capture in his painting the inner laws of nature's operations. He developed a theory of "made painting," which he expounded at the Collective of Masters of Analytic Art in 1925. (Filonov described the painting style he practised as analytic, since it relied on an analysis of perception.) The core idea of Filonov's "made painting" (so called because he granted primary importance in his art to *sdelannost*, the quality of being "made" [i.e., well made or finished]) was influenced by Rudolf Steiner's exposition of the core ideas of Goethe's science, for "made paintings" were supposed to come into being according to the same inner laws that governed the evolution of forms in the natural world.

In making a painting, Filonov eschewed sketches and other preliminary stages and worked on a painting constantly and intensely, in a form of pneumatic concentration, until it was finished, well made—or simply "made."

Filonov's idea of "made painting" had considerable influence on the Cubo-Futurists. The Cubo-Futurists expounded a panpsychic cosmology according

to which the universe and everything in it was alive and possessed psychic qualities, however rudimentary. The lineage of the Cubo-Futurists' panpsychism included the Renaissance philosophers Giordano Bruno and Tommaso Campanela; the Enlightenment philosopher Gottfried Wilhelm Leibniz; the Jena Romantic philosopher Friedrich Wilhelm Josef von Schelling; and such nineteenth- and early twentieth-century vitalists as Schopenhauer, Fechner, Wundt, Haeckel, and Bergson. The central neovitalist claim—that the life force, which animates organisms and the cosmos alike, cannot be reduced to inanimate substance—was a topic of much debate in Symbolist and Cubo-Futurist circles. In more esoteric circles, neovitalism developed along the lines of Ouspensky's "cosmic consciousness."[5] The Hindu/Theosophical idea of an all-pervasive "world soul," a universal consciousness in which each individual consciousness participates, also influenced Russian neovitalism.

Symbolism represented for many Soviet artists (indeed, for many Russians of the immediate pre-Soviet period) a reaction against the social dogmatism of the radical "generation of the [eighteen-]sixties," just as the postmillennial occultism of so many young artists in the first years of the twenty-first century represents a reaction against the conceptual freight of the amelioratist programs conceived by the radical generation of the 1960s. For many of Russia's pre-Soviet and early Soviet artists, Symbolism represented a refreshing change from positivism, materialism, rationalism, and industrialism (movements that helped make Marxism attractive to late nineteenth-century Russian thinkers), all of which steered the arts toward a social purpose. Against these doctrines and amelioratist tendencies in general, Symbolism emphasized the aesthetic function of the work of art and repudiated all proposals that would shackle art making to the role of remedying social ills. Like its French and German counterparts, Russian Symbolism had as the core of its aesthetic doctrine an epistemological principle: positivist reason cannot apprehend the inner truth of reality. Only a higher, non-rational form of cognition can grasp ultimate reality; this form of thinking is the domain of the poet and the artist—thus, poets and artists, because they rely on intuition and imagination, have access to this higher reality. Quoting Goethe's statement, "All that exists is just a symbol," Symbolists declared that adequate symbols led "the soul of the spectator *a realibus ad realiora* [from the real to a higher reality]."[6]

Russian Symbolism developed in two waves. The first, or French, wave (so called because it emulated the French example), which dominated until 1904, stressed the decadent side of the prototype movement. Like the revolutionary doctrine of nihilism, Symbolism and Russian Decadence captured the mood that spread after the assassination of Alexander II in 1881. The literary models for Symbolism and Russian Decadence included Charles Baudelaire's *Les Fleurs du Mal* (The Flowers of Evil, 1861); Arthur Rimbaud's *Une Saison en Enfer* (A

Season in Hell, 1873); Jules Barbey d'Aurevilly's *Les Diaboliques* (1874), a collection of hallucinatory tales with a satanic motif; Joris-Karl Huysmans' *Là-bas* (1891); and the magical and occult texts of Eliphas Lévi and Papus. Papus was the pseudonym for Dr Gérard-Anaclet-Vincent Encausse (1865–1916); it means "physician," and was taken from Lévi's "Nuctemeron of Apollonius of Tyana," a supplement to Lévi's *Dogme et Rituel de la Haute Magie*. Papus, with Joséphin Péladan and Oswald Wirth, was one of the founders of the Kabbalistic Order of the Rose-Croix, from which issued a dense literature of mysterious suggestion and Faustian motifs. The Decadent generation in Russia included the poets Konstantin Balmont (1867–1941), Valery Yakovlevich Bryusov (1873–1924), and Zinaida Gippius (1869–1945). One of the most spiritual among the decadent authors was Dmitry Merezhkovsky (1865–1941), Gippius's husband, who composed his *Christ and Antichrist* trilogy (the second volume, *The Romance of Leonardo da Vinci*, is especially well known), which is replete with references to occult systems and black magic and is pervaded with a sense of the ambiguities involved in distinguishing between good and evil.

Enthusiasm for the occult reached astonishing levels in St. Petersburg during Russia's Silver Age (1890–1914). In the early years of that period, artists with an interest in occult topics associated themselves with the Decadent movement. Esoteric cults of every imaginable sort, including those dedicated to the practice of erotic magic, flourished. It was from this environment that Mme Blavatsky, G.I. Gurdjieff, and the "mad monk" Grigori Efimovich Rasputin (1869–1916) emerged.

Hermann Hesse, in his *Blick ins Chaos* (Glimpse into Chaos)—a work that so impressed T.S. Eliot that he quoted from it in a note to line 367 of "The Waste Land"—comments on the novels of Dostoevsky. In them, he found a paradigm of the Russian character, the "Russian Man." The Russian Man, Hesse asserted, embodied a primitive, Asiatic ideal, an ancient, primal, occult consciousness. The Russian Man was both fascinating and menacing: he promised the renewal of the West but also its destruction. The Russian Man was both a holy man and a sinner, a saint and a criminal, an ascetic and a lecher, an angel and a devil. He was a man of extremes who knew no middle way—and because of this, he was a valuable antidote to the bourgeoisie. The Russian Man, Hesse contended, sought to discover the divine even in that which is wicked and base. Hesse intuited what in fact was the case: that many Russian cults pursued vice as the path to redemption. The ascetic lecher, the criminal saint, was one manifestation of this tendency; a fascination with the Devil, shared by occultists in Paris and St. Petersburg, was another. In fact, French Symbolism was the proximate cause of this interest. *Symbolisme* was first imported into Russia in 1890, and in its awake there arose a fascination with devils and devil worship; Satanism became the primary obsession of several poets, painters, and musicians in St. Petersburg. Drugs, suicide clubs, and other forms

of *outré* behaviour became common as diabolical themes came to command the interest of large numbers of the intelligensia. Nikolai Riabbushinsky, the host at the Black Swan, one such suicide club, published an advertisement in the club's journal, *Zolotoe runo* (The Golden Fleece), soliciting submissions for a special issue on the Devil. He received ninety-two responses.

Satanic eroticism became a subject of fascination. The philosophers, Vladimir Solovyov and Nikolai Berdyaev, the writers Dmitry Merezhkovsky and Vasily Rozanov, the poets Zinaida Gippius and Aleksandr Blok, and the artists Mikhail Vrubel and Mstislav Dobuzhinsky all incorporated demonic themes into their work. Konstantin Balmont (1867–1941) issued a book, *Evil Spell: A Book of Exorcisms*, which linked the interest in Satanism to the darkness that followed the failed revolution of 1905. He was probably right about this: morbid years ensued after the thwarted revolution, and narcotics became common among the disaffected. In St. Petersburg and Moscow, people formed circles for the study of Buddhism, Brahmanism, and Hellenism; some affected peasant garb and vowed to resurrect the ancient cults of Egypt and Assyria–Babylonia across the breadth and length of Russia. Fyodor Chaliapin (1873–1938) became a household name playing Mefistofele in Gounod's *Faust*, and the psychological techniques he introduced into operatic acting highlighted his concern with (hermetic) inwardness.

But the most renowned of the Decadents was Valery Yakovlevich Bryusov (1873–1924), author of the splendid *Ognenny angel* (The Fiery Angel, 1903)—or, to cite its full title, since that is germane to the point here, *The Fiery Angel; or, a True Story in which is related of the Devil, not once but often appearing in the Image of a Spirit of Light to a Maiden and seducing her to Various and Many Sinful Deeds, of Ungodly Practices of Magic, Alchymy, Astrology, the Cabalistical Sciences and Necromancy, of the Trial of the Said Maiden under the Presidency of His Eminence the Archbishop of Trier, as well as of Encounters and Discourses with the Knight and thrice Doctor Agrippa of Nettesheim, and with Doctor Faustus, composed by an Eyewitness*. Bryusov was a poet, novelist, playwright, translator, essayist, and pioneer of Russian modernism. He attracted attention when he published (with A.A. Lang) *Russkie simvolisty* (Russian Symbolists, 1895), an anthology of original poems by Russian Symbolists as well as of translations from the French. This work was a landmark in the development of modernism in Russia. Bryusov became the acknowledged leader of the Symbolist movement in Russia when, in 1904, he assumed the editorship of its leading critical journal, *Vesy* (The Scales). Bryusov also published ten volumes of his own original poetry between 1895 and 1921; among the most important were *Tertia vigilia* (Third Vigil), *Urbi et orbi* (To the City and the World), and his best-known collection, *Stephanos*.

Bryusov's poetry displayed great technical skill and erudition; his efforts focused on enhancing the musical qualities of poetry through sonorous word

combinations. Like the French Symbolists, he employed ambiguous and suggestive words that, he deduced, referred back to an essence, a universal meaning beyond the power of language to express. From the French Symbolists he determined that there were three interrelated modes of Symbolist poetry. He was most interested in the mode that included works that give a nearly complete picture, but in which something incompletely drawn, half-stated, is perceptible, as if several essential signs are not shown. The highly musical treatment of language and the resulting suggestive but indefinite meanings produce a poetry that treats mystical themes in a highly sensuous, indeed eroticized manner.

Ognenny angel is one of the most erotic novels of the twentieth century. It is also an astonishingly compendious work that incorporates many of the Satanic occult's principal themes: Faust, Mephistopheles, and Cornelius Agrippa all make appearances, and medieval magic and the Inquisition are rendered with impressive detail. It recounts a grand story—played out in an atmosphere of magic and sorcery in sixteenth-century Germany—of a love triangle involving the knight Ruprecht, an earnest young man torn between Love and Good, Renata, a simple woman prone to visions, and a Count Heinrich, whom she fancies to be alternately the "fiery angel" of the book's title and a devil trying to seduce her. It makes explicit the connection between religious experience and sexual hysteria. It also offers an autobiographical subtext concerning Bryusov's relationship with Andrei Bely and with the poet Nina Petrovskaya (1884–1928), who, in real life, offered accounts of troubled ritual and magical fixations, devotion to morphine, and suicide pacts. (Bryusov and Petrovskaya had a relationshop that lasted seven years, after which Petrovskaya left Bryusov and fled to Paris, where she converted to Catholicism and took the name "Renata" before committing suicide.)

The sulphurous glamour of the Avenging Angel extended to music, inspiring, for example, Modest Mussorgsky's *Ivana noch' na lysoi gore* (St. John's Night on Bald Mountain, 1867). (The mountain alluded to, some distance outside Kiev, has a treeless top; according to legend, witches gathered on this mountain, especially on St. John's Night, to perform the Witches' Sabbath.) The composition reflects the Christian's fear of dark places, which must surely encourage Satan, the dark lord, and his perverted followers, whose only desire is to torment and destroy all humanity. Prokofiev's *Ognenny angel* (Fiery Angel, 1919–23), based on Bryusov's novel, which he discovered in America in 1919, and Scriabin's Piano Sonata No. 9 (1913), which he referred to as "Messe noir" (Black Mass), reflect that same sulfurous ambience.

The Decadent phase of Russian Symbolism proclaimed the value of non-conformism and set out to shock the public. This non-conformist, "dissident" tendency of Symbolism, directed against any program that would place strictures on the imagination, gave the movement a subterranean appeal through

the first decades of the Soviet period. If the first phase of Russian Symbolism was strongly influenced by French poetry, the second was influenced by German philosophy (i.e., German Idealism). The second, or German, wave, while disowning none of the first wave's penchant for non-conformist excesses, was more philosophical and more strongly resolved to lead the soul of the spectator *a realibus ad realiora*. Prominent figures in this second wave included Vyacheslav Ivanov (1866–1949), Andrei Bely (Boris Nikolaevich Bugaev, 1880–1906), and Aleksandr Blok (1880–1949). Some of the second group of writers were influenced by the preceding, Decadent, movement. Blok, for example, used Satanism as a sign of revolt against the social order, Bely loved to shock the bourgeoisie with extreme displays of Satanism and pornography, and Ivanov proposed that "without opposition to the Deity," mystical life cannot exist.

Pavel Filonov, Ivan Kliun, Mikhail Larionov, Kazimir Malevich, and Aleksandr Rodchenko all began as Symbolist painters. Malevich's *Rozhdeniye* (Birth, 1906; but usually called Woman in Childbirth) displays typical features of the (already academic) *style moderne*.[7] While attending Moscow's Institute of Painting, Sculpture, and Architecture in 1904–5, Malevich took an interest in the metaphysical concerns of the Blue Rose, a circle of painters around Pavel Kuznetsov, whose work was animated by spiritual concerns and who employed a set of recurrent motifs—maidens, fountains, discs (suggesting cosmic form), and muted colours—to suggest occult beliefs. Malevich did not put these interests aside when he left the institute; to the contrary, he pursued them avidly at Fedor Rerberg's studio, where he worked between 1905 and 1910.

Like its French original, early Russian Symbolism attempted to grasp the inner truth of reality, a higher reality, which (again like the French) they identified with musical dynamics, the rhythms of waves of sound emerging from the cosmic orchestra.[8] They proposed that musical emotion, rather than narrative depiction, is the true goal of art. The objects we perceive with our eyes they deemed to be unreal—to be mere illusion—so they dissolved them in the waves of sound that are the higher reality. Symbolists, including Kandinsky, proposed that the more material an art is, the less dynamic it becomes and the less higher truth is invested in it. In this regard, one thinks of St. Augustine's famous distinction among different types of seeing: the lowest is corporeal vision, the direct perception of individual objects; the intermediate is spiritual vision, which draws on visual recollection and imagination (thus the later tradition often refers to this sort of vision as "imaginative"); and the highest form is intellectual vision, which relies on the contemplative faculties and, significantly, discards all likeness.[9] When St. Bernard later said that "you have not gone a long way unless you are able by purity of mind to transcend the phantasms of corporeal images that rush in from all sides," he was asserting a principle with which Augustine would have been in full agreement, just as Augustine, in turn, would have agreed with Bernard's instruction to his followers propounding the

importance of attaining a state of imageless devotion, for such devotion is higher that than which depends on images.[10] This religious tradition is ultimately the ground for Symbolist artwork.

Like the Symbolists, Malevich was familiar with the sensation of objects dissolving into an ample, dynamic emptiness. He wrote:

> I have transformed myself *in the zero of form* and have fished myself out of the *rubbishy slough of academic art.*
>
> I have destroyed the ring of the horizon and got out of the circle of objects, the horizon ring that has imprisoned the artist and the forms of nature ...
>
> To produce favorite objects and little nooks of nature is just like a thief being enraptured by his shackled legs ...
>
> *Objects have vanished like smoke; to attain the new artistic culture...*
>
> The square is not a subconscious form. It is the creation of intuitive reason. The face of the new art.
>
> The square is a living, regal infant.
>
> The first step of pure creation in art. Before it there were naive distortions and copies of nature.
>
> Our world of art has become new, nonobjective, pure ...
>
> [A] surface lives; it has been born.[11]

And in a similar vein: "Art ... no longer wishes to illustrate the history of manners, it wants to have nothing further to do with the object, as such, and believes that it can exist, in and for itself, without 'things.'" [12]

The Russian Symbolists considered colour, among artists' materials, to be especially important. In a Symbolist magazine, Blok suggested that colours, not words, are a child's primary medium of expression, so colour is a more genuine, more immediate medium than those on which professional artists rely.[13] Blok's proposal found broad acceptance from later avant-garde artists—as Bowlt points out, the Burliuk brothers (David, a poet, painter, and artistic activist; Vladimir, a painter; and Nikolai, a poet), Marc Chagall, Goncharova, Larianov, and Aleksandr Shevchenko were all to restate this idea in the years 1909–14. A later issue of *Zolotoe runo,* the Symbolist magazine that printed Blok's famous "Slova i kraski" (Words and Colours) essays, published an even more daring piece under the pseudonym D. Imgardt, which argued that the aims of art had been exhausted and that new bases for producing and assessing colours and musical tones must be found. The pressure for these new criteria would lead to a "visual music and phonic painting without themes." [14] Already in 1906, Imgardt foresaw the theatre of colours that Kandinsky was later to propose for the film medium–soon realized as the Absolute Film.

Some Symbolists, such as Bely, read Mme Blavatsky's theosophical writings and Steiner's Anthroposophical writings—Bely, in fact, took a deep and abiding interest in the latter corpus.[15] His occult interests are also evident in his novel

Serebrianyi golub' (The Silver Dove, 1908).[16] Bely owned a collection of books on occultism and was well read in the subject. He even supposed that Russians had a special affinity for the occult. The Symbolists were convinced that the world as we ordinarily experience it conceals a more profound world and that human knowledge has as its end the intuitive apprehension of this more profound world. Science and technology they considered obstacles on the seeker's path. Indeed, they decried all types of objective knowledge—and in their view that included all knowledge that comes through language. Thus, like the French Symbolists, they sought to engender the effects of music rather than those of discourse. Words, Bely explained, serve to defend the self from a hostile environment; the seeker, by contrast, must discover the essential unity between the self and the world. The soul is illuminated not by abstract knowledge or ratiocination but by intuition, which apprises us of the condition of the world's soul. Words have made the soul heavy, but the soul can escape words' gravity by attending to higher forms of knowledge. Music offers the path to understanding God, the cosmos, and humans' place in it. Like Schopenhauer, Bely proclaimed that music transcends the *principium individuonis*, the forms of time and space: time and space bar access to the plane to which Sophia, Solovyov's Beautiful Lady, summons us.

A principal source of Russian Symbolists' ideas about language was Solovyov's theological philosophy. Russian Symbolists shared with him an interest in things to come. His philosophy was basically redemptionist, and Symbolist aesthetic theory shared that goal. Music, especially the symphony (the highest musical form, according to Bely's understanding of the arts), allows us to escape from the phenomenal reality conditioned by the *principium individuonis*. Drawing on Gogol, Nietzsche, and the Biblical Apocalypse, as well as Schopenhauer, he proposed that dreams, symbols, and visions had noetic value, as they were accurate expressions of a higher order. So intimate did he consider the links between music and poetry that he claimed that his writing evolved from cosmic images that arose when he improvised on the piano, which he then arranged into storyless themes. Furthermore, a foreboding of doom drove Bely's thought, as it did that of many who took an interest in the occult. He harboured the Apocalyptic belief that the final clash between Good and Evil was about to occur, the clash that St. John of Patmos had predicted would occur, when agony would lacerate the soul of Sophia (whom Bely doubtless recognized as Solovyov's Eternal Woman-Mother), the Beautiful Lady clothed in the sun, as she witnessed the Great Whore's triumph. The penchant for new religions, so strong in Russia at the beginning of the twentieth century, foretold this final struggle: the titanic clash between Christ and the Antichrist was at hand.

Earlier Bely had foreseen a new age in which humanity would be revitalized and regenerated by passionate love and divine mercy, and his work spoke

of the "engoldening world." Soon, however, he began presenting visions of skies filled with battling giants and fearsome beasts, and madness and impotence became his common themes. Thus, when the Russo-Japanese war broke out early in 1904 (a near fulfillment of the Solovyov's prophecy of the invasion of Russia by Mongolian hordes), he concluded that the end was near. Nevertheless, it was not the possibility of an invasion from the east that alarmed him most, but a more ominous event, revealed to him in a vision, that the armed conflict foreshadowed: the confrontation between the cosmos and chaos. The Russo-Japanese war, he decided, was only an external sign of the conflict between universal spirit and world terror, between our souls and disorder. All that occurred in the months following the vision confirmed this for him: during 1905 the Czar was forced to admit defeat in the Russo-Japanese war; hundreds of students and unarmed workers were shot when a crowd assembled outside the Winter Palace to plead with the Czar for a better life; Russia experienced a nationwide general strike; a full-scale uprising of factory workers occurred in Moscow; and, of course, a mutiny of sailors took place on the "bronenosets Potyomkin" (battleship *Potemkin*).[17] All of this contributed to the Apocalypticism that drove Bely and Blok to integrate a vision of earthly doom into their work. Bely strived to feel the earth's vital force, while Blok began to include the city's back alleys in his poetry. The final doom seemed near.

It is instructive to survey the responses of Bely and Blok and their Symbolist colleagues to 1905, the year when history shook the earth to its foundations. Bely himself, who had been reading Mme Blavatsky for years, "gave himself up to [Rudolf] Steiner," thereby reinforcing his retreat into the other, higher world.[18] Valery Bryusov, who had been introduced to French Symbolist/Decadent poetry by Aleksandr Dobroliubov and who soon became the leader of the Russian Decadents, decided on a radical change of course: he developed a concern with the new society that was being born—that is, with the new society that industry would shape. He feared that this new society would be the destroyer of art, as philistine values strengthened their hold. The possibility shook him deeply: he confessed to feeling that he was sliding into the abyss. The Apocalypticism of Solovyov's followers would leave indelible marks of one form or another on the many artistic movements soon to emerge.[19]

MALEVICH, OR THE PERSISTENCE OF THE SYMBOLIST IDEAL

In the decade or so leading up to the Bolshevik Revolution, during the Revolution, and in the decade after it, there was as much ferment among artists' groups as there was among intellectuals bent on changing society (and, of course, the two groups were not mutually distinct). This ferment presents two difficulties for those who wish to understand the Russian avant-garde: first, the

ideas of the individual artists underwent great change during this period, so any attempt to identify and describe any artist's beliefs runs the risk of characterizing the whole of an artist's career by some part; and second, artists and intellectuals were not always open and honest about their discretion (not to say cowardice) during this period.

What historians and journalists often call "the Russian Revolution" was really the third revolution that had occurred in that country in little more than a decade. The first was the revolution of 1905; it did not topple the Czar, of course, but it did stir up additional ferment among intellectuals. Perhaps because it eventually failed, it strengthened occult tendencies generally and in particular the Symbolists' proclivity to withdraw into an interior, aesthetic realm. The second revolution was the one eventually led by Kerensky in March 1917 and resulted in the Mensheviks' taking power. The third was the Bolshevik Revolution of October 1917. Eras in which power shifts hands and allegiances change rapidly are notoriously eras in which one exercises discretion about one's convictions; this discretion makes it difficult to assess intellectuals' most deeply held beliefs. Following on these two challenges is a third difficulty in discerning the real meaning of statements that artists made in this period: times of ferment generally place a premium on change, so that novelty becomes a criterion of value. As a consequence, artists during times of ferment are unlikely to be completely frank about what they have valued in the tradition and what they propose to carry forward from it. This last difficulty is a general one, applying to artists and thinkers of any revolutionary era; but it becomes increasingly troublesome when dealing with the ideas of artists and intellectuals immediately after the Bolshevik Revolution, for during that time many artists, probably most of them, genuinely wanted to establish their revolutionary credentials.

Consider the statement that Anatoly Vasilievich Lunacharsky, the People's Commissar for Enlightenment in Lenin's government between 1917 and 1926, made about the great Suprematist Kazimir Severinovich Malevich: "The trouble begins when Malevich stops painting and starts writing pamphlets. I have heard that this artist's writings have thrown even the Germans into a state of confusion ... Malevich has tried to link his aims and his ways by one means or another with both the revolution and [G]od, and he has got muddled."[20]

Lunacharsky identified here the central tension in Malevich's art and that of many Russian artists of the period: it was torn between the desire to bring about a spiritual renewal and the desire to bring about political change.

For a time, the pneumatic dimension of Malevich's art was less than adequately treated (for his works were treated as formalist works). However, the publication of Malevich's poetry in the 1970s brought scholars to re-examine his spiritual proclivities, for these poems are intensely religious. Example: "I search for God, I search within myself for myself ... I search for my face, I have already drawn its outline and I strive to incarnate myself."[21]

Malevich's Suprematist works offer a meditation on the theme of the Cross; we must understand their form from within the Russian Orthodox Church's tradition of the icon. The basic Suprematist elements—square, cross, circle, oblong, line—when placed on pure white surfaces, seem to be projected onto a weightless world of infinite space. For Malevich, space was the defining element. As head of Leningrad's Institut Khudozhestvennoy Kultury (Institute of Artistic Culture, INKhUK), a branch of Narodnyi Kommisariat po Proveshcheniyu (People's Commisariat of Enlightenment), he undertook experiments in the fields of visual perception and the psycho-sociological effects of colour, form, space, and time. He was interested in geometry and was acquainted with Claude Bragdon's *Primer of Higher Space* (1913). The geometric and colouristic purity of his art served religious ends; his notions about geometry undoubtedly carried spiritual baggage. Many commentators have remarked that when he first showed his Suprematist paintings, in St. Petersburg in 1915, he hung his famous *Chernyi kvadrat na belom* (Black Square on White) in a corner of the room where wall meets ceiling, the place where Russian Orthodox families traditionally hang an icon (because three lines meet there).[22] The significance of this gesture is open to question. Critics who emphasize Malevich's credentials as a revolutionary artist argue that he was replacing the icon, the symbol of the past, with the rigorous geometric abstraction, the symbol of the future. But another interpretation is possible. Consider Malevich's own comment about *Chernyi kvadrat na belom*: "The black square on the white field was the first form in which non-objective feeling came to be expressed. The square = feeling, the white field = the void beyond this feeling."[23]

In another passage, he proposed that intuitive form should emerge from nothing; the white field, one realizes, represents the void from which the form, the black quadrilateral, comes forth.[24] One of Malevich's Russian contemporaries stated:

> There is in existence an idea which a man should always call to mind when too much subjugated by the illusions of the reality of the *unreal*, visible world in which everything has a beginning and an end. It is the idea of infinity, the fact of infinity…Let us imagine for a moment that a man begins to feel infinity in everything: every thought, every idea leads him to the realization of infinity.
> This will inevitably happen to a man approaching an understanding of a higher order of reality.
> But what will he feel under such circumstances?
> He will sense a precipice, an abyss everywhere, no matter where he looks; and experience indeed an incredible horror, fear and sadness, until this fear and sadness shall transform themselves into the joy of the sensing of a new reality…
> This sense of the infinite is the first and most terrible trial before initiation. Nothing exists! A little miserable soul feels itself suspended in an infinite void. Then even this void disappears! Nothing exists. There is only infinity.[25]

The text is by Pyotr Demianovich Ouspensky (1878–1947), a Russian author who brought an intelligence informed by mathematics and logic to interpreting and transmitting the ideas of the Greek-Armenian spiritual teacher G.I. Gurdjieff, whom he met in Moscow in 1915. The two texts, and the differences between them, reflect an interest in the void and in the conflict between negative and positive conceptions of the void that were bruited about in Moscow and St. Petersburg during these years. Teachers who expounded occultist beliefs, Symbolist thinkers, Symbolist poets, and vanguardists-to-be all spoke about the dissolution of matter, about the empty beyond that was either a blissful state of consciousness or a total, abhorrent vacuum. Malevich's 1919 essay "Suprematizm" ends with remarks about a "white beyond" that is surely an analogue of the reality beyond forms in Hindu and Buddhist belief systems. In a similar vein, Blok alluded to whiteness experienced in the ultimate of the dream state. He used white as a symbol of reality in several plays that he wrote between 1906 and 1912. Russian artists and thinkers of the period often connected the dissolution of matter with "nirvana" or with what Ouspensky called the "Miracle." Blok and Kandinsky reflected on "pure sound," while Fyodor Sologub, Konstantin Andreyevich Somov, and Blok (at least in his decadent phase) contemplated "le grand Néant." The Cubo-Futurists continued the Symbolists' and Decadents' interest in the great nothing: in 1913 the Cubo-Futurist poet Vasily Gnedov published "Poema kontsa" (Poem of the End), which ended with a black page. A group of poets and painters in Rostov-on-Don and Moscow formed a group they called the "Nichovokakh" (Nothingists) and published a manifesto, "O nichevokakh v poezzi" (On the Nothingists in Poetry) whose Dada-inspired program was to write nothing, read nothing, say nothing, and print nothing. Though their idea of nothing was clearly different from the Buddhists', there are some evident affinities between the two conceptions: a mystical conception of reality is common to both, and was common among the Russian avant-garde at the time. Thus in his Suprematist paintings, subtitled "Krasnochnye massy y chetverton izmerenii" (Colour Masses in the Fourth Dimension), Malevich tried to convey the sense of infinite vastness and freedom that Ouspensky described as characterizing the experience of fourth-dimensional consciousness. Malevich's Suprematist style, inaugurated in 1915, and the interests that gave rise to them, were to have enormous influence, even during the Soviet period. His ideas on the fourth dimension had much in common with Ouspensky's: in the writings of that mathematician and mystic, the "fourth dimension" suggested the attainment of cosmic consciousness.

SYMBOLISM AND ITS DESCENDANTS
SUPREMATISM

Suprematism was among the earliest movements in abstract art. Abstract art arose from a complex of factors. Meyer Shapiro noted that

for the artist these elementary shapes have a physiognomy; they are live expressive forms. The perfection of the sphere is not only a mathematical insight, we feel its subtle appearance of the centered and evenly rounded as a fulfillment of our need for completeness, concentration, and repose. It is the ecstatically perceived qualities of the geometrical figure that inspired the definition of God as an infinite circle (or sphere) of which the center is everywhere and the circumference nowhere. In another vein, Whitman's description of God as a square depends on his intense vision of the square as a live form:

Chanting the square deific, out of the one advancing, out of the sides;
Out of the old and new—out of the square entirely divine;
Solid, four-sided (all the sides needed) ... from this side Jehovah am I

The same form occurred to Tolstoy in his *Diary of a Madman* as an image of religious anguish. "Something was trying to tear my soul asunder but could not do so ... Always the same terror was there—red, white, square. Something is being torn and will not tear."

I shall not conclude that the circle or square on the canvas is, in some hidden sense, a religious symbol, but rather: the capacity of these geometric shapes to serve as metaphors of the divine arises from their living, often momentous, qualities for the sensitive eye.[26]

It was an essay on painters' relation to cinema that prompted Malevich to declare just how radical was the new art he was developing at the time. Much like Kandinsky, he demonstrated the radicality of his art by contrasting two types of art: Concretist and Abstractionist: "At this moment, art has divided itself into two fundamental parts: some [artists] have become representational (Concretist), easel painters and reflectors of the mode of life without having illuminated the essence of art; the others have become non-representational (Abstractionists) after having elucidated the essence of art and having renounced portraiture and reflecting the mode of life."[27] While the old arts presented illusions, the new arts expressed "the new real Reality," which he characterized in spiritual terms by defining it as "the fusion of the world with the artist."[28] The new painting did not reflect life but illuminated the essence of art; art was its pictorial self-cause; thus it was completely autotelic. Malevich believed that Suprematist art furnished ontological revelations and thus was philosophical—indeed, he maintained that its having a philosophical impetus accounted for the strength of the Suprematist system. A key influence on Malevich's artistic theories was Schopenhauer. Malevich's idea that the artist, and

the artist alone, knows a reality higher than objective reality was derived from Schopenhauer; so, too, his belief that in aesthetic experience we transcend the division between subject and object.[29] Troels Andersen, who has translated Malevich's texts into English, believes that Malevich based some of his writing on Schopenhauer's *Die Welt als Wille und Vorstellung* (The World as Will and Idea), even numbering sections of his fragmentary autobiography to correspond to relevant sections of Schopenhauer's *magnum opus*.[30]

ZAUM AND PERLOCUTIONARY POETICS

To experience this higher reality, one must escape sense. Artworks escape sense by converting their effects into a real, direct, physical form: sense and meaning too easily seem overly ideal (mental), but art can have actual, corporeal effects. Perhaps the most radical Russian development stimulated by the idea that artistic media can engender primitive physical effects was the work of the *zaum* poets Velimir Khlebnikov and Alexei Kruchenykh.[31] I refer in a companion volume to Kruchenykh and Khlebnikov's belief in the possibility of constructing a language in which meaning does not depend on reference, but strictly on that language's intrinsic properties, based on the conviction that there is a primitive substratum to language that reference has concealed.[32] The substratum operates beyond reason (the *zaum* poets claimed to accord a role to transrational knowledge and transrational experience) and affects us immediately, without our being aware of it. The *zaum* poets' ideas about the effectivity of this substratum associated individual phonemes with particular effects; each sound, they proposed, produces a distinct result—a distinct meaning that does not depend on reference.[33] *Zaum*'s transrationalism drew them toward efforts to bypass reference and representation completely, in the belief that the sounds of different phonemes have as immediate, physical an effect as the optical/physical/emotional sensations that colours provoke.

Underlying such beliefs is the notion that artworks can have perlocutionary effects that bypass the rational mind and that affect one immediately at the place where the body and mind are one. Lyubov Popova regarded painted forms in much the same way as the *zaum* writers understood poems: each painted form (like each phoneme) stored energy of a particular intensity and dynamism, and the viewer/listener's interaction with the work activated this potential energy, releasing it in such a way as to produce an effect in the viewer/listener. Malevich underwrote similar ideas—Bowlt tells us that Malevich

> could argue on the one hand that a ball, a motor, an airplane, and an arrow all used and represented the same power of dynamism. On the other hand, he re-

ferred to the "energies of black and white" and the energies of Suprematist forms as if they contained a real, traceable, applicable force that could be harnessed to drive machines. This notion brings to mind esoteric understandings of energy: Wilhelm Ostwald's "energetic imperative" and G.I. Gurdjieff's psychic translocation of objects over distances and transference of telepathic power. It was this discovery of cosmic energy, whatever its philosophical derivation, that provided Malevich with the conviction to explore the world of abstraction in the Suprematist paintings, especially in those of 1917 onward ... Malevich's aerial suprematism of the 1920s relates the story of this infinite journey into space. [cf. Fedorov on humankind's future journey]. When we realize how thematic Malevich's Suprematism was, how it distilled and allegorized nonpainterly ideas, we can better comprehend why it elicited criticisms from his soberer colleagues; why Malevich and Tatlin engaged in a fist fight in 1915, why his earnest supporter Nikolai Punin once described Malevich's ideas as a "hymn to despair," and why Kliun rejected Suprematism as the "corpse of painterly art," even though Kliun's own paintings of the early 1920s such as *Red Light Spherical Composition* invite cosmic, nonpainterly interpretations.[34]

Zaum ideas found their culminating expression in the Futurist theatre piece *Pobeda nad solntsem, Opera* (Victory over the Sun: An Opera). This extraordinary work was first performed on December 3 and 5, 1913, by the Soyuz Molodyozhi group, at the Luna Park Theatre in St. Petersburg. Later it was revived in Vitebsk.

Work on the opera began in July 1913, when Malevich, Alexei Kruchenykh, and Mikhail Matyushin took a sojourn from their urban endeavours and spent time together in Matyushin's cottage in Uusikirkko, Finland. Khlebnikov, Kruchenykh's colleague in Hylea and the author of the Prolog, was not able to attend the first performances because he had misplaced the funds he had set aside for transportation. Matyushin's regular job was as first violinist in the St. Petersburg Symphony Orchestra, and Kruchenykh claimed that the gentle singing tone of dear Matyushin's violin had inspired him to produce the libretto for the work. Yet the libretto had anything but gentle intent. In a fine article on the production, Charlotte Douglas provides the statement the three collaborators issued after the grandly titled First All-Russian Congress of Singers of the Future (Post-Futurists) convened on July 18 and 19, 1913:

> We intend to arm the world against us! ...
> The noise of explosion and the slaughter of scarecrows will rock the coming year of art! ...
> We shall announce the rights of singers and artists, lacerating the ears of those vegetating under the stump of cowardice and immobility:
> 1) To destroy the "clean, clear, honest, resonant Russian language" emasculated and smoothed out by the tongues of man from "criticism and literature."
> It is unworthy of the great "Russian people!"

2) To destroy the antiquated movement of thought according to the laws of causality, toothless common sense, "symmetrical logic" wandering about in the blue shadows of Symbolism.

3) To destroy the elegance, frivolousness and beauty of cheap public artists and writers, while constantly issuing newer and newer works in words, in books, on canvas and paper ...[35]

Kruchenykh's libretto was composed partly of nonsense phrases and alogical conjunctions of text fragments; the music, for its part, was atonal and dissonant (it included sounds produced on a detuned piano and choral singing at inharmonious intervals). A fragment of the score, an excerpt from Matyushin's "Prelude," was published in *Troe* in September 1913; it used square notes to indicate pitches that were to be raised or lowered by a quarter tone. Only that, and a second fragment of the music, is known to have survived. Kruchenykh's libretto, however, has survived intact; and several of Malevich's costume and stage designs—heavily saturated with images of the square— exist to this day.[36] The libretto is stunning: it is composed of neologisms, plays on words, and irrationalist tropes, and its syntax is purposely ambiguous or even confused. Its imagery often defies discursive interpretation. For example, the enemies of the victors are "fatty and smell of arithmetic."

The opera's narrative (insofar as it has one) concerns the acts of time travellers and tells of the sun's capture. The "victory over the sun" represents, among other ideas, the victory of technology (the electrical light) over the sun's natural light.[37] But the sun is the source of visibility, and thus—drawing from the philosophical tradition founded by Plato—it is the source of calculative reason (inasmuch as visibility traps us in a world of appearances, a world that is so much less than the world of forms, to say nothing of the realm of the Good itself). Thus it is, as Matyushin would later call it, "a sun of cheap appearances."[38] The connection between reason and the sun is traditional— Apollo is the sun god and the god of reason—and reason the Alogists understood as the enemy of singers. The theme of *Victory over the Sun* is the importance of going beyond the visible, everyday order of things to the higher world of the suprarational. The supermen who reject the past and its tradition of logic would help bring about this decisive historical event.

But there is another significance. Many Russian artists and thinkers of the time were intrigued by the possibility of time travel (an interest fuelled both by Fedorov's Cosmism and by Ouspensky's proposal that time could be thought of as just another dimension of space).[39] A "victory over the sun" is thus a triumph over the diurnal routine of time's passage: with victory over the sun, it becomes clear that the movement of a clock's hands marks nothing real; thus, that victory offers a new perspective on the continuities of space and time. In keeping with this Fedorovian character, the events of the opera take place in some indeterminate location, but definitely not earth.

The opera has two acts. In the first, a group of people attempt successfully to capture the sun in a concrete house. The second act follows the sun's victorious captors, depicting an otherworldly "tenth country" as the group's new abode. "You become like a clean mirror or a fish reservoir," declares one of the sun's captors, "where in a clear grotto carefree golden fish wag their tails like thankful turks."[40]

As the performance begins, the curtain is raised and the spectators are confronted by a second curtain with three hieroglyphs, indicating the author, the composer, and the designer. As the music begins, the second curtain parts to reveal another, against which are set a crier and a troubadour. The prologue ends and, with strange war cries ringing out, the final curtain parts.

Khlebnikov's prologue (which was added to the piece after the other parts had been composed) is clearly a Fedorovian piece, for it makes many references to time travel, reincarnation, and magic; it also speaks of the "Budetlyanin" (Future-Dweller), who lives in Budetlyandiya (Future-land) and who offers to lead the audience into the future, in which artists will change the look of nature. That much is clear; however, it must be said that *Victory over the Sun* is a riddling and elusive piece: like Bely's *Glossololia*, it puns on word roots, constructs patterns of assonance and alliteration, and permutes the prefixes and suffixes of words. The work's meanings are as much effects of the physical impact of its novel word constructions as of their conceptual or propositional content.

Act 1 has a black-and-white set. It opens with two Futurist Strongmen, clad in cardboard armour composed entirely of triangles, tearing open the curtain. The first declaims: "All's well that begins well and has no end / the world will perish but there is no end to us!"[41] (The Fedorovian idea that future humans will live forever is evident.) The Second Futurist Strongman states their aim: to throw a dust sheet over the sun and confine it in a boarded-up concrete house. Nero and Caligula appear, fused into one character, representing the horrible corrupting influence of tradition. Then another figure appears, who resembles Hermes, and then the Traveller Through the Centuries, who moves on airplane wheels and is covered with pieces of paper ringing out the progression of Ages: the Stone Age, the Middle Ages, and so on. The Traveller declares that he will "ride through all the centuries" and echoes Caligula's warning not to trust "old measurements" when he warns people not to trust "former scales." The Ill-Intentioned One and The Squabbler then arrive, quarrelling and fighting. A machine gun of the future comes on stage and stops at a telegraph pole.

The set that next appears features a section of a stringed instrument from which notes waft up and float about. After the first part of the scene, stage lights (green light with some areas left very obscure) profoundly influence how the set and costumes appear. The characters at the beginning of the scene

include Enemy Soldiers (dressed in Turkish garb), Futurist Strongmen, and Sportsmen. The First Futurist Strongman announces that "the sun lies at their feet" and that an iron bird is flying. The scene ends with news of an eclipse ("the sun has hidden and darkness has fallen").

A burial scene celebrates the eclipse ("burial") of the sun: black walls and a black floor replace the green (and black) effects of the later parts of Scene 2. Pallbearers appear in costumes of black and white with splashes of blue and red-orange; they wear black squares on their chests and hats. These squares, which rhyme with squares on the middle panel of the backdrop, represent the new and higher (non-organic) forms that eclipse the sun. Nature's circular forms (including its diurnal, lunar, and solar rhythms, which turn in circles) are overwhelmed by emerging forms of humanity's rationality.[42] The black square (which will later become an important motif in Malevich's painting) is associated with many themes; but its connection with *Victory over the Sun* makes it clear that among its associations is the idea of the waning of natural light (as nature is overtaken by a higher culture).[43]

Act II, Scene 1, depicts the captured sun as its measure is taken. The Many-and-the-One tells us that the earth, now captive, does not turn any more. The victory over time is complete. This victory achieved, we enter Tenth Country, that is, the Land of the Tenth Dimension. Malevich designed a remarkable set for this scene: his Future-Dwellers' house is a salmagundi of windows, pipes, and stairs that depicts the new space the future is bringing, the result of attaining a new perspective on a space that has been turned inside out (as Khlebnikov's libretto has it). In this new space, after the decay of the black sphere, the Alchemist's Universal Man reappears in extraordinarily coloured garb and illumined by intensely hued directional lighting.

Act II, Scene 2, concerns the treachery of appearances in this new space: vast and complex, even what appears utterly simple turns out to be unfathomable. In keeping with the theme, the sets make extensive use of spatial ambiguity and elusive puns. All times coexist in the four-dimensional space. Act II, Scenes 5 and 6, present Tenth Country's future as seen through the eyes of Fatman, who represents the bourgeoisie. Fatman exclaims, "What kind of country is this? How could I know that I will be locked up without being able to move either my arms or legs?" Having complained about his predicament, he becomes curious: "What if one could climb up the stairs to the brain of this house and open there a door #35 oh, what wonders! Yeah, all is not so simple here, although it looks just like a chest of drawers, but one just roams and roams around."

The Aviator appears—another version of the Futurist Universal Man, who corresponds both formally and conceptually to the Traveller Through the Centuries and to the Futurist Strongmen. He has crashed his plane into this complex space where "all roads come from all directions" and intones a *zaum*

song: "l l l/ kr kr kr/ tli …" The song continues until the Futurist Strongmen reappear, to close the opera much as it began: "All's well that begins well and has no end. The world will die but for us there is no end." The curtain descends—a simple form, dividing the screen with a square, within which is a second square, divided diagonally into black and white areas. The two squares are joined by diagonals linking each of the corners of the inner and outer squares, giving the effect of recession and alluding to the stage as box-like form. This design, at the end of Act ii, Scene 5, Malevich would later single out as the black square's first appearance in his work—though by this point it had appeared in a context that otherwise presented mostly alogical (*zaum*, or Alogist) drawings: his drawings for other sets that include squares, rectangles, and triangles also include other components (letters, numerals, a foot, a hand holding a sphere [a bomb?], a cigarette and cigarette smoke), whose connections with these geometric forms cannot be discursively explained. The drawing is alogical because its components (both abstract and representational) do not cohere so as to form a unified composition possessing propositional meaning. Moreover, the sets defy conventional visual logic, as forms thrust against form, creating impossible, Escherian games with perspective. The elements seem to defy meaning, to escape it, as do the images of a dream; and like the images of a dream, these parts usually constitute a rebus, whose concatenated components fail to form a discursive whole.

Benedikt Livshits, who attended the first performance of *Victory over the Sun*, wrote an illuminating text on Malevich's set design. In addition to referential elements (e.g., the house in which the son is confined, a stylized sun, and a portion of an airplane), the sets also included freestanding geometric shapes. To create dynamism and to articulate shapes, mobile lighting was also used:

> Out of the primal night the tentacles of projectors snatched part of first one and then another object and, saturating it with color, brought it to life … The innovation and originality of Malevich's device consisted first of all in the use of light as a principle which creates form, which legitimizes the existence of a thing in space …
>
> Within the limits of the stage box a painterly solid geometry was born for the first time, a strict system of volumes, reducing to a minimum the elements of chance which have been thrust on it from without by the movements of the human figures. The figures themselves were sliced by the blades of the beams; alternately hands, feet, and head were eliminated, since for Malevich they were only geometrical bodies, subject not only to decomposition into component parts but also to complete dissolution in pictorial space … Instead of the square, instead of the circle, toward which Malevich was already trying to bring his painting, he had the possibility of using them as their volumetric correlatives, the cube and the sphere.[44]

Livshits's description could have appeared, *mutatis mutandis*, in an early text in film theory. The ideas that in this new medium, characters would have no more importance than their environment, that this new medium belonged to a modern world of geometric form, that light should be accorded priority, that light could be regulated precisely in this new medium, that human movement is imprecise whereas the dynamics of the new medium would be as precise as mathematics—these were all themes taken up in early writings on film. This constitutes proof of film's affinity with the aesthetic ideals of Malevich and his colleagues. It is the claim of this book that this affinity was not simply the result of the spirit of the time being taken up with these notions; rather, the film medium exerted an influence on the founding ideals of most avant-garde art movements of the early twentieth century—the new Paragone had been constructed, and cinema turned out to be the *ottima arte*. Art historians commonly understand *Victory Over the Sun* as a work that came at a crucial moment when the aesthetic ideals of Suprematism were overtaking those of Cubo-Futurism. We remark on the telling similarity between this work and cinema and point out the relation between cinema and Suprematism.

If *Victory Over the Sun*'s nonsense phrases, strung together in an illogical sequence, and its dissonant music have their provenance in *zaum* poetics and Futurist ideas, the set design suggests an amalgam of Futurist and Suprematist ideals. Another work performed at Vitebsk around the same time was Nina Kogan's *Suprematicheskiyi balet* (Suprematist Ballet), an abstract dance that eschewed any narrative line. The sets for the ballet moved and changed constantly (somewhat like Eisenstein's sets for *Precipice*); sometimes they represented a star, sometimes a circle, and, at the ballet's end, they represented a square.[45] The actors were concealed behind geometric figures painted on cardboard, which, in being moved, assumed new configurations (arcs, crosses, etc.).[46] These sets were meant to kineticize, even (in some measure) to narrativize, the common shapes of Suprematist art: figures emerged out of a black square, moved through space and underwent a set of transformations, then returned to the square.[47] In this, one can once again see evidence that cinema had emerged as the *ottima arte* and that painters were trying to find a way to reconfigure their art so that it might share in the virtues of cinema. Kruchenykh described the event in terms that make Fedorov's influence abundantly clear:

> [Malevich's sets consisted of] large, flat configurations—triangles, circles, machine parts. The actors wore masks that resembled today's gas masks. The "likari" [performers] looked like running machines. The costumes were constructed cubistically, of cardboard and wire. This altered human anatomy—the performers' movements were limited and determined by the rhythm [established by] the designer and director. *The Song of the Anxious People* (in soft tones) and that of the Pilot (which consisted only of consonants) made a special impression on the

audience; they were sung by experienced performers ... The basic theme of the play is a defence of technology, especially aviation. The victory of technology over the cosmic forces and over biologism. We shall lock the sun into a concrete building![48]

About a decade later, El Lissitzky revised the project and created designs for an enhanced performance. In 1923 he produced a figure portfolio with ten colour lithographs inspired by the original performance and elaborated it into the "plastic design for an electro-mechanical show." In the preface to the portfolio, he explained the origins of the work:

> The present piece is the fragment of a work done in Moscow in 1920–1 [that is, seven years after the opera was mounted] ... On a square that is open and accessible from all sides we shall build a scaffold, the machinery for the show. This scaffold gives the pieces in the play the opportunity for every possible movement ... They glide, roll, hover within and above the scaffold. All parts of the scaffold and every piece in the play can be set in motion by means of electromechanical forces and equipment, and the controls will be in the hands of a single person. This is the play's director. His place is at the midpoint of the scaffold, at the center of all the energies. He directs movements, sound and light. He switches on the radio megaphone, and over the square sounds the cacophony of railroad stations, the roaring of Niagara Falls, the hammering of a rolling mill. Light beams follow the movements of the pieces, refracted through prisms and reflections ... The sun as a symbol of ancient universal energy will be torn down from the sky by modern man, who by dint of his technical mastery creates an independent source of energy. This idea of the opera is interwoven with a simultaneity of happenings. The language is alogical. Certain vocal parts are sound-poems.[49]

The work embodied the values of the modern age, the age of cinema. The belief that artworks are physically effective was associated with an idea that appeared in the writings of filmmakers/film theorists Dziga Vertov (pseudonym of Denis Abramovich Kaufman, 1895–1954) and Sergei Mikhailovich Eisenstein (1898–1948) and occultists' writings. It also provided the basis for the interest taken by thinkers of the time in practices such as vegetarianism, Gurdjieff's Haida yoga, Dalcrozean Eurythmics, Taylorism, and biomechanics (which was, in part, Meyerhold's application of Taylorism to the stage).[50] The proposition that a new body was necessary for the new times, the new spirit, and the new art was bruited about. That idea had been expounded by Symbolists as well, who proclaimed the importance of listening to the body as a means of remedying the damage that Western culture had done to the human form. This led several of them to practise yoga, fasting, and gymnastics. The example of biomechanics is equally instructive: Vsevolod Meyerhold (1874–1940) taught actors to analyze the "mechanics of movement"—for example,

to resolve a simple action such as shooting an arrow into several elementary gestures, which they would then recombine, perhaps differently ordered, into a new choreographic whole (which was performed by a body made supple by much exercise). The performance aimed to stimulate spectators physically.[51]

MALEVICH AND HIGHER REALITY

Malevich, too, wanted to produce an art that had direct, immediate, physical effects. Such effects would provoke a sense of a higher realm. The physical nature of this art's effects raises the question whether Malevich conceived of this higher reality as objective or subjective. His answer to this question is complex, for it defies the categories that the metaphysical tradition handed down from the Greeks has used to partition reality into distinct domains. Malevich offered this (admittedly poetic) statement of his purposes:

> I imagine a world of inexhaustible, unseen forms.
> For that which I do not see—an endless world arises …
> [Artists] open the hidden world and reincarnate it into the real.
> The mystery remains—an open reality and each reality is endlessly multi-faceted and polyhedral.[52]

Suprematist art, then, was to incarnate a higher reality in the world of matter. Presumably, this reality would be suprapersonal, suprasubjective. Yet Malevich (admittedly answering his adversaries) also wrote:

> [Suprematist] construction … is highly complex, it is built not for the sake of building, but in order to transmit the graph which is drawn according to the changes of my inner oscillations; thus it belongs to me, and only those who are of my kind can say so.[53]

One of these statements by Malevich proposes that Suprematist forms incarnate forms that belong to a suprapersonal, suprasubjective realm; the other states that Suprematist forms have their origins deep in the subject. Judged according to the categories of Western metaphysics, these statements are incompatible, for that which is inexhaustible and unseen (i.e., whose existence does not depend on being perceived) has the status of something non-subjective; and Western metaphysics divides the subjective and the non-subjective into distinct domains. However, there are other ways of thinking about the status of objects that belong to the domain that includes the types for Suprematist forms. Many intellectual traditions, including the hermetic tradition, reject the proposition that any existents have an existence independent of thought or perception—they maintain that all existents are ideal. Malevich evidently held this conviction—he likely believed that what belongs to the external world

is nonetheless fully subjective, and the loftier its ontological status as external form, the deeper within the self it can be discovered.

An unpublished paper by Malevich reveals him struggling to find language and metaphors that can convey an understanding of the world that does not parcel out existents into objective and subjective spaces; in working out these ideas, he returns to a notion close to that of inner oscillations:

> Our life is a radio station into which the waves of different sensations find their way and turn into various aspects of things. The switching on and off of these waves depends on the sensation controlling the radio station.[54]

It is as though consciousness is beamed into us—but only if we attend to the transmissions. Another passage extends his deliberation on the dialectic between inner and outer worlds:

> To value and concern oneself with the inner life is man's true plan and he strives to convey what is inner to life, struggling with the external and trying to make all external things inner. Stimulation, as a cosmic flame, wavers in the inner man without purpose, sense or logic—in action it is non-objective.[55]

MALEVICH, SUPREMATISM, AND SCHOPENHAUER

Malevich also revealed, by the language he applied, that his thinking about overcoming illusion and discovering the true soul of things moved along Schopenhauerian lines:

> The ascent to the heights of non-objective art is arduous and painful ... but it is nonetheless rewarding. The familiar recedes ever further and further into the background ... The contours of the objective world fade more and more and so it goes, step by step, until finally the world—"everything we loved and by which we have lived"—becomes lost to sight.
>
> No more "likenesses of reality," no idealistic images—nothing but a desert!
>
> But this desert is filled with the spirit of non-objective sensation which pervades everything.
>
> Even I was gripped by a kind of timidity bordering on fear when it came to leaving "the world of will and idea," in which I had lived and worked and in the reality of which I had believed.
>
> But a blissful sense of liberating non-objectivity drew me forth into the "desert," where nothing is real except feeling ... and so feeling became the substance of my life.[56]

"The world of will and idea" is a riff on the title of Schopenhauer's *magnum opus*, *Die Welt als Wille und Vorstellung* (The World as Will and Representation), a work in which Schopenhauer presents the realm of ordinary experience as a veil of illusion (this is the "world as idea"—or, more exactly, "as

(vertical margin text:) MODERNISM AND REVOLUTION

representation"—of Schopenhauer's title).[57] Schopenhauer was among the first Western philosophers to be influenced by Vedantic Idealism. He took the Vedantic opposition between the domains of *maya* (illusion) and Brahma as homologous with that between the phenomenal and the noumenal worlds in Kant's philosophy. Dissatisfied with Kant's conclusion than the mind is limited to acquaintance with the phenomenal world, he proposed that he could reconstruct Kantian philosophy based on what he had learned from the Upanishads and Vedantic philosophy, to show how the mind could have intimations of the character of what is ultimately real (which is a cosmic striving, a *conatus*, a sort of willing—hence Schopenhauer's title for his book).

Three features made Schopenhauer's philosophy especially attractive to Symbolists. First, he deemed the realm of individual, particularized objects to be illusory—our belief that the domain of what exists is populated by particular objects is false. Particularized existents are only phenomenal, whereas what is real is ultimately one—it is a cosmic *conatus* that animates all that appears real to the unenlightened mind. Thus, his system works out the implications of the Symbolists' sensation of the object world dissolving into a Beyond—the feeling that Malevich's *Black Square on White*, and, even more, his *Belyi kvadrat* (White Square), evoke, and that made his philosophy appealing to the Symbolists (and to Malevich).

Second, Schopenhauer proposed that the dynamics of music convey the striving that is the very core of reality—the struggle that ultimately culminates in peace and surcease of striving. Music helps lift the mind out of its involvements with the illusory realm and draws its attention to what is ultimately real. For Symbolists, too, believed that the music of poetry, more than its discursive content (if, indeed, it has any), can elevate consciousness to a point from which it can recognize higher orders of being.

Third and finally, Schopenhauer's philosophy seemed *prima facie* to agree with the hermetic tradition (which agreement many Symbolists adopted as their criterion of profound insight), which added to its appeal for Russian artists and thinkers of this era. Consider this passage from Ouspensky's *Tertium Organum*, and note its likeness to the Schopenhauerian passage from Malevich's writing (which we remarked on earlier).

> For an artist the phenomenal world is merely material—just as colours are for the painter and sounds for the musician; it is only a means for the understanding, and the expression of his understanding, of the noumenal world. At our present stage of development we possess no other means for the perception of the world of causes, which is as powerful as the one contained in art…"Occultism"—the hidden side of life—should be studied in art. An artist must be a clairvoyant, he must see that which others do not see.[58]

Schopenhauer held that space, time, and causality are only categories that the mind imposes on experience; reality itself is beyond space, time, and causality. He suggested that dreams, which arise within the brain without any external stimuli, adumbrate something of the nature of this higher reality. His implied belief in a reality beyond space, time, and causality appealed to the writer Maxim Gorky, among others.

SYMBOLISM AND ITS DESCENDANTS
CUBO-FUTURISM

Suprematism was only one of the pre-Revolution artistic movements in Russia that drew its inspiration from heterodox spiritual movements. Another was Cubo-Futurism, which was actually only one of several Futurist movements in Russia between the 1905 and 1917 Revolutions. The others were Ego-Futurism, Hylaea, and the moderate Futurism of the Centrifuge Group. The Cubo-Futurist group took form in the years 1911 to 1913. Its founding members included the Burliuk brothers (David, Vladimir, and Nikolai), the movement's two principal theorists, poets Velimir Khlebnikov and Alexei Kruchenykh, and Kazimir Malevich, Mikhail Larionov, and Natalia Goncharova. Some of these artists allied themselves with the group only for a short time: Larianov and Goncharova broke with David Burliuk, the guiding spirit of the group, in 1912. The most celebrated of the group's members, ultimately, was Vladimir Mayakovsky, whom David Burliuk had discovered in 1911, when Mayakovsky was still an art student. Other artists who participated in Cubo-Futurist events were Alexandra Exter, Benedikt Livshits, Vasily Kamensky, and Vladimir Tatlin.

Inspired by Theosophical and Gurdjievian ideas about the future development of humankind, the Cubo-Futurists believed that their art had a vital role to play in shaping the new body that was yet to emerge, which would possess new sensory capabilities. Kruchenykh, for example, in various writings, postulated that the new art would effect a change in consciousness similar to that achieved through the practice of yoga (a discipline that experienced a vogue in Moscow and St. Petersburg in the first decades of the twentieth century and a practice about which Ouspensky had much to say). The future species of humanity would possess new organs of sight and make use of a new, universal language. These ideas were widespread: cinema was discussed as a medium that would provide humanity with a new vision and as a universal language of images that all would be able to comprehend. (Dziga Vertov's writings, of only a slightly later date, would celebrate the cinematic creation of "The New Man.")

Malevich, Kruchenykh, and Matyushin all believed that Cubo-Futurism would be an art directed at a transcendental reality. Kruchenykh's conception

of a transrational, *zaum* language was rooted in mystical ideas.[59] And Matyushin interspersed quotations from Ouspensky's *Chetvertoe izmerenie: Opyt izsledovaniia oblasti neizmerimago* (The Fourth Dimension: A Study of an Unfathomable Realm) and *Tertium Organum* with his translations from Gleizes and Metzinger's *Du Cubisme* when he reviewed the book, to draw an analogy between the Cubist vision, the systems of higher dimensional geometry, and *zaum*.[60] Filonov was also among the first to create a poetry of neologism (which became a source of *zaum* poetry), and his neologisms served transcendental ends. In 1915 Mikhail Matyushin, who along with his disciples took an interest in occult questions, joined Filonov's World Flowering and published Filonov's *Propeven o prorosli mirovoi* (Chant of Universal Flowering, or alternatively, Sermon about Universal Flowering). That work consists of two long litanies on the horrors of war, which he understood as necessary for humanity's transcendence to a condition of harmony—indeed, Filonov proposed the notion of "re-evolution," the idea that decomposition, in art as in life, is necessary for new life to emerge as well as for growth. It is, essentially, a poetical drama about violence, that alludes to the Great War but also to the strife between Cain and Abel that shaped the course of history, Mediaeval Russian battles, and the revenge motive in pagan myth (which reflects the condition of humanity). But Chant of Universal Flowering does not simply refer to violence—it enacts the textual violence of linguistic rupture: a myriad of disruptive neologisms and jarring, dislocated images (e.g., "deathly lunacy," "reign of damp toads," "cunning silence," "alien darkness") and incorporates images of death, destruction, and putrefaction. Filonov's use of neologism reflected the belief he shared with Malevich, Kruchenykh, and Matyushin: that a new consciousness would evolve, associated with a new, universal language.

VITEBSK AND SYMBOLISM

Vitebsk is one of the oldest towns in Belarus. Today it is a moderate-sized industrial town as well as the home of pedagogical, medical, veterinary, technological, and other institutes. But Vitebsk was different at the beginning of the twentieth century. Then it was rustic. In the years preceding the Great War it was a small town of about 90,000 residents, roughly half of them Jewish, the rest mainly Russians, Poles, and Lithuanians. It had good rail connections to Petrograd, Moscow, and Brest, but despite these, its ambience was that of a village, with unpaved streets and wooden houses. Its almost bucolic character is depicted in the paintings of Marc Chagall, who hailed from the area.

Despite its rusticity, a wondrous phenomenon overtook the town in the years following the Bolshevik Revolution: for a brief time, it became the base of the avant-garde movement in Soviet art. Artists and intellectuals found the conditions in Moscow and Petrograd after the Great War and the February and

October Revolutions just too dire, and they fled in droves to the provinces. Vitebsk was opportunely situated, and its mineral springs had made it a spa town before the Revolution, favoured by many because it was closer than the vacation centres of the Crimea. The local government was sage enough to fund the activities of the refugee artists and intellectuals the town had attracted, so a flourishing cosmopolitan cultural life developed quickly. Shortly after the October Revolution it boasted a conservatory, five music schools, and a symphony orchestra that gave close to three hundred concerts in three years. It was also the home of several theatre companies, including an experimental theatre. So it came to have an important place in the history of twentieth-century art. Its impact on that history reveals the important influence that Symbolism continued to exert. Vitebsk, as we have noted, was the town where both *Victory Over the Sun* and Kogan's ballet were mounted.

Moreover, there was an artistic nucleus to build around. Before the arrival of the radical artists, an artistic circle had formed around a private art school headed by Yehuda Pen, Chagall's first teacher. It was no accident the first teachers at the newly established School of Art included, alongside Chagall himself, other disciples of Pen, or that nearly all of its students had attended his private school. But it was the young avant-garde artists, the champions of "left art," who launched the Vitebsk renaissance. The left artists celebrated the Bolshevik Revolution as a force that had blown away the established order, including the hoary arts that tradition had handed down. The Bolshevik Revolution had infused society with a revolutionary spirit; to further the revolution, left artists proposed to dedicate their art to stimulating a revolution in consciousness, which, they believed, would serve as a precondition for further social revolutions about to take place.[61] They advocated an art that arose from the new world of technology, an art that would directly address the people through its bright colours and its provocatively simple abstract forms, which were so in keeping with the industrial world that workers knew well.

There was another side to the Vitebsk renaissance, however. It was, in fact, Marc Chagall who introduced the new order into the area, when he returned to his hometown in 1918. After negotiating with the progressive Commissar of Enlightenment in the early Soviet government, he was appointed Commissar of Art for Vitebsk. Chagall did not share with left artists their enthusiasm for technology, nor was he a revolutionary; but he did share with them the wish to integrate art with life, to take art out into the streets and use it to transform the world. To further the people's awareness of the arts, he founded a local art museum dedicated to his work and that of left artists. In January 1919 he established the Vitebskoe Narodnoe Khudozhestvennoe Uchilishche (Vitebsk Popular Art Institute), recruiting artists such as Malevich, Ivan Puni, El Lissitzky, V. Ermalaeva, and K. Boguslavskaya. The academy's mission, as Chagall conceived it, was to give the town's children an opportunity to turn from the most

readily accessible path, the path of routine, toward the path of quest—that is what the redemptive powers of art might achieve. He solicited the townspeople's cooperation with this project, encouraging them to allow students to paint the walls and roofs of the houses. The graphics they produced ranged from Chagall-like images of flying Hassid to the more geometric forms of the avant-garde. Eisenstein, who passed through Vitebsk on a troop train in 1920, later commented on the dreary provincial town, caked in soot, but with the main streets' brick facades covered with whitewash on which were painted green circles, orange squares, and blue rectangles.[62]

Like many schools, Chagall's was the site of internal struggles, mainly between Chagall and Malevich, who tended to be more progressive, both politically and artistically. In late 1919, ten or eleven months after opening the school, Chagall left Vitebsk and returned to Moscow. Malevich stayed behind, and in early 1920 he founded UNOVIS (Utverditeli Novogo Iskusstva; Affirmers of the New Art) with the goal of inculcating the values of Suprematist art among his students. Malevich's Suprematism extended the goals of Symbolism from which Chagall's art descended (that they saw eye to eye on certain matters is the reason why Chagall invited Malevich to the Vitebsk academy in the first place). Malevich and the artists who shared his beliefs helped keep some version of the Symbolist ideal alive in the Soviet Union of the post-Revolution years. Furthermore, the presence in Vitebsk of such thinkers as Mikhail Bakhtin, who preferred Symbolism to left art, gave Symbolist ideals an enduring presence there and throughout the Soviet Union. UNOVIS affirmed that the abstract forms of pre-Revolution Suprematism, stripped down to colour planes interacting with one another and floating over a pure white ground, ought to take its rightful place as the correlative of the new and progressive social order. The final form of society would soon make its appearance, and it should be matched by a final form of art—Malevich's Suprematism. Like Richter and Eggeling's *Universelle Sprache*, this language would be universal in its impact on viewers and in its application to visual media—painting, sculpture, posters, books, everyday objects, and building.

SYMBOLISM AND ITS DESCENDANTS
FEKS

Another antecedent group in Soviet Russia that contributed to the vanguard ethos was FEKS (Fabrika Eccentricheskovo Aktyora; Factory of the Eccentric Actor). FEKS was organized by a group of Jewish artists from the provinces, especially by Sergei Yutkevich and two artists who referred to themselves as "engineers of the spectacle," Grigori Kozintsev and Leonid Trauberg. The extroverted acting style that FEKS developed pushed away feelings in a kind of pre-Brechtian *Verfremdungstechnik* (alienation device).

The FEKSy (members of FEKS) exemplified the tendency to introduce lowbrow Western culture into the new Soviet art. They wanted to make their art jazzy and to have it move at a fast clip. The FEKSy were inheritors of the shock tactics that Meyerhold had developed before the First World War; their theatre, like Meyerhold's, was broad and demonstrative, incorporating clowns and acrobats as well as elements from Radlov's People's Comedy Theatre. The FEKSy revered America as the home of Edison (both for his work with electricity and as an inventor of moving pictures), as a place where strident sounds and advertisements abounded, as the producer of lowbrow culture, including jazz, film thrillers, and pulp detective novels (known at the time as "Pinkertons"). One of their efforts to cultivate eccentricity provoked a minor scandal: their production of Nikolai Gogol's *Zhenitba* (The Marriage, 1848) introduced elements drawn from the circus, vaudeville, and the music hall; the principal characters in the play were Albert Einstein, Charlie Chaplin, and three suitors. Besides these three formal roles, there were suitors on roller skates and robots who were supposedly running on steam, electricity, and radioactivity. (FEKS had strong ties to Futurism, as the interest in electricity and radioactivity would suggest.) One character remarked, "Marriage today is ridiculous. The husband away, the wife suffers. Radium, a new force, works at a distance. A radioactive marriage is truly modern."

The play's action was a frantic collage of cacophonous sound, a cascade of acrobatic tricks and satirical couplets. It folded together tap dancing, foxtrot music, flickering lights, and frantic action. Figures in garish clothing engaged in shouted repartee about topical issues; they sang their lines in couplets; and they performed acrobatic feats and pantomime dances (as well as dances of the more ordinary sort). An affianced pair from the Gogol novel appeared in conventional theatrical guises, but the sets for the production were far from conventional: they were constructions on wheels that rolled about so that the backgrounds could be changed rapidly. The spectacle included projected images, such as a clip of Charlie Chaplin fleeing from the cops—and when that clip appeared, actors who were dressed and made up in the same way as those on the screen ran to the front of the stage and performed actions similar to those of the actors onscreen. A circus clown, shrieking ecstatically, somersaulted through the canvas backdrop, while the character Gogol bounced around on a sprung floor that propelled him to the ceiling. The public became outraged, and at the end Kozintsev came out and thanked the shouting patrons "for a scandalous reception of our scandalous work."

This sort of work obviously relates to cinema—no one explains the affinity better than Eisenstein does in "Through Theatre to Cinema." So the FEKSy, especially Grigori Kozintsev and Leonid Trauberg, pursued careers in what then was the infant art of cinema. They sought to create a distinctively modern idiom in cinema by injecting it with their ideas about acting. One of their

MODERNISM AND REVOLUTION

films, *Novyi Vavilon* (The New Babylon, 1929) represents a culmination of the experimental workshop.[63] The setting of *The New Babylon* is the 1871 Paris Commune (the title reflects both the sobriquet of 1870s Paris and the clamorous social and ethical pluralism of the Soviet Union of the mid-1920s). The film centres on a posh department store modelled after the one in Émile Zola's satire on consumerism, *Au bonheur des dames* (The Ladies' Paradise), which itself had satirized the widespread enthusiasm for the Paris emporium Le Bon Marché (an enthusiasm that in Zola's novel stood for rampant consumerism). The photography was inspired by the Impressionists (the film includes some magnificent scenes shot in fog, shadow, and moonlight), while the choreography of the shots approaches that of ballet. Dimitri Shostakovich (1906–1975) composed the score, which avoided imitating on-screen action and instead sought to jolt the viewer with its strange juxtapositions (in keeping with cinema's montage principle). For example, for a scene at the end the work, when the Communards are executed by a firing squad, Shostakovich created a distorted version of the cancan from Offenbach's *Orpheus in the Underworld*.

Because of an unresolvable conflict with the authorities in 1929, *The New Babylon* was banned. The film represented freethinking in the Stalinist era, and its banning has come to be seen as the inaugural event in the transition from NEP pluralism to Stalin's imposed "revolution from above." After this, FEKS and its stage and screen work were effectively erased from official Soviet history. Only afficionados in the West, along with a Soviet-era underground, maintained the legacy that allowed scholars subsequently to piece together what this turbulent group was about.

NOTES

1 *Mir Iskusstva* had its origin in a group of former schoolmates in St. Petersburg, who gathered frequently to discuss artistic issues. The painter Aleksandr Benois and the thinker Dmitri Filosofov presided over the group in its first months; the artists Lev Bakst and Nikolai Rerikh, along with Filosofov's cousin Sergei Diaghilev, joined soon after.

2 Kulbin and Unkovskaia were especially interested in the question of how cosmic harmony is reflected in art, in nature, and in life. On this, see John E. Bowlt, "Esoteric Culture and Russian Society," in M. Tuchman, ed., *The Spiritual in Art: Abstract Painting 1890–1985* (Los Angeles and New York: Los Angeles County Museum of Art and Abbeville Press), p. 173.

3 This information is contained in Bowlt, "Esoteric Culture and Russian Society." Bowlt's article suggests that the influence on their artmaking of the esoteric enthusiasms that many Russian artists of the first decades of the twentieth century exhibited was more limited than I believe it to have been.

4 Ibid., p. 171.

5 Ouspensky's ideas on cosmic consciousness were close to those of the Canadian psychiatrist Richard Bucke, whose *Cosmic Consciousness* was much read in Russia during this period. Ideas similar to Bucke's, propounded by William James, were also popular in Russia at this time and exerted an influence on the neovitalist circles there.

James' *Principles of Psychology* appeared in St. Petersburg in 1905, in a Russian translation titled *Psikholgiia*; a version of *Varieties of Religious Experience* (a text even more relevant to our themes) appeared in Moscow in 1909, titled *Mnogoobrazie religioznago opyta*, translated by V.G. Malakhieva-Mirovich and edited by S.V. Lurie. Regarding Henri Bergson: *Creative Evolution* appeared in Moscow in 1909 as *Tvorcheskaia evoliutsiia*, translated by M. Bulgakov; *Time and Free Will* and *An Introduction to Metaphysics* appeared in Moscow in 1911 as *Vremia i svoboda voli, s prilozheniem stati "Vvedenie k metafizike"*; and *Matter and Memory* appeared in St. Petersburg in 1911 as *Materiia i pamiat*, translated by A. Bauler.

Bergson's thought also contributed to this cluster of ideas. Bergson had a deep influence on Kazimir Malevich. Malevich was interested in dynamism, a dynamism not of the human body or of objects, but a dynamism independent of objects, one that the eye cannot catch but that can be sensed. He strived for a sensation of speed detached from corporeality. Only painting can convey this, Malevich argued, for, like Bergson, Malevich believed that film creates a conceptual motion (i.e., not an actual motion, but existing only in the mind) that does not correspond to anything in reality. While the Soviet avant-garde filmmakers strived to create an artificial synthesis of motion, Malevich was interested in a phenomenon that could not be apprehended optically.

6 Vyacheslav Ivanov, *Po zvezdam: Opyty filosifskie, èsteticheskie i kriticheskie* (reprinted Letchworth: Bradda, 1971), p. 248, in Katerina Clark and Michael Holquist, *Mikhail Bakhtin* (Cambridge: Belknap Press of Harvard University Press, 1984), p. 24.

7 Malevich's art from this period includes many images of women, for in typical Symbolist fashion, he seems to have believed that women are more evolved spiritually than men. Solovyov's writings on Sophia, and his poetry, embodied a similar attitude, as did Blok's poetry.

8 Scriabin's music epitomizes the products of such beliefs. More adventurous in theory were the ideas of the painter Nikolai Kulbin, who believed that cosmic music had different aural characteristics than the West's chromatic music: that it used dissonances and more finely resolved pitch differences than the semitone, which is the smallest interval between pitches in the scales that Western musicians have generally used. One might speculate that Kulbin's imagination was evolving toward the ethereal sounds to which electronic music apparatuses have opened our ears.

9 "Hence let us call the first kind of vision corporeal, because it is perceived through the body and presented to the senses of the body. The second will be spiritual, for whatever is not a body, and yet is something, is rightly called spirit; and certainly the image of an absent body, through it resembles a body, is not itself a body any more than is the act of vision by which it is perceived. The third kind will be intellectual, from the word 'intellect.' *Mentale* (mental) from *mens* (mind), because it is just a newly-coined word, is too ridiculous for us to employ." From St. Augustine, *The Literal Meaning of Genesis*, vol. 2, bk. 12, chap. 7 (New York: Newman, 1982), pp. 186–87.

10 For the Augustine, *The Literal Meaning of Genesis*, bk. 12:1–12; for the Bernard, *v. Cantica* 20:8.

11 In Bowlt, ed., "Nonobjective Art: Kazimir Malevich, from Cubism and Futurism to Suprematism: The New Painterly Realism, 1915," in *Russian Art of the Avant-Garde: Theory and Criticism, 1902–1934* (New York: Viking, 1976), pp. 118–19, 133–34.

12 Malevich, 1927 Bauhaus publication, *Die Gegenstandslose Welt* (The Non-Objective World), translated into German by A. von Riesen, published by Albert Langen, Munich, as Volume XI of Bauhaus books, in Robert L. Herbert, *Modern Artists on Art: Ten Unabridged Essays* (Englewood Cliffs: Prentice-Hall, 1964), p. 119.

13 Blok's article, "Slova i kraski" (Words and Colours), was published in the first issue of *Zolotoe runo* (1906); this information, again, appears in Bowlt, "Esoteric Culture and Russian Society," p. 171.

14 D. Imgardt, "Zhivopis i revoliutsiia" (Painting and Revolution), *Zolotoe run*, 5 (1906): 59, in Bowlt, "Esoteric Culture and Russian Society," p. 171.

15 Bely's birth name was Boris Nikolaevich Bugaev. He took his *nom de plume*, which combined the name of Russia's first saint with the word for white—which for Russians symbolized the Apocalypse—to avoid embarrassing his father, a renowned mathematician who had contempt for avant-garde poetry.

16 Theosophy did not actually have an official seat in Russia until 1908 (in St. Petersburg), though it had been known in the country since 1880 (and had met with the strong opposition of the Russian Church). The Neo-Gnostic/Symbolist, Nikolai Berdyaev, the composer Aleksandr Scriabin, and the painter Wassily Kandinsky were all interested in Theosophical ideas. During the writing of *Petersburg*, Bely became interested in an offshoot of Theosophy known as Anthroposophy. After reading Mme Blavatsky's *The Secret Doctrine*, he spent the years 1910 to 1916 abroad, living for several years in Dornach, Switzerland (Anthroposophy's home) as Steiner's disciple. At that time the Goetheanum, an Anthroposophical temple, was under construction, and Bely worked at the site.

Steiner believed that through training, individuals could retrieve their innate capacity to perceive a spiritual realm, a subconscious cosmic memory. One exercise involved the concentrated recollection of life before one was born. The influence of this and other of Steiner's thoughts marked Bely's *Kotik Letayev* (1917–18), his autobiographical work on his childhood (which he started to write in Switzerland), as well as his *Zapiski chudaka* (1922) and *Glossolalia* (1922).

17 Though it did not result in slaughter on the Richelieu Steps (or the Potyomkinskaya Stairway or the Potemkin Steps, which film scholars, in conformity with the film's intertitles, usually refer to as the Odessa Steps), and though it ended less nobly than Eisenstein's film suggests. The battleship sailed to the port of Constanta, on neutral Rumanian territory, and surrendered.

18 Andrei Bely, *Vospominaniia ob Alexandre Blok* (Reminiscences of Aleksandr Blok) (Letchworth: Bradda, 1964), p. 170, in Bowlt, "Esoteric Culture and Russian Society," p. 173.

19 Solovyovian Apocalypticism combined with the Prometheanism of Fedorov's artistic followers, who were convinced they possessed the power to transform the world, to produce a transformative historical dynamic.

20 In Larissa A. Zhadova, *Malevich: Suprematism and Revolution in Russian Art, 1910–1930* (London: Thames and Hudson, 1978), p. 328.

21 Kasimir Malevich, *The Artist, Infinity, Suprematism: Unpublished Writings, 1913–33*, vol. IV, ed. T. Andersen, trans. X. Hoffmann (Copenhagen: Borgens Forlag, 1978), p. 12.

22 One of the strongest pieces of evidence in support of this claim is the fact that after the Bolshevik Revolution, Malevich offered the *Chernyj kvadrat na Belom* as an emblem for the emerging spirit.

23 Malevich, *Die Gegenstandslose Welt*. This selection appears in Herbert, *Modern Artists on Art*, p. 119. Honesty demands my acknowledging (since it weighs against my claims) that this passage was written twelve years after the painting was first exhibited.

24 Malevich's remark about intuitive form emerging from nothing can be found in his *Essays on Art 1915–33*, vol. I, ed. T. Andersen (Copenhagen: Borgens Forlag, 1968), p. 12.

25 P.D. Ouspensky, *Tertium Organum: The Third Canon of Thought a Key to the Enigmas of the World* (New York: Knopf, 1969), pp. 219, 232.

26 Meyer Shapiro, "On the Humanity of Abstract Painting," in *Mondrian: On the Humanity of Abstract Painting* (New York: Braziller, 1995), pp. 13–14.

27 "Dès ce moment, l'art s'est divisé en deux parts fondomentales: les uns sont devenus figuratifs (concrétistes), peintres de chevalet et réflecteurs du mode de vie sans avoir élucidé l'essence de l'art; les autres sont devenus non-figuratifs (abstractionnistes) après avoir élucidé l'essence de l'art et avoir renoncé au portrait et à refléter le mode de vie." Malevich, "Le peintre et le cinéma," *Ciné-Revue* 1 (Moscow: 1926); reprinted in *Le Miroir Suprématiste*, translated into French and annotated by Jean-Claude and Valentine Marcadé (Laussane: Editions l'Age d'Homme, 1977), p. 107. English translation mine.

28 "La nouvelle Réalité réelle ... la fusion du monde avec l'artiste" Malevich, "Forme, couleur et sensation," in *Architecture Contemporaine* 5 (Moscow: 1928), reprinted in *Le Miroir Suprématiste*, pp. 114 and 123 respectively. English translation mine.

29 Troels Andersen, the editor of the English-language translations of Malevich's earlier writings, argues that some of them derive directly from *Die Welt als Wille und Vorstellung*. V. Andersen, "Preface" to Malevich, *The World as Non-Objectivity: Unpublished Writings, 1922–1925*, vol. 3 (Copenhagen: Borgens Forlag, 1976), pp. 7–10. Andersen goes so far as to argue that the numbering of the paragraphs in Malevich's early autobiography corresponds to relevant sections from *Die Welt als Wille und Vorstellung*.

30 Ibid.

31 Khlebnikov adopted a way of living of formidable austerity, probably out of religious convictions.

32 Khlebnikov's conception of this substratum resembles Potebnia's idea of inner form, discussed below.

33 That the individual phonemes are individually significative seems an odd claim, but probably only because our understanding of the nature of language takes as utterly basic the idea of double articulation (i.e., that the most basic elements of language, the phonemes, are not significative in and of themselves, but only in combination).

34 Bowlt, "Esoteric Culture and Russian Society," p. 176. All the references to the original sources are included in his thoroughly researched article. The reference to energy of the ball, motor, airplane, and arrow appears in his 1930 essay, "An Attempt to Determine the Relation between Color and Form in Painting," in Malevich, *The World as Non-Objectivity*, vol. 3, p. 138. His reference to the energy of black and white appears, in the form cited, in his 1921 introduction to *Suprematizm: 34 risunka* (Suprematism: Thirty-Four Drawings), in K.S. Malevich, *Essays on Art*, ed. Troels Andersen, trans. Xenia Glowak-Prus and Arnold McMillin (Copenhagen: Borgen, 1968), Volume I (1915–28), p. 125. Andersen, *Malevich* 1:125.

35 Charlotte Douglas, "Birth of a 'Royal Infant': Malevich and *Victory Over the Sun*," *Art in America* 62 (1974): 46. The notice was signed by Kruchenykh as "chairman" and Malevich as "secretary" and was dated July 20, 1913. The notice also mentioned plans for staging plays by Khlebnikov and Mayakovsky.

36 Among the many reasons contemporaries have for being interested in this work is that in his preparatory sketches for this work, we can trace Malevich's transition from Cubo-Futurism and Alogist painting to Suprematism. This is evident, for example, in Nikolai Khardzhiev, a Soviet scholar who amassed a vast collection of paintings, drawings, and manuscripts by many of the key figures in Russian art and literature of the early twentieth century. Some of the sketches make use of the analyses of spatial form that marked Cubism; in others we can see absurd juxtapositions of forms characteristic of Alogism; other drawings use the floating geometric shapes characteristic of Suprematism. The drawings thus rehearse Malevich's evolution and anticipate the direction his future would take.

Even more, the work, and its connection with the Alogism that was one of the visual languages Malevich favoured at the time, makes clear the irrationalist basis of Suprematism's metaphysical proclivities. For Alogism was an antirational yet metaphysically inclined development that flourished in the early days of the Russian avant-garde (1910–15). It declared that the value of aesthetic experience transcended conventional logic and reason; furthermore, it linked conventional language with logic and representation, as would so many avant-garde groups that followed; accordingly, its methods were meant to debunk the use of traditional representational forms. The tendency's metaphysical aspirations are most evident in its hope to attain a "higher logic" and to transcend the limits of conventional understandings of reality, to explore other dimensions. The devices used to prise open these realms, if considered as discursive constructs, appear to be gnomic if not utterly nonsensical. They answer to a higher reason, however. In a letter to the artist-composer Matyushin, Malevich wrote: "We rejected reason because we conceived of something else, which, to compare it to what we have rejected, can be called 'beyond reason,' which also has law, construction, and sense" (in Linda Dalrymple Henderson, "The Merging of Time and Space: The 'Fourth Dimension' in Russia from Ouspensky to Malevich," *Soviet Union/Union Sovietique* 5, pt. 2 [1978]: 171–203 at 183).

Other Russian artists whose works showed Alogist proclivities were the poets of the Leningrad OBERIU (Association of Real Art)—in particular, Daniil Kharms, Aleksandr Vedensky, and Konstantin Vaginov. Their work of the late 1920s and early 1930s is the last manifestation of alogism in pre–Second World War Russia.

37 El Lissitzky grew up in Vitebsk. In 1919, after studying at the polytechnic in Riga and working in Kiev, he returned there at Chagall's invitation to teach at the Vitebskoe Narodnoi khudozhestvennoi uchilishche. In 1921 he left for Moscow, then Warsaw and Berlin. In 1923, for Kurt Schwitter's *Merz* 6 (October 1927), he and Vilmos Huszár collaboratively produced a photogram titled *4/i/Lampe* (Heliokonstruktion 125 Volt; to stress their unanimity they signed themselves as El Huszár and Vilmos Lissitzky). The same year, he prepared a portfolio based on *Podbeda nan solntsem, Sieg überdie Sonne.* The similarity of the themes is evident.

38 M. Matyushin, "Futurizm v peterburge," *Futuristy. Pervyi jhuranal russkikh futuristov* 1/2: 156, in Douglas, "Birth of a 'Royal Infant,'" p. 47, whence I have taken it.

39 In fact, in P.D. Ouspensky's philosophy, the appearance that time passes is simply a product of humans' perceptual faculties.

40 In Douglas, "Birth of a 'Royal Infant,'" p. 48.

41 In fact, Malevich's sketches show that for his characters he planned costumes based on geometric shapes. The Bully's costume is a short, triangular skirt; the pants of the Attentive worker's are composed entirely of tori. The costumes for the actual performance were all made of cardboard and wire, and the actors all wore masks.

42 The measure of a circle (the ratio of the circumference to the diameter) involves an "irrational" number. In the eclipse, a new measure that does not necessarily involve irrational numbers is ascendent (the celebration of new scales and measures is one of *Pobeda nad solntsem*'s themes). John Milner, in *Kazimir Malevich and the Art of Geometry* (New Haven: Yale University Press, 1996), does a splendid job of illuminating this aspect of Malevich's work.

43 Malevich's famous *Chernyi kvadrat* (Black Square on White) is the exemplar. It is interesting that though *Chernyi kvadrat* was first exhibited to the public at the 1915 *0–10* exhibition in St. Petersburg, Malevich referred to it as having originated in 1913, nearly three years earlier. Thus (in a passage we have already quoted from), he stated: "When, in the year 1913, in my desperate attempt to free art from the ballast of objectivity, I took

refuge in the square form and exhibited a picture which consisted of nothing more than a black square on a white field, the critics and, along with them, the public sighed, 'Everything which we loved is lost. We are in a desert ... Before us is nothing but a black square on a white background!' ... Even I was gripped by a kind of timidity bordering on fear when it came to leaving 'the world of will and idea,' in which I had lived and worked and in the reality of which I had believed. But a blissful sense of liberating nonobjectivity drew me forth into the 'desert,' where nothing is real except feeling ... and so feeling became the substance of my life. This was no 'empty square' which I had exhibited but rather the feeling of nonobjectivity ... Suprematism is the rediscovery of pure art that, in the course of time, had become obscured by the accumulation of 'things' ... The black square on the white field was the first form in which nonobjective feeling came to be expressed. The square = feeling, the white field = the void beyond this feeling. Yet the general public saw in the nonobjectivity of the representation the demise of art and failed to grasp the evident fact that feeling had here assumed external form. The Suprematist square and the forms proceeding out of it can be likened to the primitive marks (symbols) of aboriginal man which represented, in their combination, *not ornament, but a feeling of rhythm.* Suprematism did not bring into being a new world of feeling but, rather, an altogether new and direct form of representation of the world of feeling ... The new art of Suprematism, which has produced new forms and form relationships by giving external expression to pictorial feeling, will become a new architecture: it will transfer these forms from the surface of canvas to space ... Suprematism has opened up new possibilities to creative art, since *by virtue of the abandonment of so-called 'practical consideration,' a plastic feeling rendered on canvas can be carried over into space.* The artist (the painter) is no longer bound to the canvas (the picture plane) and can transfer his compositions from canvas to space." Herschel B. Chipp, *Theories of Modern Art: A Source Book by Artists and Critics* (Berkeley: University of California Press, 1968), pp. 341–46). Perhaps in telling us that in 1913 he took refuge in the square, Malevich was referring to his experience on *Pobeda nad solntsem.*

44 Benedikt Livshits, *Polutoraglazyi Strlets* (Leningrad, 1933), p. 187–88; in Douglas, "Birth of a 'Royal Infant,'" p. 49, whence I have taken it.

45 An account of Nina Kogan's ballet can be found in *Ounovis* 1, published and edited by Malevich, in Andrei Nakov, *Abstrait/Concret: Art Non-Objectif Russe et Polonais* (Paris: Transédition, 1981), p. 62. Eisenstein refers to *Precipice* in *Film Form: Essays in Film Theory*, trans. and ed. Jay Leyda (New York: Harcourt Brace Jovanovich, 1977), p. 14 and n139.

46 One thinks of Oskar Schlemmer's Bauhaus dances.

47 Kogan's ballet may have been the inspiration for the film script that Malevich composed in 1927.

48 A.E. Krutschonych, "Die ersten futuristischen Veranstaltungen der Welt" (1932), in exhibition catalogue: *Sieg über die Sonne, Aspekte russischer Kunst zu Beginn des 20. Jahrhunderts* (Berlin: Akademie der Künste, 1983), p. 51. Quoted in Maur, *The Sound of Painting*, pp. 80–81.

49 Lissitzky, from the preface to the portfolio of *Pobeda nad solntsem, Opera* (Victory over the Sun: An Opera) (Hannover, 1923), in Maur, *The Sound of Painting*, p. 78.

50 Taylorism was based on the work of Frederick W. Taylor (1856–1915), who taught what in Russia, after 1903, came to be called "nauchnaya organizatsiya truda," the scientific organization of work.

Regarding Vegetarianism: David Burliuk, Velimir Khlebnikov, Mayakovsky, and Ivan Puni all gathered, beginning in 1905, at the Finnish home of the realist painter Ilya Repin and his companion Natalia Nordman, who was a strict vegetarian; after the meeting,

MODERNISM AND REVOLUTION

Nordman served vegetarian feasts—and encouraged barefoot dancing to phonograph records as well, presumably as a result of the vogue for Isadora Duncan (who made her first visit to Russia in 1905).

Regarding Taylorism: Taylor was a gifted eccentric who gave up an opportunity to attend Harvard University to became a labourer and later a foreman in Philadelphia's Midvale steelworks. He developed a subsequent career as a scientific management consultant; in that capacity he rationalized plant layouts and human labour, which he treated as a machine component. For better or for worse, he is the father of modern scientific management. His system attempts to maximize the efficient use of bodily moments in performing tasks; this "science" is based on time-and-movement measurements that specified when and how work should be done and that organizes the elementary operations necessarily to the execution of work. There is much more to Taylorism than is suggested by the common notion that it is a system for optimizing the efficiency of workers' movements (movements that have much to do with the idea of the artist as an engineer). Taylor derived his ideas about "scientific" management from the principles of production engineering. He was certain that if rational methods and systems replaced the informal organization of production, management would overcome low morale from which workers in many plants suffered. His fundamental emphasis was on rational modelling, on finding the ideal organizational form for any business or activity.

Among the most important spiritual convictions that pervaded pre-Revolution Russia were that the soul (the "animus") is the vital force responsible for giving the body life and movement—it is the body's *energeia*, its dynamic, actualizing principle. (This is just a variant of Kandinsky's famous principle that form is the outer expression of inner meaning.) Movement is life, spirit, and thus cinema's kinetic properties ally it to human being's pneumatic dimension. The writer and dramatist Leonid Andreyev (1871–1919) realized this clearly when, in 1911, in his "Pis'mo o teatre" (First Letter on Theatre), he proclaimed theatre's impending obsolescence and cinema's rise to ascendency.

51 This understanding of the purpose of theatre, film, and art was the basis of Eisenstein's first theory of film: the montage of attractions (montaž attrakcionov). Suprematist art, too, was to have physical effects. But what exactly would it convey?

52 From a poem by Malevich, originally published in Malevich, *The Artist, Infinity, Suprematism,* p. 9, in Roger Lipsey, *An Art of Our Own: The Spiritual in Twentieth Century Art* (Boston: Shambhala, 1988), p. 140.

53 Ibid., p. 35 in Malevich, p. 140 in Lipsey. Of course, it is easy enough to find the source of this idea about vibration: a similar remark appears in the writings of Annie Besant. Here is how Besant describes the reciprocal influence of the "inner oscillations" of the thinkers and the cosmic vibrations at the arupa level: "These vibrations, which shape the matter of the plane into thought-forms, give rise also—from their swiftness and subtlety—to the most exquisite and constantly changing colours, waves of varying shades like the rainbow hues in mother-of-pearl, etherealised and brightened to an indescribable extent, sweeping over and through every form, so that each presents a harmony of rippling, living, luminous, delicate colours, including many not even known to earth. Words can give no idea of the exquisite beauty and radiance shown in combinations of this subtle matter, instinct with life and motion. Every seer who has witnessed it, Hindu, Buddhist, Christian, speaks in rapturous terms of its glorious beauty ..." Annie Besant, *The Ancient Wisdom: An Outline of Theosophical Teachings* (London: Theosophical Publishing Society, 1899), p. 146.

54 Malevich, *The Artist, Infinity, Suprematism,* in Lipsey, *An Art of Our Own,* p. 144.

55 From Malevich's *God Is Not Cast Down* (1922), in Lipsey, *An Art of Our Own,* p. 145.

56 Malevich, 1927 Bauhaus publication, in Herbert, *Modern Artists on Art*, pp. 94–95, also in Lipsey, *An Art of Our Own*, pp. 140–41.

57 Arthur Schopenhauer, *Die Welt als Wille und Vorstellung*. (Zurich: Haffmans Verlag, 1988).

58 Ouspensky, *Tertium Organum*, p. 145.

59 Khlebnikov's conception of *zaum* somewhat less, for his was a more rational conception.

60 Ouspensky's *Tertium Organum* had as one goal to incorporate recent mathematical findings about four-dimensional geometry (and recent speculation about those findings) into the Theosophical system. The book is a lively text on humans' place in the greater universe and in the grand framework of space and time. The view that time is another dimension of space led him to conclude that the future can influence the past. A similar view of time led the writer Velimir Khlebnikov to conceive of the possibility of time travel. Thus, in 1915, he wrote the poem "Ka" (published in 1916) about time travel.

61 One can gather from this why Trotsky was a proponent of "left art" and why the Trotskyites have given us some of the best critical writings on progressive art.

62 V. Eisenstein, "Notes on Mayakovsky," *Iskusstvo kino* 1 (1958), first published in English (translator referred to only as M.M.) in *Anglo-Soviet Journal* 19, no. 2 (1958): 12.

63 FEKS made seven films: *Pokhozdeniya Oktyabrini* (The Adventures of Octiabrina, 1924), *Mishki Protiv Yudenicha* (Michka Versus Udenich, 1925), *Chyortovo Koleso* (The Devil's Wheel, 1926), *Shinel* (The Cloak, 1926), *Bratishka* (Little Brother, 1927), *Soyouz Velikovo Dela* (S.V.D., The Society for the Great Cause, 1928), and *Novyj Vavilon* (New Babylon, 1929). The character of the first two films gives an indication of the flavour of the group: the now lost debut film, *The Adventures of Octiabrina*, featured a surreal sequence in which aviators who hadn't joined ODVF (Voluntary Share Association for Assisting the Development of Aviation) were thrown out of an airplane (perhaps this is a satire on the fairly well-known 1923 Rodchenko Dobrolet poster). A camel fails to help these unfortunates because they don't eat cakes baked by the state monopoly; a tractor regards them as enemies because they're opposed to the "alliance" between city and village; and so on. Similarly, the finale of *The Devil's Wheel* includes an exhortation to turn the guns of the cruiser *Aurora* once more against Leningrad—this time in order to demolish its slum tenements (which the Soviet government had done nothing about during nine years in office). Thereafter, FEKS's films changed somewhat, toward a dissident formalism.

CONSTRUCTIVISM
BETWEEN PRODUCTIVISM AND SUPREMATISM

SYMBOLISM AND ITS DESCENDANTS CONSTRUCTIVISM

The Constructivist movement emerged around 1913 in the work of Vladimir Yevgrafovich Tatlin (1885–1953). Tatlin took as his starting point the three-dimensional Cubist constructions of Picasso and Braque. In 1915 he exhibited a collection of painterly reliefs and corner reliefs. In these works he abandoned the artist's traditional tools and techniques (brushes, oil paint, canvas, etc.) and adopted industrial materials such as metal and plastic. Constructivist objects occupied "real" space; thus, Constructivists' painterly reliefs used the flat wall as a background, while corner reliefs used the intersection of two walls as a background.

Constructivism was more than simply an artistic style. As Naum Gabo suggests, it was a general conception of the world. It depended on ideas about the nature of art, the relation between art and society, and the artist's place in society. Readers will know these facts about Constructivism: it was an avant-garde movement of the Soviet Union of the early 1920s; its art was allied with the Bolshevik Revolution and addressed the masses; it was devoted to integrating art and life, and to this end it eschewed traditional artistic forms and artistic media and instead worked with the materials and methods of its time (i.e., with industrial materials and industrial methods of production). The idea that a work of art is a constructed object was central to the Constructivist view of

art, and Constructivist artists stressed the constructed character of their work. They worked with industrial materials and industrial methods of production, and as a consequence their art empahsized structure and geometrical form. Moreover, the industrial world is a dynamic world, a world in which change and movement are much in evidence; so Constructivist artworks often incorporated kinetic elements or otherwise emphasized dynamism. Constructivists viewed the artist as a worker, like any other worker in industrial society; thus, the duty of an artist was similar to the duty of every other member of society: to take raw materials and reshape them into objects possessing use-value.

On November 7, 1922, in honour of the five-year anniversary of the Soviet Republic, Arseny Avraamov's (1886–1944) *Simfoniya gudkov* (Symphony of Factory Sirens) was performed in the port of Baku. The orchestra consisted of factory sirens, cannons, hydro-airplanes, machine guns, artillery equipment, automobile and autobus horns, locomotives, and the foghorns of the entire Caspian flotilla. All were coordinated by a team of conductors using coloured flags and pistols. A "steam-whistle machine" sounded "The Internationale" and "La Marseillaise," and noisy "autotransports" zipped across Baku to arrive at the festival square for a gigantic finale. (How fitted to cinema these aspirations were!) Aleksandr Mosolov (1900–1973) produced an orchestral sketch, *Zavod* (The Iron Foundry), as a movement for a ballet, *Stal* (Steel, 1927). The sketch was a brutalist piece that used cross-rhythms and layered beats to imitate the actions of a factory. Nikolai Roslavetz (1881–1944), who collaborated with Vladimir Mayakovsky and the Knave of Diamonds society, developed a new system of tone organization, which he called the *Novaya Sistema Organizatzii Zvuka* (New System of Organization of Sounds), to generate dense textures from synthetic chords as the basis for a new system of harmony; accordingly he became known as the Russian Schoenberg. In 1924 he composed two song cycles. *Poeziya Rabochih Professii* (Poems of the Workers) consisted of "Song of the Female Cleaner" and "Song of the Engineers"; *Pezni Revolutzii* (Revolutionary Songs) included "The Blacksmith," "Revolt," and "To the First of May," all for singer and piano. In 1925 he composed "The Tobacco Plant"; parts of another song cycle; *Pesni 1905 Goda* (Songs of the Year 1905), including "The Last Miracle," "The Rounds of Fire Have Been Silenced," and "Mother and Son," all for singer and piano; and added "The Weavers" and "The Sewing-Woman" to *Poems of the Workers*.

The Constructivists called for a new art—one that would be materialist and antispiritual. Rodchenko and other members of the Working Group of Constructivists declared: "The task of the Constructivist Group is the communistic expression of materialist constructive work ... The cognition of the experimental trials of the Soviets has led the group to transplant experimental activities from the abstract (transcendental) to the real ... Down with art. Long live technic. Religion is a lie. Art is a lie ... Long live the Constructivist technician."[1]

Their interest in science led Constructivist artists to make space and time key issues in their art (as it had been in the art of the Russian Futurists). Both the Futurists and the Cubists tried to find the means to compel spatial constructions to suggest the passage of time. The Futurists patterned their methods after Marey's chronophotography, while the Cubists tried to induce a sense of the fourth dimension through simultaneity, by superimposing views of objects from different vantage points. Neither strategy was wholly successful; it soon became evident that only actual movement could combine time and space. This recognition helped make film an exemplary art for the Constructivists (as it had been for the Futurists and for the Cubists). Film is a visual (spatial) art that incorporates real movement, or so it seemed to them.

The Constructivists stressed the notion of *faktura*, which is a difficult term to translate. It refers to the general texture of the artwork, especially the texture produced by the brushstrokes. Constructivists, though, used the term to stress the application of rational, constructive methods in creative processes, in contrast to the irrational and spiritual processes generally used in art making. The Constructivists understood the artist not as an inspired genius but as an engineer, one who organized material elements and from them fashioned new forms with use-value. Constructivist artists substituted impersonal materials and engineering techniques for the personal touch of the artist's *faktura* (whose presence encouraged viewers to consider the artwork as embodying the artist's self and as expressing his or her peculiar way of being). Thus the Constructivists used the term *faktura* to stress that principles of construction had replaced those of soulful "composition."

Production was central, and this led the Constructivists to skepticism about enthusiasm for things spiritual.[2] Thus in 1924 the members of LEF (Left Front of the Arts) published an antimystical statement to distinguish their ambitions from those which drove Kandinsky, Malevich, and Mayakovsky. Osip Brik reinforced the antimystical tone of the Constructivists, remarking sarcastically that there were artists "who do not paint pictures and do not work in production—they 'creatively apprehend' the 'eternal laws' of colour and form. For them the real world of things does not exist ... From the heights of their mystical insights they contemptuously gaze upon anyone who profanes the 'holy dogmas' of art through work in production, or any other sphere of material culture."[3] Such tendencies must be rejected, the Constructivists averred.

The emergence of the Constructivist ideal around 1915 coincided with the development of structural linguistics in the Moscow Linguistic Circle (founded in 1915) and the Opoyaz Group in St. Petersburg (founded in 1916). The two groups had somewhat similar aspirations. The Constructivists strived to develop a systematic understanding of the perceptual and social effects of syntagmatic relations in painting, sculpture, and the arts generally. They wished, that is, to formulate as precise and analytic an understanding of how visual

relations are constructed as structural linguistics had of the variety of functions of the different levels of language. Thus, an exhibition of Rodchenko's work in 1921 consisted of a series of hanging constructions made from wood painted silver, all fashioned from simple shapes—an ellipse, a square, a circle, a triangle, a hexagon—and utterly impersonal. All of Rodchenko's works had the same method of construction: he had cut concentric geometrical shapes from a single plane of plywood and placed several of these within one another. Since they were suspended by wires, these shapes rotated, creating a variety of three-dimensional relations between two-dimensional planes. Rodchenko's goal was to understand the nature of these elemental forms and their possible relations.

The Constructivists emerged as an actual working group on March 18, 1921, as an offshoot of the agitational-propagandist group OBMOKhU (Obshchestvo molodykh khudozhnikov; Society of Young Artists). The group took the name Pervaia Rabochaia Grupa Konstruktivistov (The First Working Group of Constructivists); its members included Aleksei Gan (author of the group's program) and Aleksandr Rodchenko and Varvara Stepanova (the founders), along with Georgy and Vladimir Stenberg, Konstantin Medunetsky, Grigori Miller, Aleksandra Miralyuova, L. Sanina, G. Smirrov, Galina and Olga Chichagova, and Karl Ioganson.[4] In 1922, Gan, Rodchenko, and Stepanova issued the "Pervaya programma rabočey gruppy konstruktivistov" (Program of the First Working Group of Producing Constructivists) on behalf of OBMOKhU,[5] which as a group was committed to creating real objects with a genuine purpose. They restricted their artistic explorations to "laboratory work" and were especially committed to transferring the results of their experiments in three-dimensional forms to the industrial sphere—to producing usable objects such as textiles and ceramics. They referred to their experiments as "intellectual production." The first exhibition of the group's "laboratory works" took place at an OBMOKhU exhibition that opened on May 22, 1921, in Moscow. It included sculptures fashioned from wooden rods, glass, wire, and metal into forms reminiscent of utilitarian open-worked structures (bridges and cranes, for example).

Three principles subtended their work: *tektonika* (the socially and politically appropriate use of industrial materials); *Konstruktsiya* (organizing this material for a given purpose); and *faktura* (the conscious handling and manipulation of this material). Rodchenko unfolded the implications of the productivist ideal to which Constructivism was committed:

> Thenceforth the picture ceased being a picture and became a painting or an object. The brush gave way to new instruments with which it was convenient and easy and more expedient to work the surface. The brush which had been so indispensable in painting which transmitted the object and its subtleties became an inadequate and imprecise instrument in the new non-objective painting and the press, the roller, the drawing pen, the compass replaced it.[6]

As the nature of the art object changed, from a finely crafted painting to an industrially produced object, the spectator's relation to the work also changed. Stepanova (1894–1958) wrote:

> Composition is the contemplative approach of the artist in his work. Technique and industry have confronted art with the problem of construction as an active process, and not contemplative reflection. The "sanctity" of a work as a single entity is destroyed. The museum, which was a treasury of this entity is now transformed into an archive.[7]

The art object, deprived of its transcendent aura, invites a different response: not so much contemplation as scrutiny and discernment.

To highlight the objecthood of the constructed work, artists strived to devise structures that had no homologues in reality. Rhythm served the purpose: the harmonic pattern of stresses has no apparent analogue in visual or auditory reality.[8] Thus there developed sound poetry, which emphasized the rhythmic energetics of verbal constructions and which often incorporated neologisms to liberate the poem from the routinized responses that conventional language causes. Mayakovsky's poetry, too, was rich in metrical innovations. In the realm of theory, Brik's "Ritm i sintaksis" (Rhythm and Syntax) proposed a "rhythmicosyntactic theory," arguing that a poem's rhythm forms an autonomous structure that can support its themes.[9] The films and film theories of Vertov and Eisenstein also stressed the importance of rhythm: Vertov's theory of intervals is, inter alia, a theory of the rhythmic organization of visual impulses, while Eisenstein's "Methods of Montage" takes rhythmic construction as central to a theory of film.[10]

The Constructivists' beliefs about the nature and role of art led inevitably to a celebration of machines. To create a contemporary art, an art appropriate to the age of the machine, one must dispense with outmoded materials (paints made from egg proteins and pulverized plant and soil matter, applied with animal hairs to dried-out plant fibres woven into a large rectangle and stretched on parts cut out of a tree trunk) and instead employ industrial materials; what is more, these works must be forged using industrial methods. This enthusiasm for industrial materials was overdetermined. It was the product partly of the strong democratic tendency toward integrating art with life. The belief that industry, the new technology of the time, pushed toward innovation also played an important role; so did the doubts young artists had as to whether traditional arts could maintain a level of innovation equal to that of industry. The conflicted status of traditional arts in a revolutionary society was yet another factor.

Film, an industrial art made with industrial materials and using industrial methods of production, seemed to offer artists a new way out of the impasse into which the traditional arts had led them. Film was a mass art and a

product of modern technology. Moreover, film was not burdened with a history that might retard change. Film did not offer simply a means to mirror machine forms (as paintings by Francis Picabia and Fernand Léger did); instead, it allowed artists to work with industrial materials and machinery. Its images were mechanical reproductions, not manually produced imitations; accordingly, it had the capacity to overcome traditional art's valorization of the "hand" of the painter.

Traditional art criticism often suggests that the feature separating the fine artist from the common run of humanity is a special talent, for which the artist's hand serves as a metonymic trope. This critical strain treats handwriting as the immediate, direct expression of the artist's unique character. The idea that art is valuable as a revelation of the uniqueness of individual personality stems from the Expressionist theory of art, a theory that was anathema to the Constructivists. For them, art making was a constructive undertaking, the product of which succeeded or failed on the basis, first, of how well it fulfilled its social function, and second, of how well adapted its internal relations were to the materials from which it was fashioned. They insisted that celebrating handwriting was essentially a relic of Renaissance individualism; thus, handwriting's elimination was a small but necessary step toward overcoming both personal style and social stratification.

There was also a geographic basis for the antipathy toward handwriting that Constructivist artists displayed. Painterly painting was associated with Mediterranean cultures, and Constructivism saw itself as a Russian/Soviet art movement, the product of a "provincial" culture. Another basis was historical: evidence of the hand was associated with handicrafts, and handicrafts had been eliminated by historical progress—that is, by the same forces that had brought about industrialization. As an artistic movement that was attempting to conform itself to the principles of Marx's philosophy, Constructivism set out to conform to what the scientific study of history had exposed: new means of production inevitably produce new artistic forms (i.e., new artistic forms appropriate to the new social organization that new means of production had created). They realized that the progressive artist participates in the progress of history instead of foolishly trying to arrest it. Machine art, art made using industrial materials and industrial methods of production, would be the art of the future. And film was the exemplar of machine art.

The Soviet art theorist who most deeply and completely realized the implications of the machine aesthetic was Nikolai Mikhailovich Tarabukin (1899–1956), who, though he disavowed any association with the Constructivist movement, nonetheless understood and explicated some of its central ideas. Tarabukin began his essay "Ot mol'berta k mashine" (From the Easel to the Machine) by asserting that from the time of the Impressionists to his own time, art had ventured onto a fateful course, one that would culminate in the degen-

eration of painting as the typical art form. The first step in this devolution was to reduce the role of subject matter, following the principle that "the concentration on painterly content in a canvas was in reverse proportion to the presence of a subject matter."[11] Modern painters (meaning painters since the time of Impressionism) had done away with representations of the literary story and with all literariness of subject matter; the still life, he averred, which is devoid of any literariness of subject matter, had "replaced the complex ideology of the Classicists and the alluring anecdote of the naturalists."[12] The same principle—that de-emphasizing subject matter results in emphasis being placed on the art object's internal, autonomous properties—applied in recent literary arts. Thus, poetry had been moving from "the word as meaning" toward "the word as sound"; beginning with Symbolism, and then with "Futurism, Acmeism and Imaginism ... an emphasis on the external structure of the poem" had replaced emphasis on mood and ideology.[13] Similarly, he asserted, "the theatre has abandoned attempts at realistic and psychological interpretations of real life and concentrates its experiments on the formal laws of the stage. Music, which has essentially never been completely enthralled by naturalism and the predominance of a subject matter (program), goes further in the exploration of the laws of rhythm and composition."[14]

Tarabukin recognized, however, that the formal tasks that artists assigned themselves were designed only partly to free the art object from subject matter. A materialist principle was involved, for the contemporary artist saw material elements as integral to artistic form—indeed, as the only incontestable basis for form. Subject matter, or any attendant ideological element, does not pertain to the material basis of any artist's medium; that is why, Tarabukin stated, the contemporary artist was dispensing with subject matter. The same logic motivated the elimination of all illusionistic elements, evident in artists' increased use of planar forms:

> Even during the flowering of Impressionism which was mainly an illusionistic trend, a reaction to it formed from within itself in the person of Cézanne, who gave more importance to colouring than to light illusions, which was the basic aim of Impressionism. With Cézanne, the painter already begins to concentrate his attention on the material and real structure of the canvas, i.e., on colour, texture, construction and on the material itself.[15]

Thus, for the problems of perspective, or the illusion of luminescent effects that were the stock in trade of Impressionist painters, the contemporary painter had traded the material problems of colour, line, and volume, which he or she resolved not illusionistically but with the planar structure of surfaces large and small.

Tarabukin went on to remark that the paths that other countries' artistic movements had blazed had been paralleled by routes that Russian artists,

completely independent of Western influences, had pursued. He then proposed a key notion concerning realism, which, he implied (albeit not unambiguously), was making Russian artistic trends distinctive:

> Contemporary aesthetic consciousness has transferred the idea of realism from the subject to the form of a work of art. Henceforth the motive of realistic strivings was not the copying of reality (as it had been for the naturalists) but, on the contrary, actuality in whatever respect ceased to be the stimulus for creative work. In the forms of his art the artist creates its actuality, and for him realism is the creation of a genuine object which is self-contained in form and content, an object which does not reproduce the objects of the real world, but which is constructed by the artist from beginning to end, outside any projected lines extending towards it from reality.[16]

This passage shows signs of strain: Tarabukin here seems not to be quite sure whether this is a modern European trend or a distinctively Russian trend. His argument earlier in the essay seems to compel him now to make the case that it is an international trend in European art. However, he wants to believe in the distinctiveness of Russian art—just before the passage quoted immediately above, he stated:

> Russian painting has gone through a whole series of stages which have been entirely original and, frequently, completely independent of Western European influences. Passing quickly from Cézanne to objective Cubism [there is evidence of the tension I alluded to], Russian painting split into a number of trends, united by a common direction. Amongst these, abstract Cubism, Suprematism and Constructivism should be mentioned. The basic stimulus for the creative aspirations of these trends was realism.[17]

Tarabukin's thesis is simple, but I think it identifies exactly what was distinctive about Soviet art of the period immediately following the Bolshevik Revolution: the notion of realism was displaced from the *subject* of a work of art to its *form*. Concomitantly, the notion of artistic material was identified with that of material *tout court*, and in the process aesthetic materialism was identified with philosophical materialism.

According to Tarabukin, this misunderstanding led Constructivists in the direction of formalism. This error arose because the Constructivists believed that they could import the concept of construction into the realm of aesthetic production without introducing any changes to it. Tarabukin recognized this error of the Constructivists:

> The painter could only adopt the general structure of the concept [of construction] from technology, and not by any means all its elements. The concept of construction in painting is composed of entirely different elements from the same concept in technology. By the general concept of construction, independent of

its form and purpose, we mean the whole complex of elements which are united into one whole by a certain kind of principle and which, in its unity, represents a system. Applying this general definition to painting, we should consider the elements of the painterly construction to be the material and real elements of the canvas, i.e., the pigments or other material, the surface texture, the structure of the colour, the technique for working the material, etc., united by the composition (the principle) and, as a whole, forming the work of art (the system).[18]

Still, making the concept of the construction central to aesthetics was the Constructivists' great achievement, Tarabukin proposed:

In their textured canvases the Russian Cubists, Suprematists, Objectivists and Constructivists whom I have already mentioned worked in the same elements which I have included as the constituents of painterly construction. Consequently, they worked, and worked a lot, on the constructive aspect of painting in the sense in which I have tried to clarify this concept. Their working on this professional and technical aspect of painting represents the great service which Russian artists have rendered to art. We can assert with confidence that in the statement and solution of many artistic problems we have, in our purely professional approach, outstripped Western European art both in theory and in practice.[19]

Nonetheless, it remained a formal enterprise, a museum art. That was not good for the new art demanded by the new social conditions in the Soviet Union:

The democratisation of the social structure and social relationships in Russia has fatally affected the forms of creativity and the masses appreciating art. In our eyes the psychology of aesthetic perception is radically changing its structure. In the period of class groups, the form of easel painting naturally permits endless variation, fragmentation and individualisation, responding to those varied requirements of a differentiated social milieu. In contrast, during a period of social democratisation, the mass viewer who demands from art forms which will express the idea of the mass, of society and the people as a whole, replaces the class consumer and patron of aesthetic values. Influenced by the requirements of this new mass consumer, art has adopted a democratic form.[20]

Film, we can well see, fit the requirements: it is a mass art and—at least in this era in the Soviet Union—all the members of society, not just an elite, appreciated it. Tarabukin's next claims go even further in highlighting the importance that film had to the emerging new art:

Contemporaneity makes completely new demands on the artist. It wants not museum "pictures" and "sculptures" from him but objects which are socially justified in form and purpose. The museums are sufficiently full not to require new variations on the old themes ... The new democratic art is social in essence, just

as individualistic art is anarchic and finds its justification among separate individuals or groups ... In a democratic art all form must be socially justified ...

But the death of painting, the death of easel painting as a form, does not yet mean the death of art in general ... At the very moment of the burial of its typical forms ... unusually wide horizons are opening out in front of visual art ... presenting art with new forms and a new content. These new forms are called "production skills."

In "production skill," "the content" is the utility and expediency of the object, its tectonism which conditions its form and construction, and which justifies its social purpose and function.[21]

Tarabukin proposed that Constructivists forsake the spiritual heritage that the Russian tradition had left them. They must make an art with (and of) the machine. Among the machines they could use was the film camera.

The Constructivist movement gave film a privileged place among the arts. The Constructivists were enthusiastic about industry, and film materials are industrially manufactured. Furthermore, films are made using industrial tools— cameras, editing tables, and projectors are just machines, which use gears and cogs and flywheels and pulleys just as other machines do. Films, moreover, use industrial methods, including working relations structured by the principle of the division of labour. Their enthusiasm for things industrial (among other factors) led the Constructivists to incorporate kinetic forms into their work. Cinema, too, is dynamic—by its nature, it is kinematic art. And because its photographic bias gives film a bias toward contemporary reality, cinema can effectively integrate art with life. Film, after all, draws its raw material (its shots) from reality and then processes that raw material (through editing) to create an object of use-value. Unless one succumbs to the lure of the bourgeois psychological story, films cannot be made any other way.[22] Thus cinema was an art that the Constructivists believed merited special attention, for it could serve as a model for recasting the other arts.

Another attribute of film made it a model art for Constructivists. Constructivists, we have noted, strived to ally their art with the Bolshevik Revolution; for them, this meant that their art must be consistent with Karl Marx's philosophy. But how did they understand Marx's philosophy? That question is too broad to be treated in any detail here, though Tarabukin's article gives us some clues regarding deficiencies in Constructivist interpretations of Marx. Marx's philosophy is often referred to as "dialectical materialism" (a term coined by Josef Dietzgen and used by Plekhanov to refer to the theory of history and consciousness that Marx and Engels expounded). It is a philosophy of change. For centuries, most philosophy aspired to know a reality beyond change. Marx's model as a philosopher, Hegel, asserted, to the contrary, that even ultimate reality undergoes change and that we learn of its nature by studying its history. However, Hegel described reality as spiritual, whereas En-

gels showed Marx that Hegel's theory could be turned on its head to reveal that history is an effect of material forces that involve human activity (the physical transformation of nature). The change that results is dialectical, that is, it proceeds by generating and resolving contradictions, but these contradictions are between objective states of affairs. Thus, Engels's theory of change offered a variety of materialism.

The dialectical dimension of dialectical materialism concerns the historical dynamic, so it celebrates movement and change (and that feature of dialectical materialism gave added impetus to the Constructivists' desire to make theirs a dynamic art). The theory of the dialectic expounded that there is a pattern to historical development. Change occurs through conflict: thesis generates antithesis, then contradiction between thesis and antithesis generates resolution at a higher level, where the common properties of the antithetic pair effect a new harmony between the pair, a harmony that does not negate the difference between the opposites. For example, the earliest societies practised communal ownership of land. However, with the development of class antagonisms, the communal form of ownership was annulled—"negatived" in Plekhanov's term—and the institution of private ownership developed. However, private ownership had its problems (it led to pauperization and the degrading system of fealty among those who did not own land), so now private ownership had to be negated. Private ownership, however, was the negation of the prior system of economic and social organization, so this negation was actually the negation of the negation. A negation of a negation marks real progress, for it does not simply cast away the old; it retains what is positive in the old, even while it continues the development at a higher plane. Thus, to leap forward to the era of late captalism, the socialist revolution, which would end the system of private property, would return the land to society (it negated private ownership), even while the higher evolution of the society in this era allowed public ownership to be more effective: what was good in the system of private ownership—certain administrative practices and technological innovations—was preserved, even while the institution itself was overturned.

NOTES

1 "Program of the Productivist Group" (1920), in S. Bann, ed., *The Tradition of Constructivism* (New York: Viking, 1974), pp. 18–20. This translation was first published in *Egyseg* (Vienna, 1922) and was reprinted in Naum Gabo, *Gabo: Constructions, Sculpture, Paintings, Drawings, and Engravings,* intro. H. Read and L. Martin (Cambridge, MA: Harvard University Press, 1957).

2 Here I emphasize the Productivist strain in Constructivism that was so ardently theorized by Boris Arvatov in *Iskusstvo i proizvodstvo. Sbornik statej* (Art and Production: A Collection of Articles) (Moscow, 1926). The book comprises four parts. The first of these examines the relations between capitalism and artisanal artistic production; the second

offers an historical commentary on easel painting; the third is an in-depth study of the relation between art and production in the workers' movement; and the fourth examines the possibilities for creating an art with the proletarian cultural system. Arvatov thus examines capitalist artistic production to formulate hypotheses about creating a new Productivist art fitted for the new socialist society.

3 In Bann, *The Tradition of Constructivism*, p. 84.

4 There is some question about the reasons why the group sometimes called itself "Pervaia Rabochaia Grupa Konstruktivistov" (The First Working Group of Constructivists) and sometimes just "Rabochaia Grupa Konstruktivistov" (The Working Group of Constructivists). Most commentary (and archival material) omits the "Pervaia"; the group's first public pronouncement used both terms. However, an early declaration of the group contained both titles: "Front khudozhestvennogo truda. Materialy k vserossiiskoi konferentsii levykh v iskusstve. Konstruktivisty. Pervaia programma rabochei gruppy konstruktivistov" (The Front of Artistic Work. Material for the All-Russia Conference of the Left in Art. The Constructivists: The First Program of The Working Group of Constructivists). That declaration was published in *Ermitazh* [Hermitage] 13 (August 1922); however, the introduction to it states that "on December 13, 1920, the First Working Group of Constructivists was formed." Christina Lodder, from whom this information is taken (*v.* "El Lissitzky and the Export of Constructivism," in Nancy Perloff and Brian Reed, eds., *Situating El Lissitzky: Vitebsk, Berlin, Moscow* [Los Angeles: Getty Research Institute, 2003], p. 44n2), speculates that the use of both names may have been to affirm the priority of the group founded by Gan, Rodchenko, and Stepanova after the Stenberg brothers and Medunetsky (in January 1922) split with other members of the group and began to exhibit their work independently. If this is true, then likely "pervaia" was attached to the group's name only retrospectively. (Portions of the *Ermitazh* document appear, in a translation by Lodder, in Charles Harrison and Paul Wood, eds., *Art in Theory 1900–1990* (Oxford: Blackwell, 1992), pp. 317–18.

5 *Ermitazh* 13 (1922): 1, reprinted, in a translation by Lodder, in Harrison and Wood, *Art in Theory*, pp. 317–18.

6 Alexander Rodchenko, exhibition pamphlet for the exhibition of the Leftist Federation in Moscow, 1917, in Benjamin H.D. Buchloh, "From Faktura to Factography," in Richard Bolton, ed., *The Contest of Meaning* (Cambridge, MA: MIT Press, 1989), p. 53.

7 Varvara Stepanova, in Camilla Gray, *The Russian Experiment in Art* (London: Thames and Hudson, 1971), pp. 250–51.

8 Of course, rhythmic structures might have homologues at subperceptual levels.

9 Originally published in *Novyi LEF* 3/6 (1927). Excerpts translated as "Contributions to the Study of Verse Language" in Ladislav Matejka and Krystyna Pomorska, eds., *Readings in Russian Poetics: Formalist and Structuralist Views*, intro. G.L. Bruns (Cambridge, MA: MIT Press, 1971).

10 "Methods of Montage" was not published in Russian in Eisenstein's lifetime. In fact, the article that Jay Leyda published under that title was written in London in November and December 1929 and was originally intended to be the second part of "Kino chetyrëkh izmerenii" (Four-Dimensional Cinema). Indeed, it originally appeared, in tranlation, as "The Fourth Dimension in the Kino: II" in *Close Up* (April 1930). Leyda retranslated it and published it under the title of "Methods of Montage" in Eisenstein, *Film Form: Essays in Film Theory*, trans. And ed. Jay Leyda (New York: Harcourt Brace, 1949), pp. 72–83. The two parts of what had originally been called "Kino chetyrëkh izmerenii" (Four Dimensional Cinema) appeared together in the Soviet Union in 1964, in *Izbrannye proizvedeniya* (Selected Works), as "Chetvërtoe izmerenie v kino" (The Fourth Dimension in Cinema).

11 An excerpt from Nikolaj Tarabukin, "Ot mol'berta k mashine" (From the Easel to the Machine), ed. and trans. Lodder, appears in Francis Frascina and Charles Harrison, eds., *Modern Art and Modernism: A Critical Anthology* (New York: Harper and Row, 1982), p. 135.

12 Ibid.

13 Ibid., 135.

14 Ibid. Parentheses in original.

15 Tarabukin, "Ot mol'berta k mashine" in ibid., p. 136.

16 Ibid.

17 Ibid.

18 Tarabukin, "Ot mol'berta k mashine" in ibid., p. 140.

19 Ibid.

20 Tarabukin, "Ot mol'berta k mashine" in ibid., p. 141.

21 Ibid., p. 142.

22 These are all features stressed in Dziga Vertov's Constructivist masterwork of 1929, *Chelovek S Kinoapparatom* (Man with a Movie Camera), which can be understood as theory of film created on film, as a film that inquires into the characteristics of the medium in which it is made, and into the social role that works in that medium can fulfill. But it is more—because it is a theory of film created on film, it is a self-reflexive work; and because it is self-reflexive, it can say, "This is a lie." Accordingly, it can get involved in paradoxes. Vertov explores these with enthusiasm.

EISENSTEIN, CONSTRUCTIVISM, AND THE DIALECTIC

That, then, is a capsule description of the theory of dialectical materialism—it describes, in a particularly rich fashion, the relations among technology, history, social formations, and ideology. The Constructivists treated dialectical materialism, a theory of history, as though it were mainly a prescription for aesthetic materialism—that is, for the view that the nature of an art medium determines which forms are appropriate to that medium. This was a major confusion—so, though we cannot treat the topic as fully as its importance deserves, we must consider how the Constructivists understood Marx's philosophy at some greater length. The Marxist theory of the dialectic was a key source of Constructivist artistic theory—at least, it was among the sources they admitted to (for, as we shall soon see, some sources for their art they did not admit). Recognizing the role that the idea of the dialectic played in Eisenstein's theories (and in his filmmaking) has enormous methodological importance.

Any critique of Constructivist cinema must confront the fact that any acquaintance with Eisenstein's films suggests that his artistic career fell into two sharply contrasting periods. The first was the period of the "mass dramas" of the 1920s, which are so specifically cinematic and which rely on a diachronic conception of montage (i.e., on the belief that the conflict between successive units provides a jolt—which Eisenstein initially referred to an "attraction"— to the viewer's mental faculties). The second was the period of grandiloquent

dramas that focused on an individual and that relied on a synchronic and polymorphic idea of montage. These films were dramas whose increasingly operatic character reflected Eisenstein's developing interest in the *Gesammtkunstwerk*. A homologous division appears in Eisenstein's theory: the theoretical works of the first period culminated, apparently, in the notion of intellectual montage; those of the second period encapsulated the ideas of vertical montage and monistic ensemble.

In 1975, David Bordwell provided what is still the most cogent explanation of the changes in Eisenstein's artistic style and of the profound changes of belief that produced them. In "Eisenstein's Epistemological Shift" he accepted the common view that Eisenstein's films underwent a marked change; he also presented an uncommonly well-defined criterion for discriminating between the two periods. Bordwell claimed that the earlier films and writings subscribed to a dialectical model resting on ideas drawn from reflexology whereas the later films and writings depended on an associationist psychology and replaced the idea of the dialectic with that of organic unity.[1] In his later book, *The Cinema of Eisenstein*, Bordwell repudiated the view he offered in that earlier article, insisting instead on the fundamental continuity of Eisenstein's oeuvre, both theoretical and practical. Yet the evidence of change in Eisenstein's film theory and in his filmmaking is just too striking to dismiss—which argues that Bordwell's earlier view was the more nearly correct.

An adequate understanding of Eisenstein's oeuvre must keep in view the difference between the early and later films, and the early and later theoretical writings, even while delineating the conceptual ligatures that bind together the different elements of his output as a whole. To trace the evolution of Eisenstein's thought and to identify the changes it underwent, we must identify the fundamental principles that drove his work, both theoretical and practical—for it is the evolution of those principles that accounts for the profound differences between *Stachka* (The Strike), *Bronenosets Potyomkin* (Battleship Potemkin) and *Oktyabr* (October) on the one hand and *Aleksandr Nevski* (Alexander Nevsky) and *Ivan Grozny* (Ivan the Terrible) on the other.

THE FACT
NATURE AND ITS TRANSFORMATION

A problematic question that Eisenstein's theory of cinema addressed, from its origin to its conclusion, was this: How can a graphic sign (or, in his later work, an iconic sound) that, owing to its resemblance to its referent, possesses a natural, direct, and immediate signification, be transformed into a sign that possesses conventional signification and thus be made open to the possibilities of narrative and drama? The importance of this question is such that it is still the fundamental problem of film semiotics. Yet among film semioticians, only the

Estonian Yuri Lotman made it central to his semiotic theory. Eisenstein did recognize the crucial importance of this question, and his efforts at answering it are still unrivalled. This makes him a theorist who deserves consideration as a contemporary aesthetician.

Eisenstein took an even greater interest than Lotman in the means for transforming an iconic sign into an aesthetic element. One view of the power of aesthetic signs considers that these aesthetic effects result from signs' *lack* of communicative function—that is, from their *not* stating something, as most signs do. This view holds that aesthetic signs have the power they do because they exert a force or a pressure on consciousness—they *do* something rather than *state* something. They are active. A depictive sign, a picture, T.E. Hulme contended, is a dead spot. Aesthetic signs, as Futurists, Cubists, Vorticists, and others pointed out, can be almost anything, but they must be dynamic. Eisenstein accepted this view.

The question of how something as static as an iconic sign (an element that is fixed by its referential value) can be transformed into an active element is the key question of Eisenstein's film theory. The centrality he accords to this question explains the impact that Fenollosa's classic (and wildly speculative) essay had on Eisenstein in the 1920s. Fenollosa's essay concerns the discharge of forces that occurs as discrete pictographic elements (which themselves are verbs, that is, according to Fenollosa, words that do something) are combined in the Chinese written character.[2] The question of how an iconic sign can be made active arose right at the beginning of Eisenstein's theorizing: it appears in his 1924 essay "The Montage of Film Attractions."[3] The essay's answer is the key to *agit*, to which the young Eisenstein lost no opportunity to reaffirm his commitment. At the time, he defined an "attraction" as something that exerts a measurable pressure on the consciousness of the spectator. It *does*, rather than shows, a point on which Aumond rightly insists when he observes how consistently the early Eisenstein polemicized against "representation."

What happened to this problematic question as Eisenstein's thought progressed? We can discover the answer in his 1932 essay "'Odolzhaites'!" (Help Yourself! or, A Course in Film Treatment).[4] There he enthusiastically described the montage lists that he drew up for Dreiser's *An American Tragedy* (perhaps his imagination was under the influence of James Joyce or Valery Larbaud, a French dandy and writer [1881–1957]):

Like thought itself they sometimes proceeded through visual images, with sound, synchronised or non-synchronised ... [Ellipsis in original]

sometimes like sounds, formless or formed as representational sound images ... [Ellipsis in original]

now suddenly in the coinage of intellectually formed words, as "intellectual" and dispassionate as words that are spoken, with a blank screen, a rushing

imageless visuality ... [The expression itself gives clear evidence that iconicity has been overcome. R.B.E.]

now in passionate disjointed speech, nothing but nouns or nothing but verbs; then through interjections, with the zigzags of aimless figures, hurrying along in synchronisation with them.

Now visual images racing past in complete silence,
now joined by a polyphony of sounds,
now by a polyphony of images.
Then both together.[5]

The passage's use of gerunds and participles ("rushing," "racing," "hurrying") and of nouns that derive from actions ("zigzags," "interjections") is revealing: artworks overcome conventional signification through kinetic effect. In adopting this belief, Eisenstein allied himself, quite consciously, with those twentieth-century artists such as Joyce and Pound who took an interest in how the accelerated activity of an artwork both reflects and stimulates an incessant, rapid flux of the manifold of consciousness.[6]

Eisenstein never changed his fundamental ideas about how photographic images overcome their iconic significance. He continued to argue that by becoming elements in a set of aesthetic relations, such images take on an artistic role. Nor did he ever leave behind the question of how that transformation takes place. Nor did he ever abandon his conviction that this was the central problem of film aesthetics. Furthermore, he never departed from those affiliations that initially provided him with the basic terms with which he worked on this problem, reworked it, and then reworked it again. For however much he revised his views on how this question might be answered, he continued to associate the principle of aesthetic transformation with the Marxist conception of the dialectic—a conception of movement, of change, of kinesis.

In all this, Eisenstein allied himself with the extraordinarily productive and highly variegated metacritical enterprise known as Formalism. As early as 1921, in *Recent Russian Poetry*, Roman Jakobson proposed that the proper subject of literary study was *literariness*, that is, the features distinguishing literary use of language from its practical use. Generally, the Russian Formalists suggested that extrinsic relations (relations between linguistic signifiers and the external world) have central importance in practical uses of language, whereas intrinsic relations (or intratextual relations, that is, relations among elements intrinsic to the work) have central importance in literary uses of language. The Prague School Formalist Jan Mukarovsky summarized the insight elegantly:

In poetry, as against informational language, there is a reversal in the hierarchy of relations: in the latter attention is focused above all on the relation, important from the practical point of view, between reference and reality, whereas for

the former it is the relationship between the reference and the context incorporating it that stands to the fore ... As for poetic reference, the weakening of its immediate relationship with reality makes of it an artistic device. That means that the poetic reference is not evaluated in terms of an extralinguistic mission but with relation to the role imposed upon it in the organization of the work's semantic unity.[7]

The proposition that the relations an element takes on when it is incorporated into a work of art alter the fundamental character of that element was a key tenet of Eisenstein's film theory as well. This proposition worked together in his theory with another one already mentioned—that the distinguishing feature of poetic/aesthetic language is that it *does* something rather than states something.

The effort to produce an artistic theory and practice that would be consistent with the principles of Marx's philosophy was a common aspiration among the Constructivists. The Marxist theory of labour is a key item in Marx's philosophical legacy. It views nature as, *ab initio*, an alien being that stands over against humans; labour (or industry) transforms material from this alien realm into an object that reflects the being of the transforming agent. This transformation is affected by two influences: it reflects the character of the maker and the character of the implements the maker used in transforming the raw stuff of nature. Because this reflection embodies characteristics of the agent of the transformation, the transformation overcomes the alienation that originally characterized the relation between human being and nature; so the labour process populates nature with humanized objects (objects that reflect attributes, needs, and interests of human beings).[8]

Eisenstein, with even greater commitment than most Formalists, worked through the question of how the relations intrinsic to a work of art alter the elements that enter the work of art in dialectical terms. He did so by applying the Marxist conception of labour. His theorizing took both aspects of the transformation process seriously: Pavlovian (and later, Vygotskian) psychology furnished him with the materialist concepts necessary to understand how human nature is embodied in the creative process; Formalist and materialist theories of art provided him with a means to understand the role played by the transforming medium. Like many Marxist thinkers, he believed that remoulding nature is a dialectical process: the object is transformed into something it originally was not. What began with one set of qualities acquires different features through the labour applied to it; and on this understanding, as new attributes emerge, some of the object's original qualities are negated. The object takes on opposing characteristics at different times; nonetheless, its material substance, before and after it acquires these new characteristics, is the same. So a unity perseveres through the changes—the opposing characteristics that

element possesses before and after the transformation are held together by the deeper unity that underlies them. Thinking about this in dialectical terms, we would say that the contradictions between the antithetical moments are sublated in a higher unity.

The process begins with an inert lump of matter and ends with an object that, though made from the materials of nature, reflects human needs and human interests. Through the labour process, what originally stands over against human being and is alien to its nature takes on attributes of human being. In being reworked, the raw material is transformed from matter that shares few features (or none) with human being into an object that has human features or, at least, answers to human needs. It is transformed from one entity into another—"into its opposite," we might say. This transformation releases the object's real being, for—again according to the Romantic convictions Marx held—the opposition between nature and human nature is a false notion (or, rather, a notion relative to an era in history, to be overcome through history). As does the Hegelian, the Marxian dialectic uncovers the truth of beings through time, struggle, and change.

The notion of the fragment is of key importance in Eisenstein's early film theory. Photographs he characterizes as photo-fragments of reality: "The lens cuts out part of reality as with an ax," he wrote.[9] Aumont did the valuable service of pointing out that Eisenstein's word for fragment, *kusok*, means something like "lump" or "bit" or "slice."[10] Though Aumont did not, one could relate this usage to the Marxian theory of labour, which was so central to Eisenstein's theories, by pointing out that it suggests a lump of unformed matter that labour can transform into something with use-value. The use-value of film is primarily ideological, for film helps transform bourgeois consciousness into progressive consciousness, and when the film addresses the working class, it can help emancipate them.

Vertov thought of the film material similarly: "Kino-Pravda is made with footage just as a house is made with bricks. With bricks one can make an oven, a Kremlin wall, and many other things. One can build various film-objects from footage. Just as good bricks are needed for a house, good film footage is needed to organize a film-object."[11]

Indeed, like his archrival Eisenstein, Vertov developed an account of cinema that had a dialectical form: the life-facts recorded by the camera would be transformed into "film-facts" (*kino-fakty*) through montage. The life-facts would serve as raw materials, which the filmmaking process would then transform into objects with use-value. Nevertheless, he maintained, the cinema was rooted in reality; Vertov's reasons for insisting to his *kinoks* that cinema be rooted in life-facts had the purpose of aligning film with contemporary, everyday reality—of integrating art with life.

Constructivists generally followed the principle of "baring the device" (*obnazhenie priema*) to reveal how the process of construction (*stroitel'nyi protsess*) transforms reality into an autonomous object. Vertov and his *kinoks* shared this interest in transforming fragments of nature into aesthetic elements.[12] Vertov wanted to raise to its highest possible level the dialectical tension between the object in its material existence and the aesthetic element it becomes, so he stressed capturing the object in a rather unformed state (as one pole of the dialectical unity). He decried the fictional film and extolled the importance of capturing life unstaged. He insisted, in the most vigorous terms, that filmmakers should allow neither their presence nor that of a camera to disturb the natural course of an event being filmed—that *kinoks* should record "life-facts" (*zhiznennyi fakty*) just as they are. Even Eisenstein's dramatic films, which restaged historical events, were according to Vertov merely "acted films in newsreel trousers."[13]

Viktor Pertsov, a sharp-minded commentator on film for *LEF*, praised the factual character of Vertov's films and those of Esfir Il'inica Shub (1894–1959)— Vertov's "pupil," as she styled herself:

> Vertov's film *Shestaia chast mira* [One Sixth of the World] and Shub's *Padenie dinastii Romanovih* [The Fall of the Romanov Dynasty] and *Veliki put'* [The Great Road] represent genuine agitational journalism expressed in a cinematic language. The authentic non-aesthetic impact of these films derives from the real facts which comprise the films' structures. If the cinematic juxtaposition of facts stimulates emotions, it does not mean that these emotions in and of themselves transform facts in a non-authentic aesthetic structure. We know that in staged films the impact on the audience is provided by various dramatic devices; however, in unstaged film journalism, the impact is provided by the rules of rhetoric. It is not a coincidence therefore that Vertov conceives his films on an oratorical principle. He is a true cinematic orator who makes his point in the manner dictated by the intrinsic power of the selected facts, thus building a structure which holds the attention of the audience ... To edit facts [montage] means to analyze and to synthesize, not to catalogue.[14]

Oratorical principles transform the facts, but they do so in a way that respects the theme while releasing its intrinsic power. Pertsov's insightful remarks propose the same two-tiered conception of film structure that Eisenstein offered in "Through Theatre to Cinema," in which he proposed that there are two phases of film construction: "*Primo*: photo-fragments of nature are recorded; *secundo*: these fragments are combined in various ways."[15] What distinguished Pertsov's view from Eisenstein's was the same as what distinguished Vertov's films from Eisenstein's: a greater respect for the affective power of the authentic (i.e., unstaged) shot.[16] Vertov's cinema, Pertsov suggested, had a more profound dialectical character than Eisenstein's.

The fact itself has strong effects—raw factuality in itself can dynamize perception. *LEF* noted the effectiveness of the photograph (or cinematograph):

> By photomontage we understand the usage of the photographic prints as tools of representation. The combination of photographs replaces the composition of graphic representations. The reason for this substitution resides in the fact that the photographic print is not the sketch of a visual fact, but its precise fixations [cf. Eisenstein on the photographic/cinematographic image as a photofragment of reality, or Vertov on film-facts]. The precision and the documentary character give photography an impact on the spectator that the graphic representation can never claim to achieve ... An advertisement with a photograph of the object that is being advertised is more efficient than a drawing of the same subject.[17]

The idea of the factograph played an important part in Soviet art, especially after 1921, when Lenin declared his New Economic Policy. We have already noted the *LEF* author's remark that "the precision and the documentary character give photography an impact on the spectator that the graphic representation can never achieve." Factography was founded on the principle that truthful representations—be they truthful by their nature, as photographs are, or truthful by reason of being accurate theatrical reconstructions of real events—have a special effect on viewers (and readers). This view posed a strong challenge to a fundamental principle of modernist aesthetics—that imitation has no value in artistic production. That negative view was common—no less a thinker than Mayakovsky used that tenet when he dismissed the possibility that film could become an art:

> Can cinema be an independent art form? Obviously, no ... Only an artist can extrapolate the images of art from real life while cinema can act merely as a successful or unsuccessful multiplier of the artist's images. Cinema and art are phenomena of a different order ... Art produces refined images while cinema, like a printing press, reproduces them and distributes them to the remotest parts of the world ... Hence cinema cannot be an autonomous art form. Of course, to destroy it would be stupid; it would be like deciding to do away with the typewriter or the telescope because they do not relate to theatre, literature, or Futurism.[18]

The shift that Soviet art underwent, to recognizing the impact that life-facts can have, was no doubt a result of the cinema's influence on the mentality of the time.

The polemical thrust of factography was to assert that the iconic, documentary value of the photographic image is a valuable social tool and should be respected. Artists should not see representation as something they should transcend. Some artists—though certainly not Eisenstein or Vertov—even argued

that the photograph must serve to make reality visible, without mediation. They insisted that since Marxism was oriented toward reality, fiction suited its goals poorly.

In his journal *Kinofot*, which he founded in 1922, Aleksei Gan promoted a factographic cinema. In an essay, "Constructivism in Cinema" (1928), he proclaimed:

> Film that demonstrates real life documentarily, and not a theatrical film show playing at life—that's what our ciné production should become ... It is not enough to link, by means of montage, individual moments of episodic phenomena of life, united under a more or less successful title. The most unexpected accidents, occurrences, and events are always linked organically with the fundamental root of social reality ... Only on such a basis can one build a vivid film of concrete, active reality—gradually departing from the newsreel.[19]

Clearly, the idea of the factograph was attractive to both Vertov and Eisenstein (the latter based *October* partly on a theatrical presentation that presented a purportedly accurate rehearsal of the storming of the Winter Palace in October 1917). Still, neither Vertov nor Eisenstein restricted himself simply to making reality visible, for neither believed that filmmaking should end with the recording of life-facts. Transformation of the facts through labour was required. The film camera, Vertov averred, had a special role to play in this. The film camera was a machine that was like the human eye, in that it could register fleeting impressions of the visual. But it was also better than the human eye, because it could slow actions or stop them, thus making them available for scrutiny. The human eye can see only in real time, but the camera eye can transform time. Vertov made this point often in his masterwork, *Chelovek S Kinoapparatom* (Man with a Movie Camera).

Vertov developed a theory based on the idea of the interval, according to which each phase in producing a film transforms the raw material of the film. He made this point in *Man with a Movie Camera* in a sequence in which he related miners mining raw material for manufacturing to a camera operator mining raw materials for a film; he then showed the film material being transformed by Elizaveta Svilova's editing.

Historians of film theory (David Bordwell could serve as an example)—and, for that matter, art historians—have not recognized the importance of the analogy that Eisenstein and Vertov drew between labour's transforming raw materials into a humanly useful object and aesthetic practice's transforming the iconic signifier into an aesthetic object. The Marxist belief that the labour process (like all processes, in fact) has a dialectical character, and that the tools used in the transforming process leave their impress on the object produced through that process, explains a feature that has long troubled commentators

on Eisenstein's theory of film. David Bordwell—and he is not alone in this—complains that Eisenstein refers to any kind of difference as a conflict:

> The concept of conflict is simply applied too broadly to be of much explanatory value. The term seems to denote any incongruity, comparison, or juxtaposition; it dwindles to difference. When Eisenstein insists on recasting all differences as conflicts, he extends the idea to questionable cases. In what meaningful sense does a camera angle represent a conflict between the profilmic object and the framing? ... [This is hardly conflict] unless one postulates in advance that all shot changes instantiate conflict—in which case no counterexample will ever test the explanatory hypothesis.[20]

The object in its natural existence is analogous to matter in its inert state. Labour, the creative wrestling with nature, transforms the natural object into something it originally was not by endowing it with new characteristics. To describe such differences as "conflicts" is precisely what we would expect from someone whose idea of struggle and conflict is bound up with the Marxist conception of labour.

Understanding the dialectical principle in operation pays rewards when that understanding is brought to bear on the analysis of Eisenstein's films. The dialectical principle highlights the possibility of analyzing a series of shots as a differential series whose elements interact with and inflect one another, albeit more through their syntagmatic than through their paradigmatic relations. As Yury Tynyanov's semiotics made clear, this differential series suffices to produce aesthetic effects without recourse to traditional plot structures. From this conception of a film—as a series of differential relations—came what David Bordwell, in *The Cinema of Eisenstein*, calls Eisenstein's "divagative" style, which mixes narrative and non-narrative modes.

Throughout his career, and well beyond the 1920s, the desire to work out a dialectical theory of film—actually, to create a theory of *all* the arts—consistent with the fundamental principles of Marx and Engels's philosophy remained Eisenstein's central project. Right to the end of his life, he continued to take this to mean working out a theory of film patterned on Marx's analysis of the labour process.[21]

Eisenstein's contribution to Formalist theory was to join the Formalist model of poetic language, which emphasized the process that transforms conventional (natural) language into poetic language, with Marx's idea of the transformation of raw materials into an object with use-value. The film medium's industrial nature and the cinematograph's iconic nature, which ensures that the raw material of film is "a photofragment of reality," strengthened the bond he discerned between these two notions.[22]

THE THEORY OF THE DIALECTIC AND
THE CONCEPT OF TRANSFORMATION

In a declaration that could seem paradoxical, or even facetious, Eisenstein proclaimed that "contempt for raw material" would drive the new cinema. His belief in the transforming power of aesthetic relations explains why we should take this in earnest. He consistently maintained that cinematic devices (*priëm*) are means for transforming raw material into something with use-value. In 1929 he described art as conflict "between natural being [i.e., raw material] and creative tendentiousness." Sometime later, in 1934, supposedly after his "epistemological break," in "Through Theatre to Cinema," he described montage in similar terms—as the "mightiest means for a creative re-moulding of nature." This statement embodies a dialectical truth I have hoped to establish in this work: that the dissent of cinema's elements from an easily achieved whole was precisely what made it seem an exemplary art form for so many early twentieth-century artists. Eisenstein affirmed that it is important that elements break with the Whole (which one should understood polyvalently, as intending the aesthetic unity, the social order, and the metaphysical One) and contend against it, that they engage in strife against the Whole so that when the Whole once again takes them into itself, they transform the Whole. This principle certainly preceded the birth of cinema, but it is important to acknowledge that the advent of cinema reinforced that principle and was viewed by many as providing a scientific (technological) endorsement of that principle. (That is the dialectical truth I hope to establish in this work.)

This productivist interest in montage derived in part from Eisenstein's enthusiasm for industry and engineering.[23] An engineer resolves her design into elementary composites, then assembles those basic elements. Eisenstein approached filmmaking in essentially the same way (and he was not alone among Soviet artists in seeing art making as being similar to engineering). Meyerhold, too, treated both the storyline and a single action much like an engineer: he resolved each into elementary components, which he could then reassemble into a new, affecting order. He did not assume that the plot was inviolate—indeed, he maintained that a story could be broken into parts and those parts reassembled in a new order. He would ignore the chronology of the original plot, shift scenes around, or break them into smaller components, which he would then recombine with other scene fragments. This is evident in his 1922 staging of Aleksandr Nikolayevich Ostrovsky's 1871 satire on the nouveau riche, *Lies* (*The Forest*). The five acts of Ostrovsky's *The Forest* became thirty-three episodes in Meyerhold's staging. (In this way, Meyerhold associated contemporaneity/ modernity with the montage principle.) He tore the text apart and rearranged it to portray parvenue gentry in terms of the class war—this was required, he argued, in order to make the theme vital for the present,

for by dissolving the plot into fragments and rearranging the fragments, he increased the tempo of the scene. The production emphasized rhythm above all other attributes (and Meyerhold's emphasis on rhythm may have influenced Eisenstein's ideas on dymamic movement, gesture, and meter). Rhythm came to serve functional goals: Meyerhold maintained (much as Eisenstein would) that rhythm is the basis of all dramatic expression. Moreover, his production used continuous movement. Meyerhold even incorporated circus elements into the work, using pantomime interludes to create contrasts in mood and tempo.

The montage principle, practised in many arts at the beginning of the twentieth century, was an important influence on this. This way of treating the plot was similar to the way Aleksandr Rodchenko treated the image in his photomontages: snapshots (including mass media photographs) could be dissolved into pieces and rearranged in a new order. It is also the method of cinema.[24] And the effect? Exactly what Eisenstein understood in his earliest theory of cinema: the recombination of fragments affects the viewer physically.

The montage principle relies on the Formalist strategy of defamiliarization. When we sever an element from the relationships it ordinarily has, and insert it into a context in which it takes on new and unfamiliar relationships, a viewer can experience that element anew—in fact, in a twofold way: the element preserves its conventional and referential relationships at the same time that, by virtue of the new relations it has assumed, it is converted into a quasi-autonomous element in a network of aesthetic relations. Thus viewers respond to it as a recognizable (conventional, referential) element yet at the same time experience it as defamiliarized—and the constructed character of the object to which it has come to belong impresses that latter sensation on them.[25] Familiarity may have made our ordinary response to the elements that make up the work routine, but the effect of placing an element in new contexts is to make the viewer perceive the elements anew—and that estrangement can impel the viewer to discover new significance to them. The gaps between the elements presented in montage can make the sequence of objects seem strange and unfamiliar, but that very difficulty makes it just that much more challenging to discern the rule that governs the syntagmatic relationships among those elements. Thus the artwork's structure is rendered "challenging" and "strange," even though its component elements, in themselves, are familiar.

In this way, the art of fact has the potential to revivify perception. Traditional art was merely a means of escape, and in this vein, Aleksei Gan and Dziga Vertov both condemned the "film mesmerization" that paralyzed the spectator's consciousness. Defamiliarization would revivify our sensory faculties. Shklovsky, for example, extolled methods of defamiliarization and of rendering perception difficult in his 1916 essay "Iskusstvo kak priem" (Art as Device). Rodchenko's photomontages (and Vertov's and Eisenstein's films) used

extreme camera angles and unusual lighting to defamiliarize shots' object matter. The reversals of cause–effect relationships in Vertov's *Man with a Movie Camera* provide a good example of the strategy, as does Eisenstein's use of Expressionist lighting, stylized make-up, histrionic acting, and symbolic *mise en scène*. Eisenstein's theory of the shot was rooted in his analysis of the difference (the "contrast" or "conflict") between the object in its natural existence and the object as represented on the screen—in other words, on the object having been "made strange."[26] The goal of the strategy of "making strange" (*otstranenie*) is to dynamize perception.

The idea that art's purpose is to dynamize perception—so central to Eisenstein's and Vertov's theories—is a key to Constructivist thought generally. El Lissitzky proposed a remarkably similar notion; when discussing his exhibitions of non-objective art for Dresden and Hanover, he associated the vivification of perception quite literally with physical movement:

> Traditionally the viewer was lulled into passivity by the paintings on the walls. Our construction/design shall make the man active. This is the function of our room ...With each movement of the viewer in space the perception of the wall changes; what was white becomes black, and vice versa. Thus, as a result of human bodily motion, a perceptual dynamic is achieved. This play makes the viewer active ...The viewer is physically engaged in interaction with the object on display.[27]

The physical movements of the spectator, his or her engagement with the exhibition, is treated as analogous to the mental activity provoked by the series of aporias that a montage of estranged objects presents.

THE CONCEPT OF TRANSFORMATION
IN EARLIER AND LATER EISENSTEIN

A single project, of describing the transformation of the factual shot into an aesthetic form, drove Eisenstein's theory. He consistently modelled that transformation on the process through which labour transforms inert lumps of matter into objects that have use-value. However, at the time he began his theoretical endeavours, a mechanical conception of the dialectic prevailed in the Soviet Union. That is why, like other thinkers of his generation, he understood the dialectical interrelations among the conflicting elements in an artwork in mechanical terms. That is also why his early theory and practice stressed the dialectical relations among successive shots.[28] The succession of shots in a film, by synthesizing opposites, conforms to the pattern that characterizes the historical process. In this period Eisenstein famously proclaimed that he approached the problem of creating an artwork in the same spirit that engineers (whose basic training he shared) approach the problems of their

profession. He contended that the day was coming when one would be able to calculate the aesthetic structure needed to produce a particular change in the viewer's consciousness in much the same way that an engineer calculates the features a town's water system must have to serve its intended role. In this, he was echoing the most famous description of Constructivism, the one offered by Naum Gabo and Antoine Pevsner in their famous "Realistichesky mani-fest"(Realist Manifesto) of 1920. Gabo and Pevsner wrote: "We construct our work as the universe constructs its own, as the engineer constructs his bridges, as the mathematician his formula of the orbits."[29]

Eisenstein's views shifted: he ceased to think of montage primarily as suc-cession. Tynyanov's and Kazansky's ideas of complex signs convinced him that every shot is a polyvalent element that possesses plural significations.[30] He came to realize that an individual shot can be a synthesis of opposing ele-ments. That is, since a shot has several features, its dominant and subsidiary characteristics can conflict: a dominant movement to the left, for example, may conflict with a subsidiary movement to the right. What is more impor-tant, the dominant feature of one shot can match the dominant feature of the succeeding (or previous) shot even while conflicting with a subsidiary ele-ment in the succeeding (or previous) shot. Such "conflict" between a sub-sidiary feature of one shot and the dominant feature of the next (or the pre-vious) was, in fact, the norm in Eisenstein's practice (though sometimes, to create especially strong jolts at the cuts, he juxtaposed opposing dominants). He believed that such constructions bring the two opposing shots into a unity because the dominant feature of the earlier shot matches the dominant feature of the succeeding shot (even while a secondary feature of the earlier shot con-flicts with the dominant feature of the later).

Eisenstein used the metaphor of an explosion to describe the relations among montage elements. Our analysis of his conception of montage explains the appropriateness of the metaphor. Consider, for example, two shots. One is a close-up, though off to one side we see through a shadowed passageway into a brighter distant element, *as though* in long shot. The next shot *is* a long shot: a secondary feature of the first shot "explodes," becoming the primary fea-ture of the second.

In the earlier phase of Eisenstein's career, the dialectical character of shot relations ensured that the montage had dynamic momentum. A dialectic of the same sort is the motor that drives history itself. This homology explains why he prefaced his untitled 1929 essay (which did not appear in the Soviet Union, but has appeared in English as "A Dialectical Approach to Film Form" and as "The Dramaturgy of Film Form") with a quotation from Ruzomovsky's *The-ory of Historical Materialism*.[31] Eisenstein's commitment to Marx and Engels's theory of the dialectic is evident in the fact that he begins "A Dialectical Ap-proach to Film Form" by comparing the ways in which the historical dialec-

tic projects itself into consciousness and into art. As the essay's emphasis on dynamizing perceptions, emotions, and ideas shows, the kinetic attributes of the shots in Eisenstein's earlier films—which he often "hyperbolized" (the word is his), sometimes to the point of including implausible background actions—arose from his desire to create film constructions with characteristics similar to those of the historical dialectic. The historical dialectic, Eisenstein came to understand, is not just a sequence of antithetically related elements: each historical moment in itself contains contradictions, out of which the succeeding era explodes.

One could cartoon the materialist conception of dialectic on which Eisenstein based his early film theory: the task was to develop an aesthetic theory and practice that conformed to the fundamentals of Marx and Engels's philosophy of dialectical materialism. In practice, as concerns film construction, this requires filmmakers to create dialectical constructions. The dialectic concerns elements in conflict. What sorts of elements will enter into dialectical relations in a work of art? Eisenstein (like many other Constructivists, as Tarabukin pointed out) seems to have concluded that a commitment to dialectical materialism required the artist to forge the materials of the medium into patterns of conflict. During the early stage of his career, Eisenstein concluded that to create film constructions that conform to Marxist principles, filmmakers must create dialectic relations (i.e., conflicts) between shots. He concluded that the doctrine of materialism's implication for aesthetics is that artistic materials have priority in determining the character of artworks; hence it is the artistic materials—the "stuff" of which the work is built—that must be arranged into patterns of oppositions—of *conflict*. This, as I noted, is a cartoon of the reasoning that led Eisenstein to the particular formulation of aesthetic materialism that his early film theory offers. Still, I believe that with the necessary refinements, it could be made to depict the truth about the genesis of his film theory.

However, Eisenstein's conclusions about the implications of Marx's materialism for aesthetics (conclusions that other Constructivist artists shared) rested on a misunderstanding. Marx's dialectical materialism implies nothing about the artist's need to be concerned about the materials of his or her medium. Rather, Marx's materialism concerns the force that drives history: it affirms that history is *not* the progress of the historical consciousness's rising to ever higher levels of self-understanding. Rather, developments in humans' capacity to transform nature into products that have use-value—developments that result from technological change (changes in the "means of production")—are what drive history forward.

Eisenstein's later film theory rejected his earlier, mechanical understanding of materialism ("material" here referring to the material of his medium): he realized that he needed to work out a more adequate (but still materialist)

theory of consciousness—specifically, of the effects that artworks have on consciousness. Historians of film theory have offered several conjectures regarding why Eisenstein began to investigate inner awareness and to develop more complex ideas about consciousness. One opinion suggests that changes in the philosophical climate in the Soviet Union—specifically, Deborin's philosophy's rise to official status—compelled him to shift position. There is something to this claim: Deborin's teachings about the quasi-autonomy of consciousness and his more organic conception of the dialectic may have helped Eisenstein recognize the shortcomings of his early theory. Nevertheless, if Deborin's rise to official status affected him, it was not because he mindlessly followed the rise and fall of philosophical fashions in the Soviet Union: the changes in his theoretical work reflect necessities internal to its own development as much as they do external influences (whether Deborinite or other).

Philosophical reputations in the Soviet Union were at best mercurial. Deborin's official status lasted a mere two years before his failure to endorse the Stalinist conception of the Party led to his being condemned and effectively silenced until Stalin's death. Eisenstein's interest in the quasi-autonomy of consciousness persisted, however, for he recognized that Deborinite concepts could fill some lacunae in his early theory. He came to recognize the limitations of positivist psychology, and Deborin, a sworn enemy of Mach, helped him work out an alternative. Similarly, he had come to recognize the problems of a mechanistic conception of the dialectic (such as that on which his earlier theory was based), and Deborin's idea of the dialectic had a much more organic and Hegelian cast.

Eisenstein's earlier theory and practice depended—explicitly and self-consciously—on the Marxist conception of art as ideology (according to the way the notion of ideology was expounded in *Die deutscher Ideologie* [The German Ideology]). There Marx writes: "Consciousness can never be anything else than conscious existence [*das bewusste Sein*], and the existence of men is their actual life-processes. If in all ideology, men and their circumstances appear upside-down as in a *camera obscura*, this phenomenon arises just as much from their historical life-process as the inversion of objects on the retina does from their physical life process."[32] Thus, as the Enlightenment thinkers did, Marx distinguished between *eidolon* and *ontos on*, separating all that is derivative from whatever is originative, shadow from reality, illusion from truth. He considered that art belongs to ideology, along with religion and morality. What is originative is what derives from the production of means to satisfy material needs. Yet at the same time, Eisenstein concluded that an art based in the labour process would not veil truth—it *would*, though, prepare the way for the overcoming of art, for the time when the installation of a town water system would be the occasion for self-enjoying production, when labourers were liberated by engaging in fulfilling creative labour whose value to the community they understood.

Eisenstein's early Constructivist commitments produced a contradiction at the heart of his early theory of cinema: on the one hand, his Formalist convictions led him to affirm the uniqueness of aesthetic experience and the difference between aesthetic forms and the forms of ordinary objects; on the other, his commitment to Marx's theory of ideology (a commitment shared by other Constructivists) led him to think of art as a product belonging to the long period in human history in which the truth lay veiled, a period that would be overcome with the dawn of the communist era. Like other Constructivists, he must have concluded that in the communist era all productive activities would become art forms, for the idea of overcoming art is everywhere implied in the ideological substructure of Constructivist practice (for instance, in its emphasis on integrating art and life and on using the contemporary technologies of production in art making). This contradiction—between the belief that artworks provide unique experiences not furnished by any other means and the idea that artworks are simply the products of a phase in human history that can, and will, be replaced by historical developments—propelled him to examine consciousness and to question what truth is, how we know it, and how we fail to know it.

Even in this, Eisenstein did not break with his earlier theories. He remained convinced that consciousness, as a natural (material) process, operated according to the laws of the dialectic: it is struggle and conflict, the clashes between opposites, that produce consciousness. The effort to discover a unity that coordinates diverse phenomena gives life to consciousness. At first, under the influence of the theory of classical conditioning, he restricted his interest, inquiring into how the more abstract, or metaphoric, or conceptual, contents of "mind" can emerge from concrete experience. Even at this stage, the pictographic character of Japanese (or Chinese) language—whose characters, he believed, juxtapose iconic elements—provided him with a model for understanding the process.

This is what language remained for Eisenstein: an indication of the powers of the mind and of the nature of mental processes. The common idea that he expounded the belief that film has a logomorphic form—that he drew parallels between the shot and a word (or, under another variant, a sentence), and between a sequence and a sentence (or a paragraph)—is nonsense. In his famous dispute with Lev Vladimirovich Kuleshov (1899–1970) and Vsevolod Pudovkin, he pointedly dismissed such models. Indeed, his comparisons of film with language were indirect, and his questions about cinema's relation to language concerned the production of artistic meaning. He seized on the idea that juxtapositions of concrete terms themselves can produce a concept: the fact that the simple juxtaposition of concrete terms can engender an abstract idea reveals the existence of an underlying mental process/physical activity that synthesizes the juxtaposed terms.[33] Thus the mental processes that make

possible the production of meaning follow dialectical laws. Eisenstein argued, more generally, that figures of speech reveal figures of thought.

In time, Eisenstein realized that the mind's ability to form a general idea from particular representations (or, more generally, from the experience of particulars) was an inadequate basis for his theory of artistic meaning—not the least because the psychological theories, the reflexology and behaviourism of Pavlov, Bechterev, and Sechenov, to which he petitioned for an explanation of the phenomenon of meaning, left the mind out of account entirely. Consequently he adopted a genetic approach to fathoming the mind's construction of meaning. He consulted the work of the psychologists Lev Vygotsky and Aleksandr Luria. In doing so he anticipated the recent shift in psychological paradigms from Skinnerian behaviourism to Chomskian cognitive psychology. Like Chomsky, he turned to examine the processing that goes on within the black box that is the mind and conducted that examination by considering what the nature of that processing must be to make it possible to produce artistic meaning.

Eisenstein never broke completely with his earlier ideas; however, he came to realize that Pavlovian efforts to reduce consciousness to material could not account for key features of consciousness (especially the more archaic or primitive features of early forms of thinking). So Deborin's thesis that consciousness is a quasi-autonomous emergent property held great appeal to him, and he adopted it. Though accepting this view introduced a new dimension into his theory, he nevertheless used this new principle to the same ends to which he had originally applied Palovian psychology—of explaining the mental functioning that makes it possible to produce aesthetic effects.

As Eisenstein's theory evolved toward a more organic idea of unity, it could accommodate and reconcile an ever greater degree of diversity.[34] The principle of organic unity depends on the belief that aesthetic relations are "internal relations"—in other words, that relations internally change the relata they relate. His earlier theory had proposed that aesthetic unities are mechanical unities, which do not internally alter the elements that enter into them. Like the earlier theory of transformation, the theory of organic unity attempts to explain how a natural signifier—whether an iconic sign or a symbol (as most signifiers that belong to a natural language are)—takes on new, aesthetic significance when it becomes part of a work of art. Moreover, the notion of organic unity is consistent with his later, revised understanding of the dialectic, for the idea that new significances emerge from the construction of complex (aesthetic) relations echoes Deborin's claim that dialectical advance produces emergent properties.

The younger Eisenstein committed himself to a narrowly circumscribed psychology rooted in a scientific positivism akin to that of Ernst Mach and the *Wiener Kreis* (Vienna Circle). His earlier aesthetic theories propounded a view

similar to that of Enlightenment thinkers such as Diderot and Boileau. This was evident in his efforts to discover the universal and inviolable laws of art—to do what the Enlightenment aesthetician, Boileau, strove to do (i.e., derive all aesthetics from a single principle). It is evident, too, in his efforts to establish aesthetics as a rigorous and exact science based on rational principles and to understand artworks as Diderot did, that is, as nexuses of constructed relations.

Enlightenment principles dominated Eisenstein's middle theory. But his ideas were to change again: increasingly, archaic levels of consciousness occupied his thinking and he grew to believe that artworks draw their strength from their close relation to such archaic strata. The impetus for this, as I argued earlier, stemmed partly from the logical demands of his theory. Still, that is only half the story. Just as important was his Mexican adventure. Even the hard-headed Jacques Aumont discusses the shift in Eisenstein's work that occurred around the time of his trip to America as a consequence of his experiences there. Mexico, then as now, demolishes rosy Enlightenment beliefs and opens one to far more terrifying realms of experience. It opened Eisenstein to strata of being he had long avoided. After Mexico, he could no longer abide the superficialities of his Enlightenment aesthetics or the superficialities of a positivist psychology. As he opened himself to those terrible realms to which his mathematical disposition had previously forbidden him access, the classical perfection of his early films gave way to the quasi-religious subliminity of his later works. Though he continued to insist that artistic form redirects primitive impulses into culturally higher forms of activity, he increasingly came to doubt that primitive passions (including religious "fanaticism") can be dominated and controlled by doctrine. Ecstatic passion is unruly.

How are we to understand what Eisenstein experienced in Mexico? One thing we know with certainty is that after his experiences in Mexico, he expanded his small library of books on what he called the "imprecise sciences" (magic, chiromancy, graphology, and the like). Certainly, books he owned before his fateful trip included a number of volumes on magic, chiromancy, and graphology. Among these was *Histoire de la magie* by Eliphas Lévi (pseudonym of Alphonse Louis Constant, 1810–1875), a writer who propounded a notion of an Adamic language corresponding closely with that of the Symbolists.[35] To these, he added, after his Mexican adventure, many books on religious and occult subjects, the purchase of which he justified as helping him understand creative method. These additions included many volumes on the Jesuits (especially on Ignatius Loyola and his methods) and on mysticism, the Kabbalah, alchemy, and astrology.[36] He took special interest in Loyola's diary from his Manresa period, in which the priest described the spiritual practices he engaged in that allowed him to achieve states of religious ecstasy. Marie Seton, in *Sergei Eisenstein*, states that the filmmaker's interest in these practices was grounded in this effect. He also took an interest in Hildegard von Bingen's visions. And

MODERNISM AND REVOLUTION

he acquired books by the Russian Symbolist writers Vyacheslav Ivanov, Andrei Bely, Valery Bryusov and Sergei Durylin, all of whom were occult practitioners; these Symbolist writers all shared his interest in mythological thinking and myth creation, in ecstasy and in the unity of the senses. For example, in 1903, Bryusov, having returned from a trip to Paris that year and having been exposed there to the atmosphere of mysticism that Paris Symbolism reflected, delivered a lecture titled "The Keys of the Mysteries" at Moscow's Imperatorskii Rossiiskii Istoricheskii muzei (Imperial Russian Historical Museum; now the Ob'edinenie Gosudarstvennyi Istorichesk'i muzei [OGIM], Consolidated State Historical Museum). Later he published his lecture in the Russian Symbolist journal *Vesy* (Libra).[37]

Ivanov speculates that the crisis Eisenstein experienced regarding art, a crisis aggravated by his Mexican trip, was the result of his having recognized art's links with the most regressive parts of the psyche (which, of course, he then began to study obsessively). His Mexican journey brought him to deliberate on art's links with diabolical forces. Eisenstein was generally interested in the liminal spaces where the old and the new confronted each other, and in revolutionary Mexico the archaic and the novel confront one another explosively.[38]

Eisenstein based his early theories of montage on the belief that physical stimuli can produce higher-order emotional and intellectual effects and thereby serve ideological ends; he even believed that scientific calculations could bring us knowledge of the precise emotional and intellectual effects of any physical stimulus. This is an extravagant notion for which one would be hard-pressed to discover any scientific basis. Even his later theories, in which the connections between the physical stimulus and the mental effect are considered in a more complex and nuanced manner, hardly have a solid scientific basis. However, his ideas do have parallels in Symbolist thought. For example, the poet Andrei Bely, whose work commanded much interest in the early years of the Soviet regime, promulgated ideas about language that were thoroughly steeped in heterodox beliefs. A word, Bely stated, is a conductor or connector that "connects two unintelligible essences: the space which is accessible to my vision, and that inner sense vibrating mutely inside me that I provisionally call ... time." The poetic word serves as a connecting agent between the poet's inner "speechless, invisible world swarming with subconscious depth" and the "speechless, senseless world" of extrapersonal realities. In this way, words conjure up a "third world."[39] Indeed, if the French Symbolists maintained that the poetic symbol connects, through correspondence, the ordinary realm to a higher realm beyond space and time, the Russian Symbolists characteristically argued that poetic language connects the inner world to the realm of empirical fact—that is, it connects the world of which intuition once granted awareness to the world of which the senses inform us. That Bely developed such notions

by reflecting on hieroglyphs—not on Chinese written characters, as Eisenstein did, but on ancient Egyptian hieroglyphs—makes the affinity between Eisenstein's ideas about language and those of Bely all the more evident.

In "Magiya slov" (The Magic of Words, 1909) Bely offered the proposition that the word is a magical, world-creating force, for the the living word

> is the expression of the innermost essence of my nature, and, to the degree that my nature is the same thing as nature in general, the word is the expression of the innermost secrets of nature [...]. If words did not exist, then neither would the world itself. My ego, once detached from its surroundings, ceases to exist. By the same token, the world, if detached from me, also ceases to exist. "I" and the "world" arise only in the process of their union in sound. Supra-individual consciousness and supra-individual nature first meet and become joined in the process of naming. Thus consciousness, nature, and the world emerge for the cognizing subject only when he is able to create a designation. Outside of speech there is neither nature, world, nor cognizing subject. In the word is given the original act of creation. The word connects the speechless, invisible world swarming in the subconscious depths of my individual consciousness with the speechless, senseless world swarming outside my individual ego. The word creates a new, third world: a world of sound symbols by means of which both the secrets of a world located outside me and those imprisoned in a world inside me come to light ... In the word and only in the word do I create for myself what surrounds me from within and from without, for I am the word and only the word.[40]

Bely's ideas about the magic word reiterate many ideas Friedrich Schlegel had proposed a century earlier. Schlegel referred to poetry as a "magic wand" (*Zauberstab*); he also described wit—a key attribute of *Universalpoesie*—as "fragmentary geniality" or "selective flashing" in which a unity can momentarily be seen.[41] His fascinating novel *Lucinde* was an allegorical work, and the author described allegory as a finite opening toward the infinite ("every allegory means God"). Furthermore, Schlegel's *Universalepoesie*, as we have seen, refers to the hieroglyphical mode of writing. Here is how Schlegel described that mode of writing:

> according to the explanation we have given of it, a symbolical representation by means of the initial letters of words. In it and through it even that which is most ordinary and common assumes a mystical character, and passes into this wonderful, imaginative, and emblematical sphere. Now the solution of this general problem lies even in this: that this (x)—this incomprehensible (x)—as the eternal Logos of the incommensurable Godhead, became also (a), (that is to say, took on Him a human life and nature,) and is even now fully and really such ...
>
> But however we may attempt by means of this or any other scientific or figurative illustrations to apprehend or to express the ineffable, the fact, and above all, a living faith in that great verity, that the divine (x) has become a human (a)— that the eternal Logos actually and really took upon Him the nature of man, and

still retains it, is the point from which a new and higher life commences. It is the ring which holds together the whole human family;— the first link in the chain of spiritual life, to which all must be referred and from which all is to proceed.

Thus, then, beginning with the emblematical representations of the fine arts, and developing the idea through several other spheres of its manifestation, I have carried the symbolical significance of human life up to the highest hiero-glyphic of all existence ... It now remains for me to exhibit it as the word which shall solve all difficulties in the problem of human existence, and shall prove an unerring guide in the conflict of life and in all its most important relations and perplexities ... For not only does it hold true of the higher pursuits and inmost being of individuals, but it has also an universal application. For this highest of all hieroglyphics, which is the beginning of a new life, forms also the foundation of the date in its sacred character.[42]

And:

In the same manner the fiery wain of divine revelation as it passes on its way scatters in single words and images many a bright spark. The radiant shadow of the word of God as it falls is sufficient to kindle and throw a new light over the whole domain of nature, by means of which the true science thereof may be firmly established, its inmost secrets explored and brought into coherence and agreement with all else.[43]

And finally, concerning the magic of language as such, and its contrast to the languages of man:

It is possible that this immediate language of mind, as a secret and invisible principle of life—as a rare and superior element—is contained also in human language, and, as it were, veiled in the outer body, which, however, becomes vis-ible only in the effects of a luminous and lofty eloquence, in which is displayed the magic force of language and of a ruling and commanding thought. Taken on the whole, however, human speech is no such immediate and magically working language of mind or spirit. It is rather a figurative language of nature, in which its great permanent hieroglyphics are mirrored again in miniature, and in rapid succession.[44]

For Bely, this "image symbol" was connected with metaphor—in "The Magic of Words" he went on to say: "The word begot myth; myth begot reli-gion; religion begot philosophy; and philosophy begot the term." These ideas would be central to Eisenstein's later theories.

Like other Symbolists, Bely believed that the word—at least, a poetic word—has magic powers. For him, naming was a magic act by which the artist con-trolled the hostile and unintelligible world pressing in from all sides. The con-nections among words were essentially charms.[45] Though he drew these ideas from natural magic, they were not so remote from Eisenstein's scientific and

technological enthusiasms. Eisenstein's commitment to the propagandistic use of film can fairly be characterized as a belief in art as magic (to adopt a phrase from the great philosopher of art, R.S. Collingwood): Andrei Bely and Konstantin Balmont (1867–1942) might have believed that verse is directed toward the goal of changing nature, but Eisenstein maintained that film was directed toward the task of changing consciousness and thereby changing society. Like the Symbolists, he was convinced of the possibility of charming the new world into existence.

EISENSTEIN, BELY, RUSSIA, AND THE MAGIC OF LANGUAGE

Eisenstein's interest in the phenomenon of religious ecstasy had roots in the Symbolist movement as well. A nineteenth-century movement, the Slavophiles, stressed the differences between Russia and "the Latin West" (this, despite the influence on them of European Romanticism, even if it was of a Herderian variety); they also cast rationality in the role of an intruder from the "bourgeois West."[46]

The appearance of Bely's *Serebrianyi golub* (The Silver Dove) renewed interest in these Slavophile beliefs. Bely began the novel when he was living among peasants in Bobrovka, cut off from what he deemed the decadent avantgarde cultures of the large Russian cities and of the West by miles and miles of forest. As he surrounded himself with ordinary people, he felt himself in touch with profound truths about life—truths that made his country unique among all. Europe, he argued, was a culture based on book learning, while Russia was a land where the people could grasp unspoken truths. Cosmopolitan learning—wide learning of *any* sort—made it impossible to grasp the inner truths of pneumatic life. Russian peasants were different from the people of "civilized" Europe—they were acquainted with raw passion rather than romantic love, with superstition (mythic knowledge) rather than book learning, with dark secrets rather than Enlightenment understanding. Only on a higher spiritual plane could the ineffable knowledge of the inner life be reconciled with the abstract learning of Europe. The grafting of the West onto Russia would bring about the Apocalypse, when the Holocaust would engulf Europe and Russia and out of the ashes of the dead the Firebird would fly. The Firebird, of course, symbolized the coming transformation.

Rudolf Steiner endorsed the Slavophiles' belief in the special character and vocation of the Russian people. He maintained that the Russian masses carried in them the seed of the coming civilization (an idea that Kandinsky also held). He also argued, remarkably, that Russian thinking is intrinsically dialectical, holding together mysticism and rationality (a trait that Eisenstein's thinking certainly displays). Steiner also believed that the Russians were open

to the continual influx of the "Christ-impulse," a characteristic he saw exemplified in Solovyov's philosophy/religion. The amalgam of philosophy and religion in Solovyov's philosophy typifies the fusion of reason and revelation, rationality and mysticism, that is so characteristically Russian. Reason, Steiner asserted, had hypertrophied in the West, and non-intellectual consciousness had become overdeveloped in the East; Russian thinking held the two in a synthesis.

The Slavophiles' interest in a distinctive Russian culture led them to pursue studies of native folktales, myths, and legends, many of which depicted the activities of supernatural beings or alluded to supernatural forces commanded by peasant dual faith (*dvoverie*), a syncretic belief system that combined Slavic paganism with Christianity. The non-rational belief systems and orgiastic rituals of many sectarian cults impressed the Symbolists, just as the shamanism of the region fascinated several turn-of-the-century revolutionaries who had been exiled to Siberia—and who wrote studies of their practices. Among those interested in these anthropological findings was Eisenstein, and shamanistic symbols appear in some of his films. Shamans induced trances (sometimes by using psychotropic agents) in which seekers had the sensation of leaving their bodies and travelling to another world to receive the learning that would allow them to heal this world. Aleksandr Blok, an admirer of Solovyov, plainly declared that the Symbolist poet is a theurgist: like the alchemist or the poet, the Symbolist, through sound, rhythm, and rhyme—and, more important, through correspondences between verbal sounds, rhythms, and rhymes and the natural world—could penetrate the mysteries and unblock the way to redemption. In true Schopenhauerian fashion, the Symbolists argued that their attunement to poetic language gave poets access to a realm beyond space and time.[47]

The Russian Symbolists placed great faith in the magic of language. Many of them proposed a glottogenetic cosmology and maintained a theurgic conception of language. They dreamt of a perfect language in which the natural object would be the truly adequate sign, or, failing that, in which the sign, through its magic powers, could conjure up the object. This conception of language, to be sure, has affinities with cinema, in which the natural object serves as a sign and the sign itself conjures up (or at least can *seem* to conjure up) the natural object itself. Influenced directly by Potebnia and Solovyov, and indirectly by the medieval tradition of realism (concerning linguistic universals), Bely maintained that owing to the special link between words (names) and their referents, the use of language affects reality—that is, the use of words brings the objects to which they refer into being.[48] "Language is the most powerful instrument of creation," he wrote in "The Magic of Words." "When I name an object with a word I thereby assert its existence. Every act of cognition arises from a name. Cognition is impossible without words."[49] Audaciously, he asserted that "the word ... creates causal relations, which are cog-

nized only subsequently... If words did not exist, then neither would the world itself."[50] All this should lead one to conjecture that his conception of language, and that of the later Russian Symbolists, was massively overdetermined, reflecting as much a theurgic tradition as a pervasive Romanticism, as much a pagan spirituality as a conception of language, and—most important for our purposes—as much the birth of cinema as that of linguistic theories.

Aleksandr Potebnia's influence is clear in an opposition that Bely develops in "The Magic of Words" between the "living word," the "word-as-flesh," which he characterizes as a flourishing organism, and the "word-as-term" (*slovotermin*), which he characterizes as a "dead crystal formed as a result of the completed process of decay of the living word." The "common prosaic word, that which has not yet lost its quality of acoustic and painterly imagery and not yet become an ideal term, is a putrid, decaying corpse." Our speech and thought is permeated with decaying words, which poison us. We long for rebirth of the word—and it will occur, with Symbolism.

Bely believed deeply in the magical and incantatory powers of language. He believed that when the word is still a "living word," it possesses special powers—powers that it will once again claim when it is reborn in Symbolist verse. Two years before a collection of Bely's essays appeared, Blok, in "Poeziia zagovorov I zaklinanii" (The Poetry of Spells and Incantations, 1908), had pondered the vital belief in the word that characterizes the ancient soul. The ancients had faith in the word and in the power of incantation because they did not think of human being as separate from nature—nor did they conceive of subject and object, word and deed, as separate. Five years after Bely's collection appeared, Balmont considered the theme of incantations in *Poeziia kak volshebstvo* (Poetry as Magic, 1915).[51] Balmont exhorted his readers to refind within themselves the primal power of casting spells; from that would emerge the word's innermost voice, which would speak magically.

Later Russian Symbolists, especially those who welcomed the Bolshevik Revolution as a means of bringing about the new world, took great interest in Richard Wagner's theatre. They recognized his path, from Feuerbach to Schopenhauer to Christ, as one they too wanted to traverse. They were also impressed with his concern to effect a new synthesis, "a new organic society." Eisenstein shared their interest in Wagner, though except for his recognition of the synaesthetic potentials of the Wagnerian *Gesamtkunstwerk*, we do not know much about the grounds for his intense interest in the dramatist-composer. This much, however, we do know about Eisenstein: he was deeply affected by religious emotions in his early childhood, and his friends in the civil service used to call him, even as an adult, "*pravoslavnyi* [Orthodox] Eisenstein" because of his Orthodox zeal. As for Eisenstein's self-conception, paraphrasing Anatole France, he called himself an Orthodox who had ceased to be a Christian.[52] Sergei Mikhailovich was an only child and had been raised

by a Christian governess and his grandmother, a devout and domineering woman who introduced him to many superstitious and popular religious notions. He would remain deeply superstitious all his life. At an early age, he was impressed with the emotions stirred by the Orthodox liturgy:

> When at Mass, Father Nicholas, dressed in a silvery chasuble and with his arms raised heavenward, stood in a cloud of incense pierced by the slanting rays of the sun. As he performed the sacrament of the Eucharist, the bells, certainly prompted by a mysterious force, pealed from the lofty belfry, and it actually seemed that the heavens had opened and grace was pouring out upon the sinful world.
>
> From such moments springs my lifelong weakness for the ornate in religious services.

Few can watch *Alexander Nevsky* or *Ivan the Terrible* without recollecting something of the emotions that liturgy induces. In this context, one is likely to remember the priest and mathematician Pavel Florensky's argument, launched just after the Revolution, that the Orthodox service should be preserved because it was a total art form involving all the senses. We should not forget that Florensky, like Kandinsky, was a bridge between the Symbolist phase and the avant-garde phase in Russian cultural history.

RUDOLF STEINER'S ANTHROPOSOPHY
AND THE AVANT-GARDE

Much as in the present day among esoteric and occult groups, the teachings of the various turn-of-the-century groups were not distinct: members belonging to one group often borrowed from other groups' teachings, and different groups sometimes drew on common sources. One group active in Russia in the early 1920s was the Anthroposophists. Steiner's ideas on transmutation were similar to Fedorov's (and were likely one ingredient in that complex of notions from which Eisenstein borrowed). Goethean ideas found widespread acceptance in nineteenth- and early-twentieth-century Russia. One of the bases for Steiner's system was Goethe's ideas on metamorphosis: Goethe had argued that the whole of an organism is contained in every one of its parts; thus, the laws of the cosmos were embedded in every element of every organism.[53] Eisenstein's claim that shots in a film are not like bricks laid end-to-end but rather are like cells in an organism reflected similar beliefs.[54]

But Anthroposophy had an even more surprising resonance in Eisenstein's theory and practice. Steiner taught a form of movement, known as eurythmy, which became popular in Russia in the 1910s and early 1920s (when Anthroposophy was banned). This discipline, too, was based on Goethe's notions about metamorphosis: one moves according to the musical laws that pervade the cosmos, and through this identification incorporates the cosmic dynam-

ics in every facet of one's being. Russian Symbolists proposed similar ideas about the musicality of the laws determining the dynamics of the cosmos. The same idea resonates in Kandinsky's proposition that the more closely an art form approaches music, the more nearly it approaches the final revelation; and that the more spatial or material it becomes (the more it becomes like architecture), the more static and the more distant from the final revelation it becomes.

ROSICRUCIANISM AND THE THEORY OF TRANSFORMATION

Eisenstein also took an interest in Rosicrucianism, which teaches an esoteric, mystical gnosis. A related movement, Freemasonry, has been popular in Russia since the mid-eighteenth century—readers of *War and Peace* (bk. 2, pt. 2) will recall Tolstoy's suggestion that Freemasonry played a significant role in stimulating Russian intellectual thought. The reforms of Czar Peter II (1715–30) led to many Western philosophical and cultural ideas being introduced into Russia, including Freemasonry. Soon, several Masonic lodges were propagating occult and kabbalistic ideas. The extraordinary alchemist-kabbalist le comte de Saint-Germain (1710–1784), whom many referred to as "der Wundermann," was in St. Petersburg in 1762 and participated in the conspiracy to make Catherine the Great Empress of Russia. During Catherine's reign (1762–96), the Masonic tradition grew in scale and influence. Many in the aristocracy and intelligentsia took up Rosicrucianism and, later, Martinism.[55] Le comte de Saint-Germain himself became a close friend of Count Alexei Grigoryevich Orlov (1737–1808) and was made a Russian general, taking the astonishing name "General Welldone." Russia's national poet, Alexander Pushkin, joined a Masonic lodge in 1821 (these lodges were officially proscribed the following year, during the obscurantist reaction near the end of the reign of Alexander I—himself a one-time Freemason).[56] In 1912, while melancholic, the great Symbolist poet Blok wrote an opera, *The Rose and the Cross*, that referred repeatedly to the practices of Rosicrucianism, an esoteric faith that, like Theosophy and kabbalism, was revived during the Russian Symbolist era: astral projection, aura reading, hypnotism, meditation, all were Rosicrucian practices.

The Decadent movement also influenced the social environment. Maria Naglowska (1883–1936), a member of the St. Petersburg aristocracy, referred to the cultural atmosphere of the time as decadent and "fiendish." This was after encountering the Khlysty sect—a mystical and messianic sect that practised orgiastic rites. That atmosphere spread to the Czar's court. "Papus" (the pseudonym of Gérard Encausse) visited Russia three times, in 1901, 1905, and 1906, serving Nicholas II and Alexandra as both a physician and an occult consultant. He is said to have conjured up, in October 1905, the spirit of Alexander III, Nicholas's father, who prophesied that Nicholas would meet his downfall at the

hands of revolutionaries. Papus is reported to have told the Czar that he could avert Alexander's prophesy with magic so long as he was alive (his claim proved accurate: Nicholas kept his hold on the Russian throne until 141 days after Papus's death).

Though Papus served the Czar and Czarina in an essentially shamanic capacity, he became concerned about their heavy reliance on occultism to assist them in formulating government policy. During their later correspondence, he warned them many times against the influence of the Siberian *staretz* (dervish, wandering monk) Grigori Yefimovich Rasputin (1871–1916). The "Black Monk," who was acquainted with the Khlysty and Skoptsy sects, has been greatly slandered: the exceptional influence he exerted over the hysterical Czarina and the irresolute Czar was the result of the gratitude the two felt for him because of his remarkable faculty for inducing hypnosis, which he applied to treat their haemophiliac son, the Czarevich Alexei. Had Rasputin not been murdered (with extreme difficulty, as evidenced in his almost supernatural resistance to poisons and bullets) by a group of jealous aristocrats, he would likely have obtained Russia's withdrawal from the war, and the Romanov family would have avoided creating the conditions that led to the outbreak of the Bolshevik Revolution, and their tragic destiny.

Yet legend does persist: Rasputin had turned toward the spiritual life when he encountered a renegade sect among the Orthodox at Verkhoturye Monastery. That sect's adherents, the Skopsty, believed that the only way to reach God was through sinful actions: once a sin had been committed and confessed, the penitent could achieve forgiveness. Sin, for them, was necessary to drive out sin. The young Rasputin would not have a place among the most benign, or even the most chaste, young men of his time; but the sinning peasant was guided by the doctrine that the gravity of his sins (and the ardour of his confession) placed him among those most eligible for salvation. The debauched, lecherous peasant donned monk's garb, developed his own self-gratifying doctrines, and travelled the country as a *startsy*—that is, a spiritual adviser, not necessarily a priest, whom people turn to for advice. He could claim that status without having to forsake sin. Rasputin is only one late example of monks serving as spiritual advisers—a tradition that Eisenstein referred to in "Le Bon Dieu," which some saw as a form of orthodox esoterism.

Freemasonry and Rosicrucianism were widespread in Russia in the decades before the Bolshevik Revolution. Nicholas Nikolaevich Astrov (1868–1934), the one-time mayor of Moscow and a member of Denikin's government during the Civil War, was a Freemason; so were Alexander Feodorovich Kerensky (1881–1970) and his minister Alexander Ivanovich Konovalov (1875–1948). Though Freemasonry was still officially proscribed, by 1906 the Freemasons in Moscow and St. Petersburg were once again well organized. About fifteen prominent Russians, most of them members of the Constitutional-Democrats

Party (KaDets), became Freemasons in France and subsequently established new lodges in Russia. The North Star Lodge (in St. Petersburg) and the Renewal Lodge (in Moscow) were founded, albeit with the greatest caution. Prominent members of the forward-looking urban intelligentsia entered these and other lodges: scientists, lawyers, writers, Duma members, and so on. Three years after these groups were founded, the Russian secret police discovered their activities and the members ("brothers") once more had to go underground. During the First World War the monitoring of Freemasons became less strict, and by 1917 there were about thirty lodges all over Russia. The influences of Western-style occultism, Iranian/Zoroastrian Cosmist ideas, and alchemical notions met in the city of Kaluga, the historical centre of the Theosophical Society in Russia.

The Russian esoteric and spiritual tradition survived the Bolshevik Revolution. The proclamation of historical materialism and the dialectics of Marxism, state-mandated atheism, and the new system of governance did not erase these doctrines (though it sometimes forced them to take shelter behind another name). Artists and intellectuals hid their interest in these topics but did not one and all surrender them. Eisenstein engaged in a deep and profitable study of alchemy, the Rosicrucian tradition, and Gnosticism. The writer Vsevolod Ivanov (1895–1963), who earlier had written lyrical prose about the Civil War in Siberia, fell under the influence of occult ideas, a development reflected in his *Taynoye taynykh* (The Secret of Secrets, 1927) and especially in the semi-autobiographical *Pokhozhdeniya fakira* (The Adventures of a Fakir, 1934–35), a work filled with references to magic, hypnosis, and Eastern mysticism. The great Mikhail Bulgakov (1891–1940) introduced enigmatic references to numerological codes and kabbalistic gematria into most of his works and visited Faustian subjects and demonology in his masterpiece, *Master i Margarita* (The Master and Margarita, a book on which he worked throughout the 1930s, though it was not published until 1967).[57] Even the Socialist Realism of Maxim Gorky (1868–1936) was indebted to a sort of positivistic occultism based on modern studies of thought transfer, hypnotic suggestion, psychophysical energy emanations, and parapsychology.

Eisenstein, as we have noted, was not immune to this secret enthusiasm for occult investigations. He was introduced to the Rosicrucian sect by the Freemason Pavel Arensky (son of the composer Anton Arensky) and in August 1920 was initiated into the order. While travelling as a volunteer with a Red Army engineering unit during the Civil War, he saw a poster announcing a lecture by a Professor Zubakin on Bergson's theory of laughter.[58] The young Eisenstein was intrigued by the announcement and returned the following day. Zubakin appeared dressed in the long black cloak, black hat, and black gloves of a Rosicrucian bishop (Zubakin had adopted the name "Bogori II" for this role); his appearance so impressed Eisenstein that the film

director-to-be attended initiation ceremonies and became a knight of the Rosicrucian order.

Afterwards, Eisenstein and a few others were taken to a small room in a military barrack housing rowdy Red Army soldiers. An assistant announced that the bishop would receive them. Bogori II entered and washed the feet of his prospective proselytes. The bishop said a few words, then the proselytes linked hands and walked by a mirror that, Eisenstein remarked facetiously, sent the integrated group into the astral.[59] In the following days, Bogori II systematically instructed his new knights in occultist principles, arcana, and the tarot, gave lectures on Rosicrucianism and its connections to Freemansonry, spoke about Egyptian magic and the Kabbalah, and told of secret Russian lodges. Eisenstein reported to his mother that Zubakin could see each person's astral and read a person's secret thoughts; Zubakin's knowledge, he enthused, was without bounds.[60]

Another initiate who participated in the Rosicrucian ritual held that day in Minsk in 1920 was the director Valentin Smyshlyaev, who the following year mounted a Proletkult stage production of *Meksikanets* (The Mexican), on which Eisenstein worked as set designer. Eisenstein, in his work on the play, strived to break the conventions of bourgeois theatre by proposing that a boxing ring be built inside the theatre and that all the participants in the bout, save the protagonist, wear masks or grotesque make-up. The idea was not accepted. Despite the enormous success of the play, Eisenstein felt cheated by Smyshlyaev's traditional Moscow Art Theater approach.[61] Nonetheless, this artistic involvement with a Rosicrucian friend would have a strong an impact on Eisenstein— indeed, working with Rosicrucians at crucial junctures would become something of pattern throughout his career.

WHAT WOULD EISENSTEIN HAVE HEARD
IN A ROSICRUCIAN LODGE?

Rosicrucians generally claim that their teachings have their origins in esoteric Egyptian temple teachings, which declared the Sun to be the symbol of the great reality, of love, truth, and light. They contend that in turning to these Egyptian teachings, they are returning to the source of Western philosophy, for Thales, Pythagoras, and Plotinus—so they point out—had all studied the doctrines of the Egyptian mystery religion. They contend that history has obscured these truths and that as a result, Western philosophy has developed in the wrong direction. A few, however, remain aware of these great teachings and pass them on from disciple to disciple. They claim that during the time of Charlemagne (742–814), the French philosopher Arnault introduced esoteric doctrines into France; they also claim that during the medieval period, mystical knowledge was widespread, albeit often couched in symbolism or other-

wise disguised. For example, it was hidden in troubadours' love songs, in alchemical formularies, in the symbolical system known as the Kabbalah, and in the rituals of knightly orders.

A Rosicrucian document titled *Corpus hermeticum*, a compendium of esoteric doctrines, played a seminal role in the revival of hermetic philosophy in the sixteenth century.[62] Alchemy—the art of transmutation—holds an especially prominent place in Roscrucianism (as prominent a place as the idea of transformation held in Eisenstein's theories and practices). Alchemy had its origins among the Alexandrian Greeks (though versions were found in India and China, and pre-Hellenic Egyptian papyri describe alchemical operations). The earliest date one can be sure of in alchemy is that of the treatise of Bolos Mendes (the pseudo-Democritus), who wrote in the second century before Christ. (That text survives only in Syriac and is frightfully obscure. It imposes on the proto-alchemists who might read it the condition that nothing of what it expounds be exposed clearly to anyone.) A collection of magical papyri is housed in Leyden; among these are proto-alchemical tracts. The library at St. Mark's, Venice, in a tenth-century collection that comprises volumes on Egyptian magic, Greek philosophy, Gnosticism, Neoplatonism, Babylonian astrology, and pagan mythology, holds several Greek alchemical writings that deal with the transmutation of metals (and the fabrication of false jewellery). It is interesting that these alchemical texts (recipe books in the art of fraud, many of them) are grouped with hermetical tractates; it seems that Byzantine and Egyptian librarians already understood their connections with Gnostic, Neopythagorean and Neoplatonic literatures.

The Arabs drew alchemical ideas from the Greeks, who in turn transmitted them to Europe. European alchemists and the Knights Templar (the latter came into contact with the Arab world during the Crusades) brought alchemy to the West. Renowned alchemists who were also Rosicrucians include Paracelsus, Cagliostro, Nicholas Flamel, Robert Fludd, and Roger Bacon and his archrival, Albertus Magnus.

The popular understanding is that alchemy focused on efforts to turn base metal into gold; in fact, alchemy was more concerned with changing the base elements of human character into more noble virtues and with releasing the wisdom of the divine self. The alchemist projected the process of psychological individuation onto the phenomenon of chemical transformation: releasing philosophic gold from base metal is a metaphor for the psychological processes involved in releasing a person from life's basic contradictions. These contradictions are the result of an inadequate, dualistic view of reality: a truer vision of life interprets reality monistically and proposes that the conciliation, on a higher plane, of contradictions is a developmental process, one through which the *homo maior* (the human endowed with eternal youth) emerges. The *homo maior* can also be identified

with the integrated personality of the Gnostic Anthropos—that is, with the original of the Androgyne—and with the Rebis, the double thing of Alchemical literature, for individuation comes partly through overcoming the male–female duality at a higher level of integration.[63] (Eisenstein's troubled relations with his homosexual urges might well have been why Rebis appealed to him.)

The origin of the name "Rosicrucian" is contested. Some say that it derives from the order's symbol, which combines a rose and a cross, and that it has a doctrinal significance associated with the Rosicrucian proverb "No cross, no crown" (i.e., one reaches the "rose" [the divine] only through the "cross" [earthly suffering]); others say that it stems from the name Christian Rosenkreutz (1378–1484), reputedly a wise man who studied numerology, magic, alchemy, and the Kabbalah, and to whom the order claims to trace its history. Claims for such provenance are doubtful, however, for there is no record of the order's existence before the early seventeenth century, when two pamphlets were published, one in 1614 and one in 1615, announcing its existence. These pamphlets celebrated the discovery of Rosenkreutz's tomb (supposedly in 1604, 120 years after his death) and proclaimed that many records and inscriptions found therein provided the basis for a general reformation of knowledge that would better society and lead humankind back to the state of Adam in Paradise.[64]

The two pamphlets were titled *Fama fraternitatis Rosa Crucis* ("Fama" has many and contradictory meanings, but the title likely means "News of the Fraternity of the Rose-Cross") and *Confessio fraternitatis* (Testament of the Fraternity); they were probably written by Tobias Hess (1568–1614) and the Lutheran theologian Johann Valentin Andreae (1586–1654). Hess was a lawyer and a theologian (his study of the Bible led him to conclude that it contained a secret chronology according to which humanity evolved through three eras: those of the Father, the Son, and the Holy Spirit, the last of which he referred to as the "Triangle of Fire") who had predicted that 1620 would mark the beginning of the Era of the Holy Spirit). Hess was also a Paracelsian medical doctor learned in esoteric lore. Andreae belonged to an important Lutheran family in Tübingen. Both texts displayed a peculiar amalgam characteristic of Rosicrucianism, one that combined Christian Kabbalism with Pythagorism and Paracelsian teachings. The pamphlets declared that the world had entered the age of Mercury, the "lord of the World," and that an Adamic language would soon be revealed through which hidden secrets of the Bible and creation alike would be disclosed.[65]

In 1616 a third document was "discovered" and published in Strasbourg (it was almost certainly written by Andreae): a novel about Rosenkreutz that became the real charter of the Rosicrucian movement. This text, *Chymische Hockzeit Christiani Rosencreutz: Anno 1459* (The Chemical Wedding of Chris-

tian Rosenkreutz in the Year 1459), describes the life of a mythic character who is said to have lived for 106 years, from 1378 to 1484. The term "chemical wedding" refers to the fusion of Sulphur and Mercury to produce gold. This transmutation of base elements into gold serves as an allegory for the inner journey of transformation.

Rosicrucianism spread through Europe with astonishing speed. The philosopher/mathematician René Descartes was influenced by members of the Rosicrucian Brotherhood.[66] The need to keep that brotherhood secret probably originated in the fact that the organization was antinationalistic (on the grounds that humans everywhere are alike and that political institutions should reflect this) as well as anti-Catholic (on the grounds that the Catholic Church had taken positions in opposition to the science of Copernicus and Kepler, both of whom rejected the Jesuit position that the earth was the centre of the cosmos). This latter opposition would have brought members up against the Inquisition. The Jesuits placed one Adam Hashmayr in irons on a galley for publishing the *Fama fraternitatis*.

Even in the late nineteenth and early twentieth centuries, Rosicrucianism incorporated many alchemical ideas.[67] Thus, just as alchemists propose to harness decay and regeneration to their ends, Rosicrucianism (like Russian peasant religion) embraces the idea that salvation is a cleansing process.[68] The alchemical quest starts with a search for the *materia prima*, an unformed, base material from which gold can be drawn. Prime matter has two essential properties, Philosophic Sulphur and Philosophic Mercury. Alchemists presented these two properties as masculine and feminine aspects of matter, and alchemical illustrations often symbolized the two as King and Queen, or the sun and the moon. The goal of the alchemist in the laboratory was to separate, refine, and purify these two properties. Alchemical engravings often figure the relation between the two properties as a romance that culminates in their intercourse and the birth of their child, the philosopher's stone. *The Chemical Wedding* recounts just that tale.

The literal transmutation of base metals into gold is only the most external and physical meaning of alchemy. In its inner, esoteric meaning, transmutation stands for spiritual change. Gold, as the last stage in a chain of transmutations, symbolizes the soul's perfection. During the seventeenth century, alchemical symbolism and (in some measure) alchemy's esoteric teachings (along with those of the Kabbalah and natural magic) penetrated the literary world; consequently, it had a major influence on modern poetry. The Romantics took up kabbalist and alchemical doctrines and handed them down to nineteenth- and twentieth-century poets. In the twentieth century, the commentaries of Carl Jung and Mircea Eliade on alchemy reinforced the importance of its repertoire of symbols.

MODERNISM AND REVOLUTION

Like the alchemists, Rosicrucians emphasize the importance of gaining control over the natural war between opposites. They maintain that when one controls this strife, an exalted conjunction occurs that has as its issue the sublime hermaphrodite. Eisenstein treated these Rosicrucian symbols as image-forms that needed to be interpreted if they were to reveal deep truths about reality. He adapted the Rosicrucian idea of strife between opposites by understanding it as an adumbration of the concept of the dialectic. Likewise, he adapted the Rosicrucian/alchemical idea of transmutation by understanding it on the model of Formalist ideas about the transformation of the aesthetic element by its context. And he reworked the Rosicrucian idea of the hermaphrodite into the idea of the mutual interpenetration and transformation of shot attributes in the *coniunctio* of montage. More than that, he viewed Wagner's *Die Walküre* as a drama about the non-differentiated state of early humanity, symbolized by the unity of the sexes—thus, a sketch for the world tree he prepared for a production of that work he hoped to mount shows Siegmund and Sieglinde as "united in the coniunctio," while in another, depicting a proscenium ring enclosing a little Valhalla, the ring takes the form of Uroborus, that famous alchemical symbol of the unity of opposites.[69] Eisenstein repeatedly proposed (most notably in "A Dialectical Approach to Film Form") that the antithetic pairs that filmmaking brings into a dialectical relation are nature and industry (activity), inertia and dynamism, base matter and high abstraction— and that the *coniunctio* of these dialectical pairs is transformative.[70] Thus, through a transformation akin to that which the alchemist practises, inert representations become active images, themes become texts, pieces of literature become active film compositions, individual frames become dynamic entities. He searched obsessively for a higher, "rational" principle that could transfigure elemental and unconscious nature.

ROSICRUCIANISM AND EISENSTEIN'S AESTHETIC THEORY

Sergei Yutkevich, a film director who in the early 1920s worked with Eisenstein on theatre projects, broke with the ideas of Eisenstein and montage theorists (and their efforts to identify the essence of cinema). The terms in which he couched his criticism are telling:

> Nowhere is there so much search for a philosopher's stone, so much quasi-medieval scholasticism as in the problems of cinema theory. Working as they were in a new art, the artists and innovators really needed to recognize and establish its specific quality. In its time it was montage which was named the philosopher's stone of cinema, and it was furiously defended, as much in theory as in practice, as the major element in the specificity of the new art.[71]

The reference to the philosopher's stone is perhaps more than a figure of speech: naming the true basis of an opponent's position through what presents itself as a simple trope is one of the features of writing in an age of persecution. This much certainly is true: the alchemical/Rosicrucian tradition understands evolution as a working out of the tensions between ascent and descent (analogues of the processes of *solve et coagula*, separation and rejoining). Eisenstein's effort to work out the relation between the regressive and the progressive strains that are simultaneously involved in an artwork, between the archaic and the highly evolved, invoked a similar idea:

> The influence of an art work is based on the fact that in it you have two processes going on simultaneously: a swift progressive ascent along the line of the most developed ideological level of consciousness and at the same a descent through the structure of form down to the deepest layer of sensuous thinking [*chuvstvennoe myshlenie*]. The polar cultivation of these two lines of aspiration creates the remarkable tension in the unity of form and content, which characterizes the true work of art.[72]

Eisenstein stressed that the dialectics of an artwork involve a curious doubleness. That is, two processes are occurring simultaneously: a rapid, progressive ascent to the most developed lines of ideological (or theoretical) intelligence, and at the same time a descent through structure to the deepest level of sensuous thinking (*chuvstvennoe myshlenie*). This descent/ascent relates to the primal mystery experience, of which the Demeter–Persephone myth forms the archetype; it also connects with the experience of death and rebirth, cycles that are key to Rosicrucian cosmology. The extent to which Eisenstein dwelled on the theme of the primal experience has troubled commentators, who often have resisted deliberating on the links between deeper levels of sensuous thinking and the occult. Indeed, the extent to which he dwelled on this theme reveals the importance he attached to the dark and violent forces that lurk in an artwork and in the human psyche. His principal goal for his later art theory was to plumb the depths of the non-differentiated human psyche, to retrieve the treasures of the deepest layer of sensuous thinking and then incorporate them into a *Gesamtkunstwerk* that would redeploy their powers, turning them toward the cultivation of ecstasy.

Eisenstein even expressed his theoretical endeavours as a confrontation with mystery:

> First master art.
> Then destroy it.
> Penetrate into the mysteries of art.
> Unveil them.
> Master art.

Become a master.
And then snatch off its mask, expose it, and destroy it![73]

Recall here the Gnostic apothegm which states the antithetical conception that underlies this transformational impulse: "Everything that can be broken should be broken." One might equally recall the alchemical idea that the destruction of the self (*mortificatio*) is a stage on the route to redemption. Eisenstein's thinking on film moved on parallel lines: the film artist literally sacrificed certain elements in the old theatrical art so that the new art might emerge.

The stages of alchemical development offer a model of personal growth. The developmental process begins with encountering an event that disturbs the balance between aspects of reality; it then proceeds, by regrouping these sundered aspects, to the development of a new identity; and it culminates in the consolidation of this identity in action. But these are also the stages in a political revolution, and they are similar to phases of a dramatic structure; what is more, these stages mark the parts of the tale that *Battleship Potemkin* recounts.[74] Rosicrucianism, like alchemy, concerns personal transformation and purification; however, it is easy to connect personal purification and social revolution—and Russian newspaper articles suggest that many understood the connection between the two in alchemical terms.

As we have noted, *coincidentia oppositorum* is a key idea in many occult systems, including Rosicrucianism. And not just occult systems: the idea that absolute freedom comes from being released from conditioning by pairs of opposites appears in many of the world's religious systems. Despite their different provenances, and despite the radically different ontologies the two bodies of thought imply, there is an impressive congruence between certain Marxist teachings on the dialectic and religious (including Rosicrucian) teachings on the reconciliation of opposites.[75] Like Marxist dialectical theories, Rosicrucian instruction on reconciling opposites offers the epistemological proposition that any entity or any process can be known only through its opposite (and through bringing the opposites together in a higher synthesis). Like dialectical materialism, Rosicrucianism teaches that each synthetic unity becomes the subject of a new moment of integration—that it forms the antithesis for reconciliation with a new opposite in a yet more embracing unity. And like dialectical materialism, Rosicrucianism characterizes this integrative process as having transformational power—though the Rosicrucian adept places greater emphasis on transforming spirit than does the exponent of dialectical materialism. Like the Hegelian and the Hegelian Marxist, the Rosicrucian adept avers that at the end of the dialectical process, the Absolute is revealed.

According to Rosicrucians, this ladder of ascent has seven stages: *calcination* (accepting our life as we find it and acting in accordance with the principles of morality, justice, and truth); *sublimation* (which involves a switch in

focus from the self to the non-self as we develop the ability to feel the suffering of others); *solution* (a dissolving of the self into a greater whole, during which stage we develop a constant self-consciousness of the sort that Gurdjieff and Ouspensky teach); *putrefaction* (which disturbs the just-formed balance among the elements—indeed, it was putrefaction that first led to the elements' separating; this stage involves the purification of the feelings that our self-attention has brought to the surface); *coagulation* (or sometimes "child's play," the goal of which is to balance the four alchemical elements, earth, air, fire, and water, which balancing strengthens our intuitive capacities so that we can act with confidence); and *tincture* (which grants cosmic consciousness, that is, knowledge of the Absolute); which results in the *coniunctio* (the uniting of the opposites represented in the four alchemical qualities, hot and cold, wet and dry). The purification achieved in this last step results in another cycle's beginning.

One can discern here an extraordinary association of ideas. Largely because of its Christian borrowings, Rosicrucianism teaches that we attain the saving gnosis not by turning away from the world, but rather by recognizing the immanence of the divine principle in the objects of the material realm. The later Eisenstein shared this interest in sympathetic participation. Furthermore, like many other occult groups, Rosicrucians believe that matter is sensate and that there is a conscious energy inherent in all matter that leads all beings to strive for further development. Some of Eisenstein's remarks on the dialectic make the same point. For example, in "A Dialectical Approach to Film Form" he asserts that art is the meeting point of matter and energy; the idea of interacting active and passive principles is a key to that essay. Rosicrucianism, too, teaches the importance of the sensation of sympathetic participation in the life of the universe. Such participation prepares one to experience universal empathy. Cinema itself elicits a similar sort of participation, for it engenders kinaesthetic effects through purely optical means: empathetic experience allows us to experience the life of another's inward sensations through purely pneumatic means. The kinaesthetic experience that cinema induces allows us to experience the sensation of another's movement, of being transported along in the place of the other. Indeed, cinema, by picturing the movements of the farthest reaches of the universe, can make us experience a connection with those far-flung places and, potentially, with the universe as a whole—and it seems to do so by non-material means (and the forms by which it conveys these sensations seem as immaterial as light). Cinema, therefore, is the ultimate pneumatic influencing machine—an idea not too distant from Chaliapin's conviction that the highest purpose of art is to penetrate humans' souls.

The Rosicrucian/alchemical system proposes a progress through solution and putrefaction to coagulation and, finally, tincture; that is, it involves separating elements and then reuniting them in a new configuration. Ideas of

division and conjunction, dismemberment and reconstitution, part and whole, separation and unification, were central to Eisenstein's film theory—indeed, his most basic conception of cinema was that it is a synthesis of the arts: cinema had taken over the other arts, dissolved them into their elements, and reconfigured them.

Rosicrucian doctrines overlapped Eisenstein's interests in another way. He had a deep interest in synaesthesia (an interest that deepened in tandem with his interest in occult forms of experience). He even quoted Karl von Eckartshausen (1752–1803), a German writer, a specialist in magic and the occult traditions, who had built a clavichord that used glass tubes filled with varicoloured liquids, illuminated from behind by glass candles.[76] A key of this instrument, when pressed, lifted a corresponding tube to reveal the colours; the tube then lowered itself and was covered up again while the note died away:

> I have long tried to determine the harmony of all sense impressions, to make it manifest and perceptible.
>
> To this end I improved the ocular music invented by Pere Castel.
>
> I constructed this machine in all its perfection, so that whole chords can be produced, just like tonal chords. Here is a description of the instrument.
>
> I had cylindrical glasses, about half an inch in diameter, made of equal size, and filled them with diluted chemical colours. I arranged these glasses like the keys of a clavichord, placing the shades of colour like the notes. Behind these glasses I placed little lobes of brass, which covered the glasses so that no colour could be seen. These lobes were connected by wires with the keyboard of the clavichord, so that the lobe was lifted when a key was struck, rendering the colour visible. Just as a note dies away when the finger is removed from a key, so the colour disappears, since the metal lobe drops quickly because of its weight, covering the colour. The clavichord is illuminated from behind by wax candles. The beauty of the colours is indescribable, surpassing the most splendid of jewels. Nor can one express the visual impression awakened by the various colour chords.[77]

The Rosicrucians developed a cosmology which proposed that the ultimately real is akin to energy and that this reality vibrates. I have already noted that in the 1930s, a North American branch of the Rosicrucian movement, the Ancient and Mystical Order Rosae Crucis (AMORC), invested much time and expense in building a Colour Organ, the Luxatone, and justified that time and expense in just those terms.

Rosicrucianism teaches that all phenomena are linked by a grand design that becomes apparent in the correspondences among their forms. But Eisenstein thought of aesthetic unity as emerging through the interrelation of dialectical elements.[78] Moreover, Rosicrucianism teaches that that grand design is manifested in hierarchies of ever more encompassing designs. Eisenstein's

ideas about unity were based on similar ideas. His writings (most notably his article on pathos in *Battleship Potemkin*) lay out hierarchies of structures in his films: an artwork's pathos is a totality dependent on the potential of its elements to provoke ecstatic experience; the pathetic effect of the whole then induces a particular psychic state that gives colour to the theme of the artwork and causes it to resonate—"to vibrate," we might say. So we can find echoes of Rosicrucian ideas of synthesis in Eisenstein's earlier writings—ideas are even more obvious in his later writings, especially in "Laocoön," where he uses the alchemical categories of dispersion and reintegration. Those categories provide the very bases of his later theory of montage.[79]

Rosicrucianism also teaches that humans have a latent sixth sense that some have developed and that all will eventually develop. This sense enables its possessor to perceive and investigate the superphysical realms, whither the dead go. It teaches, too, that the earth is an academy to which we are reborn repeatedly, learning new lessons during each sojourn, and evolving toward greater perfection of character and of the powers it confers. The idea of the new human, possessing enhanced sensory powers, was a common one in artistic circles during the Constructivist era, and one that Eisenstein (and Vertov) took up.

CONSTRUCTIVISM AND COUNTERSCIENCE

One should not imagine that such occult interests necessarily arose from an antiscientific animus. Of course, sometimes they did. But sometimes they did not: occult tendencies are also evident in Wilhelm Ostwald's thinking, and Ostwald won the Nobel Prize in Chemistry. Ernst Mach (1838–1916) was also attracted to Ernst Haeckel's (1834–1919) nature/sun worship, his paganism (perhaps authorized in Germany by the precedent that Goethe had set), his *volkisch* tendencies, and his advocacy of eugenics and euthanasia. These ideas belong to the alchemical tradition; and alchemy is a counterscience, perhaps, but it is not an antiscience. Rosicrucians believe in progress and in adapting their beliefs to the times. The system of worship suited to the spiritual needs of one age is unsuited to the altered intellectual condition of another, they posited, and the scientific temperament of modernity is not something that humans should ignore. Besides, the scientific community at the end of the nineteenth century displayed a remarkable acceptance of claims we would now consign to the province of the occult as well as a remarkable desire to discover the physical basis of psychic phenomena.

Among those whose ideas found remarkable acceptance in the late nineteenth century was Franz Anton Mesmer (1734–1815). Mesmer considered himself to be the Newton of the human soul. Mesmerism intrigued a broad range of writers and thinkers in France, Germany, Great Britain, and the United

States, including Johann Gottlieb Fichte, Honoré de Balzac, Guy de Maupassant, E.T.A. Hoffmann, Edgar Allan Poe, Nathaniel Hawthorne, Elizabeth Barrett Browning, and Robert Louis Stevenson. For many French thinkers of the 1780s, mesmerism offered a deep and compelling explanation of nature, one that penetrated to those wonderful invisible forces that give nature its shape; indeed, some believed that it offered insight into the forces governing society and politics. We generally associate the name "Mesmer" with hypnotism, but not until the 1840s was that phenomenon named after him. Mesmer himself referred to it as "animal magnetism" or, earlier on, "animal gravitation." He used the term "animal" because it was associated with the soul, or "anima." Animal gravitation was a matter of attraction, in his view—in fact, he modelled his understanding of animal gravitation on the attraction that physical bodies have for one another (i.e., on gravity) and on the attraction that social beings feel for one another (i.e., "love"). One recalls Newton's remarks about the occult forces of attraction (on which he brought the light of science to bear, even while he thought of them in the alchemical manner).

Newton, however, was not alone in the heterodox tradition in believing that forces of attraction are basic to the constitution of reality: the idea that cosmic magnetism guides the movements of both heavenly and earthly bodies is a venerable one in the German esoteric tradition; it was propounded by both Paracelsus and Athanasius Kircher. Mesmer himself was a Freemason and was probably acquainted with Paracelsus' idea of cosmic magnetism through Freemasonry. Indeed, Mesmer's dissertation at the University of Vienna (M.D., 1766), which borrowed heavily from the work of the British physician Richard Mead (some assess the borrowings as extensive enough to justify a charge of plagiarism), analyzed how the gravitational attraction of the planets affected human health by altering the conditions of an invisible fluid found in the human body and throughout nature.[80] Titled *Dissertatio physicomedice de planetarum influxu*, the thesis argued that the gravitational influence the planets' rotation exercised on human physiology (analogous to the tidal effects the moon exerts on bodies of water) accounted for the periodic incidence of disease. At this time, Mesmer also believed that a body's well-being depended on whether the body's "animal gravitation" was in harmonic alignment with the planets.

Mesmer's teaching spoke of a universally diffused "fluid" (similar in respects to the universally diffused "ether" of Sir William Crookes and Sir Oliver Lodge). This immaterial substance, an "imponderable" (i.e., weightless) fluid, was required to explain the transmission of influence. It courses from person to person and from human to the cosmos, and it holds the key to sickness and health. Mesmer contended that disease resulted from a disequilibrium of this fluid within the body. Cure required redirecting the fluid's course within the body, and this could be accomplished by the intervention of a physician, who served

as a conduit by which animal magnetism could be channelled out of the universe at large and into the patient's body. During treatment, patients experienced a magnetic "crisis," something akin to an electric shock and involving seizures and hysteric fits, from which they recovered cured. Disease was the result of obstacles to the flow of animal magnetism through the body, and these obstacles could be broken by "crises" (trance states often ending in delirium or convulsions). Mesmer conceived of this magnetic fluid on the model of electrical theory; he maintained that it is polarized and conductible and that it could be accumulated and discharged. He believed that "animal gravitation" could be activated by any magnetized object and manipulated by any trained person. By running his hands over the patient's body, the physician searched out the poles of its magnetic fields. He then made passes over the body with magnetized objects, to the end of restoring the harmony of personal fluid flow.

There was a history to the therapeutic use of "magenetic passes" that antedated Mesmer. Maximillian Hell, a Czech-born Jesuit priest who served as chief astronomer at the University of Vienna, influenced Mesmer's ideas by suggesting that magnetism may influence a body. Under Hell's influence, Mesmer began experimenting with magnets. One of the first cases in which he used magnetism for curative ends was that of Fräulein Franziska Oesterlin (a relative of Frau Mesmer). The patient suffered from several recurring conditions, which came and went in regular cycles. Aware that English physicians had used magnets for treating sundry conditions, Mesmer asked Hell for magnets for this purpose, and Hell made some for him in the astronomy department; the magnets had different shapes according to the part of the body they were intended to treat. On July 28, 1774, Mesmer asked Fräulein Osterlin to swallow an iron-rich solution and affixed magnets to her stomach and legs. Oesterlin felt a mysterious fluid coursing through her body, then went into convulsions. Afterwards, her symptoms began to subside. Mermer declared her completely cured after a course of such treatments. These experiments led him to conclude that a clear link existed between his theory of animal gravitation and magnetism as we ordinarily know it: the magnets exerted an effect on patients similar to that which celestial gravity exerts on terrestrial bodies. This led him to change his theory of "gravitational fluid" to one of "magnetic fluid" and to rename his theory of "animal gravitation"; now it was "animal magnetism."

Mesmer's ideas on this universally diffused medium had resonances in the conception of the ether that some of his contemporaries proposed. While Sir Isaac Newton had referred to the ether in both the *Principia* and the *Optics*, he had treated its existence as a hypothesis. Unlike Newton himself, however, many of his followers asserted that the existence of the ether was the only plausible explanation for the transmission of gravity, light, heat, and magnetism. It is likely that Mesmer drew his idea of an imponderable fluid from

Newton's followers—one reason why he declared himself the Newton of the human soul. What makes this "fluid" wondrous, he suggested, is that it can act at a distance just like magnetism. This animal gravitation directs human behaviour just as gravity holds the planets in orbit; so animal magnetism explains how the soul is guided toward love, health, and communication. (Mesmer claimed to have given the therapeutic process a new scientific basis; in fact, he was simply reviving esoteric ideas.) An early critic of Mesmer's work, Michel Augustin Thouret, realized this; in *Recherches et doutes sur le magnétisme animal* (Researches and Doubts about Animal Magnetism, 1784), he traced the idea of a cosmic fluid through Paracelsus (1493–1541), Jan Baptista van Helmont (1577–1644), Robert Fludd (1574–1637), and William Maxwell, a Scottish physician and the author of *De Medicina Magnetica* (ed. George Franco [Frankfurt: Zubradt, 1679]). Paracelsus was especially important in this connection: Mesmer's universal fluid is a relative of Paracelsus' "sidereal force," an emanation of the stars and celestial bodies within man. Mesmer's supporters, of course, countered that Mesmer had himself stated that he gave an old idea a new scientific basis. Nonetheless, Thouret established beyond any doubt that Mesmer's theory was rooted in esoteric traditions: his "fluid" was a modern way of encapsulating long-standing speculations about the nature of "subtle" agents, such as *pneuma*, that are so important in Western esotericism, especially in its view that nature is a vital being. The similarity of mesmeric ideas to the Western esoteric tradition ensured that mesmerism would find supporters among nineteenth-century occultists.[81]

Mesmer's practice thrived. On January 10, 1768, he had married a wealthy widow, ten years older than himself. With his wife's resources and those accruing from his practice, he became a patron of the arts. His Viennese friends included Gluck, Haydn, and the Mozart family—all of whom were Freemasons. Wolfgang Amadeus Mozart presented his first opera, *Bastien und Bastienne*, at Mesmer's private theatre, and Wolfgang's father, Leopold, recorded in a letter his impressions of the magnificence of Mesmer's estate.

Mesmer soon gave up the use of magnets (possibly because he realized that he would have to admit Hell's priority) and claimed that curative fluid could be mobilized by the will of a well-trained practitioner and broadcast to bodies in the vicinity. He began passing his hands over the patient's body, without touching it, and reported that cures resulted. The most dramatic improvements occurred when the patients responded to the magnetic "passes" by succumbing to a convulsive trance. Fits and trances took on an emblematic importance for observers of the "cures," becoming a common entertainment—so much so it roused the ire of the medical establishment in Vienna, where Mesmer had launched his practice. In 1778, Mesmer moved his practice to Paris, where he took a mansion on Place Vendôme.[82] Mesmer's prickly personality and haughty but cultivated manner endowed him with the sort of

presence that was welcomed in those calamitous times that yearned for radical endeavours (France had just been defeated in a war with Britain, corruption was widespread, the economy uncertain, the King weak, and the Queen a spendthrift). High society circulated stories about Mesmer's astonishing cures for a wide assortment of afflictions. "Mesmeric baths" and the *baquet* became conversation topics and were sought out by members of the aristocracy. In 1780, Mesmer announced his intention to leave Paris; the princess de Lamballe and the duchess de Chaulnes were such ardent supporters of mesmerism that they persuaded the queen to offer Franz Anton a lucrative contract to stay in the city (a contract that Mesmer refused). The Societé de l'Harmonie, a secret society (its members had to sign an undertaking that they would not pass on any part of Mesmer's teachings without his written permission, nor would they establish a clinic without his permission), founded for the purpose of teaching mesmeric principles, was established in Paris in 1783. Branches soon appeared in other cities.

Besides guiding the flow of magnetic fluid with the hands, Mesmer's therapeutic regimen also involved the practitioner focusing his eyes on the afflicted parts of the patient's body until the (usually neurotic) patient went into a "crisis." Mesmer believed it was the concentration of the therapist's animal magnetism in his eyes (and the treatment constellation did usually involve a male doctor and a hysteric female patient) that accounted for the regimen's healing power, as that concentration led to a total fusion of the two souls. It is this condition of being totally *en rapport*, "in communication," that is especially important for our purposes. The "communication" of electricity (as it was called) through the human body fascinated people in Paris and London in the late eighteenth century. In one common parlour stunt, people linked hands and "communicated" electricity from the person at the beginning of the line to the person at the end. Mesmer adapted the game for therapeutic (and commercial) ends: patients would gather around a *baquet*—a large wooden tub containing bottles of magnetic metal, stone, and glass—which Mesmer then magnetized (supposedly) by touching or pointing. Around the tub were many large metal rods with handles. The dozen or so ladies and gentlemen of the Parisian *beau monde* grasped them and pressed them against the body as they watched the proceedings.[83] A faint music penetrated the chamber from another room; it would trail off and, to the accompaniment of a glass harmonica, a door would open, revealing a large figure cloaked in a long purple robe embroidered with Rosicrucian alchemical symbols and carrying an iron sceptre in one hand. The figure, Mesmer himself, would look around the room and then, staring at one man, issue the command: "Dormez!" The man's eyes would close and his head fall to his chest. A shudder would run through the other patients. Then the large, purple-robed figure would point his iron sceptre at a nearby woman, and she would succumb, crying out that tingling sensations were coursing

through her body. Soon the others in the circle would experience these strange feelings—some participants would even begin to flail about. Assistants would attend to these patients and take them to the "chambre de crises."

Mesmer became wealthy again. However, his good fortune was short lived: he and mesmerist healing soon fell under suspicion. In 1784 the Royal French Academy of Science set up a committee (which included Benjamin Franklin, Antoine Lavoisier, and J.I. Guillotin, the popularizer of the well-known device for decapitation) to examine his methods. Their report concluded that evidence to support the existence of mesmeric fluid was inadequate. His very public failure, years earlier (in 1777), to cure the pianist Maria-Theresia von Paradis, who had lost her sight at age three as a result of some psychological condition, and some other much discussed therapeutic failures in 1785, brought him into further disrepute.[84] Mesmer's discreditation made the dishabille of his female patients and their orgasmic crises the butt of jokes. Yet despite this reversal in fortunes, mesmerism continued to spread—the academic skepticism about the technique's therapeutic benefits became widespread after the French Royal Panel issued its report on animal magnetism, but this does not seem not to have dampened the public's enthusiasm for the practice.

Mesmer's most important disciple was Armand-Marie-Jacques de Chastenet, the marquis de Puységur (1751–1825), an aristocrat and landowner whom some consider the founder of modern psychotherapy. Working with Victor Race, a young peasant on the family estate near Soissons, Puységur discovered a better form of "crisis" than the intensely convulsive ones that had brought Mesmer disrepute. This "perfect crisis" was a somnambulistic sleep state in which patients carried out the commands of the magnetizer and on reawakening exhibited no memory of having done so. Victor would not normally have dared confide his personal problems to the lord of the manor, but in magnetic sleep he noted that he was disturbed by a quarrel he had had with his sister. Puységur suggested that he try to resolve the quarrel; when he reawakened, he acted on the marquis's suggestion, but without remembering Puységur's instruction.

Such experiences led Puységur to realize that magnetic effects depend on the force of the magnetizer's personal belief in the efficacy of magnetic cure, the will to cure, and the therapist's rapport with the patient. In 1784, Puységur embodied these ideas in his *Mémoires pour servir a l'histoire et a l'établissement du magnétisme animal* (Memoirs of the Founding History of Animal Magnetism [Paris: 1784]; the book seems to have been self-published), one of the earliest works of modern psychotherapy.

In Europe, Abbé José Custodio de Faria, Général François-Joseph Noizet, Étienne Félix, Baron d'Hénin de Cuvillers, and Alexandre Bertrand continued to develop mesmerist ideas. Faria's *De la cause du sommeil lucide* (The Causes of Lucid Sleep [Paris: Horiac, 1819]) presented a technique for trance induc-

tion ("fixation") that is still in use. Faria emphasized the importance of the subject's will in inducing trance, recognized the existence of individual differences in susceptibility to somnambulistic sleep, and announced the principle of suggestion, which he believed to be effective not only in magnetic sleep but in the waking state as well. Noizet's *Mémoire sur le somnambulisme*, presented to the Berlin Royal Academy in 1820 but only published in 1854, and Hénin de Cuvillers' *Le magnétisme éclairé, ou introduction aux archives du magnétisme animal* (Paris: Barrois l'aîné, 1920), presented extended accounts of mesmeric effects in terms of suggestion and belief. Bertrand's *Traité du somnambulisme, et les différentes modifications qu'il presente* (Treatise on Somnambulism and Some Different Form in Which It Appears [Paris: Denta, 1823]) was the first systematic scientific study of magnetic phenomena.

In 1829 the Swabian physician and poet Justinus Kerner (1786–1862) published his account of his treatment of Friederike Hauffe, the "Seeress of Prevorst," whose hysteria he treated with magneticism. As Hauffe's trance states involved seeing spirits, Kerner's work linked spiritualism with mesmerism. Mesmerism arrived in the United States in 1838, carried by Charles Poyen de Saint Sauveur; there it became allied briefly with phrenology and more extensively with spiritualism (an alliance that culminated in the New Thought movement, which so influenced William James). Phineas Quimby, an American physician, publicized mesmerism widely. Meanwhile, the leading American spiritualist, Andrew Jackson Davis, a shoemaker with the gift of clairvoyance, also practised mesmerism and in his trance state made medical diagnoses.

Animal magnetism also had a following in England, where it had been endorsed by John Elliotson, Chair of Medicine at the University College of London (and a close friend of Charles Dickens, William Thackeray, and Wilkie Collins). Elliotson was a liberal thinker, disposed toward dealing with the broader issues of philosophical biology. He was also an exponent of causes such as penal reform, workers' education, and the abolition of capital punishment. He became a convert to mesmerism after the French magnetist Baron Dupotet conducted a demonstration in the charity hospital in 1836 that impressed him deeply. His advocacy caused so much controversy that the university dismissed him from his post. However, through his journal, *The Zoist*, he continued to sponsor the idea of magnetic influence. Most of the scientific community interpreted the cures as due simply to the influence of the imagination.

In the early 1840s, a scientist from Manchester, James Braid, tried to settle the issue whether mesmeric cures were the result of magnetic influence or the imagination. Braid noticed that experimental subjects in trances were unable to open their eyes. This observation led him to suspect that trances were a result of neuromuscular exhaustion. Staring fixedly at an object induces a stress on the oculomotor muscles, especially when the subject is in a state of absolute repose, and leads to a form of "nervous sleep," or "hypnotism." Many

began to research Braid's hypnotism, and before too long hypnotism had usurped the public appeal that mesmerism once had.

Theories about hypnotic influences were widespread around the time of the birth of cinema. In 1895 (the year that cinema was invented), the French sociologist and Egyptologist Gustave Le Bon (1841–1931) published *Psychologie des Foules* (The Crowd: A Study of the Popular Mind), one of the founding works of the discipline of mass psychology.[85] It was an enormously popular work—within one year of its appearance it had been translated into eighteen languages—and it influenced a range of people, from Teddy Roosevelt to the founders of the new industry of public relations (of manufacturing the *hallucination publicitaire*). The work stresses the irrationalist basis of crowd psychology and the need to sway the masses through irrationalist means. His antidemocratic bias led him to theorize the means by which the psychology of the masses could be taken over by their leaders and transformed into a means to dominate them. Le Bon asserted that ideas are transmitted to a crowd by affirmation, repetition, and contagion, through a near-automatic process that he insisted belonged to the hypnotic order. Thus in becoming part of a crowd, the person forsakes rational faculties and falls into a state approaching hypnotic fascination; the life of the mind is paralyzed, and one becomes a slave to the unconscious. People who become part of a crowd experience the destruction of some of their faculties, and so, like the hypnotic subject, become extremely suggestible (a condition that may affect their actions). An image (e.g., a cinematic image) may then influence them.

A special sort of interest in hypnotism developed in Russia, in the very period when Eisenstein was developing his theories of cinema. In 1930, K. Platonov published *Slovo kak fiziologicheskii I lechebnyi faktor* (The Word as a Physiological and Therapeutic Factor; a revised version appeared in 1955). The work details the experimental and clinical work the author conducted on hypnosis under Pavlov's direction. They measured physical responses to suggestions; the book, which presents various Soviet methods of suggestion, induction, hypnosis, and psychotherapy, is a fascinating amalgam of ideas from Charcot, Bely, Marx, and Pavlov.

Even more closely related to Eisenstein's is the work of a reflexologist/hypnotist who has been all but forgotten, Vladimir Bekhterev (1857–1927). Bekhterev's *Vnushenie I evo rol' v obshchestvennoi ztiani* (Suggestion and Its Role in Social Life, 1908) is a study of "psychological contagion" (i.e., of the ways in which our minds are influenced by something other than rational argument, reasonable persuasion, or conscious reflection). As the monograph's title implies, the central explanatory concept is that of suggestion. Bekhterev had been drawn to this notion by his extensive experience with hypnosis. He defines suggestion as the direct induction of psychic states from one person to another by words or gestures; his book surveys a wide variety of phenomena

that illustrate suggestion at work. These include cases of humans' psychological attunement to one another (as when one person involuntarily imitates another's stutter or one person's cheerfulness infects others); the formation and maintenance of false and irrational beliefs, or inappropriate or exaggerated desires and emotions (such as, for example, are formed within religious sects or in cases of mass hysteria); and various phenomena of crowd psychology, such as panic, mob violence, and revolutionary fervour. Bekhterev analyzed the phenomenon by applying a broad distinction between the "personal" and the "general" psychic spheres. Some thoughts enter the mind through the personal sphere—these thoughts are present to consciousness and subject to rational evaluation. Some "thoughts," however, bypass the personal sphere and enter the mind through the general sphere—these thoughts function independently of consciousness and reason, that is, by way of suggestion. Bekhterev, then, conceived of subpersonal processes that create the framework within which people can openly hold and act on transpersonal configurations of beliefs and desires.

The phantasy image behind all these ideas was that of souls *en rapport:* if souls could be *en rapport*, then they could share every thought and every feeling. Among late nineteenth-century thinkers, from the association between mesmerism and electricity, the common idea developed that at the speed of light all minds/souls merge, thought becomes a nöosphere, and ideas hang in the ether. The electromagnetic medium of radio seemed to confirm it. The idea that thought could be transmitted through the air laid the basis for thinking that mesmerism and hypnotism had the potential to exert social control. Thus the notion that mass media might exert their influence through some sort of mass hypnosis became a commonplace in the literature of dystopia. For Eisenstein, cinema was precisely such an influencing machine. Of course, his conception of cinema and its influence on spectators was overdetermined; even so, mesmerism was one model he used for grasping its potent effects—like Malevich, he harboured the quasi-scientific notion that our experience consists of tuning into waves of influence (and that cinema had raised the effect of waves of influence to a new level). That helps explain why Eisenstein's film theory denies that activity on the spectator's part plays much of a role in making meaning—if one simply tunes in thoughts "hanging in the air," just as radio receivers tune in radio waves, the spectator needn't do much in order to produce meaning. The potential of this influencing machine explains, too, why Eisenstein approached cinema with such reformist zeal.

Eisenstein would probably have been appalled to read the assertion I have made, but that is only because the idea of communicating directly through electricity had little appeal for him. He would have found more acceptable the assertion that his conception of cinema was based on ideas about communication that had developed in response to electrical media such as the telegraph

and the radio. In the popular mind, the telegraph was a means for putting souls *en rapport*. When Samuel B. Morse applied to the U.S. Congress in 1842 for the funds to build a telegraph line from Washington to Baltimore, a member of Congress from Tennessee sarcastically suggested that the government instead allocate half the amount on research into mesmerism. This rejoinder reveals the association in the popular mind of the times between animal magnetism and electromagnetism. The transmission of information can easily be mistaken as having no physical requirements. Thus the popular mind's conception of the telegraph drew on older ideas about immaterial action, including discourses concerning angelic intelligence and the spiritual transmission of divine intelligence.

At least for a brief time in the late nineteenth century (though long enough to significantly influence an emerging model of communication), advanced thinkers as well as common people considered telepathy and telegraphy to be closely related. As odd as the idea of telepathic communication seems to us, whose ideas of scientific rigour are different from Russian ideas of the early twentieth century, the notion interested the scientific community at the beginning of the century. The Canadian philosopher of science, Ian Hacking, has commented on the scientific interest that led to the coining of the term "telepathy."[86] It was first used in 1882 by Frederic W.H. Myers, and was defined as "the communication of impression of any kind from one mind to another, independently of the recognized channels of sense."[87] Myers did not intend that the term refer to any occult or spiritualist power—he and other members of the Society of Psychical Research used the term to distance the phenomena they studied from all that was paranormal and to make those phenomena objects of legitimate scientific research. Two centuries before Myers, the Cambridge Platonist the Reverend Joseph Glavil (1636–1680), the author of *Sadducismus triumphatus*, had offered a demonstration of telepathy at Oxford University (he professed to have learned the technique from a student who had learned it from Roma).[88] The Royal Society looked into the phenomena of second sight, clairvoyance, and thought transference. Several of its early members, including Pepys, Robert Boyle, and Glanvill (like Pepys and Boyle, a founding member of the Royal Society), examined these topics quite closely. From that time until well into the nineteenth century, the idea of telepathic communication did not seem outlandish. It gained even more widespread acceptance in the late nineteenth and early twentieth centuries, perhaps most of all in Russia, where it interested Maxim Gorky, among others. On the basis, probably, of the occult belief that reality is ultimately energy, the Cosmist Nikolai Fedorov assumed that nervous energy was identical with electricity and that electric current could transmit psychological thought processes.[89] The notion that the brain emits physically measurable radiation—a notion referred to as "brain radio"—was the foundation for many research programs.[90]

Telepathy seemed to many people essentially a form of telegraphy; and telegraphy seemed to many the scientifically developed analogue of telepathy. Telegraphy, because it seemed to transfer intelligence over distances, was associated with Spiritualism. Spiritualism's practice of communicating with the spirits of the departed modelled itself on telegraphy's capacity to receive remote messages—indeed, the method the Fox sisters devised for complex communication with the dead—of having the dead spell out their messages by having one of the sisters recite the alphabet until the spirit signalled, with three knocks, that the next letter in the text of the message had been reached—was called in Spiritualist circles "spiritual telegraphy." A newspaper account of the Fox sisters' 1852 tour of England described them as using "a systematic mode of telegraphy."[91] The idea of receiving distant messages, which applies both to telegraphy and to "spiritual telegraphy," established a way of thinking about modern communication.

Bely and the Symbolists contemplated the capacities of the word to transform inner reality, to charm a new subjective world into existence. This brought them to consider the parallels between art and telepathic communication. Telepathy, they proclaimed, provided means for souls to establish direct contact, a technology for which no word was required to serve as the conductor that "connects two unintelligible essences." In their circles, the term "telepathy" was used specifically to refer to mediums' apparently remarkable access to private facts about dead people with whom they could not have had contact. Myers and the members of the Society for Psychical Research supposed that this remarkable knowledge, if it existed, was the result of communication not with spirits of the departed, but with the sitters' unconscious minds through some quasi-physical process of thought transference. Soon after Myers invented the term "telepathy," other coinages followed: "telekinesis" in 1890 and "telesthesia" (for the sharing of feelings at a distance) in 1892. The idea of telepathy spread rapidly through Anglo-American culture in the 1890s.

The idea of the direct communication of thoughts without any semiotic medium is an age-old dream—indeed, angels were said to be capable of such communication. The title of a 1913 book by Horace C. Stantorn gives some sense of the heady ideas associated with telepathy: *Telepathy of the Celestial World: Psychic Phenomena Here but the Foreshadowings of Our Transcendent Faculties Hereafter; Evidence from Psychology and Scripture That the Celestial Can Instantaneously Communicate across Distance Indefinitely Great* (New York: Fleming H. Revell). The radio—the "wireless"—was another instrument that seemed to make possible the direct communication of messages (one might just as well say "thoughts"), without any semiotic medium. As a writer from the time put it, messages could be conveyed "through space, for great distances, from brain to brain in the entire absence of any known means of physical communication between two widely separated stations."[92] In 1902 the

arch-Imperialist Victorian writer Rudyard Kipling published in *Scribners* a story titled "Wireless," which compared Spiritualist communication with the souls of the dead and wireless communication. In the tale, a young man, a man with a soul like John Keats's, a pharmacist dying of consumption and in love with a woman named Fanny, but ignorant of Keats's poetry, begins spontaneously to compose passages from the Romantic poet's work; meanwhile, upstairs an amateur wireless operator attempts to send messages to and receive messages from the English Channel, but his efforts at electromagnetic induction (pulling signals out of the air) are less successful than the dying pharmacist's poetic induction. Kipling's story is built on the phenomenon that art making, Spiritualism, and the wireless have in common: signals suspended in the air can be drawn down by a medium sensitive to their vibrations. The story also suggests that what poets call "inspiration" is similarly a sort of induction.

What Kipling explored through the devices of fiction in "Wireless," Upton Sinclair explored through a case study in *Mental Radio* (1930). That book includes 146 drawings, most of them in pairs, the first usually drawn by Upton Sinclair (though some were done by another person), the second by his wife, Mary Craig Kimbrough. Mary Craig Kimbrough Sinclair, who claimed to have "mind reading" or telepathic abilities, asked Sinclair to help her better understand these capacities. In one room, Upton would make a drawing and place it in a sealed envelope, while in another, Mary would "tune in" the drawing and make her own copy, or would record a telepathic message sent from someone far away. Some experiments were done with the "sender" and "receiver" separated by more than 40 kilometres; most, though, had Upton drawing images in one room with the door closed while Mary attempted to receive them in a different room. Upton and Mary continued to collect scientific data over three years and came to believe that the pairs of images gave evidence of transference of thought without a medium (what Upton called "mental radio"), though in truth, anyone not predisposed to believe in the occult would likely have found the pairings generally quite unalike. Upton interpreted the results by comparing telepathy to radio broadcasting, with one brain sending out a "vibration" and another picking it up. The results convinced him that telepathy is real, that it is unaffected by distance, that it can be cultivated and trained, and—most important—that it can be verified and studied scientifically. He was a pioneer in this belief: he conducted his experiments just as formal research in parapsychology was getting underway (J.B. Rhine's Parapsychology Laboratory at Duke University was not founded until 1935, five years after the publication of *Mental Radio*). *Mental Radio* was viewed as a pioneering work. It appeared with the support of William McDougall, the chair of the Duke Psychology Department, who in 1930 himself performed experiments with Mary and wrote the introduction to the book.

The name "wireless" conjures up the idea of action at a distance. At the beginning of the twentieth century, many people viewed the wireless as the epitome of direct communication of intelligence with no material requirements other than that universal substance known as the ether. It represented, therefore, direct contact between people through an invisible and ever so elusive material linkage. Among those who took an interest in the wireless was Sir William Crookes; his case provides evidence that even scientists and engineers, people who shared something of Eisenstein's background, were not immune to enthusiasms that most people today would dismiss as antiscience. Crookes, a student of Faraday, the discoverer of the element thallium and the inventor of the cathode ray tube, was also a Spiritualist, spirit photographer, and audio recordist of voices of the dead. In 1892 he published a popular and enormously influential article, "Some Possibilities of Electricity." In it he considered the possibility of transmitting and receiving intelligence by wireless telegraphy. Two friends could communicate by wireless transmitter and receiver, he noted. That was the least radical of his forecasts (i.e., that the apparatus for wireless telegraphy could be dispensed with entirely, as brain waves—by which he meant the information carrier in telepathic communications—could surely be transmitted from one person to another).[93] The article made it clear that for Crookes—and this was true of many people around the turn of the century— the propagation of electromagnetic waves and the transmission of thoughts (to apply this to Eisenstein's case, think of influence) were analogous processes. Communications between individuals were essentially the transmission and reception of signals analogous to radio signals—and like the reception of the radio signals, the reception of thought signals was automatic, provided that the carriers' transmitting frequency corresponded to that of the receiving unit. That conception is at the heart of what I take as the notion of intersubjectivity that underpinned Eisenstein's theory and practice.

Not even the materialist commitments of the official Soviet philosophy could eliminate this interest in thought transference. The belief that thought could be transmitted through the ether persisted in Soviet Russia, as is evident in the strange, wondrous story of Lev Sergeyevich Terman (1896–1993) or, as he called himself after he moved to America, Leo Theremin. Theremin explained in an 1989 interview with the musicologist Olivia Mattis: "I wanted to invent ... an instrument that would not operate mechanically ... that would create sound without using any mechanical energy, like the conductor of an orchestra. The orchestra plays mechanically, using mechanical energy, [but] the conductor just moves his hands, and his movements have an effect on the music." In 1917, at a technical institute in Russia where he was a student, quite by accident he discovered the phenomenon that would make possible his magical new instrument. He was developing a device to measure the density of gases under pressure and discovered that the apparatus was extremely

sensitive, interpreting even the slightest motion of his hands in the surrounding air. Fascinated by the phenomenon, he attached earphones to the device and found that fluctuations of the density of the gases resulted in different musical tones. He revealed his discovery to officials at the institute, and they encouraged him to adapt his gas-measuring apparatus as a musical instrument. He called the instrument, which he patented in 1921, the "Etherphone," for he believed that it served as a means for making etheric waves audible. In 1922 he exhibited the apparatus, first to a conference of physicists and engineers in Leningrad and then at an electronics exposition in Moscow. News of the device travelled to Lenin, who summoned Theremin to his office for a personal demonstration. Lenin expressed enthusiasm for the instrument, hoping it would serve as a propaganda tool for his program of national electrification. (He was also pleased that after a short demonstration and some initial help from the inventor with positioning his hands, he could play Glinka's "Skylark," a piece Lenin loved very much.)

Theremin developed the Etherphone into another musical device, to which he gave the eponymous names of, first, "Therovox," and then "Theremin." The first composer whom he commissioned to write a composition for it was A.F. Paschtschenko, whose composition—along with the inventor's own composition for Theremin and orchestra, significantly titled "A Symphonic Mystery"—was premiered by the Leningrad Orchestra in May 1924.

Lenin immediately ordered that six hundred Theremins be produced and he sent the inventor across Russia to demonstrate the instrument. The device so amazed people that in 1927, Stalin sent the engineer abroad to help show off the new Soviet regime's latest technological and scientific advances. In 1928 he presented a flurry of concerts in Germany, France, and Britain. The public was entranced by the seemingly magical powers of the device and by Theremin's highly theatrical technique of playing. When he appeared at the Paris Opera, the police had to be called to keep order among the audience. For the first time in the opera house's history, standing room was sold in the boxes.

The popular press often described the Theremin's sound as "etheric." In the October 2, 1927, issue of the *New York Times*, tucked away in column 6 of the section 2, there was an announcement of a new musical curiosity presented in Berlin the day before. The article carried the headline "Ether Wave Music Amazes Savants." At times the media reported that the sound seemed to be magically drawn from the air. One reviewer described Theremin's conducting: "His looks grow tender. The inventor becomes the musician. The fingers of his right hand ... vibrate in free air. Invisibly a soul sings, and we listen, thrilled. The works of such composers as Grieg, Saint-Saëns, Scriabin, are played."[94] The performance technique of the renowned Theremin virtuoso Clara Rockmore (née Reisenberg, and also from St. Petersburg) was referred to as "aerial fingering."[95] The association of Theremin's instrument with the ether persisted

even during his American odyssey. In 1929, Joseph Schillinger wrote a break-through piece, the *First Airphonic Suite*.[96] The association has proved persist-ent: in 1999, Mode issued a collection of historical recordings for Theremin under the title *Music from the Ether—Original Works for Theremin*.[97]

Theremin played on the association that identified his music with music of the ether. In a 1991 interview with the synthesizer pioneer Robert Moog, he allowed that he had originally "conceived of an instrument that would create sound without using any mechanical energy, like the conductor of an orches-tra," and indeed the Theremin was the first instrument to produce sound using a non-acoustic medium and to divorce the production of sound from the ac-tions of the performer (or at least that hid the connection between the two).[98] Both features of the Theremin contributed to the impression of a magical phenomenon—to the impression of a frictionless identification of imagination, movement, and sound, the perfect fusion of mind and body.

THE ENGINEER OF HUMAN SOULS

Were Eisenstein and the Constructivists not hard-nosed scientists, artists who approached the construction of an artwork much as one might approach in-stalling a town's water system? Were they not examplars of *l'artiste-proizvodstven-nik* (artist-productivists, of the sort that Boris Arvatov valorized), engineer-builders who worked at once in the domains of art, technology, and science, who made it possible to escape the sphere of illusion in order to edify material ex-istence? The reader would be justified in wondering whether occult ideas could have had any role at all in Eisenstein's thought. Doubts about the role that het-erodox ideas played might be dispelled by considering that Eisenstein carried his belief about the pragmatics of artworks—according to which physical re-sponses can produce effects of a higher order (emotional and intellectual effects) that will reform the person—beyond any degree that any sober scientist or en-gineer of today would likely endorse. He asserted that scientific means could af-ford us knowledge about which physical stimuli must be deployed to produce some intended alteration in the viewer's ideology—that in the future, when more was known about what underlies sensation and thought, it would be pos-sible to calculate which stimuli, of which intensity and in which precise order, must be provided to reform people's thinking. This is obviously an extrava-gant notion for which one would be hard-pressed to discover any scientific basis. We are clearly in the realm of magic here, not sober empirical science.

Others shared Eisenstein's belief in the possibility of constituting a science of art. Another artist who accepted the most radical implications of Fechner's thought was Malevich. In 1922, just about the same year that Eisenstein was de-veloping the notion of the attraction (a theatrical element that subjects the audience to emotion or physiological influence), Malevich wrote that

the modern artist is a scientist. The artist-scientist develops his activity quite consciously and he orients his artistic effect in accordance with a definite plan; he reveals the innermost motives for a phenomenon and for its reflex action; he endeavours to move from one phenomenon to another consciously and according to plan. So an artistic science now begins to take shape.[99]

Rodchenko offered these revolutionary proclamations on art and art-making:

CONSTRUCTION [is the] organisation of elements
 CONSTRUCTION is the MODERN PHILOSOPHY
 ART, like every science, is one of the branches of MATHEMATICS
 CONSTRUCTION represents the contemporary demand for ORGANISATION and the utilitarian use of materials.
 CONSTRUCTIVE LIFE IS THE ART OF THE FUTURE
 ART which has no part in life will be filed away in the archaeological museum of ANTIQUITY
 It is time for ART to flow organisedly into life.
 A CONSTRUCTIVELY ORGANISED life is above the mystical art of magicians ...
 Conscious and organised LIFE, the ability to SEE and CONSTRUCT, that is the modern art.
 The MAN who has organised his life, his work and himself is the MODERN MAN.
 WORK for LIFE and not for PALACES, TEMPLES, CEMETERIES and MUSEUMS ...
 Consciousness, EXPERIMENT ... the goal: CONSTRUCTION.
 Technology and mathematics these are the BROTHERS of modern ART.[100]

A.V. Babichev, a member of the Rabochaja Gruppa Objektivnogo Analiza (Working Group for Objective Analysis), a Productivist group to which Rodchenko and Stepanova also belonged, wrote that art "is an informed analysis of the concrete tasks which social life poses ... If art bcomes public property it will organize the consciousness and psyche of the masses by organizing objects and ideas."[101] The Arvanovist/Taylorist resonances we can detect in this passage reinforce the influence the American industrial engineer had on Eisenstein and Meyerhold.

Eisenstein, the paradigm of the engineer/designer, an enthusiast for science and technology—we know the description. Still, we might also be aware, however vaguely, that the description rests on a set of assumptions—assumptions that concern, inter alia, what science is. Russia in the first decades of the twentieth century understood science differently from today. It is important, then, to consider what sorts of ideas Eisenstein and the Constructivists might have harboured about science. So, too, is it worthwhile to consider what it would

be like to be an engineer of human souls. Let us focus on the project of designing and producing "the new human" and the ideas that gave shape to it.

We all know that Eisenstein's was a cinema of effects, calculated (in the strictest sense of the word) to produce new human beings endowed with a heightened sensibility—new humans who would be ideal citizens for the new Soviet state. This conception of cinema's mission drew him to an interest in psychological issues. We all know, too, that his conception of cinema began with a notion of the effectivity of the attraction, which he defined as "any element that subjects the audience to emotional or logical influence." When he first introduced the term "attraction," he noted that the theatre's basic material derives from the audience and (in perfect conformity with Constructivist principles) he declared that appropriately moulding the audience is the central task of utilitarian theatre. All the ingredients that make up a theatrical piece— a snippet of dialogue, a part of a costume, a part of the set, a sound effect— have, whatever their differences, a common quality: a potential for influence:

> An attraction (in our diagnosis of theatre) is any aggressive moment in theatre, i.e. any element of it that subjects the audience to emotional or physiological influence, verified by experience and mathematically calculated to produce specific emotional shocks in the spectator in their proper order within the whole. These shocks provide the only opportunity of perceiving the ideological aspect of what is being shown, the final ideological conclusion. (The path to knowledge encapsulated in the phrase, 'through the living play of the passions,' is specific to theatre.) [102]

FECHNER AND THE SCIENCE OF EFFECTS

Film scholars usually identify Pavlov as the psychologist whose ideas swayed Eisenstein toward the notion of the attraction. Pavlov *was* an influence, but the ideas of another pioneering psychologist, whose influence in Russia was enormous, were just as important. I refer to Gustav Fechner (1801–87), a versatile *Naturforscher*, who conducted the first rigorous experiments in psychology. Fechner was among the scientific investigators of what we would now consider occult phenomena. But before he embarked on those studies, he was a pioneer in empirical psychology, and his *Elemente der Psychophysik* (Elements of Psychophysics [Leipzig: Breitkopf und Härtel, 1860]) set out conclusions he had arrived at through investigations into visual brightness, into the sensations produced by lifting weights, and into tactual and visual distance. The book promulgated, as he said, the "exact science of the functional relations or relations of dependency between body and mind." His laboratory work was painstaking, and *Elements of Psychophysics* showed him to be a sober and scrupulous researcher with a real talent for conceiving and constructing experiments and for formulating mathematical models of findings those experiments produced.

Eventually, though, his scientific research led him to develop an extraordinary Cosmism akin to Emanuel Swedenborg's, one that depicted the universe as a pantheistic nexus of interconnected forms in which animals, plants, and planets all had souls that were facets of a universal consciousness.

A core idea of Eisenstein's film aesthetics, that of the attraction, has parallels with Fechner's ideas about the sensations. Even the idea of the artist as an "engineer of human souls" arises from a psychophysical parallelism such as that Fechner expounded. Fechner developed a law stating that the intensity of a sensation varies with the natural logarithm of its physical stimulus. That is, he proposed an empirical finding relating sensations to stimuli, mental effects to physical causes. His work began with the recognition that sensation could not be measured directly, but only indirectly, through gauging the stimulus that produces it. Accordingly, he needed a means to correlate a sensation, an ideal phenomenon, with the physical stimulus that caused it. He took a cue from E.H. Weber, who had observed that the rate of change of a response varies with the magnitude of the stimulus that produces it; thus the greater the stimulus, the larger any change in the stimulus must be for us to notice a difference. Consequently, a "just noticeable difference" (a "jnd") in sensation is given by the following differential equation: the constant, $jnd = \delta R/R$ (where R is the magnitude of the stimulus (*Reiz*). Fechner generalized from this, holding that if the equation applies for a jnd, it must also apply for any small increment in sensation. So he proposed that for any change in sensation, $\delta S = c\delta R/R$ (where c is simply a constant of proportionality). By integrating and rearranging (and taking r to be the unit of R) we get

$$S = c \ln R.$$

The equation has a remarkable form, for it states an identity between ideal and material phenomena. The form of Fechner's famous "psychophysical equation" must have resembled that of the equations that Eisenstein had in mind when he proposed calculating the effects of his aggressive moments; indeed, it may even have been the basis for the formulas he hoped to use, for Fechner's work was well known in Moscow in the first decades of the twentieth century.[103] A core idea of Eisenstein's film aesthetics—the idea that a physical phenomenon, the attraction, results in a determinable magnitude of sensation—was exactly the point of Fechner's investigations into sensation. The idea of the artist as an "engineer of human souls" arose from a concept of psychophysical correlation similar to that which formed the core idea of Fechner's research program. (That phrase was coined by Yury Olesha and then used by Joseph Stalin in a speech he made to Soviet writers at the home of Maxim Gorky on October 26, 1932. Later, it was taken up by Andrei Zhadanov.)

The German chemist Wilhelm Ostwald (1853–1932) transformed Fechner's psychophysical psychology into a theory of a psychophysical (nervous) energy. Ostwald subscribed to the occult principle that energy, not matter, was the basic principle of all matter. He developed the theory of Energeticism, which asserted that reality is nothing more than energy in the various states of transformation.[104] His cosmology was thus monistic, and it presented the single fundamental reality as eternal, for Ostwald maintained that energy can neither be created nor destroyed. Like the Russian Cosmist Nikolai Fedorov, he became obsessed with the idea of conserving energy and using it only to some purpose. He was especially concerned that proper use be made of the holy energy given off by the sun; in time he became a sun worshipper and turned to eugenics as a means of perfecting human beings. His concern with the conservation of energy brought him to treat sex exactly as the Rosicrucians do, as a force that humans must preserve. Ostwald's concern with the conservation of energy put him out of sympathy with ideas about the redemptory beneficence of the female principle such as were taught by his well-known follower, Solovyov. It also convinced him that the future being that evolution would bring forth would be asexual—a conviction that later would be evident in artistic representations of the new postsexual human, such as El Lissitzky's.

Stimulated by Ostwald's work, a Moscovite psychiatrist named Naum Kotik investigated this psychophysical energy. In 1904 he published *Die Emanation der psycho-physischen Energie* (The Emanation of Psychophysical Energy) (Weisbaden: Bergman, 1908), which argued that thinking acts are followed by an emission of a special type of energy. It also proposed that thinking is both mental and physical. As a physical phenomenon, it is an energy that circulates in the human body from the brain to the extremities and back again and that finally accumulates on the surface of the body; he also maintained that this energy penetrates air with difficulty and physical objects with even greater difficulty. The principle that governs its movement is that it flows from a body with a positive charge to a body with negative psychic charge. As a mental phenomenon, it directly enters other brains and produces the same images there as in the brain of the person who originally conceived it. This energy allows for the telepathic conveyance of thoughts; thus in higher concentration it is useful for mass suggestion.

Another form of psychophysiology re-enforced the influence of Fechner's special form of that discipline. The commercialization of electrical power in Germany, begun in 1900, transformed society, introducing many new gadgets and transforming work and leisure. As the introduction of transformative technologies always does, it stimulated thinkers to consider what this technology had to say about the constitution of reality, including the nature of mind. (The widespread introduction of computer technology in the 1980s did much the same thing, producing works such as Douglas Hofstadter's *Gödel,*

Escher, Bach and Marvin Minsky's *The Society of Mind*.) Electricity seems a ghostly, pneumatic phenomenon, and from the time of Luigi Galvani (1737–1798) many thinkers hypothesized that there was some connection between electricity and consciousness. (When Galvani discovered that electrical charges could make a frog's leg twitch, he was convinced that he was seeing the effects of what he called animal electricity, the life force within the muscles of the frog; this led him to frame his hypothesis of "bioelectrogenesis.") Early twentieth-century thinkers revived ideas about there being close links between psychic life and electricity, speculating that electrical devices could be used for investigating psychophysical phenomena.[105] Electroencephalography, the recording of electrical brain waves, was one tool they used, and some investigators extended this idea to "diagnoscopy"—that is, to personality profiling by a sort of electric phrenology. Diagnoscopy, whose leading exponent was the Ukrainian-born physician Zachar Bissky (founder of Bissky's Bios-Institut für Praktische Menschführung), involved electrically stimulating specific "reaction zones" on the surface of the head by touching them with a detecting electrode, which closed an electric circuit to produce a tone of varying amplitude. The volume of the tone measured the intensity of the associated psychical quality. A complete examination of an individual's personality required that the diagnostician probe approximately fifty reaction zones, each of which represented specific character traits. In this way could be developed a personality profile, which took the form of a graphic chart of the intensity of psychic processes associated with each reaction zone.[106]

Diagnoscopy was greeted with great enthusiasm, as it seemed to offer an efficient, technological alternative to the labour-intensive, time-consuming processes of psychological testing and interviewing. Diagnoscopy was rapidly embraced as a tool for vocational guidance. While academic psychologists often reacted with horror and denounced diagnoscopy as quackery, the popular press responded with enthusiasm, celebrating electroencephalography as a mind-reading device, an X-ray of the soul. A few years later, after Bissky's device had fallen out of interest, electroencephlograms (EEGs) were treated as psychograms. Thus, psychophysiology combined with electrical engineering to ground an electric epistemology rooted in a new scientific means of understanding the psyche, as electricity was taken as the medium of psychic processes (a medium newly susceptible to empirical study). A sort of electropsychology that assimilated ideas about electrical technology, the physical body, and psychic life developed in Germany in the middle and late 1920s, and this electropsychology was soon embraced by Russian investigators. Using models based on new technology to conceptualize the body has a long history: the industrial age gave birth to the conception of the body as a machine, and the age of electicity gave birth to the idea of the body/mind as an electrical system (just as the computer age has given birth to the idea of the cyborg).[107] Mod-

els drawn for electrical research understandingly emphasized neurophysio-logical research; they took neurophysiology as the fundamental science for understanding human being.

It is well known that Arvanovist/Taylorist ideas, passed on by Meyerhold, had an important role in shaping Eisenstein's theoretical ideas. There is a con-nection between Taylorism and diagnoscopy. Diagnoscopy was considered an extension of psychotechnics. Psychotechnics started in Germany with the pub-lication (in 1914) of Hugo Münsterberg's book of that title. Originally it was a branch of applied psychology that served the organizational needs of the nation at war; after the war it helped reorganize and modernize the economy. Psychotechnics studied organizational dynamics, as Taylorism did—that is, it strived to allocate the work force to jobs in ways that could best serve society (here it departed from purely Taylor's labour rationalization), and it empha-sized individual needs. Modern, rational, humane corporations began em-ploying psychotechnics. Psychologists such as Fritz Giese and Robert Werner Schulte used psychotechnics to study various occupations, conducting a thor-ough scientific investigation of their mental profiles, required skills, and body movements (the last two were central topics of Taylorist analysis). Giese, who had obtained a professorship at Stuttgart's Technische Universität, went on to assemble a team of researchers and brought out his multivolume *Hand-buch der Arbeitswissenschaft* (Manual of Work Science [Halle: Carl Marhold Verlagbuchhandlung, 1925–34]), a work whose title is so reminiscent of Arva-novist/Taylorist ideas. Giese and Schulte also used psychotechnics to study occult phenomena and *Körperkultur*—in fact, Giese's first book concerned the transmission of thought waves, while Schulte investigated paranormal practices.[108] Both Giese and Schulte adopted Bissky's diagnoscopy as an exten-sion of their method and independently applied it to the study of job fitted-ness. Their first reports on the topic were made 1925–26; both proclaimed that diagnoscopy's predictions of job-suitedness were as accurate as other psy-chotechnical methods and that the application of the findings of this discipline could result in the rationalization of life and labour.

Diagnoscopy was only one of a series of electrical devices that purported to reveal thought processes. Between 1924 and 1929, Hans Berger developed the "Elektrenkephalogramm" (electroencephalogram, EEG), another device that was greeted as a means of recording the operations of the psyche, in this case by means of moving lines inscribed on photographic paper. In this way the brain itself made a recording of its activities.[109] The apparatus received wide-spread attention, including many reports in the popular press, within weeks of Berger's summarizing paper in *Medizinische Welt*.[110] The idea that the EEG provided a graph of the operations of human thought seemed, however briefly, to be convincing, for it fit with a model of thinking at the time that was based on electricity and the transmission of energy (a model of thinking that seemed

as acceptable in its day as the model of thinking as computation was not so very long ago).

THE CINEMA AND SPIRITUAL TECHNOLOGY

For people living in the first two decades of the twentieth century, for whom moving pictures were themselves a miracle, the connections between cinema and the marvels of unseen waves were many. The earliest cinema audiences, in fact, attended the exhibitions chiefly to see the newest technological spectacle. The attraction was not so much the actual film shown, but the novelty of seeing moving pictures (which were often taken as outward manifestations of principles of animation). Motion pictures were often presented side by side with examples of X-rays and microscopy, technologies that people of the time perceived to be relatives of cinema.[111] By a remarkable historical coincidence, 1895 was the year of Röntgen's discovery of X-rays, Marconi's invention of radio telegraphy, the Lumière Brothers' development of the movie camera, the Russian Konstantin Tsiolkovsky's announcement of the principle of the rocket drive, and the publication of Freud's early studies on hysteria. In people's consciousness, these developments were all related. The discovery of radium, the invention of magnetic sound recording, the first voice radio transmissions, the first powered flight, the formulation of the Special Theory of Relativity, the development of the photon theory of light, all took place during the first few years of cinema, and in short order the era of steam gave way to the era of electricity. All of these contributed to a change in humans' understanding of themselves and of the cosmos in which they live—indeed, the most fundamental change since Newton. For people living in the first two decades of the twentieth century, for whom moving pictures were themselves a miracle, cinema had many affinities with the marvels of unseen waves.

Furthermore, the late nineteenth century was a time during which the desire to conjure up a double of our reality was very strong. In "Le Mythe du cinéma total" (The Myth of the Total Cinema), André Bazin presented an outline of the history of the idea of a true cinema, a machine that could duplicate reality in all its features—usually in the service of creating an amalgam of the real and the fantastic (like that found in newspapers of the day [if not today], which were [are] a bizarre mix of truth and fiction). In 1900, Raoul Grimoin-Sanson invented Ballon-Cineorama, a ten-projector, audience-surrounding virtuality system, and premiered it at the Paris Exhibition.[112]

The era was just as enthusiastic about the possibility of creating a machine that thinks as we humans do. "Talking heads" and artificial talking people became something of a vogue. Thomas Edison took out a patent for a phonograph doll in 1878. At first he wanted simply to build a doll around a phonograph, but he soon realized that it was practical to build a doll out of

factory-made parts with a miniature phonograph inside. So in 1889 his company began to mass-produce talking dolls. The doll was twenty-two inches tall, with a steel torso, a head of German bisque, and jointed wooden limbs. This doll, of which the Edison factory produced 500 per day, recited nursery rhymes when wound up; within the doll a needle tracked grooves on a wax-covered disc. Other manufacturers soon were competing to produce similar novelties. In France the famous Jumeau doll-making firm produced Bébé Phonographe in 1893; a small plate in her chest covered the inner mechanism, which one wound from the rear. The twenty-five-inch doll herself had a charming, Jumeau-type bisque head, beautiful eyes, and jointed arms and legs; and, as a European, she could speak French, English, or Spanish (switching languages when cylinders within the doll were changed). Mary Hillier reported that "at the Paris Exhibition 1900, a special room was devoted to the Phonograph doll, with girls recording at benches."[113] Needless to say, this enthusiasm for talking mechanical figures posed questions about the physical basis of consciousness—questions of the sort that Fechner's famous psychophysical equation seemed to answer.

Microcinematography, too, exerted a strong fascination, not the least because of its connection with the topic of pollution: in 1903, Cecil Hepworth made a film using pseudo-microcinematography with the revealing title *This Unclean World*; a Pathé film of 1905, *Le Déjeuner du savant* (The Scholar's Lunch), intercuts a scientist having lunch with repulsive close-ups of microbes; a Biograph comedy of 1907, *Love Microbe*, reprises the same theme but treats it in a lighter vein. Much has been made of the fact that such films exploited potentials inherent in cinema, and that claim is undoubtedly true. Nevertheless, it should not be thought that the desire to demonstrate the potentials of the new medium alone accounted for these microcinematographic works, for that *topos* of microcinematography, pollution, was also treated in works realized in other media. For example, in 1922, the year of his death, the poet Khlebnikov, perhaps out of presentiment of his death, wrote a dream play, *Pruzhina chakhotki* (The Tuberculosis Spirochete), which depicted the behaviours of a blood cell and the coil-shaped bacteria that cause consumption. (On this matter of contagion, one should recall that the topic of pollution is a favourite Gnostic *topos*, for it can easily be taken as evidence of the corruptness of matter; also, Fedorov proposed that the dead return, sometimes as ghosts but as often as microbes and infections.) Pollution, a spreading, invisible taint, was on people's minds, and new technologies could join art in making that invisible reality visible.

Microphotography also appealed because of its apparent ability to make matter transparent, somewhat after the fashion of Röntgen rays. As evidence of this appeal and of the influence that microcinematography had on other arts, one can point to the play the Freemason Nikolai Nikolayevich Evreinov

(1887–1953) mounted in a St. Petersburg cabaret in 1914. *V kulisakh dushi* (In the Side-Scenes of the Soul) was a short piece that took place entirely inside the body: The stage formed a diaphragm; above it was a large heart, suspended by an aorta and beating between 55 and 125 times a minute, surrounded by lungs contracting and expanding fourteen to eighteen times a minute, and vertebrae at the centre of the backdrop along with nerves stretched over the diaphragm. The actors moved through the viscera, with Mikhail Bobyshev's sets suggesting the dynamics of their emotions. Using a giant rendering of the interior of the body as a stage set invites other associations, especially that of the return to the womb (a subject to which Eisenstein devoted an autobiographical essay).[114] And who were the characters in Evreinov's play? They represented the division of the person familiar from Rosicrucian thought: the Emotional Self, the Rational Self, and the Subconscious Self.

THE CINEMA AND X-RAYS

Another technology akin to cinema, one that presented itself as the materialization of occult powers, was the X-ray. The association between cinema and Röntgen's enchanting discovery was often remarked on in cinema's early years. With the development of the X-ray arose the fantasy of a human being possessing an enhanced vision that could penetrate barriers—of a person with X-ray eyes, as the movie title has it. Consider some early films: George Albert Smith's *The X-Ray Fiend* (1897) shows the skeletons of two lovers embracing as they are revealed by a professor's X-ray machine; Méliès's *Les Rayons Röntgen* (A Novice at X-ray) associates magic with X-rays (a scientist uses an X-ray machine to extract a patient's skeleton, which leaps out of the man's body while his flesh slumps to the floor); *Le Monstre* (The Monster, 1903), also by Méliès, shows an Egyptian pharaoh performing magical tricks with his wife's skeleton, an image to which X-rays had by then given special significance; Emile Cohl's *Les Lunettes Féerique* (The Enchanted Spectacles) shows a family gathering, with each person putting on X-ray spectacles that reveal whatever passes through the wearer; and *Un ragno nel cervello* (A Spider in the Brain, 1912) shows X-rays being used to locate a large spider that has burrowed its way into a person's brain.[115]

Both Stanislaw Przybyszewski and Maxim Gorky imagined that X-rays made it possible to see the soul—to actually see thought.[116] Przybyszewski wrote:

> They were sitting face to face. They were looking into each other's eyes and were totally alien and indifferent toward each other. Yet, a beam of light dwelt in his eyes, something similar to Röntgen's rays: he could see through her and through himself, he could see something emanating from inside their souls, he could see their hidden *selves* coming closer to each other and looking at each other with so much curiosity and desire.[117]

In a pseudonymously published essay concerning X-rays, Gorky wrote

Imagine that someone wants to know you better.

He takes a picture of your skull, and if this skull contained some thoughts, the negative will reveal them as black blots, or snakelike spirals, or some other unattractive form.

If he wishes, he can try to photograph your conscience, and the negative will also show all the excrescences and blots.

In a word, every person will be seen through now, and however thick and impenetrable your skin might be, the new light makes it transparent like glass.[118]

The occult nature of the X-rays was argued by the theosophist leaders Mme Blavatsky and Annie Besant:

Among the more significant of late discoveries has been that of the Röntgen or X-rays, vibrations in the ether which pass through matter hitherto regarded as opaque, and, for instance, enable a photograph to be taken of the skeleton within a living body, or of a bullet imbedded in an internal organ. These vibrations are alleged to be seventy-five times smaller than the smallest light vibrations, and thus can pass through matter impermeable to light and heat. Now eight years before the X-rays were discovered *The Secret Doctrine* was published, and in that Mme. Blavatsky remarked: "Matter has extension, colour, motion (molecular motion), taste and smell, corresponding to the existing senses of man, and the next characteristic it develops—let us call it for the moment 'Permeability'—will correspond to the next sense of man, which we may call 'normal clairvoyance' ... A partial familiarity with the characteristic of matter—permeability—which should be developed concurrently with the sixth sense, may be expected to develop at the proper period in this Round. But with the next Element added to our resources in the next Round, Permeability will become so manifest a characteristic of matter that the densest forms of this Round will seem to man's perceptions as obstructive to him as a thick fog, and no more." The fulfilment of the latter part of this quotation lies in the future, but the earlier part is now verified, for the discovery of the X-rays has completed a singular chain.

Besant continues the text by arguing that X-rays simply embody a power that some special individuals have long since possessed—they are, then, the technological embodiment of human capacity:

Not long ago, a little boy in America saw the bones of his father's hand through the covering flesh, and medical observations established the fact that he "saw by the X-rays," or, to use our own phrase, was " physically clairvoyant." Other people here and there show this faculty, born with them, "variations" pointing to a line of evolution. Under hypnotic conditions many persons show this same power, and "hypnotic lucidity" is a well-established fact. Others become clairvoyant by practice. Surely when these facts are set side by side: etheric vibrations by which

certain objects may be seen through opaque matter; occasional instances of people born with a power to receive and respond to those vibrations; many people able to receive and respond to them when shut off from the vibrations they normally respond to; artificial development of the power to receive to and respond to them; we have definite signs of the evolution of a new sense and sense-organ. The sense-organ is rudimentary in the normal person, is at least partially developed in the born clairvoyant, is susceptible of stimulation in most people when the developed senses are temporarily silenced, and may have its development forced by special means. Here the positive declaration of Ancient Science, based on innumerable experiences, is in way of verification by the discoveries of Modern Science.[119]

A few years after Besant composed this text—indeed, around the time that Eisenstein was working on *Stekliannyi Dom* (The Glass House), German thinkers Ernst Bloch, in "The Anxiety of the Engineer," and Eugen Diesel, in "The Uncanny of the Technical Age" (both dating from 1929), explored the belief that technology is a modern manifestation of the marvellous. Bloch compared television's "latest technology" with the "realms of the magic mirror."[120] Diesel, a son of the famous inventor, was more effusive: "that which was hitherto seen only in dreams or which belonged to the realm of the miraculous, is now available in everyday experience"[121] Diesel alluded obliquely to Freud's 1919 essay in which he defined the uncanny as "a sudden, ghostly appearance." Diesel identified a "mechanical uncanny" that arises "directly from the machine in itself," and characterized it as an "uncanny 'of the second kind' ... dissolving old measures of time and space." Diesel declared that "a whole new artificial world" was coming into being, a world "in which nothing could be certain" because material reality appeared only as a ghostly phantom on the screen or in a magic mirror in the living room.[122] He thus gave voice to that widespread modern anxiety: that the real had become phantasmal and that the phantasmal had become reality itself. The ontological status of cinematic representations had been taken to define the ontological status of real entities.

X-rays make thought visible (i.e., they reveal and thereby transmit thoughts); the cinema is the sister of X-rays; therefore the cinema too can transmit thought. This suppressed deduction helped shape Soviet filmmakers' ideas about montage. Cinema was an occult tool: the technology of cinema, they believed, allowed the marvel of telepathic communication to become an everyday reality. That the cinema is a technology for conveying thoughts played a role in shaping Soviet filmmakers' ideas about film montage (as made evident by Eisenstein's preliminary notes for a film of Dreiser's *American Tragedy*). Montage construction shapes cinema into the mimesis of human thought—it puts the shape of thinking on display. Projecting a montage film thus transmits thoughts to its viewers. But beyond its general influence on the idea of mon-

tage, the idea that cinema is the sister of X-rays might well have had the more concrete result that Yuri Tsivian points out: Eisenstein's film *Stachka* (Strike, 1924) offers a sequence in which the faces of police spies dissolve into the faces of animals. In a conversation with Alexander Belenson, Eisenstein explained that he liked the technique of dissolves when he made *Strike* because of their ability to "bare the essence of things." [123] We know that the idea that every person is associated with a particular animal (that suggests character) is common in pagan thought.

The X-ray was viewed as a machine that could render transparent not only the mind but also matter. In its intrusive immodesty, which made privacy obsolete, the X-ray was akin to cinema. Such were the ideas that impelled Eisenstein to undertake *Stekliannyi Dom* (The Glass House), a project he worked on after filming *Battleship Potemkin*. Between 1926 and 1930 he developed a script for the proposed film, which was based on the notion that cinema and X-rays are kin. The treatment for the film dealt with the familiar themes of art in the era of modernity: mimesis versus abstraction, statics versus dynamics, and visual perception in the era of mechanical "vision." Eisenstein worked on the film primarily during his ill-fated American sojourn (though he conceived of it in Berlin in 1926, after talking to Fritz Lang and Thea von Harbou, Lang's wife and the scriptwriter on *Metropolis*); he intended the film to be an avant-garde parody of American living.[124] *The Glass House* was to be set in a multistorey building made entirely of glass—glass walls, glass ceilings, glass floors, glass windows. Glassy surfaces are one of the features of the modern world, and Eisenstein intended to push this modernity—this American modernity—to its limits.[125] He wanted to abolish the sensation of hardness and weight (the modern world is the phantasmal world of weightless images, of spectres, of X-rays), to blur the distinctions between inside and outside (as X-rays and, in a way, close-ups had done). He wanted light to dissolve the materiality of glass and in this way carry to its conclusion what building with glass had initiated. Transparency had become a modern ideal—or rather, cultures whose modernity engendered a yearning to revert to archaic ways of living had taken transparency as an ideal. The lack of a distinction between the private and the public spheres and a sort of moral exhibitionism were believed to be common characteristics of communal societies—and many progressives believed would be characteristic of the better society to come.[126] Eisenstein's idea for the film developed out of, and was partly a critique of, utopian claims for the glass facade (and of glass architecture).

The work would be partly a polemical response to Mies van der Rohe's proposal to build a glass tower on Berlin's Friederichstrasse. It would be a response, too, to ideas that Bruno Taut (1880–1938) and the European Constructivists Le Corbusier (1887–1965) and Mart Stam (1899–1986) advanced (and which their work exemplified). Taut's group "Die gläserne Kette" (The

Glass Chain) had proposed that glass cathedrals would allow people to experience the cosmic play of nature; the Constructivists believed that glass walls could expose the reality of social structures and thereby contribute to their amelioration (in much the same way that the science of hygienics had shown the relation between poor architectural design and the spread of infectious diseases and had established the health benefits of interiors filled with sunshine).[127] Eisenstein's view was somewhat less sanguine: his glass walls isolated people even while leaving them exposed. Glass walls did nothing to make the social order more harmonious; rather, it left people exposed and open to exploitation, and so angered those living within them that they destroyed their exposed visual spaces.[128]

Eisenstein conceived of his glass palace as providing an image of American life. He hoped that an American author, perhaps Upton Sinclair, might write the script. Mary Pickford and Douglas Fairbanks arrived in Moscow on July 1926 and invited Eisenstein to make films for United Artists (a company they had started with Griffith and Chaplin); he offered them his film about new forms of architecture and the new life of the new man, the project we know of as *The Glass House*. The connection raised Eisenstein's hopes, and he asked an American journalist in Moscow, Albert Williams, to contact Sinclair. He did, and Sinclair wrote back to Williams to express his doubts that Fairbanks would produce such a film.

That Eisenstein conceived of this work as commentary on American living is confirmed by the fact that he pasted a page from the June 1930 issue of *New York Magazine*, presenting Frank Lloyd Wright's Glass Tower, into his diary, appending this gloss: "This is a glass skyscraper that I invented in Berlin." America and Germany merged in his mind as presaging life in the future. In his notes on the project he alternated between using the German and English titles for the project, *Das Glashaus* and *The Glass House*.

Eisenstein's earliest ideas for the film were for a quasi-abstract work. The elevator and the camera would be the principal protagonists: the elevator would stand for the camera's material eye, roaming the building's various floors.[129] Many of the building's inhabitants would be "blind." Some of the inhabitants would be invisible to others (so, for example, a husband would be unable to see his wife's lover, and the well fed would not be able to see the starving). The camera, though, would be all-seeing. Eisenstein described the impression he hoped the building would give.[130] "The transparent building," Eisenstein wrote, "should look like a person under Roentgen rays. The sole opaque object in the glass house, the elevator (a black iron box with lights like gloomy all-seeing eyes) looks like a backbone or a key in the pocket [of this X-rayed figure]."[131]

Vision, and the possibility of seeing from different angles, is the prerogative of the mechanical eye. Thus, the mobile camera ironizes vision.[132] Eisen-

stein, accordingly, characterized the genre to which *The Glass House* would belong as "the comedy of the eye."[133] But it was strange comedy (in keeping with Eisenstein's well-documented sadistic tendencies): the ultimate violations of privacy are visited on the inhabitants. (Eisenstein was under considerable duress during the period he worked on the script; while engaged in this work, he consulted Charlie Chaplin's psychiatrist, Dr. Reynolds.) This interest in perpetrating violence against his actors prompted Eisenstein to plan to juxtapose clothed with nude actors and mechanical instruments with human flesh: "The mechanical man sent to rape the nudiste girls. The nudiste chief succombes [*sic*] with the tailor's daughter."[134]

Eisenstein even claimed that the project was to be about "graduation in nudity."[135] He treated the end of privacy as largely but not wholly negative, for the demise of privacy also marks the advent of communal spirit, for which nudity serves as a metaphor:

> *L'Idealiste "en Jesus-Christ".*
> Looks like [the poet] Nadson. But blonde and wearing horn-rimmed spectacles. Cloven little beard. His "enlightenment" [*prozrenie*]. He preaches. [As he does so], his luxuriously clad audience becomes naked. Gradually. "Bare your souls." A transitional stage is particularly good, when all that is left on gentlemen are starched ruffs. Nothing except adornments on the ladies. A transition from *recueillement religieux* to erotic curiosity … Of course, all this [should be treated as] *symbolique*, [in the same manner] as the transparency of the walls in the house.[136]

Whence do these "nudiste" ideas arise? Partly it is in that strange fascination with sexuality that emerged among the avant-garde around 1906, especially among the Decadents. The writings of Artsybashev, Kuzmin, and Zinovieva-Annibal all show the sinister curiosity that avant-garde writers had for the dark side of life and its relation to sexuality. Aleksandr Kuprin's *Iama* (The Pit), published in two parts in 1909 and 1914, is another work that displays the same fascination. Kuprin based his novel on a painstaking study of police reports and public health records; it depicted what life must have been like for the sexual slaves of the time and how "the life" drew prostitutes down into the pit. Before the First World War, Moscow had a "Suicide Club" that exploited an erotic fascination with death; some reports claim that there was a Temple to Eros in St. Petersburg where men, women, and children engaged in sexual rites. Russia's decadent aristocrats developed a vogue for necrophilia, and much society gossip concerned Prince Felix Yusupov's (1887–1967) transvestite exploits, his alleged bisexuality, and, of course, his participation in murdering Rasputin on the night of December 16–17, 1916.

NIKOLAI FEDOROV'S COSMISM

A more important source for Eisenstein's "nudiste" ideas can be found in the strange and wondrous "Cosmism" of Nikolai Fedorov (1828–1903). Fedorov was a curious figure who worked in the library of the Rumiantsev Museum and who was reputed to be familiar with the contents of every one of its holdings. Perhaps because he was the bastard child of an aristocratic father and a neighbour woman, he was predisposed toward asceticism—he lived in a closet-sized room at the back of the Pashkov Mansion (one of the most beautiful Renaissance-style buildings in Moscow), slept on a humpback trunk, wore the same clothes winter and summer, refused all promotions, and gave away most of his meagre salary to the poor. He was also among the most erudite people of his generation, and he attracted an extraordinarily talented group of people to him—among them Feodor Dostoevsky, Leo Tolstoy, and Vladimir Solovyov. His position as the librarian of one of the more important Russian cultural institutions brought him into contact with the most important Russian intellectuals of his time: the revolutionary social democrats and socialists, and, eventually, the Bolsheviks (especially Aleksandr Bogdanov, 1873–1928 and Anatoly Vasilievich Lunacharsky, 1875–1933), who saw Fedorov's "Plan" for transforming the world as simply another term for Worldwide Revolution and who identified Fedorov's Absolute Cosmic Life with communist society.[137]

Fedorov published no books in his lifetime. He was referred to fondly as "Moscow's Socrates" because of his resolve to publish almost nothing, preferring that his ideas be spread orally, among the devout people of his inner circle. After his death, however, two disciples, N.P. Peterson and V.A. Kozhevnikov published a two-volume edition of discourses he had dictated, under the title *Filosofia obshchago dela* (Philosophy of the Common Task). The book was printed in an edition of 480, every one of them stamped "not for sale," and placed in institutional libraries and the libraries of anyone who requested them.

Fedorov's thought was eclectic and far-ranging; however, it was ultimately dominated by a single theme: the annihilation of death. He proposed that the common task of humanity was to overcome death and that this goal would be achieved by collecting the dispersed atoms of the dead and reassembling them (a process that would be guided by the loving recollection of the departed). Fedorov also believed that technological advances would serve soteriological ends; hence, he advocated colonizing space (to accommodate the increase in population that would occur when the dead were raised), harnessing solar energy, regulating the climate, and irrigating Arabia with icebergs brought down from the Arctic. (He proposed to explode mountains of the Pamir to open a southward route from the tundra so that the people of the region could bring ice down from northern regions, melt it, and turn the immense Arabian desert

into fertile soil. He even calculated how much dynamite would be required to achieve this.) Fedorov also foresaw the technological reproduction and remaking of the human body through cloning and the use of prosthetic organs.[138]

Fedorov's ideas on transformation accorded with those of the Gnostics, who maintained that acquiring knowledge of a kind can purify the self and thus overcome death. Gnostic systems such as Fedorov's have often led to an interest in rejuvenation and in exploring the possibility of overcoming mortality— to the belief that knowledge can transform our being by transmuting its base, material, mortal existence into the gold of eternal spiritual life.

The futurology of Fedorov was later reflected in the hypermodern architecture of Yakov Chernikov, Nikolai Ladovsky, Ivan Leonidov, and Constantin Melnidov; in an interest in interplanetary travel; and in the use of atomic energy, which would animate the work of later Soviet artists. Ivan Kudriashev, a Suprematist who had studied with Malevich at Moscow's SVOMAS (Svobodnye masterskie; State Free Art Studios) in 1918 and 1919, when Malevich had begun using the image of space flight (to suggest a cosmic journey), may have inspired Malevich to deepen his interest in rocketry and space travel. Kudriashev was enthusiastic about rocketry (which linked him back to Fedorov)—Kudriashev's father had built working models for Konstantin Tsiolkovsky, a Russian pioneer of rocketry and a disciple of Fedorov, who believed that colonizing space would result in human perfection.[139] Kudriashev's geometric abstracts of the 1920s exemplified Malevich's great interest in the topic, for they depicted motion through deep space. Recall here that the futurological enthusiasm displayed by these artists, and by many others of 1920s, was a product of the machine age, of which cinema was one manifestation. Thus from the time of Méliès, cinema has been connected with space travel.

The Symbolist bent in Fedorov's thought (Symbolist *avant la lettre*) was associated more generally with "the modern." Fedorov's marvellously baroque Cosmism remained in the background of Bolshevik thought (further evidence of its suppressed dependence on late nineteenth-century idealism). Bolshevik intellectuals had absorbed his thought through his Symbolist disciples, and Fedorovian idealism provided the imaginative space within which the possibilities of space travel—as well as many utopian proposals for refashioning human being—could later be explored (as part of the more general attempt to bring about a total revolution of everyday life). Poets and painters dreamed of victory over the sun—but that was just one form that imagining the transcendence of nature assumed. For many Soviet artists the earth was a space to be escaped from, not least because it partook in the pagan trinity of an early Slavic image of the maternal body—*mat' syra zemlia* (Mother Moist Earth). That image was too soft for the new utopian consciousness of the technological age.

Fedorov's secretiveness makes it difficult to determine the sources of his ideas.[140] We can say that the themes of his writing have a Gnostic "shape." One

belief system he often cited with approval was the religion of the ancient Iranians outlined in the *Zend-Avesta*; indeed, Zoroastrianism is generally viewed as an ingredient of ancient Gnosticism. The twentieth-century philosopher Eric Voegelin has written brilliantly on the Gnostic character of our conceptions of technology, and Fedorov carried that tendency of modern thought further than almost anyone else. Like Eisenstein's, Fedorov's thought was an unstable brew of science and religion. In Fedorov's case, as in Eisenstein's, that brew led to a striking enthusiasm for technology: he took what had been the business of magicians and sorcerers (the conquest of natural law, the transcendence of space and time, the advance into new dimensions of reality, and above all else the victory over death) and made it the business of technology.

Rosicrucian convictions were widespread in Fedorov's Russia and probably also did much to shape his ideas. The Rosicrucians teach that only one force exists in the universe—namely, the Power of God, which He sent forth through space as a Word—not a single word, however, but the Creative Fiat. This Creative Fiat, by its vibration (Fedorov helped inject the term "vibration" into Symbolist thought), marshalled millions of chaotic atoms into many shapes and forms, from starfish to star, from microbe to man—indeed, all things that constitute and inhabit the universe. The syllables and sounds of this Creative Word, Fedorov averred, were sent forth one after another through all the ages. They created new species and steered older ones in their evolution. All this went on according to a plan conceived in the Divine Mind even before the dynamic force of creative energy was first sent out into the abyss of space. Fedorov proposed that love guides the synthesis of the dispersed atoms. The Rosicrucians maintain a rather similar (if less material) conception: a Rosicrucian prayer asks, "Our heavenly Father, according to Thy will, may the Love-Wisdom Principle of Divine Power eradicate discord and establish harmony and universal peace in the hearts and affairs of men." Eisenstein too, in "Laocoön," discussed the idea of breaking a person into pieces and scattering his parts around, leaving it to the reader, through an application of the "Osiris principle," to bring him to life as whole person.

Engel's theory of the dialectic was a theory about the dialectic's power to transform reality through its forward march; it was about the fate of being that would be realized through cosmic evolution—so it, too, had analogies to features of Fedorov's Cosmism. That analogy, as Eisenstein likely understood, allowed speaking of the dialectic to serve as a way of talking about Cosmist ideas. Discourses based on that secret meaning of the dialectic became an important feature of cultural life under the Soviet Union's persecutory regime.

The idea for which Fedorov is best known is that of the immanent universal resurrection, which, in Gnostic fashion, he averred would be brought about through human effort. The resurrection, he insisted, would be carried out by

scientific means and through physical processes. He proposed that a future time would experience the resurrection of the bodies of the forefathers—that the bodies of the departed would be rescued from their graves and reunited with their spirits, which for now were roaming the cosmos. All humanity would have to participate in this Supreme Action, the effort to bring about the universal resurrection. Fedorov plumped for the unstinting allocation of resources to carry out this ultimate task, arguing that technology had made universal salvation possible. The issue of universal salvation had been a thorny one in the Orthodox Church, as in most other Christian denominations. In Matthew (25:31), Christ predicts a Last Judgment that will discriminate between those who are saved and others. At that time, God "will separate people into two groups as the shepherd separates the sheep from the goats." Yet at the same time, fundamental to Christian teaching is the proposition that forgiveness must be universal. Will the judgment at the end of time extend forgiveness to all, or will it distinguish the saved from the damned? The official doctrine of the Orthodox church reflects the latter; but ever since Patristic times, some thinkers (e.g., Origen and Gregory of Nyssa) have maintained that the former possibility might be realized.[141] Fedorov (and Solovyov) insisted that universal salvation was the only alternative, that it would be contrary to God's plan for humankind to save only a select group.[142]

Fedorov's Cosmism depicted the universe as evolving from matter, through consciousness, to perfect self-consciousness—a perfect self-consciousness that would hold all in its embrace. Thus in one key respect Fedorov's notions about the role of human effort in salvation differed from the esoteric doctrines of the Gnostics: he portrayed the progress of history as advancing not through the knowledge that particular individuals possess (as the Gnostics believed), but rather through the development of the universal or cosmic mind. Accordingly, he maintained that Enlightenment comes by all, through all, and for the sake of all.[143] Thus humanity should make a Common Cause—so proclaimed *Filosofia obshchago dela* (The Philosophy of the Common Cause). The Common Cause is scientific, social, economic, cultural, psychological, spiritual, industrial, cosmic—it is the common struggle against Death and for the Absolute and Infinite Life. Fedorov called the strategy of this fight "the Plan."

Fedorov's Cosmism was markedly anthropocentric, a feature that linked it with the Russian God-Builder movement of the early twentieth century. The anthropocentric roots of Fedorov's Cosmism were reflected in his notion of "the new human." Like so many late nineteenth-century cosmologies, Cosmism proposed an evolutionary conception of reality, but one in which human being would play a key role. The Cosmists held that the human world is a site of transition between the biosphere (the sphere of living matter) and

the nöosphere (the sphere of reason), since humans are living matter endowed with reason. Cosmic evolution depends on human beings to reach its goal, which is the perfection of total integration. Thus during the final stages of the evolutionary process all humankind must be united into a single organism, a higher planetary consciousness able to guide further development, an organism capable of guiding and perfecting the universe, of overcoming disease and death, and, finally, of bringing forth an immortal human race. Fedorov believed that aesthetic experience would accomplish these goals.

Fedorov's stress on the key role that human effort plays in salvation was typical of Gnostic thinking—that is, our striving can carry us beyond the world as it is and help to bring forth the world as it ought to be. In its ideas about bringing forth the ideal kingdom, Fedorov's Cosmism reworks Gnostic ideas of self-perfection and self-deification, including the idea of the resurrection of the dead, which has a long tradition in occult and Gnostic thought.[144]

The idea that science can uncover powerful psychic–cosmic energies—an idea so fundamental to Fedorov's redemptionist program—also has Gnostic provenance. The Gnostic strain in Fedorov's thought is also evident in the technologism that characterized his ideas on transmutation. Solovyov, writing to his "dear teacher," asked how, if the dead were merely to be reconstituted as they were, they would avoid killing one another, and even devouring one another, in the ideal world to come. In this exchange, Solovyov argued that the intervention of grace was necessary to free the resurrected humans of their desire to visit harm on one another; Fedorov, true to his Gnostic principles, responded by rejecting any suggestion that a miraculous transformation, effected through grace, was necessary. No spiritual transformation would be necessary, Fedorov argued—aesthetic transformation would suffice to effect this change.

THE NEW BODY

Fedorov's belief in the aesthetic transformation of humanity led him to consider a question that would play a large role in art theories in early twentieth-century Russia: How could new bodies be created that would be suited for the future world? Art, Fedorov argued, lies at the intersection of material and ideal reality, so it is able to transfigure the human body. Science will resurrect the bodies of the departed, Fedorov predicted, but art will restructure them. A principal concern of Fedorov was how to bring forth a blissful collective organism. His solution: The body's earthly constitution would have to be fundamentally changed. Cosmic nutritional substances would be invented, along with new organs for digestion. Cosmic transmutations of the body would then occur that left behind the body's zoomorphous nature as it developed vegeta-

tive organs. These new vegetative organs would make the body capable of feeding on and accumulating the all-pervading cosmic substance—that is, light (just as plants are nourished through photosynthesis). The flesh body would be converted into a photosynthesizing biomass that would flourish in the light and warmth of special greenhouses in outer space. This new body would make sunshine (and light generally) a primary economic resource, one that could be consumed and reproduced by the new human organism. The worker and the machine that produced the cosmic resource (light) would in time fuse into one entity.

Fedorov's ideas on the transformed human being of the future resurrection made possible the broad acceptance, among Russian artists of the early twentieth century, of the conviction that the technologies the historical process brought forth would ultimately transform the human body, endowing it with increased sensory abilities. That idea appeared in the theories of Vertov (which celebrated technology as the latest step in the evolution of sensory devices) and Eisenstein (consider "Laocoön"), as well as in *Pobeda nad solntsem, Opera* (Victory Over the Sun: An Opera, 1913) mounted by Burliuk, Matyushin, Malevich, and their colleagues.[145] The belief was widespread that the human form could be improved or even perfected. Mikhail Vrubel pointed out the need for supplementary limbs and even proposed developing a supplementary body, one that would allow one to reach freely in all directions (such would be the make-up of its new wrists); Pavel Filonov (1883–1941) argued that changes in diet could result in greater visual acuity; and Mikhail Matyushin (1866–1934) developed a conception of *Zor-Ved* (see–know), to which his paintings and microtonal music were linked. Matyushin was a formidable theorist and at the time one of the most learned avant-garde artists in Russia (which suggests how he gathered a fascinating group of young artists around him).[146] Matyushin's aesthetic theory had been inspired by Symbolism, Pantheism, and Futurism as well as by the Theosophical theories of Hinton, Ouspensky, and Gurdjieff. He was also a musician, composer, painter, and colour theorist who in 1932 published "Zakonomernost' izmeniaemosti tsvetovykh sochetanii. Spravochnik po tsvetu" (The Laws Governing the Variability of Colour Combinations: A Reference Book on Colour, hereafter *Colour Handbook*), one of the last manifestos from the Russian avant-garde, in an edition of four hundred copies.

In the preface to *Colour Handbook*, Matyushin argued that having a "world view" is essential to understanding colour concepts; he termed the fundamental concepts of his "world view" as follows: "Organic Culture" and "Spatial Realism." These had also been the names of the workshops he had supervised as a Bolshevik professor.[147] For those workshops, Matyushin had developed a training program that included yoga, meditation, and various other pneumatic exercises, the purpose of which was to encourage his students' artistic

development. His notions about how these exercises would foster their artistic development are fascinating: Learning that the common housefly has a very wide radius of sight, while a dog has a very narrow one, brought Matyushin to reflect on the natural variability of optical phenomena, and those reflections led him to conclude that human beings could expand their optical radius. But this expansion was not to be effected simply by improvements to the eye itself: his *Zor-Ved* system, developed after 1913, maintained there are dormant optical reflexes in the soles of the feet and the back of the head and that these reflexes could be awakened, allowing one to paint "landscapes from all points of view." Among the exercises that he proposed for developing these abilities was to practise seeing with each eye separately, to develop a sort of strabismus. Matyushin referred to this sort of seeing as "expanded" or "amplified" vision (recall how the intelligensia had responded to the discovery of X-rays). "Amplified vision" did not include just the eyes; he expanded it to involve hearing, tactility, and thinking—in short, a kind of conscious synaesthesia. He considered this analogous to the expansion of consciousness through yoga, in that it would allow people to see the world as revealed through meditation. His ideas about expanded vision may even have been influenced by the yogic belief (which is recorded in Boris Ender's diary from March 1920) that the eyes are only the secondary organ of vision and that the primary organ of vision is a nerve centre, an "internal eye" in the brain. Once humans had developed the capacity for circumvision (at which stage of development their visual apparatus would encompass a panoramic visual angle of 360 degrees), not only would colours present themselves more intensely than through the visual apparatus that humans at present possessed, but as well, humans would experience a new spatial reality, that of the fourth dimension. Matyushin pointed out that to untrained eyes a stone would seem inert, immobile, static, dead; seen by the *trained* eye, it would be seen as belonging to the fourth dimension. Moreover, the low-frequency waves of solid materials (such as stones and minerals) would become visible; thus it would become evident that stones and minerals possessed vital energies (albeit of low frequency). To the untutored eye, cars seem to move at one speed, people at another, and trees to grow at yet a third; thus, to the untutored eye, the world appears a disorderly collection of fragments with no harmony among them. To the tutored eye—that is, the eye that had developed the capacity for "amplified vision"—the organic unity of the whole world would be evident.[148]

Matyushin believed that evolution would ensure that at some time in the future all humans would possess expanded vision—all people would see in a way that lacked directional references. Thus he declared: "*Zorved* signifies a physiological change from former ways of seeing and entails a completely different way of representing the seen. *Zorved* for the first time introduces observation and experiments of the hitherto closed 'back plane,' all that space which

remains outside the human sphere because of insufficient experiment."[149] As one might expect, he connected abstract art to expanded vision, which he believed revealed the true nature of reality.[150] Matyushin's Organic Culture was founded on physiological concepts about human perception, and (against Malevich) it favoured the use of curved lines to indicate the organic character of preception. His concept of Organic Culture influenced artists such as Nikolai Kulbin and Pavel Filonov.

Despite its occult provenance (in Ouspensky's systematization of the Gurdjieff's teachings), Matyushin's extravagant hypothesis of circumvision was subjected to further investigation, throughout the 1910s and 1920s, by his colleagues, Boris, Maria, Xenia, and Yuri Ender and Pavel Mansurov, and at the Rossiskaia Akademia Hudojestvenih Nauk (RAHN) (Russian Academy of Artistic Sciences) in Moscow and the Petrograd State Free Art-Teaching Studio. What is more, his conjectures had parallels in research into colour perception conducted by conventional scientists, including Sergei Kravkov (1894–1951), who in the 1940s became one of the most important investigators of the physiology of vision and an investigator of the effects of sound on the experience of colour; Petr Lazarev (1978–1942), who also investigated "nervous energy," which he understood to be a form of electromagnetism, as well as light and telepathy as immediate communication; and the Psihofizicheskaia Laboratoria (Psycho-Physical Laboratory) of the Gosudarstvennaia Akademia Hudojestvennih Nauk (GAHN; State Academy of Artistic Sciences) in Moscow. Related laboratory work was carried out at the Moscow Centre for the Scientific Organization of Labour (originally a centre for the study of Taylorist ideas), an institute with which both Malevich and Meyerhold were associated.

Matyushin also studied the interaction of colour and sound. These studies led him to conclude that through evolution yet to come, the colour-receiving cones of the eye would spread from the centre of the retina toward the periphery, resulting in the improvement of colour perception and the perception of colour movement (since, given the present constitution of the eye, the perception of motion is more acute at the retina's periphery than at its centre). His experiments in colour perception used simple, coloured forms that could be moved in a controlled environment (allowing colour, shape, and motion to be varied independently); these experiments revealed that sound influences perceptions of colour and form. Thus a low, rough noise makes a given colour seem darker and redder whereas a high, piercing tone makes it seem more transparent and more blue. Matyushin and Ender used similar means to study how colour could affect perceptions of shape.

This belief led to an interest in the development of consciousness through several stages. The conception of levels of consciousness, of lower and higher forms of nervous activity, had been put forward by Gurdjieff, Ouspensky, Steiner, Blavatsky, and so on. In *Tertium Organum*, Ouspensky set out four

stages in spiritual development, stages marked by an increasing ability to perceive forms in four dimensions, a new feeling of time, a greater appreciation of the reality of the infinite, and an expanded sense of the universe as a living organism; even more remarkable, in light of Eisenstein's musical analogies, was Ouspensky's assertion that the development of a higher consciousness was evidenced in the development of the sensation of a world harmony. M.V. Lodyzhensky's popular exposition *Sverkhsoznanie i puti k ego dostizheniiu* (Superconsciousness and Ways to Achieve It) explained the methods that practitioners of Raja Yoga and Christian asceticism used to achieve higher states of consciousness; he claimed that higher consciousness is the product of organic evolution and that a historic juncture was in the offing, when anthropological development would transform the human faculties of clairvoyance from their present incipient condition into fully developed physical organs. That claim influenced many Cubo-Futurists, including Matyushin.

Other artists were less patient and less inclined to rely on evolution to produce longed-for changes in human being. Their notions about remaking the human body were more revolutionary than evolutionary; they looked for ways to redesign the body that would have immediate results. Thus, between 1912 and 1914, several Cubo-Futurists, including Burliuk, Goncharova, Larionov, and Zdanevich mounted performance artworks *avant la lettre* by painting their faces and bodies with codes, cryptic messages, and ceremonial images of animals and birds, along with Rayonist forms, and parading their decorated bodies through the streets. For their body decorations they drew from American Aboriginal and African body painting, Polynesian tincturing, and Ancient Scythian tattooing. What made the ancient practices attractive was that they were means for contacting the Divine. Zdanevich and Larionov explained their behaviour in a 1913 manifesto, "Pochemu My Rasskrashivayemsja: Manifest Futuristov" (Why We Paint Ourselves: A Futurist Manifesto), in which they noted their connection with Filippo Marinetti and Umberto Boccioni and contended that their body art transformed the body into a hyperaccelerated phenomenon.[151] Remarks that Burliuk, Goncharova, Larionov, and others made about the hyperaccelerated body reveal that these thinkers believed that the ideal body was a body of energy. The human body of energy could meet with the Divine, itself a body of energy.

Some thinkers proposed more traditional means. Theosophists taught vegetarianism as a way to purify the body. Gurdjieff advocated developing the body/mind through haida yoga. Others preached salutary diets as a means of controlling the body; still others advocated physical exercise and endurance tests as means for attaining spiritual revelation. Filonov was impressed with the extreme attention that yogis and Arab peasants gave to the thorough mastication of food and became greatly concerned with methods that might lead to getting maximum benefit from food. The practices of fasting and gymnastics be-

came common among the vanguard as preparation for the final journey, and so did the practice of vagabondism (understood as the earthly analogue of the great journey to come). This was one motivation for Filonov's trip to the Holy Land in 1908, for Khlebnikov's journeys through Russia, for Kuznetsov's longing to see the Russian steppe again, for Gurdjieff's travels through the Caucasus, and for Petrov-Vodkin's bicycle trip to Western museums.

A key figure in popularizing these ways of thinking about the body was Isadora Duncan, whose Russian tour of 1905 many Symbolists attended. The Expressionist dynamics of Duncan's dancing took hold, and some Symbolists began to practise modern dance. In March 1907 a "Mme. K.," accompanied by Nikolai Tcherepnin, Rebikov, and Scriabin, performed Greek dances at a musical evening mounted as part of a Blue Rose exhibition. Barefoot dancing became a cause in Russia, as it had in Germany. By the early 1910s the Dalcroze method of eurythmics had a large following in Russia. Around this time, Taylorism and Meyerhold's biomechanics also commanded attention. (Duncan's ideas would have a long life in Russia. In 1922 she married the Russian poet Serge Esenin, whom she had met in February 1921 while performing with the Bolshoi Theatre in Moscow. From 1921 to 1924 she had a school of dance in Moscow.)

Many thinkers and artists concluded that Western people could tap energies inherent in the body—energies we had lost contact with—by resorting to such non-Western practices as yoga, meditation, and vegetarianism. And from these beliefs about contacting energy, it was easy to conclude that by eliminating the toxic effects of hyperrationality that were producing a necrosis of the body, one might attain a higher consciousness that would rejuvenate oneself and so allow one to triumph over death.

Thinkers such as Lev Bakst had expounded on the importance of the body. Indeed, many Russian artists of the period took an interest in the idealized body. This idealization took several forms. One was the utopian pursuit of body development—"amplification"—through exercise and eurhythmics. Another was the effort to fashion a new, technologically improved body. That idea, most readers will know, appealed to Lissitzky, Eisenstein, and Vertov, among others. Yet another was the effort to recover the innocent prelapsarian body. Thinkers went to great efforts to discover what must be done to recover the pristine body. A common proposal was to practise nudity, which would enable one to be comfortable in one's body. The idea was not terribly shocking—the paganism that underlies Russian Orthodoxy was more tolerant of nudity than the Roman Church.

Indeed, Czar Nicholas II had removed all restrictions on social nudity and was himself an avid nudist. He thought that nudity could help preserve and improve the health of society. Lenin tried to establish nude beaches in the Soviet Union (the conviction that nudity was healthy was one of the few beliefs

that he and the Czar would have shared), and in the early 1920s nudists marched in the streets of Petrograd to celebrate the body.

Among the most dedicated believers in the principle that nudity had redemptive potentials was the painter, boxer, and life model Ivan Miasoedov. Miasoedov's activities fused the idealization of the body through corporeal amplification with the idealization of the pristine body. In 1912 he issued his *Manifest nagoty* (Manifesto of Nudity), declaring that the naked body is preferable to the clothed one. The nudism that Miasoedov expounded attracted many converts, including Leonid Andreev and Maximilian Voloshin; it even received a degree of official recognition when the first Soviet Nudists organized a Vecher Obnajenovo Tela (Evening of the Denuded Body) in Moscow in 1922, to celebrate nudity as the truly democratic manner of presenting oneself. Among artists, there were three Nikolais—Evreinov, Kulbin, and Kalmakov—whose collaborations were based on this conviction.[152] Between 1910 and 1912 the playwright Evreinov and the painter Kulbin collaborated on the manifesto "Nagota na Stzene" (Nudity on Stage), which celebrated the expressive potential of the naked body. During the same period, Evreinov collaborated with the painter Kalmakov on a version of *Salomé*. Its set would have represented intimate details of the female anatomy. Though officials banned the play, Kalmakov continued to produce paintings for the set, signing them with a stylized phallus. They were not alone in their interest in presenting nude actors on stage. In 1914 the director of the Chamber Theatre of Moscow, Alexander Tairov, mounted a production of Kalidasa's *Sakuntala*, with designs by Pavel Kuznetsov, which presented painted nude bodies on stage. In connection with this performance, Tairov asserted his conviction that theatregoers should accept on-stage nudity as a distinctive and joyous theatrical costume and that painted nudes have nothing in common with the artificial bas-reliefs of common theatrical productions. Lev Bakst, too, proposed putting nude players on stage. At the same time, the Bolshevik revolutionary Aleksandra Kollontai began to teach the benefits of free love and placed the doctrine of free love into practice in her life.

Fedorov's interest in expanding the body's powers had more to do with Gnostic ideas of self-perfection. Probably on the basis of the occult conviction that reality is ultimately energy, Fedorov had assumed that nervous energy is identical to electricity and that electrical currents could transmit thought processes. The *fedorovtsy*, Fedorov's followers, continued to advocate Fedorov's ideas about amplifying human ability, developing them into plans to increase humans' pneumatic powers, to transform nervous energy into light and heat, and to use telepathy as a form of human communication. Thus in 1923 the physiologist Sergei Beknev suggested that in the future, human beings would be able to turn themselves into generators of heat and light whenever they wished and to use thought to change the structure of matter.[153]

Eisenstein did not draw directly on Fedorov's marvellously baroque system. But he did propose a revolution in consciousness, to be brought about by the new art: "The new art must set a limit to the dualism of the spheres of 'emotion' and 'reason' ... It must restore to science its sensuality. [How Goethean!] To the intellectual process its fire and passion. It must plunge the abstract process of thought into the cauldron of practical activity." Cinema would be his tool: "A cinema of extreme cognition and extreme sensuality that has mastered the entire arsenal of affective optical, acoustical and biomechanical stimulates."[154] And what, we should ask, was this "extreme cognition"?

MEXICO AND MALLARMÉ

In *Cinéma et réalité* (Cinema and Reality), Artaud stated:

> The human skin of things, the epidermis of reality: this is the primary raw material of cinema. Cinema exalts matter and reveals it to us in its profound spirituality, in its relations with the spirit from which it has emerged. Images are born, are derived from one another purely as images, impose an objective synthesis more penetrating than any abstraction, create worlds which ask nothing of anyone or anything. But out of this pure play of appearances, out of this so to speak transubstantiation of elements is born an inorganic language that moves the mind by osmosis and without any kind of transposition in words. And because it works with matter itself, cinema creates situations that arise from the mere collision of objects, forms, repulsion, attractions.[155]

The Surrealists' enthusiasm for American popular cinema—an enthusiasm shared by Eisenstein and many of his Soviet contemporaries—has long been a familiar topic. What are we to make of this interest? A remark by Cesare Zavattini provides a startling clue: in the early 1950s, in a polemical piece of neorealist advocacy attacking the tradition extolled by classical film theory, he wrote:

> This powerful desire of the [neorealist] cinema to see and to analyse, this hunger for reality, for truth, is a kind of concrete homage to other people, that is, to all who exist. This, among other things, is what distinguishes neorealism from the American cinema. In effect, the American position is diametrically opposed to our own: whereas we are attracted by the truth, by the reality which touches us and which we want to know and understand directly and thoroughly, the Americans continue to satisfy themselves with a sweetened version of truth produced through transpositions.[156]

Zavattini aimed his remarks directly at the American melodrama and indirectly at the "white telephone" movies of his native country. We recognize, however, and not without a start, the applicability of Zavattini's remark to

Eisenstein's filmmaking, for Eisenstein's films, too, propose a "version of the truth produced through transpositions." André Bazin is compelling on this point when in "Montage Interdit" he contrasts Eisenstein's cinema with the fables of children's tales by Albert Lamorisse and asserts that montage translates the real into the realm of the imaginary. Even if montage constructions are composites of elements belonging to the natural order, the creative process of montage willy-nilly lifts these composites to an imaginary order.

The transformational premises of the Soviet filmmakers asserted that an artwork's formal structure transcends the given order of reality to form a higher order. Eisenstein persistently, and increasingly over the years he devoted to elaborating his film theory, insisted that artistic forms (and religious forms, too, for that matter) serve to redirect primitive impulses toward a culturally higher type of activity. Efforts to identify the nature of this higher order caused Constructivists much grief. They did not want to conclude that this higher order was ideal—thus, they argued that the forms they were constructing still belonged to the material realm—they stressed that they were arrangements of material elements and that they had effects in the material realm of social relationships. If their art transcended the given order, it did so only in the sense that it presented a view of what human existence could be, not simply what it was.

Still, the paradox of Constructivism becomes evident when we juxtapose Eisenstein's ideas with those of Robert Bresson (a juxtaposition that might seem almost perverse to some). Take this passage from Bresson's *Notes sur le cinématographie* (Notes on Cinematography), in which Bresson prescribes a cinematic practice that he called

> cinematographic film, where expression is obtained by relations of images and of sounds, and should not be a mimicry done with gestures and intonations of voice ... One that does not analyze or explain. That *recomposes* ... An image must be transformed by contact with other images, as is a colour by contact with other colours ... No art without transformation ... Cinematographic film, where the images, like the words in a dictionary, have no power and value except through their position and relation ... No absolute value in an image. Images and sounds will owe their value and their power solely to the use to which you destine them ... IN THIS LANGUAGE OF IMAGES, ONE MUST LOSE COMPLETELY THE NOTION OF IMAGE. THE IMAGES MUST EXCLUDE THE IDEA OF IMAGE.[157]

"Cinematography" is essentially Bresson's word for the good object that contrasts with the bad object, cinema. The bad object proceeds by representation of real events, while a cinematograph comes into existence by the transformation of cinematic elements through juxtaposition—exactly as Eisenstein averred. Bresson's filmmaking is ordinarily described as transcendental, and perhaps

Eisenstein's should be as well. Certainly the similarity tells us much about the roots of Eisenstein's style and the character of his aesthetic theories. Symbolism influenced Eisenstein's later theories. His later writings—his writings on the monistic ensemble, on ecstasy, on colour—are replete with Symbolist ideas. That is not to say that his early writings do not use the Symbolist lexicon—they do, from time to time. But the later writings especially strongly imply (and adumbrate) Symbolist ideas.

The quasi-religious sublimity of the films that Eisenstein made after his visit to Mexico must be addressed. To address that topic is difficult, however—so difficult that none have so far succeeded with it. The zeal with which critics from the recent past have gone about identifying the politically progressive elements in the Constructivist program, and Eisenstein's own discretion regarding his more unruly sources, make writing about these matters seem an act of tergiversation—of apostasy from the artist's Holy Writ. Perhaps the most secure point at which to begin is to accept that Eisenstein loved the advanced literature of his contemporaries, a remarkably vital and eclectic collection of people. He was especially interested in the work of James Joyce, a radical artist by any genuinely aesthetic criterion. To get some sense of the influence, consider that classic piece of Symbolist aesthetics, G.-Albert Aurier's "Symbolism in Painting: Paul Gauguin" (1891):

> Indeed, in the eyes of the artist—that is, the one who must be the *Expresser of Absolute Beings*—objects are only relative beings, which are nothing but a translation proportionate to the relativity of our intellects, of Ideas, of absolute and essential beings. Objects cannot have value more than objects as such. They can appear to him only as *signs*. They are the letters of an enormous alphabet which only the man of genius knows how to spell.
>
> To write his thought, his poem, with these signs, realizing that the sign, even if it is indispensable, is nothing in itself and that the idea alone is everything, seems to be the task of the artist whose eye is able to distinguish essences from tangible objects. The first consequence of this principle, too evident to justify pause, is a necessary *simplification in the vocabulary of the sign*. If this were not true, would not the painter then in fact resemble the naïve writer who believed he was adding something to his work by refining and ornamenting his handwriting with useless curls?[158]

The core of this *doxa* is the theory of the transmutation of the sign by the idea. But Eisenstein's aesthetics, in its own way, proposes a similar theory of transmutation (though he was chary about how he expressed his ideas, for he was impelled to avoid giving away that his theory had idealist leanings). He recognized that the relation between a signifier and its referent in photographic and cinematographic media was especially strong; but this only entailed for him the necessity to find the mightiest means of (dialectically) negating and then sublating this reference. He thought of the individual

object-fragment as something that is not significant in itself but that becomes a semiotic agent through transformation—that is, it only becomes a semiotic agent as it becomes part of a matrix of active elements whose unity is shaped by considerations of the element's effectivity within a matrix of active elements. The matrix's effectivity is modified by the effectivity of each of its elements, while the effectivity of each individual element is modified by the effectivity of the whole. He identified montage as the means that transforms the shot from a referential entity to an active element: through montage, a fragment of natural reality is transmuted into a new entity, one with a new significance (a new effectivity); this transformation occurs as the fragment from natural reality is incorporated into a new, higher reality (and its effects are modified by those of surrounding elements).

Perhaps Eisenstein would have disagreed with the Symbolists about the nature of the ligature that holds the individual elements that make up an artwork in a higher unity. Still, this new, higher reality, since it possesses significance, must belong to the order of ideas—with that he would have agreed. For Marxists, however, consciousness is simply an epiphenomenon of matter, one that supervenes on natural processes—and Eisenstein seemed genuinely committed to some view of consciousness and meaning that was consistent with the Marxist beliefs, rather than with the Symbolist view that consciousness opens onto a Beyond that is higher than the domain of matter.

Nonetheless this difference has less importance than it seems prima facie to possess. A key to Symbolist theory is the notion that the inner and the outer worlds correspond—this notion is, for example, the basis of the idea that natural objects form a primal hieroglyphic language. Marxists, like Symbolists, subscribe to monism (even though the single reality they conceive has a profoundly different character from the Ultimate Reality that the Symbolists conceived)—and so like Symbolist aesthetics, Marxist aesthetics maintain that the representing token (or the active semiotic element) and its referent belong to the same order of reality. Thus the aesthetic transformation does not lift the representing token into a different ontological realm: the transformation is from inertness to activity. The signifier is vital, but it still corresponds to the inert world of matter. Furthermore, Symbolism conformed to the ideals of the oracular, illuminist, and idealist traditions, and it placed extreme emphasis on subjectivity. Eisenstein's interest in James Joyce's inner monologue—an interest he developed out of his enthusiasm for Lev Vygotsky's idea of inner speech—was similarly subjectivist. But we can be more definite than that: his understanding of both Joyce and inner speech was massively influenced by Symbolism.

Eisenstein's frequent references to Mallarmé tell us much about the filmmaker's Symbolist proclivities. Mallarmé was obsessed with the idea of correspondences, which Baudelaire had introduced in *Fleurs du Mal* (The Flowers of Evil). The Symbolists generally accepted the metaphysics of Baudelaire's

Sonnet des Correspondances (Correspondances), with its suggestion that all phenomena of the material realm have symbolic value, for they point to higher, metaphysical reality—that the phenomena of the material world are linked to one another and to realities of the higher realm by the mysterious bonds of analogies that poetry and music alone can vouchsafe. Like Schlegel, Mallarmé saw the universe as bound together by subtle analogies that only the poet could detect.

Mallarmé was drawn toward forms that employed ellipses and unconventional syntax, the purpose of which was to evoke a sense of mystery. Eisenstein's montage is similarly elliptical and disjunctive. Indeed, his use of parataxis developed out of Symbolist notions, akin to the notion of correspondence that Mallarmé drew from Baudelaire. This explains why Eisenstein praised Mallarmé's poetry for its power to create a "generalized image."[159] The filiations of the idea of the generalized image are extraordinary to ponder.[160] Like Schlegel, Baudelaire and Mallarmé pursued the notion of correspondence to ideal realms; for them, the analogies that bound the universe together lay beyond the realm of the appearance—they claimed that these analogies belonged to a realm that could be likened only to the ideal realm of Plato's forms.

Still, if one reads them carefully, Eisenstein's remarks on the generalized image, and indeed his remarks about a higher reality that is disclosed in the relationship between juxtaposed shots, offer nothing inconsistent with such a Platonic conception of the universal. In 1937 he asked himself about the Odessa Steps sequence: "What is it in our example that achieves this effect of lifting the generalisation beyond the bounds of mere depiction? Or rather, which one of the complex of expressive means used in our example carries out the function of this ultimate, maximal generalisation?"[161]

Then, likely recognizing the accusation to which he has exposed himself, he attached a footnote that this maximal generalization would occur "without making a 'leap' into the 'cosmos.'" He then proceeded to answer the question he had posed about the generalized image being raised beyond the bounds of mere depiction: "It is not the narrative by montage, but the *rhythm* of the montage, for of course the rhythm of the scene is the final, ultimate generalisation to which the theme can be subjected while retaining the vital link with the event yet simultaneously extending far beyond it; not breaking its texture but raising it to the utmost limits of specific generalisation."[162]

To which he again appended a parenthetical qualifier: "i.e., without drifting off into 'cosmic abstractions.'"[163] One suspects that he explicitly disavowed any tendency toward a cosmic drift in his thought and practice for fear that some might recognize the filiation of his ideas and, by that, his secret allegiances. Lest one be prompted to dismiss such suspicions as unwarranted, as arising from a proclivity to indulge the urge to engage in baseless psychological speculation, consider this Symbolist text of Pavel Florensky:

An artistic perception of objects in movement can occur only when the law of outer movement is interpreted and assimilated as a specific rhythm of our inner life; when the object in motion almost dissolves in our soul, imparting its movement in the form of vibrations. In an artistic sense, the movement of external objects indicates merely the trembling of the motionless soul. The artist's task is to contain these inner rhythms within the soul that vibrates.[164]

Read carefully the following explanation for cinema's perlocutionary effects and you will see it sounds less like the scientific analysis we are led to expect. Instead, we discern evidence of the sources of ideas: the enthusiasm for, and inquiry into, telepathy; Fedorov and the Biocosmists; Lucien Lévy-Bruhl (a writer formulating his ideas at the very same time that Eisenstein was developing his theory of cinema); and Leonid Vasiliev's parapsychological research. Vasiliev's work from 1921 to 1938 was reported in *Eksperimentalnoi Issledovaniya Mislennovo Vnusheniya* (Experiments in Mental Suggestion, 1962), which purports to demonstrate that the thoughts of one person can directly affect the physiology of another distant person. Eisenstein continued the foregoing discussion of his new method in the arts thus:

> You are *not seeing the depiction of an argument*: the *image of an argument* is evoked within you; you participate in the process of the image of an argument coming into being [again, how Goethean!], and thereby you are drawn into it as though you were a third participant in the evolving dispute ...
>
> Herein lies the relevance of Stanislavsky's advice to the effect that the actor must, when playing, recreate a process and not act out the results of a process.[165]

The passage goes on to provide further evidence of the Symbolist provenance of his ideas on transformation:

> There are fights and fights. There is the fight which is planned and rehearsed, in which the chosen scenario unfolds move by move and action by action just as it was planned; and yet that fight will be as lifeless, ineffective, unconvincing and emotionally unexciting as the depiction of a fight in "long shot" on the screen. On the other hand, there is the fight in which every phase "arises" before the spectator's eyes ... is created, brought to life, as the active expression of an emotional logic deriving from the aims which the actors set themselves in their progression from phase to phase of the action ... Its effect will be distinctive to the same extent that the effect of the *montage-structured* fight differs from the fight shot from one set-up in long shot. The art of montage in film-making *is not an analogy with but is exactly the same thing* as an actor's playing on stage; provided that the actor is not playing something ready-made but if, instead, his playing is a process within which, step by step, emotions are brought into being that are in true accord with the circumstances.[166]

Eisenstein argues here (as Kandinsky had done) that representations in different media can be identical—that they are identical if their effects are identical. This claim is, of course, contrary to the materialist principles that are fundamental to his theoretical edifice. I do think that he genuinely strived to develop a materialist aesthetic—one, moreover, that granted priority to the essential features of each medium, the features that differentiate any medium from other media. But he also felt the appeal of Symbolism and its interest in extreme states of mind. These interests he had to conceal—or, at least express in code. The repression of his Symbolist convictions (a repression so thoroughly internalized that it became part of the dynamic of his thinking) introduced into his writing a tension that we have already seen is typical of the Symbolist view of the relations among the Sister Arts. Despite his assertion that the essence of each medium must be found in the features that distinguish it from adjacent media, he restated his claim that, though film is the art medium that most completely exemplifies this new method in the arts, that though it is the *ottima arte* and akin to a *Universalpoesie*, it is essentially like other artistic media:

> Cinema is only a technically more advanced and well-equipped art form. The best "preparatory school" for learning montage construction is theatre. But examples for study are even to be found far outside the scope of both: in literature, for example. Indeed, the aspiring film director could derive enormous benefit from studying the change of levels, the interplay of details in close-up, the glimpses of the behaviour of heroes and episodic characters, the type-casting and crowd scenes in long shot that unfold on the grandiose canvas of the Battle of Borodino in Tolstoy's *War and Peace*.[167]

Historians of Soviet cinema have commonly said that Eisenstein's ideas about process draw on a modernist conception of the artwork as self-referential. The above passage hardly accords with that view.

The basis for arguing that an object and its representation (a montage construction) can be "exactly the same thing" is a perlocutionary theory of art. Eisenstein's ideas about perlocutionary effects are associated with heterodox ideas about thought transmission, magic, and setting the soul into vibration. Consider, more specifically, the connection between the perlocutionary conception of art and his remarks on Scriabin's method of composing:

> Scriabin too sets himself this objective: 'What he sought was not a description of the act, not a representation of the act but *the act itself*.
>
> Scriabin achieves this objective better than anyone else. Nay, more: in his work the very act of creativity can be perceived through the act of bringing the work of art into being.
>
> Scriabin is attracted by the *dynamic of the creative process* and its embodiment in art. In this respect he is reminiscent of Rodin, who daringly attempted to

convey in sculpture not merely the movement of forms *but their very genesis*. In Sadko Rimsky-Korsakov shows us an image of the artist performing existing works or improvising, and we see the same thing in Liszt's *Orpheus*, but no one except Scriabin reveals to the listener the very *laboratory of musical creativity*. When we listen to him we are initiated into the agonies of artistic creation; this can be said of the "Divine Poem" and the "Poem of Ecstasy."

And the same thing can be perceived in montage, the method of an art form within which both Stanislavsky and Scriabin were destined to merge in synthesis, an art form which, in ways achieved by no other, unites man in action with the music of active form and reveals him both visually and aurally.[168]

EISENSTEIN, THE MONISTIC ENSEMBLE, AND SYMBOLISM

The passage hardly accords with the proposition that Eisenstein's ideas about process stem from a modernist conception of the artwork as self-referential. Something else has influenced his thoughts on the topic—and that something can be traced back to the heterodox tradition as it was handed down to him by the Symbolists. Scriabin—of all people! Scriabin who dreamed for the last many years of his life of a giant synaesthetic composition that he titled the *Mysterium*. But Eisenstein's ideas on synaesthesia were close to the Symbolist composer's:

> An image of colour may come through in an author's writing not only by his verbal use of a palette of colours, not only by his choice of sounds, but from the actual prototype of what he is describing in words: the shimmering effect of light and colours which one occasionally senses through the "canvas" of a verbal description can at times glow even more brightly than the same subject matter depicted, but less perfectly, on actual canvas (see, for example, Huysmans' [that paradigmatic Symbolist author!] description of jewels "glowing like flowers," or the *texture* of descriptive passages in Oscar Wilde [a decadent whose work possesses Symbolist features]) ...
>
> I think Gogol wrote with no less an *immediacy* of colour perception [than a Chinese painter], the only difference being that, unlike the Chinese primitive painter, with Gogol colour played not only a superficially depictive role; it was also integral to his total visual and aural conception of his subject matter.
>
> His characters are so lively and many-sided and at the same time so strongly individualised that each of them 'comes through' with his own range of colours. This chromatic gamut is twofold, and, depending on the style and genre of the particular work, it emerges differently in the various characters. [Gogol's] realistic novel *Dead Souls* tends to use colour in character drawing in a straightforwardly pictorial way, whereas a tale of fantasy, such as *The Terrible Vengeance*, uses colour more as a generalising device, coming close to a strictly chromatic image (at times almost to a symbol) ...

There are places where Gogol's descriptive use of colour reaches such a degree of "tangibility" that it is almost as much of a direct transference from the mental picture [!] that was obviously in his mind's eye as was the example taken from Chinese painters. The optical equivalence is so strong that the descriptive colours begin to cast reflected tones on each other! … In other words, the drama itself, the struggle between the characters, is not confined to the structure of the plot! It also "shows through" in colour … It is also curious to note that this battle waged in terms of the dynamics of colour relates not only to the fictional characters but also to the struggle that was going on inside the author who created them. The range of colours in Gogol's early works, blazing with the bright fullness of the spectrum of primary colours, undergoes a change in the later works written towards the end of his life, when he moves over to a palette containing more grey and black. 'He gets closer to the palette of the cinema', as I remarked to the late Andrei Bely, whose researches into colour and statistics on Gogol's work I have used here.[169]

Andrei Bely, the Symbolist poet, whose enthusiasm for the occult is evident from "Magiya slov" (The Magic of Words), had a similar interest in synaesthesia.

Other Symbolist ideas influenced Eisenstein's interest in the monistic ensemble and his ideas about the *Gesamtkunstwerk*. He owed much to Mallarmé's followers and to Wagner for his ideas on both issues—Eisenstein became involved in the efforts of some of Mallarmé's followers to extend Mallarmé's poetic explorations to the theatre. These disciples understood that to do so they would have to reject the naturalistic theatre and the *pièce à thèse*. So they created works in which actors, set against fragments of scenery, declaimed fragments of poetic dialogues, accompanied by music and dance or mime (that illustrated the point of the text). Thus, this Symbolist theatre integrated elements in what was essentially a monistic ensemble, just as Eisenstein proposed to do.

Eisenstein's commentary on the relations among colour, sound, and image also recall Kandinsky's thought and practice—not just his stage presentation *Der gelbe Klang* (Yellow Sound), but even more his comments in his memoirs about the importance in creating an integrated choral artistic structure, whose paradigmatic example, Kandinsky believed, was *Lohengrin*.[170]

In 1929, Eisenstein wrote an essay that deals with the core idea of the theory of transformation, that of the "third meaning"; that idea involves the question of how combining the representation of two concrete forms can produce a notion that cannot be represented by a single graphic form.[171] In that essay he locates the material basis for this possibility in the relation between two successive still frames that, combined on the retina (where they superimpose one on the other rather than succeed one another), produce movement through a phenomenon that perceptual psychologists call the *phi* phenomenon: if two

MODERNISM AND REVOLUTION

graphic forms are projected alternatively, for very short durations, on the same screen, the observer either sees one form transforming into the other or sees the two shapes existing simultaneously. Similarly, if the same object is projected alternately, for very short durations, at two different areas of the screen, the viewer sees the result as a single object jumping from the one point to the other. Eisenstein's discussion of the issue in "A Dialectical Approach to Film Form" (or "The Dramaturgy of Film Form") is revealing:

> We know that the phenomenon of movement in film resides in the fact that still pictures of a moved body blend movement when they are shown in quick succession one after the other.
>
> The vulgar description of what happens—as a *blending*—has also led to the vulgar notion of montage mentioned above.
>
> Let us describe the course of the said phenomenon more precisely, just as it really is, and draw our conclusion accordingly.
>
> Is that correct? In pictorial-phraseological terms, yes.
>
> But not in mechanical terms.
>
> For in fact each sequential element is arrayed, not *next* to the one it follows, but on *top* of it. For:
>
> the idea (sensation) of movement arises in the process of superimposing on the retained impression of the object's first position the object's newly visible second position.
>
> That is how, on the other hand, the phenomenon of spatial depth as the optical superimposition of two planes in stereoscopy arises. The superimposition of two dimensions of the same mass gives rise to a completely new higher dimension.
>
> In this instance, in the case of stereoscopy, the superimposition of two non-identical two-dimensionalities gives rise to stereoscopic three-dimensionality. In another field: concrete word (denotation) set against concrete word produces abstract concept.
>
> As in Japanese, in which *material* ideogram set against *material* ideogram produces *transcendental result* (concept).[172]

"Higher dimension," "transcendental result"—the lexis is not that of scientific psychology; nor is it that of Engels on the dialectic.

Vertov offered similar views on the *phi* phenomenon. He, too, understood that phenomenon to lie at the heart of cinema. What is even more significant, he believed that an account of the phenomenon required the notion of the dialectic. Vertov employed the *phi* effect extensively in *Chelovek S Kinoapparatom* (Man with a Movie Camera)—mostly to create an impression akin to that of two scenes being superimposed over each other, but with this crucial difference: the superimposition is produced through a stroboscopic effect. The resulting stroboscopic pulsation has a visceral impact on the viewer, who experiences what Vertov called "intervals"—experiences, that is to say, a pul-

sation that arises from the difference between one image and the image that replaces it in the system of exchange. The effect's aggressive nature impresses on us that it (the effect), and, indeed, perception in general, is a corporal affair; it also drives home the inadequacy, the limitations, of the fleshy eye. Furthermore, Vertov realized, such stroboscopically produced superimpositions are produced by purely cinematic means—such perceptions cannot otherwise be elicited. The uniqueness of such perceptions confirmed Vertov in his belief that the true revolutionary cinema would reshape viewers' perceptions, making it possible for them to penetrate the appearances of the external world and discern the patterns of its structural depth.

"A Dialectical Approach to Film Form" belongs with "Za Kadrom" (Beyond the Shot, or, The Cinematographic Principle and the Ideogram, 1929), "Perspektivy" (Perspectives, 1929), and "Kino chetyrëkh izmerenii" (Four-Dimensional Cinema, or, The Fourth Dimension in Cinema, 1929) to the period when Eisenstein was planning his "spherical book," that is, to the period when he took an interest in psychoanalytic theory. All of these essays allow us to see how far his ideas on transformation had evolved: in his early theories, Constructivist notions were to the fore; his later theories were more heavily influenced by Symbolism (and by the only psychological theory adequate to explicating Symbolist experience). We have already pointed out that Constructivists aspired to produce an artistic theory and practice that would integrate art with life. Marx's theory of the labour process showed them how they could account for that unity without giving up the idea that real-world elements are transformed as they are incorporated into a work of art. Marx and Engels's writings offered a theory of the dialectical process (a theory that Marxists generally took as a general theory of process) that explained that a second moment in a process emerges through the negation of the previous, and that a third moment then comes forth as the negation of the second—that is, as the negation of the negation.[173] This third moment, this negation of the negation, holds the first moment and the antithetical second in a higher unity. The higher unity that is formed demands the negation of the first moment, yet it also preserves attributes of the first moment—it cancels features of the first moment (so that new qualities might emerge) while it preserves other features.

Marxists used this dialectical account to explain the labour process—in the first moment of dialectical process, the labourer confronts the raw material of nature, which stands over against him, as an alien (non-human) entity; the second moment is the transformation of the raw material by the human labour expended on the object, which cancels attributes of the raw material's original character. The third moment involves acknowledging the influence of the raw material on the final product, and that this influence interacts with the human design and the human interests that guide its human transformation—that each (raw material and human design) transforms the other, cancelling

certain of its attributes and preserving others. In this way, the alien character of the original material is overcome as the object acquires a use-value (and in so doing enters into the human orbit of exchange). This account, which Eisenstein repeats in "A Dialectical Approach to Film Form," could constitute the basis for an account of artistic production, the Constructivists declared.

It is to cinema, among all the arts, that this conception applies paradigmatically. Cinema is the exemplar of an art that draws on real-world elements and that transforms those elements by integrating them into a higher unity. This alone was reason enough for the Constructivists to hold cinema in especially high esteem. But there were other reasons for the Constructivists to take a special interest in the cinema. In their efforts to integrate art with life, the Constructivists advocated the use of contemporary materials and contemporary methods of production (instead of the traditional art media, made, for example, from mixing egg whites with ground-up vegetable matter). To use contemporary materials and contemporary methods of production meant, for the Constructivists, using industrial materials and industrial methods of production. The cinematic apparatus had a thoroughly industrial character: it consisted of an ensemble of machines and industrially manufactured materials. Moreover, most films were made by teams of craftspeople, who resembled teams of factory workers.

The Constructivists thought of their world as one in which change was fundamental. This conviction was, in fact, overdetermined: it arose, in part out of the rapid and enormous changes that were taking place in their society; in part out of the common belief, embodied in Henry Adams's writings on the Virgin and the dynamo, that the machine had accelerated the pace of change; and in part from Marx's emphasis on the dynamics of the dialectic. However overdetermined the Constructivists' interest in dynamism, that interest made cinema all the more appealing to them. Even the manner in which cinema created the impression of movement engaged them, for that impression arose in a manner for which the dialectical provided the best account. That is the gist of Eisenstein's "A Dialectical Approach to Film Form."

In Eisenstein's later writings, the relationship between the depicted content of two shots and the unrepresentable unifying concept or image becomes the question of the relation between "representation" (*izobrazhenie*) and the "global image" (*obraz*, also means "icon"), a question that he treats as an element in his theory of "ecstasy" (*ekstaz*). The provenance of the terms "ekstaz" and "obraz," and the role they played in Russian avant-garde circles, must be taken into account. The terms had been in common use since the time Symbolism was in its ascendency. The Symbolists drew them from Ouspensky's *Tertium Organum*; Ouspensky had drawn them from Plotinus.[174] Alexei Kruchenykh and the Futurist group used the terms in their poetics of *zaum*, that is, of "trans-sense."

Eisenstein's treatment of *obraz* is tied to his notion of "the sum total"; his first concerted attack on the problem of the "sum total"—on the unpresentable whole that surpasses the represented content in the individual representations—occurred in significantly titled "Kino chetyrëkh izmerenii" (Four-Dimensional Cinema, or, The Fourth Dimension in Cinema, 1929).[175] When Eisenstein expounds his conception of the sum total, he resorts to the musical analogies of the dominant and the overtone series, which become one fused sound. For examples of the knowing use of overtones, he pointed out that Beethoven's works provide none, but that Debussy and Scriabin's works—works by Symbolist composers—do.[176] Eisenstein played at providing a scientific basis for understanding the reflex effect of a complex of stimuli that are bound together in unity, but in this he hardly deviated from that of such occultists as Rudolf Steiner.[177] When he came to explain this effect, he explained that the conjoint effect of several simultaneously effective physiological stimuli is a single psychic result—and then went on to state that "the 'psychic' in perception is merely the physiological process of a *higher nervous activity.*"[178] The concept of a higher nervous activity is a spiritual, not a scientific, concept.

It is in "Four-Dimensional Cinema," too, that Eisenstein first offered evidence of how fundamental the idea of *ekstaz* had become in his thinking.[179] *Ekstaz*, it seems, is needed to apprehend this fourth dimension, which can be revealed in process but not recorded. "The visual overtone proves to be a real piece," Eisenstein writes, "a real element ... of what is spatially unrepresentable in three-dimensional space and only emerges and exists in the fourth dimension (three plus time)."[180]

EISENSTEIN, SYMBOLISM, AND THE FOURTH DIMENSION

Enthusiasm for the idea of the fourth dimension was widespread among the Russian Symbolists and their successors, largely through the influence of Ouspensky. Swayed by Charles H. Hinton, Ouspensky proposed that thinking about higher dimensions of space was a good exercise for intuition.[181] In 1911, Matyushin, the exponent of circumvision, published a theoretical work on the problem of form, colour, spatial plastics, and the fourth dimension in painting.[182] In 1913, shortly after Gleizes and Metzinger's *Du cubisme* appeared in Paris, Matyushin presented, in the almanac of the Youth Alliance, an article on that book, which dealt with Ouspensky's mystical thought.[183] Ouspensky himself wrote:

We regard a line as an infinite number of points; a surface as an infinite number of lines; a solid as an infinite number of surfaces.

By analogy with this it is possible to assume that a four-dimensional body should be regarded as an infinite number of three-dimensional bodies, and four-dimensional space as an infinite number of three-dimensional spaces ... Further, we know that a line is limited by points, a surface is limited by lines, a solid is limited by surfaces. It is possible, therefore, that four-dimensional space is limited by *three-dimensional bodies* ...

We know that it is possible to draw an image of a three-dimensional body on a plane, that it is possible to draw a cube, a polyhedron, or a sphere. But it will not be a real cube or a real sphere, but only the projection of a cube or a sphere on a plane. So it may be that we are justified in thinking that the three-dimensional bodies we see in our space are *images* so to speak, of four-dimensional bodies, incomprehensible for us. In analogy with this it is possible to consider that it is necessary to regard a four-dimensional body as an infinite number of three-dimensional bodies, and four-dimensional space as an infinite number of three-dimensional spaces.[184]

Eisenstein proposed similar ideas, the closing qualification notwithstanding:

My inward spiritual experience is not an object. Spirit is never object: the existence of that which exists is never an object. It is thought which determines the objectified phenomenal world. The primacy of the mind over being can be asserted. But this is not the final truth. The mind itself is determined by the noumenal world, by the "intelligible freedom" (in the Kantian sense) of that primary world. What also needs to be asserted is the supremacy of the primarily existent, of that which initially exists, over the mind. Idealism passes into realism.[185]

In the same essay, Eisenstein decries the separation of the arts from one another and the consequent degeneration of each. His lexis is telling: "It was, indeed, the loss of a wholeness of inner vision, alongside the loss of an integrated world-view, which was ultimately the cause of this disintegration [of the arts] into separate, dead fragments" ("Unity in the Image," *Selected Works, Volume II: Towards a Theory of Montage*, p. 276).

The similarities with Ouspensky are striking: Ouspensky's *Tertium Organum* begins with a discussion of Kant's idea of space as a condition of the phenomenal world—a stance that, he suggests, mediates between the view that space is subjective and the view that space is objective. Partway through *Tertium Organum*, he writes:

The *three-dimensionality* of space as an objective phenomenon remains just as enigmatical and inconceivable as before ...

Beginning with Kant, who affirms that space is *a property of the receptivity of the world by our consciousness*, I intentionally deviated far from this idea and regarded space as *a property of the world*.

Along with Hinton, I postulated that our space itself bears within it the relations which permit us to establish its relations to higher space, and on the

foundation of this postulate I built a whole series of analogies which somewhat clarified for us the problems of space and time and their mutual co-relations, but which, as was said, did not explain anything concerning the principal question of *the causes of the three-dimensionality of space* ...

[To arrive directly at an answer] we shall keep strictly up to the fundamental propositions of Kant: ... *We bear within ourselves the conditions of our space, and therefore within ourself shall we find the conditions which will permit us to establish correlations between our space and higher space.*

In other words, we shall find the conditions of the three-dimensionality of the world in our psyche, in our receptive apparatus—*and shall find exactly there the conditions of the possibility of the higher dimensional world.*

Propounding the problem in this way, we put ourselves upon the direct path, and shall receive an answer to our question, what is space and its three-dimensionality?

How may we approach the solution to this problem?

Plainly, by studying our consciousness and its properties.[186]

Eisenstein, of course, recognized the similarities between his ideas and Ouspensky's—indeed, he felt compelled to distance himself from accusations that he had taken his theory toward mysticism (essentially, I believe he realized that the provenance of the ideas he was expounding might be identified). So he attempted to defuse the danger those accusations would have posed:

The fourth dimension?!

Einstein? Mysticism?

It is time to stop being frightened of this "beast," the fourth dimension. Einstein himself assures us:

The non-mathematician is seized by a mysterious shuddering when he hears of "four-dimensional" things, by a feeling not unlike that awakened by thoughts of the occult. And yet there is no more common-place statement than that the world in which we live is a four-dimensional space-time continuum.

We shall soon acquire a concrete orientation in this fourth dimension and feel just as much at home as if we were in our bedsocks!

And then the question would arise of a fifth dimension![187]

"Einstein? Mysticism?" In response to Eisenstein's question, we might point out that Einstein did not talk of dimensions higher than the fourth, or of the evolution of consciousness that might allow it to apprehend higher dimensions. However Gurdjieff, Ouspensky, Leadbeater, and Steiner did. Eisenstein was no fool: he well understood the repressive conditions under which he was working (we know now that both the KGB and Stalin himself kept a file on him). So he hastened to obscure the similarity—but his efforts perhaps were a bit too hasty: the filiations between his ideas of the fourth dimension and

those propounded by various esoteric masters are all too easy to detect. Here is Ouspensky on the topic that Eisenstein just raised:

> The fourth dimension is connected with "time" and with "motion." But we shall not be able to understand the *fourth dimension* so long as we do not understand the fifth dimension.
>
> Attempting to look at time as an object, Kant says that it has one dimension; this means he represents time to himself as a line extending from an infinite future into an infinite past. We are aware of one point of this line—always only one point. This point has no dimension because what we call the present in the ordinary sense of the word is only the recent past and at times also the immediate future.
>
> This would be correct in relation to our *illusory* idea of time. But in reality eternity is not an infinite extension of time, but a *line perpendicular to time*; for, if eternity exists, each moment is eternal. The line of time proceeds in the order of sequence of events according to their causal interdependence—first the cause, then the effect: *before, now, after.* The line of *eternity* proceeds in a direction perpendicular to this line.[188]

But I think there is more to it than that. The occult belief in the existence of a fourth dimension, and the conviction that the existence of that dimension required abstract forms, was much discussed among European and Russian artists. One basis for these ideas had been established in Russia when, in 1829, Nikolai Ivanovich Lobachevsky (1792–1856) demonstrated the consistency of a set of geometric axioms, postulates, and theorems that rejected Euclid's notorious fifth axiom—roughly equivalent to the proposition that given any straight line and a point outside the line, one and only one line can be drawn through the point such that the line has the property that, even if extended to infinity in either direction, it will not meet the given line. Lobachevsky replaced that axiom with the proposition that an infinity of such lines exists. (A geometry constructed on the surface of a hyperboloid meets the requirements.)[189] His work lay for some time in near complete obscurity until a related development in Germany brought it to people's attention. In 1854, Bernhard Riemann (1826–1866) showed that a consistent geometry can be developed that maintains that given a line and a point outside the line, no line can be drawn through the point parallel to the given line. (A geometry constructed on the surface of a sphere meets the requirements.)

The work of A.F. Möbius (1790–1868) made possible the creation of geometric systems applying to n-dimensions. In 1864, just around the time of Riemann's discoveries, the Italian Eugenio Beltrami (1835–1900), extending Gauss's work on curvature, proposed the "pseudo-sphere," a four-dimensional sphere, as an example of a figure from a non-Euclidean geometry. Non-Euclidean geometries became associated with higher-dimensional geometries. Amateur mathematicians took up the study of geometries of dimensions greater

than three and toyed with developing the capacity to visualize hypercubes and hypersolids of all sorts—generally, with visualizing the fourth dimension and entities that might occupy four dimensions.[190] One advocate of such exercises was Charles Howard Hinton, who, in *A New Era of Thought*, claimed that eliminating the self is a necessary propaedeutic to apprehending the fourth dimension and that the self could be cast away by concentrating one's attention on the arrangements of matter.[191] In particular, he suggested that one concentrate on multicoloured cubes in order to visualize the hypercube (the three-dimension projection of which he referred to as a "tesseract"). The idea of higher dimensions was invoked to explain magical phenomena. In 1878, in *Quarterly Review of Science*, a Leipzig astronomer named J.C.F. Zöllner published an article discussing an incident in which an American Spiritualist, Henry Slade, is said to have untied cords that had been knotted together and sealed in a box without so much as touching them and to have extracted a coin from a sealed box. Zöllner's explanation? "Slade's soul was … so far raised in the fourth dimension, that the contents of the [sealed, opaque box] in front of him were visible in particular detail."[192]

As important a critic as Apollinaire maintained that the Cubist painters possessed a sense of the fourth dimension, the "dimension of infinity," and that it was this that enabled them to break through the human conception of beauty that had dominated all previous art. In *Du cubisme*, Gleizes and Metzinger stated: "If we wished to tie the painter's space to a particular geometry, we should have to refer it to the non-Euclidean scientists; we should have to study, at some length, certain of Rieman's [*sic*] theorems."[193] Related issues preoccupied El Lissitzky, who by any reasonable measure is a major figure in twentieth-century art. It is sometimes contended that he was an exemplar of the artist-designer-engineer.[194] Here are some comments the artist offered about the conviction that mathematics provides us with models of universal applicability and about the use of models from contemporary advanced mathematics in art-making:

> It is commonly assumed that perspective representation of space is objective, unequivocal, and obvious. People say, "the camera too sees the world in terms of perspective," but this ignores the fact that, contrary to common practice in the West, the Chinese have built a camera with concave rather than convex lenses, thereby producing an equally objective image of the world in the mechanical sense, but obviously quite different in all other respects. Perspective representation of space is based on a rigid three-dimensional view of the world based on the laws of Euclidean geometry. The world is put into a cubic box and transformed within the picture plane into something resembling a pyramidal form… Hence, the apex of the visual cone has its location either in our eye, i.e., in front of the object, or is projected to the horizon, i.e., behind the object. The former approach has been taken by the East, the latter by the West.[195]

Thus, Lissitzky insisted on the relative character of what are commonly supposed to be objective and therefore universal truths. He continued by revealing that he was aware of the developments in mathematics that undermined these supposed objective, universal truths: "[A] fundamental reorientation has taken place in science. The geocentric cosmic order of Ptolemy has been replaced by the heliocentric order of Copernicus. Rigid Euclidean space has been destroyed by Lobachevski, Gauss, and Rieman [*sic* in Harrison and Wood]." Here he was referring to the development of non-Euclidean geometries that had destroyed the belief in the certainty and universal applicability of Euclidean geometry.[196]

Lissitzky's beliefs about the relativity of our conception of space led him to an inference made by many other thinkers of his time (and many subsequent thinkers as well): proceeding to irrationalist conclusions, he argued that if reason (whose paradigms are mathematics and science) cannot provide us with certain knowledge, we must take other means to grasp the higher truths—we must rely on intuition of a nearly religious or mystical sort, and on the imagination. Beliefs of this sort made Symbolists' ideas appealing to many artists. Here, then, Lissitzky, fifteen years after Symbolism had lost its grip on the imagination of Russian artists, offering ideas about spatial intuition that dyed-in-the-wool Symbolists would have had no trouble accepting. He understood that the new painting had redefined the space of painting; no longer was it the push-and-pull relations among forms lying on a surface:

> New optical experience has taught us that two surfaces of different intensity must be conceived as having a varying distance relationship between them, even though they may lie in the same plane.
>
> Irrational Space.
>
> Strictly speaking, distances in this space are measured only by the intensity and the position of rigidly defined color planes. Such space is structured within a framework of the most unequivocal directions: vertically, horizontally, or diagonally. It is a positional system. These distances cannot be measured with a finite scale, as for instance objects in planimetric or perspective space. Here distances are irrational and cannot be represented as a finite relationship of two whole numbers ...
>
> Suprematism has extended the apex of the finite visual cone of perspective into infinity.
>
> It has broken through the "blue lampshade of the heavens." The color of space is no longer assumed to be a single *blue* ray of the color spectrum, but the whole spectrum—*white*. Suprematist space can be formed in front of the surface as well as in depth. If one assigns the value 0 to the picture surface, then one may call the depth direction—(negative), and the frontal direction + (positive), or vice versa. Thus, suprematism has swept away the illusion of three-dimen-

sional space on a plane, replacing it by the ultimate illusion of *irrational* space [here he is referring to the mathematical concept of an irrational number, such as π or e, which cannot be written down in decimal form with exact accuracy, but can be specified with ever greater accuracy by using an ever greater number of digits and extending their number farther and farther towards infinity] with attributes of infinite extensibility in depth and foreground.[197]

Lissitzky's irrational space in the end is a subjective (or transsubjective) space. We have seen that Eisenstein described the process of forming the monistic ensemble as a Goethean interior process: "the *image of* [the event] is evoked within you; you participate in the process of the image of [the event] coming into being." This emphasis on intentionality is characteristic of Symbolist thought, and it only grew more marked in the later Eisenstein. The role of the subject in forming the monistic ensemble assumed an ever more central place in his thought:

A fight filmed from a single viewpoint in a long shot will always remain the *depiction* of a fight and will never be the *perception* [notice the alternation of terms that intend elements that belong to exterior and interior realms respectively] of a fight, i.e., something with which we feel immediately involved in the same way that we feel involved in a fight between two live people, genuinely (even though intentionally) fighting before our eyes. So what *is* the difference between this and a fight consisting of a number of fragments which *also* depict a fight, though not as a whole but in parts?!

It is that these separate fragments function not as depiction but as *stimuli that provoke associations*. The convention of their *partialness* is particularly conducive to this, because it forces our imagination to add to them and thereby activates to an unusual degree the spectator's emotions and intellect. As a result, the spectator is *not* subjected to a series of fragments of actions and events, but to a swarm of real events and actions evoked in his imagination and his emotions by the use of skilfully chosen suggestive details.

As the event itself progresses, you are drawn into its sequence, its unfolding, its coming-into being—unlike your ready-made perception of a scene in long shot, which *presents itself* instead of unfolding before us as an evolving process...

You are *not seeing the depiction of an argument:* the *image of an argument* is evoked within you; you participate in the process of the image of an argument coming into being, and thereby you are drawn into it as though you were a third participant in the evolving dispute.[198]

Through this synthesis, a sympathetic correspondence between the inner and outer worlds develops. We see, then, that Eisenstein's reason for rejecting straightforward, literal depiction is much the same as Hegel's: literal depiction makes the artwork too external a phenomenon. Through depiction, no higher unity evolves, so the object or event depicted remains external.

MODERNISM AND REVOLUTION

Eisenstein's remarks on in the issue of the artwork's taking on too external a character reveals his concern for the subjective dimension of the higher unit that is an image—a concern that itself speaks to the Symbolist affiliations of his aesthetic theories (or, at least, of his later theories).[199] If there were any doubt about this, it is dispelled by the implications of a passage that appears later in the same text, in which he attributes objective reality to the correspondence between proprioceptive response and external gesture:

> Herein lies the relevance of Stanislavsky's advice to the effect that the actor must, when playing, recreate a process and not act out the results of a process. He expresses it as follows:
>
>> The mistake most actors make is that they think about the result instead of about the action that must prepare it. By avoiding action and aiming straight at the result you get a forced product which can lead to nothing but ham acting.
>
>> Scriabin too sets himself this objective: "What he sought was not a description of the act, not a representation of the act but *the act itself*."[200]

Here Eisenstein uses the term "process" to refer to the proprioceptive development of an act or gesture. Proprioception is important, he believes, because it is the sympathetic response in the internal world to the dynamics of the external world and, conversely, the projection of internal sense onto the representation of an exterior realm. This idea would have been familiar to Schopenhauer's Symbolist followers, who, like the renowned pessimist they adopted as their mentor, stressed that proprioception underpins a participatory form of consciousness. In his *Memoirs*, Eisenstein waxed poetic on the participatory mentality: "In general, museums should be seen at night. Only at night ... is it possible to merge with what one sees, and not simply to survey it."[201] In a related vein, to suggest the primitive nature of the experience, he wrote: "The lamp had only to burn out ... and you would be wholly in the power of dark, latent forces and forms of thought."[202] This conviction about the value of participatory experience prepared the ground for Eisenstein's perlocutionary conception of a work of art.

Eisenstein argued that our understanding of representation depends on a mental process akin to the participatory mentality: it is not likeness in outward appearance that allows us to understand the relation between representamen and represented form—it is, rather, a *feeling*, at an undifferentiated stage of thought, that allows us to have an empathic response to the outward contours of what we see or touch. When our empathic response to one contour resembles our empathic response to another, we sense a primeval generalization, or principle, that allows the one contour to stand for the other—and this is the prototype for a sort of thinking that allows one entity to stand for another because they possess common features:

Imitation ...

According to Aristotle, the basic principle of artistic creativity.

Like the creative urge itself therefore, also the key to mastery of form ...

But imitation of what?

Of the form that we see? No! ...

Mastery of principle is the real mastery of objects!

Principle or form?

Anyone who sees Aristotle as an imitator of the form of objects misunderstands him ...

India has the god Brahma. The god is depicted sucking his own foot. The phallic symbol is crystal clear: Brahma, who is also the god of eternity and immortality, is devouring his own sperm ...

But ... were the wretched Indians really so wrong?... If the greatest mystery of immortality is addressed in this instance, then the most that medicine has to offer us is conceived in accordance with the same principles.

I was overwrought. Had a headache and so on. The doctor prescribed glycerine phosphate. I wanted to know what it was made of. Aesculapius explained to me that it was the same stuff that parts of the brain were made of. [Here we approach Boehm's idea of signatures.]

How many people take blood cures ...

How many mineral cures ...

The age of form is drawing to a close. [Notice the idea of eras? Of what provenance is it?]

We are penetrating matter. We are penetrating behind appearances into the principle of appearances. [The underlying reality, behind the illusion?—of what provenance is this?] [203]

Later in the same piece he becomes more definite about the role that participatory consciousness plays in artistic representation.

The actor was and is the most direct object of imitation. We never know precisely what is going on inside another person.

We see his expression. We mimic it. We empathise. And we draw the conclusion that he must feel the same way as we feel at that moment.

The actor shows us how to feel.[204]

This is all well and good, Eisenstein suggested, but there are better ways to penetrate behind appearances to the principle. What method did he recommend? Symbolist methods of montage evoke something that is never really shown: the composite, formed through montage, which Eisenstein referred to as the "total image."

The title of the essay from which these passages are drawn identifies mimesis as a form of mastery. "How," we might well ask, "can mimesis be a form of mastery?" Eisenstein's answer is stunning:

Play with facts (montage of visible events). The creation of a new world …
We must seize the principle of nature and the new technological man will become Almighty in the sense that the Bible attributes to the Almighty.[205]

Surely no one can read this without thinking of Voegelin's ideas of "technological man" as a Gnostic. This participatory knowledge was a much discussed topic in Russian artistic circles in the late nineteenth and early twentieth centuries. We have already seen that Nikolai Berdyaev argued, as Solovyov and Frank did, that being cannot be grasped by reason, because being is concrete, dynamic, and particular while reason employs abstract categories that, like Plato's universals, are unchangeable and universal. Like Bergson, Berdyaev argued that being is grasped through a form of intuition through which we take part in the life of the entity we know—in this regard (and in others), his ideas on being resembled Bergson's ideas on *élan vital*:

> When, in opposing the subject and the object, philosophical theory abstracts them both from Being, it makes the apprehension of Being impossible. To oppose knowledge and Being is to exclude knowledge from Being. Thus the knowing subject is confronted with Being as an apprehensible but abstract object with which no communion is possible. The objective state is itself the source of this abstraction, which excludes any communion or, as Lévy-Bruhl puts it, any "participation" in the object, although concepts may be formed about it. The nature of the object is purely general; it contains no element of irreducible originality, which is the sign of the individual.[206]

While Eisenstein would not have shared Berdyaev's belief that the fall into abstract thinking is the original sin of humankind, he certainly would have agreed with Berdyaev and the Symbolists about the importance of transforming knowledge back into a form of communion with (participation in) the lives of that which one knows. This belief was among the factors that led Berdyaev and the Symbolists to embrace the conviction that the importance of the arts is that they are of a temple, cultist origin—and that conviction led them to argue that the arts sustain a religious outlook in the secular world of modernity. The political environment in which he worked precluded Eisenstein's openly endorsing the claim that the arts will play a vital role in restoring that outlook, but if one reads his writings on *ekstaz*, one cannot but conclude that in his mind, he went a considerable distance toward accepting the central importance of the religious experience. *Ekstaz*, after all, is associated with figures such as Hildegard von Bingen, Theresa of Avila, John of the Cross, and (perhaps dearest to Eisenstein's heart) Ignatius Loyola.

Eisenstein recognized that the method the Symbolist poets used was also his. Like them, he did not depict an event, but instead, through montage,

evoked the process of its coming to be. He began his commentary on "the Symbolists and their leader, Mallarmé," by quoting the master: "Nommer un objet, c'est supprimer les trois quarts de la joissance d'un poème." He went on to probe the reason for this effect:

> I believe these words say the same thing. Not to name things in a poem but to make the image emerge out of the poem: therein lies the power of poetry's effect on us.
>
> Not to "muddy the waters" by explicitly naming things is a method of giving the reader that shower of clues which conjures up for him the desired generalised image.
>
> That is how we must understand Georges Bonneau's remark about Mallarmé: "Art does not consist of suggesting to others what one feels oneself, but of creating for them incentives to their own powers of suggestion."[207]

The idea that "nomina sunt odiosa" (as he often expressed it) became a common theme in Eisenstein's writing.

At a 1998 conference, Yuri Tsivian presented an edit list—which Eisenstein likely used in preparing an earlier version of *October*—and argued that it incorporated images that Symbolist literature had made familiar. His point is well taken, but the argument for *October*'s Symbolist character can also be made by pointing out that the list conforms to his description of the method of Symbolist literature. Here is the edit list for two consecutive series of shots, one suggesting "the rape" of the Winter Palace, the other playing on the castration of power figures:

387 The sailors who have sided with the Bolsheviks open a door to a semi-circular lavatory (semi-circular) [an allusion to the female parts]

388 They open a door: a lavatory (rectangular) / Cupboards by the bathtubs

389 The Winter Palace numbers 200 separate lavatories

390 The sailor [The sailor's hat tells us he is from the warship "*Amur*"—but this is also an instance of paranomasia, since "Amur" is also the Russian name for Eros, the god of love]

391 The statue

392 A bidet

393 Disgusted, the sailor wipes his bayonet [an allusion to having raped someone disgusting]

394 He rummages in the linen

395 Breaks the grating

396 Trunks

397 He finds the women amongst the linen

398 The women on their knees

399 The linen flying in the air

400 The sailor says "Ugh!" and lights a cigarette [the post-coital relaxation]

Shots 394 to 400 collectively evoke a rape that is never depicted. The evocation of the rape accords with Eisenstein's suggestion in *October* that the members of the Women's Battalion of Death were raped during the storming of the Winter Palace—something that had been rumoured at the time of the Revolution but that investigation had discredited. Tsivian suggests that Eisenstein clung to the story for the same reason this sequence connects revolution and rape: he conceived of the Revolution as an erotic conquest. Presenting Kerensky, the head of the Provisional Government, as effeminate makes the same point (the Bolshevik revolution represented the rape of an effeminate government), as does the suggestion that Kerensky patterned his leadership on that of the last members of the Romanov dynasty, when the Czarina, Alexandra, had great power. Eisenstein even depicts the storming of the Winter Palace as an invasion of interior space by a phalanx from the outside.[208]

The next sequence suggests a group of soldiers attacking a sailor defending the Winter Palace. It goes further than that, however, since the method of implication sexualizes the attack, turning it into a castration:

401 The cadets rush in through the door
402 The cadets take aim
403 The sailor jumps across to the wall / He gropes for [the text here is corrupt, but Tsivian does a fine job of establishing that he must be reaching for a bomb/egg]
404 The cadets take a step forward
405 The sailor raises his head threateningly
406 Salvo from Avrora/two gun
407 Windows shatter
408 A whirl of feathers
409 Cows panicking
410 The sailor holding a bomb in the whirl of feathers
411 The cadets abandon arms
412 A storm of feathers
413 A boy jumps on to the throne
414 The sailor with the St. Nicholas egg in his hands ["Nicholas" was, of course, the Czar's name, as well as that of a saint]
415 Trunks full of medals are broken open
416 A basket full of eggs is overturned
417 Etuis, cocked hats, gloves
418 Nicholas II's eggs roll [everyone should catch the irony here]
419 Medals pouring out
420 The crockery is locked up in the pantry

Tsivian comments on the import of the explosion: Eisenstein's method, building on that of the Symbolists, invests objects with supplementary mean-

ings (meanings in addition to those they usually have). He also draws a connection between the meanings of the egg and an explosion:

> Structurally the sequence is built round the salvo from the *Arora*, the pivotal point of the uprising. Semantically it centres round the idea of explosion. The egg/bomb correlation connects violence with procreation, a coalescence that is quite natural for a film that is an apologia for the Revolution. A shot of a peasant boy rejoicing on the Tsar's throne, which marks the climax of the screen version of this sequence, comes in the editing script version immediately after the burst of feathers, suggesting, in somewhat Méliès-like fashion, that the boy emerges from the explosion. In the screen version the idea of revolution as explosion is reinforced at the discursive level by the famous jump-cut "boy by the throne/boy on the throne."
>
> By violating the rules of continuity editing Eisenstein intended to take the moment out of ordinary, serial, experientially-motivated time. Diegetically the idea of marking historical moments and projecting them, as it were, into eternity is expressed in *October* by the obsessive use of clocks. In the passage from script to screen we can see clearly how the mechanism of intellectual cinema is made to work. In order to define the moment of revolution (burst, leap) as opposed to evolution (gradual, eventless development) Eisenstein dropped the diegetic symbolism of the exploding egg and proposed its discursive equivalent, a jump-cut.[209]

Eisenstein admittedly issued a series of denunciations of Mallarmé's faults, but those familiar with the persecuted's mode of writing might well wonder whether these denunciations were politically motivated. Indeed, as the persecuted do, he appended to these denunciations a qualifying remark that exceeds the denunciation in importance:

> What does Mallarmé do? As a Symbolist, he is inevitably regressive and one-sided in method. On the one hand, he takes it as axiomatic that every element of a verbal depiction is read and "felt" differently by each perceiver [isn't this just what Eisenstein has claimed to be doing?]. In this he is a "Chinese" [consider Eisenstein's own enthusiasm for Chinese, based in Fenollosa's famous essay on the "Chinese Character as a Medium for Poetry"]; he is also blatantly asocial in denying the similarity of image perception by people of the same social background or class. This makes him excessively individualistic, with the result that he avoids insisting on any image as definitive. [It is here where he proceeds to a qualifying remark which, clearly, is more important to Eisenstein than the assertions he has just made.] Yet at the same time it is just this that spurs him on to arrange his indicative fragments in such a way that the resulting generalising image approaches what he sees and senses himself. Mallarmé is not at all aimless; he is in his own way a consistent "constructor of a way of life"; the trouble is that the form and structure of the world he builds is at variance with the real world around him, from which he retreats into "other" worlds, worlds of the senses but

MODERNISM AND REVOLUTION

which lack concrete objectivity. [This is the criticism, but Eisenstein immediately qualifies it with a remark that exceeds the criticism in importance.] No one will deny that this is what he does. See, for example, the comments in Benedikt Lifshits' translated anthology, *French Lyric Poets of the 19th and 20th Centuries*:

> Not a single French poet before or since Mallarmé was as all-embracing and absolute in pursuit of the "transformation" of reality and in the construction of "another" reality. All the symbolic images in Mallarmé's poetry, as in such poems as "The Swan," "The Faun," "Hérodiade," "The Windows," etc., need to be decoded as ideas for realising an imaginary world that the poet found within himself and which was susceptible to proof of being the uniquely authentic reality.

By the means that he adopted to construct the image of his world, Mallarmé cannot help aligning himself with both the underlying principles and the practical techniques of the montage method. [What follows is again a criticism that, really, presents a larger area of agreement.] It is specifically a case of "alignment" rather than complete attachment. Apart from anything else, in order to attain that, he has to pass though the pre-image stage of affect, which attracts him, i.e., his urge to express diffuse nuances of feeling rather than the clear perception of an image. [Recall here Eisenstein's interest in the nuances that distinguish "a dark window" from "an unlit window," and his concern to find a montage equivalent for the difference that language draws so easily.] In this he is again "Chinese."[210]

The construction of a screen space and time that are independent of the space and time of reality; pre-representational forms of consciousness; and montage's capacity to create a total image that surpasses what is depicted in the montage elements: all are deep themes in Eisenstein's work. He identified the source of all of these themes in Mallarmé's Symbolist writing.

Eisenstein used a quotation from Benedikt Lifshits to connect Mallarmé to the theory of transformation. As early as 1928, Osip Brik had recognized not only that Eisenstein's theory of transformation deviated from that of the LEF movement with which he (Brik) was affiliated, but also that it could be connected to the Symbolists:

> Eisenstein's idea, as expressed in his latest articles and statements, consists in the view that the artist, the film director, must not be a slave to his material, that the main consideration in film work must be the artistic design or, in Eisenstein's terminology, the "slogan." This slogan determines not only the selection but the actual shape of the material. The Lef view that the main consideration in cinema art is the raw material seems to him to be too narrow, it seems to tie creative flights of fancy too closely to empirical reality.
>
> Eisenstein does not want to think of cinema as a means of showing actual reality [in his desire to show actual reality, Dziga Vertov was closer to the Lef ideal]; he has pretensions to philosophical film treatises ...

From our point of view Eisenstein's achievement lies in the fact that he has broken down the canons of played film and that he takes the principle of the creative transformation of raw material to the point of absurdity. In their time the Symbolists in literature and the "Non-Objective" painters did the same and this work was a historical necessity.[211]

And the most Symbolist of all of Eisenstein's ideas was that of *ekstaz*.

EISENSTEIN'S PANGRAPHISM AND
THE THEORY OF IMITATION

Eisenstein's aesthetic was dominated by the idea of imitation. That fact was not clear at first, but after Malevich's attack on Eisenstein in "I likuyut liki na ekranah" (Visages Are Victorious on the Screen), Eisenstein gave the concept a more important place (and formulated it more clearly). At home in the Soviet Union, he had dismissed the abstract films of the German avant-garde; but at the Congress of Independent Film in La Sarraz (1929), in the company of the likes of Hans Richter and Walther Ruttmann, he had to defend himself against charges (such as Malevich's) that his realist images were artistically reactionary. The crux of his response was that film does not represent motion mimetically: the motion the film viewer perceives is an illusory motion, a *concept* of motion.

Eisenstein's conception of imitation was capacious: it was based on the belief that language (and therefore all other forms of expression, since all are logomorphic) is fashioned on primeval imitative action. Mikhail Iampolsky contends that Eisenstein's theory is similar in its broad outlines to the theories of such thinkers as Bühler, Cassirer, Nikolai Marr (1865–1934), Vygotsky, Lévy-Bruhl, and Piaget.[212] Karl Bühler (1865–1934), a psychologist and member of the Prague Linguistic Circle, studied the psychology of thought processes. The Marburg Neo-Kantian philosopher Ernst Cassirer (1874–1945) showed that symbolic forms shape human perceptions of reality. Marr (1865–1934), a half-Georgian, half-Scot linguist, proposed the extravagant hypothesis of a universal ur-language that developed from gesture and preverbal thought processes. Lev Vygotsky (1896–1934) studied the relationship between thought and language and the role of culture and interpersonal communication in shaping thought processes. Lucien Lévy-Bruhl (1857–1939) studied the differences between the "primitive mind" and the "Western mind," essentially describing primitive thinking as primary-process thinking. Jean Piaget (1896–1980) identified stages in child development.

Iampolsky is not wrong in thinking this, to be sure, though there are figures who are much closer to Eisenstein's milieu: there had developed in nineteenth-century Russia a Romantic scientific tradition encompassing such

figures as N.I.Veselovsky, Jan Baudouin de Courtenay, and A.A.Potebnia. Veselovsky was an archaeologist who unearthed the treasures of the Maykop culture—a discovery that strengthened Russians' interest in ethnocultural anthropology. Baudouin de Courtenay (1845–1929) was a Polish-Russian linguist, one of the founders of phonology and structural linguistics, and among the earliest to understand language as a system for alternating different units: phonemes (a concept he had a role in developing), morphemes, and syntagma.

Aleksandr Afanasevich Potebnia (1835–1891) had an especially important role. He was a Ukrainian linguist, a professor at Kharkov (now Kharkiv) University, and the author of such books as *Mysl' i jazyk* (Thought and Language, 1862) and *Iz lekcij po teorii slovesnosti* (literally, From Lectures on the Theory of Wordness, or, From Lectures on the Theory of Literacy, but translated as Course in Literary Theory). His theory, known as "potebnianstvo," flourished in the Russian empire in the late nineteenth and early twentieth centuries and in the Soviet Union during the 1920s. It attracted scores of adherents, who constituted a formal critical school at Kharkiv and there published a critical journal. Potebnia's career took a drastic turn for the worse in the 1930s, when his work was officially renounced in the Soviet Union. In the West he remains virtually unknown.

Potebnia introduced into Russia the Romantic theory of language, Wilhelm von Humboldt's in particular, and modified it so as to strengthen its affinities with ideas about language that had developed in Russia from the Middle Ages onwards. His writings inaugurated a discussion in Russia on the role that speech plays in consciousness, on the experience of speech, and on the role language plays in cognitive life; he also established a precedent for treating language as crucial to the concept of self.

Potebnia's theory of language was a massive elaboration of Humboldt's notion that language and the concept of the self are indissolubly linked. Like Humboldt before him (and Bakhtin after him), he emphasized that language is dynamic. Humboldt had conceived of language as activity (*energeia*), not as thing (*ergon*); in Potebnia's version, this became the distinction between language's "doing something" as against its "being something." He argued that language does not represent discrete existing entities; rather, it acquires meanings through the antinomies it embodies. Nor does language use convey thoughts from speaker to listener; rather, language use awakens in the listener an analogous thought process in the listener's mind as that which occurred in the speaker's mind while speaking.

Language use enables us to formulate thoughts. For we do not have thoughts that precede language, nor do we have a direct, unmediated apprehension of the self. The effect of language is to cleave the speaker's mental world into the "I" and the "not-I"; the word also enables the speaker's apperception of his thoughts. Prior to our acquiring language, our mental processes are constituted

as a stream of fugitive perceptions; these mental states are inchoate; only when they find expression in language do they become clear to us. Through articulate sound these inchoate perceptions are objectified and made available to higher cognitive processes.

Potebnia's theory diverged from Humboldt's regarding "inner form." Humboldt conceived "inner form" to be the basic (inner) structure of language as a whole—indeed, he often wrote of "innere Sprachform" (the inner form of language). Potebnia's conception concerned individual words, not language as a whole. He proposed that a word has three aspects: its outer form, that is, its sound (the chain of phonemes we articulate when using it); its content, that is, that through which the outer form, the sound, attaches to a particular referent or set of referents; and the inner form (sometimes he used the term "inner image"), that is, the word's etymological import, in which, he believed, resides the verbal potential for expression. He believed that this potential always exceeds any specific referent. This dynamic, unrestricted possibility gives poetry its special vitality, for this inner form transcends the meaning that arises through reference and acts as the *energeia* beneath the word; the word is animated by an impulse to actualize the poetic potential of the word. Sometimes in his discussion of inner form, Potebnia describes this inner potentiality as a rich, multivalent image and content, as a specific meaning (reference) to which that image has relevance. Thus the multivalent image becomes reduced to a singular, definite meaning (though the root meaning of the indefinite multivalent image remains embedded in the word as a persistent potentiality that might be actualized differently from what is realized in any given usage). Like the later Formalists, he drew a cardinal distinction between practical and literary (or poetic) language. That distinction had to do with the differing relations of the words of the language to these underlying polysemic images: the words that constitute literary or poetic language retain a much closer relation to the images whose *energeia* motivates them than do the words that constitute practical language. It was this belief that poetry and literature retain a close relation with images that led him to his famous maxim (which Shklovsky so vigorously rejected) that art is thinking in images.

One function of words is to develop apperception; inner form has a role in this development. Potebnia's ideas about the role of language in opening up a space of apperception relies on his conception of how perception occurs. He pictured the process of perceiving as occurring in stages. In the initial stage, one first becomes aware of something—a raw sensum is apprehended for a fleeting instant. Then a reserve of prior thought operates outside consciousness on this raw sensum to produce a percept; in this way, feeling memories become associated with the sensum's qualia (the qualities pertaining to the properties of the form) and the apprehended sense-datum is formed. Potebnia believed that the word helps associate qualia with this reserve of prior thought and that

what is constituted thereby is also a word. The raw sensum, as it becomes a defined mental pecularity, becomes a word, and this process of transforming it into a word allows the sensum to be perceived again, that is, to be apperceived. He also characterized the inner form of a word as the relation of the content of a thought to consciousness. This latter claim seems difficult to reconcile with his characterization of the inner form of a word as resembling an image. We can go some distance to grasping what he means by inner form if we think of it something like the primary energy behind (or within) a word, an energy that he suspects is almost imagistic and that powers the word, so that it might become perception and apperception. Because the core, the "inner form" of the word, is active, the word, in Potebnia's theory, is not a passive material entity that stands for some extralinguistic reality; rather, it is an agency through which the self works out its relation to the world.

Potebnia's relevance to Eisenstein's theory relates to the role that inner speech played in Eisenstein's aesthetics: in his thought, inner speech serves as the primeval imitative action. Potebnia influenced the traditions out of which the idea of inner speech emerged. As an exponent of the systems differentiation principle, he maintained that early childhood experience is sensuous and integral: in such experience no part can be separated from any other. During the maturational process, this initially integral psychological reality is broken down into distinct elements that are related to one another in a system. The child forms ideas by decomposing primordially integral experience and by using language to generalize sensual images. Originally, experiential properties are fused one with another, and properties deriving from the object experienced cannot be distinguished from those deriving from the child's attitudes. With the acquisition of language, the child's internal states are separated from the conditions of the objects experienced, and different properties of experience are distinguished. Subject and object are differentiated and come to be thought of as independent realities.

Experience is divided into structural units: words (which, Potebnia pointed out, have the character of words-concepts) are linked with objects in the external world, or with parts or properties of objects, or with interrelations among objects, by temporal links. The mechanism that binds words-concepts to objects is the differentiation of the spatio-temporal systems of excitation. The result of such differentiation is a logically ordered and strictly differentiated representation of a world—a world in which the subject is separated from external and internal influences. The objects of the world are characterized by their specific properties and locations; causes are separated from consequences; the real is separated from the seeming; the rational from the irrational; and so on.

Eisenstein, too, contrasted rational language, the means for communicating rational concepts, with the affective aspects of word-images. More telling

is that he, too, contrasted prelogical, sensuous thought (*chuvstvennoe myshle-nie*) with logical thought, non-differentiated and differentiated thinking (and maintained that the tension between them helps explain the power of thought); and just as Potebnia (following a mythic pattern) described the maturational process as the loss of an initially integral psychological reality and a break with sensuous experience, Eisenstein likewise cast the rupture with sensuous think-ing as a traumatic episode in the mental development of humanity. Further-more, Eisenstein, too, sought to restore integral experience (though the inte-gral form he sought was admittedly different from that which Potebnia's thought valorized). For Eisenstein, Dionysius represented prelogic, Apollo, logic; Dionysius, the animal-elemental, Apollo, the sunny-wise. Eisenstein strived to see these two tendencies synthesized in the figure of Orpheus, the artist. Art represented integral experience (and that integral experience re-mained close to prelogical sensuous thought (*chuvstvennoe myshlenie*).

Potebnia made contributions to literary theory, folklore, and ethnogra-phy—fields in which Eisenstein, too, would take an interest. Potebnia believed that language embodied a world view—that the spirit of a people is incar-nated in language; and like Eisenstein, he believed that a people's spirit takes form in its customs, its traditions, and its songs. Potebnia understood the evo-lution of the human capacity for language in materialist terms, as the evolu-tion of a tool that was adaptational—that fitted humans for survival.

These ideas helped shape Vygotsky's conception of inner speech (a key in-fluence on Eisenstein's later aesthetics). Inner speech uses a restricted linguis-tic code that interacts with sensory images and with affects to produce a mul-tidimensional code which reflects that mind's originary unity with the world. Much inner speech is self-directed (as when we think to ourselves "Keep on! Don't give up! You'll finish this yet!"); though in form such utterances are di-rected toward another, their actual pragmatics are such that these comments are really directed toward oneself. Furthermore, inner speech relies heavily on such non-verbal features as intonation and stress (far more so than the self-directed speech I have just given an example of), and its enunciatory mode is similar to that of intimate, colloquial conversation.

Potebnia's ideas helped shape Vygotsky's notion of the early form of speech—and that conception of an originary unity with the world that is the ground of Potebnia's and Vygotsky's thought helped Eisenstein work out his ideas on mimesis. Eisenstein's conception of inner speech, as we have noted, is based on the proposition that all forms of imitation are based on a primeval imitative action, and the notion of a participatory consciousness sometimes serves Eisenstein as this basis.[213] But Vygotsky was far from the only influence on Eisenstein's notion of mimesis. Baudouin de Courtenay also treated language as a form of action—indeed, the pragmatics of the communicative process were generally of interest to the early Soviet semioticians.[214] Soviet semioticians

often treated poetics as the effort to identify the features that distinguish poetic language from ordinary language—and the features they identified to that purpose are attributes that inner speech also possesses.

Theories of such thinkers as Potebnia, Baudouin de Courtenay, and Veselovsky all displayed Romantic leanings—Potebnia's belief in an undifferentiated primal experience in which the self is fused with the world (to take it as an example) is paradigmatically Romantic. This Romantic approach to science was part of a Slav tradition. Because of their Romantic commitments, Soviet semioticians did not treat semiotics as an abstract approach to the study of sign systems: their semiotics was applied in the field to cultural anthropology (cultural semiotics is a discipline of long-standing importance in Russia), historical ethnography, social psychology, poetics, and art criticism. As scientific as their approach might have been, the interest that Formalist theorists (e.g., Bernstein, Bogatyrev, Durnovo, Jakobson, Jakubinsky, Yarkho, Larin, Polivanov, Propp, Reformatsky, Shcherba, Trubetskoy, Tynyanov, Ushakov, Vinogradov, Vinokur, Zhumunsky) took in ethnographic studies overlapped the Romantics' interest in folk culture as a genuine expression of a premodern relation with reality.[215] A similar Romantic approach can be discerned in the cultural anthropology/cultural poetics of Mikhail Bakhtin, V. Propp, O.M. Freydenberg and Lev Vygotsky. Eisenstein's interest in Walt Disney's films reflected a similar Romantic interest in folk culture—in his piece on Disney, he notes that "through his whole system of devices, themes and subjects, Disney constantly gives us prescriptions for folkloric, mythological, pre-logical thought."[216] Eisenstein's interests after 1929 led him to draw ideas from the history of religions (Potter), criminology (Wulffen), folklore (Kagorov), anthropology (Tylor and Lévy-Bruhl), historical poetics (Veselovsky), child psychology (Vygotsky, Kerschensteiner, and Werner), and "archaic schizophrenic thought" (Storch).

Eisenstein used these ideas to study the archaic strata of human psychology. In his later years he devoted an increasing portion of his writing to examining the analogies among literary, linguistic, music, pictorial, and cinematic sign systems, and to showing that all derive from a primeval mimetic basis. He sought to show that the common elements and common structures in novels, poetry, images, and film arise from an archaic stratum of consciousness that puts us in touch with the thinking of premoderns:

> Our deep-seated instinct for self-preservation leads us to use as food what we ourselves consist of.
>
> In instinctive primitive form there is however no distinction between external attribute, internal content and principle. It is all the same, so you eat what you see. If you eat your own likeness, you live forever.
>
> This atavistic cannibalism is evident in the highly intellectualised mythology of the Greeks.

Chronos (Saturn). Eternity. Immortality... And Chronos... devours his own children ...

The sacrifice of one's own image in the form of a human likeness in order to achieve eternal life: does not the same idea also lie at the basis of the Christian myth?[217]

This belief in an underlying, undifferentiated, prelogical consciousness brings Eisenstein's thought close to that of the Symbolists on the one hand and occult practitioners on the other.[218] As important, this interest in prelogical consciousness provided him with a way of explaining how film could be an instrument of higher, internal vision—a super-vision that is not the product of an optical technology and that does not forsake the realm of the organic.[219]

MIMESIS, PANGRAPHISM, AND THE LANGUAGE OF ADAM

For Eisenstein, influenced as he was by the Slav tradition of Romantic science (including that of Baudouin de Courtenay and, especially, Potebnia), the dynamics of internal speech were of signal importance: inner speech is movement. This idea that inner speech is dynamic connects inner speech with other media: its gestures resemble the dynamics of a line of music or the flow of graphic line. Its movement conveys the energy of thought—of an archaic slab of thought in which concepts and feelings are undifferentiated.

As Iampolsky points out, this led Eisenstein to a sort of pangraphism. Before considering the problematics of pangraphism, we must consider one more strain of thought that contributed to Eisenstein's views on imitation and analogy. His use of the hermeneutical principle of analogy received support from an unlikely source—American (New England) Transcendentalism. The early semiologist John Locke had argued that the relation between words and things is arbitrary—that no sure relation locks words to things. Against this view, which seemed to render significance uncertain, the New England Transcendentalists sought to identify texts whose meaning was sure—and fixed for all time. In the end, they concluded that the universe is a sacred text, composed by God in the language of nature. The hermeneutical principle they used to decipher the language of nature was based on the doctrine of signatures, or correspondences, which Emanuel Swedenborg drew from Jakob Boehme. According to this doctrine there are correspondences between the spiritual world and the material one—that is, God inscribed into the Book of Nature a set of correspondences to immaterial forms that determine their meaning. This language of correspondences was the primordial language, the "Adamic" language, which Ralph Waldo Emerson considered the language of pure poetry:

> Because of this radical correspondence between visible things and human thoughts, savages, who have only what is necessary, converse in figures. As we

go back in history, language becomes more picturesque, until its infancy, when it is all poetry; or all spiritual facts are represented by natural symbols. The same symbols are found to make the original elements of all languages. It has moreover been observed, that the idioms of all languages approach each other in passages of the greatest eloquence and power. And as this is the first language, so is it the last. This immediate dependence of language upon nature, this conversion of an outward phenomenon into a type of somewhat in human life, never loses its power to affect us. It is this which gives that piquancy to the conversation of a strong-natured farmer or backwoodsman, which all men relish.

A man's power to connect his thought with its proper symbol, and so to utter it, depends on the simplicity of his character, that is, upon his love of truth, and his desire to communicate it without loss. The corruption of man is followed by the corruption of language. When simplicity of character and the sovereignty of ideas is broken up by the prevalence of secondary desires,—the desire of riches, of pleasure, of power, and of praise,—and duplicity and falsehood take place of simplicity and truth, the power over nature as an interpreter of the will is in a degree lost; new imagery ceases to be created, and old words are perverted to stand for things which are not; a paper currency is employed, when there is no bullion in the vaults. In due time, the fraud is manifest, and words lose all power to stimulate the understanding or the affections. Hundreds of writers may be found in every long-civilized nation, who for a short time believe, and make others believe, that they see and utter truths, who do not of themselves clothe one thought in its natural garment, but who feed unconsciously on the language created by the primary writers of the country, those, namely, who hold primarily on nature.

But wise men pierce this rotten diction and fasten words again to visible things; so that picturesque language is at once a commanding certificate that he who employs it, is a man in alliance with truth and God.[220]

In the Adamic language, words (signs of the invisible processes of the human thought) and things have a natural, not an arbitrary, correspondence. This idea, repeated in Walter Benjamin's "Die Aufgabe des Übersetzers" (The Task of the Translator) found widespread appeal: the many lists one finds in Walt Whitman's *Leaves of Grass* are attempts to summon reality by calling things by their proper (i.e., natural) names. Emerson concurred:

The poet alone knows astronomy, chemistry, vegetation, and animation, for he does not stop at these facts, but employs them as signs. He knows why the plain or meadow of space was strown with these flowers we call suns and moons and stars; why the great deep is adorned with animals, with men, and gods; for in every word he speaks he rides on them as the horses of thought.

By virtue of this science the poet is the Namer, or Language-maker, naming things sometimes after their appearance, sometimes after their essence, and giving to every one its own name and not another's, thereby rejoicing the intellect, which delights in detachment or boundary. The poets made all the words,

and therefore language is the archives of history, and, if we must say it, a sort of tomb of the muses. For though the origin of most of our words is forgotten, each word was at first a stroke of genius, and obtained currency because for the moment it symbolized the world to the first speaker and to the hearer. The etymologist finds the deadest word to have been once a brilliant picture. Language is fossil poetry. As the limestone of the continent consists of infinite masses of the shells of animalcules, so language is made up of images or tropes, which now, in their secondary use, have long ceased to remind us of their poetic origin. But the poet names the thing because he sees it, or comes one step nearer to it than any other. This expression or naming is not art, but a second nature, grown out of the first, as a leaf out of a tree. What we call nature is a certain self-regulated motion or change; and nature does all things by her own hands, and does not leave another to baptize her but baptizes herself; and this through the metamorphosis again.[221]

In the Adamic language, words and things come together. In an extraordinary anticipation of Peirce's ideas on semeiosy, Emerson stated:

For though life is great, and fascinates and absorbs; and though all men are intelligent of the symbols through which it is named; yet they cannot originally use them. We are symbols and inhabit symbols; workmen, work, and tools, words and things, birth and death, all are emblems; but we sympathize with the symbols, and being infatuated with the economical uses of things, we do not know that they are thoughts. The poet, by an ulterior intellectual perception, gives them a power which makes their old use forgotten, and puts eyes and a tongue into every dumb and inanimate object. He perceives the independence of the thought on the symbol, the stability of the thought, the accidency and fugacity of the symbol. As the eyes of Lyncæus were said to see through the earth, so the poet turns the world to glass, and shows us all things in their right series and procession. For through that better perception he stands one step nearer to things, and sees the flowing or metamorphosis; perceives that thought is multiform; that within the form of every creature is a force impelling it to ascend into a higher form; and following with his eyes the life, uses the forms which express that life, and so his speech flows with the flowing of nature. All the facts of the animal economy, sex, nutriment, gestation, birth, growth, are symbols of the passage of the world into the soul of man, to suffer there a change and reappear a new and higher fact. He uses forms according to the life, and not according to the form. This is true science.[222]

In *Nature*, Emerson wrote:

The moment our discourse rises above the ground line of familiar facts and is inflamed with passion or exalted by thought, it clothes itself in images. A man conversing in earnest, if he watch his intellectual processes, will find that always a material image more or less luminous arises in his mind, contemporaneous with every thought, which furnishes the vestment of the thought. Hence, good

MODERNISM AND REVOLUTION

writing and brilliant discourse are perpetual allegories. This imagery is sponta-
neous. It is the blending of experience with the present action of the mind. It is
proper creation. It is the working of the Original Cause through the instru-
ments he has already made.[223]

Of course, cinema is an extraordinary machine for fastening signs to things.
Emerson foresaw the character of cinema when, in a passage just quoted, he
remarked that "the poet turns the world to glass, and shows us all things in their
right series and procession. For, through that better perception, he stands one
step nearer to things, and sees the flowing or metamorphosis; perceives that
thought is multiform; that within the form of every creature is a force im-
pelling it to ascend into a higher form; and, following with his eyes the life, uses
the forms which express that life" (a statement that does pretty well as a de-
scription of Stan Brakhage's films). In the essay "Art," Emerson anticipates, in
an astonishing fashion, cinema when he describes the picture that nature paints
of the street with moving men, women, and children.

Emerson's "Representative Men" offers an almost eerie anticipation of the
Eisensteinian/Tynianovian theory of universal analogy. It appears in a pas-
sage criticizing one feature of Swedenborg's hermeneutics of correspondence:

Having adopted the belief that certain books of the Old and New Testaments were
exact allegories, or written in the angelic and ecstatic mode, he employed his re-
maining years in extricating from the literal, the universal sense. He had borrowed
from Plato the fine fable of "a most ancient people, men better than we and
dwelling nigher to the gods;" and Swedenborg added, that they used the earth
symbolically; that these, when they saw terrestrial objects, did not think at all
about them, but only about those which they signified. The correspondence be-
tween thoughts and things henceforward occupied him. "The very organic form
resembles the end inscribed on it." A man is in general and in particular an or-
ganized justice or injustice, selfishness or gratitude. And the cause of this har-
mony he assigned in the "Arcana": "The reason why all and single things, in the
heavens and on earth, are representative, is because they exist from an influx of
the Lord, through heaven." This design of exhibiting such correspondences,
which, if adequately executed, would be the poem of the world, in which all
history and science would play an essential part, was narrowed and defeated by
the exclusively theologic direction which his inquiries took. His perception of
nature is not human and universal, but is mystical and Hebraic. He fastens each
natural object to a theologic notion;—a horse signifies carnal understanding; a
tree, perception; the moon, faith; a cat means this; an ostrich, that; an artichoke,
this other; and poorly tethers every symbol to a several ecclesiastic sense. The
slippery Proteus is not so easily caught. In nature, each individual symbol plays
innumerable parts, as each particle of matter circulates in turn through every
system. The central identity enables any one symbol to express successively all
the qualities and shades of real being. In the transmission of the heavenly wa-

ters, every hose fits every hydrant. Nature avenges herself speedily on the hard pedantry that would chain her waves. She is no literalist. Every thing must be taken genially, and we must be at the top of our condition to understand any thing rightly.[224]

Eisenstein, too, was committed to discovering a textual mechanics that undergirded all existents. He expounded his views on the topic under the rubric of "mimesis," or imitation. What he offered amounted to a form of "pangraphism" (to use Iampolsky's term).[225] Iampolsky shows that Eisenstein contrasted two sorts of imitation: the sort that copies form (which Eisenstein characterized as "magical"), and the sort that is based on what he called a "principle." His argument had an evolutionary basis: the age of specular mimesis, of copying the outer form of things, was past. Humans now required a means for penetrating matter, for going beyond phenomenal appearances to the principle behind the appearance, beyond specular mimesis to imitation of the "principle."

Eisenstein's beliefs about mimesis, including his belief about the "principle," were connected to his interest in prelogical forms of thought, an interest that claimed a larger and larger portion of his theoretical endeavours over time. Apprehension begins, prior to representation (be it verbal or visual), with a form of undifferentiated awareness; and the subject of this undifferentiated awareness he called the "principle."[226] This apprehension, as Eisenstein understood it, took the form of what he called "mimesis." Lang, a psychologist and cultural anthropologist, influenced Eisenstein's beliefs about an archaic form of mimesis, which he termed "savage realism." As Eisenstein was to do later, Lang distinguished between the type of realism that aims at the appearance of an object and the type of realism that aims at how the object really *is*. "Savage realism"—realism that aims at how an object really *is*—imitates the object through an empathetic projection that eventuates in an imitative gesture. Thus a movement of the hand mimics the dynamics of the principle. Eisenstein, following Lang and Levy-Bruhl, conceived of this primitive sort of imitation as an elementary form of thought—and like them, he believed that from this primal participation in the dynamics of the object's fundamental character, thought emerges. He went so far as to argue that even the eye's movement, tracing out the contours of an object or a movement, participates in its inner character, its "principle." When a human eye follows a line, it generates the proprioceptive experience the person would have had if he or she had drawn the line; in this way it masters (becomes at one with) the inner principle that produced that contour.

This led Eisenstein to a belief he shared with Malevich—that dynamism inflects the relation between conscious and unconscious thinking.[227] Eisenstein, like Lev Vygotsky, conceived of the unconscious in rather broad terms and

seemed uncomfortable with Freud's view that the unconscious harboured primarily sexual content. His ideas about transformation seem to have had some affinities with those of Vygotsky, who maintained that art reflects the transformation of the unconscious processes (the unconscious content is filtered through a semiotic mediatory mechanism) into behavioural and cognitive manifestations that possess a social form and a social being.

Iampolsky focuses his discussion of Eisenstein's pangraphism on the concept of the line.[228] A melody traces out a line; the development of a story describes a contour. Line is a general principle, or agent, that generates specific meaning.

In his notes for the never completed *Summa* of montage theory, to be titled "Montazh" (his preparatory notes were eventually collected by Naum Kleiman and published in English translation as "Montage 1937"), Eisenstein quoted approvingly Lawrence Binyon's assertion that the painting of Asia is the art of the line.[229] Eisenstein also noted that Hindu aestheticians declared that it is line (*rekha*) that intrigues the master, while the public is drawn to colour.[230] But line, Eisenstein noted, just stands for the generalized image—and artistic compositions depend on the coexistence of a specific instance of depiction (the grapheme) and the generalizing image.[231] Examples of the emphasis on generalization, he pointed out, are to be found in Chinese painting, especially that of the "southern" or "literary" school, which exemplifies the tendency to abstract all that is transitory and impermanent from the image and to present a generalized, essential reality. He went on to quote Chiang Yee:

> The painters of the "literary" school do not study a landscape tree by tree and stone by stone, and fill in every detail as it appears to them, with brush and ink; certainly they may have been familiar with the scene for months and years, without seeing anything in it to perpetuate: suddenly they may glance at the same water and rocks in a moment when the spirit is awake, and become conscious of having looked at naked "reality," free from the Shadow of Life. In that Moment they will take up the brush and paint the "bones," as it were, of the Real Form; small details are unnecessary.

To which Eisenstein appended an extraordinary remark: that the Chinese painter's interest in "bones"—in "Real Form," in the generalized essence of the phenomenon—was also his.[232]

This "principle," this dynamism, was for Eisenstein the inner power of the dialectic. "It is of the highest importance," Hegel wrote, "to ascertain and understand rightly the nature of Dialectic. Wherever there is movement, wherever there is life, wherever anything is carried into effect in the actual world, there Dialectic is at work."[233] And, again: "Dialectic is wholly different; its purpose is to study things in their *own being and movement* and thus to demonstrate the finitude of the partial categories of understanding."[234] Eisenstein

was able to convince himself that the dialectic studies what he called "the principle," and, thus, that his occult-inspired endeavours accorded with the fundamental principles of Marxian philosophy.[235]

The conviction that the inner being of all existents is a vital striving implies that each entity fundamentally resembles every other—and that implication is hardly a conclusion an orthodox Marxist would embrace.[236] Yet it is the root of a conviction fundamental to Eisenstein's later work: that existence is a text of universal connections.

Eisenstein's pangraphism construed the analogies or correspondences that Boehme thought so telling as evidence of the importance of "principle." Swedenborg and Emerson, both influenced by Boehme, also described correspondences as similarities among the underlying principle (or dynamic form) of objects: phenomena that are related through these correspondences are linked not primarily by having similar outward forms but by sharing in the same underlying principle (though of course that underlying dynamic agency tends to produce outward forms that are marked by some measure of likeness). This is the notion that lay behind the auditory/visual correspondence that Eisenstein charted for *Alexander Nevsky*.

The idea of a primitive, participatory form of consciousness also underpinned Eisenstein's ideas about vertical montage. For all the graphs and charts of parallelism between the shape of melodies in Prokofiev's score for *Alexander Nevsky* and the shape of the movements, or of the visual forms, on the screen, Eisenstein was required to admit, in the end, that all that held the two together was a similarity in gesture between the image and the sound. Responding to the criticism that Theodore Adorno and Hanns Eisler had offered to the idea of vertical montage (which linked sounds and images that had similar contours), Eisenstein responded: "Eisler thinks that there is no common denominator between the pair: galoshes and drum (even though a linear connection is possible, for instance) ... Image is transformed into gesture: gesture underlies both. Then you can construct whatever counterpoints you want."[237]

Eisenstein's ideas about mimesis extended to the belief that there is a Hegelian pattern in the evolution of mentality, a tripartite pattern that he believed repeated itself again and again. In the first phase, consciousness is absorbed in particulars: no generalized concept is yet formed. In the second phase, alongside awareness of particulars is an awareness of what is common to them all. In the third and final phase, generalization "swallows up the particular, the 'random,' the transitory, even though it is the latter which actually lends flesh and blood and concrete objectivity to this 'idea' of the phenomenon."[238] Hegel held that Classical art, the art that brings the particular and the Concept into harmonious accord, represented the highest achievement in the history of art; Eisenstein similarly privileged the second moment in the history of consciousness, the moment he referred to as the "realistic" because it

mediated between (or brought into a harmonious accord) the "naturalistic" and the "stylized."

Eisenstein depicted creation as a process through which what is essentially indefinite takes definite form. The task of the viewer/critic is to trace the process back in the opposite direction, looking behind the constructed form to discover the principles that give it shape. Language—the word—plays a role in this decreation (a process that is exactly antithetical to that laid out in the Johanine text); that is part of the claim one makes when one asserts that a certain painting is a literary painting. Still, there is in Eisenstein's conception of the generalized image a remarkable tendency to see the general as the Real Form that, in a kenotic gesture, takes on transitory, accidental characteristics when it becomes incarnated in matter. So the Hegelian conception of the relation between the Universal and the particular was not the only conception of that relation he maintained: Eisenstein sometimes understood the relation of the general to the particular in a remarkably Neoplatonic fashion, whose currency in the Russia of his time derived from the spiritual tone of the age, manifested in widespread interest in Ouspensky's writings. This is the context of his distinction between representation (*izobrazhenie*) and the "global image" (*obraz*). That he believed that a global image is apprehended in a state of *ecstaz* indicates the Ouspenskian/Neoplatonic provenance of those ideas (for there are many more commonplace, non-transcendentalist explanations for the development of generalized images).[239]

Eisenstein often wrote of knowledge as though it were the quest to reveal the Real Form—what he called the "bone structure"—that underlies particulars. This is also the nature of artistic analysis—a critic strives to peel away the flesh of the artistic work in order to expose its skeleton. Iampolsky offers this commendable commentary on the method of the "artistic X-ray," from which I quote at length:

> The metaphor of the skeleton, of the bone-structure, was to prove extremely important for Eisenstein's method of recognising a principle. The imitation of principle became the denial of the body in order to reveal the skeleton. It has to be said that this dark metaphor came to Eisenstein, at least in part, from those Symbolists who were involved in theosophy and anthroposophy. These recent mystical teachings were, like Eisenstein's theory, orientated towards a particular kind of evolutionism. Genetically preceding forms were preserved, according to Rudolf Steiner for instance, in the form of invisible astral bodies that were however revealed to the "initiated." The Theosophists were seriously involved in attempts to fix invisible geometric sketches of what Annie Besant called "forms/thoughts" and in so doing they directly referred to the experience of X-rays. Maximilian Voloshin, who was close to Anthroposophy, wrote an article with the significant title, "The Skeleton of Painting" in 1904 in which he stated: "The artist must reduce the entire variegated world to a basic combination of angles

and curves," that is, he had to remove from the flesh that was visible the skeleton that had been revealed inside it. The same Voloshin read, for example, the painting of K.F. Bogayevsky as palaeontological codes [consider Eisenstein's enthusiasm for inquiries in the primal roots of art and culture], seeing in them concealed prehistoric skeletons. The Anthroposophist Andrei Bely in his *Petersburg*, which is suffused with the leitmotiv of the rejection of the corporeal and the journey to the astral, provided us with a description of the movement from formula to body that is very similar to Eisenstein's: "Nikolai Apollonovich's logical premises furnished the bones; the syllogisms surrounding these bones were covered with stiff sinews; the content of his logical activity was overgrown with flesh and skin." Indeed, we note that the passage quoted ends with an episode for which the sequence of the gods in Eisenstein's *October* might be taken as a paraphrase. We are talking about the scene in which the head of an ancient primitive idol extrudes through the metamorphoses of the gods—Confucius, Buddha and Chronos. The passage through accretions of flesh to the skeleton is analogous to the passage through appearance and the accretion of later deities to their schematic predecessor, and that is a thought process close to Eisenstein's. On the other hand, the development of abstraction from Theosophy was a path common to many artists at the turn of the century, including Kandinsky and Mondrian."[240]

Iampolsky brilliantly connects the metaphor of the skeleton to the Theosophical and Anthroposophical movements that were so important in Russia in the late nineteenth and early twentieth centuries. Specifically, he points to Rudolf Steiner's belief in genetic forms and to his conviction that these old genetic forms are preserved in astral bodies, which spiritually evolved individuals have the capacity to see.[241] The thought-forms that were the subject of Annie Besant and Charles Leadbeater's study also bear similarities to the fundamental topic of Eisenstein's research in his later years—that is, the "principle."

EISENSTEIN AND SYMBOLIST COLOUR THEORY

We have commented already on the Symbolists' belief in colour's primacy; specifically, we cited Blok's conviction that colours, not words, are a child's primary medium of expression, and thus colour is a more genuine, more immediate medium than those on which professional artists normally rely. So it not surprising that Eisenstein had a great interest in colour and that when colour film became available he became interested in its possibilities.

Ideas about participatory forms of consciousness of the sort that interested Eisenstein are often associated in Symbolist literature and Symbolist theory with another form of experience: synaesthesia. We have commented on the Symbolists' conviction that an organic parallel exists between sound and colour. Eisenstein, too, considered the parallel between sound and colour, and

his research into this matter generally concerned synaesthesia. In the way of a persecuted writer, he strived to distance himself from Symbolist (and esoteric) writings on the topic by offering a few critical comments and then qualifying his criticism with remarks that reveal his true commitment. Thus, in "On Colour," he introduces the topic of synaesthesia with the seemingly dismissive remark that "some eccentrics claim to find a musical note that is the sole, absolute equivalent to a single colour which possesses such a multitude of objective links and subjective associations ... This urge to find an absolute equivalence between colour and sound persistently rises to the surface of the human psyche; what is more, I can say without fear of contradiction that they invariably coincide with periods when mysticism is in the ascendant."[242] He goes on to discuss the belief in auditory/visual correspondence that was advanced by August Wilhelm Schlegel (1767–1845), the older brother of Friedrich Schlegel and a founder of the Romantic movement in Germany, and by Arthur Rimbaud (1854–1891). He allows that the phenomenon preoccupied the Symbolists; then, having dismissed their ideas about such correspondence, he argues for an almost identical belief—but he wants us to believe his ideas about the phenomenon have "scientific" grounds:

> Cases are certainly known to medical pathology in which a regressive type of patient is possessed of synaesthetic perceptions to such a degree that he cannot walk across a multicoloured carpet without stumbling. He perceives the polychrome patterns of the carpet as though they were actually at different depths or heights, and as he gauges the need to lift his foot in accordance with them he is inevitably caused to stumble by the disparity between the different heights to which he raises his feet and the absolutely smooth surface of the floor.[243]

He goes on to discuss a man, 'S,' who regularly experienced synaesthesia. However, S's synaesthesia was different from those cases he purportedly deemed suspect (i.e., of Schlegel and Rimbaud), in that S's experiences of colours accompanied not vowels, but consonants. This hardly seems like the difference between a mystical and a scientific belief, but Eisenstein capitalized on it.

Eisenstein believed that synaesthesia offered evidence of a primitive substratum of experience (note his remark that the medical pathology that leads a patient to display synaesthesia involves regression—a reversion to the primitive); and he took great pains to identify this substratum by examining writings by Frazier; by exploring myth and Greek theatre; by studying Otto Rank's and Sigmund Freud's psychology; and by deliberating on the Scythians' artistic program as well as Kruchenykh and Khlebnikov's engagement with related issues, which that highlighted the irrationalist ("trans-sense") source of these ideas.[244] All these topics of inquiry highlight his interest in a substratum of intelligence that operates beyond reason (the *zaum* poets claimed to accord a role to transrational knowledge and transrational experience) and that affects

us immediately, without our being aware of it. Marie Seton's commentary on the topic offers some insight into the depth of Eisenstein's interests in these topics: as she points out, he hoped to produce a synthesis of the various fields of knowledge that he considered to be important for a filmmaker. That synthesis would take the form of a series of volumes, each devoted to a different subject and its relation and application to filmmaking.[245] She set out the purpose of the third volume:

> Another book was to be devoted to painting and what it could teach the cinematographer about the unity of form and content. The full realization of the importance of composition in the enrichment of the film medium had come to Sergei Mikhailovich in Mexico, where composition had become one of his primary concerns. It was then he told me of his conviction that primary form—the triangle and the circle—revealed to man the "mystery" of higher truths in symbolic form—the triangle: God, Man and the Universe, and the circle: immortality.[246]

One can imagine a Theosophist, a Rosicrucian, or a Gurdjievian talking this way—but a scientific materialist? Edoardo G. Grossi advances the claim that Eisenstein's theoretical project was rooted in an approach to ethnological study typical of the Soviet scientific school; indeed, he goes so far as to say that Eisenstein's theory is better understood as a contribution to the work of that scientific school rather than as an effort to explicate the accomplishments of the Soviet avant-garde.[247] The evidence contradicts this: the notion that there exists a primeval protological form of consciousness, which Eisenstein pursued into such writers as Lévy-Bruhl, Vygotsky, and Luria, came to him through his Symbolist and avant-garde involvements. His aesthetic investigations first convinced him of the importance of protological consciousness; then, his interest aroused, he tried to reconcile this interest in protological consciousness with science, which he continued to claim was his guide. He attempted to reconcile his aesthetic enthusiasm to science (especially the social sciences and the science of history) by arguing that these alternative forms of consciousness are the vestiges of primitive mentalities and that the varieties of consciousness confirm the proposition that mentalities are superstructural features whose features are determined by the social formation within which they arise.

But Eisenstein's interest in reanimating protological consciousness is hardly consistent with historical materialism. For historical materialists, convinced as they are that consciousness undergoes change and that this change is adaptive, must maintain that no good can come of preserving atavistic mentalities; indeed, to cling to such outmoded forms of consciousness is to defy the march of history, since the advance of history has rendered those forms obsolete. His evolutionary convictions, shaped by his Hegelian and Marxist convictions, taught that developments in art and culture reflect society's progressive development.

But Eisenstein also believed that the phenomenon of art promotes regression to earlier stages of consciousness—to an undifferentiated, protological, and wholly sensuous apprehension of reality. One must acknowledge that this injected a contradiction into the heart of his aesthetic theory. Yet, though this may be so, one should bear in mind that his psychological interests were not part of a purely scientific effort at showing, through historical study, how changes in social relations bring about transformations in mentality—rather, what he wanted to do was awaken atavistic mentalities. Furthermore, one dimension of his interest in the liminal spaces between the old and new was his conviction that the sensuous perception of the world had been replaced by logical thinking and that our present psychological condition had been affected by this central trauma. The complexity of such an interest allowed him to state, quite sincerely, that he was disposed to deal with all issues with an extreme of rationality and that he only wanted to press these atavistic mentalities into the service of the citizens of the new Soviet society, who—like humans at other times and places—required them for their mental hygiene.

Eisenstein's theory of art was rooted more in ideas about the primitive effects that artworks have than in the compositional *topoi* to which his writings gave such attention (a fact that became all the more evident as his thought progressed). While travelling in Western Europe in 1929 and 1930, he visited the Louvre in the company of Jean Mitry; there he saw that Neoplatonic masterwork, Leonardo's *La Vergine delle rocce* (Madonna of the Rocks, 1483–86). Mitry provides this account of Eisenstein's reaction:

"Look," he said, "I know that the feelings of balance, harmony, and perfection this work arouses in me depend in part on the geometrical organization of lines and forms, on the spatial arrangement of characters and setting. But I should have to use a compass and straight edge before I could be absolutely certainly certain of this, I should have to analyze the basic design. Now my knowledge of how the painting works does not make me feel any the less the intense emotion, the ecstasy which overwhelms me and seizes all my being. Reason enlightens me, but it does its job after the fact. It does not destroy feeling, it illuminates it. Nevertheless, unconsciously, as if by a reflex action [!], I transfer to the canvas—to the represented thing—all the feelings awakened in me by the representation, thus making those feelings part of it."[248]

The key feature in aesthetic experience is ecstacy; structural principles are secondary and support that primary response. The painting's symbolism further encourages and preserves that primary response.

Add to this mathematical operation the more or less obscure appeals made by the symbolic side of the work: the transfigured, idealized characters are no longer characters but ideas incarnate. [Could this remark be Eisenstein's acknowledgment that his intellectual cinema had at its basis an idea of the symbol not far

removed from that of the Symbolists?] And everything is a symbol: the look is a symbol, the gesture is a symbol, the positions are symbols. Even the setting participates; its hidden meaning gushes onto the character of representation, with which it harmonizes as a secondary tone. [Here Eisenstein is certainly acknowledging a parallel to his conception of overtonal montage—but consider this: the work he cites as presenting a parallel to his way of working is a painting that is a veritable catalogue of Neoplatonic visual devices.] Forgetting for the moment the pictorial qualities, the grace of the faces and perspective, which are important as well, we still have the symbolism of the rock; that of the spring spurting from the rock; that of the grotto; that of the crags through which light penetrates to struggle with shadow; and that of the background, which is always present in Leonardo's work: the tall glaciers, the faults and the dark lakes, the light struggling with the shadow and conquering it, the ice melting into water, are so many "harmonic resonators" [Eisenstein is surely alluding to the Neoplatonic idea of harmony, but the esoteric affiliations of the expression should not go unnoted], so many figurations, so many "singular moments" which illuminate in our subconscious the meaning of the painting, but which, perceived and received without at first being really understood and ordered, leave unease and disquiet in the mind of the one receiving them. And since everything (the general impression, the emotion) is instinctively transferred to the content, it is easy to see what richness of feeling immediately permeates that content.[249]

Seton also commented on the projected fourth volume of Eisenstein's encyclopaedic compendium, which would synthesize the various fields of knowledge he considered to be important to filmmakers. Her notes on that volume are as revealing as her remarks on the third:

In a fourth [book], he intended to examine the customs of people through the ages, analyze symbols and create a reservoir of research material for the film director. In connection with this book, he talked at length about the surviving customs of Greece and retraced the life of centuries to the age of myth, the age when it seemed to him there had existed a certain primal unity of all of man's activities.[250]

Again, the idea that human consciousness had been altered profoundly—changed nearly completely—when the primal unity of consciousness was shattered is one that the Symbolists held dear. They called on artists to restore the primeval mentality that is the home of the human heart and mind. The historical materialist's take on the issue is very different indeed.

Seton notes that Eisenstein dreamed of writing this volume, while allowing that he would never be able to complete it

though the notes for it existed on many pages of his books and on sheaves of paper. It was to cover the meaning of religious experience, of ecstasy and man's relation to his gods ... For him there was a "mystery," and the "mystery" was finding the

meaning of God and Christ. The names evolved, the forms and symbols changed from place to place and epoch to epoch, but the "mystery" remained.[251]

The true importance of synaesthesia for Eisenstein's system is simply this: it reveals that a higher form of consciousness, capable of experiencing the unity of sound and colour, could still be activated. This inner unity is a higher form of reality than the sundered world apprehended by the externally directed senses. The inwardness of this prelogical realm caused him to associate synaesthesia with the phenomenon of inner speech and to associate inner speech with the Symbolist doctrine that the purpose of art is to objectify the inner world. He tried to connect this idea with the Marxist idea of objectification of the human being through labour, by quoting Lenin: "This genuine inner synchronicity [of colour and sound in synaesthesia] is like the truth, of which Lenin wrote, 'The truth is a process. From a subjective idea man proceeds towards objective truth *through* "practice" (and technique).'"[252] But there are reasons to doubt that Eisenstein's views on these topics derived from historical materialism. Unpublished notes from 1934 confirm our claims that his interests in synaesthesia and in participatory forms of consciousness were the result of Symbolist influences. In one passage he considered, first, the mysticism of Swedenborg, then continued to the idea that there are multiple phenomenal worlds but that underlying this multiplicity of phenomenal appearances is a real, objective unity. The worlds had been divided into "a multiplicity of worlds: the world of the real [*Handlungswelt*], the world of the imagination [*Vorstellunswelt*], and the conceptual world [*Begriffswelt*]. In this multiplicity, the world of 'things in themselves' emerged, perceived through the veil of vision and appearance, and it was this world that the artist-clairvoyant [cf. Rimbaud's notion of the *voyant*, so beloved by Symbolists] also perceived."[253]

Eisenstein's interest in primitive forms of consciousness brought in its wake the idea of evolution. But of course, as he did about fights, we can point out that there is evolution and there is evolution: there is the evolution Darwin analyzed, and there is the evolution Plekhanov contemplated, and there is the evolution Lenin discussed. In addition to the dialectical materialist's idea of evolution, there is also the concept of evolution expounded in writers such as Gurdjieff, Ouspensky, Blavatsky, Besant, and Steiner—and of course, the last is the version the Symbolists favoured. What about Eisenstein—which did he favour? Given the number of times he deliberated on the differences between the theories of gradual evolution that Plekhanov proposed and the theories of revolutionary change that Lenin offered, one might think it obvious that some form of economic/social evolution was closer to his own. However, we should be careful to acknowledge that allusions to Gurdjieff, Ouspensky, Blavatsky, and Steiner appear in his work with a frequency that might trouble those who wish to see him as the avatar of the artist-engineer. The frequency

with which these esoteric thinkers appear in his writings reflects how deeply embedded Symbolist ideas were in his thought. In his splendid article on mimesis in Eisenstein's film theory, Mikhail Iampolsky proposed:

> Since for Eisenstein any hypothesis was finally proved by projecting it on to evolution, he developed this metaphor [of an underlying principle which is the basis of representation] in an evolutionary way. He quoted from Emerson's account of Swedenborg's [!] teaching (*Representative Men*) a fantastical passage in which the entire history of evolution from the serpent and the caterpillar to man himself is depicted as the history of adding to skeletons and rearranging them. And in a note written in 1933 he enthusiastically revealed another fantastical evolutionary law of correspondence between a skeleton and a thought pattern: "Self-imitation. (Hurrah!) Shouldn't I write about it as a process of developing the consciousness? Nerve tissue reproduces the skeleton etc. and thought reproduces action. It is the same in evolution." The nervous system as the purveyor of thought graphically repeated the pattern of the skeleton as the purveyor of action. In man there occurred an internal mirror-image mimesis of the schemas, structures and principles from which consciousness derived.[254]

Yes, and ontogeny repeats phylogeny. Is this science or is it some form of the esoteric (e.g., Swendenborgian) doctrine of signatures?

Symbolism exerted a pressure on Eisenstein's earlier thought (and accounts in some measure for the Grand Guignol features of *Strike*); however, those pressures were largely contained and hardly apparent. But when the Soviet philosopher Deborin began arguing the relative independence of consciousness (i.e., that the events of consciousness form a chain, which, while being affected by events outside the realm of consciousness, events in the so-called external world, has a coherence of its own), those pressures became increasingly manifest. What separates Marxists from Symbolists is their view on an even more fundamental topic: history. The first half of the nineteenth century had witnessed the concept of history become a fundamental category of consciousness and had experienced an almost unbridled enthusiasm for the historical process. By mid-century this enthusiasm was waning. The proliferation of seemingly intractable social problems cast doubt on the dogma of progress. Values the Enlightenment had bequeathed to subsequent eras—the primacy of reason, the meaningfulness of history, the rational foundations of morality—disappeared almost overnight. Baudelaire, French Impressionism, and the philosophy of Nietzsche appeared within a few years of one another, and all announced a different sense of time than the linear time that the Judaeo-Christian tradition had passed on to early modern Europe as a legacy. Individual judgment took the place of universal history as the arbiter of value.

But if individual consciousness does not occupy the judgment seat, deciding all matters of value, then what agent does? This was the key issue that the Symbolists took up. The question haunted Eisenstein, too—to the very end.

NOTES

1 The emphasis that Bordwell places on organic unity in both the article and the book is especially valuable for explaining Eisenstein's evolution toward more all-encompassing forms of unity that integrate seemingly irreconcilable features. Some artists succeed by creating forms that reconcile seemingly incompatible elements, and both "Eisenstein's Epistemological Shift" (v. David Bordwell, *Screen* 15, no. 4 [1974/75]) and *The Cinema of Eisenstein* lead us toward the conclusion that the latter Eisenstein is such an artist.

2 Thus, Fenollosa's essay appealed to Eisenstein for the same reason it appealed to the key figure in American poetics of the last half century, Ezra Pound, a man who made the kinetic impact of poetry the criterion of poetic value and who referred to Fenollosa's as the greatest essay in linguistics.

3 S.M. Eisenstein, *Selected Works, Volume 1: Writings* 1922–1934, ed. and trans. R. Taylor (London: BFI, 1988), pp. 39–58.

4 The essay originally appeared in *Proletarskoe kino* (Proletarian Cinema) 17 (1932): 19–29. Taylor usefully informs readers that the title cites a recurrent phrase in Gogol's short story, "How Ivan Ivanovich Quarrelled with Ivan Nikiforovich."

5 Ibid., pp. 235–36.

6 But, of course, the kinetic theories presented in the later writings develop themes already present in the earlier. Thus, as I point out below, Eisenstein's interest in kinesis had roots in Marxian theories about the historical dialectic. Furthermore, his early films use movement thematically. In both *Bronenosets Potyomkin* and *Oktyabr*, movements along parallel horizontals and verticals correlate with repression, diagonal movements or movements askew from one another correlate with real (usually progressive) activities, and movements in circles correlate with tumult or with uncontrolled activity that has not yet found a direction.

7 Jan Mukařovský, "Poetic Reference," trans. I.R. Titunik, in Ladislav Matejka and Irwin R. Titunik, eds., *Semiotics of Art* (Cambridge: MIT Press, 1976), p. 157.

8 Indeed, Marx's philosophy is enriched by the interest it takes in the interrelations between two problematics that arise from that understanding: the way that our nature shapes the tools we use; and the way those tools reciprocally affect our nature.

9 Eisenstein, "Beyond the Shot" (more commonly, "The Cinematographic Principle and the Ideogram"), in Eisenstein, *Selected Works, Volume 1*, pp. 161–80.

10 Jacques Aumont, *Montage Eisenstein*, trans. L. Hildreth, C. Penley, and A. Ross (Indianapolis: Indiana University Press, 1987), p. 30.

11 Dziga Vertov, "On 'Kino-Pravda,'" in *Kino-Eye: The Writings of Dziga Vertov*, ed. and intro. A. Michelson, trans. K. O'Brien (Berkeley: University of California Press, 1984), p. 45.

12 "Kinoks" is a neologism of Vertovian coinage that means, essentially, a "filmer." "Oko" is a suffix that makes a verb out of a noun, but it is also an archaic word for "eye." There is more to the wonderful complexity of the neologism—the suffix is used for a "machine that does something," much as we use "print*er*" to refer to a machine that prints. But we also use the suffix "er" to refer to a person who does something, as well as to machines (a printer can also be a person who practises the trade of printing), whereas in Russian the suffix "oko" is used only for machines. So when Vertov writes "we, Kinoks," Russians understand that he is referring to the (human) film machines that the new culture has produced. Thus, Kinoks are new people, people who have been transformed by the industrial age into machines that film.

13 Vertov, "In Defense of Newsreels," in *Kino-Eye*, p. 146.

14 Vikoto Pertsov, "'Igra' i demonstratiia" (Play and Demonstration), *Novy LEF* 11/12 (1927): 35–42, in Vlada Petrič, *Constructivism in Film: The Man with the Movie Camera: A Cinematic Analysis* (Cambridge: Cambridge University Press, 1987), pp. 19–20.

15 Eisenstein, "Through Theatre to Cinema," in *Film Form and the Film Sense*, ed. and trans. J. Leyda (New York: Meridian, 1967), p. 3.

16 This conception of the photograph/cinematograph was more closely aligned with the idea of photograph in Western modernism than with its conception in Soviet Russia. Russian institutions acknowledged the aesthetic potential of photography much earlier than those in the West: at the end of the nineteenth century, the Russian Academy of Fine Arts officially recognized photography, placing it on par with the other fine arts. At the time, this was a position that Western photographers could only dream of. Indeed, the Russian progressive intelligentsia regarded photography as a marker of cultural modernity. For them, owning photographs was a declaration of their affiliation with progressive tendencies. Thus, photographs were widely exhibited as works of art in travelling exhibitions as well as in large-circulation magazines. By contrast, Stieglitz's *Camera Work* had just under one thousand subscribers.

 Yet we should not underestimate the importance that Soviet artists attached to the issue of restaging events. A panel discussion among Osip Brik, Sergei Tretyakov (1892–1937 [executed]), Viktor Shklovsky, and Esfir Shub, published in the December 1927 issue of *Novy LEF*, asserted that the controversy between staged and unstaged film was the basic issue confronting contemporary cinema. The discussion generally favoured greater ontological authenticity and thus preferred Vertov's approach to that of Eisenstein. Another panel discussion, this one among Brik, Pertsov, and Shklovsky, published in *Novy LEF* in April 1928, praised Vertov's *The Eleventh Year* for its "life facticity." At the same panel, Brik condemned *Octyabr* for its restagings.

 The following articles in the November and December 1927 issues of *Novyj LEF* dealt with the specific issue of facticity: Viktor Shklovsky, "Mistakes and Inventions" (pp. 29–33); Osip Brik, "The Fixation of Fact (Extract)" (pp. 49–50); and Esfir Shub, "We Do Not Deny the Element of Mastery" (pp. 58–59). An article in the April 1928 issue of *Novyj LEF* concerned itself with the same: The *Lef* Ring [Osip Brik, Viktor Pertsov, Viktor Shklovsky], "Comrades! A Clash of Views!" (pp. 27–36). (All four articles are reprinted in Richard Taylor, ed. and trans., and Ian Christie, co-ed., *The Film Factory: Russian and Soviet Cinema in Documents* [Cambridge: Harvard University Press, 1988].)

17 Anonymous, *Lef* 4 (1924), cited in Benjamin H.D. Buchloh, "From Faktura to Factography," in R. Bolton, ed., *The Contest of Meaning* (Cambridge, MA: MIT Press, 1992), p. 60.

18 Vladimir Mayakovsky, "Unichtozhenie kinematografom; teatra; kak priznak vozrozhdeniia teatral'noga iskusstva" (The Destruction of the 'Theatre' by Cinematography as a Sign of the Rebirth of Theatrical Art), originally published in *Kinozhurnal* 16 (August 1913): 5, reprinted in *Complete Works*, vol. 1, p. 278. The title of the article reveals much about Mayakovsky's anxieties regarding the impact of cinema.

18 Alexei Gan, "Constructivism in Cinema," originally published in 1928, reprinted in translation in Stephen Bann, ed., *The Tradition of Constructivism* (New York: Viking, 1974), p. 130.

20 Bordwell, *The Cinema of Eisenstein*, p. 130.

21 In fact, his ambition was to create not simply a Marxist theory of film, but a Marxist theory of all the arts: like contemporary postmodernists, Eisenstein was as interested in uncovering the principles that all the arts share as he was in identifying the specific properties of the various artistic media; and as interested in drawing on art's historical

MODERNISM AND REVOLUTION

strengths as he was in returning to the zero point of artistic construction. He hoped to reformulate art, beginning from the beginning, with the basic, inviolable principles of the specific medium with which he worked. He considered the linguistic analogues of artistic construction; accordingly, he considered the distinction between the aesthetic use of photography (in film) and its ordinary, everyday non-aesthetic use on the model of the distinction between poetic language and natural language.

Nonetheless, Eisenstein's belief that aesthetic images are distinguished by their activities and effects opened up a large enough aesthetic space to exempt his "Formalist" theories from the rather feeble criticism, based on an outmoded American-type modernism, that Peter Wollen offered in his weekend excursion into the avant-garde, titled "The Two Avant-Gardes."

22 Eisenstein also understood the activity of aesthetic images through the concept of the labour; that is, he related their use value to the work they did in transforming the spectator's consciousness. Here, again, he joined Formalist ideas with strict Marxian ideas. The work that images do is to transform consciousness. But this is also the function of a work of art on the Shklovskian theory, for art serves to vivify awareness.

23 I say "in part" because, as we shall see, there were other dimensions to his theory—Eisenstein's influences and antecedents were not all practitioners in the realm of the technological.

24 El Lissitzky understood the montage of elements, on a page as much as on a stage, to be essentially cinematic. Regarding his 1922 book, *Of Two Squares*, he noted that the action unrolled like a film and that that the typographical montage used therein resulted in the reader being carried through space and time (as in a film). *V.* Yve-Alain Bois, "El Lissitzky: Reading Lessons," *October* 11 (Winter 1979). Likewise, on the first page of the catalogue for the USSR Pavilion at the International Press Exhibition (*Pressa*) mounted in Cologne in 1928, he remarked: "Here you see in a typographic kino-show the passage of the contents of the Soviet Pavilion." Lissitzky, "Katalog des Sowjet Pavillons auf der Internationalen Presse-Ausstellung" (Cologne: Dumont Verlag, 1928), p. 16, in Buchloh, "From Faktura to Factography," in Bolton, ed., *The Contest of Meaning*, p. 63.

About Lissitzky's installation, Buchloh remarked: "While the scale and size of the photomontage—it was installed on the wall at a considerable height—aligned the work with a tradition of architectural decoration and mural painting, the sequencing of the images and their emphatic dependence on camera technology and movement related the work to the experience of cinematic viewing, such as that of the newsreel. In their mostly enthusiastic reviews, many visitors to the *Pressa* exhibition actually discussed the theatrical and cinematic aspects of the photofresco. One critic reminisced that one went through "a drama that unfolded in time and space. One went through expositions, climaxes, retardations and finales."

Reviewing both the Dresden *Hygiene Exhibition* design by Lissitzky and the Cologne *Pressa* design, a less well-disposed critic still had to admit the design's affiliation with the most advanced forms of cinematic production: "The first impression is brilliant. Excellent the technique, the arrangement, the organization, the modern way it has been constructed ... How well the Russians know how to achieve the visual effects their films have been showing us for years" (ibid., pp. 65–67).

25 Eisenstein's ideas on the degree of autonomy possessed by the quasi-autonomous elements in nexus of aesthetic relations varied over time (or at least he professed to change his mind on this topic). At first, he conceived of the elements in an aesthetic nexus as being like parts in a machine: he believed that they are not changed (or not much changed) by entering into relations with other aesthetic elements. Later he claimed to

have changed his mind on this, as he began to conceive of aesthetic relations not as mechanical but rather as organic: each relatum is internally changed by its relation to other relata.

26 Vertov's conception of the interval could be invoked here.

27 Lissitzky, "Demonstrationsräume," in Buchloh, "From Faktura to Factography," in Bolton, *The Contest of Meaning*, p. 56.

28 Analyses of Eisenstein's films have never described the dialectics of their montage quite correctly.

29 Naum Gabo and Antoine Pevsner, "Realist Manifesto" (1922), in Charles Harrison and Paul Wood, eds., *Art in Theory 1900–1990* (Oxford: Blackwell, 1992), p. 298. The term "Konstruktivizm" appeared for the first time in this manifesto, which presents a very pure and clear statement of the movement's core beliefs.

30 In "The Fourth Dimension in Cinema" (*Writings, Volume 1*, p. 182), Eisenstein states that "the shot never becomes a letter but always remains an ambiguous hieroglyph." He goes on immediately to relate the multiplicity of the film frame's meaning to its intrinsic relations: "It can be read only in context, just like the hieroglyph, acquiring specific *meaning*, *sense* and even *pronunciation* (sometimes dramatically opposed to one another)."

31 The article is unpublished in Russian. "This piece written by [Eisenstein] in German, exists in two typescripts, one dated 'Moscow, 29 April 1929' and the other dated 'Zurich, 29 November, 1929'... Jay Leyda translated it and included it as 'A Dialectical Approach to Film Form' (a change of title approved by [Eisenstein]) in *Film Form*, pp. 45–63." In Taylor's endnotes to *Eisenstein: Selected Works, Volume 1* (London: BRI, 1988), pp. 317–18n51. Taylor's new translation (with François Albera, from the same book, appears under the title "The Dramaturgy of Film Form."

32 Karl Marx and Frederick Engels, *The German Ideology*, pt. 1, ed. and intro. C.J. Arthur (New York: International, 1947), p. 47.

33 Stan Brakhage's *Film Biographies* offers a splendid poetic statement of this line of reasoning.

34 Bear in mind that by the mid-1920s, dissent in the Soviet Union, even among the intelligentsia, was quite widespread. Vladimir Brovkin's *Russia After Lenin: Politics, Culture, and Society, 1921–29* (London: Routledge, 1998), does a splendid job of revealing just how widespread it was and how it led to a subculture of individualism and religiosity. Indeed, Brovkin shows that Stalin's cultural revolution was driven by the fact that the Bolshevik party was fighting for survival. It was a question of crushing politico-cultural pluralism or losing control of the country. This explains why Stalin ordained the policy of proletarianisation that destroyed the avant-garde.

35 Eisenstein had acquired Lévi's book earlier, within a few years of being initiated into the Rosicrucian sect; but he did expand his library on the imprecise sciences considerably during the time he spent filming in Europe and the United States in 1929, and in the year and a half he spent in Mexico.

36 That Ignatius Loyola's *Spiritual Exercises* figures among the texts that influenced Eisenstein is interesting. Martin Lefebvre has made much of the connection—appropriately so. In "Eisenstein, Rhetoric, and Imaginicity: Towards a Revolutionary Memoria," *Screen* 414 (Winter 2000): 349–68, Lefebvre points out that Eisenstein and St. Ignatius shared a belief in the power of images to institute a memory as a coherent, organized, and unified way of seeing the world. Eisenstein's treatment of the global image reveals the extent to which his interests overlapped with those of Loyola's *Spiritual Exercises*: the global image can serve as a mnemonic device to awaken (or elaborate) an individual or

collective memory, the memoria that constitute the principal goal of Jesuit rhetoric and homily. Lefebvre contends that Eisenstein believed that the dialectic laws of nature guarantee a connection between the individual memoria of the spectator (or filmmaker) and a collective memoria—though I would stress that Eisenstein is here stretching the term "dialectic" to include Platonic and (more importantly) Neoplatonic philosophy. This has interesting implications for Eisenstein's theory of spectatorship: he treats the spectator much as Loyola does the spiritual exercitant—that is, according to the power of memory to project images onto the "inner cinema" of the soul or mind. A degree of freedom is accorded to the spectator, and his/her active participation is required, for much like Loyola's exercitant, the cinema spectator is relatively free to employ imagination in creating his/her own memoria. But this freedom is only relative, for it plays out only within the confines of certain *topoi*, or locations, that frame the labour of imagination and direct it in its work of shaping memory.

37 It should not be thought that Eisenstein's interest in myth began with his trip to Mexico: *Oktyabr* makes it amply clear that he was aware of the mythical power of allegory even in the early phases of his career. Bryusov's article appeared as "Klychi tain" in *Vesy* 1 (1904). *Vesy* is sometimes translated as "Scales," and indeed it can mean that, but it is also the Russian word for the astrological sign Libra. The article puts forward the orthodox Symbolist view that art trades in intuition, a faculty that allows one to transcend visible reality and apprehend reality's core.

38 That Soviet writers and artists of the 1930s diverted their energies away from high, radical art toward various folk interests undoubtedly helped sway Eisenstein toward an interest in Mexico. But I contend that there is more to his fascination with that troubled country than that.

39 Andrey Bely, "Magiya Slov" (The Magic of Words), originally published in *Simvolizm* (Moscow, 1910): 429–30, reprinted in translation in *Selected Essays of Andrey Bely*, ed. and trans. S. Cassedy (Berkeley: University of California Press, 1985), p. 94.

40 Ibid., pp. 93–94.

41 Schlegel was also sympathetic to the sort of Gnosticism that Bely embraced. In *Philosophy of Language* he stated that a new theory had been proposed to overcome the deficiencies of the Hindu idea of metempsychosis. In that theory, "this life has been astronomically depicted in the brightest and most attractive colours as a walk among the stars, continually ascending from one sidereal existence to another. In the limited range of human knowledge, it is alike impossible to deny or to prove the possibility of such a migration among the stars. But it is evidently a wiser course, and one far more agreeable to the nature and limits of man's powers of understanding, for him to confine his views to his own immediate home—the earth, investigating, sifting, and divining its mysteries, than to lose himself in airy dreams amid the whole starry universe" (Friedrich von Schlegel, "Philosophy of Life," in *Philosophy of Life, and Philosophy of Language: In a Course of Lectures*, trans. A.J.W. Morrison (London: Bohn, 1847), p. 139.

 This, of course, is pure Gnosticism.

42 Ibid., pp. 277–78.

43 Ibid., p. 70.

44 Ibid., p. 46.

45 V. Bely, "The Magic of Words," p. 95.

46 In his early and middle twenties, Vladimir Solovyov had associated with Slavophiles and with other conservative nationalist groups. Then in March 1881, when he was twenty-eight, an event occurred that changed his life irrevocably by converting him to liberal causes. While lecturing on Slavophile themes to a large audience in St. Petersburg, he alluded

to six members of the terrorist group *Narodnaia volya* (The People's Will) who were on trial for assassinating Alexander II. He told the audience that the situation presented the new Czar with an "unprecedented opportunity to affirm the Christian principle of all-forgiveness" by pardoning his father's assassins. The audience broke out in torrent of "bravos" from those who assumed that Solovyov was endorsing the radicals' cause, and hisses and jeers from the conservative Slavophiles in the audience.

Solovyov returned to the podium to explain that his point was that a Christian state should not impose the death penalty. Nonetheless, news of Solovyov's scandalous remarks was bruited abroad, and came to the attention of authorities, including the Minister of the Interior and Czar Alexander III. The Czar reprimanded Solovyov for expressing an inappropriate opinion (he also saw to the hanging of five of the six members of *Narodnaia volya* charged with assassinating Alexander II) and for a short time enjoined him from lecturing. These actions so outraged Solovyov that he rethought his Slavophile commitments and decided that Christian morality demanded more liberal positions. Thus he came to argue that the progress of history is the gradual revelation of the Kingdom of God in the life of humankind and that the task of the true Christian is to transform social institutions, to make them compatible with the Kingdom of God. The revelation of the Kingdom of God provided humankind with a standard of perfection that it should strive to attain here on earth. This was the basis of Solovyov's liberalism.

47 Bely's statements on this topic have an especially marked Schopenhauerian cast.

48 To be sure, Bely's thinking on this matter was not precise. He sometimes wrote as if he believed that words are truly creative, that they create the objects of extramental reality. At other times, he wrote as if language created the phenomenal reality, the world with which experience acquaints us.

49 Bely, "The Magic of Words," p. 93.

50 *Ibid.*, p. 95, 93.

51 Konstantin Balmont, *Poeziia kak volshebstvo* (1915, reprinted Letchworth: Prideaux, 1973).

52 Eisenstein's early enthusiasm for Orthodoxy is surely reflected in his handling of Pimen, the Russian Orthodox priest in *Ivan Grozny* (1945/46).

53 Johann Wolfgang von Goethe, *Wisdom and Experience,* ed. and trans. Hermann J. Weigand (New York: Pantheon, 1949), p. 76. The cited passage appears in Alice Raphael, *Goethe and the Philosopher's Stone* (New York: Garrett, 1965), p. 246.

54 And it is important to acknowledge that Eisenstein first proposed such a belief when he was more strongly committed to a Constructivist conception of unity (the assemblage of parts) than to a Romantic conception of organic unity. Implicit in his belief system was the idea that one comes into identity with the musical dynamics of the cosmos, thus the cosmos comes to influence every dimension of one's being.

55 Papus (Dr. Gérard Encausse) formed an organization called l'Ordre des Supérieurs Inconnus, commonly known as the Order of the Martinists, which was based on two extinct Masonic rites: the Rite of Elus-Cohens or Elected Priests of Martinez Paschalis, or de Pasqually (c.1700–1774); and the Rectified Rite of Saint-Martin of Louis Claude de Saint-Martin (1743–1803, a student of de Pasqually who wrote under the pseudonym "The Unknown Philosopher"). Papus claimed to possess de Pasqually's original manscripts and to have been given authority in the Rite of Saint-Martin by his friend Henri Viscount Delaage (who in turn claimed that his maternal grandfather had been initiated into the order by Saint–Martin himself, and who had attempted to revive the order in 1887). The Martinist Order was to become a primary focus for Papus, and continues today as one of his most enduring legacies.

56 Suspicions about Masonic and Rosicrucian conspiracies remained rife in Russia for a very long time—perhaps that is another reason why Eisenstein took pains to conceal his Rosicrucian interests.

57 Moreover, in the 1920s Bulgakov wrote a presumably autobiographical short story about a country doctor addicted to morphine. Also, in the 1920s and 1930s he remained addicted to drugs–his third wife, Yelena Bulgakova, often had to assist him in obtaining them.

58 Boris Mikhailovich Zubakin (1894–1938) was a truly impressive figure—a poet, improviser, scientist, sculptor, and professor of archeology. He was acquainted with key figures of Russian culture and corresponded with Gorky, Veresaev, and Piast; he was also a member of Bakhtin's circle in Nevel (he and Bakhtin had attended the same gymnasium). He was a colourful personality, fond of incantation and word play (as a party trick, he would make up a poem, incorporating a dozen or so words he was given, and then another, incorporating the words in reverse order).

Reading of Eisenstein's enthusiasm for the appearance of the Rosicrucian bishop, one may recall his portrayal (during and after the colour sequence) of the mock crowning of Ivan and his *oprichnina*—the black-robed monks looking for all the world like members of a cult, presided over by the initiator Ivan. (For example, Ivan seems to assume the role of initiator in the colour sequence depicting Vladimir Staritsky's mock crowning—a crowning that leads to his downfall.)

59 V. Eisenstein, *Selected Works, Volume IV: Beyond the Stars: The Memoirs of S.M. Eisenstein*, trans. William Powell (London: British Film Institute, 1995), pp. 80, 82.

60 V. Oksana Bulgakowa, *Sergei Eisenstein: A Biography*, trans. A. Dwyer (San Francisco: Potemkin, 2001), pp. 15ff.

Initiated into the order with Eisenstein was the actor and anthroposophist Mikhail Aleksandrovich Chekhov (1891–1955), an actor in Stanislavsky's Moscow Art Theatre who attempted to meld the ideas of his artistic mentor with Rudolf Steiner's ideas on language. Later, when Eisenstein wrote about this period in his life, he presented it as a trifling matter, adding that he soon tried to distance himself as much as possible from the Rosicrucians, Steiner, and "Madame Blavatskaya." But he was more involved in the sect than he let on: the Rosicrucian order gave him access to many important figures in Soviet theatre. Furthermore, his description of his exchange with Chekhov (from Eisenstein, *Selected Works, Volume IV, Beyond the Stars: The Memoirs of Sergei Eisenstein*, ed. Richard Taylor, trans. William Powell [London: British Film Institute, 1995], p. 83) is telling. He wrote of evening discussions with the actor that centred on Theosophy, Rudolf Steiner, hypnosis, and yoga:

> I remember one conversation we had about the "invisible lotus" which flowered, useen, in the devotee's breast. I remember the reverential silence and the glassy eyes of the believers fixed on their teacher.
>
> Chekhov and I went out on to the street.
>
> A thin covering of snow. Silence.
>
> Dogs frisked playfully around the street lamps.
>
> "I have to believe there is something in the invisible lotus," said Chekhov. "Take these dogs. We cannot see anything and yet they can scent something under each other's little tails …"
>
> Cynicism of this order often goes hand in hand with belief. Such was Chekhov.

One suspects that Eisenstein could have applied the assessment to himself—that, when he wrote that cynicism often goes hand in hand with belief, he was making a personal allusion.

Mikhail Chekhov's ideas have real parallels with Eisenstein's. Chekhov believed that the character of one's language embodied a view about the relation between the individual

and the supra-individual. Steiner's ideas about language led Chekhov to believe that every sound has a life of its own, its own gestus, which exists independently of any particular use one makes of that sound, and that the energy of sound influences an individual's being when he or she uses it. Vowels corresponds to the inner world of emotions, desires, and passions, while consonants imitate the outer world, and the interplay between vowels and consonants in one's speech embodies the interaction between the inner and outer realms. Eisenstein's interest in dynamic form and its unconscious effects suggest related ideas about gestus.

61 Alma Law and Mel Gordon, *Meyerhold, Eisenstein, and Biomechanics: Actor's Training in Revolutionary Russia* (London: McFarland, 1967), p. 77.

62 Often claimed for this work is a spurious provenance, one that traces the document back to the time of Moses. Isaac Casaubon discredited this claim.

63 The fantasy of androgyny is linked to the human desire for eternal existence.

64 The documents offer a fantastic tale of Christain Rosenkreutz's life. The story goes that his parents put him in a monastery when he was five years old. While there, he learned Greek and Latin. He left the monastery when he was sixteen to join a group of magicians. He travelled with them for five years, and from them he learned the art of magic. On parting from the magicians, he continued to travel on his own, first to Turkey, then to Damascus, then into Arabia. In Arabia he learned of a city in the desert, Damcar, known only to philosophers, whose residents possessed extraordinary knowledge of the secret workings of nature. He succeeded in learning Damcar's location, and went there, where he was received well by the citizenry, who seemed to have been expecting him. He shared with them the knowledge he had acquired in the monastery and from the magicians, and they shared with him their secret knowledge.

Rosenkreutz remained in Damcar for thee years, during which time he mastered their knowledge of the occult operations of the universe. After that time, he travelled to the Barbary Coast, where he lived for two years in the city of Fez, where he met and learned from Kabbalists and sages. It was in Fez that he conceived the idea of reforming the sciences and using the teachings of the reformed sciences to improve society.

To spread his teaching, Rosenkreutz went first to Spain, but there he met resistance, even contempt. So he set out across Europe, but everywhere he met with the same ridicule. He returned to Germany, where he built a large house, in which he pursued his studies in isolation and kept the science he developed to himself. The scientific instruments he built, he revealed to no one.

Christian Rosenkreutz died in 1484 at the age of 106 and was buried in a cave. Many gold vessels, supposedly with magical powers, were buried with him. One hundred twenty years after his death, his burial cave was rediscovered, quite by chance. According to the legend, the cave was filled with natural light even though there was no entrance for the sun's rays. Everything in the cave shone brightly. The light revealed a bright plate of copper on which were mysterious inscriptions (including the initials R.C.); as well as figurines, also with mysterious inscriptions, and various items that had belonged to Rosenkreutz: bells, mirrors, and books, including a dictionary. One of the inscriptions read "Post cxx Annos Patebo" ("After 120 years, I shall be found").

The scholars who rediscovered the cave deciphered those writing of Rosenkreutz that had been found there, and used the knowledge to found the secret Brotherhood of the Rosenkreutz, whose mission was to reform the world using the sciences—specifically, Rosenkreutz's mathematics, physics, chemistry, and medicine. The Brotherhood was bound by six rules:

1. Brothers must heal and distribute free medicine to anyone who needs it.

2. Brothers must dress to conform to the customs of the society in which they live.

3. Members of the Brotherhood must meet once a year.

4. Each brother must choose a successor, to enable the brotherhood and its work to continue.

5. Each brother must carry a hidden seal, inscribed with the letters "R.C."

6. Members will keep the society secret for one hundred years.

The brotherhood worked to develop a magic language that could serve as a secret code for the new science. This new science would be the basis for improving society; members of the brotherhood, living in accordance with the customs of the locales in which they lived, would be able to inject their knowledge into discussions about the constitution of a good society.

65 The "Confessio Fraternitatis" states: "These characters and letters, as God hath here and there incorporated them in the Holy Scriptures, the Bible, so hath he imprinted them most apparently into the wonderful creation of heaven and earth, yea in all beasts. So that like as the mathematician and astronomer can long before see and know the eclipses which are to come, so we may verily foreknow and foresee the darkness of obscurations of the church, and how long they shall last. From which characters or letters we have borrowed our magic writing, and have found out, and made, a new language for ourselves, in the which withall is expressed and declared the nature of all things. So that it is no wonder that we are not so eloquent in other languages, the which we know that they are altogether disagreeing to the language of our forefathers, Adam and Enoch, and were through the Babylonical confusion wholly hidden."

The Rosicrucian views about language reflect a correspondence between the highest form of writing (i.e., writing in the Adamic language) and the constitution of reality. The French Rosicrucian Eliphas Lévi (mentioned earlier) highlighted this aspect of the doctrine between 1855 and 1860. So, precisely, did Eisenstein with his film theory, which presents cinema as both highly logomorphic and homologous with the dialectical structure of reality. Moreover, his film theory describes how fragments of reality can be incorporated into an logomorphic construction that possesses both the discursive powers of language and the evidential powers of language's referents. It follows that deciphering a text is a process equivalent to discerning the mysteries of reality. In the end, phenomenologies of reading and seeing are collapsed (as they are in Benjamin's similarly heterodox ideas about language). The point is that these ideas about language are very close to those to which the Rosicrucians commit believers.

66 On this, *v.* Henri-Gaston Gouhier's *Les premières pensées de Descartes: Contribution à l'histoire de l'anti-renaissance* (Paris: Vrin, 1958); A.C. Grayling, *Descartes: The Life of René Descartes and Its Place in His Times* (New York: Walker, 2006); and, a more populist account, Amir D. Aczel, *Descartes' Secret Notebook: A True Tale of Mathematics, Mysticism, and the Quest to Understand the Universe* (New York: Broadway, 2005).

67 In large measure, the fate of Rosicrucianism was simply the fate of alchemy once skepticism about its basis developed. In 1661 the alchemist Robert Boyle published a treatise titled *The Sceptical Chemist* that questioned Aristotle's theory (one of the bases of alchemical theory) that only four basic elements made up the material universe. Boyle's book was widely read, and soon enough the chemical transmutation theory was rejected. By the late eighteenth century, theories of spiritual transmutation as well had by and large been rejected. But with the loss of scientific legitimacy, the mystical aspects of Rosicrucianism grew.

68 Recall that the event that galvanized the *Potemkin*'s sailors was being forced to eat maggot-ridden meat. Also, V.V. Ivanov reports that in his unpublished manuscripts, Eisenstein grappled with ideas of corruption of the lower orders—he seemed, in fact, in Rosicrucian

fashion, to associate the inertness of matter (a characteristic that "A Dialectical Approach to Film Form" stresses) with corruptness, baseness, beastliness, and taint. On this, see Ivanov, *Ocherki po istorii semiotiki v sssr* (Sketches of the History of Semiotics in the USSR) (Moscow: Nauka, 1976), p. 181, cited in Aleksander Zholkovsky, "Eisenstein's Poetics," in John E. Bowlt and Olga Matich, eds., *Laboratory of Dreams: The Russian Avante-Garde and Cultural Experiment* (Cambridge: Cambridge University Press, 1996), p. 248.

69 A production of *Die Walküre* by Eisenstein opened at the Bolshoi Opera Theatre on November 21, 1940. Productions of Wagner's *Ring* cycle were relatively uncommon in Soviet Russia. It was not always thus: indeed, Fyodor Chaliapin was one of Wagner's most enthusiastic advocates, and that, along with St. Petersburg's legendary enthusiasm for opera and Lenin's passion for the composer (who had, of course, early in life, as a follower of Bakunin, written the radical tract "Art and Revolution"), ensured that Wagnerian operas held an important place in Russian cultural life. This changed with Stalin's cultural revolution—indeed, Valery Gergiev's production of the entire *Der Ring des Nibelungen*, at St. Petersburg's Mariinsky Theatre from June 13 to 18, 2003, was the first in Russia since before the First World War. The 2003 production was mounted primarily as a pro-German gesture.

70 Eisenstein treated his work on *Die Walküre* as an extension of his research into mythology (and the psychological processes that give rise to myth). The relation between Siegmund and Sieglinde he considered an emblem of the early stage in human development, when marriage between brother and sister was not despised, but accepted as natural. (Duchamp, who also took a deep interest in alchemy, was also intrigued by the image of the androgyne and harboured feelings for his sister.)

71 In Luda and Jean Schnitzer, "Teenage Artists of the Revolution," in Marcel Martin, ed., *Cinema in Revolution* (New York: Hill and Wang, 1973), p. 39.

72 Eisenstein, *Izbrannye proizvedeniya*, vol. 2 (Moscow: Izkusstvo, 1963–70), pp. 120–21; in Håkan Lövgren, *Eisenstein's Labyrinth: Aspects of a Cinematic Synthesis of the Arts* (Stockholm: Almqvist & Wiksell, 1996), p. 33.

73 Eisenstein, *Notes of a Film Director,* trans. X. Danko (New York: Dover, 1970), p. 14. He even used the metaphor of the "seven veils" to refer to the mystery of creation.

74 Furthermore, Eisenstein clearly understood the structural analogies between dramatic structure and the phases in a revolution. His film aesthetics also relied on analogizing the effects that the new art would have on viewers' consciousness and the social effects of revolution. The analogy has convinced few subsequent theorists—who, despite being unconvinced, have not asked how a thinker so strong as Eisenstein was led to such misconceptions. I am arguing that that question is important, and that the answer to it concerns his belief that all reality unfolds through a single, all-embracing evolutionary process. The provenance of this idea is in heterodox systems.

75 Though the congruence is not quite as startling as it might at first seem. The contours of nineteenth-century occultism developed out of the same spirit of reconciliation as fuelled Hegel's philosophy (indeed, occultists such as Rudolf Steiner often sound like simplifiers/popularizers/perverters of Hegelianism); and, of course, Marx adopted Hegel's dialectical principle and transformed it to accord with different convictions on the topics of ontology.

76 Writers writing under persecutory regimes often use such allusions to indicate the hidden meaning of their texts.

77 From Karl von Eckartshausen's *Disclosures of Magic from Tested Experiences of Occult Philosophic Sciences and Veiled Secrets of Nature* (1791). Eisenstein, *The Film Sense*, ed. and trans. J. Leyda (London: Faber and Faber, 1968), pp. 74–75.

78 No doubt, Eisenstein derived his ideas from those of the Formalists, as well as from Marxist ideas on the dialectic. I have attempted to point out that a signal contribution on Eisenstein's part was the synthesis of Formalist with Marxist ideas. Here I wish to point out that occult (and specifically Rosicrucian) ideas also had a role in shaping his massively overdetermined conception of artistic unity.

79 See especially "Laocoön," in Eisenstein, *Selected Works, Volume II, Towards a Theory of Montage*, ed. Glenny and Taylor, trans. Glenny (London: British Film Institute, 1991), pp. 180–95.

80 To be sure, Newton himself believed that the body contained an invisible fluid that responded to planetary gravitation.

81 Mme Blavatsky discusses mesmerism in *Isis Unveiled* and *The Secret Doctrine*. Among the several authorities on mesmerism or animal magnetism quoted in the former, besides Mesmer and Thouret, are Baron Étienne–Félix d'Henin de Cuvillier, *Annales du magnétisme animal* (1814–16); Joseph-Philippe-François Deleuze, *Bibliothèque de magnétisme animal* (1877); Marquis de Puységur, *Magnétisme animal considéré dans ses rapports avec diverses branches de la physique* (1804–7); and Baron Jules Dupotet de Sennevoy, *Cours du magnétisme en sept leçons, deuxieme edition, augmentee du rapport sur les experiences magnetiques faites par la Commission de l'Academie Royale de Medecine en 1831* (Paris, 1840). Mme Blavatsky documented the trials and tribulations of mesmerism as it was investigated by official commissions led by Benjamin Franklin (1784) and the French Academy (1824, 1826), hardly pausing before recounting the later successful experiments of Puységur. V. Blavatsky, *Isis Unveiled*, Vol. I, pp. 173–75. She was especially enthusiastic about the demonstrations of Baron Dupotet and Regazzoni. She discussed at length Regazzoni's display of mesmeric powers in Paris in May 1856 (strangers whom he had blindfolded were blocked by the mesmeric power of "kabalistic" lines he had drawn across the floor; and a blindfolded girl was made to topple over, as if by lightning, by magnetic fluid that Regazzoni emitted. Mme Blavatsky, *Isis Unveiled*, Vol. I, pp. 142–43, 283.

82 Paris proved considerably more tolerant of these incontinent "crises"; nevertheless, they created enough of a scandal that two commissions were appointed to look into the effectiveness of Mesmer's cures. One commission, appointed by the academy, included Benjamin Franklin and Antoine Lavoisier. Neither commission endorsed Mesmer's claims.

83 Evidence of the association that the popular mind would make between the affairs that went on at the baquet and at the cinema can be found in the fact that in 1905, Georges Méliès made a film, *Le baquet de Mesmer*.

84 Mesmer had experienced some initial success in treating Maria Theresia, for she temporarily recovered her sight when he first treated her. However, an ophthalmologist who had failed to cure her stated that the cure was not genuine. Eventually, for whatever reasons, Maria Theresia's father became upset with Mesmer and went over to Mesmer's residence, sword in hand, to demand that Franz Anton stop treating his daughter.

 Perhaps his outrage was the result of self-interest: as Maria Theresia's sight improved, her piano-playing deteriorated to the point that she was in danger of losing a pension she received from the Empress. Whatever the reason, Maria Theresia relapsed; she had a reasonably successful career as pianist and composer but never again recovered her sight.

85 Le Bon was a French academic of the *fonctionaire* type who had been alarmed by the Paris Commune of 1871. He shared the common conviction of the time that the nation-state is a sort of spiritual entity; he believed that with the growth of democratic politics, the old systems of hierarchy and deference were breaking down and that the mob at any moment could seize control and destroy all the values of civil society. This led him to in-

vestigate the social psychology of the crowd and the technologies of crowd control in the modern metropolis. He concluded that the crowd is not driven by rational argument, but by the solar plexus—that it responds solely to emotional appeals and is incapable of thought or reason. A leader, it follows, must appeal not to logic but to unconscious motivations, and the most effective way to do this is through the use of images.

86 *V.* Ian Hacking, "Telepathy: Origins of Randomization in Experimental Design," *Isis* 79 (September 1988): 427–51. The most relevant section is "iv: Telepathy and the Society for Psychical Research," pp. 435–37.

87 F.W.H. Myers, in *Proceedings of the Society for Psychical Research* 1/2 (1882): 147, in John Durham Peters, *Speaking into the Air: A History of the Idea of Communication* (Chicago: University of Chicago Press, 1999), p. 105.

88 The full title of Glanville's book is *Sadducismus triumphatus: or, Full and plain evidence concerning witches and apparitions. In two parts. The first treating of their possibility. The second of their real existence* (London: A. Bettesworth, J. Batley, W. Mears, and J. Hooke, 1726).

89 In the later nineteenth century the nervous system was often understood on the model of a telegraphy system—that is, it passed messages from the centre of the system to the extremities, and from the extremities to the centre, along nerve "cables." See Ernst Kapp, *Grundlinien einer Philosophie der Technik. Zur Entstehungsgeschichte der Cultur aus neuen Gesichtspunkten* (Braunschweig: Westermann, 1877). I am indebted to Cornelius Borck, "Electrotechnological Adventures in Psychodiagnosis in Weimar Germany," *Science in Context* 14, no. 4 (2001): 565–90.

90 For example, the exploration of long-distance telepathy conducted by the St. Petersburg physiologist Leonid Vasiliev (1891–1966). Vasiliev became one of the leading psychical researchers in the Soviet Union and a contributor to *Bessmertie* (Immortality), journal of the Petrograd Biocosmists-Immortalists, a group that proclaimed the immediate abolition of bondage to space and time and that supported investigations into hypnosis and mental suggestion conducted by the physiological psychologist Vladimir Bekhterev (1857–1927) at the Petrograd Institute for Brain Research. Bekhterev also worked with the animal trainer Vladimir Durov in exploring how to convey movement commands to trained dogs. "Research" programs similar to those of the Biocosmists extended beyond the Soviet Union: the Viennese physiologist Eugen Steinach (1861–1944) conducted experiments on the revitalization of organisms.

But there was a more orthodox basis for this type of research. Toward the end of the nineteenth century, the electrical activity of cortical neurons was an important subject of neurophysiological research. Interest in this continued well into the twentieth century, including the twentieth-century Soviet Union. The Ukrainian physiologist Vladimir Pravdich-Neminsky continued to investigate this field, recording the electrical activity of the exposed brains of various vertebrates. In 1925 he published an "electrocerebrogram" of the vertebrate's brain (Wladimir W. Prawdicz-Neminski, "Zur Kenntnis der elektrischen und der Innervationsvorgänge in den funktionellen Elementen und Geweben des tierischen Organismus. Electrocerebrogramm der Säugetiere," *Pflüger's Archiv* 209: 362–82. (I am again indebted to Cornelius Borck for this reference: "Electricity as a Medium of Psychic Life," *Science in Context* 14, no. 4 [2001]: 55n10.) If the brain is an electrical system, and if electrical systems can transmit thoughts, as radio can be thought to do, then why cannot brains? That question seemed to lie behind this research program.

The term "brain radio" has a wonderful resonance with Dziga Vertov's terms "radio ear" and "kino eye."

91 John Morley, *Death, Heaven, and the Victorians* (London: Studio Vista, 1971), p. 105.

92 James T. Knowles, "Wireless Telegraphy and 'Brain Waves,'" *Living Age* 222 (1899, July 8): 100–6 at 100, in Peters, *Speaking into the Air*, p. 106.

93 The electro-physiological sense of the term "brain waves" only came into existence in the 1930s.

94 Anon., "The Latest Marvel in Music," *Literary Digest* 95 (1927): 30, in Albert Glinsky, *Theremin: Ether Music and Epsionage* (Urbana: University of Illinois Press, 2000), p. 52.

95 V. Thomas Rhea, "Review of *The Art of the Theremin* [by Clara Rockmore]," *Computer Music Journal* 13, no. 1 (1989): 61–63.

96 Other pieces by Schillinger that had a part composed for theremin included *Melody* (1929) and *Mouvement électronique et pathétique* (1932).

97 Besides Paschencko, other composers wrote pieces for the theremin. They included Bohuslav Martinu (1890–1959), *Fantasia for Theremin, Oboe, Piano, and String Quartet* (1944); Edgar Varèse (1883–1965), *Ecuatorial* (1934) for solo baritone, four trumpets, four trombones, piano, organ, two fingerboard theremins, and percussion; Percy Grainger (1882–1961), that enthusiast for cosmic, impersonal music, who took to the instrument because of its potential to free him from the tyranny of pitch and equally divided durations, and who wrote *Free Music* for theremin and string quartet (c. 1936), *Free Music No.* 1 for four theremins (1935), and *Free Music No.* 2 for six theremins (1935–36); Nicolas Slonimsky (1894–1995), whose *Dream Scents* (1934) was based on a movement from *Silouettes ibériennes* (1928) for theremin and piano; and Anis Fuleihan (1901–1970), *Fantasy: Concerto for Theremin and Orchestra* (1945). Varèse had hoped to work with Theremin on developing the Russian's musical instrument and was devastated when Theremin returned to Russia in 1938—an exit he made accompanied by Soviet agents and around which has grown the legend that he had been kidnapped by the KGB, for whom he worked, though in fact he left precipitously (and under protection) because of bad debts.

98 Olivia Mattis, "Interview with Leon Theremin," published with Robert Moog as co-author in "Pulling Music Out of Thin Air," *Keyboard* (February 1992): 46–54 at 49.

99 In Krystyna Rubinger, ed., exhibition catalogue: *Kasimir Malewitsch: zum* 100 *Geburtstag* (Köln: Gallerie Gmurzynska, 1978), p. 47, in Roger Lipsey, *An Art of Our Own* (Boston: Shambhala, 1997), p. 159.

100 Alexander Rodchencko, "Slogans, Vkhutemas 1921," in David Elliott, ed., *Rodchenko and the Arts of Revolutionary Russia* (New York: Pantheon, 1979), p. 129.

101 A.V. Babichev, in Buchloh, "From Faktura to Factography," p. 54. The program of this working group (developed by Babichev) was to conduct experimental studies of "artistic elements" and their "organization" in different types of artistic works.

Though Rodchenko, Stepanova, and Popova associated with the working group at one time, the thrust of the group was to complement and to counterbalance the work of the Section on Monuments, which was headed by Kandinsky and in which Rodchenko, Stepanova, and Popova were active.

102 Eisenstein, *Selected Works, Volume 1*, p. 34. I discuss Fechner's work in a forthcoming book, *In the Destructive Element Immerse: The Cinema and the Dionysiac Avant-Garde in the Twentieth Century.*

103 Fechner's influence on Russian art of the early twentieth century may have been broader, for there was another dimension to his exploration of the continuity of the psychological and the physical: he studied threshold phenomena such as extremely faint shades of colour, which he took as straddling the border between the two realms. It is possible that these threshold experiences influenced the Russian *Zor-Ved* artist, Mikhail Matyushin, and his investigations of barely observable transformations of form by colour and of

colour by sound, which he seemed to treat as investigations into the unseen world that could be disclosed only by a form of attention equivalent to meditation.

104 To be sure, Fechner had preceded Ostwald in this, in works such as *Das Büchlein vom Leben nach dem Tod* (The Book of Life After Death; 1836); *Nanna, oder das Seelenleben der Planzen* (Nanna, or the Spiritual Life of Plants; 1848), Nanna being the Norse goddess of flowers; *Zend-Avesta, oder über die Dinge des Himmels und des Jenseits* (Zend-Avesta [the revelation of the word], or Concerning the Things of Heavens and the Time to Come; 1851), in which he argued that consciousness exists in all things, that our universal mother, the earth, is a being akin to us, but more perfect, and that the soul cannot die because all being is conscious; *Über die Seelenfrage* (On the Spiritual Questions; 1861), in which he exhorted the public, "Steh' auf!" (Get up! or, Rise from your beds!); and *Die drei Motive und Gründe des Glaubens* (The Three Motives and Bases for Belief; 1863).

105 German investigators' use of electrical tools for studying psychophysiology is discussed in a fascinating article by Cornelius Borck, "Electricity as a Medium of Psychic: Life Electrotechnological Adventures into Psychodiagnosis in Weimar Germany," *Science in Context* 14, no. 4 (2001): 565–90.

106 The renowned biographer Emil Ludwig celebrated Bissky's methods in a newspaper article published on March 6, 1926 (the same year Eisenstein released *Bronenosets Potyomkin*). In that article he compared diagnoscopy with Röntgen rays, suggesting that whereas Röntgen rays revealed the concrete entities in the body's interior, diagnoscopy revealed the abstract entities; *v.* "Die Durchleuchtung der Seele," *Berliner Illustrirte Zeitung* 34, no. 10 (1926): 299–306. Another article on diagnoscopy appeared in the *Berliner Börsenkurier* on May 5, 1926, titled "Radio-Illumination of the Soul."

107 The cyborg is an interesting notion, for it explicitly figures the body as a cultural product, part of a system of exchanges between technological and physiological development. That idea appealed to many Russian avant-garde artists, and Eisenstein would almost certainly have been familiar with it.

108 Fritz Giese, *Die Lehre von den Gedankenwellen* (The Science of Thought Waves) (Leipzig: Altmann, 1910); Robert Werner Schulte, "Experimental-psychologische Untersuchungen zur Prüfung der Kontroll bedingungen bei okkultischen Dunkelsitzungen" (Experimental Psychology Investigations Aimed at Verifying Occult Sciences Under Controlled Conditions), *Zeitschrift für Okkultismus* (Journal of Occult Sciences) 1 (1925–26): 248–62.

109 Berger's interests were related to Fechner's; Berger, however, was less interested in commercially exploiting his apparatus and more interested in the search for physiological correlates of psychic processes—in fact, in the general study of mental activity. In his view, the EEG testified to the material existence of psychic life.

110 Adolf Friedländer had also reported on Bissky's diagnoscopy. He published the first popular article on Berger's device, in the *Frankfurter Zeitung*, on October 29, 1929, just weeks after Berger's first report. A torrent of articles ensued. Of course, many predicted that soon one would be able to decode the content of thoughts recorded on the photographic paper.

111 One example of the association made explicit: In 1905, Roland Rood, writing in *Camera Work*, declared that "the position of pictorial photography from the philosophical standpoint is intensely interesting. One might say that it has entered the art-world as has radium the physical world; there is something decidedly uncanny about it, and we really don't know where we stand." Rood, "Has the Painter's Judgement of Photographs Any Value?" *Camera Work* 11 (1905): 42, in Dickran Tashjian, *Skyscraper Primitives: Dada and the American Avant-Garde* (Middleton: Wesleyan University Press, 1975), pp. 16–17.

112 Raoul Grimoin-Sanson described the apparatus in *Le Film de ma vie* (Paris: Henri de Parville, 1926).

Entertainments of the period became ever more realistic. The Paris morgue was a good example, for there bodies of crime victims were placed on display, ostensibly so that the public could identify the corpses but in fact for entertainment.

113 Mary Hillier, *Automata and Mechanical Toys: An Illustrated History* (London: Jupiter, 1976), p. 94.

114 Eisenstein, "Monsieur, madame et bébé," in *Selected Works, Volume IV*, pp. 487–507. Regarding the image of the return to the womb: the work of an alchemist—that is, identifying prime matter—is a metaphor for the alchemist's inner experience, which is often figured as a return to the womb, as relearning embryonic respiration; these experiences are preconditions for the reforming of the self. Uroboros also symbolizes coitus, and so, as the product of condensation, the idea that coitus is a return to the womb—a notion that Sándor Ferenczi propounded in *Talassa* (1924), a book that Eisenstein admired; it is also an image of nature's cyclic self-fertilization (Eisenstein planned to stage Siegmunde and Sieglinde's "coniunctio" under Yggadrisil by hanging a gigantic Uroboros figure over the proscenium). For Eisenstein used the symbol to stand, too, for the unity of opposites: the synthesis of female and male, of reason and passion, liquid and metal, spirit and matter, the lunar principle and the solar principle, Dionysian and Apollonian principles, the archaic principle that threatened/promised to return and displace the rational principle that history had evolved, natural being and civilized being: in short, the old and the new—Uroboros is the symbol of the reconciliation of opposites.

115 Here is more evidence of the links that existed in the early twentieth century among cinema, magic, X-rays, and electrical phenomena: the career of an early special-effects technician combined work in all these fields. Kenneth Joseph Strickfaden was born in Montana in 1896. He earned a masters in chemistry and physics. Later, he constructed electrical instruments for wireless communications, X-rays, tuned rotary gaps, and Tesla coils; he was also an expert photographer. After working during the late 1920s as a technician who kept electrical instruments in tune for various motion picture studios, he began assembling prop devices for mad scientist scenes in movies such as *Frankenstein* (1931), *Chandu the Magician* (1932), and *The Mask of Fu Manchu* (1932). In 1933 he took his gadgetry on tour in the "Kenstrick Space Age Science Show" and carved out a second career.

Chandu the Magician combines many of the themes we are exploring here in a (rather hackneyed) narrative form. Chandu, the protagonist, seems powerless against the evil antagonist Roxor despite possessing supernatural yogic abilities. Chandu's sweetheart Nadji is kidnapped. Chandu, meanwhile, is placed in a sarcophagus, about to be buried alive. However, Chandu escapes and mesmerizes Roxor while the death-ray mechanism whirs into life. The machine explodes, destroying Roxor's stone temple and all those within it. However, Chandu and Nadji escape harm, and end the film with a kiss before mysteriously disappearing before the assembled photographers can make any images of them.

116 There were also films that suggested cinema's power to make thought visible. For example, Emile Cohl's *Le Retapeur de Cervelle* (1910/Pathé) depicts a doctor looking into his patient's brain and seeing a collection of hideous and grotesque figures. This film includes an animated sequence.

117 Stanislaw Prybyszewski, *Homo Sapiens* (Moscow, 1905), in Yuri Tsivian, "Media Fantasies and Penetrating Vision," in Bowlt and Matich, *Laboratory of Dreams*, p. 87.

118 Iegudiil Khlamide (Maxim Gorky), "Mezhdu prochim" (By the Way), *Samarskaia Gazeta* 18 (January 23, 1896), in ibid., p. 92.

119 Annie Besant, "Ancient and Modern Science,"originally published in *Theosophical Review*, September 1900, later collected as Lecture 6 in *Evolution and Occultism: Essays and Addresses, Volume III* (London: Theosophical Publishing Society, 1913). The first passage cited, pp. 143–44; the second, 144–46. The quotation from Mme Blavatsky is from *The Secret Doctrine, Volume I*, pp. 272, 278.

120 Ernst Bloch, "Die Angst des Ingenieurs" (1929), *Gesamtausgabe, Volume IX* (Frankfurt am Main, 1985), p. 354; translated by Andrew Joron and others as "The Anxiety of the Engineer," in *Literary Essays* (Stanford: Stanford University Press, 1998), p. 310; quoted in an modified form in Stefan Andriopoulos, "Psychic Television," *Critical Inquiry* 31 (2005): 619. I have drawn the quotation from Andriopoulos.

121 Eugen Diesel, "Das Unheimliche des technischen Zeitalters" (The Uncanny of the Technical Age) *Zeitwende* (Turning Points) 5 (1929): 241, in S. Andriopoulos, "Psychic Television," *Critical Inquiry* 31 (Spring 2005): 619.

122 These quotes from Diesel all come from "Das Unheimliche des technischen Zeitalters" ("The Uncanny of the Technical Age"), pp. 239–43; I have taken them all from Stefan Andriopoulos, "Psychic Television," 619.

123 Alexander Belenson, *Kino Segodnia* (Moscow, 1925), p. 81, in Tsivian, "Media Fantasies and Penetrating Vision," p. 93.

124 *Metropolis* was a significant influence: Eisenstein visited the set where Lang was shooting it and saw the Eternal Gardens, that is, a giant glass dome inside which are specially bred fern-like plants, whose leaves drop close to made streams, fountains, and bridges and beautiful girls with painted faces.

125 Consider the huge Galerie des Machines, also constructed for the 1889 World Exposition, which employed the new industrial materials of metal and glass, thus exposing the unique engineering that allowed its massive size. Or again, consider the 1900 World Exposition in Paris and how its design encouraged the eye to wander: visitors could not only ascend the Eiffel Tower but also travel around on the continuously moving *trottoir roulant*—and the Lumières' cameras caught the mobile visions that each made possible.

126 To use Walter Benjamin's descriptors for the values that transparency might engender. V. Walter Benjamin, "Surrealism," in *Selected Writings, Volume II* (Cambridge, MA: Harvard University Press, 2003), p. 209.

127 The German poet Paul Scheerbart (1863–1915) published an extraordinary text, *Glasarchitektur* (Glass Architecture), trans. J. Palmes (New York: Praeger, 1972), in which he linked the concepts of utopia and transparency and suggested that transparency opens people to the play of cosmic forces. For Scheerbart, the new technologies of construction had strong links with that decade's metaphysical interests and spiritual values— and would help spiritual movements develop into potent creative forces. Glass, he realized, has much in common with light (and light is a traditional image of spiritual things).

128 Quite possibly, Eisenstein had a deeper understanding of human needs than the utopian architects. Two renowned twentieth-century architects, the extraordinary Mies van der Rohe and the more derivative Philip Johnson, designed glass houses: van der Rohe built Farnsworth House (1951) in Plano, Illinois, for a Chicago doctor; Johnson built the Glass House (1949) in New Canaan, Connecticut, for himself. Neither house was inhabited for long. The projects were utopian and were more about certain architectural ideals than about commodious living.

Glass houses have always resonated with utopian themes. In the summer of 1913, Bruno Taut met Scheerbart in a workshop for glass painting and mosaic. They became good friends, and the following summer they collaborated on the Glass House at the Cologne Werkbund Exhibition of 1914. Taut designed the building and organized its

construction, but Scheerbart's ideas and visions gave the design the form it assumed. Scheerbart's maxims were engraved on the facade: "COLOURED GLASS DESTROYS HATRED," "WITHOUT A GLASS PALACE LIFE IS A BURDEN." Scheerbart's couplet "Light seeks to penetrate the whole cosmos / And is alive in crystal" says much about the mystical context of the glass house.

129 This interest in the mobile camera was probably prompted by Eisenstein's visit to the set of *Metropolis*. For there he discussed the advantages of an "unchained" (i.e., mobile) camera with the cinematographers Karl Freund and Gunther Rittau, both of whom were past masters at camera movement.

130 In 1928, after the crises with making *Oktyabr*, Eisenstein altered his plans: he converted the mechanical eye into a human eye, giving the gift of vision to a poet. In this way he transformed his comedy of the eye into a "drama of enlightenment." Human relationships were opaque until the poet rendered them transparent, and whenever the poet made a relationship transparent, a murder or suicide occurred. In this way, vision became a dangerous activity.

The project changed again while he was in Hollywood. It became the story of a conflict among an aged architect, a mad poet (the architect's son), and a robot. The architect constructs the house for high-minded ideals; the crazed poet doubts the viability of that architect's model and, sharing his vision with others, dies; the robot, the ideal mechanized citizen of the new mechanized world, destroys the house. In the end the robot turns out to be the real architect and destroys his own work. In this way the Constructivist social ideal is dismantled, undone by the psychological drama of the Oedipal relation.

131 Eisenstein, "S. Eisenstein's Glass House," *Iskusstvo Kino* 3 (1979): 95–96, in Tsivian, "Media Fantasies and Penetrating Vision," p. 96.

132 Again, we see evidence that cinema stands for a way of knowing that brings traditional epistemological values into disrepute. Vision had been considered the loftiest of the senses and to stand for ideal, disembodied knowledge. Since the birth of cinema, that conception of knowledge has been dismissed.

133 Of course, the work dramatizes the power of the gaze that Michel Foucault has theorized. These panoptical ideas arose from a hyperbolization of the mechanized gaze. So long as Eisenstein focused on the mechanical gaze, the connection of the plot with cinema was clear. In time, however, he began to discuss another form of vision, the interior vision of the poet; this severed the film's link with "the new vision"—the plot became the story of the danger of the new vision and the value of inner illumination.

134 Eisenstein, "S. Eisenstein's Glass House," p. 107; Eisenstein's original was in English, as he was hoping an American producer might be interested in it. See Tsivian, "Media Fantasies and Penetrating Vision," p. 96.

I have argued that Russian Symbolism had a profound influence on Eisenstein's art. It is important to mention in this context the projects of Mikhail Artsybashev and Yevgeny Zamyatin. Artsybashev represented a phase in post-Symbolist/post-Decadent literature that conveyed Russian intellectuals' bourgeoning fascination with sex. Homosexual love, male and female, became a theme of Russian art after 1905. Mikhail Kuzmin published *Kryl'ia* (Wings), a novel defending pederasty, then Lydia Zinovieva-Annibal published *Tridsat' tri uroda* (Thirty-Three Abominations), about lesbian love. Months later, she published *Tragicheskii zverinets* (Tragic Menagerie), a book of stories depicting a pubescent girl's exploration of her body. Before long, an attitude of "tryn-trava" (What the hell? Who gives a damn?) developed, essentially an attitude grounded in the conviction that there are no moral values, so one might as well do what gives one pleasure. Artsybashev's avant-garde novel *Sanin* gave expression to precisely that attitude, with its heroes

encouraging Russians to indulge unreservedly in sexual pleasure; but, the novel shows, such pleasure leads only to despair, as women are left with all too heavy responsibilities and the men collapse into remorse and suicide.

Even so, Artsybashev had imagined a society in which sexual instinct alone would be what attracted men and women to each other. The dissident writer Yevgeny Zamyatin's futuristic novel *We* gave more precise form to that vision. Zamyatin was a naval engineer who established his reputation as a writer while working as a ship designer. However, he found himself at odds with the regime after the Bolsheviks seized power; twice he was arrested, and once he was ordered deported. Zamyatin wrote *We* in 1920–21, but it was not published until 1929—that led to his persecution, though he gave several public readings to considerable acclaim. In *We*, a "Single State" has emerged, in which workers live in glass houses and follow a Taylorist regime laid down in the Tables—they have numbers rather than names, wear identical uniforms, eat chemical foods, experience rationed sex, and participate in assignations (thus overcoming jealousy). They are ruled by a "Benefactor" who is re-elected over and over again. The parallels with Eisenstein's project for *Glass House* are extraordinary—and the novel was much discussed among Eisenstein's circle: Aleksei Gan planned a stage version of the novel, with costumes to be designed by Aleksandr Rodchenko. (Reproductions of Rodchenko's designs for The Singer, The Bourgeois, and The Policeman can be found in Plate 624 in Thomas Krens, ed., *The Great Utopia: The Russian and Soviet Avant-Garde, 1915–1932* [New York: Michael Govan, 1992]).

Zamyatin's *We* was inspired largely by the writer's experience of War Communism. War Communism was imposed by the Bolsheviks during the Civil War (1918–21). Its characteristic features were a forced egalitarianism and a near militaristic regimentation of life (justified by the fact that Russia was in a "state of siege"). Food and fuel were rationed, a curfew was imposed, and freedom of expression was severely restricted. By these means the Bolshevik Party-state consolidated its monopoly on most economic and political activities. Does the parallel with Eisenstein's work not suggest his despair over Party-state regulation? Even more remarkable are the traces of Fedorov's thought we can detect in the novel. One of the characters, D-503 (through whose eyes we experience much of what takes place), believes that happiness is possible only in the absence of freedom. He is a gifted mathematician whose work has made possible the Integral, the spaceship that will take the culture of One State to other worlds.

135 S. Eisenstein, "S. Eisenstein's Glass House," *Iskusstvo Kino*, no. 3 (1979), p. 107; passage quoted in Tsivian, "Media Fantasies and Penetrating Vision,"in John E. Bowlt and Olga Matich, eds., *op. cit.*, p. 96.

136 Eisenstein, "S. Eisenstein's Glass House," pp. 103–4, in Tsivian, "Media Fantasies and Penetrating Vision," p. 99.

137 Aleksandr Aleksandrovich Bogdanov (pseudonym of Malinovsky, 1873–1928) was a politician, philosopher, and doctor. In 1909 the Bolsheviks expelled him for his polemics against Lenin, who had attacked him rudely for his *empiriomonizm* (empirio monism). His reputation recovered somewhat during the October Revolution, for he was a theoretician and promoter of Proletkult. Shortly afterwards, he was again attacked by Lenin, and, after 1921 he devoted himself to medical research. He died after conducting a series of medical experiments on himself.

Lessons he gave to Proletkult in the spring of 1919 established some of the bases of the productivist strain of Constructivism, including these ideas: that the worker combines the figure of the organizer/executive with that of the maker; that labour should be considered creative and positive (thus the belief that the production of material goods

is equivalent to the production of artistic works); that work is the foundation of quotidian life (in other words, the life of the worker is entirely determined by his life in the factory); and that the machine is to be valorized as a collaborator with humans and thereby invested with a new technological beauty.

Bogdanov eventually developed a utopian, magical, theurigical variety of communism that was obsessed with the vital fluid. Committed to the belief that blood could resurrect the dead, he founded a Moscow institute for the transfusion of blood, and died during an an experiment in blood transfusion. Fedorov's influence on these ideas and activities is clear.

138 Fedorov's ideas have links to the Soviet commitment to space exploration. Among the greatest Cosmist scientists were K. Tsiolkovsky, the father of Russian aeronautics and cosmonautics, and Vladimir Vernadsky, a geochemist. Ziolkovsky examined, however tentatively, topics of UFOlogy and tried to construct devices for communicating with extraterrestial intelligences. He also founded "hylosoism," a discipline whose purpose was to reveal the innate intelligence of matter, and was an active participant in the Spiritualist Movement. He also had incessant visions of "objects from parallel worlds." His many unusual ideas, above all his belief that all matter is living—a proposition that Soviet science officially rejected in the Stalinist 1930s—created a deep bond between him and his students of aereonautics and cosmonautics. The Soviet hero Yuri Gagarin, the first man in space, during his orbit around to the earth, caused great scandal when he transmitted a symbolic salute to Nikolai Kostantinovich Rerikh, a painter, yogi, and Russian occultist, saying that the world looked just like Rerikh's paintings. Rerikh's works were forbidden to the Soviet public. At the time, he was living near the Himalayas, and was a Theosophist as well as a member of the AMORC Rosicrucian circle. He was also a student of yoga and close to the Cosmist sensibility. The scientists in charge of the Russian cosmonaut program were well aware of their Cosmist, eschatological, and mystical mission. Even today, in Gagarin's birthplace, the rumour circulates that he did not die, and many wait for his return (from a secret prison or a lunatic asylum where officials have locked up "enemies").

The geochemist Vernadsky is considered the greatest Soviet scientist: his ideas have exerted an influence on chemistry, engineering, philosophy, and, above all, atomic physics; his concept of the "nöosphere" relates to ideas expounded by contemporary ecologists, the disciple of Henri Bergson, Edouard LeRoy and, above all, the heretical Jesuit Teilhard de Chardin. More to the present point, Vernadsky shared with Fedorov dreams of the "Plan" and the Common Cause, fantasies of contacts to be made with extraterrestrial cosmic entities in the coming "age of the nöosphere." Like many other Cosmists, he died mad. Underneath Soviet Russia's official cloak of atheism and materialism, Cosmism was a secret motor of communist science: covert familiarity with heterodox disciplines such as parapsychology, tele-aesthesis, hypnotism, ufology, and so on, has always characterized the thought of many of students and intellectuals of the time. From the years of the Revolution until the Stalinist period and then (albeit in a less covert way) during the epoch between Khrushchev's thaw and Gorbachov's *perestroika*, Cosmism was inextricably linked to Soviet science.

139 Tsiolkovsky was the first to work out the mathematical calculations of spaceflight. He outlined in precise, mathematical terms precisely how, following Newton's Third Law, a reaction thrust motor could allow a rocket to escape the earth's gravitational field.

140 Discerning the shape of his thinking was made all the more difficult after 1923, when certain cults (whose teachings were essentially Gnostic) were banned. After that, those who were acquainted with Fedorov in his later years (he died in 1903) would be reluctant to divulge what they knew of his interest in this topic.

141 Some readers will be familiar with the question as it appears in another (troubling) context: the current actions of many on the Christian Right, who condemn the doctrine of universal salvation (basing that criticism on interpretations of the Crucifixion that offer only "limited" or "definite" atonement, atonement only for His people, the people of the so-called "Spiritual Israel"). They argue this point against those whom they accuse of Arminianism (after the Dutch theologian Jacobus Arminius), which teaches that Christ's atonement was for all. Of course, in this context, the repudiation of the principle of universal salvation is used in the service of proclaiming that those who do not agree with them (and, of course, they characterize themselves as following Christ's teaching) will be condemned to Hell.

142 Among those who were persuaded by Nikolai Fedorov's writings and teachings to adopt some version of Cosmism were Konstantin Tsiolkovsky (1857–1935), Vladimir Vernadsky (1863–1945), and Aleksandr Chizhevsky (1897–1964). Related Cosmist ideas can found in the writings of Vladimir Solovyov and Pavel Florensky (1882–1937).

Florensky was an extremely interesting thinker, of relevance to the themes we are dealing with here. We should treat his ideas at greater length, but space does not permit. Suffice it to say that the point of departure of Florensky's thought was a critique of rationalism (in somewhat the same vein as Solovyov's *Kritikaotvlechennykh nachal* [A Critique of Abstract Principles], 1877–80; though with a more pronounced tendency to separate himself from all European, i.e., primarily German, trends in philosophy). In *Stolp i utverzhdeniehe* (The Pillar and Ground of Truth), he criticizes the Enlightenment/positivist principle of self-evidence, arguing that it erroneously represents truth as external to the perceiver and devolves upon the tautology that each given is given simply as itself: in other words, "every A is an A" is the principle that underlies the positivist epistemology. This law of identity, "A is A," is the heart of Western rationalism. Florensky points out that from the raw given, the "there is," one cannot derive an "it must be so"— the metaphysics of theodicy, not logic, is required for that! Florensky also protested that the law of identity is a law of negation (presumably because each A must be defined through the not-A), of emptiness, of nothingness of death. This deleterious rationalism engenders what Florensky calls an "*epoche*" (Greek for "stoppage" or "suppression"); this epoche is a corrosive state of doubt, skepticism, *acedia*. It is a form of spiritual lassitude that cannot assent to any proposition until it has been demonstrated definitively; the contingent nature of the everyday world makes it impossible to demonstrate any proposition with certainty, so this spiritual state puts off forever epistemological and metaphysical commitments of all sorts.

In *Stolp i utverzhdenie istiny: Opyt pravoslavnoi Feoditsei v dvenadtsati pismakh* (The Pillar and Ground of the Truth: An Essay in Orthodox Theodicy in Twelve Latters, 1908 [published 1924]), Florensky proposed that to counter the lassitude, the acedia, of the *epoche*, people should learn to travel by touch and feel, to be guided not by skepticism but by instinct, so that the unity of whole would be revealed to them.

143 One might consider in this connection the extreme emphasis Eisenstein placed on the idea of the mass hero.

144 Stalin may have been influenced by Fedorov. Against the views of Trotsky, Bukharin, and Kamenev, Stalin proposed the preservation of Lenin's body. This resulted in a state cult: eventually, the bodies of Stalin, of Dimitrov, the head of the Bulgarian Communist Party, of Gottwald, the head of the Czech Communist Party, and in more recent times, of Ho Chi Minh and even of Neto, the head of the Angola Popular Republic, were all mummified in Lenin's Tomb. Were they being prepared for the universal resurrection of the dead?

145 Two extraordinary ideas—that the human body needed to be reconstructed to accommodate it to life in the cosmos, and that it should be refashioned with expanded capacities—were actually expressed by some early Soviet space scientists.

146 And even among his contemporaries, Matyushin garnered considerable respect: Malevich's 1913 portrait of Matyushin, done in the Cubo-Futurist idiom, is one of his greatest achievements.

147 Some of Matyushin's ideas are discussed in A. Povelikhina, "Matiushin's Spatial System," *The Structurist* 15/16 (1975–76): 64–70.

148 Thus, Matyushin's *Colour Handbook* is illustrated with thirty colour charts, each of which shows a combination of three different colours. In that work the interconnections among colours are primary, not the perception of a colour in isolation.

149 M. Matyushin, "Ne iskusstvo a zhizn" (Not Art But Life), *Zhizn' iskusstva* 20 (1923): 15; in translated form in Christina Lodder, *Russian Constructivism* (New Haven: Yale University Press, 1983), p. 206.

150 Kazimir Malevich was fascinated by the historicity of vision. For him, vision was the product not simply of biology, but also of culture, and for him, abstraction was a further evolution of vision—one that, because it eschews the image, can disclose metaphysical reality. This new vision is certainly not the product of the metallic culture—of the gramophone, radio, or film—for that metallic culture distances us from organic life.

The Cine-Eye that Vertov celebrated was no less historical, Malevich believed: the mechanical eye of the camera was informed by a set of historical assumptions. Thus the camera eye imitated Monet's eye, or Shishkin's eye, or Rubens's eye; the camera only represented phenomena previously seen. A new system of vision would not be the result of a new technical apparatus, which could only model a pre-existing vision. The new vision would instead be the product of the evolution of visual culture, of a new society's striving to free itself from old symbols, from old designs, from an old body language. Nothing less than a new vision would be needed by the new society.

151 While I was working on this manuscript, I had two Russian-speaking research assistants on my film/electrical engineering research project, Anna Joukova and Alla Gadassik. I often appealed to one or the other when I needed help with the complexities of the Russian language and in tracking Russian sources. I asked Alla to help me with the title of this document, and she responded with a note that the Russian term for painting oneself suggests expending effort to remake oneself through recolouring and decorating one's form.

152 Kulbin was also the author of an extraordinary manifesto, "Free Music," in *Studiya Impressionistov* (Studio of Impressionists) (St. Petersburg: Butkovskaya, 1910), which includes this ringing declaration that relates biology and Cosmism with musical freedom: "People are organs of a living earth ... and the cells of its body. The symphony of the cosmic concert is the music of nature—the natural 'free music.' If you pay attention to this art and laws of its development, everybody knows that the noises of the sea, wind, thunderstorm, makes a symphony as well as the music of birds ... but right now, people exploit the music of nature according to the old laws ... If they were paying more attention, they would be enlightened more ... It would turn out that water, air and birds, don't sing according to our notes, but using all the notes that they find pleasure in ... and with that, the laws of the natural music are observed exactly."

153 But the idea that consciousness can act on consciousness is also found in Rosicrucianism, which maintains that the invisible bodies of man can be acted upon by Will.

154 Sergei Eisenstein, "Perspektivy," *Iskusstvo* 1/2 (1929): 116–22; the passages cited are from a translation by Jay Leyda—"Perspectives," in Eisenstein, *Selected Works, Volume I*, p. 158.

155 Antonin Artaud, "Cinema and Reality," in S. Sontag, ed., *Antonin Artaud: Selected Writings* (Berkeley: University of California Press, 1976), pp. 151–52.

156 Cesare Zavattini, "A Thesis on Neo-Realism," in *Springtime in Italy: A Reader on Neo-Realism*, ed. D. Overbey (Hamden: Archon, 1978), p. 69.

157 Robert Bresson, *Notes on Cinematography*, trans. J. Griffin (New York: Urizen, 1977), pp. 5/15, 5/16, 5/18, 11/28, 33/71.

158 G.-Albert Aurier, "Symbolism in Painting: Paul Gauguin," in Herschel B. Chipp, *Theories of Modern Art: A Source Book by Artists and Critic* (Berkeley: University of California Press, 1968), p. 90.

159 An evaluator of an earlier version of this manuscript criticized my linking Mallarmé and parataxis and objected to my claim that Mallarmé's writings make use of parataxis. So I thought it might be useful to offer support for the connection. My reading of Mallarmé receives excellent support in Andrew Elbon, "Digression in Mallarmé," *SubStance 89* 28, no. 2 (1999): 74–94. Again, Malcolm Bowie, writing on the renowned *Un Coup de dés*, notes that the multiply construable individual units within the poem "exert upon each other an associative pull strong enough to cancel the intricate syntactic patterning which holds them apart; in so doing they become a mosaic of reciprocally explaining fragments, a counter–syntax, a refusal of hierarchy." That mosaic is the very essence of parataxis (Bowie, "The Question of *Un Coup de Dés*," in Malcom Bowie, Alison Fairlie, and Alison Finch, eds., *Baudelaire, Mallarmé, Valéry: New Essays in Honour of Lloyd Austin*, [Cambridge: Cambridge University Press, 1982], pp. 142–50 at 145). The brilliant Brazilian poet Augusto de Campos, speaking of the reason why Mallarmé was a central figure in the constellation of influences that revived avant-garde poetry in Brazil (for the first time since the "Generation of 45") refers to *Un coup de dés's* use of paranomasia, which he defines as related to parataxis: "breaking physically with the linear structure of discourse, including the imagination to organize itself by juxtaposition and coordination [parataxis] rather than by subordination [hypotaxis], and permitting a multiplicity of readings and points of view through the exploration of graphic resources." He cites Pignatari from the "The Illusion of Contiguity": "Pignatari develops the conceit of paronomasia or paramorphism, linking it to the notions of parataxis, spatiality, and verticality, and referring it to rhyme as well." He then quotes Pignatari: "Paronomasia breaks discourse [hypotaxis], turning it spatial [parataxis], creating a non-linear syntax, an analogical-topological syntax." He continues to cite approvingly Pignatari's example of masterful parataxis: "Rhyme is vertical paronomasia at its most common. Mallarmé's *Un Coup de Dés* and later concrete poems work with audiovisual, horizontal, and vertical paronomasias." V. Roland Green, "From Dante to the Post-Concrete: An Interview with Augusto de Campos," *Harvard Library Bulletin* 3, no. 2 (1992): 19–35. The source for the quotations from Pignataria is Décio Pignatari, "A Ilusão da Contigüidade," *Atraves* 1 (1976): 36, though, since I do not have Portuguese, I have taken them from the interview with Campos published in *Harvard Library Bulletin*. There is a brilliant poet citing a brilliant critic, making the same point for which I was so roundly criticized. No less a critic Louis Armand concurs: "Arguably, typographical concretion had first entered the avant-garde vocabulary with the publication of Stephane Mallarme's *Un Coup de Dés* in 1897. Its 'simultaneous vision of the page,' locating it somewhere between poetry and drawing, provides yet another context for reading Joyce's 'sketchbook.' The physical juxtaposition of text-objects, like the radical forms of catachresis and parataxis described by Lautreamont, suggest spatio-temporal relations beyond forms of narrative continuity which previously characterised Joyce's work." Louis Armand, in "Introduction: Through a Glass Darkly: Reflections on the Other Joyce," in

Clare Wallace and Louis Armand, eds., *Giacomo Joyce: Envoyes of the Other*, 2nd ed. with new introduction (London: Faber & Faber, 2006). I could go on.

160 Eisenstein, "Laocoön," in *Selected Works, Volume 11: Towards a Theory of Montage*, ed. M. Glenny and R. Taylor (London: British Film Institute), p. 164.

161 Ibid., p. 130.

162 Ibid.

163 Ibid.

164 Pavel Florensky, *Analiz prostanstvennosi i vremeni v khudozhestvenno-izobrazitel'nykh proizvedeniiakh* (Moscow: Progress, 1993), p. 267, in Nicoletta Misler, "Towards an Exact Aesthetics," in Bowlt and Matich, *Laboratory of Dreams*, p. 128.

165 Eisenstein, "Laocoön," pp. 135–36.

166 Ibid., pp. 135–36.

167 Ibid., p. 137.

168 Ibid., p. 136.

169 Eisenstein, "On Colour," in *Selected Works, Volume 11*, pp. 262–63.

170 As Pavel Florensky pointed out, the integrated work of art, embodied in both the opera and the circus, has parallels with another significant form in the lives of many Russians—that is, the Orthodox mass.

171 Among other goals, the Film und Foto exhibition was constructed to present the films of the European avant-garde. Eisenstein was supposed to present a reel of excerpts from various Soviet films, including films by Vertov. Vertov was initially commissioned to write the catalogue text representing the Soviet filmmakers, but the demands of completing *Chelovek S Kinoapparatom* (Man with a Movie Camera) required that he decline the offer. The exhibition largely concerned the advent of a new sort of vision—"a new, tenser and more constructive way of seeing"; this was one of Vertov's great themes, and Franz Roh and Jan Tschichold's catalogue for exhibition, *Foto-Auge: 76 Fotos der Zeit* (Photo-Eye: 76 Photos of Time; even the title is Vertovian), inventoried the ways that the camera could serve as technological prothesis for vision, expanding the capacities of the unaided eye. The techniques surveyed all recall Vertov's techniques: motion frozen by the camera; unusual vantage points (from extremely high or low angles); extreme close-ups; telescopic views; and the reversal of tones (by printing positive to negative). In the end, Eisenstein's essay did not appear in the catalogue, for it arrived too late in Stuttgart. It was first published, in English (trans. Ivor Montagu), in *Close up* 8 (September 1931): 167–81.

172 Eisenstein, "The Dramaturgy of Film Form," in *Selected Works, Volume 1*, p. 164.

173 Eisenstein seizes on the dialectics of the labour theory of value to offer a response to the critique that Malevich had advanced in "And Visages Are Victorious on the Screen." Eisenstein seems to recognize that his theory of transformation (based on Marx's theory of labour) is congruent with Malevich's theory of the additional element. Yet Malevich failed to balance the opposing elements of the artistic dialectic—that is, the dialectic between the organic natural and the idea (reason, the concept) as a principle of transformation. When the principle of transformation is too rational, when the teleological principle hypertrophies, art becomes a mathematical technicality—a landscape becomes a topographical map, and a St. Sebastian becomes an anatomical atlas. On the other hand, if the organic natural hypertrophies, art diffuses into formlessness. The latter is what happened with Malevich, as the Russian painter became a Wilhelm von Kaulbach (a court painter to Ludwig I of Bavaria), producing works that have slid into formlessness.

174 I am being too categorical in the reference to Ouspensky and Plotinus. Ouspensky, a very lively writer, maintained the Theosophical (and more generally heterodox) belief that

mystical tradition had been passed from Hermes Trimegistus through Pythagorus, and had survived underground during the times when the teachings of first the Roman Catholic Church and later empirical science held sway. Alchemy, magic, astrology, and the Kabala all represented fragments of this hidden tradition that had its origins in the library of Alexandria. Indeed, Ouspensky took an interest in tarot cards, which, he suggested, had been in that library and which served as a kind of philosophical machine, a philosophical "abacus." (Readers might recall that Leibniz, too, had proposed the possibility of a reckoning machine, as well as the idea that all philosophical problems might be reduced to problems in calculation. One might note, too, that Leibniz was a Rosicrucian.)

175　One must acknowledge that the idea of a unity, the discord between the elements of which constitutes only one aspect (another of which is the negation of the negation), has a Hegelian provenance. That this is so does not, however, provide grounds to refute the assertion that Eisenstein's idea of the "total image" (and more generally his conception of the relation between the representable elements incorporated into an unrepresentable whole and that unrepresentable whole itself) has affinity with occult ideas that circulated widely amongst Eisenstein's colleagues and their immediate predecessors. I have already pointed out that one of the results of the enthusiasm for things occult in the last decade of the nineteenth century and the first decade of the twentieth was to disseminate watered-down versions of some of the leading ideas of Hegel's metaphysics. Eisenstein likely realized this, and since his situation required him to be circumspect if he was to maintain access to film funds, he would certainly have preferred to support the ideas he was expounding with quotations from Hegel rather than with quotations from Gurdjieff and Ouspensky.

　　In fact, in 1913 the painter and composer Mikhail Matyushin drew on Ouspensky's idea of the fourth dimension in his translation of Gleizes and Metzinger's *Du cubisme*; the idea of higher dimensions was also a favourite of Malevich, whose interest in Gurdjieff and Ouspensky's writings has already been noted.

176　Eisenstein, "The Fourth Dimension in Cinema," in *Selected Works, Volume I*, pp. 182–83.

177　At this point in Eisenstein's development, "reflex effect" denoted something physiological, not something conditioned.

178　Ibid., p. 183; italics in original.

179　Ibid., p. 184.

180　Ibid., p. 185.

181　Another set of ideas about the fourth dimension was offered by Claude Bragdon, the English translator, together with the Russian Nicholas Bessaraboff, of Ouspensky's *Tertium Organum* (which translation he published through his own Rochester-based Manas Press). In *Primer of Higher Space* (1913), and later in *The New Image* (1928) and *The Frozen Fountain: Being Essays on Architecture and the Art of Design in Space* (1932), Bragdon offered a view of the fourth dimension that can also be found in Ouspensky's writings. According to Bragdon, motion and time in the three-dimensional world are merely inadequate ways of understanding the constitution of timeless and motionless four-dimensional reality (phenomenal representations of a very different noumenal reality, to use a language closer to that which Eisenstein would subsequently use)—just as the experience of a sphere descending in Abbott's *Flatland: A Romance in Many Dimensions* (1884) was the experience of a point growing into widening circles that after a while begin to shrink, and disappear after they have shrunk to a point. Thus Bragdon could assert that time does not flow any more than space flows—time is simply a measure of space, just as length, breadth, and thickness are. For Bragdon—who also held that everything in this

world, including colours, has its counterpart in a specific form on another plane—this made his ideas attractive to people interested in visual music. He held that the astral plane existed in the fourth dimension.

Ouspensky was familiar with Bragdon's ideas; in 1914, in St. Petersburg, he had obtained a copy of Bragdon's 1912 Christian parable *Man the Square: A Higher Space Parable*. Ouspensky later recalled the book as one that carried a message of a common thought and a common understanding with his own work.

182 Matyushin's archive in Pushkin House includes a manuscript from 1912–13 titled "The Sensation of the Fourth Dimension." Alla Povilikhina published an article on Matyushin's hypergeometry, "Matyushin's Spatial System," in *Structurist* 15/16 (1975–76).

183 This information appears in Vladimir Kruglov, "Die Epoche des großen Spiritismus— symbolistische Tendenzen in der frühen russischen Avantgarde," in Hellmut Seemann, ed., *Okkultismus und Avantgarde: Von Munch bis Mondrian, 1900–1915* (Frankfurt: Schirn Kunsthalle, 1995), p. 184. No references are given for the original articles.

184 Ouspensky, *Tertium Organum: The Third Canon of Thought: A Key to the Enigmas of the World*, trans. N. Besseraboff and C. Bragdon, intro. C. Bragdon, 2nd US ed. (New York: Knopf, 1927), pp. 36–37. This conception of the fourth dimension was precisely the conception that Marcel Duchamp relied on when he created *The Large Glass*. The notes collected in *À l'infinitif* (White Box) reveal that the three-dimensional Bride is the shadow or projection of a four-dimensional Bride (whereas the Bachelor Machine belongs to the three-dimensional realm ruled by perspective and gravity).

185 Nicolai Berdyaev, "Objectification," in James M. Edie, James P. Scanlan, and Mary-Barbara Zeldin, eds., with the collaboration of George L. Kline, *Russian Philosophy, Volume III* (Knoxville: University of Tennessee Press, 1976), p. 193. On the matter of Berdyaev's Kantian affinities, it is interesting that Eisenstein brushes up against Kantian aesthetics, as expounded by the Marburg neo-Kantian Hermann Cohen, in "Unity in the Image," an essay that again treats the topic of the sort of unity that belongs to a higher order than the elements of which it is formed. Of course, one way to interpret this unity is to say that it is forged by the activity of the mind and belongs to the phenomenal realm. This is probably the most level-headed way to understand it, but it opens the way to conceiving that these "transcendent unities" are subjective and ideal; and Eisenstein understandably takes proleptic action to preclude the possibility of being accused of Idealism (or even Transcendental Idealism). Accordingly in that essay, he goes to great lengths to defend himself against the threat of being labelled a Kantian, and avows that he fundamentally disagrees "in principle with the concepts of this follower of Kant" and that "the author's very premises, in their subsequent development, are taken to conclusions which for us are entirely unacceptable." Eisenstein, "Unity in the Image," in *Selected Works, Volume II*, p. 268n. Indeed, it is all the more understandable given that Cohen's example concerned the simile of the sun as "a bridegroom coming out of his chamber and rejoicing as a strong man to run a race" (Psalm 19:5).

The principle that Cohen expounds in the passage from *Ästhetik des reinen Gefühls* (Berlin, 1912), from which Eisenstein quoted is central to Eisenstein's thought, viz., "the metamorphosis of identity into image." Cohen states (in Eisenstein, "Unity in the Image," *Selected Works, Volume II*, p. 269):

> We now understand the power of the *comparative particle*. It is not only a copula of superior degree, but at the same time an *entity* of extended degree. It establishes a new, unique association of units, which exist not only in semantic units but in their subjective links with *the emotions associated with denotative words*... [Ellipses in Eisenstein's citation.]

The *denotative words* in poetry are at the same time words that connote emotion; sentences made from them are also emotive sentences. If we may perceive the *comparative particle* as an entity of extended degree, we must pursue this quality further still, in order to explain systematically how it is that through comparison poetry not only acquires its aesthetic uniqueness but *thereby becomes the common, fundamental linguistic element of all the arts* which make use of the device of *comparison*.

To be sure, this is just another way of formulating the transformative principle that is the heart of Eisenstein's aesthetics.

One wonders at Eisenstein's proleptic talents (or his will, or whatever it was that failed him here), for he uses the next example to set out his notion of a higher unity emerging from two concrete representations. That example is stereoscopy—i.e., the superposition of a pair of binocular images. He compares this with a higher form of unity, motion as it emerges from the successive presentation of static frames presented sufficiently rapidly that they superimpose on the retina. In the former, two images are slightly separated spatially, in the other, temporally. However, he then goes on to discuss what would happen if the two images were not binocular, but images of two different things. This carries him right into the domain of the Gestalt psychology of Wölfgang Kohler and his colleagues—that is to say, the psychological theory of the neo-Kantians. In this way he reveals how similar his conception of unity is to that of the neo-Kantians.

186 Ouspensky, *Tertium Organum*, pp. 78–79.

187 Eisenstein, "The Fourth Dimension in Cinema," p. 185.

188 Ouspensky, *Tertium Organum*, p. 32. The polemical background to Eisenstein's article may help explain these occult references. In this article, he responds (in passing) to the critique that Malevich had offered in "And Visages Are Victorious on the Screen." Malevich, of course, was interested in Gurdjieff and Ouspensky, so Eisenstein could be responding to Malevich in his own terms; Malevich, he proposes, does not really understand dynamics in the cinema, so he has no access to the filmic fourth dimension.

189 Nikolai Lobachevsky, *On the Principles of Geometry, Volume 1*, pp. 192–96, in B.A. Rosenfeld, *A History of Non-Euclidean Geometry: Evolution of the Concept of Geometric Space* (New York: Springer Verlag, 1988), pp. 206–12. Ouspensky discusses Lobachevsky's geometry at several points in *Tertium Organum*, including, notably, at pp. 75–77.

190 An odd pursuit in which I confess to have engaged, but I am not alone among filmmakers in having done so: as Don McWilliams's documentary on Norman McLaren proves that filmmaker did as well. But McLaren was also deeply concerned over an issue that preoccupied alike Eisenstein and such avowed cinema occultists as Fischinger, that of audiovisual synthesis.

191 Charles Hinton's books include *What Is the Fourth Dimension?* (1884), *A Plane World* (1884), *A Picture of Our Universe* (1884), *Many Dimensions* (1885), *An Unfinished Communication* (1885), *A New Era of Thought* (1888), *The Fourth Dimension* (1904), *The Recognition of the Fourth Dimension* (1902), and *An Episode of Flatland* (1907).

192 Johann Zöllner, *Transcendentale Physik* (Transcendental Physics), Vol. 3 of *Wissenschaftliche Abhandlungen*, trans. Charles D. Massey (Boston: Colby & Rich, 1879), 147–48.

193 Albert Gleizes and Jean Metzinger, "Du Cubisme," in Harrison and Wood, eds., *Art in Theory, 1900–1990*. (Oxford: Blackwell, 1992), p. 190.

194 We can admit this much of the claim. El Lissitzky expressed Productivist sympathies in his important essay, "Preodolenie iskusstva" (Overcoming Art, 1921), *Experiment* 5 (1999). His famous *El Lissitzky: Der Konstrukteur. Selbstbildnis* (The Constructor, Self-Portrait) of 1924 might seem, prima facie, to be a celebration of Constructivist Productivism.

However, elsewhere in this book I have pointed out the lingering influence that UNO-VIS and its spiritual ideals exerted on him and the distress that he expressed at the re-duction of Constructivism to Productivism and at Productivists' proposal that artists become engineers and compasses to produce technical drawings. Regarding the fa-mous self-portrait, most readers will have noted the similarity to works concerning the Creation by Michelangelo and Blake. Lissitzky's mystical leanings were recognized—as early as 1928, Traugott Schalcher noted: "Lissitzky is not really very Russian at all, but more of a modern Pan-European. His self-portrait bears this out. The hand that proj-ects from the brain between his eyes and forehead is that of an intellectual. The hand is holding a pair of compasses. In the top left hand corner are the letters XYZ. The Y is intersected by the thin arc of a circle. The background consists of a sheet of paper with a pattern of squares drawn on it. The pattern extends over the face, too. The forehead and cheeks are covered with thin vertical and horizontal lines. Or is it that the lines have spread from the face onto the paper? Whichever it is, we can see, on and around the face with its fascinating eyes and pointed nose, squares, rectangles and a triangle even, thrown into relief by half-tone shading. XYZ—for the artist the Last Things are no more than three letters of the alphabet [is this a reference to gematria?], and dispassion-ately he draws the circle of his experience through the middle of them. The character of this portrait is one of cool and calculating reflection bound up with geometrical mysticism." Schalcher, "El Lissitzky, Moskau," *Gebrauchsgrafik* 5, no. 12 (1928), in So-phie Lissitzky-Küppers, *El Lissitzky: Life, Letters, Texts* (London: Thames and Hudson, 1968), p. 382. Ann Dickerman does a nice job of showing that his famous self-portait is as much about irrationality as about rationality, and as much about embodiment as about technology (v. "El Lissitzky's Camera Corpus," in Nancy Perloff and Brian Reed, *Situating El Lissitzky: Vitebsk, Berlin, Moscow* [Los Angeles: Getty Research Institute, 2003], pp. 153–76).

195 Lissitzky, "A. and Pangeometry" ("A." is his standard abbreviation for "art"), originally published in German in Carl Einstein and Paul Westheim, eds., *Europa Almanach* (Pots-dam: 1925) and included in Harrison and Wood, *Art in Theory*, p. 304.

196 Ibid., p. 303.

197 Ibid., p. 305.

198 Eisenstein, "Laocoön," pp. 134–35.

199 To be sure, Eisenstein's Romantic proclivities, and his formidable theoretical intelli-gence—which ensured that these proclivities expressed themselves in a profound under-standing of the key themes of the Romantic tradition—meant that discovering the unity of the subjective and objective realms held a signal importance for him. Marxism, of course, understood this unity in a particular way, that is, in a cogent but ultimately too restricted manner: it explained consciousness as a reflection of material reality. That was one of the appeals of Marx and Engels' thought, but Eisenstein must have come to understand that that view leaves much out of account. His investigations of the phenom-enon he called "ekstaz" served partly to complete what was missing.

200 Ibid., p. 136.

201 Eisenstein, "Museum at Night," in *Immoral Memories*, trans. H. Marshall (Boston: Houghton Mifflin, 1983), p. 173.

202 Ibid., p. 180.

203 Eisenstein, "Imitation as Mastery," in Ian Christie and Richard Taylor, eds., *Eisenstein Rediscovered* (London: Routledge, 1993), pp. 66–68. In September 1929 a group of pro-gressive filmmakers and film enthusiasts (including Walther Ruttmann, Enrico Pram-polini, Hans Richter, Béla Balázs, Léon Moussinac, Ivor Montagu, and Alberto Caval-

canti) gathered at the Swiss château of La Sarraz, where just the year before a group of twenty-eight European architects organized by Le Corbusier, Hélène de Mandrot, owner of the castle, and Sigfried Giedion (the first secretary-general), and including Karl Moser, first president, Victor Bourgeois, Pierre Chareau, Josef Frank, Gabriel Guevrekian, Max Ernst Haefeli, Hugo Häring, A. Höchel, Huib Hoste, Le Corbusier's cousin Pierre Jeanneret, André Lurçat, Ernst May, A.G. Mercadal, Hannes Meyer, Werner Max Moser, Carlo Enrico Rava, Gerrit Rietveld, Alberto Sartoris, Hans Schmidt, Mart Stam, Rudolf Steiger, Henri-Robert Von der Mühll, and Juan de Zavala, founded the Congres Internationaux d'Architecture Moderne (CIAM, 1928–59), to defend the avant-garde architectural values that were still under attack in Europe and to serve as the think tank of the Modern Movement, or International Style, in architecture. The filmmakers' meeting, the Premier Congrès international du cinéma indépendant (CICI) was convened to discuss new trends in cinema. What was discussed at that meeting of remarkable film people has intrigued scholars, who know the roster of participants partly from the handbills for the meeting (they are reproduced in Ulrich Gregor's remarkable anthology, *Stationen der Moderne im Filme II: Texte, Manifeste Pamphlete* [Berlin: Freude der deutschen Kinemathek, 1989], p. 200) but more from the amusing still photographs that remain of the meeting. (Gregor devotes an entire section of his anthology, pages 199 to 219, to the first CICI.) They have been intrigued, too, by the film that Eisenstein made on the occasion of the congress, with Hans Richter and Walther Ruttmann as actors; but that film, *La Guerre entre le film indépendant et le film industriel—Tempête sur La Sarraz*, is lost.

It seems that understanding what went on at that meeting must be limited to conjecture, since there is no record of the discussions that took place there. However, forty years after Eisenstein's death, the indefatigable Eisenstein scholar and archivist Naum Kleiman discovered two sets of notes in *Tzentral'nyi gosudarstvennyi archiv literatury is'russtva SSSR* (Central State Archive of Literature and Art of the USSR, TsGALI) for Eisenstein's address to this conference. Kleiman combined the two sets into one text, which he published as "Imitation as Mastery" (Ian Christie and Richard Taylor, eds., *Eisenstein Rediscovered* [London: Routledge, 1993], pp. 66–71).

204 Ibid., p. 70.

205 Ibid., pp. 70–71.

206 Nicolai Berdyaev, "Existentialism" (from *Solitude and Society*), in Edie et al., *Russian Philosophy, Volume III*, p. 182.

207 Eisenstein, "Laocoön," pp. 163–64. In reading this, one thinks about Aleksandr Potebnia's ideas about images and language discussed above and about his maxim that art is thinking in images (ideas discussed below).

208 There is certainly a troubling antiwoman bias to this, for the suggestion here is that a corrupt effeminate regime would be invaded and set aright by assault from the masculine principle.

209 Tsivian, "Eisenstein and Russian Symbolist Culture: An Unknown Script of *October*," in Christie and Taylor, *Eisenstein Rediscovered*, pp. 91–92.

210 Ibid., pp. 164–65.

211 Osip Brik, Viktor Pertsov, and Viktor Shklovsky, "Ring Lefa: Tovarishchi! Sshibaites' mneniyami!" (The *Lef* Ring: Comrades! A Clash of Views!), *Novy Lef* 4 (1928), reprinted in Taylor, trans., Taylor and Christie, eds., *The Film Factory: Russian and Soviet Cinema Documents* (Cambridge, MA: Harvard University Press, 1988), p. 230.

212 Mikhail Iampolsky, "Mimesis in Eisenstein," in Christie and Taylor, *Eisenstein Rediscovered*, p. 178. He makes a similar point in *The Memory of Tiresias: Intextuality and Film*, p. 225.

213 At other times, it was a mimetic gesture that captured the dynamic movement of some-
thing resembling Schopenhauer's Will. This explains Eisenstein's famous comparison
of learning to draw with learning to dance, and his claim that drawing and dance are
fruits of the same loin, two different embodiments of the same impulse (*v.* Eisenstein,
"How I Learned to Draw (A Chapter about My Dancing Lessons)," in *Selected Works,
Volume IV*, pp. 567–91.

214 Eisenstein must have felt an affinity with those who proposed that there is a very con-
crete connection between gesture and thought: he underlined the following passage in
Jack Lindsay's *A Short History of Culture*: "Out of the harmoniously adopted move-
ments of the body are mental patterns evolved." This information comes from Iampol-
sky, "Mimesis in Eisenstein," p. 178.

215 Petr Bogatyrev's *Magical Acts, Rites, and Beliefs of Subcarpathian Rus* (originally pub-
lished in Paris in 1929 as *Actes Magiques, rites et croyances en Russie subcarpathique*, and
first published in English by Columbia University Press as *Vampires in the Carpathians:
Magical Acts, Rites, and Beliefs in Subcarpathian Rus'*) is a momument in cultural the-
ory/cultural studies. The isolation of the Subcarpathian Rus, who lived in remote moun-
tain villages, allowed for the survival of traditional folklore and for the perpetuation of
magical practices that elsewhere modernity had overcome.

216 Eisenstein, *Eisenstein on Disney*, trans. A. Upchurch, ed. J. Leyda (London: Methuen, 1988),
p. 23.

217 Eisenstein, "Imitation as Mastery," in Christie and Taylor, *Eisenstein Rediscovered*, p. 69.

218 On this, it is worth noting that in "Imitation as Mastery," Eisenstein described Jehovah
as "the tyrannical demi-urge of the Bible" Christie and Taylor, *Eisenstein Rediscovered*,
p. 67. It is perhaps too slight a reference to hang much on, but Gnostic groups often
represent the Creator God of the Bible as a second God, a tyrannical demiurge.

219 We have seen that the introduction of the poet into the script for *The Glass House* in-
jected into the film project precisely the contrast between those two sorts of vision—and
may have doomed the film.

220 Ralph Waldo Emerson, "Nature," in C. Bode with M. Cowley, eds., *The Portable Emer-
son* (London: Penguin, 1981), pp. 21–22. I have delineated an Emersonian strain in Amer-
ican avant-garde art in *The Films of Stan Brakhage in the American Tradition of Ezra
Pound, Gertrude Stein, and Charles Olson* (Waterloo: Wilfrid Laurier University Press,
1998).

221 Emerson, "The Poet," in *The Portable Emerson*, pp. 252–53. The influence of Goethe's *Die
Metamorphose der Pflanzen* will be clear to all.

222 Ibid., pp. 251–52.

223 Emerson, "Nature," pp. 22–23.

224 Emerson, "Swedenborg; or, The Mystic," in *English Traits, Representative Men, and
Other Essays* (London: Dent, 1910), pp. 212–13.

225 Iampolski, "The Invisible Text as Universal Equivalence: Sergei Eisenstein," in *The Mem-
ory of Tiresias*, pp. 221–43.

226 The great American filmmaker Stan Brakhage has also concerned himself with protolog-
ical and preverbal thinking, which he calls "moving visual thinking" (in my view, not the
best handle for his conception). His remarks on moving visual thinking bear compari-
son with Eisenstein's commentary on imitation (or mimesis). Moreover, his painted
films make it clear that a pan-graphism of the sort that Iampolsky attributes to Eisen-
stein also plays an active role in Brakhage's understanding of that mode of apprehension.
It is interesting that Andrew Lang played an important role in the formulation of
Brakhage's ideas on protological perception too. In Brakhage's case, however, it was

Lang's commentary on hypnagogic imagery that was important, whereas in Eisenstein's case it was Lang's ideas on archaic forms of representation.

227 A key influence on this is Schopenhauer. Eisenstein seems to have believed that feeling the dynamic impulse that gives rise to the line opens one to the dynamism of the Will. This also explains why he famously believed in a deep corporeal relation between dancing and drawing—Schopenhauer, it should be remembered, believed that the experience of the inward body provided intimations about the nature of Will.

228 My remarks should make it clear that I believe that Iampolski does not take sufficient account of the fact that for Eisenstein the line is a trace of a movement—that the line is the contour a movement describes. Dynamism is central to Eisenstein's remarks on line.

229 Most readers will know Laurence Binyon as the person who produced what many consider to be the greatest translation of Dante's *Commedia*—the translation that Pound praised so highly. Binyon was also an original writer who produced two volumes of poetry, *Lyric Poems* (1894) and *Odes* (1901). During the First World War he wrote "The Fallen," a poem inscribed on many British cenotaphs. Yet not until after that poem was published did Binyon go to the front, and then as an orderly. After the Armistice he returned to the British Museum's printed books department, where he was in charge of Oriental prints and paintings. Binyon wrote several books on art including, *Painting in the Far East* (1908), *Japanese Art* (1909), *Botticelli* (1913), and *Drawings and Engravings of William Blake* (1922).

230 In the uncompleted *Montazh* (Montage), Eisenstein identified a third phase of montage: "Third Phase. The picture does not move. The generalisation proceeds rhythmically in the melody and harmony of the sound component that simultaneously runs through it" (Eisenstein, "Montage (1937)," in Glenny and Taylor, eds., *Selected Works, Volume II*, p. 247).

This idea has much to do with imitation, which by 1937 he was identifying with the mental process that makes montage possible. But a further description he gave of the third phase is simply astonishing: "actual movement has been transferred to a higher phase, into the realm of vibration." I think that pretty much cinches the case for Eisenstein's esoteric influences: the wonder of the sound film is that it transposes cinema to a vibratory plane.

231 Ibid., pp. 27–28.

232 Ibid., p. 28; the quotation from Chiang Yee is from *The Chinese Eye: An Interpretation of Chinese Painting* (London: Methuen, 1935), pp. 98–99.

233 Georg W.F. Hegel, *The Logic of Hegel*, in William Wallace, trans. and ed., *The Encyclopaedia of the Philosophical Sciences* (Oxford: Oxford University Press, 1968), p. 148.

234 Ibid., pp. 148–49.

235 Any reader of Marx's *Grundrisse* will know just how indebted Marx was to Hegel's *Logik*—and Hiroshi Uchida's *Marx's Grundrisse and Hegel's Logic* (Routledge, 1988) is excellent on this topic, as is Terrell Carver's "Marx—And Hegel's *Logic*" (*Political Studies* 24, no. 1: 57–68). The structure of *Grundrisse* is patterned after the *Wissenschaft der Logik* (1816, 1831): the *Grundrisse*'s "Introduction" corresponds to the *Logik*'s "The Doctrine of Notion"; the *Grundrisse*'s "Chapter on Money" corresponds to the *Logik*'s "The Doctrine of Being"; and the *Grundrisse*'s "Chapter on Capital" corresponds to the *Logik*'s "The Doctrine of Essence." Regarding the influence of Hegel's logic on Marx, it is known that while Marx was writing his *Critique of Political Economy* (1861–63), he reread Hegel's Shorter Logic. And there is that famous statement in the preface to the Second German Edition of *Das Kapital*: "That was why I frankly proclaimed myself a disciple of that

great thinker, and even, in *Das Kapital*, toyed with the use of Hegelian terminology when discussing the theory of value. Although in Hegel's hands dialectic underwent a mystification, this does not obviate the fact that he was the first to expound the general forms of its movement in a comprehensive and fully conscious way. In Hegel's writings, dialectic stands on its head. You must turn it right way up again if you want to discover the rational kernel that is hidden away within the wrappings of mystification." Marx, *Capital: A Critique of Political Economy*, 4th German ed., trans. E. and C. Paul (New York: Dutton, 1930), p. 873.

Eisenstein's claims to be interested in the "general forms of motion" was then quite legitimate, even under the Stalinist tyranny (though of course, as a persecuted writer, he wrote in code).

This reference to writing in code raises questions of methodology, so a methodological note on the imperatives of writing about texts that one suspects were written in code seems to be in order. A text that has helped shaped how I read Eisenstein's writings (especially those texts he wrote after 1928) is Leo Strauss's *Persecution and the Art of Writing* (Chicago: University of Chicago Press, 1988; first published 1952). I find the proposals Strauss offers in that book very helpful in interpreting how writers actually write, not in the enviable world of North American academics, where scholars have often been able to state plainly what they believe, but in a more common world, where persecution is an unfortunate fact of life and where often writers cannot say exactly what they mean. There is plenty of evidence that Eisenstein was a persecuted writer and that interpreting his work requires us to read between the lines. Reading between the lines, of course, is always a dangerous matter, for the process invites unwarranted conjecture. What is more, reading between the lines often requires discounting statements an author actually makes—a practice that should chill the heart of any respectful reader who has absorbed the discipline of heeding the author's actual text. Nonetheless, this dangerous practice is sometimes necessary to discern the meanings of writers who are not free to state their opinions and who learn ways for saying A to mean B that still allow some portion of their readers to recognize that A means B. The sleuthing required involves close readings of texts to expose their inconsistencies, to expose the reasons for believing that though an author states A, he or she does not believe A, a willingness to engage in historical inquiry, and keen understanding of the textual practices that persecuted writers have used. I have attempted to use Strauss's writings on Maimonides, Halevi, and Spinoza as a hermeneutical model.

Strauss argues that "persecution gives rise to a peculiar technique of writing, and therewith to a peculiar type of literature, in which the truth about all crucial things is presented exclusively between the lines" (ibid., p. 25). He states, further: "The fact which makes this literature possible can be expressed in the axiom that thoughtless men are careless readers, and only thoughtful men are careful readers" (ibid.). Strauss goes on to describe when reading between the lines is called for: "One is not entitled to delete a passage, nor to emend its text, before one has fully considered all reasonable possibilities of understanding the passage as it stands—one of these possibilities being that the passage may be ironic. If a master of the art of writing commits such blunders as would shame an intelligent high school boy [the text was written in an era when it was it assumed that writers were normatively male] it is reasonable to assume that they are intentional." (ibid., p. 30).

Thus, following these interpretative protocols, a critic shows that a statement that an author (e.g., Eisenstein) makes really does not make sense in the context that the author stipulates for it, but makes perfect sense in another context (which persecuted writers

often raise only to deny)—the interpreter who follows Strauss's method has the burden of examining the historical context in which the author wrote to expose some themes that would have been available to writers of the period (whether through tradition, in exoteric texts of the time, or in esoteric texts of the period to which the author might have had access) in order to excavate the context in which the offfending statement can be seen to make good sense. This is what I have tried to do with Eisenstein. Thus, when he purports to distinguish his "scientific" conception of synaesthesia from a suspect mystical version discussed by Schlegel and Rimbaud, on the peculiar grounds that the mystical version of linguistically induced synaesthesia is brought by vowels, while the scientifically legitimate version is brought on by consonants, we know we are dealing with a statement that lacks plausibility. The claim is too evidently unwarranted—but as Strauss has recommended, when a master of the art of writing (which I certainly take Eisenstein to be) commits a blunder that would shame a high school student, then a generous reader will take these blunders to be intentional—that is, as indicating that the text should be read at another (unfortunately inexplicit) level. I have tried, as readers who follow these protocols of this hermeneutical practice do, to unearth a context in which Eisenstein claims about synaesthesia become cogent, and this involves considering the ideas that were being covertly discussed in Russia at the time, and drawing connections between different themes in Eisenstein's writings that he himself left deliberately unstated. I have tried to show that when these connections are made, a new shape for Eisenstein's theory comes into relief. Admittedly, this method runs dangers, for it necessarily reads into the texts (reads "between the lines," as Strauss says), but the benefits are twofold: (1) it dispenses with some prima facie blunders (such as that I just referred to); and (2) it sometimes configures a more plausible shape for the outlines of a persecuted writer's thought than can canonical readings that, on methodological grounds, refuse to be read into a text.

To give another example, Eisenstein, when discussing the filmic fourth dimensions, offers this sharp choice: "Einstein? Mysticism?" He then goes on to offer reasons why his views about the fourth dimension should be considered scientific views, views of the sort that Einstein would have endorsed. However, he then goes on to discuss developing an intuition of the fourth dimension that will allow us to feel at home in it and to propose that once we have done that, we will go on to develop an intuition of the fifth dimension. As I point out in the text, Einstein did not discuss developing a feeling for the fourth dimension, or dimensions beyond the fourth. However, Gurdjieff, Ouspensky, Leadbeater, and Steiner all did. We would have to take Eisenstein as scientifically naive to believe that Einstein's ideas on the fourth dimension were as this text presents them. I have too much respect for Eisenstein to conclude that. I believe that there is something else going on in the text—that he is inviting knowledgeable readers to read between the lines. In the text, he protests vigorously against the possibility that his views might be mistaken for those of an occultist. I believe that this is an example of a strategy with which people familiar with the writings of persecuted thinkers are acquainted: a writer who might be criticized for adopting position A may state ironically, "Of course, I would never accept position A—that position is completely bankrupt," thereby raising a defence against the censor, while at the same time providing a clue to those who have discerned the framework of his/her thinking.

Certainly this method has its dangers; as Strauss points out, one runs a risk of being accused of sloppiness or scholarly recklessness by those who are methodologically committed to the principle that "the only presentations of an author's views that can be accepted as true are those ultimately borne out by his explicit statements." However, as

Strauss notes, for persecuted writers, such evidence cannot always be found, so other interpretative protocols are necessary.

236 Indeed, Schopenhauer, Hegel's archrival, likely influenced Eisenstein's belief that dynamic or reality is a form of striving.

237 From Naum Kleinman and Marina Nesteva, "Vydayushchiisya khudozhnik-gumanist," *Sovetskaya muzyka* 9 (1979): 72, in Iampolsky, "The Essential Bone Structure: Mimesis in Eisenstein," in Christie and Taylor, *Eisenstein Rediscovered*, pp. 179–80.

238 Eisenstein, "Montage 1937," p. 30.

239 Ouspensky drew on Neoplatonic thought when he introduced the ideas of ecstasy (*ekstaz*) and image (*obraz*) in *Tertium Organum*; they became common in Russian avant-garde circles in the first decade of the twentieth century; they were used by the poet Kryuchenykh, for example.

240 Iampolsky, "The Essential Bone Structure," pp. 185–86.

241 Iampolski, *The Memory of Tiresias*, p. 238.

242 Eisenstein, "On Colour," pp. 256–57.

243 Ibid., p. 259.

244 Kruchenykh and Khlebnikov offered parallel beliefs to those of Eisenstein, for they argued that there is a primitive substratum to language that reference has concealed. Regarding Eisenstein's interest in Freud: in 1927 he conceived the idea of writing a psychoanalytic autobiography, "My Art in Live" [*sic*], a book whose title certainly played on that of Stanislavsky's autobiography and probably was meant to re-enact Freud's heroic self-analysis. Eisenstein continued to pursue these ideas after 1929, when Freud's influence was officially condemned. He continued to seek out books on psychoanalysis during the 1930s and 1940s: he had books by Sigmund Freud, Alfred Adler, Hans Sachs, Otto Rank, and C.G. Jung in his library.

245 And here she appears to stay close to the facts.

246 Marie Seton, *Eisenstein*, rev. ed. (London: Dobson, 1978), pp. 298–99.

247 Edoardo G. Grossi, "Eisenstein as Theoretician," in Christie and Taylor, *Eisenstein Rediscovered*, pp. 167–76.

248 Jean Mitry, *S.M. Eisenstein* (Paris: Seghers, 1956), pp. 140–41, in Léon Moussinac, *Sergei Eisenstein* (New York: Crown, 1970), p. 87.

249 Ibid.

250 Seton, *Eisenstein*, p. 300.

251 Ibid., p. 301.

252 Eisenstein, "On Colour," p. 261.

253 The fragment is discussed in Iampolsky, "The Essential Bone structure," p. 182.

254 Ibid., pp. 186–87.

POSTSCRIPT

The impetus so evident in the first decades of the twentieth century, to bring forth a new art that would eschew representation, and to do without any depicted objects, has been widely understood as a movement of purification: any element or any formal device that was not rooted in the nature of material would be eliminated from the new art, and its artistic forms would be solidly grounded in the material in which it was realized. Artistic forms profit from being true to the materials in which they are realized—so it was said—as they are then grounded in the real stuff of which they are made. In this way artworks escape from dissembling imitation, the result of their having a derivative existence dependent on their models, and become full-fledged objects with the same sort of material existence that rocks and tables and curling stones have. Another way of bringing the form of an artwork into alignment with the materials in which it is realized is to free it from the corrupting influence of forms imported from other media: painting becomes true to the nature of its material when it understands that it is not drawing (and so dispenses with outlining contours and colouring them in) and not sculpture (and so dispenses with the illusion of three-dimensional forms). Painting becomes painting when it understands that it is produced by smearing coloured goo on a two-dimensional surface (and that, despite the simplicity of the description, offers plenty to be getting on with). Similarly, cinema becomes cinema when it does away with the influence of

literature or theatre and takes as its reality that it is articulated light, light given spatio-temporal form in being projected by a machine that runs at a fixed, nearly unvarying, speed.

One strength of these descriptions is that they placed artistic form at the centre of discussions about the arts. This view taught that artworks do not communicate discursively, through the propositions they impart to us. Artworks communicate differently—they are perlocutional (i.e., their meaning lies in what they *do* to us). Thus, these descriptions established the basis for the more recent development of corporeal aesthetics.

That strength I acknowledge. However, in this book I have tried to propose a new history of the development of early modernist ideals. I have retained the view that early modernism's strength was to acknowledge that the propositional content of artworks has only slight (if any) aesthetic relevance, that their real meaning derives from what they *do* to us. By examining two exemplary moments in early modernist art, I have tried to show that this view of the nature of artworks and their effects, far from being a contemporary discovery, was a well-elaborated, well-defended position in the first decades of the last century. But I argue that notions of how artworks affect us were far different from what they are generally understood to be. In the first decades of the twentieth century it was widely accepted that artworks affect us pneumatically. Once this is understood, I contend, a host of new understandings about the aesthetics of early modernism follow. One of these concerns the importance of cinema for early modernist art. Historians of early modernist art have dealt with the topic of how early modernist artists proposed to recast cinema. They have claimed that its dynamism was attractive to the city-dwelling, automobile-driving denizens of the modern era—but they have also noted that advanced artists of the time believed that cinema could realize its dynamic virtues only by escaping the burden of representation and the pernicious influences of literature and theatre. I have taken a different tack than that of most art historians who write about art and cinema in the early decades of the twentieth century. Instead of focusing first on how Surrealist or Dada or Cubist ideals influenced the form of certain "avant-garde" films made during that period, I have begun by considering the influence that cinema had on modernist ideals (more exactly, the actual programs for aesthetic revision propagated by the artists involved in two exemplary early modernist movements). I have argued that in the early years of the twentieth century, a new "Paragone" of the arts erupted, with many artists and art theorists contending that cinema was the "ottima arte." For them, cinema was a paradigmatic pneumatic influencing machine, one that provided a model of how the other arts should be reformulated. I have attempted to show generally that early modernist artworks whose radical nature still enchants us grew out of a far different climate of ideas than they are generally thought to have had. By examining the intellectual/spiritual

climate in Germany and Russia in the first decades of the twentieth century, I have tried to show that cinema was understood far differently than we, who live after the age of the machine, understand it. Much of this book has focused on examining documents from the period in order to establish how widespread the notion was that the specific virtue of artistic communication is that it operates pneumatically, and that cinema was part of a complex of apparatuses (which included telegraphy, the radio, X-rays, and later electrical devices) that were also understood as confirming the principles of pneumatic philosophy.

I believe that this new history helps us understand aspects of early modernism that traditional accounts cannot explain. Synaesthetic notions challenge beliefs in the rigorous separation of the arts—and so this new history helps explain why, throughout a period that was purportedly dominated by beliefs about the autonomy of each artistic medium, ideas of a synthesis of the arts flourished. The conception of the artwork as a pneumatic influencing machine (or rather a "corporo-pneumatic" influencing machine, for the spiritual movements that we have considered generally considered that spirit can be affected by matter as both arise from a common field of be-ing) helps explain the persistence of the synaesthetic ideal in a way that the more common understanding of early modernist aesthetics cannot. What is more, the assertion that the participants in the various vanguard art movements that arose in the first decades of the twentieth century bring the mediumistic autonomy thesis into question: Just how committed to that ideal could artists be who, having concluded that cinema was the "top art," wanted to reformulate poetry, literature, painting, and performance so that these other arts would take on the virtues of cinema?

I have also explored in some depth some of the benefits of the approach I have taken. For example, I have tried to show that there is a remarkable logic to the development of Eisenstein's theory and practice—that we need neither overemphasize the division of work into sharply demarcated periods, nor ignore the enormous differences between early Eisenstein and late Eisenstein. His work underwent significant transformation, I argue, precisely for the reason that the latent pneumatic ideals he harboured demanded to be more fully acknowledged—he could not have retained his intellectual integrity had he ignored them. I believe that understanding the role this pneumatic philosophy played in Russia in the first decades of the twentieth century allows one to develop a more complete, more integral, view of his oeuvre. And, as I show in the first chapter, this new history also allows us to understand how Constructivism was interpreted when it was exported to Germany.

I stated at the outset that I believe the new history I have proposed can clarify the relations among various twentieth-century vanguard art movements in a way that other approaches have not been able to do. I have shown

that seemingly Apollian avant-garde movements developed out of a far more contestational, anti-Enlightenment spirit than has generally been recognized. To outline the close relation between the seemingly Apollian avant-garde and the more evidently Dionysian avant-garde, by expounding the anti-Enlightenment projects that animated both, is the task for another book.

APPENDIX

VIKING EGGELING'S *DIAGONAL-SYMPHONIE*
AN ANALYSIS

Viking Eggeling's first film, which likely was never exhibited publicly (and possibly was not finished), was *Horizontal-vertikal Orchester* (1923); it was organized, as the title suggests, along vertical and horizontal vectors. His next film was organized on diagonal vectors.[1] P. Adam Sitney explained:

> In his film *Symphonie Diagonale* figures move along alternative diagonal lines crossing the screen from upper left to lower right and from upper right to lower left. At the same time they seem to move in depth from the surface of the screen to an imaginary receding point at its center, as Richter's squares had, and back again. Finally, Eggeling's shapes evolve in straight and elaborately curved lines while they pursue their diagonal and emerging-receding movements. The musicality of *Symphonie Diagonale* comes from its exhaustive use of reciprocal movements. An elaboration along one diagonal axis is mirrored ... by its disunion at another end; a movement into the screen precedes one out of it.[2]

This description is wonderfully precise and careful (as Sitney's writing always is). Nonetheless, I would question whether his description of Eggeling's use of emerging–receding movement is entirely accurate. What is described simply as recession can be experienced in a more ambiguous manner: as much as a shrinking of a form on a two-dimensional surface as the recession of a form

through the third dimension. I shall sometimes use the terms "recession" and "recede," and their contraries, but it should be understood that the language is an inaccurate shorthand, for phenomena that could perhaps be described as shrinking (or expanding) that suggest advancing or receding in depth, are not actually experienced as processive or recessive movements.

Standish D. Lawder remarked that Eggeling's *Diagonal-Symphonie* "must be regarded as much a demonstration of a theory of art as a work of art in itself."[3] The statement is easy to contest, and therefore must be contested. Even so, one must acknowledge that there is an analytical character to Eggeling's work. A spectacularly focused effort—as dedicated and single-minded as Mondrian's in the period 1912 to 1919—led Eggeling to simplify natural forms to calligraphic notations. Having reached these basic, simple, highly schematized elements, he was able to combine these notations freely, to combine them and to vary them, showing them developing and then receding.

Eggeling referred to the principle that preoccupied him while he worked on *Diagonal-Symphonie* as "Eidodynamik" (visual dynamism). This principle maintained that the basic element of cinema was projected light and that it was that element which should be the basis of a film's form. In this regard the film that struck him as the truest was Fernand Léger and Dudley Murphy's *Ballet Mécanique*. The importance of the light's being projected was twofold: it lent light a particular quality; and it gave a temporal shape to changes in light. In unpublished notes from the period of *Diagonal-Symphonie*, Eggeling recorded the following:

> Film. *Passage of time* characterises the invention and creation of forms, an unbroken advance of the absolutely new. Sinking—rising … *Theory of development*: true and striking interpretation. Natural classification to gather the organisms together and to divide the groups into subordinate sections where similarities appear to be still greater and so on. The characters of a group always appear as a common theme which each subordinate section varies in its special way. Relation between the originator and what he creates: a relationship of ideal kinship. The logical, deductive relationship of the forms + chronological continuities of the species … The old *geometry* operated with static figures, the new explores the different variations of a function, which is to say, the continuity of the movement through which an image is produced.[4]

The idea of the different variation of a function no doubt refers to ideas from that branch of mathematics known as analysis, a key topic of which is that of continuous functions. Eggeling understood this field as the mathematics of motion: while artists previously had talked about basic geometrical elements— circles and triangles and squares—he thought in terms of motion paths, of *a* moving from point one to point two while *b* moves from point two to point three, whatever *a* and *b* are (a square, a circle, a rod, a cone, a shape with no

name). *Diagonal-Symphonie* is consistent with this: the basic visual forms it uses are shapes for which we have no names, though they do seem to flow and so have a dynamism.

Lázló Moholy-Nagy confirmed the importance of time in Viking Eggeling's theories. In *Malerei, Photographie, Film*, he wrote that Eggeling was

> the first after the Futurists to do so—further developed the importance of the time problem, which revolutionised the whole existing aesthetic and formulated a scientifically precise set of problems ... His experiments at first borrowed from the complexities of musical composition, its division of time, regulation of tempo and its whole structure. But he gradually began to discover the vision-time element and thus his first work to be constructed as a drama of forms became an ABC of motion phenomena in chiaroscuro and variation of direction.[5]

The film shows the basic elements depicted above, the themes of the film, undergoing evolution from one phrase to the next in a strictly regulated time. These elements serve as instruments the film is played on (Eggeling and Richter formulated this analogy while they were working with scrolls—indeed, these "instruments" are the same elements that Eggeling used in his scroll paintings). In the film, these basic instrumental themes interact with one another through time. Eggeling gave each of these different "instruments" a particular motion.

The *Diagonal-Symphonie* uses many devices derived from cinema's temporal component. Polyphony is one such form of construction: the differential evolution of different visual lines is a key example. Polyphonic development would be impossible in Johann Sebastian Bach's music if music were not an art of time: each of the contrapuntally developing lines (to take that example) would be represented simply as a chord. The concept of polyphony holds no meaning for artworks that do not exist in time, for only through time is it possible to make such a distinction between voices as counterpoint requires.

Furthermore, time allowed symmetry to be handled differently, that is, contrapuntally. Eggeling was interested in *Kontrast-Analogie*, and a symmetrical image has an element of contrast and an element of analogy built into it: half the figure resembles the other half (they are "analogous") but is also the reverse—the opposite of (or a contrast with) the other. In a time-based medium, this *Kontrast-Analogie* can be even more boldly stated by presenting first one half of the image, then the other half—by presenting first one form and then a second that is related to the first by *Konstrast-Analogie*. The mental synthesis of the two forms then represents a synthesis of opposites-in-unity. The possibility of effecting such a synthesis made the serial presentation of symmetrically related forms appealing to Eggeling.

Time also allows morphological evolution to be presented: the components of a drawing do not have to be shown at once. With film, the viewer can observe the actual growth of form (that topic which so intrigued Goethe). Figures are added in succession until the image is complete. The removal of figures need not be done in one step either. At times, Eggeling erased a figure by tracing it, line by line, until it was gone; he also used different shades of grey in time to create the effect of images fading in and out.

An inevitable result of introducing time was the impulse toward rhythm—the thrust to create rhythmic forms: Eggeling had to be concerned not only with the organization of figures in space but also with the organization of figures in time. The duration for which figures remain on the screen, the speed with which they appear and disappear, and the separation between different figures in time all contribute to the rhythm of the piece.

The film has a five-part structure. In the first part, the various themes appear independently or in combination only with a small number of other themes. In the second part of the film (a short section, near the middle in the film's running time), all the themes are combined. In the third part, theme 8 is explored at greater length. In the fourth part, themes 1 and 2 are briefly restated. All the themes reappear for the fifth, concluding part. Eggeling creates varieties of texture by layering different "instruments" in different sections of the piece, creating effects analogous to orchestration in music.

The formal drama of *Diagonal-Symphonie* differs significantly from those of Ruttmann's works. In contrast to the stark architecture that characterizes Ruttmann's best work, the figures in Eggeling's film are filigree-like, small, white shapes on a black background; these filigree forms undergo playful variations. Though the film is based on an elaborately worked-out set of principles, the evolution of the variations does not seemed forced: the lines appear to draw themselves and to dissolve so that their animation has something magical about it. Ruttmann's *Lichtspiel Opus Nr. 1* is dynamic, colourful, exuberant; Eggeling's *Diagonal-Symphonie* is rigorous and complex. Ruttman's film, as we noted earlier, uses elaborate choreographies with many entrances, exits, and collisions, and there is much contrapuntal movement; Eggeling's film treats the screen as an autonomous visual field: forms undergo development or variation within this self-contained space but do not enter or exit from it. Ruttmann's film, with its expansive gestures, exhilarates us; Eggeling's film rewards contemplation of subtle differences. Ruttmann's film follows the traditional dramatic arc and continues to introduce novel forms, novel configurations, and novel patterns of development right to its end; Eggeling begins his film by introducing a complex form—a master shape with many intricate details (many curves, sharp angles, a series of parallel forms that can be seen as coexisting variations, similar to the variations that develop through time)—which essentially represents a synthesis

of the available resources, and then parses this complex form, displaying variants of its various constituents, in patterns that unfold according to principles of contrast and analogy. Thus the master shape serves the film rather as a dominant form; subsequent parts of the film isolate, extract, and develop elements of this whole, rather as some Baroque chamber compositions first present a complex ensemble form and then have solo instruments develop individual parts of this complex. In *Diagonal-Symphonie*, as in a Baroque composition, parts move to the foreground or to the background and forms grow larger and smaller. As in a Baroque composition, sometimes pairs of forms interact with each other, usually antithetically (contrapuntally): one form contracts while the other expands, one form moves in one direction while the other moves in the opposite direction. Finally, as voices in a Baroque composition appear and then disappear, forms in *Diagonal-Symphonie* fade in and fade out.

Richter's *Rhythmus* films, too, are very different from Eggeling's *Diagonal-Symphonie* and from Walther Ruttman's abstract works. Richter's *Rhythmus 21* is a dynamic composition of grey, white, and black rectangular forms (cf. the paintings of Piet Mondrian). This is unlike Walther Ruttman's abstract works, which often use curving, improvisational forms. The screen is treated as a planar surface, and the forms move across its surface, not into or out of it. Richter uses many boundary-echoing devices to contain all the forms within the limits of the frame, and he does not allow forms to bleed over the frame's limits. *Rhythmus 23* resembles Eggeling's *Diagonal-Symphonie*. *Rhythmus 25*, no longer extant, was based on the 1923 scroll *Orchestration der Farbe* and concerned light and colour.

The theme-and-variations structure of *Diagonal-Symphonie* reflects the seven or eight years that Eggeling spent working out his *Generalbaß der Malerei*; the ideas he developed during that period also determined how he introduced dynamism into the film—to "animate" the forms. He created about one hundred variants of a master shape, usually on scrolls containing ten to twenty images. Erna Niemeyer then traced these variations onto tinfoil, cut them out, and animated them by slicing a small portion away and taking a frame.

The film produces hardly any effect of depth; the tension it elicits results exclusively from the relationships of the shapes on the surface and their diagonal development. It thus has the form of a composition that presents a series of variations on a suite of diagonal master themes.

The following analysis presents the film's basic themes and charts the variations they undergo.

SHOT DESCRIPTION/ANALYSIS

Themes from the *Diagonal-Symphonie*

1	2	3	4	5	6	7	8	9	10

Shape 11 is simply an arc of a large circle.
Shape 12 is a variant of shape 7, but flipped, the lines straightened, so that it becomes like a "V" with a long arm, to which is added another line that, together with part of the long arm of the large "V," forms a smaller, inverted "V."

[Times begin with the first image.]

SEQUENCE ONE: 00:00:00–00:00:27

[NB: Shape 1 refers to the triangular shape represented in box one of the legend. Though the form remains basically the same throughout the sequence, it does undergo slight shifts. Differences in the density and number of diagonal lines making up the shape are slight but significant. All shapes represented in the legend should only be considered a point of reference for the shapes that appear on screen.]

Shape 1 appears in the centre of the screen, the straight edge of its base angled toward the top right corner. The shape decreases in size as it traces a diagonal path from the centre to the upper right of the screen, creating the illusion of receding into the artificial depth of the screen, before disappearing.

Shape 1 appears in the centre of the screen with its base angled toward the top left. The shape appears to recede from the centre to the upper left of the screen, then disappears.

Shape 1 appears with its base angled toward the top right of the screen and recedes from the centre to the upper right of the screen. As the original shape recedes it is replaced by a smaller Shape 1 that grows as the original shrinks. As the second shape attains its full size the first shape is at its smallest. Both shapes disappear.

Shape 1 appears, base angled toward the top left of the screen, and recedes toward the lower right of the screen, as an identical shape grows to replace it. Both shapes disappear.

Shape 1 appears, base angled toward the top right of the screen, and recedes toward the top right corner of the screen, as an identical shape grows to replace it. Both shapes disappear.

Shape 1 appears, base angled toward the top left of the screen, and recedes toward the upper right corner of the screen as an identical shape grows to replace it. Both shapes disappear.

Shape 1 appears, base angled toward the top right of the screen, and recedes toward the upper right corner of the screen. An identical shape grows to replace it. Both shapes disappear.

Shape 1 appears, base angled toward the top left of the screen, and recedes toward the upper left corner of the screen. An identical shape grows to replace it. Both shapes disappear.

Shape 1 appears, base toward the top right of the screen, and recedes from the centre toward the upper right corner of the screen. As it shrinks it is replaced by an identical but smaller Shape 1 that has been flipped on its vertical and horizontal axes, its base angled toward the bottom left of the screen. As the second shape attains its full size, the first shape (its mirror image) is at its smallest. Both shapes disappear.

Shape 1 appears, base angled toward the top left of the screen, and recedes from the centre toward the upper left corner of the screen. As it shrinks it is replaced by a second Shape 1 that has been flipped on its horizontal and vertical axes. Both shapes disappear.

Shape 1 appears, base angled toward the top right of the screen, the triangle lengthening in a diagonal from the screen's upper right to lower left. Shape 1 disappears.

Shape 1 appears, base angled toward the top left of the screen, and grows, the triangle lengthening along the diagonal from the screen's upper left to lower right. Shape 1 disappears.

Shape 1 appears, base toward the top right of the screen, and recedes from the centre toward the lower left corner of the screen. An identical shape grows to replace it. Both shapes disappear.

Shape 1 appears, base angled toward the top left of the screen, and recedes from the centre toward the top left corner of the screen. An identical shape grows to replace it. Both shapes disappear.

Shape 1 appears, base angled toward the bottom right corner of the screen, and recedes from the centre to the upper left corner of the screen. An identical shape grows to replace it. Both shapes disappear.

Shape 1 appears, base toward the bottom left of the screen and grows, the triangle lengthening along the diagonal from the screen's lower left to upper right. Shape 1 disappears.

Shape 1 appears, base toward the bottom right of screen, and grows, the triangle lengthening along the diagonal from the screen's lower right to upper left. Shape 1 disappears.

SEQUENCE TWO: 00:00:28–00:00:39

Shape 2 appears at the top centre of the screen. It forms a 45 degree diagonal slash from the upper right to centre left of the screen. Remaining in the same angle and position, Shape 2 undergoes 19 minor variations on its basic form. These variations consist of the disappearing and reappearing of the small lines and angles that constitute the form. The variations occur at a very regular rhythm.

SEQUENCE THREE: 00:00:40–00:01:06

A compound shape appears at the centre of the screen, bisecting the screen from the top right to the bottom left corner at an angle of approximately 45 degrees. The initial cluster consists of the following component shapes (listed from the bottom of the screen to the top): Shape 3, Shape 4, Shape 2.

The compound shape begins to vary, its component shapes appear and disappear (at the same regular rhythm as Shape 2 underwent its own permutations in the second sequence of the film.) The variations are as follows:

Shapes 9 and 10 are added to the cluster.

Shape 2 disappears briefly.

Shape 5 begins to "undraw" itself.

Shape 2 reappears and begins to undergo the same transformations as described in sequence two.

Shapes 3 and 4 begin to undraw and redraw themselves, undergoing permutations of their basic forms.

Shape 10 disappears completely.

Shape 9 disappears completely.

Shapes 3, 4, and 2 continue to undergo transformations at a regular rhythm.

The compound shape disappears and reappears flipped on its horizontal axis, bisecting the screen from the top left corner to the bottom right corner.

Permutations of component Shapes 3, 4, and 2 continue at a regular rhythm.

The compound shape disappears and reappears back in its original orientation.

Permutations of Shapes 3, 4, and 2 continue at a regular rhythm.

The pattern of flipping the cluster of shapes back and forth along its horizontal axis continues. Each time the cluster disappears and reappears (11 times in total), it is held on screen for varying lengths of time (1 to 6 seconds). Shapes 3, 4, and 2 continue their variation in a regular and simultaneous rhythm. Occasionally Shapes 5, 7, and 10 also appear on screen briefly.

SEQUENCE FOUR: 00:01:07–00:01:10

Shapes 6 and 3 appear on screen simultaneously. Shape 3 has its flat base an-
gled toward the top left of the screen and its spine curving down toward
the bottom right. Shape 6 has its flat edge at the centre of the screen at a
45 degree angle. Shape 3 is much larger than Shape 6.

Both shapes disappear and reappear, Shape 3 growing progressively smaller
in three stages as Shape 6 grows progressively larger.

Shape 3 disappears. Shape 6 disappears.

SEQUENCE FIVE: 00:01:11–00:01:14

A compound shape appears at the centre of the screen. It is composed of Shape
3 (base toward the left of the screen) and Shape 12 (angling off from the base
of Shape 3 toward the top centre of the screen) and a larger version of
Shape 12 (tracing the contours of the two other shapes).

Shape 3 undraws and redraws itself (from its shortest vertical line, at the right
of the screen, to its longest, at the left side of the screen) three times over.

Shape 3 and both versions of Shape 12 undraw themselves line by line, emp-
tying the screen gradually.

SEQUENCE SIX: 00:01:14–00:01:24

A compound shape appears at the centre of the screen. It is drawn in line by
line then begins to undergo transformations.

The lower left corner of the screen is occupied by Shape 6, which appears and
then quickly undraws itself, line by line, from bottom to top.

The upper centre of the screen is occupied by a compound shape made up of
Shape 4 and Shape 12.

Shape 4 undraws itself and disappears.

Arrow-like Shape 10 emerges attached to Shape 12. The head of the arrow is po-
sitioned at the centre of the screen while the arching base of the arrow
stretches toward the centre left of the screen.

Shape 12 disappears progressively from the top toward the centre of the screen.

Shape 6 reappears at the bottom left of the screen as Shape 10 is disappearing
from its head to its tip.

Shape 6 undraws itself, line by line, from top to bottom.

SEQUENCE SEVEN: 00:01:25–00:01:29

A new compound shape appears. It is composed of Shape 5 at the upper left
of the cluster and Shape 3 at the lower right of the cluster (at the screen's
centre). The two shapes are joined by Shape 12.

Shape 5 undraws itself.

Shape 3 undraws itself.

Shape 10 draws itself in at the lower right of the cluster (at the screen's centre, with the arrow's head exactly at the centre of the screen and its base arching off to the right of the screen), opposite to where Shape 3 had been.

Shape 12 disappears progressively toward the centre of the screen, where Shape 10 remains.

Shape 10 disappears from head to tip (centre to lower right of the screen).

SEQUENCE EIGHT: 00:01:30−00:01:35

A variation on the compound shape from the previous sequence appears in the upper left corner of the screen. It is constituted of a number of shapes drawn in progressively in the following order: Shape 5 at the right side of the cluster, a variation on Shape 12 positioned at a 45 degree angle from the upper left to lower right of the screen, Shape 3 at the lower left of the cluster.

As soon as Shape 3 is completed, Shape 5 begins to erase itself from top to bottom.

Shape 3 undraws from left to right.

Shape 12 undraws itself from bottom to top as Shape 10 draws itself in at the far left of the cluster with its head facing the centre of the screen and its base arching off to the left.

Shape 10 undraws itself from head to tip.

SEQUENCE NINE: 00:01:36−00:01:44

A compound shape appears progressively. It is nearly identical to the cluster in sequence six.

The lower left corner of the screen is occupied by Shape 6.

Shape 6 undraws itself, line by line, from bottom to top.

The upper centre of the screen is occupied by Shape 3, which is drawn in progressively.

A variation on Shape 12 is drawn in around Shape 3.

Shape 3 undraws itself and disappears as Shape 10 emerges as part of the structure formed by Shape 12. The head of the arrow is exactly at the screen's centre, while the arching base of the arrow stretches toward the centre left of the screen.

The lines of Shape 12 disappear progressively from the screen.

Shape 6 reappears at the bottom left of the screen.

Shape 10 undraws itself from head to tip.

Shape 6 undraws itself, line by line, from top to bottom.

SEQUENCE TEN: 00:01:45–00:01:53

The previous sequence plays itself out over again with all shapes flipped on the vertical axis (which places Shape 6 at the bottom right of the screen and the cluster of shapes at the top left).

SEQUENCE ELEVEN: 00:01:54–00:02:00

Shape 6 appears at the centre left of the screen. It draws and undraws itself several times as a cluster of shapes emerges directly above it in the top left corner of the screen.

This compound shape appears progressively from its top to its bottom. It is made up of the following component shapes: Shape 3 is at the uppermost left of the screen. Its appearance is followed by the appearance of Shape 12, which joins Shape 3 to Shape 5 (positioned close to the top centre of the screen.)

Shape 10 appears at the left centre of the quickly disappearing cluster with its head pointing toward the centre of the screen and its tail arching to the left.

Shape 10 undraws itself from head to tail.

SEQUENCE TWELVE: 00:01:58–00:02:16

A compound shape appears in the centre of the screen. It is a combination of Shape 5 and Shape 1. Shape 5 is positioned vertically at the centre of the screen. Shape 1 is on a 45 degree angle (from left to right, with its flat base at the bottom of the screen) at the base (bottom centre of the screen) of Shape 5.

Shape 5 begins to disappear from top to bottom. Shape 1 disappears from beneath it.

The same compound shape appears (flipped on its vertical axis) and undraws itself in the same pattern.

The compound shape appears (in its original orientation) with the exception of the Shape 1 component, which has been flipped on its horizontal axis leaving its flat base pointing toward the top of the screen. The compound shape undraws itself in the same pattern as previously.

The same compound shape appears (flipped on its vertical axis) and undraws itself in the same pattern.

The original shape appears (in its original orientation with the Shape 1 component in its original position) and undraws itself in the same pattern.

A similar compound shape appears, the only differences being that it is slightly reduced in size and that Shape 5 is made up of two, rather than three, "S" lines. Also, the Shape 1 component is again positioned with its base toward the top of the screen. The compound shape undraws itself in the same pattern.

A similar compound shape appears, the only variations being that it remains slightly reduced in size, Shape 5 is made up of one, rather than two or three, "S" lines, and the Shape 1 component is in its original orientation. It undraws itself in the same fashion as in the previous sequence.

A similar compound shape appears. It is reduced once again in size. The Shape 5 is made up of two "S" lines. The base is flipped on its horizontal axis. It undraws itself in the same pattern.

A similar compound shape appears. Shape 5 is made up of three "S" lines, while the Shape 1 component is in its original position. It undraws itself in the same pattern.

SEQUENCE THIRTEEN: 00:02:17–00:02:22

A compound shape appears to the left of the screen. It is made up of Shape 8 at the bottom centre of the screen, and Shape 1 with its base at the bottom centre of the screen and its lines dissecting the screen at a 45 degree angle. A combination of Shape 5 and Shape 10 is to the upper right of Shape 1. The compound shape undraws itself from the top left corner to bottom centre of the screen.

The compound shape appears again, this time flipped on its vertical axis. It undraws itself from top right to bottom left.

SEQUENCE FOURTEEN: 00:02:23–00:02:26

A compound shape appears progressively from the top left corner of the screen to the bottom centre. It comprises the following shapes, in order of appearance: Shape 5 at the upper left side of the cluster, Shape 11 connecting Shape 5 to Shape 3 (flipped horizontally and vertically), Shape 10 at the right side of the cluster (with its head pointing left and its tail arching right), and Shape 12, which is not directly connected to the cluster but tracks its periphery at the left side of the screen.

The compound shape begins to undraw itself before Shape 12 has finished appearing. Shape 10 at the right of the cluster is the last to disappear.

The same compound shape reappears, flipped on its vertical axis, and the same sequence of events occurs over again.

SEQUENCE FIFTEEN: 00:02:27–00:02:49

A very complex compound shape appears at the left of the screen. It is a variation on the compound shape in sequence 13, though more elaborate. It includes Shape 3, Shape 5, Shape 6, Shape 8, Shape 10, Shape 11, and Shape 12. But Shape 1 is the most prominent component shape. It is oriented at an angle of 45 degrees.

The compound shape appears slightly to the left of centre screen.

Its various component shapes begin to disappear, reappear, and reposition themselves within the cluster, creating a quick and complex rhythm.

The compound shape disappears and reappears flipped on its vertical axis.

The play of disappearing and reappearing begins again.

The compound shape progressively undraws itself, leaving Shape 6 as the last component shape onscreen.

The compound shape reappears in its original orientation. Again the rhythm of disappearing and reappearing plays itself out. The compound shape then undraws itself, leaving Shape 6 the last component shape onscreen.

SEQUENCE SIXTEEN: 00:02:50–00:02:56

Two versions of Shape 6 appear on screen together, one at the very bottom left of the screen, the other higher up and further right. Their identical straight edges are facing each other, their rounded edges outward. They are separated by a gap at least equal in width to the shapes themselves.

The two shapes disappear and reappear with their flat edges almost touching, thus forming a circle split by a slight diagonal gap.

The shapes disappear and reappear briefly at opposite ends of the screen. One semicircle is in the upper left corner of the screen, while the other is in the bottom left. The former is nearly four times bigger than the latter.

The two shapes reappear near the centre of the screen, their flat edges nearly touching. The larger of the two is positioned closer to the top right corner, the smaller is lower down near the bottom left corner. As the larger of the two starts sliding downward toward the bottom left corner of the frame it begins to shrink in size. As the smaller Shape 6 begins sliding upward, toward the upper right corner, it begins to increase in size. Both shapes disappear.

The two shapes reappear briefly at opposite ends of the screen once again. The shape in the upper left corner of the screen is now the smaller, while the shape in the bottom left is nearly 4 times bigger.

The shapes reappear in the centre of the screen with their flat edges nearly touching. The smaller shape is positioned close to the bottom right corner

of the screen, the larger is higher up, near the top left corner of the screen. The smaller shape slides upward, increasing in size at it does, while the larger shape shrinks as it is sliding downward toward the bottom right corner. Both shapes disappear.

The two shapes reappear briefly at opposite ends of the screen once again. The shape in the bottom left corner of the screen is the larger, while the shape in the upper right is the smaller.

The two shapes reappear near the centre of the screen with their two flat edges nearly touching. As the larger of the two starts sliding downward toward the bottom left corner of the frame it begins to shrink in size. As the smaller Shape 6 begins sliding upward, toward the upper right corner, it begins to increase in size. Both shapes disappear.

SEQUENCE SEVENTEEN: 00:02:57–00:03:12

Shape 1 appears with its base angled toward the bottom right corner of the screen. It recedes into the false depth of the screen as it did in the first sequence, sliding toward the bottom right corner as it does so.

Shape 1 appears with its base angled toward the bottom left of the screen. As it recedes toward the top right corner of the screen, an identical shape grows to fill its place.

Shape 1 appears, its base angled toward the top left of the screen. As it shrinks it slides toward the upper left corner of the screen. It is replaced by an identical Shape 1 that has been flipped on its horizontal axis (base facing down), which grows upward, toward the upper left corner. As the second shape attains its full size the first shape is at its smallest. Both shapes disappear.

Shape 1 appears, base angled toward the top right of the screen. As it shrinks and slides toward the upper right corner of the screen it is replaced by an identical Shape 1 that has been flipped on its horizontal axis (base facing down) which grows upward toward the upper right corner. As the second shape attains its full size the first shape is at its smallest. Both shapes disappear.

Shape 1 appears, its base angled toward the bottom right of the screen. As it recedes toward the top left corner of the screen, an identical shape grows to fill its place.

Shape 1 appears, its base angled toward the bottom left of the screen. As it recedes toward the top right corner of the screen, an identical shape grows to fill its place.

Shape 1 appears, its base angled toward the bottom right of the screen. As it recedes toward the upper left corner of the screen, it is replaced by an iden-

tical shape, which grows from the bottom right of the screen. Both shapes disappear.

Shape 1 appears with its base angled toward the bottom left of the screen. It grows diagonally toward the top right corner of the screen.

A small version of Shape 1 appears with its base toward the bottom right of the screen. It grows diagonally toward the top left of the screen.

SEQUENCE EIGHTEEN: 00:03:13–00:04:50

A compound shape appears at the centre of the screen. It is made up of Shape 1, Shape 8, and Shape 12. The multiple lines that make up Shape 1 begin to disappear and reappear in a polyphonic movement that serves to emphasize the diagonal positioning of the cluster of shapes. In the upper left corner a smaller version of Shape 1 (flipped on its vertical axis) is joined to the larger shape by Shape 12. Other small elements appear and disappear rhythmically.

The compound shape flips on its vertical axis and its various components continue to appear and disappear, each with its own rhythm.

The compound shape flips back to its original position and its various components continue to appear and disappear each with its own rhythm.

A new compound shape appears. Shape 1 is the dominant component of the compound shape. But added on to this are a number of small shapes that appear and disappear in and around the main shape. Shape 1, Shape 3, Shape 4, Shape 5, Shape 8, and Shape 12 are present as are other non-identifiable straight lines and curved lines. Each of the many components of this compound shape appear and disappear at their own rhythm, creating a regular polyphonic texture.

The compound shape is flipped on its vertical axis and continues its pattern of movement.

The compound shape reappears in its original position and continues its pattern of movement.

The compound shape is flipped on its vertical axis and continues its pattern of movement.

The compound shape reappears in its original position and continues its pattern of movement.

The compound shape is flipped on its vertical axis and continues its pattern of movement.

The compound shape reappears in its original position and continues its pattern of movement.

The compound shape is flipped on its vertical axis and continues its pattern of movement.

The compound shape reappears in its original position and continues its pattern of movement.

At this point the compound shape becomes progressively more simple. Shape 1 still forms the dominant element of the cluster of shapes. Shapes 10 and 6 are added to the cluster. The shape's rhythm, though it remains polyphonic, as before, becomes slower and simpler.

The compound shape flips on its vertical axis and continues its pattern of movement.

The compound shape reappears in its original position and continues its pattern of movement.

The compound shape flips on its vertical axis and continues its pattern of movement.

The compound shape reappears in its original position and continues its pattern of movement.

The compound shape flips on its vertical axis and continues its pattern of movement.

The compound shape reappears in its original position and continues its pattern of movement.

The compound shape flips on its vertical axis and continues its pattern of movement.

The compound shape reappears in its original position and continues its pattern of movement.

The compound shape flips on its vertical axis and continues its pattern of movement.

The compound shape reappears in its original position and continues its pattern of movement.

As the shape continues its flipping pattern it begins to shrink, thus seeming to recede into the centre of the screen (it flips back and forth an additional seven times).

SEQUENCE NINETEEN: 00:05:00–00:05:22

Shape 1 (flipped on its vertical axis with its base toward the bottom of the screen) appears and recedes from the bottom right to upper left. As it shrinks it is replaced by an identical shape that has been flipped on its vertical axis. As the second shape attains its full size the first shape is at its smallest.

The original Shape 1 begins to grow again, as the second Shape 1 recedes along the same diagonal path on which it grew.

Shape 1 appears at the centre of the screen with its base at the bottom left of the screen, its tip angled toward the top right. It shrinks in size and slides toward the bottom left as an identical shape grows to take its place, sliding from the top right toward the bottom left. Once the second Shape 1 is at full size it begins to shrink back toward the top right as the original Shape 1 grows back, from the bottom left, to retake its original position.

Shape 1 appears with its base near the bottom right of the screen and its tip toward the top left. As it shrinks it is replaced by an identical shape that has been flipped on its vertical axis. As the second shape attains its full size the first shape is at its smallest.

Shape 1 appears with its base near the bottom left of the screen and its tip toward the top right. As it shrinks it is replaced by an identical shape that has been flipped on its vertical axis. As the second shape attains its full size the first shape is at its smallest.

Shape 1 appears with its base near the top left of the screen and its tip toward the bottom right. As it shrinks it is replaced by an identical shape that has been flipped on its vertical axis. As the second shape attains its full size the first shape is at its smallest.

Shape 1 appears with its base toward the bottom left of the screen, its tip toward the upper right. It shrinks and slides toward the upper right. As it shrinks it is replaced by an identical Shape 1 which grows from the bottom left toward the upper right. As the second shape attains its full size the first shape is at its smallest.

Shape 1 appears with its base toward the bottom right of the screen and its tip toward the upper left. It shrinks and slides toward the upper left. As it shrinks it is replaced by an identical Shape 1, which grows from the bottom right toward the upper left. As the second shape attains its full size the first shape is at its smallest.

Shape 1 appears with its base near the bottom left of the screen and its tip toward the top right. As it shrinks it is replaced by an identical shape that has been flipped on its vertical axis. As the second shape attains its full size the first shape is at its smallest.

Shape 1 appears with its base near the bottom right of the screen and its tip toward the top left. As it shrinks it is replaced by an identical shape that has been flipped on its vertical axis. As the second shape attains its full size the first shape is at its smallest.

Shape 1 appears with its base at the bottom left of the screen and its tip toward the top right. As it shrinks and slides toward the bottom left, it is replaced by an identical shape which grows as it slides down from the upper right.

Shape 1 appears with its base at the bottom right of the screen and its tip toward the top left. As it shrinks and slides toward the upper left, it is replaced by an identical shape, which grows as it slides upward from the lower right.

SEQUENCE TWENTY: 00:05:23–00:05:28

Shape 2 appears at the bottom centre of the screen. It forms a diagonal angle from the lower left toward the upper right of the screen at an angle of 45 degrees. Remaining in the same angle and position, Shape 2 undergoes many slight variations on its basic form. These variations consist of lines and angles appearing and disappearing at regular intervals.

SEQUENCE TWENTY-ONE: 00:05:29–00:05:39

Shape 1 appears with its base at the top left of the screen and its tip toward the bottom right. As it shrinks and slides toward the bottom right, it is replaced by an identical shape, which grows as it slides down from the upper left.

Shape 1 appears with its base at the top right of the screen and its tip toward the bottom left. As it shrinks and slides toward the bottom left, it is replaced by an identical shape, which grows as it slides down from the upper right.

Shape 1 appears with its base at the upper left of the screen. The shape lengthens as it grows, its tip sliding toward the bottom right.

Shape 1 appears with its base at the upper right of the screen. The shape lengthens as it grows, its tip sliding toward the bottom left.

Shape 1 appears with its base at the top left of the screen and its tip toward the bottom right. As it shrinks and slides toward the top left, it is replaced by an identical shape, flipped on its horizontal axis, which grows as it slides up from the bottom left.

Shape 1 appears with its base at the bottom left of the screen and its tip toward the top right. As it shrinks and slides toward the bottom left, it is replaced by an identical shape, flipped on its horizontal axis, which grows as it slides down from the top right.

SEQUENCE TWENTY-TWO : 00:05:40–00:05:48

Two versions of Shape 6 appear on the screen in opposite corners. At the top left corner is a small version of the shape, at a 45 degree angle, with its flat edge facing left. Near the bottom right corner of the screen is the second shape, also angled at 45 degrees, its flat edge facing the right side of the screen, this version is approximately four times larger than its partner.

The two shapes begin sliding toward each other in a diagonal path. The larger version shrinks as it slides toward the upper left corner while the smaller version grows and lengthens as it slides toward the bottom right. When each of the shapes reaches the original position of the other they both disappear.

Two versions of Shape 6 appear on the screen. The smaller is in the upper right corner while the larger is in the bottom left. The two slide toward each other on a diagonal path. As the smaller shape slides downward toward the lower left corner, it grows and lengthens. As the larger shape slides upward toward the upper right, it shrinks. When each of the shapes reaches the original position of the other they both disappear.

Two versions of Shape 6 appear on the screen in opposite corners. The smaller shape is in the upper left, while the larger is in the lower right. The two shapes begin sliding toward each other in a diagonal path. The larger version shrinks as it slides toward the upper left corner while the smaller version grows and lengthens as it slides toward the bottom right. When each of the shapes reaches the original position of the other they both disappear.

Two perfectly identical images appear at the centre left of the screen. One is a mirror image of the other, and they are positioned with their flat edges facing inwards at a 45 degree angle, thus creating a circle from two semi-circles.

The two halves separate, repositioning themselves with a gap between them.

SEQUENCE TWENTY-THREE: 00:05:49–00:06:20

A small compound shape appears on the screen. It is a hybrid of Shapes 12 and 6. The base of Shape 12 is positioned at an angle toward the top left corner of the screen. Shape 6 is grafted onto the larger Shape 12.

The compound shape disappears and reappears slightly larger and flipped on its vertical axis.

The compound shape disappears and reappears slightly larger and in its original position.

The compound shape disappears and reappears slightly larger and flipped on its vertical axis.

The compound shape disappears and reappears slightly larger and in its original position.

The compound shape disappears and reappears slightly larger and flipped on its vertical axis.

The compound shape disappears and reappears slightly larger and in its original position. Additional component shapes begin to draw themselves in to the right of the compound shape. Shape 3 is identifiable among them.

The compound shape disappears and reappears flipped on its horizontal axis. The same additional component shapes begin to draw themselves in to the right of the compound shape.

The compound shape disappears and reappears flipped on its vertical axis. Additional component shapes begin to draw themselves in contingent to the original shape. Shape 12 becomes Shape 8, with various other component shapes positioned around it, such as Shape 3, Shape 5, Shape 6, and Shape 11. All the components begin to undraw and redraw themselves at various speeds, creating the same polyphonic rhythm we saw in sequence eighteen.

The compound shape appears briefly flipped on its vertical axis. It disappears and reappears in its original position. The rhythmic movements of the various components continue.

NOTES

1 Erna (Ré) Niemeyer-Soupault declared that the print of the *Diagonal-Symphonie* that commonly circulates is not the original that she and Viking Eggeling worked on: "cette version est un faux." She maintains that the original is not as heavy and that there is more linear subordination of form and line. She suspects that the film was the result of Richter's reworking Eggeling's material.

2 P. Adams Sitney, *Visionary Film: The American Avant-Garde* (Oxford: Oxford University Press, 1979), p. 229.

3 Standish D. Lawder, *The Cubist Cinema* (New York: NYU Press), p. 54.

4 In Louise O'Konor, "The Film Experiments of Viking Eggeling," *Cinema Studies* 2, no. 2 (1966): 29.

5 Lázló Moholy-Nagy, *Painting, Photography, Film*, trans. J. Seligman (London: Lund Humphries, 1969), pp. 20–21.

Newton, Sir Isaac, 28; on colour and sound, 47–48, 52, 171n18; colour theory of, 149, 151–52, 153, 157; and colour top, 177–78n58; Goethe's opposition to, 149, 151–52, 153; and work of Mesmer, 318, 319–20
Nicholas II, and family of, 305–306, 355–56, 380
Niemeyer, Erna, 194–95n208, 198n230, 201n260
non-objective/non-representational art. *See* abstract art
Novalis, 27–28
nudism, 345, 346, 355–56

O

OBMOKhU (Society of Young Artists), 130–31, 268–69
occult: and Absolute Film, 86–106; and abstract art, 15–23; and cinema, 342–43; and Constructivism, 317–31; core beliefs of, 16–17; and sacred geometry, 19–23; and Symbolism, 227, 228–32; and technology, 338–43; and telecommunications technology, 106–10, 325–31; and vibration theory, 24–30, 44. *See also* Absolute Film, and early occult sources/influences; Kircher, Athanasius; Rosicrucianism; Spiritualism; Theosophy
Oetinger, Friedrich Christoph, 87, 180n97
Olcott, Henry Steel, 23
Opoyaz Group (linguistics), 267
Optophone (Hausmann), 66, 69–77
Orthodoxy, Russian, 221, 355; and Eisenstein, 303–304, 409n52; and Kandinsky, 18; liturgy of, as total art form, 304, 426n170; and Malevich, 237; and Rasputin, 306; and universal salvation, 349; and worship of Sophia, 206–209, 210, 213, 234
Ostrovsky, Aleksandr, *Lies (The Forest)*, 289–90
Ostwald, Wilhelm, 241, 317, 335, 417n104
ottima arte, xvii–xviii; cinema as, xix, xxii, xxiv, 246, 363, 440; light-play as, 79; music as, 61–63, 79; painting as, xvii, xx, 41; sculpture as, xvii–xviii; and tensions among the arts, 62–63. See also *Universalpoesie*
Ouspensky, Pyotr, 228, 237–38, 315; on fourth dimension, 238, 252, 369–72; and Ploti-

nus, 368, 426–27n174; *Tertium Organum*, 250, 252, 263n60, 353–54, 368, 370–71, 428n124, 429n189, 436n239

P

painting, xiii, xviii; Constructivist view of, 270–74; and ekphrastic art, xv–xvi, xxvii n3, 28; Leonardo on, xvi–xvii; as *ottima arte*, xvii, xx, 41; vs. poetry, xv–xxv, xxvii–xxviii n4; vs. sculpture, xvii–xviii; and time, 5, 6–7. *See also* visual vs. nonvisual, in arts
"Papus" (Gérard Encausse), 16, 229, 305–306, 409n55
Paracelsus, 318, 320
Paradis, Maria Theresia von, 322, 414n84
Paragone, xix, 246, 440. *See also* arts, interactions/comparisons among; *ottima arte*
Pašánek, Zdeněk, 56
Pavlov, Ivan, and theories of, 283, 296, 324, 333
Péladan, Joséphin, 16, 229
Pepper, John Henry, 105–106
perception, 8–13; and intuition, 14–15; and language, 10–11; and "pure visuality," 10–13; and sensation, 8, 10
Peredvizhniki (Russian realist artists), 225
Pervaia Rabochaia Grupa Konstruktivistov, 268, 276n4
Petrov-Vodkin, Kuzma, 226, 355
phantasmagoria, 104–106
photogram, 39–40
photography, 7, 166–67; and microphotography, 339–40; and modernity's crisis of cognition, xi, 3–5, 8, 13; and photomontage, 166, 290–91
Piaget, Jean, 383
Picabia, Francis, 76, 270; and *Entr'acte*, 163, 164, 165
Picasso, Pablo, 111, 265
Plato, xiv, xviii, 19, 22, 36n29, 86, 220, 242, 361, 378
Platonov, K.I., 324
Plotinus, 28, 90, 218, 308, 368, 426–27n174
pneumatic epistemology: and abstract art, xii–xiii; and cinema, xi, xii; Enlightenment view of, xxvi; and modernity's crisis of cognition, xi, xxv–xxvi
Poe, Edgar Allan, 3–4, 226, 318

FILM+MEDIASTUDIES

Film studies is the critical exploration of cinematic texts as art and entertainment, as well as the industries that produce them and the audiences that consume them. Although a medium barely one hundred years old, film is already transformed through the emergence of new media forms. Media studies is an interdisciplinary field that considers the nature and effects of mass media upon individuals and society and analyzes media content and representations. Despite changing modes of consumption—especially the proliferation of individuated viewing technologies—film has retained its cultural dominance into the 21st century, and it is this transformative moment that the WLU Press Film and Media Studies series addresses.

Our Film and Media Studies series includes topics such as identity, gender, sexuality, class, race, visuality, space, music, new media, aesthetics, genre, youth culture, popular culture, consumer culture, regional/national cinemas, film policy, film theory, and film history.

Wilfrid Laurier University Press invites submissions. For further information, please contact the Series editors, all of whom are in the Department of English and Film Studies at Wilfrid Laurier University:

Dr. Philippa Gates
Email: pgates@wlu.ca

Dr. Russell Kilbourn
Email: rkilbourn@wlu.ca

Dr. Ute Lischke
Email: ulischke@wlu.ca

Department of English and Film Studies
Wilfrid Laurier University
75 University Avenue West
Waterloo, ON N2L 3C5
Canada
Phone: 519-884-0710
Fax: 519-884-8307

Books in the Film and Media Studies Series
Published by Wilfrid Laurier University Press

The Young, the Restless, and the Dead: Interviews with Canadian Filmmakers / George Melnyk, editor / 2008 / xiv + 134 pp. / photos / ISBN 978-1-55458-036-1

Programming Reality: Perspectives on English-Canadian Television / Zoë Druick and Aspa Kotsopoulos, editors / 2008 / x + 344 pp. / photos / ISBN 978-1-55458-010-1

Harmony and Dissent: Film and Avant-garde Art Movements in the Early Twentieth Century / R. Bruce Elder / 2008 / 516 pp. / ISBN 978-1-55458-028-6